Date Due

Seaforth			

BRODART Cat. No. 23 233 Printed in U.S.A.

The Book of Canadian Antiques

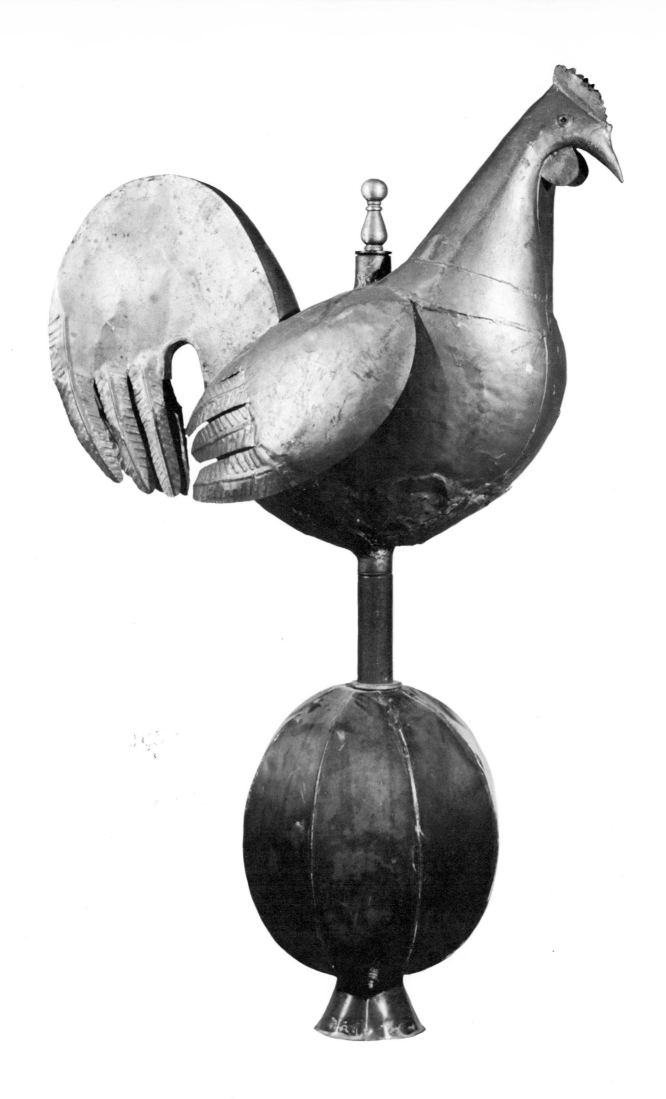

The Book of Canadian Antiques

Edited by Donald Blake Webster

Curator of Canadiana, Royal Ontario Museum

McGraw-Hill Ryerson Limited

Toronto Montreal New York London

ISBN 0-07-082140-2

Library of Congress Catalog Number 74-10381

1 2 3 4 5 6 7 8 9 10 MMT 3 2 1 0 9 8 7 6 5 4

Printed and bound in Canada

Designed by Pirjo Selistemagi
Typeset in Kennerley Old Style
by Moore Type Foundry
Colour separation by Colourgraph Reproduction
Lithographed by McLaren Morris and Todd Ltd.
Bound by John Deyell Limited

Frontispiece:
Sheet-iron gilded weathercock, Quebec, 19th century, in the collection of the Canadiana Department, Royal Ontario Museum.

Contents

The Contributors

UNA ABRAHAMSON, formerly Consumer Affairs Editor of *Chatelaine*, is an active writer and broadcaster on consumer affairs and home economics, as well as an authority on domestic and social history. She is the author of *God Bless Our Home*, a social history of domestic life in Canada, and *Crafts Canada*, as well as articles in *Chatelaine*, *Canadian Antiques Collector* and other magazines. At present in public relations, Una Abrahamson lives in Don Mills, Ontario.

MARY ALLODI is Curatorial Assistant in the Canadiana Department of the Royal Ontario Museum, Toronto, and is compiler of *Canadian Watercolours and Drawings in the Royal Ontario Museum*. She has contributed to *Antiques*, *Canadian Antiques Collector*, *Artscanada* and other periodicals. She lives in Toronto.

HAROLD B. and DOROTHY K. BURNHAM were co-authors of *"Keep me warm one night" Early handweaving in eastern Canada*. The late Harold Burnham was Curator of Textiles at the Royal Ontario Museum and an international authority on textiles. Dorothy Burnham was the first curator of the museum's textile department and has returned to the full time staff as Associate Curator of her old department. Her most recent publication is the museum's booklet *Cut my cote*.

ELIZABETH COLLARD is the author of *Nineteenth-Century Pottery and Porcelain in Canada*, as well as articles in *Antiques*, *Country Life*, *Canadian Antiques Collector* and other periodicals. Internationally recognized for her contribution to the history of ceramics, she has received an honorary LL.D. from Mount Allison University, and is a member of both the English Ceramic Circle and the American Ceramic Circle. She lives in Montreal.

EDITH G. FIRTH is Head of the Canadiana and Manuscripts Section of the Metropolitan Toronto Central Library. She is the author of *The Town of York, 1793–1815* and *The Town of York, 1815-1834*, as well as articles in *Ontario History*, *Canadian Archivist* and other periodicals. She was the Editor, Ontario Series, Champlain Society, 1963–1971, and is now Editor of the *Papers* of the Bibliographical Society of Canada. She lives in Toronto.

S. JAMES GOODING is Director, Museum Restoration Service, and Editor of *The Canadian Journal of Arms Collecting*. His books include *The Canadian Gunsmiths, 1608–1900*, *The Gunsmiths of Canada: A Checklist of Tradesmen* and *An Introduction to British Artillery in North America*. His articles have appeared in *The Canadian Journal of Arms Collecting*, *The American Rifleman*, *The Beaver* and other periodicals. He lives in Ottawa.

RALPH GREENHILL's previous books include *Early Photography in Canada*, *Rural Ontario* (with Verschoyle Blake) and *Niagara* (with Tom Mahoney). Well known both as a photographer and a photo-historian, Ralph Greenhill was at one time an assiduous collector of early photography; his personal collection is now in the National Gallery of Canada. He lives in Don Mills, Ontario.

JANET HOLMES is Curatorial Assistant in the Canadiana Department of the Royal Ontario Museum, and Assistant Professor, Department of Fine Arts, University of Toronto. She is a well known authority on Canadian glass, has contributed articles on glass patterns to *Canadian Antiques Collector*, and lectures on various areas of Canadiana. She lives in Toronto.

HELENA IGNATIEFF is Assistant Curator in the Canadiana Department of the Royal Ontario Museum, Toronto. Long a respected authority on Canadian silver, her articles have appeared in *Canadian Antiques Collector* and *Canadian Interiors*. She lives in Toronto.

The late GEORGE E. G. MACLAREN recently retired as Chief Curator of History at the Nova Scotia Museum, Halifax, and continued as Consultant to that department until his death. He was the author of *The Pictou Book* and *Antique Furniture by Nova Scotia Craftsmen*, booklets on Nova Scotia glass, foundries figureheads, engravers and chairs, as well as numerous articles in periodicals. He lived in Halifax.

A. LYNN MCMURRAY is Head of Geography and Urban Studies at North Toronto Collegiate. His previous works include *Lands of Change* and two books on Toronto. He is a respected collector of Canadian country furniture and folk art, and lives in Toronto.

JEAN PALARDY, O.C., is a specialist in the cultural history of French Canada. His book *The Early Furniture of French Canada* is the leading reference in the field. He is consultant to a number of museums and organizations, including the Museum of Man, the McCord Museum, the Military and Maritime Museum of Montreal, and the restoration of the Fortress of Louisbourg. He is superintendant-consultant for the restoration of the Château de Ramesay and is a member of the Cultural Property Commission of the Province of Quebec and the Jacques Viger Commission of Old Montreal. Jean Palardy lives in Montreal.

LORIS RUSSELL, former Director of the National Museum of Canada, is Curator Emeritus of the Royal Ontario Museum and Professor Emeritus of the University of Toronto. He is the author of *A Heritage of Light* and *Everyday Life in Colonial Canada*, as well as papers and reports in geology, palaeontology, museology and cultural history. He has contributed to the *Canadian Journal of Earth Sciences*, *American Journal of Science* and other periodicals. He lives in Toronto.

HUIA G. RYDER was formerly Art Curator at the New Brunswick Museum, Saint John. She is the author of *Antique Furniture by New Brunswick Craftsmen*, for which she was awarded the Certificate of Merit of the Association of State and Local History, and *Edward John Russell, Marine Artist*, as well as numerous articles in periodicals. She has lectured widely in New Brunswick and Nova Scotia and for four years conducted a television program for the New Brunswick Museum. She is now a free-lance author and historical consultant and lives in West Saint John, New Brunswick.

PHILIP SHACKLETON is one of the leading authorities on early Canadian furniture. As well as being an antique dealer, he has long been a consultant on the restoration and furnishing of period buildings and historic sites, including Upper Canada Village, Dundurn Castle and many others. He is the author of *The Furniture of Old Ontario*. He lives in Manotick, Ontario.

JEAN TRUDEL is Curator of Early Canadian Art at The National Gallery of Canada. He was previously Conservateur de l'art traditionnel, Musée du Québec. One of the leading experts on traditional arts of Quebec, he has contributed to a number of periodicals, including *Vie des arts* and *Canadian Antiques Collector*. He is the author of the book *Un Chef d'oeuvre de l'art ancien du Québec, La Chapelle des Ursulines*. He lives in Hull, Quebec.

NANCY WILLSON is Technician in the Canadiana Department of the Royal Ontario Museum, Toronto, and is a student of early iron and ironwork. She is responsible, among many things, for the conservation of artifacts, including iron, from excavations carried out by the Canadiana Department. She lives in Toronto.

Acknowledgments

It is always the duty of an author (or in this case the general editor), in putting down the final words before a book is complete, to credit all those who have aided and abetted. No one who has contributed should be forgotten; at the same time, by unwritten tradition, such remarks should be mercifully brief.

The writing of this page in my case is a particular pleasure, for though this book has not involved a large number of people, it has called for considerable effort in an enjoyable working relationship. As a complex compilation, the book has proceeded almost unbelievably smoothly and on schedule in all its stages, without any serious delays or malfunctions.

For this, while their names elsewhere cover their own articles, I would thank first of all the individual authors. Without exception they upheld their commitments, submitted their articles with minimum reminder and before deadlines, cooperated in the editing process, corrected their galley proofs promptly, and avoided indulgence in literary preciousness or special demands. Those authors who provided photographs with their articles have my additional thanks, for they made the assemblage and range for illustration selection that much broader, and in some instances went to real trouble to arrange for special color photography.

Robin Brass, general books editor at McGraw-Hill Ryerson, warrants the most special acknowledgment, for this book was his idea in the first place, and it is he who has guided and overseen it in every aspect from the beginning. Maud Wilkie, assistant editor with the publishers, had the monumental function of checking facts, catching inconsistencies, clarifying phraseology, and unifying structure and spelling, from a dozen different writing styles. Pirjo Selistemagi did the layout and design, incorporating widely different types of photographs in nearly every chapter.

In the background areas, Janet Holmes not only contributed her two articles but also compiled much of the bibliography as well as reading my articles and captions. My wife Lonnie, who is my constant editor and mentor, as well as reading and criticising articles and my more editorial sections, provided a considerable input into illustration selection. I would also thank Mr. Charles P. de Volpi who, though he appears here only as "PRIVATE COLLECTION", offered *carte blanche* to his broad collection for illustrations in several articles, and most particularly to his research notes and collection which were substantive to the pewter and copper article.

My special thanks go to the late Harold Burnham, who constantly encouraged this book, and who finished the major part of his article in spite of serious illness.

It seems to me that it is the duty of museums to disperse as broadly as possible the personal knowledge, and the advantages and attributes of the collections which they possess, consistent with preservation of the collections. As curator of the Canadiana Department at the Royal Ontario Museum (an obvious bias), I would not hesitate to say that we have overall the finest and broadest Canadian decorative arts collection in the country. Much of it, unfortunately, is not widely known. Since a large portion of the collection has rarely or never been previously published, I have deliberately chosen to draw on it heavily for illustration, without apology, on the grounds of seizing an opportunity to share what we have.

D.B.W.

Introduction

When the publishers first approached me with the idea of a wide-ranging book on Canadian antiques, I had some initial doubts as to whether the time had yet come for what would essentially be a second-generation book—a compendium of already available knowledge. So much primary research remains to be done in the whole area of Canadian material history and decorative arts that the field is still inadequately explored.

In Canada the popularity of antique collecting has grown so fast that it has outpaced the work of the relatively few scholars in the field, and as a result collecting is based too much on assumption and too little on fact. Building a background of research and publication on any nation's antiquities requires generations, not merely decades, of work. Britain and France have been producing books on antiques for over a century; the United States for some eighty years; Canada for a little more than a dozen years.

We decided, however, that such a book, carefully planned, would be of special value to antique collectors and enthusiasts, as a guide to the fascinating scope of Canadian antiques. Composed of articles by recognized authorities and researchers, it would indeed be a second-generation book but would also include the latest work of a number of authors whose earlier books are in some cases out of print and scarce.

Choosing the topics to be included involved the very definition of an antique as well as the exercise of subjective selectivity. Any book of this sort, however, has its obvious limits, and thus we decided to stick to categories of objects that are undeniably antique, and generally accepted as being of antiquarian and collector interest.

Limiting of geographical coverage became necessary, both because of the absence of previous work or reliable information, and the late settlement dates of some areas. Very little is known, for example, of Newfoundland antiques, beyond some existing pieces of 19th century country furniture. Work is currently in progress on Prince Edward Island furniture, but this still remains to be well defined. In the West, on the other hand, widespread settlement, and particularly population concentration, occurred only after the commercial crafts were already in decline. The Winnipeg area of Manitoba is an exception, and produced some country furniture from the 1850s on, as well as utilitarian pottery, but not of particular distinction or of a regionally characteristic type.

Because so few good specialized-subject Canadian antiques books exist, we have also introduced a few exploratory articles on new categories (for example, pewter and copper). These concern objects certainly "collectable," but which have not previously been studied or written upon from a Canadian aspect, and which therefore are being collected in an information vacuum.

This then is a collector's book, devoted first to outlining just what Canadian antiques are and what the overall range is for collectors. It is not meant to be an in-depth study nor can it possibly be the last word on the subjects included, but we have added an extensive bibliography for those who wish to investigate further. Neither is this book intended to promote collecting; there is little mention of relative prices and values, and no list of dealers or sources of objects. Those who desire must seek, and those who seek may find, and to many collectors, like hunters, the exhilaration of the chase equals or exceeds the ultimate prize of the catch.

Wherever possible, the book emphasizes, deliberately, original quality and esthetic appeal. Age, though it may be a determiner of antiquity, does not alone confer excellence or any particular distinction. The length of time an object has survived does not mean that it is, or ever was, "good" in a qualitative sense. I do not suggest that only antique objects of great taste and sophistication are worthy of attention or collecting—that would be ridiculously short-sighted—but of all the reasons for collecting Canadian antiques, the concept of original quality is generally the least recognized or understood.

Perhaps one reason for this is that the pioneer aspect of history in this country has been quite over-done. Early Canada was not all log houses and rough pine furniture, and this, in

fact, is what people worked mightily to rise above. Most of them did tolerably well. Colonial Canada was never wholly a spinning-wheel and wooden-hay-fork society, and historical over-emphasis of the pioneer syndrome is at least partly responsible for the scalped pine fetish which pervades the Canadian antiques world—the idea that all wood must look raw and pioneer-stereotyped, devoid of original finish or the patina of age. Antiquarians of no other country would put up with some of the destructive refinishing practices that are still standard procedure in Canada.

Another myth which has hindered the appreciation of individual quality in craftsmanship in Canada is the idea that the country began its existence only in 1867, with all prior periods being a sort of colonial dark ages. Confederation in fact was largely a political change, which affected not at all the basic daily life, environment, or the material possessions, of most of the population. The prime period of individual commercial craftsmanship, from the aspect of quality of its products, was the colonial period, both French and English, of approximately 1700 to 1830. By the time of Confederation, both new technology and growing industrialization had already eroded the individual crafts to the point of terminal decline.

Colonial Canada did in fact produce excellent and sophisticated furniture, well designed and fine silver, and other admirable craft work. So tenacious has been the pioneer syndrome, however, that while the collecting of and furnishing with Canadian antiques has become tremendously popular, the aspect of design and craft excellence in Canadian antiques has gone virtually unnoticed. The illustrations for this book have thus been chosen intentionally, as far as possible, to show the best that was produced in preference to the most typical.

What makes an antique, and what makes something collectable? The two are hardly synonymous. One definition I have heard is that antiques are objects which ceased to be made before the memory of any living person, that is, which are approximately 80 years of age. Both Canadian and U.S. Customs use 100 years as a definition for duty-free import. Dictionary definitions are multiple, emphasizing not only great age, but also simple disappearance from common usage. From a present view of the antique collecting scene in Canada, probably the latter definition is the most generally operative.

Though the categories included in this book accord with a very conventional definition of "antique," there is much to be said for the concept that an antique may be any class of object which is no longer in common use, or even obsolete forms of things which are still in use. This brings our definition of an antique very close indeed to contemporary products.

At one time objects which ceased to be produced, or became obsolete, often remained in use for decades or even generations. In our increasingly throw-away age of the 20th century, however, the obsolete object, becoming *closed-ended*, goes out of common use much more rapidly, in a few years or sometimes even months, and thus becomes "antique." Such 20th century antiques (for example, soft drink bottles, comic books, iron toys, advertising signs, and so on), in spite of perhaps massive original production, are also certain to become progressively more scarce. The throw-away environment accelerates the inevitable decrease in numbers of specimens. Going a step further, the "future antiques" concept lies behind the collecting even of contemporary objects, on the grounds that they will ultimately become antiques.

Collecting must be motivated by various factors, some inherent in individual preferences and some in the nature of the objects collected. Specialist collecting (as opposed to the pack-rat approach), a focus on some particular class of object rather than generalized accumulating, presumes a goal as well as basic motivation. Just what makes objects collectable, or desirable for collections? The criterion is obviously not antiquity, since people collect many things other than antiques.

The basic requirement for collectability is probably finite variety—a visible scope to the object category. It is the range encompassed by a collection, in relation to the whole possible scope to be collected, that both gives a collection meaning and stimulates the collector. A limited supply of objects is not a prime requirement for collectability, but scarcity creates demand and price value, and is a corollary to most areas of collecting.

Seashells, for example, collected by many people, are available in unlimited quantity, but offer finite variety in a limited number of existing species. The same is true of stamps, fossils, coins, or minerals. It is the range of examples, from common to rare, rather than the overall quantity, which has clear boundaries.

Conversely, few people seriously collect plastic bar swizzle-sticks, paper matchbook covers, or picture post cards, except perhaps as souvenirs of travels. These are classes of objects with open-ended variety, the collecting of which would offer no challenges. The collector is by nature a competitive animal, striving both toward the potential limits of whatever he collects, and against other collectors of the same.

If, however, the plastic swizzle-stick were rendered obsolete, then it would immediately become closed-ended, antique, and collectable, with somewhere an obvious limit to possible variety. Then swizzle-stick scholars would commence research to determine types and categories, relative rarities, and so on.

Antiques, forever out of production and obsolete for contemporary usage, are closed-ended by their very nature. In time they inevitably decrease in extant numbers, and superimposed antiquarian demand creates additional scarcity or rarity, and hence very substantial prices.

The popularity of antique collecting generally, and of Canadian antiques in particular, has increased very rapidly in the last decade, and, if anything, the pace is accelerating. There are undoubtedly many complex reasons for this, but three come readily to mind. First is the growth of a general national awareness of material history (including architecture as well as portable antiques), probably stimulated in good part by the 1967 Centennial and all that has emerged from it. Secondly, the pressures and frustrations of current urban life seem to have generated a reaction to the pace and plasticity of modern society. This manifests itself, in one way, in an attempt to surround oneself with objects of earlier ages of solidity and material permanency. As a motive for collecting antiques, the nostalgic urge, seeking at least the appearance of a quieter life style, is strong with many people and probably increasing.

Finally, there is an investment and even speculative motive, with a widespread belief that antiques and art generally are a relatively inflation-proof commodity with strong positive growth potential. Thus collecting antiques has become in

recent years much more than an aesthetic avocation and an expression of taste.

The burgeoning of antique collecting in Canada has created a number of problems of which most collectors are unaware. Though Canada at present is hardly overwhelmed with background studies and books on its antiquities, massive collecting has led to the rapid movement of objects in the antiques trade. Great quantities of antiques, some significant, have been taken away from their original contexts or locations without any attempt at recording. This will make future antiques studies that much more difficult, and in some cases impossible.

Rapid price appreciation of antiques has been universal in the western world in recent years, but in Canada it appears somewhat overheated. The Canadian antiques market is heavily geared to popular demand and the influence of fashion, but with little appreciation of the usual standards of quality or rarity. The market is also based too much on guess-work, wish-hope, and speculative instinct, but on no great amount of knowledge. This is easily seen when the appearance of a new book, or even a relatively obscure monograph, on any specific subject leads to a rapid increase in the market prices of objects in that category in a matter of months. The practice of scrape-and-grind furniture refinishing, far too prevalent, is another of the more ruinous influences of fashion, in demanding the re-making of the past to suit the fugitive whims of the moment, to the detriment of the object as a valid antique.

Collecting Canadian antiques, and particularly objects of any historical or cultural significance, requires on the collector's part a certain responsibility to those objects, and to both their meaning and future. For one thing, the collector should develop a sense of material history—the concept that the antiquity collected is not an isolated entity, but is also a physical record of a past culture, domestic environment, and craft or industry. Since few objects self-record their origins by way of integral markings, the aspect of context is most important. The responsible collector or dealer, in finding a significant antique in its original context or location, or acquiring it from descendants of its original owners, should make notes of associated fact and hearsay. That record should stay with the object when it changes hands. Collecting without recording, where the opportunity exists to do so, is the excising of objects forever from their historical perspective.

The collector must also realize, sooner or later, that he can never wholly own the antiques he collects, since objects are granted the potential of considerably greater permanency than are people. The antiques one acquires may already have survived anyone now living, and may also have passed through numerous hands and perhaps previous collections. It then becomes the current collector's duty to maintain and preserve his objects in such a way that they continue to survive.

We might call this the idea of custodianship. The collector may have the power of complete or partial destruction, but he is in effect still only the custodian of his collection while it is in his possession. He has quite likely paid dearly for the objects of this responsibility. Inept housing or care, and destructive refinishing or other incompetent restoration, not only erode his investment, but are a gross disservice to future antiquarians.

Finally, the antiquarian must know what he is doing, and constantly endeavour to learn as much as possible about the subject he is collecting. If he fails in this, he is simply going to wind up financially burned, paying too much for too little on the one hand, or missing bargains for lack of recognition on the other. The same is true in any field which involves the investment of money, whether it be stocks or real estate or whatever.

At the very outset the antique collector should read widely—in background histories as well as in descriptive antiques books. He should examine museum collections, visit dealers, go to antique shows, and generally try to develop a true feel for the antiques field. This I can only call the instinct and judgment of experience, probably as important as simple raw knowledge, but something which must be developed rather than learned.

It should be remembered that the antiques market is anarchistic, too competitive to be self-regulating or collusive, based on supply and demand influences, and subject to little organization and no restraint. There are no effective price standards (and published price "guides" should be treated only as that), and it is common to find two or more virtually identical, or qualitatively indifferent, objects at wildly varied asking prices.

While prime antiques of quality or significance tend to disappear into permanent public or long-term private collections, many other antiques float in the market, changing hands rapidly at ever increasing prices. The concept of "one last buyer," risky but highly operative, follows the idea that no matter how much one has paid for something, there is always at least one other person willing to pay more.

There is little awareness that antiques reproduction and outright fakery are increasing rapidly. Reproduction becomes particularly practical for objects which can be manufactured without too much difficulty, but for which a high demand exists. Most reputable reproductions are marked reasonably permanently by their makers, but still, a bit of "restoration," combined with several unknowledgeable changes of hands, can easily see reproductions bought and sold as original.

The dividing line between reproduction and fakery is indistinct, being a matter of initial intent. Made-up or grossly altered objects, albeit from original parts, markings applied where none originally existed, or the artificial addition to reproductions of the ravages of age, are, let us say, certainly suspicious. The rule of *caveat emptor*, let the buyer beware, must never be forgotten.

Antique collecting is one of the great esthetic pleasures of our over-pressured 20th-century existence, allowing us to wander in nostalgia and escape into history, to indulge in a concrete fashion our taste and expertise, and to make financial investments that can be enjoyed as their value (hopefully) appreciates. At the same time, collecting antiques is a field of activity in which knowledge and sound judgment are the only weapons, and in which being so armed offers the only route to real satisfaction.

D. B. WEBSTER

The Book of Canadian Antiques

French-Canadian Furniture

Jean Palardy

Thanks to France's actively expansionist policy under Richelieu, and thanks also to the creation of large companies and to the determination of the great pioneer, Champlain, New France became a settlement at the beginning of the 17th century. The French came to the shores of the St. Lawrence not merely to establish trading posts, but to create a new country. First to Port Royal, then to Quebec, flocked peasants and craftsmen— a body of settlers who not only contributed to the progress of the *Métropole* but who gradually evolved an original society. Marc Lescarbot tells us that from the first there was official concern to bring to Canada "a number of carpenters, cabinet-makers, locksmiths, masons, tailors, etc."

Most of the settlers were empty-handed common folk, attracted by the dream of liberty in a prodigiously vast and rich land. Risks and dangers there would be, no doubt; but there would also be limitless possibilities. They left France with hearts filled with hope and courage, but with few worldly possessions. They brought with them only light luggage, not only because they were poor but because the ships that brought them were small. They brought little furniture—traveling furniture, we might say: chests in which they stored their few pieces of clothing and tools that would be of prime use to them. Even the rich among them, great officials of church and government, experienced a number of difficulties crossing the formidable barrier of the ocean. Witness the account of Madame de la Peltrie's difficulties in 1639: "Having been unable to find room, reports tell us, for the baggage of her small colony [which included Mother Marie de l'Incarnation], on the boats which were to leave in the spring, having spoken up too late, she had a vessel fitted out at her own expense, loaded it with supplies, furniture and other necessary things, to a total of 8,000 livres."

It is obvious that the common settlers could not afford such expenses as these. Thus, they had to build in this new land the furniture that they needed, just as they had to build the houses which were to shelter them from the rigors of the Canadian climate. The conditions under which the settlers emigrated explain why very little furniture of French origin is to be found in Canada.

The emigrants set to work to recreate as well as they could the style of daily living they had known in France. In their minds, the powerful traditions of their homeland persisted. As most of them came from Normandy, Picardy, Ile de France and the western provinces: Brittany, Saintonge, Aunis, Poitou, the influence of these regions is well represented in Canada, wherever the French settled. Not only in Acadia and the St. Lawrence valley, but as far as Detroit, the Mississippi Valley, and even Louisiana.

Although originally inspired by the distinctive style of their provinces of origin, the first French Canadians gradually created an original architectural style, adapted to the climate and using the materials available to them. The Canadian house sometimes looks like the houses of Normandy, Brittany, Auvergne, Creuse, Corrèze, Cantal and Aveyron, but it is also considerably different from them, as is its furniture.

Compared with the furniture of France, the furniture of New France is massive. Buffets, armoires, commodes, tables, and chairs—all are sturdy. Early Canadian furniture was carved and decorated from solid wood. Although it reproduces the structure of French furniture, it is simpler, and its details have an original rustic accent.

When we look at an early Canadian piece of furniture, we can derive great pleasure from the purity of line which generally prevails, and from discerning the numerous transpositions, interpretations and simplifications that set our furniture apart from French furniture. The Canadian craftsman gave his work a personal touch. To elegance under sturdiness, to simple good taste, to a certain unbalance which upsets anticipated proportions, he added a fanciful and ingenious inventiveness.

CHESTS OR COFFRES

Until the end of the Middle Ages, furniture in the homes of even rich merchants and noblemen was extremely simple. It

which Marie Ivonne Couillard claims to be the one her father Pierre Couillard gave her when she married and in which is the clothing that her father gave her at the time of her marriage to David." In the 18th century, when the armoire became an important piece of furniture, often replacing the chest, the bride took an armoire with her; then, with the evolution of customs, in the 19th century she took a bed, and today she takes a bedroom set.

Chests were generally simple, and sturdy. They were made of tongue-and-groove pine planks held together with dowels and mortise-and-tenon joints. The lid was generally attached by strong hinges and closed at the front with a heavy lock; in fact all ancient chests had a lock and key.

Some chests had several panels separated by stiles. Designs, most often diamond shapes, diamond points, or linen-folds, decorated the panels. Canadian craftsmen simplified to an extreme degree the already strongly stylized panel designs. Another Canadian characteristic, shaped panels, was rare in France.

Many flat-topped or dome-topped chests were covered in calfskin or porpoise skin, but while many inventories mention these, only a few have survived, in convents.

Some chests were made to be placed on special tables which sometimes had spiraled or twisted legs in Henry IV-Louis XIII style. Some tables had bracket feet in the English style and others had a drawer in the lower part of the façade, thus becoming forerunners of the commode.

Chests were generally placed at the foot of the bed, although they might be placed beside the bed or used as a footstool. Sometimes they were placed against the wall of the common room and served as a seat for social evenings during the winter, as in the old song *La destinée, la Rose au bois:*

> *Les garçons en visite*
> *Assis sur le coffre comme c'est bien la façon*
> *Pour jouer la musique*
> *Et aussi le violon.*

(The boys, when paying a visit, would sit on the chest as was the custom and play the harmonica and the violin.)

LOW BUFFETS

The term *bahut* is often incorrectly used to designate the low buffet. Usually made of pine, butternut, or yellow birch, the low buffet generally had two doors and sometimes drawers placed above the doors. The doors and side panels were decorated with lozenges, simplified linen-fold pattern, or diamond-points. Influenced by the Louis XV fashion, these panels and lower rails became shaped. A few low buffets had a bow or serpentine front. In certain very rare cases, the doors had an accentuated bulge in the baroque style.

The dimensions of the low buffet were considerably larger than those of the chest, except for depth. It was mainly used for storing food and dishes.

There appears to be no mention of the low buffet before the 18th century. From then on, according to the inventories, it usually was part of the household furniture. One inventory, dated 1732, describes this piece exactly: "A buffet of pine with two closing doors, furnished with hinges, key and ironwork."

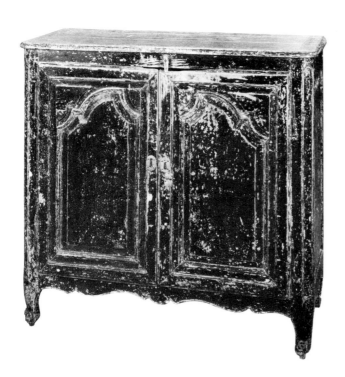

Low buffet or buffet-bas, with Louis XV paneled doors and scrolled feet, from the Lévis area of Quebec, dating probably to the third quarter of the 18th century. This piece has at least three coats of overlying paint, and the original finish has not been determined. CANADIANA, ROYAL ONTARIO MUSEUM

was limited to chests or coffers, tables, dressers, benches, and beds. The chest was the principal storage unit. Rich people stored their clothing, silver and jewels in chests, and peasants stored their clothes and food in chests.

Until the 17th century, the chest was often called a *bahut* or *coffre-bahut.* The chest and the *bahut* are, however, two distinctly different pieces. One can tell them apart by the structure of their lids. The chest is flat-topped, whereas the *bahut* is dome-topped. The *bahut* usually looks like a convex-top traveling trunk, although it is sometimes completely round and of especially small dimensions, so that it might be carried under the arm. The chest, on the other hand, was an important item of household furniture. After 1725, the term *coffre* replaced *bahut* in inventories.

These chests or *bahuts* were the first pieces of furniture that were brought to New France. Numerous references to them are found in archives. An inventory dated 1651 reads ". . . an old wooden chest with several garments." Another, dated 1662, mentions "a dome-topped chest covered in red Levant morocco, locking with a key of medium size."

We have noted previously that flat-topped and dome-topped chests were as common as tables or benches and could be found in every house. In the 17th century the bride always took to her new home a chest as part of her trousseau. And so we read in an inventory dated 1684 ". . . add to this a chest

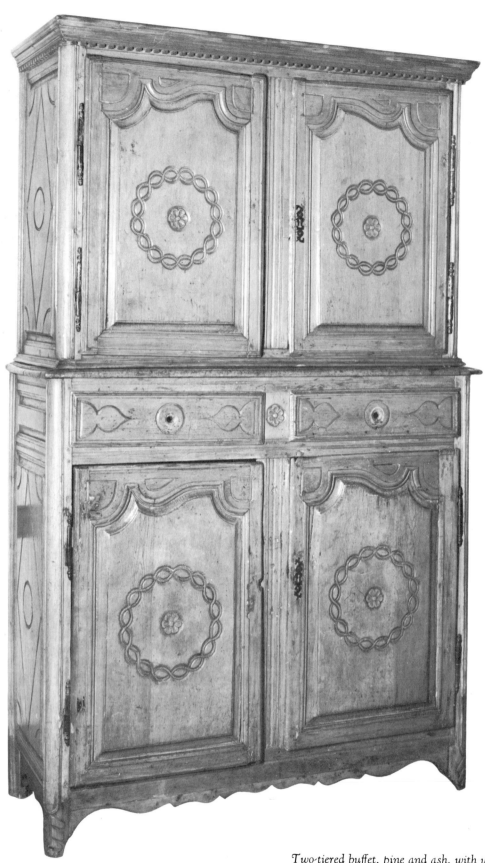

Two-tiered buffet, pine and ash, with upper and lower sections as separate units. The Louis XV panels are carved with rosettes inside geometric wreaths. This handsome piece originated in Sainte-Croix-de-Lotbinière, c. 1780–1800.

CANADIANA, ROYAL ONTARIO MUSEUM

TWO-TIERED BUFFETS

The two-tiered buffet is the principal link between the chest and the armoire. Very simple in structure, it looks like two chests, one set upon the other, or a low buffet set on another buffet of slightly larger dimensions.

The Canadian two-tiered buffet is one of the most beautiful pieces of the 17th and early 18th century, and differs only in detail from the traditional French model. Unfortunately, very few have come down to us. It was used for storing dishes, linen, etc. Here is a description of a two-tiered buffet and its contents, as found in the inventory, dated 1673, of the goods and chattels of Jeanne Mance: ". . . a buffet of jointed birch with four doors, having two drawers locked with two keys . . . opening . . . the buffet with the keys . . . we found the following articles:

First: Ten pairs of unbleached linen sheets, for what they are worth.

Item: Twenty-six chemises, new and old.

Item: A chrisom-cloth in *Couppé* stitch.

Item: Six dozen embroidered napkins and eight linen napkins.

Item: Eight tablecloths of coarse linen.

Item: Three large embroidered tablecloths.

Item: A camisole of *Bazin.*

Item: In the upper part of the buffet, four salt-cellars, an ewer, four plates, a ladle, two candlesticks and the base of another, all of pewter.

Item: In a napkin, about a pound and a half of brown sugar.

Item: In a little linen bag about a half pound of starch, a pound and a half of rice and about a half pound of peppercorns in wooden boxes."

The two-tiered buffets were made of pine, yellow birch, or butternut, with a projecting double molding and panels decorated with low relief lozenges or diamond-points. Sometimes the cornice, always jutting out and rich with moldings, was embellished with a broken pediment in the Italian Renaissance style.

BUFFET-DRESSERS

The dresser or buffet-dresser was very common in Canadian homes in the 18th century. It used to be called "a little buffet with upper shelves." In 1691, "the woodworker Parent undertook to do the woodwork at the house . . . and to make a partition for a cupboard for dishes at the side of the lower room having a door and being tongued and grooved and whitened on the sides, on top of which he will make a dresser to keep dishes. . . ."

The dresser was divided in two parts, the lower being a low buffet, usually having drawers for cutlery and used for storing food and utensils, the top being used as a serving table. Above were the shelves where faïence and pewter were displayed as in a Welsh dresser.

GLAZED BUFFETS

Closely related to the buffet-dresser, the window-doored buffet served the same purpose. The glazed buffet was constructed in either one or two tiers, the lower part being used for food and utensils, and the upper part for dishes. The majority were influenced by English or American styles, although a few have

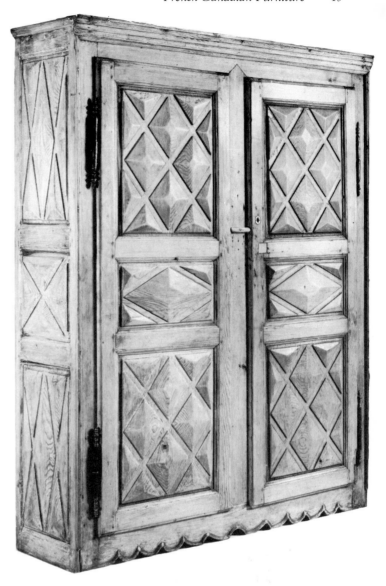

Armoire of the Louis XIII type, of pine, with diamond-point carved door and end panels. The iron hinges of this piece, with decorative turned finials as extensions of the pivot pins, are much larger than the usual armoire hinge. This armoire dates c. 1720-40.

CANADIANA, ROYAL ONTARIO MUSEUM

shaped panels in the Louis XV style. During the 18th and 19th centuries, these pieces were found in large farmhouses and wealthy homes, where they were used either as buffets or bookcases.

CORNER CABINETS

Corner cabinets or cupboards were also called *buffets d'encoignure* or *écoinçons.* In Canada they are still called *armoires de coins, coinçons,* or *coins.*

The corner cabinet's lower section formed a buffet and had one or two doors. Like the low buffet, it sometimes had one or two drawers. The upper section was most often glazed and used for displaying plates.

Corner cabinets became popular in rural districts of French Canada around the middle of the 18th century and continued to be made until the middle of the 19th century. The earliest ones were built at the same time as the house, across one corner of the common room, and consisted only of a front attached to the whitewashed wall of roughcast.

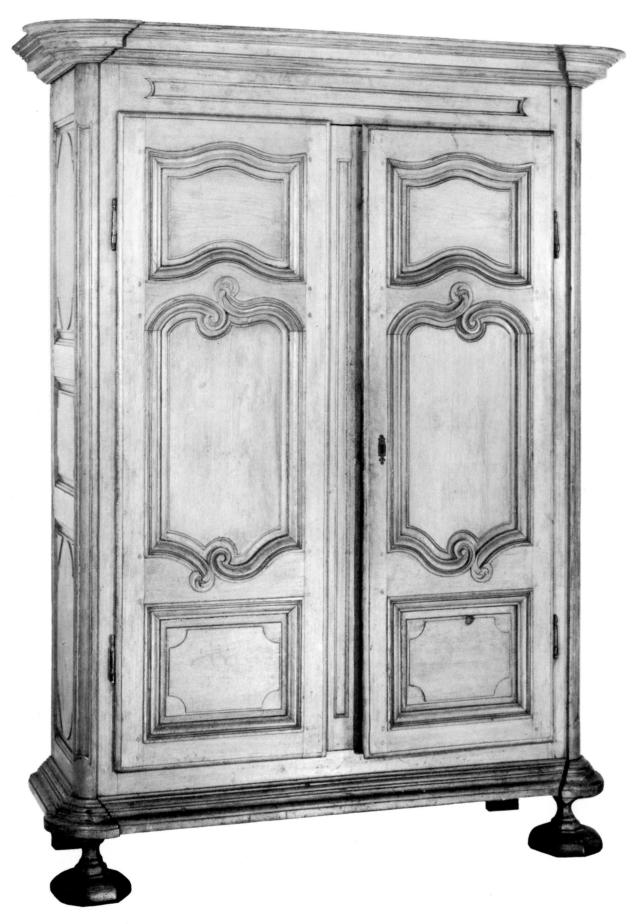

Burgundian armoire, pine, with large mushroom feet separate
from the vertical corner posts, shaped door panels, and a heavy
top cornice which is removable as a unit, a feature most uncommon
in Canadian armoires. The piece dates from the mid- or late
18th century.

CANADIANA, ROYAL ONTARIO MUSEUM

Armoire, pine, with door and end panels carved with lozenge and ▷
diamond-point designs. So-called diamond-point armoires are a
Louis XIII form, and in Quebec date from the early 18th century.
This rather elaborate example is from Yamachiche, Quebec,
dating c. 1720–40.

QUEBEC MUSEUM

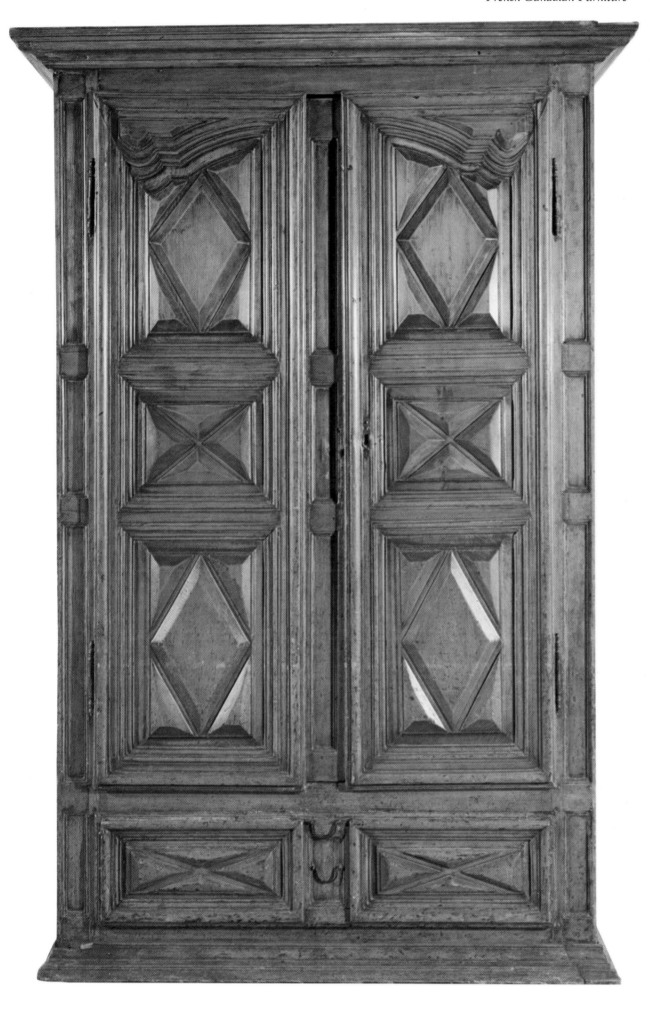

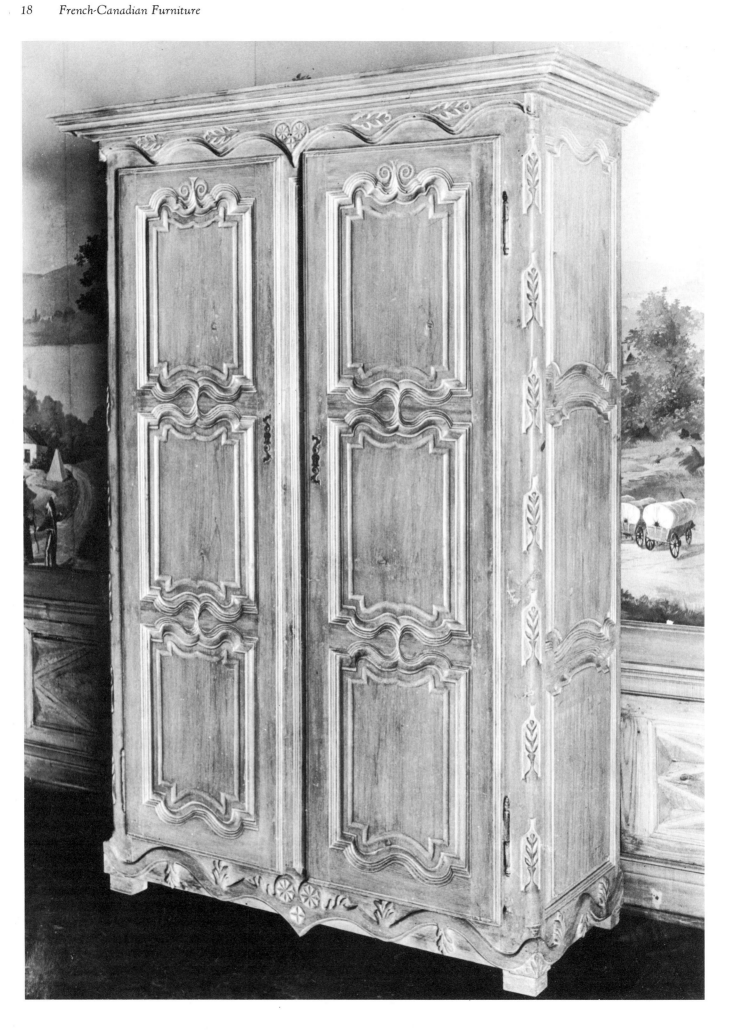

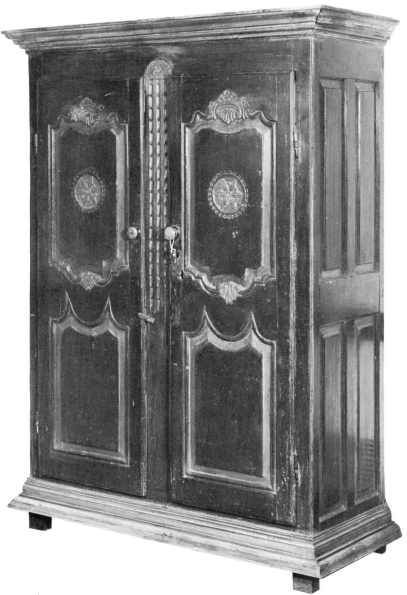

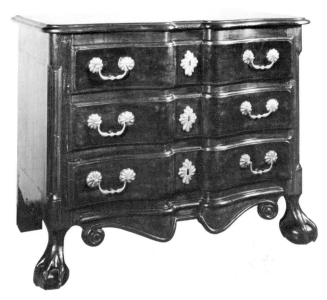

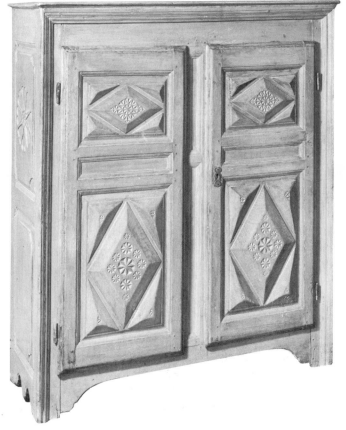

△
Armoire, with Louis XV shaped door panels, and rosettes carved in the upper panels with scrollwork in the stiles. The somewhat Gothic points of the lower panels are unusual. This armoire, which has 19th-century green paint overlying the original lighter green, came from Les Cèdres, Quebec, and was made in the late 18th or very early 19th century.
CANADIANA, ROYAL ONTARIO MUSEUM

Commode, stained butternut in a Louis XVI manner, with △ arbalète drawer fronts block-carved from solid sections of wood, and large ball and claw feet. This is a very large and imposing piece for a Quebec commode, and dates from the mid-18th century.
CANADIANA, ROYAL ONTARIO MUSEUM

Small armoire, with diamond-point door panels but concave cor- ▷ nered end panels, and very unusual geometric rosette carving. Of pine, as are all but a very few Quebec armoires, this piece is from Yamachiche, Quebec, and dates from the first half of the 18th century.
QUEBEC MUSEUM

◁ An extremely elaborate armoire with shaped and grooved panels, and relief-carved vase and foliage motifs as well as geometric motifs. This piece was found in Batiscan, Quebec, and dates from the latter half of the 18th century.
CANADIANA, ROYAL ONTARIO MUSEUM

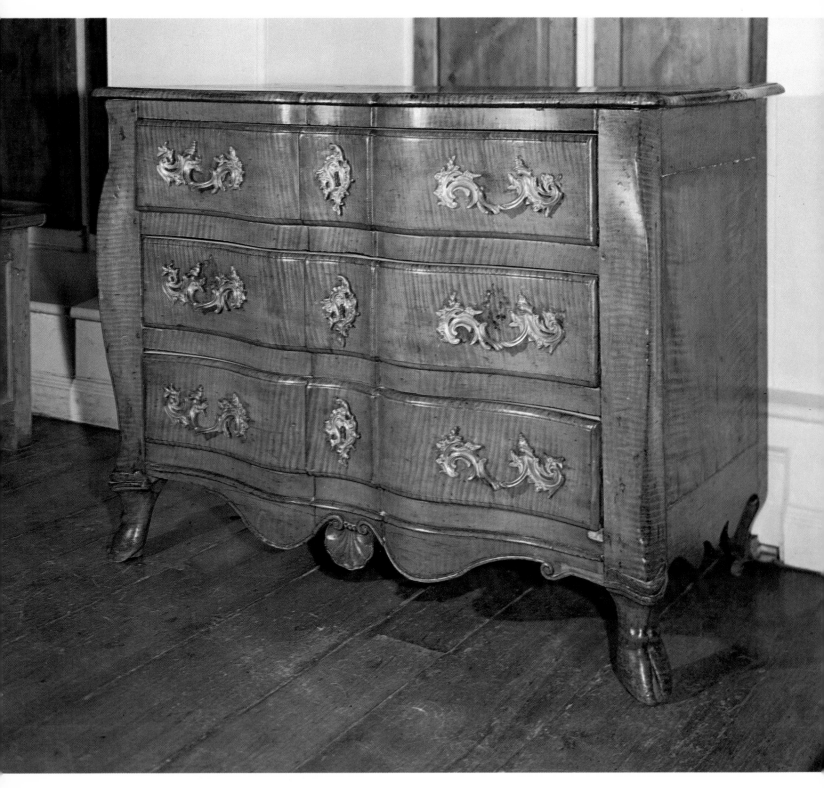

Commode, curly maple, with serpentine drawer fronts, shaped and carved skirt, and feet as animal hoofs in a Louis XIV manner. This is a most unusual piece from the Montreal area, and dates c. 1770–90. MONTREAL MUSEUM OF FINE ARTS

Armoire, pine, with shaped Louis XV panels and original red ▷ paint. This very large and imposing piece is from the St-Marc-sur-Richelieu area, c. 1780. CANADIANA, ROYAL ONTARIO MUSEUM

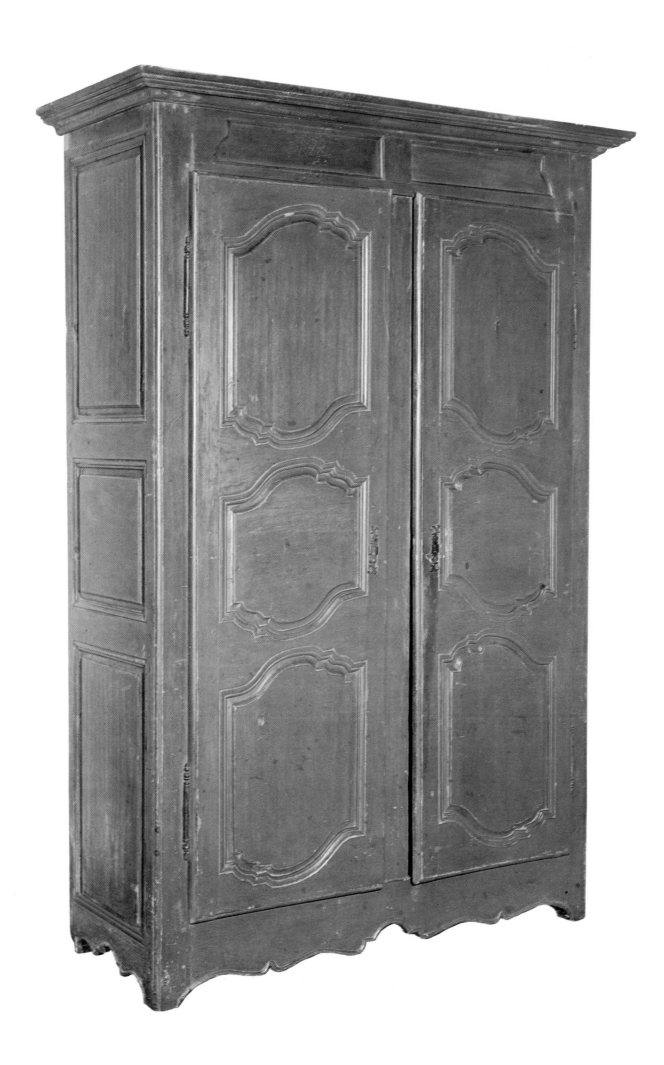

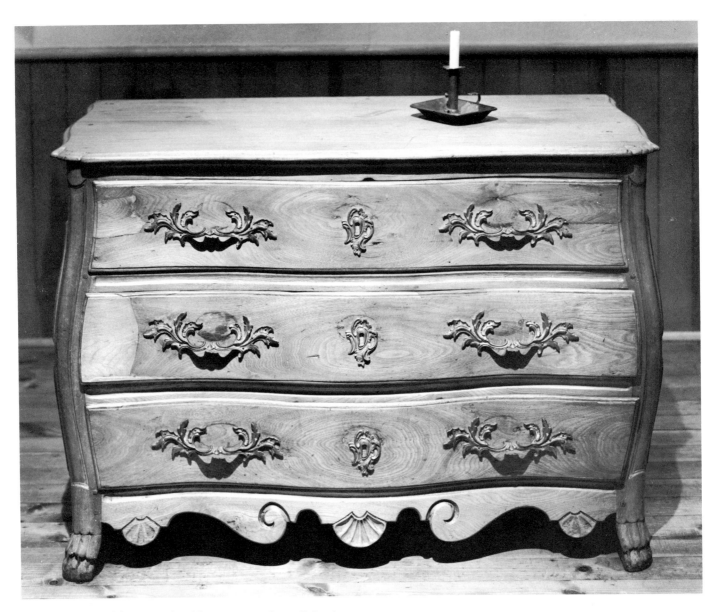

Tombeau or bombée *commode of butternut, with swelled sides and serpentine front, scroll- and shell-carved skirt, and claw feet.* Bombée *commodes of Quebec origin are extremely rare; only six examples are known. This piece, of the late 18th century, may be from the Eastern Townships area.*

CANADIANA, ROYAL ONTARIO MUSEUM

Corner cabinets were either separately two-tiered, or built in one piece; some had a flat façade, some a bow front, and others a serpentine front. In a few exceptional cases, the upper section had shelves or open steps which receded and became narrower towards the top. Some had no lower section and were little more than hanging shelves (with or without glass doors) attached to the wall.

The corner cabinet was given a place of honor in one corner of the common room and later of the parlor. The housewife always took great pride in her corner cabinet, in which she displayed her bibelots and prettiest dishes.

ARMOIRES

The armoire was derived from the chest, through the buffet. An early armoire, like a two-tiered buffet, looks like two chests placed one upon the other; its framework, however, is in one piece. The façade of the early armoire has four (*armoire à l'ancienne*) or two doors. (Wardrobes [[*bonnetières*]] have only one door.) The armoire, like the two-tiered buffet is topped with a cornice.

The most common sort of armoire has two doors. The earliest armoires had doors with simple panels, sometimes carved with lozenges, inside a double frame of projecting molding. This decoration was succeeded by the diamond-point motif in high relief. Antique dealers and collectors often confuse lozenges and diamond-points. Lozenges do not project; their apparent relief is caused by grooves cut in the panels. Diamond-points, on the other hand, are carved out of a thick panel in relief. The lozenge made its appearance on armoire doors in the 17th century, and it was not until the 18th century that it was transformed into a diamond-point. The evolution of the diamond-point design began when the carved outline of

the lozenge became deeper and the sides were beveled. Soon after, diamond-points in high relief began to appear.

The armoire is one of the most interesting and elaborate of the rural pieces. Because of its large surface, it gave cabinet-makers the opportunity to use a wide variety of structural design and decoration. Generally speaking, Canadian armoires lack balance because of the bulkiness of their top and bottom rails. In France this feature rarely appears except in a few Lorraine armoires. Other characteristics of the Canadian armoire and two-tiered buffet are the cornices, rails and uprights of the doors. Cornices usually projected, and doors had some curious combinations of moldings. In spite of these awkward touches, Canadian armoires have an appealing, slightly primitive air. They were always held together, like smaller pieces, with mortise-and-tenon joints and pegs, and were not glued.

The fantasy period of the Canadian armoire coincided with the era of prosperity following the Seven Years' War. It brought with it an abundance of ornamentation in the spirit of Louis XV, interpreted in Canadian fashion—center posts carved with foliated scroll-work, shaped doors, and panels and bottom rails ornamented with multiple spirals, rosettes and shells. Later, the panels, center-posts, stiles and rails over-flowed with foliage, seaweed, hearts, suns, ribbons, fluting, reeding and fine zig-zag incisions, the last suggesting Iroquois and Huron ceramic motifs and also resembling the designs found on certain armoires from the Bresse area of Burgundy.

Elegant armoires combining the spirit of both Louis XVI and the English Adam brothers began to make their appearance towards the end of the 18th century. The Adam style seems to be the English style that had most influence on French-Canadian craftsmen. Some of the late 18th-century armoires and several rare two-tiered buffets with dome tops and bulging fronts and sides have been preserved. A notable example of this style is attributed to François Baillairgé.

There were also armoires and commodes in the Canadian rococo style derived, after an interval, from Louis XV *rocaille*, which began to appear in the late 18th and early 19th centuries. They were made in the Montreal region in the workshops of church carvers and woodworkers such as the Liéberts, the Quévillons, the Pépins and their apprentices.

COMMODES

Havard, in his *Dictionnaire de l'Ameublement* asserts that the commode, like the armoire, was originally inspired by the coffer. The commode was first introduced in Paris between 1695 and 1700. It has been shown that the beginning of this evolution was the introduction of a drawer at the bottom of the coffer. It seems plausible that gradually the interior of the coffer was entirely fitted with drawers. Indeed, the small coffer that Madame d'Ailleboust bequeathed to the sisters of the Hôtel-Dieu de Québec in 1685 may be considered an example of the transitional commode-coffer, consisting as it does of a small coffer with two drawers resting on a Louis XIII base. If this piece dates before 1685, and it is difficult to doubt that it does, it predates the recorded appearance of the first French commode in 1695.

Mr. de Salverte, on the other hand, states that the commode is derived from the "Mazarin" desk whose drawers were extended. This transformation does not seem to have been made before 1690. According to Guillaume Janneau, the first

commodes, works of the master cabinet-maker Charles André Boulle, appeared around 1695.

In France, the commode was never very popular in peasant homes and did not appear in country districts until after 1750.

E. Z. Massicotte, after intensive research into ancient inventories, states that the commode did not appear in Canada until after 1750. I have found in my own researches, however, that some commodes existed in New France as early as 1745. In the inventory of possessions of Jean Boucher *dit* Belleville, dated May 3rd, 1745, we read, "In the room was found a commode of walnut with brass ornaments including six handles and fittings, appraised and valued at thirty-five livres. . . ." Also, in 1749 Madame Bégon wished to sell her furniture before leaving for France. She complained that an agent of the *intendant* Bigot did not want "to take dining tables or commodes. He preferred to have them made."

Commodes seem to have been very rare in the middle of the 18th century, but from the end of the century they were mentioned more frequently in inventories. They were increasingly found in habitant homes in Canada during the period of peace and prosperity which dates from the British conquest until 1830. The fact that they were a luxury item did not prevent the habitant from having them made for himself, just as he ordered spoons, forks and goblets of silver from native silversmiths. Louis Franquet, the Royal Engineer, while on a mission to Canada, stopped at an inn in La Chesnaye to spend the night. He wrote: "Stayed at the inn of Madame Lamothe, store keeper; best reception; ate well and slept even better; efficient service; passed a comfortable night in clean beds of the *duchesse* type. Judging from the furnishings of this house, one must conclude that the country folk here are too well off. . . ."

According to my observations, the earliest commodes had a flat front with three or four drawers. They were sturdy pieces with strong stiles and a slightly shaped bottom rail. The drawers had moldings all around them and the feet were straight. They were most often built of butternut, pine, yellow birch, or wavy maple.

Next to appear were commodes with rounded corners, serpentine fronted with plain sides or with shaped panels on the side. A few took on sinuous lines with a dip in the curve of the façade—the so-called *arbalète*-fronted or crossbow commode. Others had bow fronts or projecting fronts, after the English or American breakfront model. Others, called *Régence* commodes, had a serpentine front, shaped sides and stiles, and cabriole feet.

By examining the structure of these commodes, one can see that the stiles have been carved from a single piece of wood and the front has been cut by a shaping saw from a single thick plank. The craftsmen did not take the trouble to shape the interior as was done in the drawers of French commodes. In Canada there was no reason to skimp on wood. On the other hand, Canadian commodes were rather small compared with French commodes of the same period, which were large and sometimes bulky. The sides of the drawers were generally dovetailed with one enormous dovetail in the middle and a half dovetail at the top and bottom, the whole being consolidated with a big hand-forged nail. In nearly two centuries the joints have not loosened. The backs of Canadian commodes

are generally made of wide planks, tongued and grooved, and assembled horizontally. Channels are cut in the back stiles of the commode and the boards are slid into position from top to bottom. The ends of these boards are either thinned to make a flat molding like those around the edges of an armoire panel, or simply beveled with a gouge or ax.

There were very few commodes of the *tombeau* type (called *bombée* in Canada), the façade and sides of which swelled out considerably and the lower rails of which were extravagantly curved, with a central decoration of carved shells and flowers.

In another type of commode, the drawer façades were embellished with small rectangular panels, with a tiny panel in the center for the keyhole. It resembled the French commodes of the Dauphiné and Lyonnais districts.

At the beginning of the 19th century, the commode with a pierced or open-work lower rail decorated with Louis XV *rocaille* appeared. This commode was made by church carvers who drew upon *rocaille* designs but gave them a heavy rococo appearance. The façade of these commodes was generally serpentine-fronted but projecting in the center—Canadian in character but inspired by the American breakfront. The cabriole feet were Louis XV in style, a long S with curve and countercurve, decorated with shaped floral motifs. On the stiles and lower rails there were sometimes floral designs of the Louis XVI period, such as interlacing, fluting, palmettes, etc. Some of these commodes, typical of the work of Quévillon and his apprentices, lack simplicity and elegance compared to other commodes of the same era. They are nevertheless beautiful and very Canadian.

The most popular type of commode between 1775 and 1825 in Canada, especially in the Montreal region, was the *arbalète*-fronted or crossbow commode, whose feet were carved in claw-and-ball design—the claws of a lion or griffin, the talons of an eagle, or even an old human hand with knotty fingers gripping a ball. Where did the Canadian cabinetmakers get this idea? They were not inspired by the large church candlesticks, for which this type of foot did not make its appearance until the end of the 18th century, when English woodworkers and cabinetmakers had set up shop in Quebec and Montreal. In the English styles of those days there was an enormous variety of spiral and claw-and-ball feet. They appear on the Queen Anne, William and Mary, and Chippendale designs which reached New England around 1760. The claw-and-ball design is Chippendale rococo in origin and its influence can be traced as far as the Low Countries. The Dutch (and Venetians) were themselves influenced by Chinese bronzes which they brought from the East. In France, this type of foot was unknown except in the Bordeaux region where there was lively trade with England.

There is an amazing variety of Canadian commodes, all of which are interesting. Generally speaking, Canadian craftsmen showed imagination in their work and little respect for traditional design.

BEDS

Beds were given various names in Canada between 1650 and 1760—*cabanes* (closed beds), *lits à quenouilles*, *lits à colonnes* (four posters), *châlits*, *bois de lit* (bedsteads), *couchettes* (cots), *roulettes* (truckle-beds). Very few examples of these beds have come down to us.

The *cabane* was popular in 17th and 18th centuries, but disappeared when stoves were introduced. It was a type of enclosed bed, rougher than those of Brittany or Auvergne, built of spruce, balsam, or pine planks with one or two doors. Mother Marie de l'Incarnation recorded in 1644 that "our beds are made of wood, and close like armoires, and although they are lined with blankets or serge, it is difficult to keep warm." In other words, a *cabane* was simply a large box or cabinet with one or two doors, made of planks and covered on top. The bed itself, with a plank bottom, was most often built all of a piece with the cabin, though sometimes a four-poster bed or cot was placed in the interior.

It was related in 1661 that Sister de Bresolles "having gone to bed in one of the plank *cabanes* built in the Canadian fashion, the better to protect herself from the cold, heard three distinct knocks behind her head and some moaning. . . ." It was Sister Pilon, one of her companions who had died several days before and who had returned to give her a mysterious message.

These *cabanes* were designed in the early days of the colony as protection against the cold and the glacial draughts which blew in through every crack of the large common room, where the only heat was provided by one or two fires which generally died down during the night. The *cabane* also provided privacy for undressing and sleeping in early colonial common rooms where men and women, soldiers and clergy all lived side by side. The Abbé Charles Glandelet, in his *Notes* on Sister Marie Barbier of the Assumption, of the Congregation of Notre Dame, wrote that "a young man approached her with very wicked intentions while she was asleep, and tried to force open the doors of the *cabane* in which was her bed. He almost succeeded in doing so, being the stronger of the two, but she addressed herself to that Mother of Love and Purity, who instantly gave her such strength in holding the doors shut, that the other found himself obliged to withdraw." Here is proof that *cabanes* had doors. They also served as wardrobes where clothing and personal belongings were kept.

Four-posters and bedsteads were to be found in nearly every house. They had curtains which could be drawn for privacy and to keep out the cold. The high posts at each corner might be chamfered, tapering towards the top ("pencil-point beds" in New England), or turned in spindles, or formed like spiralled or twisted columns. On the upper frame was attached the linen canopy, called *ciel de lit*. Many beds had two posts at the foot and a large tapestry-covered panel at the head, for extra warmth.

Another type of bed, which may possibly have been the celebrated *lit à la duchesse*, was observed in 1776 in several country homes in the Batiscan region by a German officer in the Hessian troops during the American War of Independence. "There is at least one double bed in each bedroom and the bed-curtains usually hang from a square baldaquin which is attached to the ceiling. The beds are square and without posts."

Terminology led to some confusion in Canada in the 17th and 18th centuries. Four-poster beds (*lits à quenouilles*) were also termed *bois de lit*. *Châlit* was also confused with the four-poster. The *châlit* in France was a frame of wood on which a mattress was placed, and it had a wooden headboard.

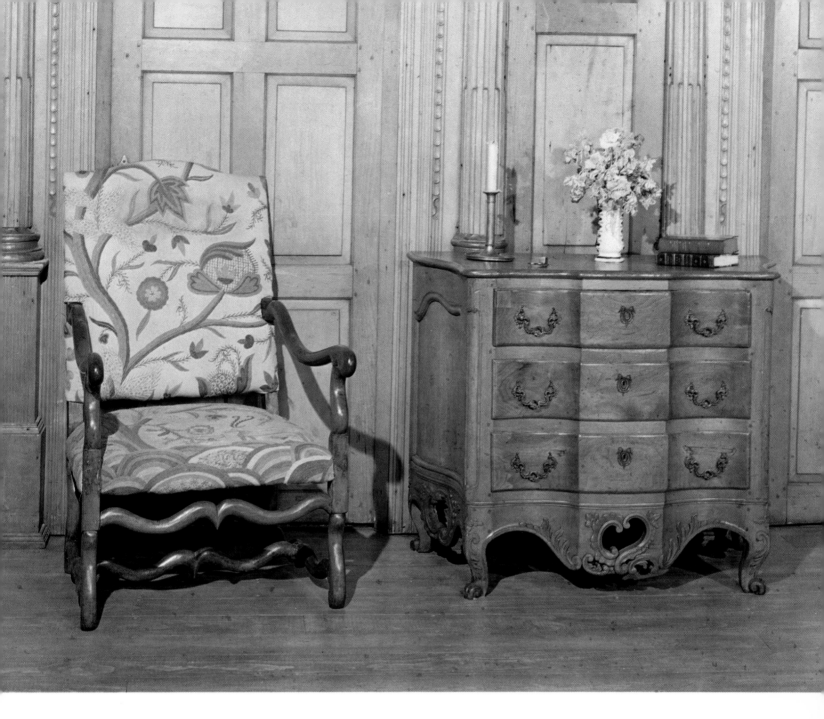

Left: Armchair, maple, of the Louis XIII os de mouton *type, the name coming from the shape of legs and stretchers. Such elegant chairs as a Quebec form are quite uncommon, and most examples date from the mid-18th century.*
Right: Commode, butternut, with breakfront drawers, serpentine sides, and Louis XV rocaille *carved skirt and legs. Montreal area, c. 1770–1800.* CANADIANA, ROYAL ONTARIO MUSEUM

Birch cots with turned or plain legs are mentioned in inventories. There is no mention of drapes or curtains in the description of these cots. They were low bedsteads with neither posts nor canopy—open beds in the style of 19th century cots. No early specimens of these cots have been found.

There were also trestle-beds (*baudets*) and truckle-beds (*roulettes*). The trestles were folding bed-frames covered with coarse linen. Truckle-beds were small, low children's cots, which probably had casters fitted to the feet to enable them to be pushed under larger beds during the day.

Sleigh beds or *carriole* beds (called *lits-bateaux* in Languedoc) were introduced in the 19th century. They took their design from the Late Empire period. Spindle beds were also to

be found in many Canadian houses in the 19th century, and were still being made at Murray Bay about 1930 for summer residences.

All these beds had bolsters, palliasses and mattresses which were filled with straw, chicken or duck feathers, goose down, milkweed, or the feathers of carrier pigeons. The last seem to have been exceptional and only the richer bourgeois could afford them.

The bed has always played an important role in Canadian customs and continues to do so. It represents all stages of family life, being intimately linked with marriage and with the subsequent births. Children of a first marriage are distinguished from those of a second by being called children from the first

Louis XIII side table, birch and pine, with a turned finial in the center of the stretcher. Tables of this type date from the late 17th and very early 18th century, and numbers of Quebec examples, of widely varying sizes, survive.

CANADIANA, ROYAL ONTARIO MUSEUM

or second bed, *du premier lit, du deuxième lit,* as in France. And the dying, surrounded by the family, often lay in the bed in which they had been born.

TABLES

Square, round and oval tables were to be found in the homes of Canadian habitants, but the long tables which were common in the homes of French peasants are rarely mentioned.

Folding tables (*tables pliantes* or *tables ployantes*) were most popular because they occupied little space between meals when folded and placed against a wall in the common room. The top of the table was usually made of three large pine boards, or narrow planks with tongue-and-groove joints, with a molding around the edge. Sometimes the top would be framed as well as tongued and grooved, to prevent the planks from warping. Wooden pegs were inserted into the legs and apron to strengthen the top. The apron, legs and stretchers

were of birch and were held together with mortise-and-tenon joints.

The legs of all these tables were plain, turned or chamfered. (A chamfer is a bevel cut made on the square edges or corners of a leg or rail to lighten its appearance.) An inventory of 1745 contains the earliest mention of a table with cabriole legs (*pieds de biche*).

A table which was very popular in habitant homes in the 19th century was the table-chair (*table à bascule*). It had a round or square top which, when lifted, formed the back of a chair. This table seems to have been unknown in France but was found in Great Britain and New England.

There were several types of refectory tables used in convents and monasteries. The legs were usually turned or shaped in the form of lyres, pilasters, or columns. Most of these tables had individual drawers in which each nun or monk kept napkin, knife and fork, etc.

Church or general-purpose stool, birch, with structural members turned in the Louis XIII manner, and a handhold cut through the top, dating from the early 18th century.

CANADIANA, ROYAL ONTARIO MUSEUM

There are also a number of little tables with a variety of curved legs in the *Régence* and Louis XV manners, as well as *demi-lune* serving-tables and little dressing-tables in the *Régence* manner, with cabriole legs. These were quite common in the homes of Canadian habitants after 1750.

Another small table that was found in a few homes, and particularly in convents, was the sewing-table (*travailleuse*) with single or coupled legs. It sometimes had a lower shelf and was often fitted with a drawer to hold needlework equipment.

Pedestal tables or candle tables (*guéridons*) were widespread in the 17th and 18th centuries, but have almost completely disappeared today. They were round and had a single central leg that terminated in a tripod or turned disc. Candelabras, candlesticks, or saucer-shaped candle holders (*martinets*) would be placed upon them, and as they were easy to carry, they would often be moved to the bedside for reading.

There were also small country tables, perhaps the most interesting of all, to which peasant woodworkers added all sorts of naive touches in the shaping of the frieze.

Before ending this discussion of tables, let us say a word about washstands, which were very common in the 19th century. They were small and light, and in many homes were placed near the bucket-bench. The men, coming in from the fields at noon, would wash their hands there in a basin, near which there would be a soap dish containing homemade soap (*savon du pays*). The small washstand, however, would usually be found in the parents' bedroom or in the guest room, with a faience basin and water jug placed upon it. It was usually made of pine, birch, or ash and had one or two drawers, and

sometimes a lower shelf. Some had a hole in the top to hold the basin and often there was a shaped splashboard around three sides of the top and towel-rails on the sides. Their shape resembles certain French serving-tables and Burgundy bedside tables. In recent years, washstands have been steadily replaced by washbasins with running water in most rural houses of French Canada.

SEATS

Low and high stools and benches were in use in the colony from the beginning of the 17th century. These simple seats had no backs and were easy to move about.

There were two types of stools (*tabourets*). The smaller ones were used as footstools for resting and warming the feet near the fireplace. The others, somewhat higher, were used for sitting on. Most of them had turned legs in the Louis XIII manner or legs in the Louis XIV *os de mouton* style. The high stool often had a shaped hole in the top which was used as a handgrip when moving it about.

Benches were placed on each side of the table in the common room, or against the walls for evening parties (*veillées*).

Benches with backs made their appearance in country houses in the 18th century. The backs had a grill-work of shaped vertical splats or turned vertical spindles. The coffer-bench (*banc-coffre*) as in France, particularly Brittany, was placed beside the closed bed or the four-poster and served as a chest for storing linen and as a step for climbing into bed.

The bench-bed (*banc-lit*) (is supposed to have existed in France in the 16th century, but has long since disappeared there. It appeared in Canada at the beginning of the 19th century, probably imported from Ireland where it was called a settle-bed. It was also known in Sweden and Finland and closely resembled the Bresse *arche-banc* and the Breton coffer-bench from which it was derived. In Canada it was called the beggar's bed. It was used as both a seat and a storage chest during the day and as a bed at night, for it was hinged to open into a bed-frame. It was not unusual in the homes of large habitant families to put as many as four children in such a bed, "feet to feet" on a layer of straw or a palliasse. Also, a settle-bed might be kept for wandering beggars who would be offered hospitality for a night.

Chairs were uncommon in peasant homes in 17th-century France, yet in Canada they were widely used to supplement benches and stools. The most popular were jointed chairs made of birch with a pine-board seat and a back which was an open frame without spindles. They resembled the French Lorraine chairs which had chamfered or turned legs and H-stretchers. In Canada they were called *Côte de Beaupré* or *Ile d'Orléans* chairs, as they were found in every house in that region of the Lower St. Lawrence. The rush-seat chair (*chaise à la capucine*), with slightly inclined back-posts, straight legs and turned rungs, was to be found everywhere in Canada but was especially common in the Montreal region. It was a light chair with cut-out or shaped slats in the back. It continued to be made well into the present century, and only a few years ago could be bought new in the Bonsecours Market, Montreal.

Many varieties of these chairs, from all periods and from all parts of French Canada, still exist today. Chairs which are more than two hundred years old are as solid as if they had been made yesterday. The early woodworkers used wood that

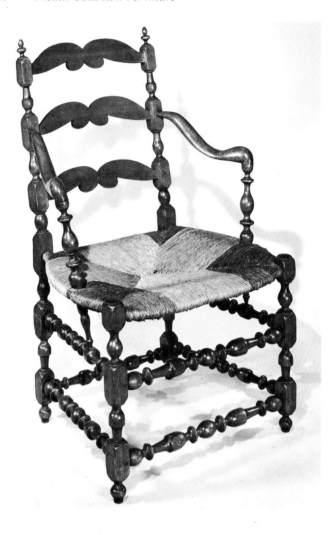

was almost green for the back posts and legs and well-dried wood for the rails, rungs and stretchers. As the green wood dried, the grip on the rails and stretchers tightened like a vice, with the result that although glue was never used, these chairs never wobbled or came apart.

Armchairs. It seems that armchairs made their appearance in the middle of the 17th century. They were the classical armchairs in the Louis XIII style, the baluster understructure, chamfered cubes, and long, curved armrests designed to follow the line of the human arm. They had high backs with either a square or an arched top rail, and nearly all were upholstered. Such an armchair was the ideal fireside seat, its high back covered with tapestry or gros point offering good protection against draughts.

Another chair which was to be found in all parts of French Canada in the 18th century was the *os de mouton* armchair. This was a transitional piece leading from the Louis XIII to the Louis XIV style, in which scrolls replaced rectilinear forms. In Canada, the *os de mouton* was called the *fauteuil du seigneur*. The habitants having seen this type of chair in the *seigneur's* manor, quickly imitated it for use in their own homes. A great variety of specimens exist, some roughly made and some the work of craftsmen. At first, they were made with bracket posts, the two front legs rising to a certain height then curving back in a continuous line to form the armrests of the chair. In the early 18th century, the armrests were supported by brackets set back a little from the front of the chair to allow the ladies, whose skirts had taken on more ample proportions, to seat themselves elegantly without feeling confined.

Another popular armchair in French Canada was the straw or rush-seat armchair (*fauteuil à la capucine*), which was almost identical with the *bonne femme* armchair of Orléanais and the Loire Valley. This had elegantly shaped back rails as well as set back arm-supports which went through the seat frame and were pegged into the first lateral rung. The Canadian armchair (*à la capucine*) is distinguished from the French armchair (*à la capucine* or *bonne femme*) of the period by its greater number of chamfered cubes on the front legs and back posts, and also by the very special turnings on the stretchers.

The *capucine* chair could never have the solidity of the jointed chairs which were put together with mortise-and-tenon. It was made with dowelled rungs, like the little rush-seat chairs which were so common in all periods. However, it is one of the most beautiful Canadian pieces, and all the more charming for its rustic air.

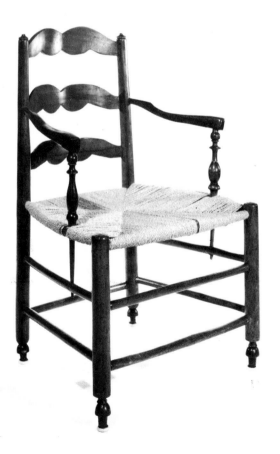

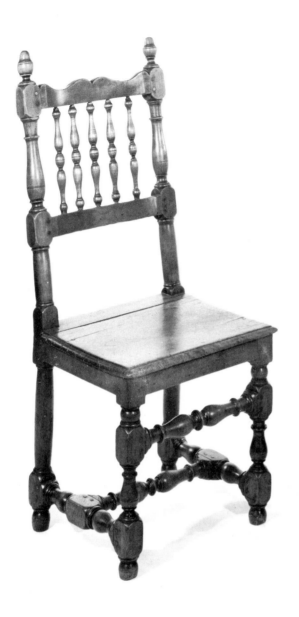

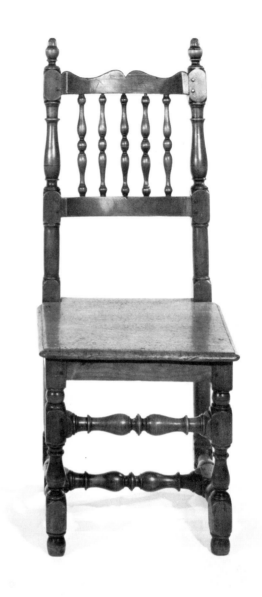

Pair of baluster-back chairs, maple, with turned legs, stretchers, and back uprights in the Louis XIII style. These chairs, made in the late 17th or early 18th century, are from the Hospice of the Grey Nuns, Quebec.　CANADIANA, ROYAL ONTARIO MUSEUM

Straight chair, maple, of the Ile d'Orléans type, with simple but heavy turning and construction in the Louis XIII manner. One of a pair, this chair is originally from the Hôtel-Dieu in Quebec and dates from the late 17th or early 18th century.

CANADIANA, ROYAL ONTARIO MUSEUM

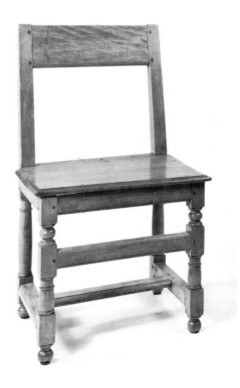

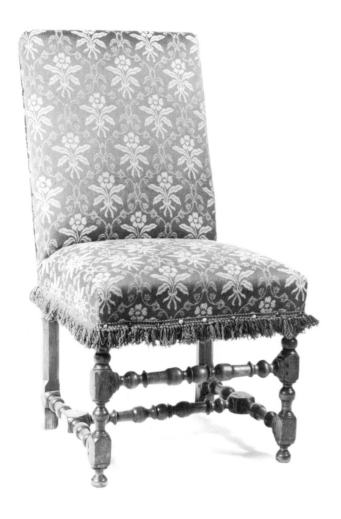

Upholstered Louis XIII chair with turned maple base frame, but square chamfered back legs, c. 1720.

CANADIANA, ROYAL ONTARIO MUSEUM

A whole range of Canadian armchairs have appeared since the 18th century, all of them modifications of the *capucine* armchair, but rougher and more naive in their workmanship. It is in these designs that we find proof of the originality and inventiveness of the Canadian chairmakers and woodworkers, who excelled in the production of country-style chairs.

Another armchair sometimes mentioned in inventories is the *bergère*. This chair, wide and deep, sometimes had wings, its seat was fitted with a cushion, and the space below the arm-rests was upholstered. However, I have not been able to find a single specimen of the *bergère* which has survived the passage of time and the all-too-numerous destructive fires that have occurred in Canadian households.

THE WOODS USED

The woods most frequently used for early furniture were pine, yellow birch and butternut. These varieties of trees grew tall and thick around the houses of the early settlers. They were preferred for furniture-making because they were high-branched and could provide long, knot-free planks. Yellow birch was an ideal wood, being hard and yet workable because supple. Pierre Boucher, a Canadian gentleman, wrote, "the tree called *merisier* (yellow birch) grows large, high and very straight. Its

wood is used to make furniture and gun stocks. It is red inside, and is most attractive for the sort of work done in this country." Boucher called it *merisier* because its bark resembled that of the *merisier* (wild cherry) of France.

The friezes and legs of tables were usually of yellow birch, while the top was often of pine or butternut. Chairs and arm-chairs were made of yellow birch whereas larger pieces such as armoires and buffets, were generally made of pine or butternut. Some early two-tiered buffets were made of yellow birch.

At the beginning of the 18th century, furniture was also made from red or soft maple, which was called *plaine*. The wood of this tree is softer than that of the sugar maple (white maple) and is more easily worked. Usually, maple wood which pro-duced a wavy, curly, or bird's-eye grain was used. White maple did not come into general use for furniture until the end of the 18th or beginning of the 19th century. It is as highly regarded for its appearance as red maple (*plaine*), with a curled or undulating grain or with a bird's-eye pattern of tiny curled knots, but its use is limited because it is difficult to work as it splits so easily. In spite of this drawback, some finely finished furniture in white maple has been made in Canada.

Early Canadian furniture closely resembled that of France, although it was rarely an exact copy. Often it is only by the materials used that we are able to distinguish the origins. Canadian white pine has a texture which cannot be found in any of the resinous woods of France. It is less grained than resinous French woods and its surface is more regular. In Normandy a type of balsam (*sapin*) was used which closely resembles the Canadian hemlock (*tsuga*) but has darker veins. A few pieces of Canadian hemlock furniture have been mis-takenly identified as French. Canadian yellow birch should not be confused with the *merisier* (wild cherry) of France. It is lighter in color than the cherry wood, which has a reddish-brown tinge. A number of tiny deep-red knots are sometimes to be seen on the surface of a piece of furniture made of French wild cherry; such knots are never found in Canadian yellow birch.

THE WOODWORKERS

A considerable number of craftsmen came to Canada soon after the arrival of the first peasant settlers, and they brought with them a variety of skills. These masons, smiths, carpenters, woodworkers, and other artisans came from many regions of France, including Paris. They were often hired by *seigneurs* for a minimum period of three years. In the earliest days, the peasant colonist was obliged to be a jack-of-all-trades. He developed certain rudimentary skills and made the most essen-tial utensils and furniture himself. Thus, in the first years of the colony, there were two types of furniture: the furniture of the skilled craftsman, *main de métier*, and the simple but sturdy furniture of the *habitant*, *main fruste et robuste*.

The professional woodworkers were experts thoroughly versed in their craft, who had served their apprenticeship and practiced their profession in France. Those who wished to come to Canada were carefully selected before being given their contracts. In those days, woodworking and carpentry were much less specialized professions than they are now. For ex-ample, a number of carpenters and masons were also called architects, and they were qualified to draw up plans for a build-ing. The same was true of the woodworkers whose job it was to

finish the interiors of the houses, including joinery, wainscoting, ceilings, floors, cupboards, armoires and furniture of every description. A carpenter of that time was not someone who just knocked boards together. He had thorough knowledge of all the woodworker's techniques for locking and miter joints, mortise-and-tenon, etc. Most of the church carvers were also wood-workers who knew how to make chairs and panel-work as well as statues and retables. In a country where the needs were so urgent and varied, craftsmen could not afford to be specialists.

There were some traveling woodworkers in Canada, who moved about the country looking for work. If we can believe the information which has been passed on orally, those early Canadian woodworkers were comparable to the journeymen craftsmen in France who used to travel from village to village and city to city, learning the different techniques of the provinces in the workshops of master woodworkers.

At the end of the 17th century, thanks to the efforts of the *intendant*, Jean Talon, and of Bishop Laval, two schools of arts and crafts were founded in Canada. Talon wrote, "The young men devote themselves and attack their studies in the classes for science, the arts, crafts, and particularly seamanship, with such enthusiasm that if their interest continues to grow there is reason to hope that this country will become a training ground for navigators, fishermen, sailors and craftsmen, all with a natural disposition for these professions."

It is interesting to note that the first students at the School of Arts and Crafts of the Quebec Seminary did the carving and paneling of the seminary chapel as it was described by Bacque-ville de la Pothérie: "The carving, which is valued at ten thou-sand crowns, is very beautiful; it was done by the seminarists who spared nothing to make it a work of perfection . . .".

These arts and crafts schools unfortunately did not survive for very long, disappearing at the beginning of the 18th century.

Apart from these schools, there were woodworkers and carvers who trained young men in their various crafts. In 17th-century France, the acquisition of master's papers was not simply a matter of talent but also of privilege. Even a good apprentice who graduated to the rank of journeyman could not expect to become a master automatically. In Canada, however, there was no question of privilege in the early days, talent being the only requirement. Any young man who wished to practice the craft of woodworker, carver, etc., was welcomed in a master's workshop and could himself become a master if he possessed sufficient skill. The needs of the country were too pressing to permit the exclusion of any gifted artisan.

The period of apprenticeship was generally from three to seven years, and a youngster with natural ability would join the workshop of a master between the ages of twelve and four-teen. Once the master had accepted him, the articles of appren-ticeship were registered with a notary. Craftsmen's associations in Canada enjoyed much more freedom than they did in France, where they were subjected to the many restrictions dictated by the *Jurande*. In Canada, everyone was allowed to exercise his crafts as he pleased as long as he had the talent and as long as he agreed to respect the rules of good craftsmanship: *le bel ouvrage*, as set forth in the statutes of Paris. The verb *chef-d'oeuvrer* is still used in French Canada. We often hear the praises sung of woodworkers who have a reputation for making furniture with care and artistry; one says that they *chef-d'oeuvrent* or that they are *chef-d'oeuvreux*.

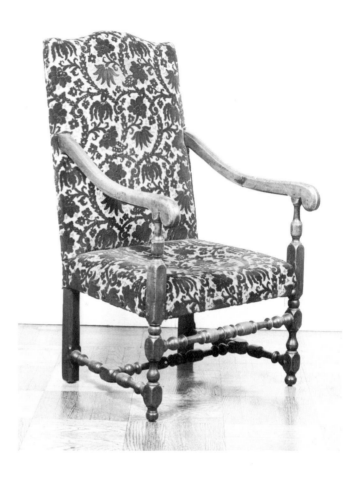

Louis XIII armchair, walnut and birch, with square and cham-fered back legs and velvet upholstery. This chair is from the Quebec area, dating c. 1720. CANADIANA, ROYAL ONTARIO MUSEUM

RESTORATION

Most of the early furniture of French Canada was stained rather than painted. As soon as the woodworker had finished a piece, he applied a color, using transparent or opaque stains which imitated French walnut or old oak, as was the custom in the French provinces. Since the native woods were very light in tone, they would soon have looked dirty if they had been left unstained. In rare cases, a piece of furniture would be finished in its natural color, but it would be protected from marks with a thin coat of clear varnish.

From the second half of the 18th century, furniture was painted. The range of colors was limited: red, blue, dark green, white tinted with yellow ochre, red ochre or iron oxide (this last was very popular). In certain parts of Quebec, especially in the region of Trois Rivières, the habitants made paint by pulverizing red earth from their fields and mixing it with lin-seed oil or skimmed milk.

If you are lucky enough to find a piece of furniture with its original coat of paint intact, it is best not to strip it, although an armoire that has had its paint stripped, revealing a slight orange tone caused when linseed oil originally penetrated the wood, can be very attractive. To expose the original coating on a

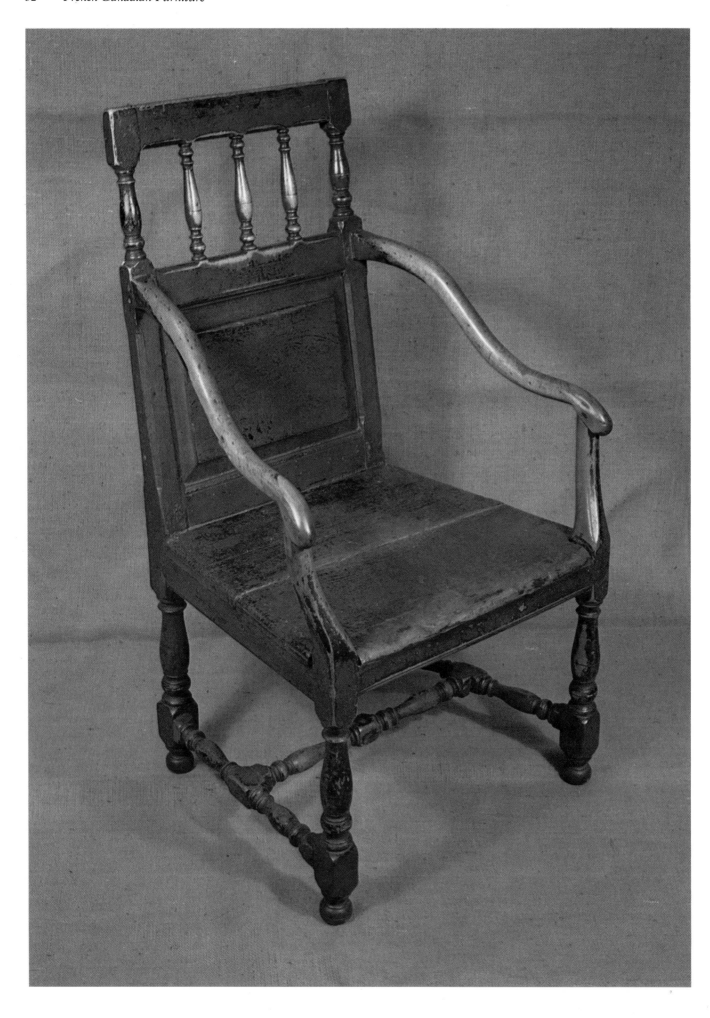

◁ *Armchair, maple and butternut, with panel and baluster back in the Louis XIII form. Chairs of this type are the earliest of Quebec armchair styles, and date from the late 17th and early 18th centuries.* CANADIANA, ROYAL ONTARIO MUSEUM

Pair of side chairs with open-cut back-splats, birch, and with ▷ woven rawhide ("snowshoe-webbing") seats. These chairs, from Caughnawaga, Quebec, c. 1830–50, are uncommon because of their back-splats, but simpler rawhide-seated chairs are still readily found. QUEBEC MUSEUM

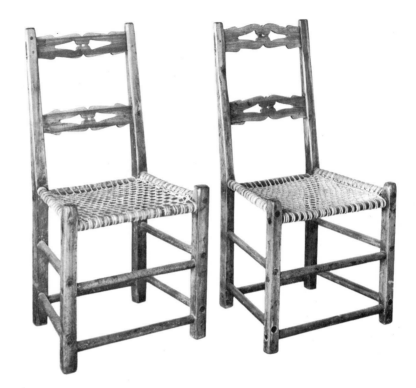

repainted piece is very delicate work, demanding extraordinary patience and a technique comparable to that of the oil-painting restorer.

Where all the paint has to be removed, the furniture should be washed with a solvent such as alcohol or a good commercial solvent. Patience is a primary requirement, as not all coats of paint will come off at the same time. Many of the ancient paints were powder colors mixed with skimmed milk to produce a type of casein paint, which created a particularly hard, almost vitrified surface, difficult to remove without a scraper. If the basic color is not too dark, some pieces can be washed with lye or caustic soda, but this is not to be recommended unless great care is taken, as these powerful solvents may lift the grain of the wood or burn the surface.

A piece of furniture which has had its paint removed should be waxed frequently, not only to preserve the wood from dust and marking, but also to give the surface a fine tone. Connoisseurs favor beeswax, which they prepare themselves.

Early Canadian furniture is usually found in country homes, but rarely in use in rooms. It might be stowed away in the attic or cellar, or in a shed or barn, or even in the henhouse. Needless to say, it is generally found dreadfully mutilated. The pieces have lost either tops, cornices and molding, or feet; sometimes they have been gnawed by rats. In almost every case there are nail-holes, ink-stains, etc.

It is, of course, possible to retain the signs of wear and age when restoring traditional furniture. However, collectors generally prefer an immaculate piece of furniture, although that is almost an impossibility if the piece was made two centuries ago. When a piece of old furniture, is to be restored, it is of the utmost importance that the work be placed in the hands of an experienced craftsman. The care and restoration of early furniture can be summed up in the words of Pierre Verlet, Chief Curator of the Department of Objets d'Art of the Louvre:

> Total conservation is impossible. The past cannot be arrested or recaptured but it is possible, with care, respect and taste, to get close to the original state of the piece, and to maintain in good condition the pleasing appearance that has been acquired over the years. All this requires infinite care, attention, and understanding of the way in which old things have evolved, and a scrupulous conservation of the past which may seem practically impossible and paradoxical in this century. But this is the stern lesson of love which early furniture teaches to those who would live with it.

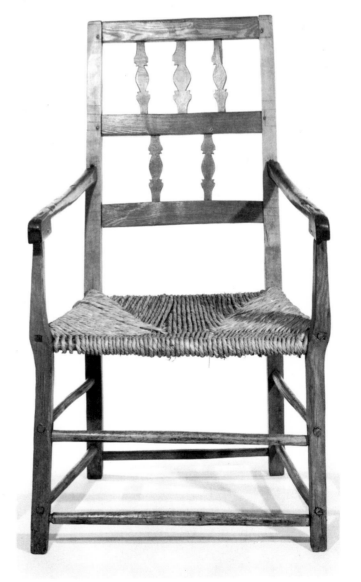

Country armchair of maple and ash, with twisted salt-marsh-grass rush seat, and bandsaw-cut vertical back slats, from eastern Quebec, c. 1820–50. CANADIANA, ROYAL ONTARIO MUSEUM

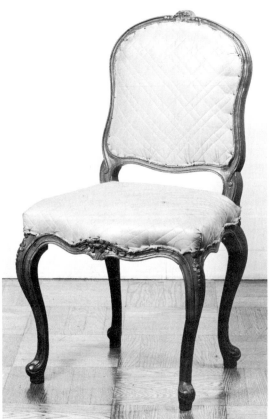

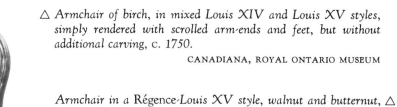

△ *Armchair of birch, in mixed Louis XIV and Louis XV styles, simply rendered with scrolled arm-ends and feet, but without additional carving, c. 1750.*

CANADIANA, ROYAL ONTARIO MUSEUM

Armchair in a Régence-Louis XV style, walnut and butternut, △ *with extensive carving on all surfaces, dating from the late 18th century.* CANADIANA, ROYAL ONTARIO MUSEUM

Louis XV armchair of birch with extensive scroll and foliage ▷ *carving, padded arms, and cabriole legs tipped with English casters. Chairs of this type were probably made in some quantity in the late 18th century, but are now quite scarce.*

CANADIANA, ROYAL ONTARIO MUSEUM

◁ *Sidechair in the Louis XV manner, of American elm, probably one of a pair or set, with floral carving on the apron, legs and crest-rail. Though collected in Kingston, Ontario, the chair probably originated in the Montreal area, dating from the late 18th century.*

CANADIANA, ROYAL ONTARIO MUSEUM

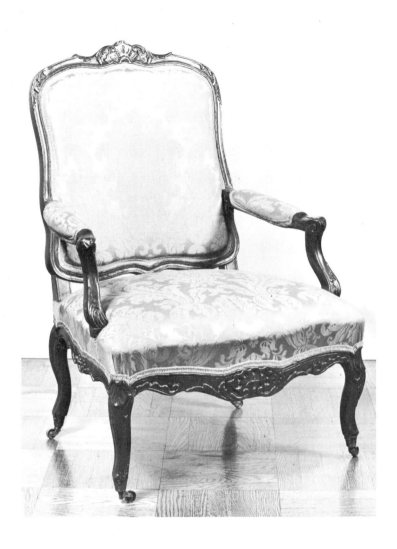

TRADITION

French-Canadian traditions have evolved over a period of three centuries. The pioneers who came to the new world in search of a better life were people of good taste. Their craftsmen were simple people, and their work was designed to appeal to men like themselves. The traditional furniture they made is both functional and decorative, the expression of a distinctive folk culture which is closely related to the folk traditions of the French provinces where the settlers originated. They worked creatively in their new country and added many personal touches.

The craftsmen of early French Canada were artists. A mere assemblage of boards could not satisfy them. They had a natural urge to embellish their pieces, giving them a character of joy and harmony, and from the poorest peasant to the wealthiest *seigneur*, from the humblest village *curé* to the bishop himself, things of beauty were of prime importance. Good taste knew no social barrier. The Seven Years' War caused poverty and misery, temporarily checked the development and encouragement of arts and crafts, but with the Treaty of Paris, Canada breathed freely again. In the reconstruction period of peace and prosperity that followed, the architects, masons, carpenters, woodworkers, carvers and silversmiths worked with a greater will than ever, continuing the traditions of the past. Furniture-makers finished their work with the exuberant decoration of the *Régence* and Louis XV styles which arrived in New

France about the middle of the 18th century, and Canadian woodworkers delighted in foliated scrolls, shells, spirals and curves. Traditional furniture in French Canada reached its peak of refinement in both technique and design between 1785 and 1820.

The most frequently encountered regional influences were those of the provinces of origin of the colonists, mostly those of the north and west of France: Normandy, Picardy, Maine, Orléanais, Anjou, Haute-Bretagne (Rennes *région*) and the west-Atlantic regions, Guérande, the Loire Valley, Touraine, Vendée, Poitou, Aunis, Saintonge, Gascogne, Béarn, Languedoc. Rarely, influences were felt from Lorraine, Savoie, Dauphiné, Burgundy, Bresse and even Provence.

In French Canada, there were only two main regional types of traditional furniture: Quebec and Montreal. The Quebec furniture was generally lighter, more elegant and simpler than that of the Montreal region, which was heavier and more baroque, more elaborately decorated, often revealing awkwardness or a combination of styles intended to "look rich." Montreal had become the prosperous headquarters for the magnates of the fur industry, at the crossroads of the Great Lakes, the West, Illinois and Mississippi.

For some unknown reason, there is a sort of "sub-region," the Lotbinière region, where a whole range of charming furniture has been discovered. Perhaps the earliest traditions were better preserved there because it was isolated for so long, for most commercial traffic passed between Quebec and Montreal along the King's road on the north shore of the St. Lawrence. Many pieces of furniture escaped vandalism and were preserved in the Lotbinière region.

Toward the end of the 18th century, when the United Empire Loyalists came to Canada from the United States, English and American influences mingled with the French. Canadian craftsmen were quick to imitate the work of these newcomers, producing furniture in the English and American fashions while retaining the most characteristic features of the French tradition. In this way, they succeeded in developing an interesting, though not always a happy, mixture of French and English styles.

From 1820 on, the furniture of French Canada gradually lost its traditional French character, and with the industrial revolution that character disappeared almost completely. Only a few woodworker-carvers employed by the church continued the great French tradition until about 1850. The most important causes of the break with French tradition were political and philosophical. When normal communications with France were cut immediately following the British conquest, French Canadians found themselves isolated from the source of their culture. This isolation became intensified after the French Revolution, for Quebec shunned its radical ideology and its dynamic influence. When Napoleon took power in France, the quarantine was further intensified. It was not until the 20th century that sustained contact with France was established. This isolation was a cultural disaster from which French Canada has not yet recovered. The break was so complete that the heritage fell into total oblivion. Until 1925 no one suspected that there had ever been an original tradition of French Canadian furniture. Fortunately, since then a reawakening of interest in cultural traditions has taken place not only in Quebec but through the whole of Canada.

Quebec Sculpture and Carving

Jean Trudel

The origins of early Quebec sculpture go back to the 17th century in the French colonies of North America, then known as New France or Canada. They spring from a main source of patronage, the Roman Catholic clergy, and a single material, wood. Designed as it is to capture the imagination of the faithful, the Roman Catholic ritual requires celebration in an appropriately splendid church interior.

It was essential in this immense new land, peopled by tribes with strange customs, that the clergy be able to keep the new inhabitants in the straight path of religion. Religion, even more than language, constituted a frontier with the very prosperous colonies of New England. The clergy of New France built churches with the wholehearted support of the inhabitants, who saw in them a symbol of security.

By the end of the 17th century the interiors of these churches were so richly decorated that they provided work enough for several wood carvers to make a livelihood practicing their art. There was indeed sculpture other than that of a religious nature in New France, but there is no doubt that without the Catholic religion, the growth of artistic traditions in the colony would have been very slow. Once built, the churches gave wood carvers great scope for variety of ornamentation.

It must be borne in mind that each church interior was, in a sense, a permanent workshop. Even after construction, which often took several years, the interior decorations underwent alterations, which might be major or minor according to the taste of the clergy and parishioners. Frequently churches were destroyed by fire or were demolished because of deterioration due to age; in such event a new church had to be built, with new decoration. Sculptors did not lack for work.

Typical décor of a Quebec church between the 17th and 19th centuries comprised several areas of ornamentation, requiring in the sculptor a wide range of knowledge. It might well happen that an overall plan was conceived and drawn up by a sculptor and submitted to the curé and body of churchwardens for their approval. Very few such plans have come down to us; they were usually drawn in original only, being returned to the sculptor after approval by the church. There is frequent reference to these plans in notarized contracts signed by the sculptors and churchwardens.

In order to design overall plans for retables, the sculptors needed a certain knowledge of architecture. This knowledge they acquired from various treatises on architecture obtained from France, the most popular of which was undoubtedly that by Jacques Barrozio dit Vignole (Vignola, 1507—Rome, 1573), whose *Treatise on the Five Orders of Architecture* was published and republished in France; in many forms, right up to the mid-19th century. It contained the general principles of architecture prevalent in Europe since the Italian Renaissance. These same principles, adapted by the sculptors, were transposed and applied to the interior decoration of churches. Vignole's work served also as a repertory of ornamental motifs carved in wood.

Inside a church the central point was the main altar, which stood in the chancel, the area where mass was celebrated. The main lines of design of the retable and vaulting were made to lead the eye of the worshipper toward the main altar. This latter was usually designed as a small edifice resting on a base (or altar "tomb") which enclosed within its center the tabernacle, in which were kept the sacred vessels.

Pair of church sculptures, gessoed and gilded over pine. These figures, from the Grey Nuns seminary at Charlesbourg, are attributed to Thomas Baillairgé, one of the best of the later church carvers, and date from the early 19th century.

CANADIANA, ROYAL ONTARIO MUSEUM

Pine wall plaque as a trophy of music, finely gilded, by André Paquet (1799–1860), of Quebec, c. 1830–40.

NATIONAL GALLERY OF CANADA

Console table of pine, with elaborate carving and openwork cross-stretcher, originally gessoed and gilded; one of a pair. These tables are from the church at Longueuil, Quebec, all the interior of which was carved by Louis Aimable Quévillon and his associates between 1818 and 1821. CANADIANA, ROYAL ONTARIO MUSEUM

Church sculpture of the Virgin and Child, gilded and poly-chromed over pine, by Paul Jourdain dit Labrosse (Montreal, 1697–1769), c. 1749. NATIONAL GALLERY OF CANADA

Wall plaque, carved in relief, of an angel with a book; with gilded relief and white painted background. This carving is by François Baillairgé (1759–1830) of Quebec, c. 1800–20.

NATIONAL GALLERY OF CANADA

△
Small church sculpture of the Virgin and Child, gilded over pine, and attributed to François-Noël Levasseur (1703–94) of Quebec, c. 1760–70. CANADIANA, ROYAL ONTARIO MUSEUM

Figure of a kneeling angel, in pine, now cleaned but probably gilded originally, by Jean-Noël Levasseur, c. 1750.

NATIONAL GALLERY OF CANADA

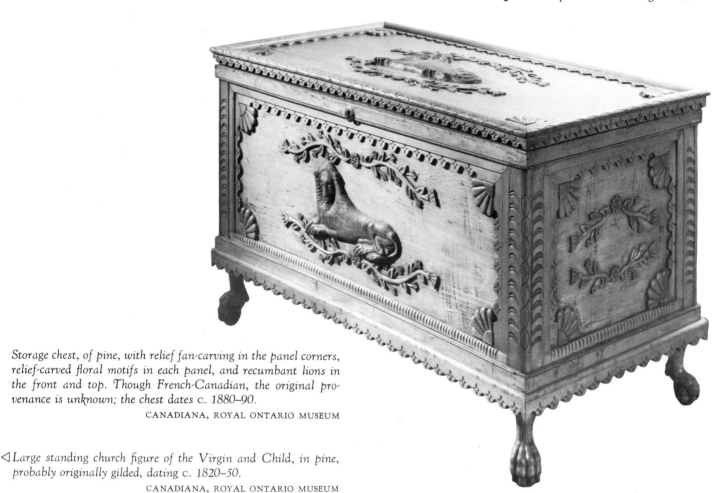

Storage chest, of pine, with relief fan-carving in the panel corners, relief-carved floral motifs in each panel, and recumbant lions in the front and top. Though French-Canadian, the original provenance is unknown; the chest dates c. 1880–90.

CANADIANA, ROYAL ONTARIO MUSEUM

◁ *Large standing church figure of the Virgin and Child, in pine, probably originally gilded, dating c. 1820–50.*

CANADIANA, ROYAL ONTARIO MUSEUM

Often the side altars were simplified versions of the main altar. There were other furnishings too, such as the pulpit from which sermons were given; the churchwardens' pew; and the font where newborn babes were christened. Before even thinking of embellishing this church furniture with carvings, the sculptor had first to construct it, and to this end he had to know thoroughly every secret of the woodworker's art. The whole of the wood carver's art was ultimately based upon joinery. At a pinch, a good joiner could execute works of ornamental carving. He could turn his hand to carving out of wood the capitals or friezes, the columns or pilasters. He could even manage certain repetitive decoration motifs. However, only a sculptor could execute representations of figures in full relief. Therein lay the crux of his own particular art.

In every church and in every chapel there were statues, statuettes and representational carvings in relief. The subjects to be represented had been determined by the sculptor and his employers, and for the most part followed a well-defined iconographic program. Furthermore, the final finishing of the figures by gilding and polychromy was often left to the sculptor, and this work was just as important as the actual carving. In addition to his knowledge of architecture, of joinery, of sculpture proper, and of gilding and painting, a good church sculptor had also to possess an aptitude for management and be able to direct his assistants. It was difficult for him to work alone if he had many orders to fill.

The art of sculpture was learned and handed down through apprenticeship. Contracts between master sculptors and apprentice sculptors were signed in the presence of a notary. The apprenticeship started at about age fourteen, and could last seven years. The sculptor undertook to teach everything he knew of his art, to provide room and board, and to treat his apprentice humanely. The apprentice undertook to be obedient; occasionally the apprentice's father engaged himself to bring his son back to the master sculptor if perchance he ran away, Most often, however, the sculptor paid a certain sum of money each year either to the apprentice or his parents. Thus, in exchange for the imparting of his knowledge and for a little money, the sculptor acquired an employee whose development he could influence as he wished and who could assist him in his work. This system was modeled on that prevalent in France, but in North America it was not hedged about with such rigid regulations.

It followed that a sculptor's excellence depended largely upon the training he had received. From 1630 to 1760 the number of qualified wood joiners in New France was surpassed only by the number of construction carpenters and masons. There, indeed, lay fertile soil for the development of good sculptors in wood. We can also see how it was that every sculpture was not necessarily done by a professional. Whereas a wide field of knowledge was required before undertaking the total decorative design of a church interior, one need only be able to work and carve wood a little in order to produce, say, a weathervane in the shape of a horse.

Those sculptors who had learned their craft through apprenticeship could not be said to have had a proper academic training. They had followed no course in anatomy or in perspective given by experts, and no one pronounced upon their

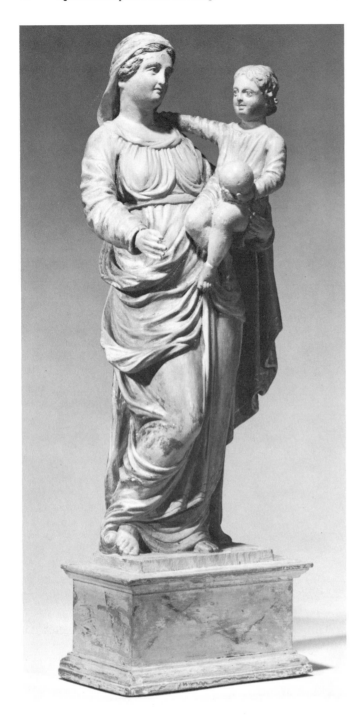

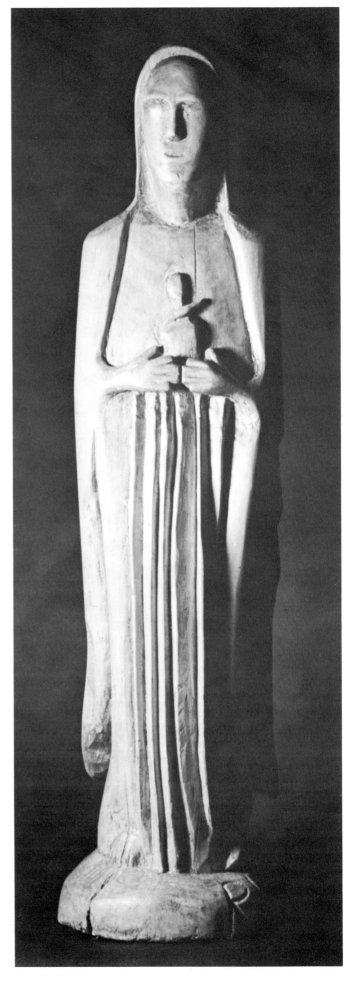

Figure of the Virgin and Child, pine, polychromed, with traces of original gilding, mid-19th century.

NATIONAL GALLERY OF CANADA

Primitive carved pine figure of the Virgin and Child, perhaps with an Indian influence, Quebec, late 19th century.

CANADIANA, ROYAL ONTARIO MUSEUM

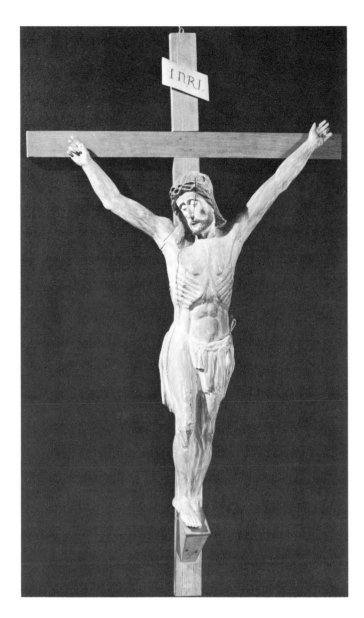

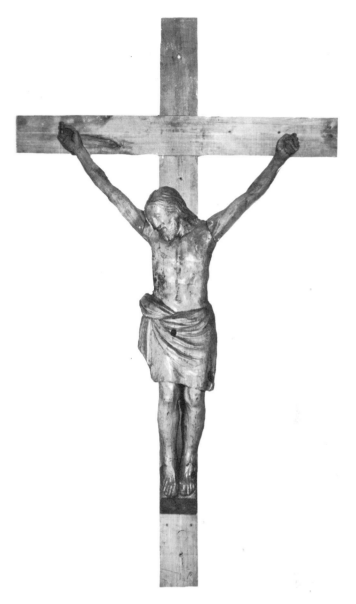

Primitive crucifix, of carved pine originally gessoed and gilded, on an oak cross, Quebec, c. 1860.

Large primitive crucifix, of pine, originally painted—probably in multiple colors—Quebec, c. 1840.

fitness to be "received" as sculptors at the end of their apprenticeship. They learned to meet needs, and to do so in the most effective way possible. It is for these reasons that great differences can be found in the quality of work produced in Quebec since the 17th century, and that there can be found so many works of a character that, according to present-day criteria, would be termed naive or primitive.

While church sculpture was the raison d'être of the art in Quebec, churchmen were not the only people to commission work from sculptors. From the beginning of the 17th century many wooden ships were built or repaired in Quebec, and their decoration was often entrusted to sculptors. Few of these ship carvings have survived, for most of the figureheads have rotted away, or been lost with the ships at sea over the four corners of the world.

Doubtless, also, shop signs comprised a large part of secular sculpture. Very few of these have come down to us, because through exposure in all weathers they finally disintegrated and were replaced. Of these shop signs the best known

to us, because they are free-standing and date from the 19th century, are tobacconist's figures representing Indians holding cigars, tobacco leaves or pipes. This type of sign was common in the United States. However, of all work ordered from sculptors, secular subjects were far less numerous than religious ones. We are distinguishing here, of course, between works commissioned from professional sculptors as professionals, and carvings that might have been executed for their own use or pleasure by amateurs.

It is generally agreed that sculpture in Quebec originated about the last quarter of the 17th century, but there were churches and chapels in existence long before then. We now have evidence that the clergy imported from France all the things necessary to decorate the places of worship. Among objects imported—and the practice was prevalent from the 17th to the 19th century—were even altars and, needless to say, statues carved in wood. It was often difficult to distinguish between the works that had been imported and those that were made in New France. Even scientific analysis aimed at

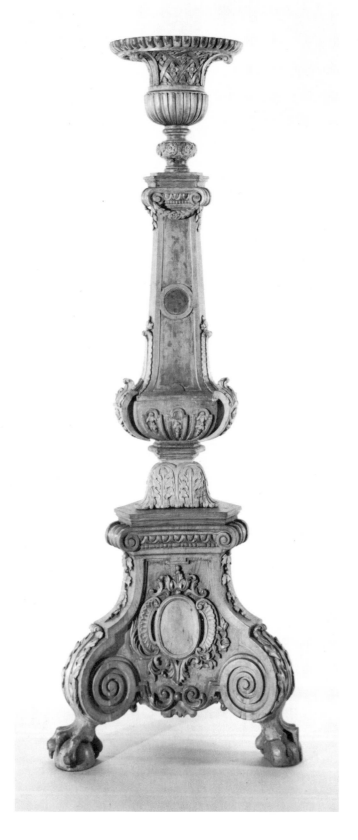

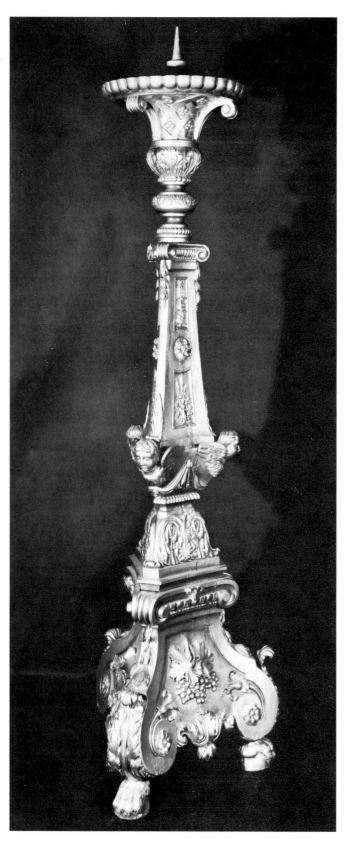

Tall Easter candlestick carved of pine, now cleaned, about 1780 by Philippe Liébert (1734–1804) of Montreal.

NATIONAL GALLERY OF CANADA

Tall Easter candlestick, gessoed and gilded over pine, c. 1780. This piece is by an excellent carver, though it is so far unattributed.

CANADIANA, ROYAL ONTARIO MUSEUM

Three-tiered chandelier, with a carved pine center column painted ▷ blue and gold, and thin forged iron arms holding wooden candle sockets. Attributed to Louis Quévillon or a partner or apprentice, c. 1815–30. CANADIANA, ROYAL ONTARIO MUSEUM

determining the nature of wood structure does not always yield proof when one is dealing with woods that might as likely be found in Europe as in America. Furthermore, the sculpture brought in from France was closely related in style to that produced locally; all of which compels great caution in attributing the country of origin.

The *Confrérie-de-Sainte-Anne*, which was founded in Quebec in 1657 and was modeled on the French guild that had existed since 1290, somehow managed to survive right up to the middle of the 19th century. This was a professional and a religious association of joiners which also included some sculptors in its membership.

Ste-Anne's chapel in the Church of Notre Dame of Quebec was given over to the *Confrérie*. They had decorated this chapel at their own expense and, as evidenced by the contract for construction of the retable in 1660, the decorative design included elements of sculpture such as, for example, two columns embellished up to one-third height by ornamental motifs. The brotherhood supervised the religious duties of its members, and set aside funds for assistance to any of them who might be in need. It was an attempt at a tradesmen's or craft guild, such as existed in France for many categories of artisan. Some sculptors were included in the association because they were also joiners, but there was never a guild of sculptors alone.

The works imported from France were not sufficient to decorate every church that was built in the second half of the 17th century. At the same time, the woodworkers lacked the requisite knowledge to undertake elaborate sculptures. To meet this need, sculptors had to be brought over from France, and they had to impart their skills to apprentices.

There is much mention of the "school of St. Joachim," a sort of school of arts and crafts set up under the aegis of the Quebec Seminary. It was through the negotiations by this seminary that in 1675 there came to Quebec one Michel Fauchois, a sculptor's apprentice, on a four-year engagement, and Samuel Genner, a sculptor, engaged for three years. Perhaps it was also through the Seminary that Jacques Leblond de Latour (Bordeaux, 1671—Baie-St-Paul, 1715) was recruited. He came from the artistic milieu of Bordeaux; his father was the official painter for the town and was a member of the Royal Academy of painting and sculpture. When Jacques Leblond de Latour arrived in Quebec in 1690 he was probably in possession of an excellent artistic training. He is credited with the interior embellishments of the Quebec Seminary chapel, and of the churches of Château-Richer, Ste-Anne-de-Beaupré and of L'Ange-Gardien. Carvings from these two latter churches still exist. It is noteworthy that Leblond de Latour, who was certainly one of the finest sculptors of that period, became a priest—a fact which well illustrates the close links between clergy and sculptors in New France.

The names of other sculptors are associated with the school at St. Joachim, namely Denys Mallet (Alençon, c. 1607—Montreal, 1704), Charles Vézina (L'Ange-Gardien, 1685—Les Ecureuils, 1755), and Abbé Pierre Gabriel le Prévost (Quebec, 1674—Ste-Foy, 1756). What we know of the school at St. Joachim rests on the evidence of a very few documents, and its role in the development of sculptors has probably been overrated at the expense of traditional apprenticeship.

The most famous sculptors of the French regime bear the name Levasseur. They were descended from two brothers,

Nineteenth-century primitive kneeling angel figure, of carved pine painted black. NATIONAL GALLERY OF CANADA

Twelve statuettes representing Christ and the Apostles, in polychromed pine, by Philippe Hébert (1850–1917), c. 1900. The statuettes are against the altar of the church of St-Joseph-de-Soulanges at Les Cèdres, Quebec. This altar, of pine, is heavily carved and the relief portions gilded, in the manner of several early 19th-century church carvers, such as Baillairgé and Quévillon.

QUEBEC MUSEUM

carpenter-joiners of Paris, who played a prime part in the foundation of the *Confrérie-de-Sainte-Anne*. They were Jean Levasseur *dit* Lavigne, the grandfather of the sculptor Noël Levasseur (Quebec, 1680—Quebec, 1740) and Pierre Levasseur *dit* Lespérance, grandfather of Pierre-Noël Levasseur (Quebec, 1690—Quebec, 1770). Noël Levasseur lived for a while in Montreal at the beginning of the 18th century. There he was associated with Charles Chaboillez (Troyes, c. 1654—Montreal, 1708), one of the first sculptors to work in this town. Noël Levasseur was back in Quebec about 1703. In 1712 he engaged a sculptor named Jean Jacquiés *dit* Leblond (Brussels, 1688—New France, after 1724), who later worked in the Trois-Rivières region. In 1715 Noël Levasseur sculpted ship carvings. One of the large works of the early days of Quebec sculpture has been attributed to him, namely the main altar for

the chapel of the General Hospital of Quebec (c. 1722–23). His sons François-Noël (Quebec, 1703—Quebec, 1794) and Jean-Baptiste-Antoine (Quebec, 1717—Quebec, 1775) doubtless assisted him, and worked together in partnership after his death. They were very prolific; numerous works are attributed to them, including the old main altar (1741) of the Church of Batiscan, which is preserved in the Quebec Museum.

Pierre-Noël Levasseur had married the daughter of the architect François de Lajoue in 1719. He worked for a while in the Montreal region, only to return to Quebec in 1725. He received many commissions for ship carvings. Between 1742 and 1744 he carved the statues of St. Peter and St. Paul for the church at Charlesbourg, and he took the trouble to sign them. At least two of his sons also took up wood sculpture—Stanislas, born in 1732, and Pierre-Noël, born in 1719. The latter was

Figure of St. Peter, 1884, in pine by Louis Jobin (1845–1928), the last of the great Quebec church wood-sculptors.

NATIONAL GALLERY OF CANADA

Photograph of the carving shop of Louis Jobin, at Ste-Anne-de-Beaupré, c. 1910. Two large figures are nearing completion here, and Jobin may be the man in the background.

CANADIANA, ROYAL ONTARIO MUSEUM

sent by his father to Rochefort in France to study sculpture, but he never returned. The major work executed by Pierre-Noël Levasseur is the interior décor for the Ursulines' chapel in Quebec (1726-36), which until recently had been attributed to Noël Levasseur. During the last fifty years of the French regime, and even later, the Levasseur family monopolized most of the orders for sculpture in and around Quebec. This is a striking example of the transmission of a craft through a family, and this was not an isolated case.

The best known Montreal sculptor of the French regime was Paul Jourdain *dit* Labrosse (Montreal, 1697—Montreal, 1769). He received commissions for several retables for churches in and around Montreal, and several statues signed and dated by him have come down to us. Just as Pierre-Noël Levasseur had done in Quebec from 1737 onwards, Labrosse worked as a land surveyor after 1758.

The town of Trois-Rivières was an important center for sculpture during the French regime, because of the presence there about 1730 of Gilles Bolvin (Flanders, c. 1711—Trois-Rivières, 1766). A close friend of the Recollet Joseph Quintal, parish priest of Trois-Rivières from 1729 to 1736 and architect, Bolvin executed the sculpture for the interior décor of several

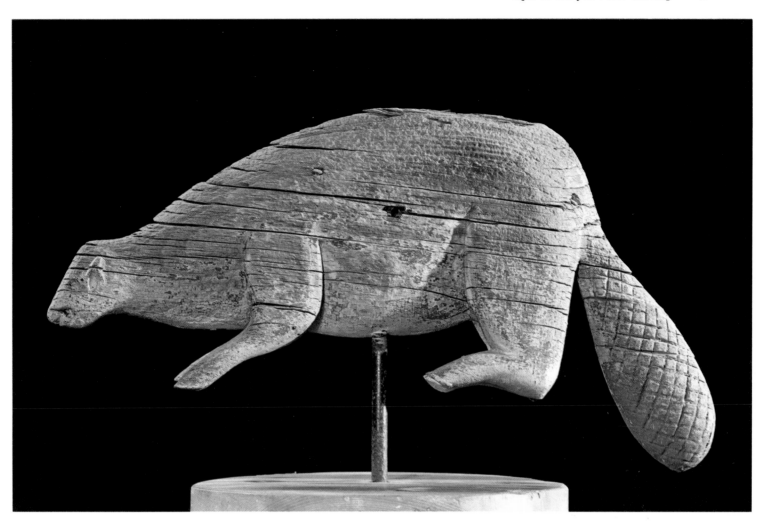

Weather vane figure of a beaver, carved in pine. This piece originally topped a barn or house weather vane, and was probably brightly painted, though it is now well weathered. From the Bécancour area, c. 1875. CANADIANA, ROYAL ONTARIO MUSEUM

churches of the region. The main altar of the church at Boucherville (c. 1745) still illustrates Bolvin's very baroque spirit—a penchant that characterized many of the sculptors of the Montreal region even up to the middle of the 19th century.

The British conquest changed nothing in the traditions of wood sculpture which had been established in New France. There were no great changes in style, and churches continued to be built and decorated as called for by increases in population. In Quebec the sculpting monopoly exercised by the Levasseurs continued for a while, to be replaced from 1770 on by that of the Baillairgés.

Jean Baillairgé (France, 1726—Quebec, 1805) came to Quebec in 1741. He had been trained as a joiner but lost no time in turning his hand to the interior ornamentation of churches, in which he was later aided by his two sons, François (Quebec, 1759—Quebec, 1830) and Pierre-Florent (Quebec, 1761—Quebec, 1812). Jean Baillairgé sent his son François to Paris from 1778 to 1781 so that he might perfect his skills in painting, sculpture and architecture. Thus François Baillairgé became one of the few Quebec sculptors to have received an "academic" training, since he studied in Paris under the direction of Jean-Baptiste Stouf (1747-1826), a sculptor who

became an Academician in 1784.

The Baillairgés, father and sons, worked on the interior decorations of Notre-Dame de Québec, which was rebuilt between 1778 and 1800 after its destruction in 1759. Photographs still exist of this interior, with sculpture by François Baillairgé, which was destroyed by fire in 1922. It had been one of the major works of the Baillairgé family. François had a son, Thomas (Quebec, 1791—Quebec, 1859), who worked with him on other large projects, including the total decorative designs of St-Joachim (the only one still intact to this day), of Baie-St-Paul, and of St-Ambroise-de-la-Jeune-Lorette. All these works were executed between 1810 and 1820.

Thomas Baillairgé became a close friend of Abbé Jérôme Demers (1774-1853), who in 1828 wrote a treatise on architecture, and who had been Vicar General to the Bishop of Quebec from 1825 to 1853. François Baillairgé's son interested himself more with architecture than with sculpture, in which he excelled, but which he preferred to leave to his numerous disciples. The Baillairgé family played a key role in the art history of old Quebec. Over and above their talent, François and Thomas possessed a range of knowledge that still astonishes, when compared to that of the artists who preceded and

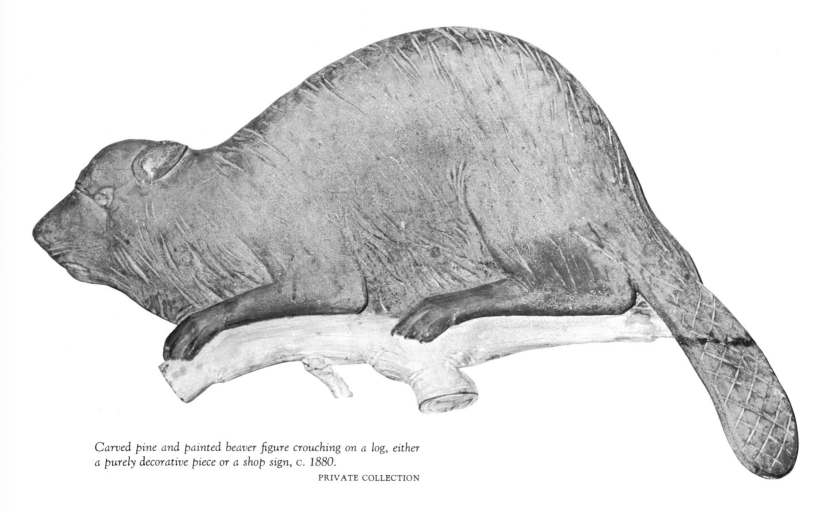

Carved pine and painted beaver figure crouching on a log, either a purely decorative piece or a shop sign, c. 1880.

PRIVATE COLLECTION

followed them.

In Montreal after the conquest many notable sculptors plied their craft, but there was no monopoly by a single family as in Quebec. The first of these wood carvers, Philippe Liébert (France, 1732 or 1734—Montreal, 1804), had probably arrived in New France shortly before 1759. All his works date from the British regime, among them the sacristy doors of the church of Sault-au-Récollet, which are ornamented by relief carving without equal. It is perhaps Liébert who trained Louis Quévillon (Sault-au-Récollet, 1749—St-Vincent-de-Paul, 1823).

Instead of working with either apprentices or members of his family, as had until then been the practice of Quebec sculptors, Quévillon formed a partnership with three other sculptors from the Montreal region, Joseph Pépin (Sault-au-Récollet, 1770—St-Vincent-de-Paul, 1842), Paul Rollin (1789—Blainville, 1855) and René St-James dit Beauvais (St-Constant, 1785—St-Philippe, 1837).

These four sculptors trained a great many apprentices, who helped them with a large number of commissions for the decorative embellishment of church interiors. Orders came from as far away as that Baillairgé stronghold, the Quebec region. Although without the theoretical knowledge of the Baillairgés, the St-Vincent-de-Paul sculptors could compete with them through their organizing abilities, which enabled

them to complete the works they undertook in a very short time.

The apprentices whom Quévillon and his associates had trained went off and established themselves in various places throughout Quebec. In contrast with the Baillairgés' style, which inclined towards an ever more pure and uncluttered neoclassicism, the sculptors of St-Vincent-de-Paul had a great liking for motifs in the Louis XV style, and mixed these in with elements of the Louis XVI style.

There were many other sculptors in wood besides the Baillairgés, and Quévillon and his partners. To give but one example, the interior décor of the church of Acadia (1803–1822), near Montreal, was executed by a sculptor of Swiss origin, Georges Finsterer, and his son Daniel (born in Acadia in 1791). They both lived in that parish, where they owned and cultivated land while at the same time working at the ornamentation of the church. We have been able here to mention only the most outstanding sculptors, that is, those a knowledge of whose work is essential to a study of the history of wood sculpture in Quebec.

About 1825, events occurred that were ultimately to prove a turning point for wood sculpture in Quebec. These were the arrival of Italian plasterers, and the fashion for the neo-Gothic style. The plasterers could very quickly and very

*Pine and whitewashed weather vane figure of a fish, from the
Bécancour, Quebec, area, late 19th or early 20th century. Wooden
weather vane figures of this period are found in many motifs,
among which fishes are fairly common.*

CANADIANA, ROYAL ONTARIO MUSEUM

cheaply fabricate cast-plaster statues and ornamental motifs
which could afterwards be integrated into the interior décor of
churches.

Interior designs changed completely with the construction
of neo-Gothic churches, whose huge interiors would now entail
tremendous expense if wood was used for the decorations.
Wood carvers received fewer and fewer orders during the
second half of the 19th century, and gradually they stopped
training apprentices. The traditions established during the
French regime were disappearing.

There were, nevertheless, a few sculptors who per-
petuated those traditions up until the 20th century. Jean-
Baptiste Coté (Quebec, 1832—Quebec, 1907) spent a good part
of his life carving ship decorations and, when steam replaced
sail, he did religious subjects. Louis Jobin (St-Raymond,
1845—Ste-Anne-de-Beaupré, 1928) is the best known of the
last sculptors of Quebec to have been trained by apprentice-
ship. It was orders for religious works that enabled him to
earn his living.

A great number of the ecclesiastical sculptures to be
found today in public and private collections came from

Quebec churches. These works are extremely difficult to attri-
bute and to date, because research into the works of Quebec
sculptors is not very advanced. Studies on the styles of the
various wood carvers are almost nonexistent, and this makes
even more difficult the identification of works that have been
torn from group settings in churches where they had a definite
place. At times the task of the historian of Quebec art may be
likened in certain aspects to that of the archaeologist.

Besides the sculptors who developed in response to the
need for church ornamentation, and who plied their trade on a
professional basis, there existed also, especially in the 19th
century, self-taught "village artisans." Their highly stylized
creations constitute an altogether separate but no less interest-
ing facet of early sculpture in Quebec. These people were for
the most part not professionals earning their living solely by
their craft. Instead they were farmers, tradesmen, carpenters,
or people in other trades who took up carving on a part-time
or wholly individual basis, sometimes carving only for them-
selves and friends, and sometimes selling their output.

It was the village artisans of all degrees of skill who
produced carved figures, both standing statues and crucifixes,

for the poorer churches that could not afford the skills of the master sculptors. These same village carvers made great numbers of small crucifixes and figures for the homes of their neighbors; many such pieces in great variety still exist.

Local carvers also produced many other types of decorative objects, such as wooden utensils, particularly spoons, geometrically carved checkerboards, and small jewelry and trinket boxes, as well as childrens' toys and dolls in great profusion. Barn roof decorations and weathervane figures were also made in great number, with roosters, fishes, horses and beavers being perhaps the most popular motifs in the 19th century. In the early part of the present century the range of these motifs extended even to automobiles, dirigibles and airplanes.

The professional church sculptors are gone forever, for in a century of mechanically produced objects their skills are obsolete; but they are remembered for the many great examples of their art they left behind. The craft of the village carvers, however, has never really died out, though it declined in the early 20th century. In recent years, in fact, as part of a general craft revival in Quebec, there has come a great resurgence of traditional wood carving, with virtually everything being fashioned in wood that possibly can be. At present, however, the orientation is focussed primarily on the tourist trade, rather than toward the churches, religion and the village, but the imagination and skills of the carvers have not diminished.

Butcher shop sign of a bull, carved of pine and painted; attributed to Louis Jobin during his Montreal period, c. 1880–90.
CANADIANA, ROYAL ONTARIO MUSEUM

Furniture
of English Quebec

D. B. Webster

Change, or even continuity, in the material history and decorative arts of a people is not governed solely by cultural factors. To be sure, the physical trappings of society have always been influenced strongly by tradition (conservative and implying continuity), by fashion (which often mandates change), and finally by utility born of necessity (affected by both tradition and fashion, but dependent on neither). However, from time to time a comparatively sudden and definable shift or strong trend in fashion has come about because of events whose long-lasting effects are quite distinct from cultural influences. Factors such as military conquests, political upheavals, or major technological advances cause changes which lead to cultural alteration and social reconstructuring.

Such was the case in Quebec and in French areas of the Maritimes. The English conquest of New France in 1759–60, and the whole solidification of British North America during the following decades, resulted ultimately in cultural realignments well beyond simple political changes.

New France before 1760 had been a semifeudal entity with a polarized society. At the top were the landholding *seigneurs* (who were often as well fur-trade entrepreneurs), and the hierarchies of government and of the state church. At the lower end of the scale were the landless habitants—tenant farmers, fishermen, urban laborers and, of course, woodsmen and voyageurs.

The artisan group—the trained cabinetmakers, wood sculptors, silversmiths, and builders—who produced so much of the work described elsewhere in this book, were in a sense a class apart. Compared to the habitants, the artisans were independent people, but only within certain definite strictures. First, there existed no possibility of growth from a craft orientation to manufacturing, for this would have brought direct competition with the French export industry. Eighteenth-century colonies were, by economic rationale, to be raw materials suppliers and consumers of home manufactures; they were not to be competitive producers. Secondly, in a society based heavily on court favor (i.e. titles and granted lands), or on ecclesiastical office, even the comparatively independent artisan group could hardly presume either to social equality with, or to full social independence from, the ruling church and seigneurial aristocracy.

The finer artisans of New France were thus producers of objects for a fairly small market. Consequently they were heavily dependent on the patronage and favor of the wealth concentrated in the landed gentry, churches and government.

With this background it is not difficult to see why examples of the decorative arts of the French period are relatively rare, and the best work extremely so. The finest furniture—the carved armoires, the *arbalète* commodes, the Louis XIV and XV armchairs—graced the townhouses or manors of *seigneurs* and clergy, not the stone cottages of peasants or *pescheurs*. The finest wood carving was commissioned for churches, or occasionally for wood-paneled rooms in the grander houses. The finest Quebec silver is very largely ecclesiastical; even silver flatware was limited generally to the monied elite, and domestic hollowware was uncommon even there.

As in much of Europe, there did not exist in New France a true middle class, a bourgeoisie, in the sense of socially and financially self-reliant professional or entrepreneurial groups not dependent on a ruling landholding class. The first English population coming into Quebec was, of course, made up of those people connected with the military and with colonial administration—the so-called garrison society. By 1785, however, the British base had grown substantially, with the coming of many types of English and Scottish emigrants, from clergy to merchants, from farmers to shipbuilders. This base was increased with an influx of American Loyalists, many settling in the now Eastern Townships (substantial French settlement had always been limited to the major river valleys). British or American, these people, very generally categorized, were yeomen in the English definition—untitled freeholders—neither dependent on nor responsible to landed gentry or clergy.

Drop-leaf, swing-leg table of mixed birch and maple, with club-footed cabriole legs and an extended scalloped apron typical of the Queen Anne period of the earlier 18th century. However, style alone would date the table impossibly early, so this must instead be considered a stylistic throwback, from the Eastern Townships area, of the late 18th century.

CANADIANA, ROYAL ONTARIO MUSEUM

The new immigration included small numbers of cabinet-makers, trained and experienced in building furniture according to prevailing English designs and styles. These came after about 1785; none are recorded earlier. It had required the passage of twenty to twenty-five years following the conquest for a sufficiently large British population and market base to develop to support sophisticated cabinetmaking. This is indicated also by the fact that the earliest surviving Anglo-Quebec furniture dates stylistically from the 1785–1790 period, with none known that can be firmly established as earlier. (The same is true of the Maritimes. Though Halifax was a thriving English garrison and port by 1750, there is no extant native furniture of this period, and no record of resident cabinet-makers before the 1780s).

The basic English style of the 1780s was what might be called late Chippendale, evolved with changes in the direction of simplification from the designs of Thomas Chippendale, published first in his *The Gentleman and Cabinet-Maker's Director* of 1754. The primary wood was, of course, West Indian mahogany, used in finer pieces both for structural members and for veneering, and imported from the Carribean into Quebec, Montreal and Halifax. In simpler and less expensive furniture, however, butternut, birch, and maple were commonly substituted, and birch was typically used, particularly in chairs. Cherry, though a beautiful wood often called the "poor man's mahogany" (and with a proper finish, even more pleasing), occurs in Anglo-Quebec furniture only rarely, and then only in the minor parts of furniture; the tree is not native to Quebec.

There is no question but that the best of the English-derived furniture of the 1785 and 1820 period was, qualitatively, among the finest furniture ever produced in Canada. In spite of the regional divisions of this book, however, this furniture, overall, must be looked at in terms of design and period, for regional variations are limited to minor structural details, and to differences in woods from one area to another.

The study of sophisticated English-Canadian furniture, in Quebec as elsewhere, raises immediate questions of identifica-

Secretary desk, of mahogany with pine and poplar as secondary woods, with carved molding on the doors, claw feet, and English hardware. This secretary, one of the finest existing pieces of Canadian furniture, was made in Quebec during 1791–93 or 1796–98 for Edward Augustus, Duke of Kent and Strathern (Queen Victoria's father), while he was stationed there.

CANADIANA, ROYAL ONTARIO MUSEUM

tion. This arises from the fact that, except for long-case clocks, few cabinetmakers ever marked any piece of their furniture, except very occasionally in pen or pencil script. Only two Maritimes makers, Tulles, Pallister & McDonald of Halifax, and Thomas Nisbet of Saint John, New Brunswick, are known to have used paper labels. Thus, no matter how intensively the history of various cabinetmakers may be examined from surviving documentary records, it is in most cases impossible to make specific attributions to them of individual pieces of furniture. Conclusions are at best debatable.

We are also faced with the aspect of English-trained and American-trained cabinetmakers, working in the larger Canadian urban centers and building furniture according to designs, styles and construction techniques they had been taught as apprentices, but incorporating their own necessary adaptations. Identification, both as to Canadian origin and as to region, becomes then a study of specific details rather than of overall design: the species of wood used and their combinations;

veneers; hardware; and construction techniques. (So conservative was the apprenticeship system that only into a second generation of English-derived cabinetmaking, in the 1820–1830 period, do we begin finding stylistic adaptations that identify themselves, by form and proportion alone, decisively as Canadian.

In trying to establish a particular piece of furniture as Canadian, the best approach probably is, first, an attempt at eliminations, that is to say, can the possibility be ruled out that the piece is English or American? A firm provenance or context helps establish location—did the piece descend through a particular family (by knowledge, not supposition), or did it come from the (probably) original furnishings of a specific house? This will not, unfortunately, establish origin, for there is also considerable early English and American furniture in Canada that came, and still comes, with original immigrants, to say nothing of that which has traveled in the antiques trade in the 20th century.

Sheraton sideboard with reeded legs, of mahogany and mahogany veneers over pine as the secondary wood, and with maple line and geometric inlays. This piece is from Montreal, c. 1815–20.

CANADIANA, ROYAL ONTARIO MUSEUM

The next point is hardware. Canadian-produced fine furniture of the 1785 to 1830 period will almost invariably have English hardware, that being the usual trade source; American cabinet hardware is not known to have been imported before the mid-19th century.

Wood is the most important, and most difficult, consideration, for it is simply not possible to determine absolutely the species of all types of finished wood by eye alone. There is pine in England, for example, though different from the white pine of eastern North America. Some cabinet-woods, and particularly figured maple, were also exported to England, exactly as mahogany and cut veneers of exotic woods were imported into Canada. The use of different woods in combination is, however, of equal importance.

Under the primary wood of any complex piece of mahogany or veneered furniture are one or more species of secondary wood, used for the frame, back, drawer linings, glue blocks, and perhaps surface areas underlying veneers. If, for example, the prime secondary wood is hard oak in a piece of basically mahogany furniture, the piece is almost certainly English, since oak was only very rarely used as a secondary wood in North American furniture. If, on the other hand, the secondary wood is white pine throughout, the piece is certainly not English, for secondary pine in English furniture is as uncommon as oak in North America. In this case the piece, if combined with English hardware, is most likely Canadian. American furniture, however, particularly of the New England area, also utilized pine as a secondary wood. As well as having American hardware, however, such pieces are likely to be more definitively American (i.e. non-English) in basic design than is Canadian furniture. American furniture often also includes several different secondary woods, with as many as five species used in the structure of the same piece, a secondary mixture virtually unknown in Canadian furniture.

Essentially, then, the English-Canadian fine furniture of late 18th- and early 19th-century Quebec is basically English in design and form, including its hardware and veneering styles. However, it will typically be simpler and less elaborately veneered or inlaid than equivalent English pieces, and will include in its structure the use of native Canadian woods.

In making identifications through consideration of detail, there are unfortunately no absolute rules or criteria than can be applied to lead to certain and definitive conclusions. We are dealing, rather, with a balance of evidence situation, almost in

◁ *Card table with folding top in the Hepplewhite style, and a Chippendale scroll-framed mirror, both made in Montreal, c. 1810, for Sir James Monk, Chief Justice of Lower Canada. The table is of West Indies mahogany, with fine line inlays in maple. The mirror, also mahogany, has a gilded inner frame liner, and decorative scroll-cut base and top extensions.*
CANADIANA, ROYAL ONTARIO MUSEUM

Tall clock, of mahogany with fan inlays above the case door and in the base section. The works are English, as is true of all earlier Canadian tall clocks, though the brass face is engraved "James Orkney / Quebec," the case maker and assembler. This is one of the finest and one of the earliest of known Canadian clocks, and dates c. 1785–95. CANADIANA, ROYAL ONTARIO MUSEUM

a legal sense, leading to identification, definitively in some cases, but in many instances only beyond a reasonable doubt.

As mentioned above, the earliest prevailing design form of Anglo-Quebec furniture is the late Chippendale, emphasizing straight square or tapered legs, on both chairs and on standing pieces such as tables or sideboards. The opulent ogee or cabriole legs (often terminating in the ball-and-claw feet that characterized late Queen Anne and early Chippendale furniture) had gone out of style by the late 1780s, and do not occur on Anglo-Quebec furniture, with the exception of occasional stylistic "throwback" pieces.

Throwback pieces are individual pieces of furniture built in a style or to a design form considerably earlier than their own time, for reasons we cannot really fathom through hindsight. Obsolete design forms are common in Franco-Quebec furniture, where a not-yet-dead medieval tradition was the strongest influence on the artisans of a colony largely isolated from the French cultural mainstream. Throwback furniture is not common in the English milieu, however, for by the late 18th century new ideas, designs and popular fashions crossed the ocean quickly. There are known to exist, however, a few such pieces, largely from the Loyalist-settled Eastern Townships. These include two maple drop-leaf tables with cabriole legs ending in pad feet, in the late Queen Anne manner of the 1740s, though actually dating from the 1790s. Several existing maple gate-leg drop-leaf tables with heavy leg and stretcher turnings, though made in the 1780s or 90s, are of the late 17th century in design.

The stylized English mahogany furniture of Quebec—the finest work—originated in the cities of Montreal, Quebec, and Trois-Rivières, and was limited to those areas. Being ports, they were accessible for imported mahogany and exotic woods—as logs or cut plank—as well as of veneers and hardware. Also, as centers of increasing mercantile prosperity, it was the cities rather than the rural agricultural areas that contained the necessary concentration of both people and wealth to provide a broadly based market for fine cabinetmaking. Furniture of the Eastern Townships, whatever its design origin, is typically constructed of native hardwoods, most commonly maple or butternut, rather than of mahogany. Imported wood was too heavy and difficult to transport overland for it to be readily available at any distance from ports of entry. In rural French-speaking areas, the traditional French-derived furniture continued to be made even into the late 19th century.

In spite of the proximity of New England, both the commercial and the cultural life of urban English Quebec leaned heavily toward England. The so-called Chinese-Chippendale furniture, which became popular in a fashion wave of chinoiserie in the eastern United States in the late 1780s and '90s, had virtually no impact on Quebec; no Anglo-Quebec furniture showing a Chinese influence has been observed.

By 1800 the popularity of Chippendale designs was waning in favor of (or being combined with) Hepplewhite, Sheraton and Adam-Classical Revival forms and characteristics. With several design periods in vogue, as well as competing fashions, the finer English furniture of Quebec became increasingly mixed in its design details over the next few decades. Round-legged furniture, on better pieces with Sheraton reeded or rope-twist carving, was predominant by 1810. A Hepplewhite

Tall clock with reeded top columns and case quarter-columns, of mahogany and mahogany veneer over butternut; with floral inlays in the upper case, door, and base section. This clock was found near Quebec city, but its maker is not established; it dates from the first quarter of the 19th century.

CANADIANA, ROYAL ONTARIO MUSEUM

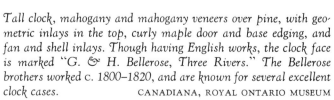

Tall clock, mahogany and mahogany veneers over pine, with geo-metric inlays in the top, curly maple door and base edging, and fan and shell inlays. Though having English works, the clock face is marked "G. & H. Bellerose, Three Rivers." The Bellerose brothers worked c. 1800–1820, and are known for several excellent clock cases.
CANADIANA, ROYAL ONTARIO MUSEUM

Bracket clock in mahogany, with brass ball feet and finials, and English works and brass face. The face is engraved "Fra. Dou-moulin à Montreal," a French-Canadian cabinetmaker working in an English manner. Nothing is known of Doumoulin, but the clock dates stylistically to the 1785–1800 period.
CANADIANA, ROYAL ONTARIO MUSEUM

Chippendale armchair in birch and butternut, in a very simple form with upholstered slip seat. This chair is typical of the late Chippendale style in Quebec, and is probably from the Eastern Townships area, c. 1790–1810.

CANADIANA, ROYAL ONTARIO MUSEUM

Pair of Chippendale sidechairs, birch, also in a very simplified manner but with good proportions, dating from 1790 to 1810, and probably from the Eastern Townships.

CANADIANA, ROYAL ONTARIO MUSEUM

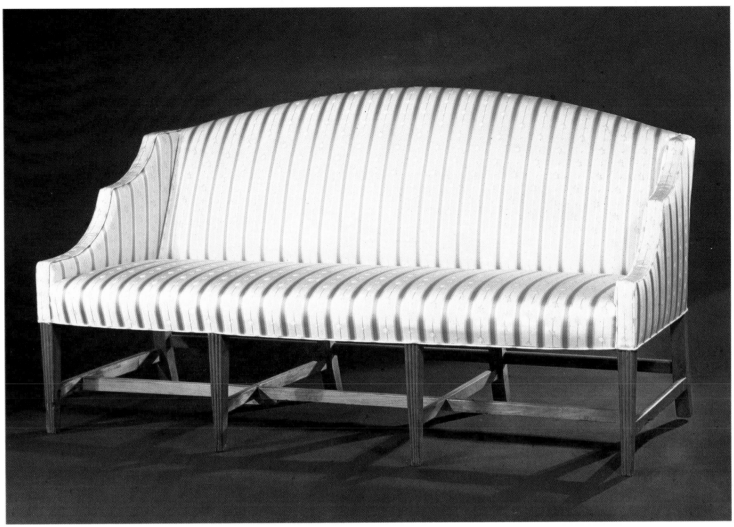

Sofa, cherry and pine frame, with late Chippendale stretcher base and tapered reeded legs, from the original furnishings of a house at Maitland, Ontario, built about 1820. The sofa may originate from eastern Ontario, though its sophistication suggests the Montreal area. In its similarity to New England pieces, this sofa also indicates an American Loyalist rather than an English derivation. CANADIANA, ROYAL ONTARIO MUSEUM

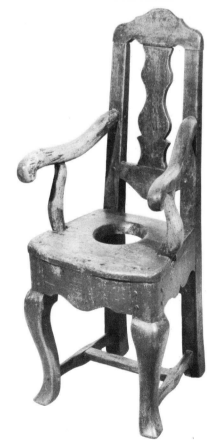

A good example of the stylistic mixture that affected French traditional cabinetmaking in the late 18th century, this child's commode chair, of birch, maple, and pine shows both definite Chippendale and Louis XV design influences, and dates c. 1790–1810. The piece has much of its original red paint.
 CANADIANA, ROYAL ONTARIO MUSEUM

influence appears in finer and lighter furniture structure (as slightly later does the Adam-Classical Revival in Grecian column and pediment forms), and in highly disciplined proportion and decorative carving, both in furniture and in architecture. By 1815 to 1825 a particularly Anglo-Quebec style, neither purely English, nor American, begins to be evident in some pieces—intangible except through detailed observation, but readily apparent none the less.

In any situation such as that in Quebec in the first half-century after the British conquest, it is beyond possibility that neither culture would have an influence on the other, and in a great many directions. To consider only furniture, the mixture of design influences that emerged in Quebec appears to have affected the work of French cabinetmakers the most, leading to very definite English characteristics being incorporated in elementally French pieces, and to traditional French traits being superimposed on pieces intended to be English-derived. This intermixture of design and construction characteristics, the English largely fashion-based, the French traditional, was limited to country or rural cabinetwork, and resulted by the early 19th century in a uniquely Quebec furniture type which might be termed "Franglais." This mingling of styles, however, is evident only in French cabinetwork; it does not seem to

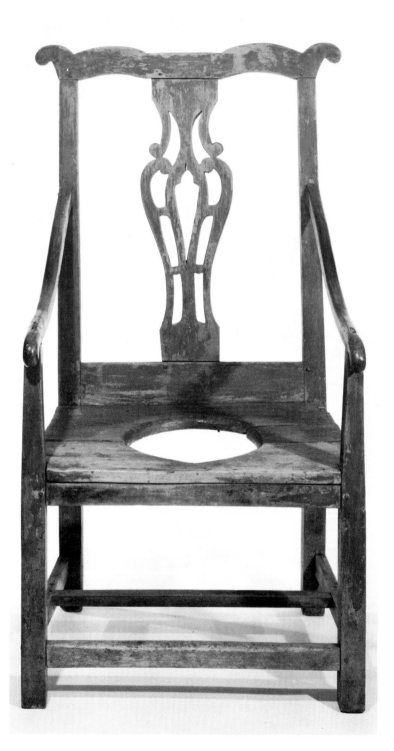

Commode chair of maple and pine, with original blue paint, in a mixed Chippendale (most evident in the back) and traditional French (arms and base) form, dating probably c. 1800.
CANADIANA, ROYAL ONTARIO MUSEUM

Sewing table (with hanging work bag missing), mahogany with secondary pine, and unusual straight ball casters, Montreal, c. 1830.
CANADIANA, ROYAL ONTARIO MUSEUM

Sofa table, mahogany with secondary pine, with two-pillared end supports and a cross stretcher. The top is outlined with a curly maple inlay, and the drawers and end-blocks with maple line inlays. The hardware is English; the table is from Montreal, c. 1820–30. CANADIANA, ROYAL ONTARIO MUSEUM

Sheraton-derivative card table, with one swinging leg to support the opened top; in mahogany and mahogany veneering over pine as a secondary wood. The piece has maple line inlays in the skirt and English hardware. It originated in Montreal in the first quarter of the 19th century.

CANADIANA, ROYAL ONTARIO MUSEUM

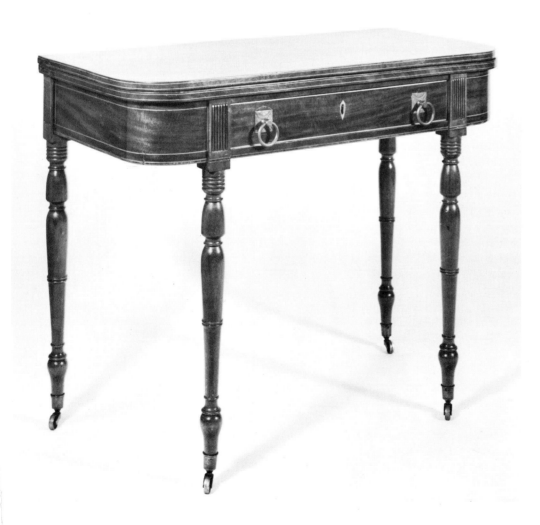

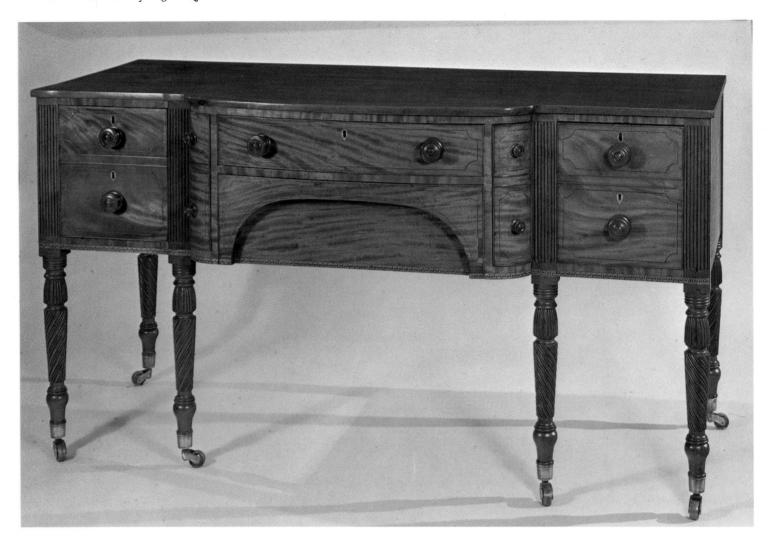

Sideboard, mahogany and mahogany veneers over pine, with reeded and rope-turned legs, and line and geometric inlays of maple. It has English casters and drawer locks; all Canadian furniture of this period utilized English hardware. This piece is from the Montreal area, c. 1820–30.

CANADIANA, ROYAL ONTARIO MUSEUM

have affected the English cabinetwork of the urban centers, since this furniture was derived from written sources—design books and drawings—and was made for a wholly English population. The English environment, it would appear, was not as readily subject to French traditional influences as was the French cabinetmaking tradition to the impact of the new culture and its different design forms.

The French power structure—government hierarchy, senior churchmen, and *seigneurs*, had in some numbers chosen to return to France following the British conquest, severely disturbing the patronage base under which the artisans of New France had operated. The strength of the French craft tradition now proved fortunate. With a relatively easygoing conquest which guaranteed the rights of French language, law and church, the craft system survived and prospered; though some prime markets were lost, and cabinetmaking was increasingly subject to alien design influences.

Though French traditional furniture making continued into the late 19th century in predominantly French areas, and in church carving even after 1900, there is no doubt that the

exodus from Quebec of the French colonial power structure contributed to a gradual decline in quality. The first furniture to disappear wholly from production by the early 19th century were those types which had superimposed style on tradition, and coincidentally were the pieces of highest quality—Louis XV paneled and carved armoires, shaped chairs, *arbalète* commodes, and *Régence* forms, as well as the more extreme of earlier design forms such as daimond-point-paneled armoires and heavily turned chairs.

By about 1810 Franco-Quebec cabinetmaking had become largely adapted to country furniture. Armoires were increasingly plain-paneled; chairs straight-backed and simple; English-influenced Quebec-type chests of drawers were replacing commodes. English-derived details, from Chippendale backs on chairs, to Chippendale bracket skirts and feet on blanket boxes and commodes, to French adaptations of wholly English furniture forms (the essence of the Anglo-Quebec style), were becoming common.

The English-derived urban cabinetmaking of Quebec in the early 19th century followed the prevailing Sheraton-Hepple-

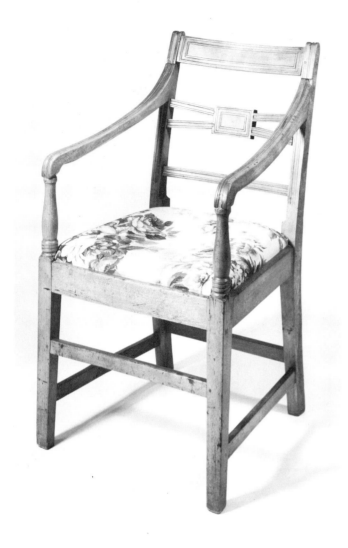

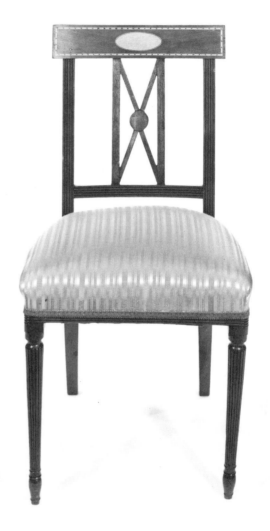

Armchair of butternut, in mixed French and English styles, with upholstered slip seat, an Anglo-Quebec ("Franglais") piece from the Ottawa Valley, c. 1830–50.

CANADIANA, ROYAL ONTARIO MUSEUM

Sheraton sidechair with reeded legs and back uprights of mahogany with an oval maple inlay, and geometric maple inlay band in the top rail. This piece is from Montreal, c. 1825–30.

CANADIANA, ROYAL ONTARIO MUSEUM

white-Classical Revival styles, for after 1805 no radically new forms emerged from England. Change now involved rather adaptations of existing designs, with a very strong tendency toward simplification. From the end of the Napoleonic Wars, the restoration of the Bourbon monarchy in France, and finally, after nearly twenty-five years, peace in Europe, the point of origin of new fashions in furnishing shifted again to France. The influence of so-called Restoration or Empire furniture, which became the prevailing design form of the 1820s, was strong in North America—Quebec included. Mixed with other now universal English-derived design characteristics, the French Empire style became the predominant influence on furniture in North America for the next thirty years. The French cabinet-making tradition in Quebec, however culturally ingrained, was already moribund by 1820 to 1825, declining in quality as well as design; and unlike earlier English styles, the Empire and later 19th-century styles came far too late to have any real impact on it.

By 1825 to 1830, in English Quebec as elsewhere, the French Empire style had become generally popular as the last

of furniture designs to be governed wholly by the desires or demands of fashion. Another force was operative by now, which doomed not only the Québecois cabinetmaking tradition—no matter its tenacity—but the English cabinetmaking craft as well—in spite of its environmental security in Lower Canada—and within half a century brought an end to the craft system as a whole.

Since the beginnings of civilization the world had depended on domestic artifacts—the tools of lifelong existence and comfort—from flint spearheads to cooking pots to furniture. All were based entirely on human skill, and created largely by human labor. Power sources were largely limited to animals, with horses as the most adaptable. Horses, however, just like men, are of measurably limited effect as power sources, and ultimately but predictably get tired. Wind and flowing water, while perhaps superior to men or horses for power output, are generally less consistent and more unpredictable.

Of all the names that have been applied to it, the 19th century can perhaps be best thought of, in a phrase, as the age of dependable artificial power. The development of reliable

Card table with turned and rope-carved support pillar, and carved scroll feet; of mahogany and mahogany veneering over pine, with a wide line inlay at the bottom of the skirt. The table is from Quebec City, c. 1840. CANADIANA, ROYAL ONTARIO MUSEUM

Card table of the swivel-top type, mahogany with secondary pine, and with a maple band inlay around the skirt. The table has a simple turned central column. It is from Quebec city, c. 1850.
CANADIANA, ROYAL ONTARIO MUSEUM

steam engines made possible not only manufacturing industry on a sizeable scale, but the dependable movement of ships, and—more important in North America—railroads. The transportation over long distances, along internal waterways and overland, of heavy or bulky goods became practicable for the first time.

The coincident invention and development of industrial machinery gradually began transferring some steps in the fabrication of objects from the skills of men to the functions of machines, and also made feasible the concept of mass production. This might be defined as the production of quantities of identical component parts, most reliably achieved by the consistency of machine processes, with different parts then to be assembled into quantities of identical finished units.

The earliest furniture produced according to the concept of mass production was probably reed-back Windsor chairs in the 18th century. Though the component parts at that time were made by hand, furniture still was being produced by factory-employed woodworkers rather than by independent cabinetmakers planning and constructing complete pieces.

In Canada, furniture factories began developing about 1830, adapting the specific design features of existing popular furniture types, primarily the Empire style, to component parts production by machinery. The factories could produce furniture to sell at far lower prices than could independent cabinetmakers, and they could also turn out far greater quantities than could possibly be sold in their own immediate areas. Thus the developing steam-powered transportation systems, as well as canal systems, were an integral part of growing industrialization, which depended on long-distance and widespread marketing.

Since the factory, unlike the individual cabinetmaker, did not and could not deal directly with the customer, specialized retailers—furniture stores—also grew up in areas quite remote from the actual manufacturing. In fact, many cabinetmakers also became dealers, handling the products of one or more factories as well as their own output, while others in the end ceased independent cabinetmaking and set up small factories of their own.

The Empire style, particularly in individually-made Montreal mahogany furniture of the 1820s and '30s, was as fine in design and craftsmanship as the earlier forms, but it was the last of the design fashions to incorporate regional details sufficient for later students to arrive at identifications. The expanding opportunity for individual rapid travel, and particularly the increasing ease of long-distance shipment of goods combined with the growth of advertising—all the result of steam power and industrialization—by 1830 began homogenizing taste, fashion, and design very quickly throughout North America. Within a decade the more sophisticated furniture produced in Montreal, Quebec and Trois-Rivières, as well as other cities by then, was emerging from factories, not cabinet-shops. Universal design uniformity was already a fact, and "North American Factory" as a style had before 1850 both replaced independent design, and largely eliminated regional characteristics. After 1840, in fact, it becomes difficult any longer to speak of "Anglo-Quebec" furniture in a regional sense at all.

The sophisticated English furniture of Quebec was made during only a rather short time span, from about 1785 and the

Chest of drawers, butternut with maple inlays, dated 1852, from the Eastern Townships of Quebec. The piece shows mixed styles, with plain corner pillars contemporary with its date, but with splayed French legs of an earlier period. Though the exact origin of this piece is not known, two other very similar chests are known to the writer, with virtually identical though less elaborate inlays.
CANADIANA, ROYAL ONTARIO MUSEUM

Sewing table of mahogany and mahogany veneering, with second-ary pine, cherry, and maple, and with carved legs ending in brass lion's-paw casters. The upper drawer is signed "I. Myrand," for Joseph Myrand, a Quebec City cabinetmaker listed in the Canadian Directory for 1857.

CANADIANA, ROYAL ONTARIO MUSEUM

Hepplewhite side table, of mahogany with mahogany veneer over pine, and with decorative inlays in maple, satinwood, and teak. This table, dating c. 1820, was found in the Quebec City area.

CANADIANA, ROYAL ONTARIO MUSEUM

Armchair in a Regency style, mahogany with pine seat frame, from the Quebec City area, c. 1825–40.

CANADIANA, ROYAL ONTARIO MUSEUM

Chest of drawers, of butternut with maple rope-carved corner pillars, and pine drawer and inner structure. The drawer fronts are relief-carved with corner fans and ovals, and the initials "F S," probably the person for whom the chest was made. This piece is from the Eastern Townships area, and dates to c. 1830.

PRIVATE COLLECTION

Chippendale period, into the Empire period, a range of slightly over half a century. The finest of this furniture was every bit as good, in design and craftsmanship, as any being made in England or the United States during the same period, albeit generally somewhat less elaborate. Such known-maker examples as the Chippendale clock cases of James Orkney of Quebec or of the Bellrose brothers of Trois-Rivières and some other Quebec-identified but unattributed pieces, are unexcelled.

Anglo-Quebec fine furniture, however, was certainly never as common as imported English cabinetwork, and known identified Quebec-made pieces are relatively rare today. However, this furniture even now has barely been recognized for what it is, and virtually nothing has been published on it. It has received attention far less, and for a much shorter time, than French-Canadian furniture, as well as being less readily distinguishable. As a result, there undoubtedly exist numbers of good early pieces, well cared for in private homes, that have not yet come to light or been explicitly examined with an eye to determining origin.

Little directed specific research has yet been done on the careers of independent English, Scottish, and American cabinetmakers in Quebec. Studies in Canadian furniture are in this way only in their first generation—that of determining Canadian origin and outlining regionality. Available information, however, indicates that probably no more than forty English-manner cabinetmakers worked in Lower Canada during the earlier range of sophisticated English cabinetmaking, and

obviously not all were active at the same time. Numerous others became active only in the Empire period, after c. 1825–1830.

Even granting probable other cabinetmakers as yet unrecorded, and reasonably prolific production, these people certainly supplied only a fraction of the contemporary demand for English-derived furnishings. Then assuming even a relatively high survival rate, for this was furniture which would be cherished and maintained, its present-day rarity becomes easily understandable. At a guess, though a reasonably reliable one, there are today certainly fewer than two hundred known pieces of English-derived mahogany or mahogany and mixed-woods furniture that have been identified, at least beyond a reasonable doubt, as the product of an early Anglo-Quebec cabinetmaker. Attempts at specific attribution to particular craftsmen are a yet more difficult exercise.

Though identification of the better Anglo-Quebec furniture requires both a good comparative knowledge of English and American furniture, and an experienced eye for examining detail, the work is well worth the effort. Among the finest examples of Canadian cabinetmaking the sophisticated Chippendale, Hepplewhite, Sheraton, and Classical Revival furniture of urban English Quebec is by all odds the least recognized, least identified and least studied of all Canadian furniture types—a very rich field for collectors and research students alike.

Nova Scotia Furniture

George E. G. MacLaren

Because of its geographical position Nova Scotia is, in all probability, the Canadian province with most readily available access to world markets and manufacturing centers. With the Atlantic coast at its front door, Nova Scotia is able to take advantage of both old and new world markets. In the period from 1870 to 1880 Nova Scotia ranked fourth among the ship-building countries of the world. Is it any wonder that its ships were so well known in all the trading ports of the world?

Nova Scotians were great collectors, not only as a result of trade but also through participation in such early conflicts as the Relief of Lucknow, 1857 (in the course of which William Hall, a black man of Avonport, N.S., became the first Canadian winner of the Victoria Cross); the Indian Mutiny; the American Civil War and the Alamo. Whaling in the Bering Sea was an active enterprise and our adventurers were to be found in the gold fields of the Klondyke, California and Australia; some of our missionaries lived and died in the South Seas. It is not difficult, therefore, to understand the reason for the diversity of material in our collections—scrimshaw from the whalers; nuggets from the gold fields; weapons and tapa cloth from the Fiji Islands; mahogany and walnut furniture of all descriptions from England, Scotland and the United States—to mention a few examples.

Following the last war, activities in the antique field have undergone a distinct change, we hope for the better. The dealers and pickers no longer have control of the market; the younger generation with a desire to be identified with the past have, as a consequence, become heavily involved in collecting the remnants of our past. Furniture is not the sole investment, the value of silver, glass and paintings is steadily increasing. One evidence of this is the number of large auctions being held in Canada by branches of two of the leading English auction houses.

NOVA SCOTIA AND ITS CABINETMAKERS

The first white men to come to Nova Scotia made their initial settlement at Port Royal (now known as Annapolis Royal) in 1604. In the group were Samuel de Champlain, Sieur de Monts, Poutrincourt and their company of one hundred and twenty artisans and soldiers. The buildings, which they removed from their original settlement on the St. Croix River in New Brunswick, were reassembled to form a habitation patterned after a 17th-century French manor house. In 1613 the habitation was burned by Captain Argall from Virginia. (The present structure was restored in 1939–40 and is now a historic site.)

The destiny of Acadia (which comprised parts of present-day Nova Scotia, New Brunswick and Maine) was then left in the hands of the traders and adventurers. Some 300 French settlers brought out by Isaac de Razilly and D'Aulnay Charnisay between 1632 and 1640 became the ancestors of our present day Acadians. They were farmers and fishermen, with a few blacksmiths and carpenters. Acadia, being a small settled area, did not have a Bishop Laval to bring in woodcarvers and other craftsmen to create a school for the development of trades so necessary in the new world, especially in the fields of home construction and decoration of churches. History reveals that these craftsmen were needed, for in 1687 Gargas, the principal clerk, visited Port Royal and recorded the state of housing to be low—dwellings were constructed of rough pieces of wood laid one on top of the other and roofed with thatch.

In the following half-century the Acadians, with planes and saws, would begin building not only their homes and barns but even making all the necessary domestic furniture. By 1755 their numbers had increased to almost ten thousand, but because of their refusal to take the oath of allegiance to the British Crown they were deported (approximately six thousand of

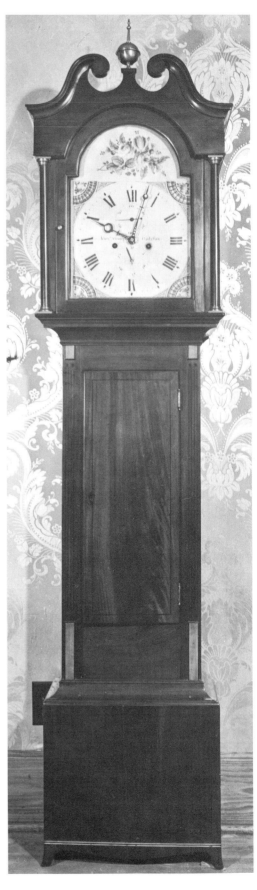

Sheraton drum table, mahogany and mahogany veneering over pine, with four drawers and four false drawer fronts. The top edge is reeded, as is the central column and the legs. The table is labeled in two of the drawers by Tulles, Pallister and McDonald of Halifax, c. 1810–11. This and the clock in the Nova Scotia Museum are the only known pieces by this short-lived partnership. This important table was sold at auction in England in 1956; the auctioneers decline to divulge the buyer, and its whereabouts is unknown. The General Editor would be most interested to learn of its current owner and location.

Tall clock, of mahogany and mahogany veneering over secondary pine, and with maple inlays. The clock was made, and is marked on the dial face, by Alexander Troup, Sr. or Jr., in Halifax, c. 1820–30.

NOVA SCOTIA MUSEUM

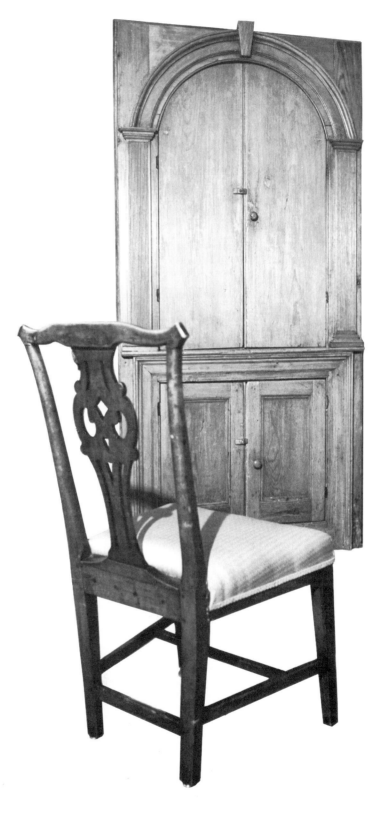

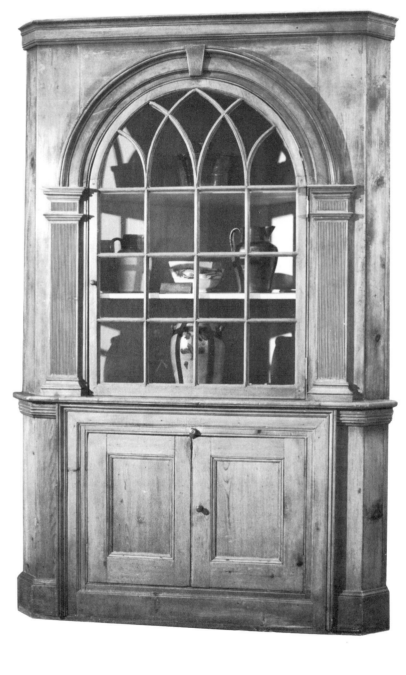

Corner cupboard, pine, with Classical Revival derivative arched door-frame and reeded side pillars. The cupboard, originally built-in, is from southwestern Nova Scotia, c. 1825–35. In the foreground is a late Chippendale side chair of birch, made by James Waddell of Halifax, c. 1813–15. NOVA SCOTIA MUSEUM

Pine corner cupboard with round-topped glazed door and arched frames, with a Classical Revival derivative arched door frame and reeded side pillars. This was also a built-in piece, c. 1825, from the southwest shore of Nova Scotia. NOVA SCOTIA MUSEUM

them) to the American colonies on the Atlantic coast. In the course of deportation their homes were burned to the extent that virtually nothing of their furnishings remained. A few chairs attributed to Acadian origin have turned up in Nova Scotia; these are characterized by their low seats, and rungs which penetrate the legs—most Acadians of that time were smaller in stature than the English. Today this type of low chair is used mainly as a hall chair.

In 1763 the Acadians were permitted to return. One group of over 900 walked through the wilderness from Boston to the Annapolis Valley, only to find their former lands occupied by the English. They then moved on to Digby County and various parts of Cape Breton and Antigonish. Those who settled in Cheticamp were later to become famous for their hooked rugs.

In 1749 Halifax was founded as a foil against the French at Louisbourg and Quebec. Being the seat of government and headquarters for the army and navy, its fortunes rose and fattened with a permanent garrison and war. In Halifax, therefore, there arose a class of wealthy officers, officials and merchants who were able to afford a rich social life and vie with each other in the importation of expensive English furniture, as well as patronizing local cabinetmakers. The following excerpts taken from Halifax newspapers between 1817 and 1846 will serve as illustrations of this.

From the *Acadian Recorder* (Halifax, Nova Scotia, December 16th, 1817):

At Mr. Alexander Stewart's Warehouse, in Mr. Jacobs' Brick Buildings, TO-MORROW, Wednesday at 12 o'clock,

A GREAT variety of very superior FURNITURE, comprising, mahogany four-post and tent Bedsteads, Sofas, Dining and Pembroke Tables, Chests of Drawers, A grecian Couch with Chairs to match, a great variety of Window Curtains, Poles, Cornices, &c. The above stock may be viewed on Tuesday, previous to the sale. The whole will be sold without reserve. The greater part being of his own manufacture, may be depended on as faithfully executed.

Also, at the same place,
Two Horses, fit for saddle or draught.

From the *Morning Chronicle* (Halifax, April 25th, 1846):

AUCTION SALES
BY DEBLOIS & MERKEL

This day Tuesday, at 12 o'clock, at the residence of Miss Barkman, Hollis Street.

Part of her Household Furniture, comprising,

Mahogany, Dining, Pembroke and other Tables, Sofas, Chairs, Window Curtains, Feather BEDS, Pillows, &c. Mattresses, Carpets, Fenders, Fire Irons, CHEST DRAWERS, Glass, China, &c. &c.

Also—KITCHEN UTENSILS

From the *Acadian Recorder* (Halifax, July 1st, 1821):

A FURTHER REDUCTION
New Furniture

The subscriber begs leave to return his sincere thanks to his friends and the public in general for past favours, and wishes to inform them that he has on hand, an assortment of the most elegant and fashionable FURNITURE, that has as yet been offered here for sale—among which are the following:—elegant pillar and claw, dining, pembroke, card and sofa Tables; ladies' work and toilet do; Secretaries and Book Cases; Chests of Drawers and Basin Stands; elegant Brass ornamented and carved Sideboards; carved plain and hair covered and common sofas and couches; Mahogany and Windsor Chairs; elegant high post Bedsteads, with carved and cable, superior to any done in this country before; plain reeded and birch do; single and double ... do; do with French ...; ladies music Stools, and portable Desks,—Also, all sorts of Window finishing; Curtain Fring(e); &c.; hair Mattresses, and Palliasses, neatly made; Bed and Window Curtains made in the most fashionable manner, on the shortest notice. All of which he offers for sale on the most reduced prices, for cash or short credit.

The above Furniture, being all manufactured by the subscriber, he will warrant to be of a very superior quality; and hopes from the satisfaction his furniture has already given both to town and country, to receive a part of the public patronage. Funerals attended on moderate terms.

William Gordon, George St.
Halifax, July 1st, 1821.

Perhaps the following description of a Halifax home and its furnishings, recorded in 1774 by two Englishmen, John Robinson and Thomas Rispin, in their *Journey through Nova Scotia* (Public Archives of Nova Scotia Bulletin, November 30th, 1944), will best serve as an illustration of the times.

The houses in Halifax are all built of wood painted to look just like freestone, and are covered with blue slate. The inhabitants are a civilized, well-behaved people, of different countries—English, Irish, Scotch and Dutch. They have a neat English church, with handsome pews and lofts, and a fine organ, a Presbyterian meeting-house as neat as the church, a Methodist preaching-house. Windsor is a township, and contains a deal of cleared land, which seems very good. Here is a large marsh, all diked in, called the King's Meadow; part of it is plowed out and grows good wheat, barley, oats and peas. At Cape Dorre, about thirty miles from Cornwallis, there is a copper mine, and a lead mine near Annapolis. The woods about Annapolis affords a great store of fine timber, such as oak, of different kinds; white and black ash; white maple; rock maple, (a very fine wood for household furniture), birch, white, yellow and black, but the black is best for furniture. The women are very industrious housewives, and spin the flax, the growth of their own farms, and weave both their linen and woolen cloth; they also bleach their linen and dye the yarn themselves. The candles, soap and starch are of their own manufacture. Their houses are generally built square, and chiefly of wood, with chimneys of brick in the centre, so contrived as to convey the smoke from all the different fireplaces. The windows are all

sashed, and as they pay no duty for them, they are very numerous and render their houses light and pleasant. They all build with post and pan; when they get about three yards high they take it in a little; about two yards higher they fix their chamber windows, and above them their roofs; some build a story higher. After being boarded, they appear very neat and compleat houses. They board the outside up to the roof, with what they call clapboards, which are about four inches broad, a quarter of an inch thick on the lower side, and exceedingly thin on the upper, so as to lay on each other's edge. They wainscot the inside and make it very neat. Their roofs are covered with planks, on these they fix what they call shingles, which are pieces of board, about eight inches long, four broad, and a quarter of an inch thick at the bottom, and thin at the top, and are used much in the same manner as we do slate in England. All their houses have cellars under them. . . .

Edward Draper, Halifax's first cabinetmaker, arrived there in 1749. A century later, research shows over six hundred (including clockmakers and chairmakers) working in various parts of the province. Almost every small town and village, especially the shipbuilding ports, were making furniture suitable for churches, homes and ships. The writer well remembers the auctions that took place in Pictou in the 1920s. When the older families died off, the furniture that had accumulated during the last century was scattered far and wide; occasionally some pieces were purchased by local buyers and appeared again at a later date to be picked up by other collectors.

PRE-LOYALIST

To fill the need for more settlers to occupy the lands left vacant by the Acadians, the Nova Scotia government, in 1760, paid the expense of transporting New England settlers from Connecticut, Massachusetts and Rhode Island. Soon 5,000 people, including fishermen from Cape Cod, occupied the land. They settled in Colchester County, particularly around Truro and the areas near Amherst and Sackville, New Brunswick, and soon had produce enough to send to Halifax and Saint John, N.B.

The best known of their cabinetmakers were James Waddell of Truro (1764–1851), Ebenezer Beattie and Robert Brown. At the time of the first settlement they made only plain tables and beds; when they were able to build fine homes they furnished them with imported furniture from New England and products of their own cabinetmakers, such as bird's-eye maple chests of drawers, maple chairs and tables and many articles of pine.

In Queens County the economy was based on the fishing and lumbering industries and most furnishings were secured in Halifax, New England and England. Shipbuilding became the main industry in the Yarmouth area, and many of the articles brought back in those ships from places such as the China Coast may still be found there.

Tall clock, mahogany with maple line inlays, and with the label inside the pendulum case of Tulles, Pallister and McDonald, Barrington St., Halifax, N.S. This fine clock was made in 1810 or 1811, and is one of two known pieces labeled by this partnership.
NOVA SCOTIA MUSEUM

Stand-up or clerk's desk of curly birch, with slant-top and a very unusual drawer arrangement, a scalloped skirt, and wooden knob drawer pulls. Curly birch was not uncommonly used in Canadian furniture, but its wavy structure can be esthetically overpowering in large sections or wide panels. This piece dates from about 1825.

NOVA SCOTIA MUSEUM

Chest of drawers, in curly maple with rope-carved birch side pillars and ebonized wooden knobs. The chest was made, and is marked, by Jacob Spinneys, location unknown, c. 1830–40.

NOVA SCOTIA MUSEUM

LOYALIST

The history of Nova Scotia was mainly changed by the influence of those people who, during the Revolution, were forced to leave their homes in New Jersey, New York, Pennsylvania and the Carolinas. Early in 1783 thousands came here by ship. Many of them were influential businessmen, government officials, and professional men, but the greatest number were farmers, teachers and disbanded soldiers. The members of this whole group became known as Loyalists because of their preference for English rule. The 20,000 new arrivals took up lands in Shelburne, Guysborough and Cumberland counties and to a lesser degree in Cape Breton.

During 1783 and 1784 the largest Loyalist town was Shelburne. Here, workmen and materials were in short supply and nearly £500,000 of their private funds was spent to meet the housing requirements. Few of the settlers were accustomed to the hard pioneer task of clearing the land; consequently they were forced to import supplies, especially food, which they were unable to grow in the rocky, sterile land around Shelburne. In view of this it was natural for them to turn to the sea, and they soon established a flourishing trade with the West Indies, exchanging lumber and fish for rum and sugar. Shipbuilding was also carried on for the South American whaling trade.

The settlement began to decline when the daily ration of pork and flour issued by the British government was no longer available, and by 1796 Shelburne was becoming a deserted town. The *Royal Gazette*, one of the three newspapers published in Shelburne, devoted its space to auction notices, advertising the sale of such furnishings as elegant Windsor chairs in a variety of patterns, eight-day repeating clocks with mahogany cases, and mahogany chairs, tables and bedsteads. Among the leading craftsmen who worked there were Charles Oliver Bruff, the noted American silversmith, and the Goddards, Daniel, Job and Henry who later went to Halifax; they were related to John Goddard, the famous cabinetmaker of Newport, Rhode Island.

LUNENBURG

The British government sent agents to Europe to recruit more settlers to occupy the empty Nova Scotia coast. They were awarded one guinea per head for each person persuaded to cross the ocean and settle here. Most of the settlers came from the provinces bordering the Rhine River, the German section of Switzerland, and from Montebéliard (French-speaking Protestants). By 1753 more than 2,000 had made the voyage, and were nicknamed "Dutch" from the German "Deutsch." A group of 1,500 founded the town of Lunenburg and lived under the security of Halifax and their own blockhouses, enduring the ordeal of Indian raids until the Indian treaty was signed in 1760. This made it possible for them to move out to the surrounding areas, where new homes were erected and they became known for their farming abilities. The makers of cradles at Lunenburg appear to have been the most sought-after craftsmen. During 1759 only twenty-six were available to take care of ninety-eight births at the various barracks. These cradles were solidly made of pine, painted to suit the taste of the owners.

In the early days of Lunenburg most furniture was made by the carpenters, working from memory on pieces patterned after those they had left at home. Not a single cabinetmaker

was listed on the passenger lists for 1750 to 1753, although thirty-five joiners arrived. The number of carpenters, ship's carpenters, turners and wheelwrights was higher in this town than in other parts of the province. Perhaps the best known craftsman was Casper Jung (Young), who was listed in 1794 as a turner and wheelwright. "Young" spinning wheels and chairs are perhaps the most collectable articles to be found in Lunenburg today. The following excerpt, taken from an article by Keith Young in the March 18th, 1966, issue of the *Chronicle-Herald*, gives additional information about the Young family.

> This chair [Johnny Young chair] took its name from the man who made them, John Young, who lived at Young's Landing, Second Peninsula, Lunenburg County.
>
> The Young family is descended from Andreas Jung, one of the original settlers from Germany in the 1700s, with the first John Young designing and building his famed chair back in 1840. His son, also John, continued the trade as did the next generation of Youngs, but later years have seen the halting of the Johnny Young rocking chairs. . . .
>
> Every part was carved by hand in a small home workshop with a full day required for the finished product; cost? one dollar exactly! As a sideline, spinning wheels were also made by Young and these sold for five dollars. The only parts not made at home were the iron pieces necessary for the wheels and these were hammered out by a blacksmith at Northwest.
>
> Perhaps the most interesting part of the rocker was the bottom. This was hand woven from rushes or reeds. To obtain these the Youngs sailed their little whaler to Tancook Island and cut the rushes that grew wild to heights of eight and nine feet. These were loaded aboard the boat and brought back home to be dried for one day outside and then taken into the workshop for the fall and winter work at the chairs.
>
> Some chairs were made with arms but mainly followed simple lines with a plain back and no arms. Most of the rockers were sold to individual families who walked or rode their horse wagons to Second Peninsula, paid their dollar and trundled homeward with the chair of their choice. One shipment of rockers went to Boston but such "big" orders were few and far between. Today a rocking chair does not occupy the home as in past days when no home was considered complete without at least four or five John Youngs standing in the kitchen and the "good room." Even yet, around Lunenburg, many a plain rocking chair is still called a Johnny Young and those owning an original chair would not part with it for many times the original cost. . . .

Being a lover of Nova Scotia furniture, I was aghast to learn from the driver of a truckload of spinning wheels who had been ahead of me on the highway that they were on their way to be sold for use as chandeliers in a modern cocktail lounge.

The citizens of Lunenburg should be proud of their achievements during the past two centuries. They were able to change from an agricultural economy to the building of great fishing vessels, notably the famous "Bluenose." They also created an intensive market for fish in the West Indies, Portugal and Spain. For the lover of architecture, Lunenburg is a unique town in our province; the picturesque waterfront, old shuttered shops on the main streets, and homes of early shipmasters are not seen in any other area of Nova Scotia.

THE SCOTS

The arrival of Scottish settlers in 1773 marked the beginning of a great immigration of the Scots to Nova Scotia and the rest of Canada. This was due to the Scottish landlords' discovery that raising sheep was more profitable than maintaining tenant farmers, and was known in history as the "Highland Clearances." This industrious group of settlers soon had a great timber trade with Great Britain owing to the closure of the Baltic by Napoleon; it was not long before the business increased to over £100,000 per annum.

By 1830, except for Halifax, Pictou was the most heavily populated area in the province and, with the prosperity and flourishing trade of the port, its intellectual activities far outdid those of other parts of the country. Pictou had many cabinet-makers who used the maple, birch and great pines growing in the area. This notice of an auction sale which appeared in the Pictou, N.S. *Mechanic and Farmer* of September 13th, 1841, will give some idea of the imported woods that were also used:

AUCTION SALES
TO BE SOLD AT PUBLIC AUCTION

In the Town of Pictou, on Tuesday the 5th day of October next, at 12 o'clock noon, at the shop Formerly occupied by the late James Munro, junr. Cabinet-maker
All the valuable STOCK owned by the Deceased, Consisting of:
MAHOGANY PLANK
 do BOARDS
do VENEERS
ROSEWOOD
Chest of TOOLS, &c. &c. &c.
And also a quantity of SHOP FURNITURE.
 CHARLOTTE MUNRO, Administrix.
Pictou, 13th, Sept. 1841.

WOODS USED BY NOVA SCOTIA CABINETMAKERS

> At Admiralty behest . . . it then [was] decided that the tightest restrictive regulations about tree-cutting should be extended to Nova Scotia, but [and] in addition no lands should be granted there for settlement until a total of 200,000 acres of woodland most suitable and most conveniently located as a source of mast timber for the navy had been marked out by His Majesty's Surveyor General of the Woods in America in one or more parcels.

From *The Foreign Protestants and the Settlement of Nova Scotia*, Bell, Winthrop (University of Toronto Press, 1961).

The tree-cutting restrictions were, on their face, severe enough: no pine, fir, or oak trees of over 12 inches in diameter at three feet from the ground were to be cut on ungranted lands, and even on enclosed lands of private owners no tree of over a 24-inch diameter one foot above the ground was to be cut without royal license; sawmill operators had to give substantial bonds for observance of the regulations; and penalties up to £100 for the cutting of a single 24-inch pine. But in the conditions of the time, and with almost unanimous determination, at least by all New Englanders, to disregard and circumvent them, these regulations were proving impossible of enforcement in the older colonies.

Chest of drawers of birch and maple, with rope-and-diamond- (or pineapple-) carved side pillars, and with top and skirt moldings and upper drawer moldings of quartered lathe-turned dowels. The keyhole escutcheons are bone, fairly common on Nova Scotia chests but not observed elsewhere. This chest was found in the Annapolis Valley of Nova Scotia; it dates c. 1830.

CANADIANA, ROYAL ONTARIO MUSEUM

Pine combination blanket box and chest of drawers, with hinged lid and two lower drawers. The upper two drawer fronts are false. The lid flange molding and post-Chippendale bracket base date this piece to the first quarter of the 19th century.

NOVA SCOTIA MUSEUM

A century thence saw the emergence of a huge industry founded on pine timber. One merchant records that in 1808 there were no fewer than twenty-six square-rigged vessels, ships, brigs and barques which arrived at Pictou, N.S. from Britain, to obtain and return cargoes of ton timber, chiefly pine. The pine wood from the Baltic area was of a more durable and firm quality and better used on outside work; our pine was more easily wrought, so was used for interior work in houses. Between 1800 and 1810, Pictou merchants loaded as many as 120 square-rigged vessels which carried cargo of over 40,000 tons of timber. The average price was £2 per ton.

It is difficult to believe that by about 1820 most of the large pine was gone, especially that which grew near the coastline. What remained was used in house construction and furniture-making; and it could always be found in every fireplace. In contradiction to the foregoing information it is interesting to note that Dr. Abraham Gesner recorded in his book, *The Industrial Resources of Nova Scotia* (published in 1849) that, at the time, pine trees 200 feet high, with trunks five feet in diameter, were not uncommon.

In Nova Scotia the cabinetmakers put pine to good use in making blanket chests, bureaus and tables. The bureau type of furniture is much sought after in Nova Scotia antique stores. Recently the charm of most pine furniture has been spoiled by the zealous restorer, who feels that antique pine furniture must be scraped and sanded off to the original boards, thus removing the scars of time that give each article its own character and help to record the lifetime of that particular piece. The original paint used to cover some of the defects (knotholes, and the like) was composed of venetian or Indian red pigment mixed with skim milk, which sank deeply into the grain. The careful restorer tries to remove as little as possible of this pigment, so that the furniture retains a dull red sheen—a finish far superior of the "skinned" look that one finds so frequently today.

Curly maple comes from the twisting of the grain of any one of several varieties, particularly the sugar maple. This wood was extensively used by Nova Scotian cabinetmakers. Many beautiful chests of drawers, and arm and side chairs, were made by James Waddell (1764–1851) of Truro. In 1862 McEwan and Reid, Halifax, exhibited maple furniture at the International Exhibition in England. One of the pieces was an easy chair, the front rail of which was carved in the form of a rabbit's head with stalks of Indian corn, wheat and barley on each side. The back was decorated with maple leaves, with a kingfisher perched on the top branch.

Black birch is sometimes called "poor man's mahogany" because its reddish, chocolate-colored stripes and spots resemble the grain of that wood. It was used a great deal for tables, bedsteads, and the like.

To see excellent examples of Nova Scotia furniture in pine, maple, and birch, one should visit the Nova Scotia Museum, History Section Branch, located on Citadel Hill. The collection there includes corner cupboards, chests of drawers, bureaus, chairs and clocks, along with many other articles of furniture.

Mahogany is said to have first reached England on Sir Walter Raleigh's return from a cruise to the West Indies in 1595—he had used some of this timber to repair his ship. Being considered an exotic wood at the time, little was known of its qualities and it was only used to make minor furniture. It did not take the place of oak or walnut until about 1724,

Corner chair in an English late Chippendale style, of birch, with grooved cross stretchers and cabriole front leg. This piece, dating c. 1785–1800, came from a house in Amherst, N.S., of which it was part of the original furnishings. The chair was probably made locally.

On the right is a square-backed Windsor armchair, of pine and maple, branded on the seat bottom: DEGANT / WAR[ranted]. HAL[ifax]. *The DeGant chair factory, operating in 1780, is the earliest known in Nova Scotia.*

CANADIANA, ROYAL ONTARIO MUSEUM

when an English cabinetmaker chanced to use a mahogany plank to make a bureau. When it proved to be so ideal for carving, large quantities were ordered from Santo Domingo and Cuba.

The first mention of mahogany in Nova Scotia was at Shelburne, when over 4000 feet were sold at an auction of a prize ship in 1786, and again in 1807. A cargo of mahogany logs was imported to Halifax, and by 1826 local cabinetmakers were protesting to the Legislature that mahogany was being sold in Boston and New York for half the Halifax price.

The extensive fish and lumber trade being carried on between Nova Scotia and the Caribbean Islands resulted in returning cargoes of mahogany, which was used by cabinet-makers in some of the smaller provincial towns. Perhaps

Thomas Chippendale's book, *The Gentleman and Cabinet-Maker's Director*, first published in 1754, led to the wide use of mahogany, as the designs illustrated in it were copied not only by George Hepplewhite but many other fine craftsmen. Nova Scotians also made many fine pieces in a modified Chippendale manner, using local hardwoods.

CHAIRS

If a man has good corn, or wood, or boards, or pigs, to sell, or can make better chairs or knives, crucibles or church organs, than anybody else, you will find a broad, hard beaten road to his house, though it be in the woods.

Emerson

Sheraton sofa, of birch, with curved sloping arms joining turned front legs. Sofas of this type are not uncommon in western and central Nova Scotia, and occur in maple as well as birch, sometimes with simple contrasting inlays in the flat section of the front legs. This piece, and most such sofas, date c. 1825–40.

NOVA SCOTIA MUSEUM

Chest of drawers with splayed front feet, of bird's-eye maple ▷ with pine inner structure and ebonized birch drawer pulls and quarter columns. The keyhole linings are bone, and the line inlays mahogany. This piece is from southwestern Nova Scotia, c. 1820. CANADIANA, ROYAL ONTARIO MUSEUM

Perhaps no province in Canada has been able to discover so many chairs made in our own province as has Nova Scotia. Our researchers have had the advantage of the use of local directories as well as newspapers (the first Canadian paper was published in Halifax in 1752). These sources have turned up evidence of twenty known chairmakers, whose examples are now in the Nova Scotia Museum collection. In addition, there are eleven known makers for whom examples have not yet been found. The early Nova Scotia Windsor-type chairs were all branded with the maker's name, while those made in the 1880s were stencilled—this helps to explain the ease with which the chairs can be dated.

The woods preferred by the Nova Scotia chairmakers included pine, of some thickness, used for saddle seats; maple and yellow birch for the turned legs and stretchers; and ash and hickory for the hoops, bows and comb pieces. Glue was seldom used to assemble the various parts. Joints were made tight by intermixing green and seasoned wood—the shrinkage of the green wood in combination with the seasoned wood held the chair securely together. The majority of the legs had bamboo turnings, some with slight swellings; they were splayed from the perpendicular by about fifteen degrees. The backs were formed with five to seven spindles, some of which had bamboo turnings. Since several varieties of wood were used, the chairs were normally painted dark green or black with yellow on the turnings.

In general, Nova Scotia Windsor chairs were more simple in both form and detail than those made in the United States.

During the 18th century the U.S. chairmakers developed their craft to a degree unknown elsewhere.

Jay Humeston was one of the first Nova Scotia chairmakers to advertise in a newspaper (1804). He declared that he made Windsor-style chairs and settees equal to the best British manufacture, as well as the best black japan for use on his chairs. He also stated that captains sailing to the West Indies could be supplied with chairs by the dozen or the gross. One of the captain's privileges during this period was to have a certain area of the ship allocated to him to be used for goods for trading purposes; as the chairs were dismantled they made a good compact cargo. Humeston usually made comb-back and hoop-back styles, and branded them "J. Humeston / Halifax / Warranted." He worked as most chairmakers did, by traveling from place to place. It is known that he was in Charleston, South Carolina, in 1798 and also in Delaware. In Shelburne, N.S., in 1790, a dozen Windsor chairs could be purchased from the departing Loyalists for sixty shillings.

Joseph Degant started to make Windsor chairs in the comb-back and arrow-back design in Halifax about 1790. Other designs with rod-backs and arms were the styles in vogue until about 1850, at which time there emerged the Sibley chair. This particular chair has become the most popular and sought-after Nova Scotia chair. The Sibley family started their chairmaking at Wittenburg, Colchester County, a valley that had a brook to provide power for the mills and for turning the saws; birch and pine could be secured from the hills close by. Michael Sibley's chairs had birch frames and curved horizontal slats;

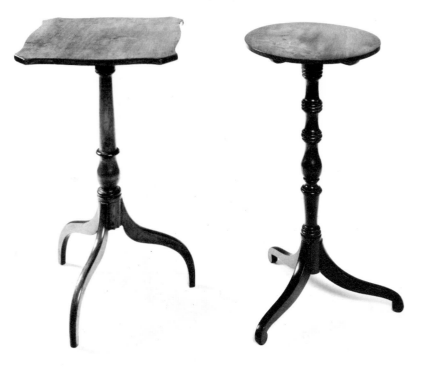

Candlestands, the left piece of birch with a hinged tilt-top, and New England-derivative top shape and legs. This piece, from western Nova Scotia, dates c. 1810–20. The right-hand piece, of mahogany and with Sheraton-derived concave legs, has a rigid top on a light cross-frame. This table, from the Halifax area, dates c. 1825–30. CANADIANA, ROYAL ONTARIO MUSEUM

Drop-leaf dining table with swinging gate legs, and with unusually wide mahogany leaves and top, dating from the second quarter of the 19th century. NOVA SCOTIA MUSEUM

Corner washstand, of pine, with delicate flared legs and design elegance. Pine as the material, in fact, does not do justice to a piece of this sophistication. The maker is not known, but the washstand dates c. 1820–40. NOVA SCOTIA MUSEUM

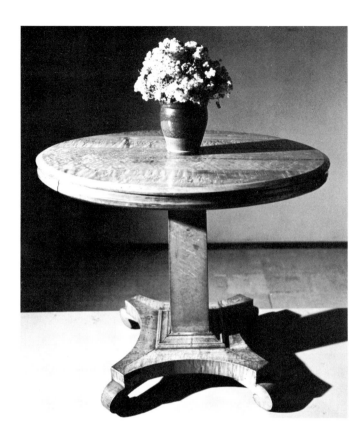

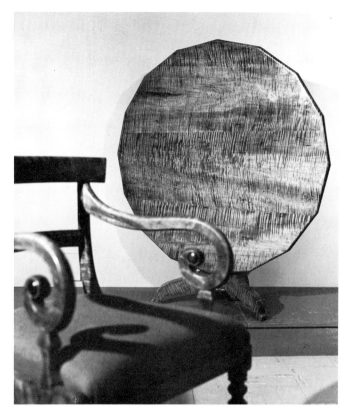

Pedestal table of bird's-eye and curly maple, rather heavily constructed in a mid-Empire manner. From the methods of joinery evident in the base, square pillar, and top, possibly a good carpenter's piece rather than a cabinetmaker's. Southern Nova Scotia, C. 1840–50. NOVA SCOTIA MUSEUM

An unusual tilt-topped table, of exceptionally heavy-grained curly maple, with scroll-cut tripod base and a sixteen-sided rather than round top. This table dates probably C. 1850. In the foreground is a scroll-armed Empire chair, also in curly maple, of the 1840s. NOVA SCOTIA MUSEUM

Country drop-leaf table, of curly maple, with two-plank top, plain birch turned legs, and extension arms to hold the leaves extended. Though this is a Nova Scotia piece C. 1840, tables of this type are a universal eastern North American form, of the second and third quarters of the 19th century.

NOVA SCOTIA MUSEUM

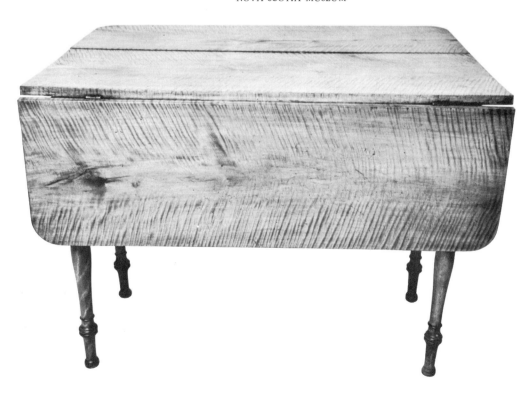

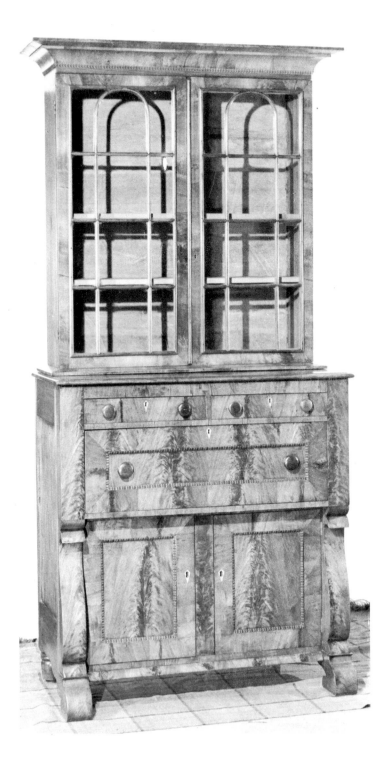

the distinguishing feature was the turned finials on the upright posts. The seats were made of "splints" or "splits", made from the trunks of black ash trees which were cut and barked, then beaten with a poleaxe until a layer could be stripped off, followed by another and another of each year's growth, until the required quantity was obtained. The stripped layers were then steamed until pliable enough to weave into chair seats. (At another period leather was used for this purpose.) When ash trees became scarce in this district, the seats were made of shaped pine. "Sibley Brothers / Stewiacke" was stamped on the seat bottoms in black ink. A variety of chairs were made, from some with slat-backs (two or three slats) to handsome chairs having eight arched slats, which were made into armchairs. Before the Sibley Brothers closed, in about 1900, they had manufactured bedsteads, spinning wheels, swifts, bureaus, wheelbarrows, spool bedsteads, bookcases, organ stools and desks, as well as chairs.

It is recorded in an old account book that Benjamin Sibley worked for Michael Sibley for one year for the sum of 10 cents per day, or $30.30 a year; for making chairs the second year he received 20 cents a day, with payment to be made at the end of the year. This transaction occurred many years before the enactment of minimum wage laws.

The following list notes those chairmakers whose branded or stencilled chairs are known. In each case the date is that of the first appearance of the maker's name in a contemporary newspaper.

ALLAN, Charles P.	Halifax and Waverley	1832
BALCOM, J.	Clements, Annapolis County	1830
BECK, J.	Cole Harbour, Halifax County	1830
COLE, George	Halifax and Centre Rawdon	1832
COLE, James	Centre Rawdon, Hants County	1817
COLE, John	Halifax and Centre Rawdon	1816
CUTTER & POWER	Halifax	1814
DEBOL, Lewis	Halifax	1825
DEGANT, Joseph	Halifax	1790
GAMMON, George	Halifax and Cole Harbour	1838
GAMMON, William	Halifax and Cole Harbour	1835
HARDING, R.	Yarmouth	1830
HART, E. H.	N. E. Margaree, Cape Breton	d. 1970
HILL, John	Amherst, Cumberland County	1880
HUMESTON, Jay	Halifax	1804
NICE, J.	Horton, Kings County	1842
SIBLEY BROS.	Lower Stewiacke, Colchester County	1870
SIBLEY, Joseph	Lower Stewiacke	1830
SIBLEY, Michael	Lower Stewiacke	1850
VINECOVE, Joseph	Halifax	1817
WILE, Zerah	Bridgewater, Lunenburg County	1866

Secretary, as a desk with cupboards beneath, and a bookcase top as a separate unit. This piece, of crotch mahogany and mahogany veneering over secondary pine, is from the Halifax area, dating c. 1840. The desk-front and cupboard door moldings are more elaborate than usual, and the lower section has the bone keyhole escutcheons unique to Nova Scotia furniture.

CANADIANA, ROYAL ONTARIO MUSEUM

Side table of mahogany, flame birch, and secondary pine, with leaf-carved central pillar, reeded legs, and English lion's paw casters. This excellent piece is marked in heavy pencil by its maker, Norman J. MacLeod of New Glasgow, N.S., c. 1830.

CANADIANA, ROYAL ONTARIO MUSEUM

The list below gives the names of the chairmakers who are known through directory listings or newspaper advertisements but whose work has not yet been identified.

Best & Whitman	Halifax	1827
Blaikie, Richard	Green Hill, Pictou County	1860
Bond, John	Halifax	1792
Brittain, John	Halifax	1790
Cummings, Andrew	Halifax	1792
Jewett, Joseph	Halifax	1793
MacLeod, George	Pictou, Pictou County	1860
MacLeod & McFeat	Halifax	1817
Minard, Elizah	Liverpool, Queens County	1767
Prince, John	Halifax	1838
Wade, John	Granville, Annapolis County	1760

Just a few years ago I had the privilege of visiting the late Mr. E. H. Hart (known as "the Cape Breton chairmaker") of Northeast Margaree, at his chair-making establishment. I found him working at his lathe being directed by his pet squirrel sitting on his shoulder. He made four-slat ladder-back chairs and turned beds. Mr. Hart informed me that working with wood taken from his property and making his chairs gave him more joy than any money he could make selling his chairs.

CLOCKS

With numerous shipping centers it was important for Nova Scotia to have artisans with the skill to repair the many and varied marine instruments and chronometers. Competent clockmakers such as Charles Geddes, John Paget and the Etter family settled in Halifax, the latter arriving with Lord Howe when Boston was evacuated in 1776. Isaac Clemens, Isaac Reed and Michael Weathers came as Loyalists to Shelburne.

Among the finest clockcase-makers was the firm of Tulles, Pallister and McDonald of Halifax, 1810 to 1812. An example of their work is in the Nova Scotia Museum collection—a tall case clock, 7 feet 5 inches high, made of mahogany, with an inlaid door and base. The Troup family of Halifax were also noted in this field, as well as being silversmiths.

John Geddie served his apprenticeship in Scotland and entered business upon his arrival in Pictou in 1817. It is claimed that he made the entire works himself, and even painted the delicate decorations on the dials of his clocks.

After the War of 1812 many Eli Terry clocks (Connecticut) were imported. They were very much admired because of the writings of T. C. Haliburton, who became famous as the author of *The Clockmaker; or, the Sayings and Doings of Samuel Slick of Slickville*, published in 1836.

In all, over 150 watch- and clock-makers were in business between 1783 and 1880, some of whom are listed below.

Adams, Thomas	Shelburne	1786–87
Barrett, Moses	Yarmouth and Amherst	1830–70
Crawford, Robert	Halifax	1822
Malcolm, John	Windsor	1791
Marsters, R. U.	Halifax	1817
Moss, Myer	Truro	1866
Mudie, T.	Halifax and Pictou	1807–67
Reed, Isaac	Shelburne	1786

MOSES BARRETT, CLOCKMAKER

Moses Barrett, an itinerant clockmaker, must have been born during the period between 1800 and 1810, since he traveled around Nova Scotia about the time of "Sam Slick" (1835), as Sam said, "selling his wares." When he stopped at a farmhouse he would assemble a clock from his stock of parts and, as partial payment, accept board and lodging.

Two examples of his work are in the Nova Scotia Museum collection. One is a wooden shelf or mantlepiece clock, probably a thirty-hour one, of the Eli Terry type, dated about 1835. This particular clock is thirty inches high from the base of the claw feet to the top of the pineapple finials. The printed label inside the case is in three sections, the center one reading: "Improved Clocks Warranted," rose-and-thistle design, "if well used" / Manufactured at Yarmouth, N.S. / by Moses Barrett," eagle-and-palm-leaf design.

Apparently Moses was in partnership with another clockmaker named Ladd, because the label on the second clock reads: "Barrett and Ladd . . . Manufactured at Amherst, N. S." (probably between 1835 and 1840). This is another typical clock of the time, with wooden works and an upright case of mahogany over pine. These specimens are representative of the gaudy, highly varnished style called "Yankee wooden clocks" worth, as Haliburton tells us, about two dollars and a half but which that smart and wily mythical peddler, Sam Slick, sold throughout the province in such numbers for forty dollars, utilizing the useful terms of what he called "soft sawder" and "human natur."

FURNITURE FACTORIES

John Bath Reed, Bridgetown, N.S., started making furniture in 1858, and by 1862 he had a two-story building with a workshop upstairs and a showroom downstairs. Later, purchasing a four-horsepower engine and an additional building in the rear, he was able to compete with the American furniture being brought into the country. By 1876, with a twenty-horsepower engine to run twelve machines, and a staff of ten men, he was able to meet the demand for his furniture. In 1878, Reed's Steam Cabinet Factory was making black walnut chairs, elaborately carved and designed by James DeForrest. Prices for Reed's furniture in 1880 were from 60 to 100 dollars for parlor suites; from 25 to 40 dollars for pine bedroom suites; 19 to 24 dollars for sofas, and from 3 to 6 dollars for walnut chairs. Solid walnut tables with marble tops were priced from 8 to 10 dollars.

In 1880 Reed sent two bedroom sets and one parlor set to the Halifax Exhibition and won a prize. James DeForrest was once again the designer. One bedroom set was of "Solid Black Walnut, heavily carved and molded with columns, and raised, beautifully polished French Walnut Burl mounted with polished slabs of white marble." The other bedroom set was of ash with raised panels of American walnut burl. The parlor set was of "Walnut upholstered in silk brocatelle of a rich crimson color, with piped back and puffed and corded edges." John Bath Reed's earliest chairs were patterned after the "Jenny Lind" style.

In 1881 Reed erected a new building for an organ factory and supplied numerous churches in the Annapolis Valley with these musical instruments.

Empire slip-seated side chairs of an English type, with an unusual back form, and probably both by the same maker. The left piece, of birch, is slightly lower than the right piece, of mahogany. Both chairs are from the Halifax area, c. 1830–40, and both may have originally been made as sets of six or eight.

CANADIANA, ROYAL ONTARIO MUSEUM

Drop-leaf, pedestal side table with early Empire base, of maple with pine upper structure. The heavy reeded and turned pedestal is very unusual for tables of this type, as are the heavy ball feet. The table dates c. 1820. NOVA SCOTIA MUSEUM

STEPHEN & SON

The senior Alexander Stephen was born in Rothes, Morayshire, in 1814. He first settled in the Musquodoboit Valley, where he married Mary Ann Guild. He moved to Halifax and became the senior partner of John Esson & Company.

In 1862 he severed his connections with that firm and entered the furniture business. His son Alexander became a member of the newly established Alexander Stephen & Son. By 1866, they had purchased the steam mills and a great part of the "Baron" Ellerhauser timberlands (12,000 acres) on Ponhook Lake, at the head of the St. Croix River near Windsor.

The Stephens started to export lumber for the British market. They also made buckets and other wooden wares from deal ends and waste pieces.

A Thomas Archibald supervised the thirty men employed there.

The firm also began to manufacture furniture on a limited scale at both Fall River and at Musquodoboit. The Stephen family was living on Queen Street at that time. Alexander, Sr., was a prominent member of the North British Society, serving as president in 1867.

The *Morning Chronicle* of June 1st, 1868, carried an advertisement for "fine furniture made at the Ellershouse factory by skilled mechanics procured in the Provinces and the United States."

At the provincial agricultural and industrial exhibition of that year, Alexander Stephen and Son were awarded several prizes for sets made from woods native to Canada. Articles of pine, chestnut and walnut soon became available. In 1881 they

Card table of mahogany in rococo style, with heavily carved skirt and legs, made by Gordon and Keith of Halifax, c. 1860–70.
NOVA SCOTIA MUSEUM

were the sole manufacturers of rattan goods in the Dominion.

The son continued the firm after his father's death in 1884, until 1890, when it became a limited company under the name of the Nova Scotia Furnishing Company.

By the year 1909 it occupied the six-story building at 72–76 Barrington Street (now the S. P. Zive & Son store), where the manufacture of fine furniture was carried on until competition from Central Canada and the United States finally forced the company to cease local manufacture.

Alexander Stephen, Jr., served as mayor of Halifax in 1897–1898.

GORDON & KEITH

For many years Gordon & Keith were the leading cabinet-makers in Halifax. They had purchased the firm of Thomson and Esson, who had been in business since the 1820s. Large

furniture establishments were unusual due to the competition of both the Ontario and American factories. Nevertheless, a large three-story building was erected in 1867, employing over thirty men who were busily making mahogany sofas, chairs, couches, bookcases, bedsteads and center tables. Chestnut was used for bedsteads and other bedroom furniture. They also made furnishings for the many barquentines built at the local shipyards.

In 1887 this factory, with its stock of furniture and workmen's tools, was destroyed by fire.

Some of the master carvers recalled then that "their work was made to last." Legs for the tables were carved separately with special knives and chisels, and when completed were handed to the joiner. The upholsterers and finishers had their separate tasks. The blocked side-front pieces were glued or dowelled, the top-rails, with their carved fruit or flowers, were kept in place by dowels also.

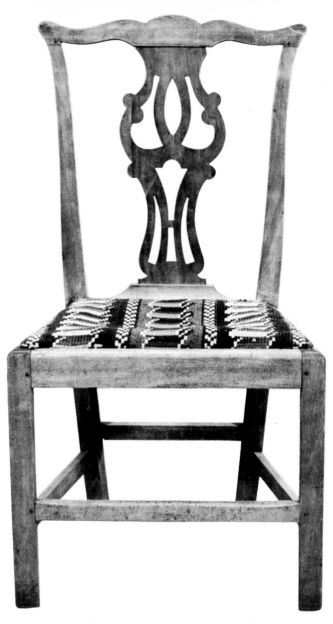

Maple late Chippendale chair, a country type, but well propor-tioned with a good openwork back, c. 1820–30. Though once probably common in the Maritimes, English Quebec, and Upper Canada, such chairs are now only occasionally found.

NOVA SCOTIA MUSEUM

Three ladder-back chairs typical of later Nova Scotia chair factory pieces, from the famous Sibley chair factory at Stewiacke, Nova Scotia, operating from c. 1830 to c. 1900. Sibley chairs are not uncommonly found even today; those with curved back-slats are earlier than straight-slatted types, and later versions have a Sibley mark stencilled under the seats. These chairs are also characterized by the heavy upper finials, and by the abrupt taper of the back uprights just above the seat.

NOVA SCOTIA MUSEUM

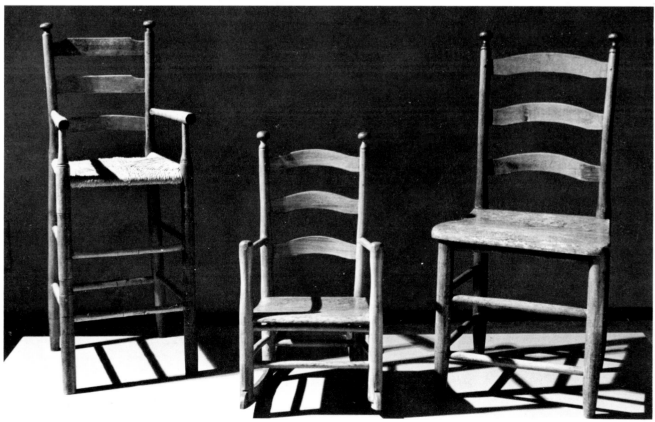

SOME EARLY NOVA SCOTIA CABINETMAKERS, AND KNOWN WORKING DATES

DRAPER, Edward	Halifax	1749
STEVENS, John	Halifax	1752
GEDDES, Robert	Halifax	1780
LAWSON, Richard	Halifax	1783
HOGG & GEDDES	Halifax	1783
GEORGE, Mr.	Halifax	1785
BLACK, William	Shelburne	1786
SPIERS, John	Shelburne	1786
GODDARD, Job	Shelburne ⎫	1786
GODDARD, Henry	Shelburne ⎬ Halifax 1783	1786
GODDARD, Daniel	Shelburne ⎭	1786
CUMMINGS, A.	Shelburne	1789
ALLISON, P.	Windsor	1791
BALL, Peter	Guysborough	1792
LOVETT, Amos	Halifax	1793
McNEAL, Alex.	Lunenburg	1794
McKENZIE, John	Halifax	1799
FRAME, James	Halifax	1799–1810
McCULLOCH, George	Pictou	1810
TULLES, PALLISTER & McDONALD	Halifax	1810
PALLISTER, Thomas	Halifax	1812
TURNER, Daniel	Halifax	1814–1816
CUMMINGS, J.	Halifax	1815
HAMILTON, STEWART & Co.	Halifax	1817
GORDON & KEITH	Halifax	1822–1857
GORDON, William	Halifax	1824
THOMSON, James	Halifax	1826
ALEXANDER, Charles	Halifax	1826
HARRISON, H.	Halifax	1826

Three manufactured Windsor chairs, a sampling of the great range of simple chairs produced by Nova Scotia and New Bruns- wick chair factories throughout the 19th century. Many of these chairs, originally shipped all over the continent, are branded by their makers on the underside of the seat. Left to right, these chairs are marked "J. BAL. [colme] CLEMENTS/WAR- RANTED" of Norton, New Brunswick, c. 1850; "G. GAM- MON/WARRANTED" of Cole Harbour, Nova Scotia, c. 1838–59; and "G. SMITH/WARRANTED" of Halifax, c. 1840. Chairs of these types, and many others, are still common in Nova Scotia particularly, but marked examples are becoming scarce. CANADIANA, ROYAL ONTARIO MUSEUM

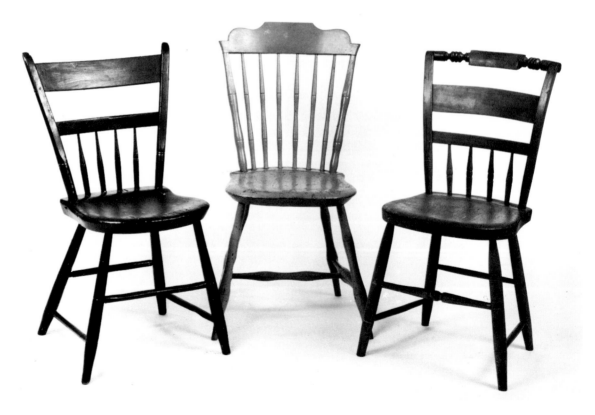

New Brunswick Furniture

Huia G. Ryder

It is only during the past fifteen years that furniture made in New Brunswick has captured the interest of other parts of Canada. The celebration which marked the first hundred years of Confederation gave impetus to a rising surge of interest in early arts and crafts. It has been a source of pride to learn that many of this province's cabinetmakers can rank with the finest in the nation, or even the continent.

The earliest New Brunswick furniture must be divided between that made by the Acadians who settled north of the Bay of Fundy after the expulsion of 1755, and that made by the New England settlers who came in 1762 to open a trading post at the mouth of the St. John River and stayed to build a community. Until 1784, New Brunswick was part of Nova Scotia.

All this early furniture was hand hewn from the native woods, pine, birch, maple, butternut (white walnut) and ash, pine being most used because of its softness. A good quantity of pine furniture has survived. Furniture of both cultures is similar in construction but differs greatly in style. Acadian furniture, while sturdy, is almost elegant. Many pieces show slightly curved legs and arm rests. Back slats are also sometimes curved, but of great importance are the tenon joints. On Acadian furniture these go completely through the wood and are clearly visible on legs and back slats of chairs. The earliest pieces show the joints as square or oblong, later a round tenon was used in construction. While there is a marked resemblance to the furniture of early Quebec, carving was never found on the earliest of Acadian furniture. The method of building was simple and economical. Joints were cut to size and set in place while wet, the swollen wood when dry was firm and strong. Early Acadian furniture is free from nails or glue. Chair seats were often made from rawhide woven in a fancy design similar to netting.

While we have mentioned a lack of carving in Acadian work of this early period, a few exceptions should be made. A most unusual pine chest has recently come to our attention in Sackville, Westmorland County. The chest is well documented by the family in whose possession it is known to have been for approximately two hundred years. The chest is small and made from pine. It has incised carving on all sides and top, also on a false panel within the lid. This panel drops down to reveal a secret space. With the exception of one panel, the carvings are of jungle beasts amid foliage. The exception is a pair of love-birds similar to the Pennsylvania Dutch design on a bridal chest. The chest is brass bound on the edges with sunken brass handles. The brass could be a later addition. In the same household was found a child's highchair with Acadian back and Regency arm rests.

Another instance of carving is worthy of mention. A set of five very early paintings were shown us by an American dealer on his return from a buying trip in the vicinity of Moncton. The primitive paintings were done on heavy pine boards about eighteen by fourteen inches. The unpainted portions formed a frame of about eight inches and around three sides of the picture. The wood had a soft pearly patina which must have been at least two hundred years old. On two of the pictures the frame was deeply carved in the Baroque style with a design of cupids and flowers, very elaborate and of fine craftmanship. The paintings were very primitive and imaginative, portraying what was probably intended as scenes from the crusades. Fighting horsemen in armor and with crude swords and shields were presented against a landscape of foliage and striped tents of Moorish or Arabian appearance. The enemy they fought were crude examples of the American Indian with feathered headdress, not the Western style, but a band through which were stuck a few straight feathers. The Indian weapon was a bow and arrow. The paintings were completely outclassed by the carved frames.

The former owner of these pictures was a very old man who had told the buyer there had originally been twelve done by an early ancestor. One had been given to a brother long before. Six had been used for firewood when he was a lad. The five we were shown had been used to cover cracks in the wall of the old homestead. We made every effort to purchase these paintings in order to keep them within the province or at least in Canada, but to no avail.

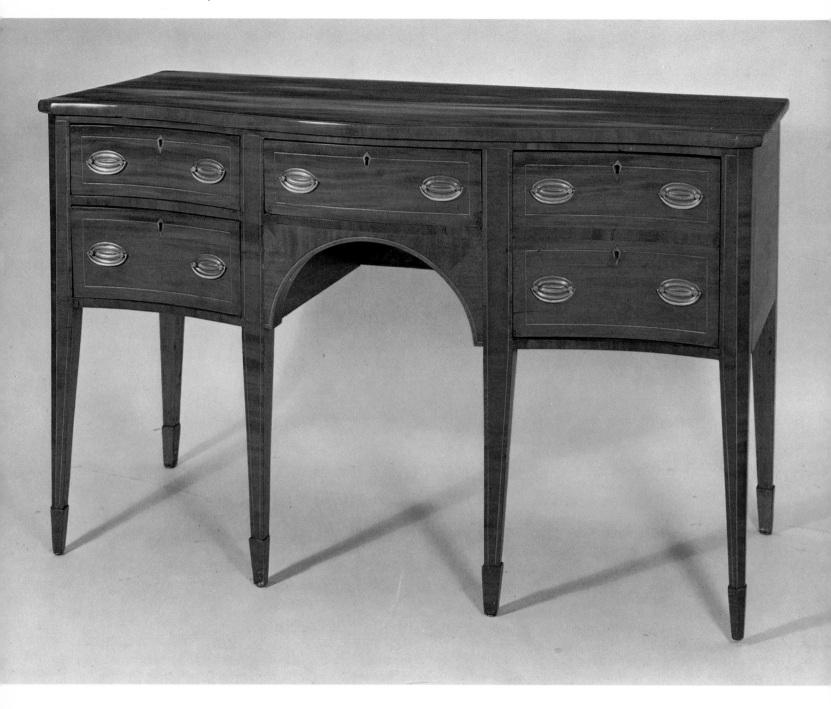

Sideboard in a Hepplewhite derivative style, with serpentine front and flared-tapered legs. The top is mahogany and the front and leg fronts are mahogany veneered over butternut, with pine drawer fronts. The line inlays and keyhole escutcheons are maple. This piece, maker unknown, is from the Saint John, N.B., area, c. 1800–15. CANADIANA, ROYAL ONTARIO MUSEUM

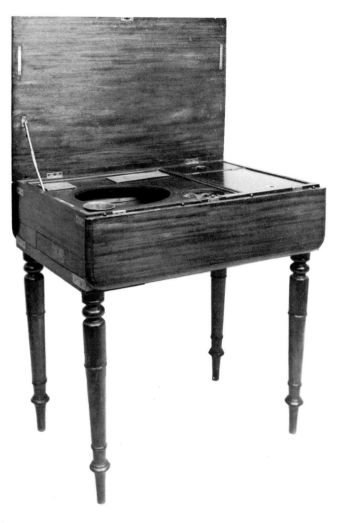

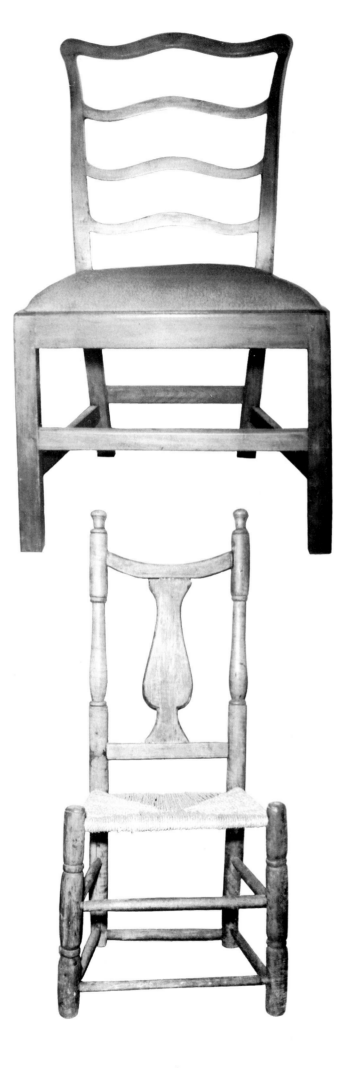

△
Portable or field wash-stand, of mahogany with English brass-work and pewter utensils. The maker is unknown, though the piece was used by Lt. Gen. John Coffin during the War of 1812, and probably made for him. NEW BRUNSWICK MUSEUM

Late Chippendale side chair with slip seat, of maple, and attri- △ *buted to Hunter & Ross of Fredericton (1788–1804), c. 1790–1800.* PRIVATE COLLECTION

Straight-backed chair, with the tall, narrow profile and a back ▷ *type characteristic of the William & Mary and Queen Anne periods of the early 18th century. This chair, of pine with a rush seat, is however a stylistic throw-back, and dates probably c. 1785–90.* NEW BRUNSWICK MUSEUM

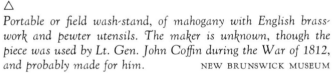

While no articles are marked, several names of Acadian cabinetmakers have come to us through old family records. Jacques Leger and his son, known as "Petit Jacques," worked near the Petitcodiac River about 1721, and fled to the Miramichi area about 1755. They returned to their homestead about 1763 and continued their furniture-making. Honoré Pelletier made a quantity of furniture at Green River, Madawaska County, from 1800 to 1840.

Interesting pieces of Acadian furniture have been found in Westmorland County. A bench made at Shemogue by a cabinetmaker whose name has been forgotten has a deep double-curved apron. One other piece which has been traced to this man was found at Baie Verte. This is a very superior piece, a chest of drawers with a large square drawer in the upper section flanked by two sets of smaller drawers. The larger drawer is elaborately carved. A chest very similar was found in Prince Edward Island, maker unknown. A much later Acadian example, a chair found in the Petitcodiac area, which had all the points of Acadian furniture, had the back stiles continuing down and curving to form the sides of the seat. Were it not a rocker we would feel tempted to place a much earlier date on this piece.

EARLY NEW ENGLAND SETTLERS

The trading firm of Simonds Hazen and White, were the first to begin business in New Brunswick. They settled at the mouth of the St. John River and were still doing business there when the Loyalists arrived in 1783. An inventory of the firm's property, recorded in 1767, shows that furniture was meagre. An interesting item is one desk and one writing desk. Letters from Mr. Simonds to his family tell a tale of few comforts in the way of furniture other than camp chairs and the bare necessities. One desk referred to was probably an accountant's desk, made from native pine with a high matching stool, a style which remained popular for many years and which is still to be found. Because the firm was, at the date of 1783, already building ships, it is most likely they were also constructing beds, camp stools, and such, for their own small community, and that they also made many for the new arrivals. We know of a number of very fine slant-top desks which were later brought to Simonds, Hazen and White from England, and some which arrived with the Loyalists.

One such desk was owned by Moses Picard, a settler in Maugerville, across the river from Fredericton. This desk is now in the New Brunswick Museum. Another interesting desk is owned by Mr. W. Milner Wood of Saint John. It carries a note signed by Joseph Hatheway, M.D. which was written in 1855. He states, "This desk was made for my grandfather, Ebenezer Hatheway Jr., in 1769. My father, Thomas Gilbert Hatheway, had it in his possession for forty-five years." The Hatheway family were the ancestors of Mrs. W. Milner Wood, who stated that the original owner had been a colorful character who was an officer in the Royal Army, a privateer, and is mentioned in the Banishment Act of the State of Massachusetts which was passed in 1778. He received a grant at Burton on the St. John River.

The early New Brunswick settlers used the native woods of pine, birch, maple, and butternut. We find the rural population still using these woods one hundred years later, although by this time black cherry was discovered as a wood most suitable for more elaborate styles of furniture and, in fact, it is still mistaken for mahogany because of a rich reddish brown color. The difference can be noted in the almost complete absence of grain. Butternut became very popular because it took a beautiful polish. This wood makes the locality of its maker easy to identify because it was found only in the valley of the St. John River in southwestern New Brunswick, along the lower St. Lawrence River, and in the hardwood regions of southwestern Quebec and Ontario. Articles made from butternut were seldom if ever painted.

Sugar maple was one of the most valuable woods in Eastern Canada, the "bird's-eye" and "curly" grains being most eagerly sought. Another wood greatly used by early settlers was birch, the yellow birch being one of the finest hardwoods and most durable for cabinet work. Any older pieces of furniture made from any of the above woods are worthy of collector's attention, and they are becoming more and more sought after.

Quite different in style from the Acadian furniture is the primitive pine furniture of the New England settlers. This is straight, strong and sturdy. No joints were visible except in one or two rare cases where the pressure of a heavy body on a seat has forced the legs to show through. The method of construction was usually the same. Back slats on the chairs and also the stretchers were thick and straight. Seats varied, often made of a single heavy plank. On some chairs we find the seat constructed with a heavy frame, on which has been laced a piece of thick cowhide applied wet and tight. The tough seats of these chairs have survived more than two hundred years of use.

Chests were an important part of early household equipment. A chest was a "keeping place."

It could be a blanket chest in the form of a box-like trunk or it could be on legs or a low stand with drawers. Many early chests combined both, with a set of drawers at the bottom of a box-like top. Another important piece of early furniture was the settle-bed. This was made to open into a bed at night and fold into a seat in the daytime. We must remember that in very many early homes, particularly those in rural areas, space was at a premium. For this reason we occasionally find a child's trundle bed. This was made very low to the floor so that it could be pushed under a larger bed in the daytime. Of particular interest and pleasure when found are the small cradles, often lovingly made with a wooden hood to keep out the draught.

This was the period for the little stool, three-legged round ones, often being referred to as crickets. Small benches were made from straight pieces of wood, mostly pine, and we must not forget the little commode chairs in the style of quaker chairs with wings. Of all chairs made for the small child these have the most character and appeal. Collecting New Brunswick furniture made before the turn of the century is not easy, but is most rewarding.

In various parts of the province, particularly Kings, Charlotte and Westmorland Counties, hutch tables have been found in good numbers. These have been made in various shapes, round, square, oblong and oval. The type most plentiful in Westmorland County tends to have what is known as a shoefoot. The style seems to follow that of the early German settlers. Many of the Kings County tables were fitted with drawers in the seat, and here we find as many large oval tables

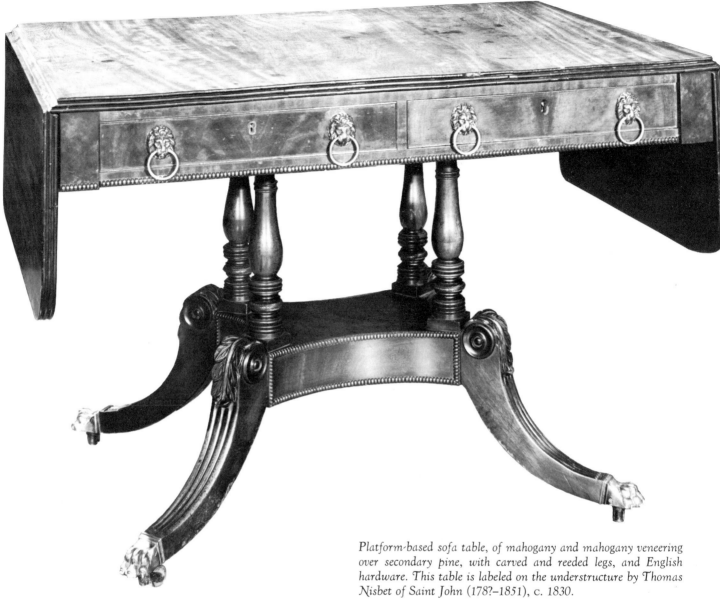

Platform-based sofa table, of mahogany and mahogany veneering over secondary pine, with carved and reeded legs, and English hardware. This table is labeled on the understructure by Thomas Nisbet of Saint John (178?–1851), c. 1830.

CANADIANA, ROYAL ONTARIO MUSEUM

Label of Thomas Nisbet, on the preceding sofa table. An identical label is located in the drawer of the maple sewing table illustrated in color.

as round-topped ones. Charlotte County favored either square or round tops. It is probable that Charlotte County settlers were for the most part from New England while Kings County were almost certainly Loyalists. Whatever the source of these tables, they are certainly a top collectors' item.

THE LOYALIST SETTLERS, 1783

In the year 1783 thousands of United Empire Loyalists settled in New Brunswick. These were the people from the thirteen colonies involved in the American Revolution who were either banished because of their activities during the war or persons who chose to live under the British Flag. A large number of the Loyalists were persons in the upper-middle-class bracket. They were military and professional people, and well-to-do tradesmen. They brought with them as many as possible of their personal belongings, silver, china, and some furniture and works of art. Crowded ships gave limited space for furniture, but it is certain that a number of beautiful pieces found their way to the province. These pieces served as models for much of the fine cabinet work which was quickly to follow.

Among the lists of Loyalist settlers we find the names of six cabinetmakers who received grants in the City of Saint John, or perhaps we should use the original name of Parrtown. Six men were listed as Joiners. A few years later we find an addition of five more cabinetmakers arriving in that city.

The Loyalists who moved up the rivers to the rich farmlands had of necessity to use the native woods which were fortunately plentiful, but the dwellers in the townships were soon able to procure more luxurious pieces of furniture. We have mentioned earlier the ship-building established by the first New England settlers. Enterprising tradesmen among the Loyalists enlarged this business, and trade grew quickly to encompass the Carribean Islands and Africa. Mahogany and other woods were returned to New Brunswick in trading vessels. With experienced cabinetmakers and joiners already on hand, within ten years we find a large number of firms already doing business.

The incorporation of Saint John as a city so early in its history (Parrtown, Carleton, Partridge and Navy Islands, with the three islands in the Reversing Falls, were formed as the first city in the British Commonwealth in 1785) has been an advantage to us in compiling our story of cabinetmakers in that area. The city was allowed to make and enforce its own by-laws, one of which required the registration of any person desiring to operate a business of any kind in the city. On May 23rd, 1785, a notice was posted that any person desiring to practice a trade must register and would then be made a Freeman of the City. We have on record therefore all cabinetmakers who registered between 1785 and 1860. Several men listed on the Loyalist lists as cabinetmakers did not register until after 1810, possibly due to lack of funds or equipment at an earlier date. Early names are Captain Challis, who was the first to register, and while no marked work is known he was

Tall clock, with a case of mahogany veneering over pine, by an unknown but probably Scottish immigrant cabinetmaker. The works are by Benjamin Wolhaupter, silversmith and clockmaker of Fredericton, c. 1825. PRIVATE COLLECTION

Corner cupboard of curly birch, a visually strong wood when used in large panels, with bracket feet and solid-paneled doors, from Point de Bute, c. 1800–20. PRIVATE COLLECTION

Corner cupboard in mahogany, with Chippendale bracket feet and unusual window framing, from Northumberland County, possibly by William Murray, c. 1800.

NEW BRUNSWICK MUSEUM

still working and advertising his trade in 1824. Daniel Fowler was the second name on the list and he moved to Long Reach in Kings County. While work by Fowler is not documented, the name of Fowler as makers of fine furniture continued in that county well into the 19th century.

Prior to 1800 we have eighteen cabinetmakers listed in Saint John City, but many of these men carried on their work within a radius of twenty-five miles of the city itself. Two at least operated as chairmakers.

The most interesting chair with a known history was built in Fredericton, ninety miles up the St. John River. It is now in the New Brunswick Museum. Alexander Ross and James Hunter were Loyalist cabinetmakers who settled in Fredericton. A record of this particular chair is traced through their correspondence with a lawyer in Saint John, Ward Chipman, who was one of New Brunswick's most distinguished citizens. These two men were his clients for several years, and a letter dated October 1788 describes the chair in detail. The address from which the letter was sent, and where the chair was made, was the Fredericton prison. The men had been jailed for debt, and the chair was part payment for lawyers' fees. A lengthy correspondence was carried on and other furniture was shipped down river to Saint John in payment for both wood and fees. The year 1790 shows the unfortunate men still in jail, but still working at their trade. Our next record shows Ross to have died in 1804, and they at that time were free men. A published notice shows Hunter assuming responsibility for Ross's debts. The only further notice we have is when James Hunter applied for a patent for an invention. We have been unable to discover what the invention was or whether patent was ever granted.

THE 19TH CENTURY

The war of 1812 was indirectly responsible for a great change in both the quality and style of New Brunswick furniture. British soldiers returning to England told of future possibilities for settlers in Canada and many craftsmen decided to try their luck in the new country. For the province this was a boon, since it brought men who had trained under the strictest apprenticeship rules in the trade of the cabinetmaker, several of whose work was as fine as any made elsewhere. Cabinetmaking in the two largest centers, Saint John and Fredericton, became a major industry.

Among the finest of these cabinetmakers was Thomas Nisbet, 1780–1851, who came to Saint John in 1813. Born in Dunse, Scotland, he was apprenticed to his father, a cabinetmaker in the best tradition. In 1803 Thomas married Margaret Graham, also of Dunse. Upon his arrival in this province he took out his papers as a wright. In 1814 he took out a second set as a "cabinetmaker." In my book, *Antique Furniture by New Brunswick Craftsmen*, I referred to Thomas Nisbet as the "Duncan Phyfe of New Brunswick." The quality of his work produced between 1814 and 1848 is equal to any produced on the continent. Since our first recording of his work we have had an opportunity to study other craftsmen of his period with new interest, and he is now receiving recognition as Canada's leading cabinetmaker of his time.

Nisbet followed the contemporary styles of his period. His early work was strongly influenced by the Regency style. The popular fashion of 1815, of spiral-twisted table legs and ornamentation of sideboards and fourposter beds, were almost a trademark during Nisbet's early years. Fortunately for today's collector, Thomas Nisbet used a label on most of his finer pieces, and many examples have been discovered in most parts of eastern Canada and the United States. They are now considered museum pieces. It is unfortunate that many examples of his work have been found minus the label, due no doubt to the careful housewife of early days, who looked on a pasted paper label as the twin of a price tag. The student of early furniture will, however, recognize the fine craftsmanship of Thomas Nisbet. On many old pieces a light square can be seen to show where a label has been. There are also many pieces of his work that can be documented by old family records.

With the resultant publicity given the placing of the Elgin Marbles in The British Museum in 1816, Nisbet followed the trend to the Greek style of ornament, and the acanthus leaf and the anthemion scroll were applied to many superb examples of his work.

Nisbet used mahogany for most of his larger work but some very delightful smaller pieces such as sewing tables have been found made from bird's-eye maple. Although birch was used for drawer linings and interiors, to date no labeled pieces of furniture made from this wood have come to light. He advertised in 1835 that he had just received a large shipment of mahogany from the West Indies.

In 1836, Thomas Nisbet, Jr., became a partner with his father. Thomas Nisbet at this period took an active interest in the world of business. He became president of the Mechanic's Whale Fishing Company. He was president of The St. John Hotel Company. Thomas, Jr., died in 1841 and another son, Robert, became a partner. Thomas Nisbet died in 1851, a very rich man. Robert Nisbet carried on the cabinetmaking business until 1856 but it had declined under his management to the extent that in 1855 the business consisted mostly of undertaking and repairs.

Alexander Lawrence of Saint John and John Warren Moore of St. Stephen were contemporaries of Thomas Nisbet. We have selected their names from a very lengthy list because of the superior quality of their work. Alexander Lawrence was born in Mathlick, Scotland, in 1788. He served a seven-year apprenticeship before coming to New Brunswick in 1817. In August of the same year he advertised in the Saint John City *Gazette* that he had commenced business as a cabinetmaker on King Street, although he did not take out Freeman papers until 1820. In 1819 he was already in partnership with Robert Sheed, a partnership which only lasted the year, and there is no record of Sheed on the city Freeman lists. We do, however, find Sheed doing business under his own name until 1823.

Lawrence advertised frequently, evidently because he changed his address very often. We find ten different addresses for his workshop. He advertised for the sale of mahogany logs, and for journeymen cabinetmakers. Lawrence's work was excellent, but differed greatly from that of Nisbet. He used a heavier flat carving, and while we do not find in his pieces the spiral turnings, yet the work, while more solid in appearance,

Combination sewing and writing table, of bird's-eye maple, with mahogany cover edging and keyhole linings. The table is labeled by Thomas Nisbet of Saint John, N.B., c. 1813–23.

CANADIANA, ROYAL ONTARIO MUSEUM

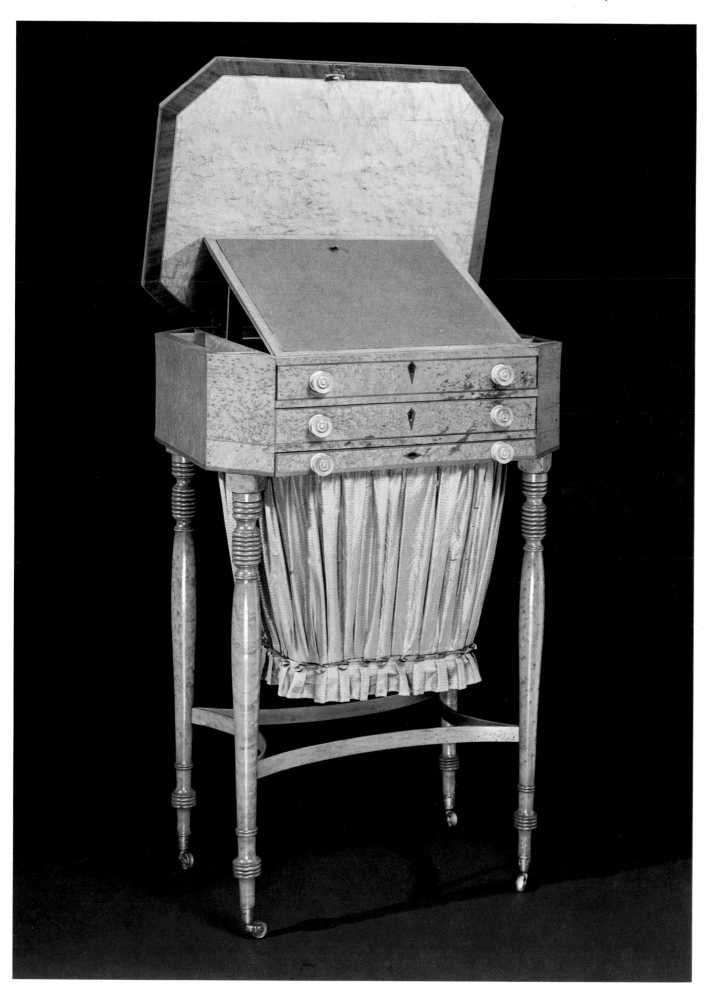

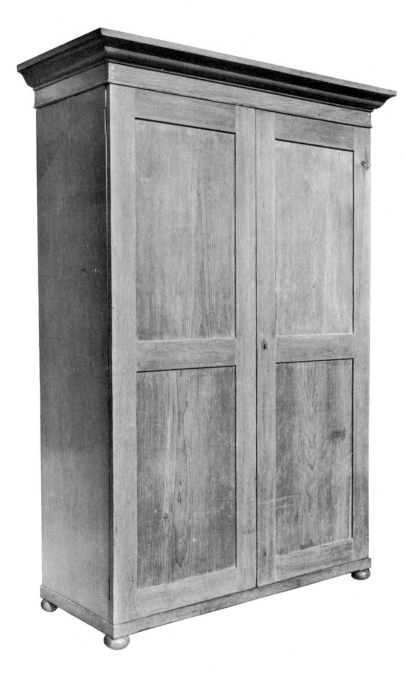

Dismountable armoire of pine, with flat-panelled doors, ball feet, and heavy cornice. The armoire is marked inside as the property of Lt. Henry Lodge, who was serving in the 104th Regiment in 1810. PRIVATE COLLECTION

The Henry Lodge armoire disassembled, in a state for shipping.

is graceful. It is unfortunate that Lawrence almost never marked his work, and we have no knowledge of a label. Documentation has come very often from old bills and receipts in the possession of descendants of the original owners. Alexander Lawrence played an important part in the development of Saint John. He founded the Sacred Music Society, the Mechanics Institute, and was a leader in Freemasonry. He trained his two sons in the cabinetmaking art and after his death in 1843 they carried on the business until the turn of the century. Joseph, the elder son, became one of the city's foremost writers and historians.

John Warren Moore was born in Moore's Mills, close to the town of St. Stephen in Charlotte County. Despite the fact that an almost complete history of the Moore family exists, we have not yet discovered where Mr. Moore was apprenticed to his trade. There is a possibility he may have learned cabinetmaking in the State of Maine, which is very close to his home, but his early style seems to be patterned after the Saint John craftsmen. John Warren Moore was born in 1812. He could trace his ancestry back through more than a hundred years of diligent, hardworking pioneer settlers in Derry, New Hampshire, where the family had gone to escape religious and other forms of persecution in Ireland; and before that, back to the mountains and caves of Ben Cruchan in Argyllshire, Scotland. Moore married Mary Louisa DeWolfe of Windsor, Nova Scotia, daughter of Dr. John DeWolfe, a prominent figure in the history of the Maritime Provinces. Two things have contributed to our large knowledge of his work. The first was Mrs. Moore's evident great pride in her husband's trade and the fact that she was a prolific letter writer, and in later life enjoyed reminiscing in her correspondence about her early life. The second is that her family, to whom she wrote so often, cherished her letters and preserved them. In addition, we owe almost all of our knowledge of Moore to a descendant, Mrs. Frank Flemington of Toronto, who not only preserved these letters which came to her hands but, with her husband's help, collected wherever possible, documented articles of Moore's work.

Almost all furniture made by Moore is of mahogany and beautifully constructed. The lines are in exceptionally good taste, and being so well and strongly made, when found the pieces need very little repair. Because Moore worked for so long a period there must still be many examples of his work to be found in Charlotte County and in the State of Maine.

Another name of record in Charlotte County and also of St. Stephen is Thomas Caswell, 1806–1894. While Caswell made many types of furniture, we consider his best work to be the numerous Windsor-type benches he made for all kinds of meeting places, church halls, schools and the like. These he

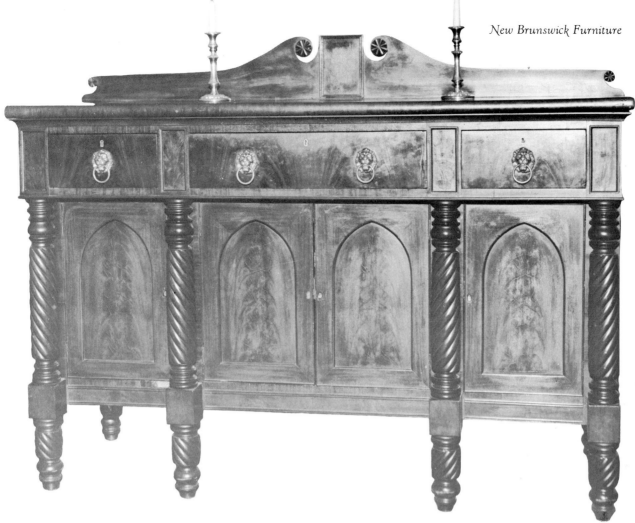

△
Sideboard, mahogany and mahogany veneering over secondary pine, with rope-carved half columns, Gothic-arched door panels, and English hardware. The piece dates c. 1850–60, and may have been made by John Warren Moore of St. Stephen (1830–93).
PRIVATE COLLECTION

Sideboard, of mahogany and mahogany veneering over secondary pine, with four heavy shaped front extensions and legs typical of the late Empire period and after. This piece was made by John Warren Moore of St. Stephen, c. 1850–80. PRIVATE COLLECTION
▽

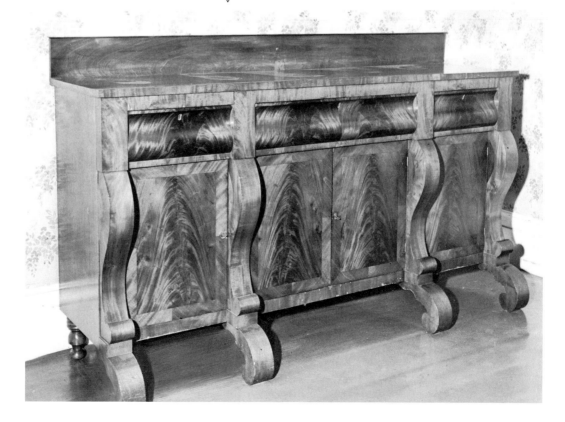

△
Slant-front desk, with heavy bracket feet, of mahogany over secondary pine, and with fine maple inlays on the inner drawers and door. This desk is marked "S. Lockwood, 1792" inside a drawer, possibly either Samuel or Solomon Lockwood, both Loyalists who came to New Brunswick from Connecticut. Though the piece is believed to be from Saint John, the name may refer to its owner rather than the cabinet maker. PRIVATE COLLECTION

Boot cupboard with two doors and a pair of side chairs, all of butternut, c. 1850, and attributed to Samuel F. Jones of Fredericton. The cupboard has flattened ball feet, a stylistic vestige of the late 17th century, very similar to those on the preceding Lodge armoire. NEW BRUNSWICK MUSEUM
▽

Early Empire sofa of West Indian mahogany, with reeded seat rail, arms and legs, and carved panels. This sofa is attributed to Alexander Lawrence of Saint John (working 1817–43), dating c. 1825–30. NEW BRUNSWICK MUSEUM

advertised to be made in any type of wood, style and length. Most benches found are of the stick-Windsor type with a stretcher underneath the seat. It should be noted here that until 1890 we have no record of the bowback Windsor being made in New Brunswick. Beautiful arrowback, yokeback, stepdown, birdcage styles were plentiful, but not bowback chairs. Probably the most popular New Brunswick chair of the late 18th and early 19th century was the rodback, which was made in all styles such as combback and railback. Caswell was an expert at all these types, and the area in which he lived has many to be found in the old homes.

Because antique chairs are so plentiful in this province, special mention should be made of some chairmakers. While most chairs are unmarked, it is possible to attribute many to individual makers. Thomas Hay took out papers in 1819. He lived in Lancaster, now part of West Saint John. He was the son of a Loyalist, John Hay, a baker. Thomas Hay is important because he quite often stencilled his name on his chairs, many of which have fortunately survived, which speaks well for the quality of his work.

Hay marked several varieties of Windsor chairs, arrowback, yokeback and stepdown. One chair of interest is known to have come from his shop, unmarked, through an apprentice, John Quinton. This man gave it to a neighbor, John Brundage, an early silversmith, and until recently it had remained in that family along with its history. This chair shows a Greek influence and the seat is caned. It still retains much of the old olive green paint with dull gold trimming. Mr. Quinton told of this chair in his diary, written in the early 1830s. He himself did not remain in the cabinetmaking business, but went on to become a prominent lawyer.

We learn from another old diary that in 1840 Thomas Hay bought land several miles up the St. John River, and commenced to make chairs with rush seats, since the rushes in that area grew profusely. This venture lasted only one year, and Hay returned to Lancaster, England, where he died in 1845.

Also beginning a chairmaking business was J. McCarthy of Mispec, located on the Bay of Fundy about fifteen miles from Saint John. The chairs made there were mostly of the Hitchcock style, sometimes called, pillowback. These chairs required rush seats, and McCarthy made a chair for each of his four grandchildren. He painted each a different color, and all four chairs are still in existence. One is in the New Brunswick Museum. In 1851 the Mispec chair business was sold to Robert McKenzie. Although McKenzie owned and operated the business until 1857, it is doubtful that he was a chairmaker himself. He was a native of Scotland and a prosperous merchant, also being listed as a tailor, a farmer, and a moneylender, of whom it was said "he never missed an opportnuity to flash a roll of bills." He also owned a grist-mill in the Mispec area. However, we do know that during this period of ownership a large number of very fine chairs were made at Mispec.

Robert McKenzie's life and many interests have been traced because he and his family were all brutally murdered at his home in Mispec. Robbery was the motive. The chairs from this factory have been easily traced because the story of the murder and robbery has been handed down with the chairs from generation to generation.

A man named Robert Parker made beautiful chairs at Tynemouth Creek, not far from Mispec, also on the Bay of

Small standing pendulum clock, with a mahogany case in a peculiarly Scottish style, and works by James Melick, c. 1830–40.
NEW BRUNSWICK MUSEUM

Fundy. We should mention here that all of this area, as far as the village of St. Martins, was a very important ship-building area, and working with woodworking tools was the life of the community. Robert Parker made chairs in the Empire style with curved and reeded arms. Both arms and back slats were steam-bent, and he used fine woods such as mahogany although a few examples of the finest maple have been known. Chairs made by Robert Parker are rare and valuable.

The subject of chairs is incomplete without mention of those made in the last half of the 19th century by James B. Emery. This exceptionally fine cabinetmaker built beautiful furniture of every kind and of almost every type of wood. He lived and worked in Saint John city. His beautifully carved lady's and gentleman's Victorian armchairs were unequalled. Many which have survived originally belonged to parlor sets. These included a large carved-back couch and very often side chairs. When obtainable, any of these pieces are highly prized. The armchairs are the most sought after, because they fit so well into the size of modern homes. Persons lucky enough to find other pieces of his work, including tables and bookcases, are indeed fortunate. The Emery business, which survived the Great Fire of Saint John in 1877, is still carried on by a descendant of the family in the same manner. In fact, work by Alban S. Emery, the last of the name, is now becoming a collector's item.

In the central part of New Brunswick, particularly Westmorland and Kent Counties, we find a plentiful supply of fire-house chairs. Like the captain's chair this is a type of low-back Windsor, but the difference between the two lies in the style of leg. The captain's chair has the legs splayed outward to make for a better balance, while the fire-house has an almost straight leg and usually a saddle seat. Another difference between the

Side chair of maple, found in Somerville, N.B., and probably an early manufactured piece, c. 1840, and originally part of a set.
PRIVATE COLLECTION

One of a pair of Empire scroll-based footstools, of mahogany with upholstered tops, by Alexander Lawrence (working 1817–43), in 1841. The original invoice for these "Ottomans" exists in the author's collection. NEW BRUNSWICK MUSEUM

Knee-hole desk of butternut, with hinged writing surface and pull-out supports, and fan-carving in the center corners. The upper section is closed by a sliding cover. This desk, c. 1815–20, is attributed to Thomas Beatty of Carleton, N.B.

NEW BRUNSWICK MUSEUM

Side chair, of mahogany with plain turned front legs but an elaborately carved back, c. 1835–45, and probably part of a set. This chair was originally owned by Joseph Cunard of Halifax.
PRIVATE COLLECTION

Rococco parlor or lady's chair, of heavily carved mahogany, made by James Emery of Saint John, c. 1860–65, and owned by a descendant.
PRIVATE COLLECTION

two chairs is that the captain's chair has an arm which is continuous to the seat while the fire-house arm ends in a turned rod. It should also be noted that the Eastern Canadian captain's chair has much more spread to the legs than that of American make, probably because the American type was used more often on the large rivers and lakes rather than on coastal waters. Both the above chair forms are now being eagerly bought up, although they probably date from later than 1850. We must also not forget the many little Windsor stools, both of the three- and four-legged style. The seats of these little stools were exceptionally thick and well rounded on the edges. There is nothing more charming than to see one used today beside a fireside.

The name of Fowler for many years dominated cabinetmaking in Kings County. We spoke earlier of Daniel, who had been among the first to register in Saint John before moving to Hampton in Kings County. The descendants of this man carried on the trade through several generations, and while chairs of all kinds were made in this general area, Kings County is best known and gained much fame for beautiful spool beds. The name "spool bed" is given to many types, and we find beds with a ball turning very much in evidence, and others which show a combination of spool and ball. One of the finest

beds we have ever examined was a mixture of spool, ball, and acorn turning.

It would be safe to say that at least eighty percent of the many spool beds made in Kings county were from the village of Upham. Woods used were pine, maple, butternut and birch. The village is situated close to Hampton on the Hammond River, and is one of the beautiful and unspoiled parts of the province. Named after Loyalist Jabez Upham, whose family lived and worked there all through the 19th century. The wealth of good timberland and its accessibility made this a natural place for cabinetmaking. An important cabinetmaking family there was named Fenwick, and another was named Titus, both making furniture well into the 1870s. We find the names of Upham, Fenwick, Titus and Fowler linked several ways in different combinations as partners, so it is impossible to separate the work of the different makers. Occasionally a stencilled mark was used, but most often on chairs.

Spool turning was very often found as a decoration on chests of drawers and even on sideboards and tables.

In fact many tables have a complete leg made of spool turning. Of course all this turning was of the latter half of the century when the machine lathe was used. Whenever or wherever used, the spool furniture is particularly attractive and

Secretary, in pine, with relief-carved elk on the round door panels, and grapes with leaves on the drawers of the desk section, and floral relief carving on the bookcase doors. This is a specially constructed piece, by an unknown maker, but made for Abraham Gesner at the Albertine Mines, c. 1850, while he was developing the production of kerosene from coal. NEW BRUNSWICK MUSEUM

hopefully sought. There is still much of it in Kings County, and as with all the old pieces, the value is rising quickly.

Although the names of Jonas and John D. Howe are familiar ones in the history of Saint John, their story as cabinet-makers rightly begins in Kings County. They started in a small factory on the Kingston Peninsula early in the 1860s, moving a few years later to Rothesay where they formed a partnership with Albert J. Lordly in 1864. The group later moved to Saint John. Several very superior articles of furniture have been shown us which were made during the early days on the Peninsula. They were unmarked, but from their style and craftsmanship must be credited to the Howe brothers. After the great fire of 1877, the partnership of Howe and Lordly was dissolved and Lordly started his own business, which was later absorbed into a company. John Howe was the moving spirit in his partnership with his brother and he started a new and entirely different type of work. Almost all of this new furniture was made from superior woods and most of it was heavily carved. John Howe did the designs for most of his carving, and first won recognition for the design of a panel for the Young monument which still stands in King Square. This was made as a memorial to a young man who had lost his life in Courtenay Bay in an effort to save a drowning child. There are many churches and other buildings in Saint John which proudly boast of Howe's beautiful work.

Another community which was prominent for cabinet-making and the crafting of smaller furniture was a village called St. Martin's. There is a narrow road called Factory Lane on which was located the cabinet works of John Bradshaw, whose family had been well known for shipbuilding. St. Martin's is on the Fundy coast, and is a delightful hamlet mostly inhabited by retired persons. In many of the beautiful old homes can still be found lovely old handmade articles of furniture made in the early days by ship builders and carvers.

We have tried to put in a short space a history of the many articles of fine work made over almost two hundred years in one province. It has been impossible to mention every one of the many cabinetmakers who worked during that period, and a number of names and places have been omitted. To emphasize the importance and scope of the work done in New Brunswick we would like to quote a few lines of a press notice which appeared in 1853, when Saint John celebrated the turning of the first sod for the European and North American Railway. Part of the celebration was a monster parade in which all labor unions participated.

We find the following account:

CABINETMAKERS

A Marshall, with banners and a work bench with workmen in full operation. A carriage with furniture and their workshops with men at work. Both looked very well. Banner with a figure of Justice and a motto on obverse of a sideboard, hands-locked, and the words "Love and Unity."

In recent years there has been an exceptional demand for New Brunswick's furniture, notably among the younger generation who use it for their modern homes because it is easier to build a room around than the more stylized modern designs. It is also an investment for there is little doubt that it will continue to increase in price. But, most important, it is an investment in history and sentiment.

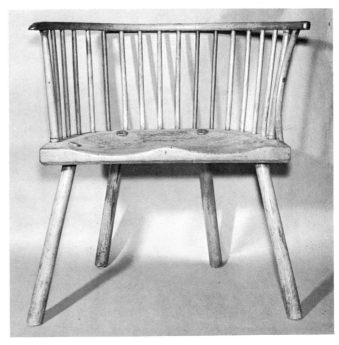

Home-made country Windsor captain's chair, late 18th century, of the American type with vertical reeding full around the back. The legs are held in place by end wedges in the single-plank, saddle-carved seat.　　　NEW BRUNSWICK MUSEUM

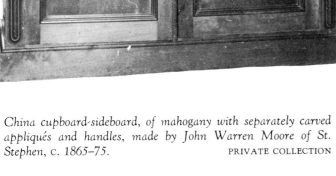

China cupboard-sideboard, of mahogany with separately carved appliqués and handles, made by John Warren Moore of St. Stephen, c. 1865–75.　　　PRIVATE COLLECTION

Ontario Furniture

Philip Shackleton

It is heartening to observe today in the collecting of indigenous furniture a distinct trend away from complete preoccupation with the crude and naive products that have for so long been the principal stock-in-trade of dealers in locally made antiques. The growing favor accorded to what it seems best, for the time being, to call finer furniture, made in a variety of period styles, is a sign of increasing maturity among collectors.

Some balance is being brought to the odd view that the progress of civilization in the olden days here depended entirely upon the ability of householders to improvise tables from tree trunk slabs and chairs from saplings or the precious packing boxes which carried their effects from the old land. It is a matter of acknowledging that there existed here in the 18th and 19th centuries something more than a pine-board culture.

Basic utility pieces from pioneer kitchens have surely had more than ample attention by the collectors of artifacts from our local domestic past. The shift in attention to the furniture of the drawing room, the parlor, and the dining room, is a belated recognition by collectors that some of their forebears not only aspired to the finer things of life but to some extent actually managed to realize such aspirations.

Although there survive today very few pieces whose pedigrees convince us they were actually in use here by 18th-century citizens of Ontario, still the literary and other documentary records of the period indicate that fine furniture really did come to the early frontier.

It, wasn't familiar to the common soldier, nor to the common settler, but for garrison officers, for the administrators, and for some of the more affluent or the more stubborn of landed immigrants, formal furniture in some quantity is suggested by scattered testimony in the printed recollections of the time. Some Loyalists managed to bring a few treasured pieces from their old homes. British officers, attempting to cushion themselves against the rugged aspects of a North American posting, contrived to bring an impressive array of exotic furniture to the Upper Canada bush land.

Preservation of a drawing room tradition here did not depend only upon imported pieces in the Georgian traditions of the passing century. The more numerous and more detailed paper records of the early 19th century make it clear that better furniture, locally made as well as imported, was by no means unfamiliar in the homes of gentlefolk in the growing colony. And notices by local cabinetmakers appeared in the first periodicals to be published in Niagara, York (now Toronto), and Kingston.

Some few early inventories of household effects assure us that sofas and secretaries in mahogany, and dining tables, chests of drawers, and card tables in cherry were familiar in better-off homes of the late 18th century.

Military officers and civil administrators, both in transient professions, made frequent use of those early newspapers to advertise the sale of their furniture before returning to Britain. Not only did they usually realize good prices here but they were also saved shipping costs.

Sales by auction were quite common, both of private estates and of merchants' stock, and period newspaper announcements list gilded looking glasses, sofas covered in haircloth, French bedsteads, Pembroke tables, and other better furniture in rosewood, mahogany, black walnut, maple and birch.

Add to these the much more detailed advertising notices of the general merchants of the first decade of the 19th century, and one can draw up a considerable inventory of imported hardware—all sorts of brass fittings, hinges, casters, clock parts, handles and knobs—materials of use only to makers of furniture of a certain quality.

Further documentary evidence of the existence of appreciable quantities of formal furniture in the early years can be found in the claims for compensation made to the government by private citizens who had lost or suffered damage to their property during the War of 1812.

References to household furniture up to this time were

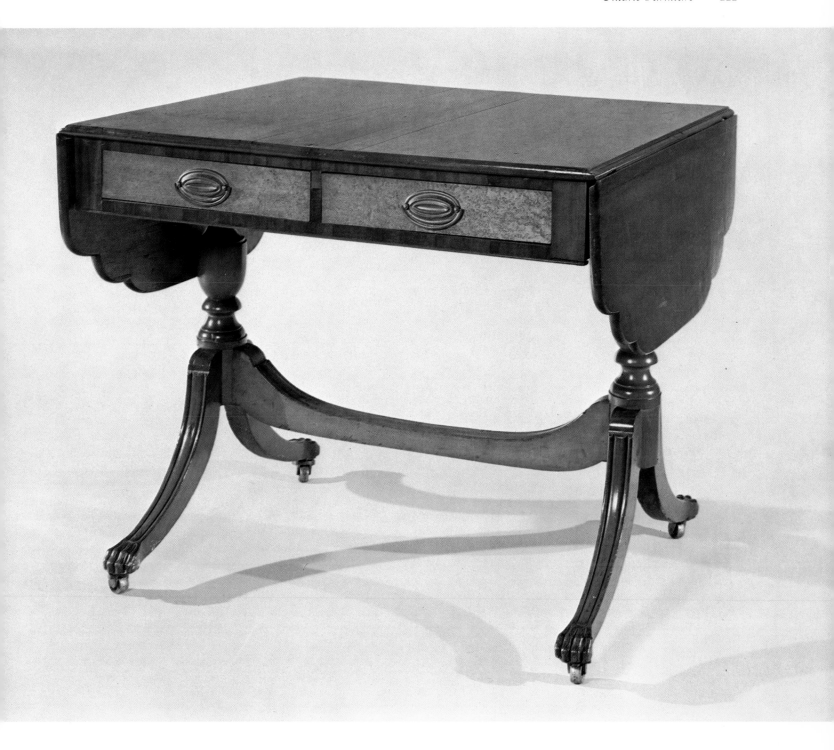

Sofa table, cherry and bird's-eye maple with pine as a secondary wood, and with concave stretcher and legs. This piece was found in Napanee, Ontario, and dates c. 1810. The maker is not known, but the table is one of the finest existing pieces of Ontario furniture.
CANADIANA, ROYAL ONTARIO MUSEUM

largely incidental; day-to-day living on any kind of frontier is such that descriptions of furniture in use have very low priority ratings in personal, official or commercial documents. But after that war, with recompense for lost property at stake, the quality of detailed description improved immensely.

Losses due to enemy action were sustained by private persons all along the colonial border but the town of Niagara had been completely and deliberately destroyed by the invaders, and the worthies of that community in their post-war claims have left us a catalogue of household items that proves this town was certainly no rude outpost of empire.

One reads of parlor sofas, of double bedsteads, of sets of tables, upholstered chairs, elegant dining tables, sideboards, tea chests, desks and bookcases—hardly the furnishings of a shanty community. And although claimants described in minute detail some of the humblest items lost, there appears to be no specific mention of dough boxes and dry sinks. The woods frequently are identified—mahogany, rosewood, black walnut and cherry—and since the latter two are woods native to Ontario, it appears that a significant quantity of the finer furniture lost was probably the work of domestic cabinetmakers.

Records that survive in archives and libraries make it obvious that furniture of some period quality, of some pretension even, was available to citizens of means in the very early period and, of course, in ever greater quantities as the 19th century advanced.

The rather belated present-day enthusiasm among some collectors for that which the original owners would have considered their best drawing room furniture owes some debt to a few good regional museums in Ontario and a great deal to the missionary work of the curatorial staff responsible for the Canadian furniture collection in the Royal Ontario Museum. One can inspect there a constantly growing display of the kind of Canadian-made furniture of which its period proprietors would have been proud.

Thanks in like measure are due to those few individuals who have chosen and arranged the period furnishings for such restored exhibition sites as Upper Canada Village, Black Creek Pioneer Village, and individual historic buildings open to the public throughout the province. It may be true that not every last building has been perfectly done. Not every one may be meticulously correct in every last detail according to its terminal dates. But the average grading for authenticity in furnishings is exceedingly high, and the influence that these "living museum" projects have had in restoring a realistic understanding of bygone household living is difficult to exaggerate.

Having confirmed that even pioneers in this land may have had some acquaintance with fashion and style according to the standards of their period, it may not be amiss to remark that high style is one thing and that the rendering of its spirit by craftsmen far removed from its point of origin or inspiration may be quite another.

The latest word on fashion reached Upper Canada from London and New York, frequently via Montreal, sometimes directly across the lake and river boundary from the bustling and enterprising United States. The state of communications within the colony and between it and the outside world was something less than instantly efficient and so one can understand gaps in understanding and modifications in the pure gospel between fashion arbiter and the neighborhood furniture-maker.

With new-won favor these days for the "better" products of our immediate cultural past, there has been, quite predictably, some little pompous expertising on standards of correctness in design. It is, of course, largely harmless. The thoroughly natural legacy of our colonial background includes some desire to recall our ancestors and their works as perhaps a little grander than they truly were.

Although the furniture craftsmen of early Ontario aimed at fashion's ideal, the truth is that in the best meaning of the word, the work that they produced was and is provincial. To call it so is not to deprecate it but rather to bring a realistic standard to any assessment of craftwork past. To say that some product is provincial is not to label it as crude but to identify it as a suburban or country town version of the Paris original.

The charm, in fact, and the character that distinguishes the work of those Upper Canadian cabinetmakers from that of their peers in more worldly communities lies primarily in their peculiar tempering of fashion-plate design and their substitution of locally available woods and other materials.

The conservatism of the provincial artisan is manifest in the traditional time lag between city and country enthusiasm for a new fashion. Just as they did among country craftsmen everywhere, older furniture styles remained popular in old Ontario for many years after they had been discarded by the most up-to-date furniture-makers in those world capitals where changing fashion was deemed a matter of the most vital concern.

This is the kind of conservatism that saw Georgian period influence retained in much of the furniture work of the first half of the 19th century, the kind responsible for the persistence of Sheraton styling in some chairs as late as 1850 and of Chippendale period details in some larger country cupboards even later. Provincial furniture is of a distinctly country style, but of a style that reflects formal tastes of times gone.

The primitive experience on the frontier is one that is very well documented. There exists a wealth of books in which literate pioneers and observing travelers have reported and reminisced on the hardships of early life in old Ontario. Armed with a couple of these books, any handyman today could put together with basic tools and from extremely basic materials the kind of makeshift furniture that was the household stock of many families.

Travelers in Upper Canada in the 1820s and '30s remarked frequently on the crude quality of shanty and cabin furnishings—tables like chopping blocks, rude benches made of wooden slabs with sapling lengths for legs, even chunks of granite to serve for seats beside a fireplace.

Something that possibly has not been adequately understood is that cottage life in Britain and Ireland at the time was possibly no more refined. Many thousands of the old world immigrants who pioneered Upper Canada came from humble homes where furniture was sparse and frequently of the simplest forms. Peasant folk generally, well into the 19th century, had for their furnishings perhaps a few homemade benches, a table or two, a crude bed and perhaps a spinning wheel.

The familiar homemade bedstead in Upper Canadian cabins was framed of saplings and mortised into a wall and a pair of upright poles. It was completed by weaving a "spring bottom"

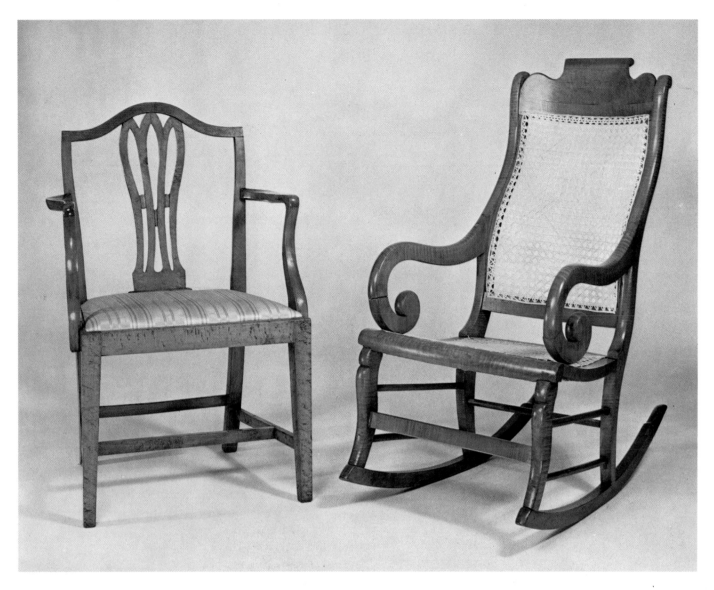

Left: A late Chippendale armchair, with Hepplewhite influence as well, in curly and bird's-eye maple. Probably eastern Ontario, c. 1800.
Right: Empire period scroll-armed rocking chair, in curly maple with caned seat and back. This is probably a manufacturer's piece, c. 1840, though it is not marked.

CANADIANA, ROYAL ONTARIO MUSEUM

of basswood bark. Strictly a makeshift piece of furniture, few homesteaders kept such a bed once they could buy something more comfortable or prepossessing.

Many settlers acquired professionally made furniture as soon as possible. But the period of settlement extended over at least a hundred years, and the tradition of hacking a home and many of its comforts out of the bush was not yet an unfamiliar one late in the 19th century.

For some settlers of limited means, the experience of turning bush into farm land in the 1870s was little different from that of the old-timers who had arrived in the 1780s.

There was a continuing pioneer tradition over this long period, and the kinds of furniture made by local carpenters or the householders themselves changed very little. We innocent observers today should not be severely chided if we confuse that furniture made to satisfy simple needs in the late 19th century with the same type of the late 18th.

It was not so much the common people newly arrived who were upset by the quality of domestic life on the frontier.

Rather it was those of gentler birth and of old world privilege who suffered sometimes a culture shock on the untamed edges of the new world. Demobilized military officers, for example, frequently found themselves unfitted by their training and experience to the kind of do-it-yourself life style required of settlers. And commentators of the period wrote that gentlemen did not demean themselves by learning to serve as their own joiners and glaziers.

Emigrants' guides, written and published in surprising numbers by visitors to Ontario, offered from about 1815 onward a comprehensive store of usually sound counsel to those preparing to leave the British Isles. For one particular, they advised that furniture should not be brought out, that furniture of ordinary quality should be sold before leaving.

Some cautioned that finer furniture was not suited to cabin life in Canada and advised intending settlers to improvise the kind of basic pieces they would require. Some writers detailed the kind of professionally made furniture that could be acquired in Ontario—desks, tables and chests of drawers in black walnut

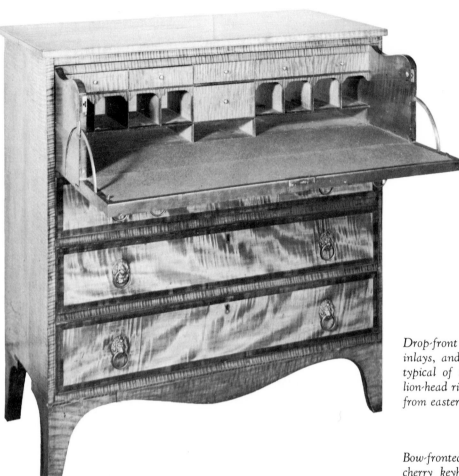

Drop-front desk, of curly maple with mahogany drawer-edge inlays, and secondary pine. The piece has splayed tapered legs typical of such pieces of the early 19th century, with English lion-head ring drawer pulls and other brasswork, and is probably from eastern Ontario, c. 1800–20.

CANADIANA, ROYAL ONTARIO MUSEUM

Bow-fronted sideboard with square-tapered legs, curly maple with cherry keyhole liner inlays, and with English hardware. The secondary structural wood is pine. Eastern Ontario, c. 1800–20.

CANADIANA, ROYAL ONTARIO MUSEUM

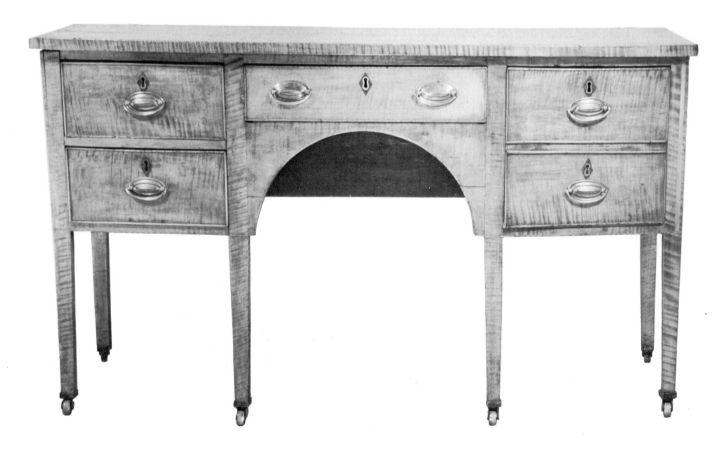

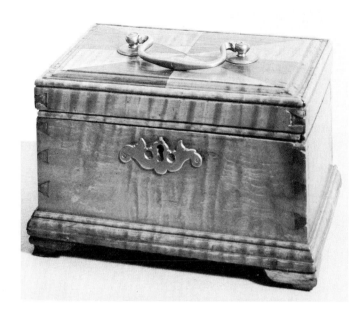

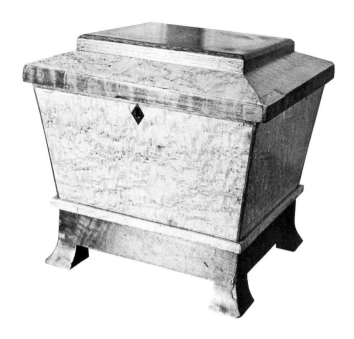

Tea caddy in a late Chippendale form, of curly maple with block laminated maple and walnut lid, and with Chippendale hardware and exposed corner dovetailing. Probably eastern Ontario, c. 1800.

PRIVATE COLLECTION

Chest of drawers, from eastern Ontario, with birch frame and top, walnut drawer fronts, and curly maple inlay bands lining the drawer fronts and around the top. The flared legs and the hardware date this piece to c. 1815.

CANADIANA, ROYAL ONTARIO MUSEUM

Flared-footed sewing box, of bird's-eye maple with walnut veneered base and keyhole escutcheon. The inner tray for thread and needles is of West Indian mahogany. This piece is of uncertain origin, pointing up the difficulty of locating some pieces that have been removed from original context. The inlaid keyhole liner and mahogany tray could suggest Nova Scotia origin, though the walnut veneer and the overall form, similar to other known Upper Canada boxes, suggest Ontario origin. The piece was found in Ontario, and dates c. 1815-20.

CANADIANA, ROYAL ONTARIO MUSEUM

Drop-leaf, gate-leg dining table with separate banquet extensions, in a late Sheraton style, and entirely of cherry with an inlaid walnut band across the bottom of aprons and corner-posts of legs. With ring and rope-carved legs, this table is most unusual, dating c. 1820–30, and such tables with original extensions intact are rare. CANADIANA, ROYAL ONTARIO MUSEUM

◁ Drop-leaf Pembroke table with X-stretcher base and chamfered straight tapered legs, of cherry with pine drawer structure, from the Niagara Peninsula of Ontario, c. 1805–20.
CANADIANA, ROYAL ONTARIO MUSEUM

Sheraton side table with unusually light reeded legs, western Ontario, c. 1825–30, of chestnut, a most uncommon cabinet wood. The opal glass knob is probably an American import.
CANADIANA, ROYAL ONTARIO MUSEUM

◁ Corner cupboard of curly maple, with beveled corner panels, bracket feet, and heavy cornice molding, made by William Thompson in Agincourt, Ontario, c. 1850–60.
CANADIANA, ROYAL ONTARIO MUSEUM

Side table in a late Sheraton derivation, of birch with turned and rope-carved legs, walnut band drawer inlays, and curly maple band inlays vertically in the upper leg corner-posts. The skirt of the table is scrolled and carved with beading. This table, from central Ontario, dates perhaps as late as 1840.

CANADIANA, ROYAL ONTARIO MUSEUM

A much simpler side table, of birch with curly maple top and drawer front, and plain turned legs, dating c. 1830-50. Great numbers of tables of this type were made in the third quarter of the 19th century, usually of mixed woods, and often with legs that are disproportionately heavy for the overall design.

CANADIANA, ROYAL ONTARIO MUSEUM

and cherry, high-post beds, walnut chairs with hair-stuffed seats. Some even suggested that newcomers could buy better furniture in Ontario than they might have had back home.

The impression left by the total of documentary evidence is that there were great disparities in the quality and in the styles displayed in the homes and home furnishings of the citizens of Ontario, at least before 1850. We have some indication of wealth and some expression of formal styles to be found in communities along the frontier, the towns growing along the southern lake and river border; also of some development of yeoman quality and modified fashion for the relatively prosperous, more particularly for the second and third generations. And we have unmistakable evidence that a great many homes were never furnished with anything more than the bare necessities. A lack of ready cash was one reason and isolation another; even if located only a few miles inland, primitive roads and inadequate communications meant that Upper Canada farmers often waited for many years even for things they could afford.

In the late 17th and early 18th centuries, today's Ontario was part of New France but settlement was minimal—just a few scattered forts and a small farm community along the Detroit River. The furniture of French tradition that has been found in Ontario is identical with that of humbler character made in the old towns and villages of Quebec.

For the thirty-five-year period from the end of the American Revolution to the War of 1812–14, Ontario belonged primarily to the Loyalists, the settlers who came as refugees from the new republic to the south. Certainly there were cabinetmakers among them, men who furnished the better quality homes built in significant numbers in Niagara and York and scattered as well in village and rural sites from the upper St. Lawrence to the Detroit River.

It is unfortunate that the sparse records have preserved for us the names of scarcely more than ten furniture-makers of the period. They worked for the most part to fill specific orders, and largely in the better native cabinet woods. Traditional slat-back and Windsor chairs, the latter mostly in American patterns, were popular. Their heritage in cabinet work was the wealth of Georgian period work and it was they who adapted the models of Chippendale, Hepplewhite and Sheraton to the relatively simple needs of an Upper Canadian clientele.

Population increased considerably from 1815 to 1840, as did the number of furniture-makers. It was a period when craftsmen were more directly influenced in their work by the latest fashions from London and New York. And it was the period when the first of the style guides were published in Britain specifically for the middle class. Throughout the western world the middle class was becoming increasingly the most important sector of national populations.

The ferment of the industrial revolution provided the background for a confusing succession of romantically conceived historical styles—sometimes applied to buildings, sometimes to furniture, and sometimes to both. Dominant was the neo-classic, the basic inspiration for a dozen different styles which varied in degree of weight and proportion and in the character of decorative details.

The French Directoire and the Empire, English Regency, the designs published in Britain by Thomas Hope and George Smith, the American versions of Empire—these are the better known of the "Grecian" trends which were to some extent taken up and also modified by furniture-makers in Ontario.

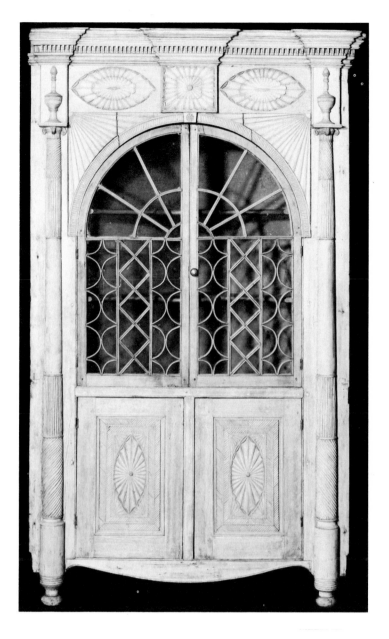

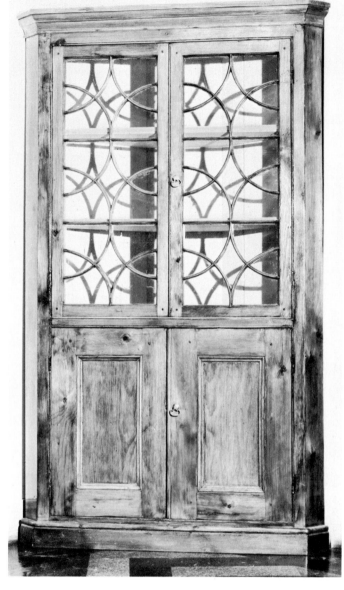

Pine corner cupboard in an Adam style, with elaborately carved fluted oval medallions, square, and corner fans, and fluted and rope-carved side pillars topped by urns. This unusual piece with its complex upper door lattice-work is from the Kingston area, c. 1800–20. CANADIANA, ROYAL ONTARIO MUSEUM

Corner cupboard of pine, in relatively simple form, but with unusual circular bowed window framing in the upper doors. This cupboard is from eastern Ontario, dating c. 1840.
CANADIANA, ROYAL ONTARIO MUSEUM

Mahogany had become the cabinet wood increasingly favored by fashionable cabinetmakers. Although so exotic a wood had scarcely been available for craftsmen here in the opening years of the 19th century, its supply was apparently sufficient after 1825 to make a great many Empire style sofas, card tables with carved paw feet, also sideboards, commodes and chests of drawers in somewhat provincialized renderings of the current neo-classical styles. Some superiority was implied by furniture-makers in the late '30s who advertised that their mahogany came direct from New York.

The same styles were interpreted as well in the less expensive and more readily available home-grown cherry, maple, birch and walnut. Cabinet pieces were still largely custom made, clients still dealing directly with the maker. Chair-making, however, had become something of a specialty trade.

Furniture-makers in smaller communities made and stocked anything in demand; however, in larger towns the chairmaker was often a distinctly separate tradesman from the cabinet-maker, and unlike the cabinetmaker, he did little custom work. Even in 1802, a York chairmaker's advertisement made it clear that finished chairs were kept in stock for sale.

Chairmakers produced in great quantities Windsor chairs of some obvious Sheraton influence, the kind that period writers sometimes called "painted Canadian chairs" and which present-day collectors call arrowback and rodback chairs. Paints, which had been offered in good supply and variety by major merchants since 1800, were used increasingly in this period to finish and ornament cheaper furniture, including stencilled decorations and grained patterns.

Common chairs in particular were gaily painted, the

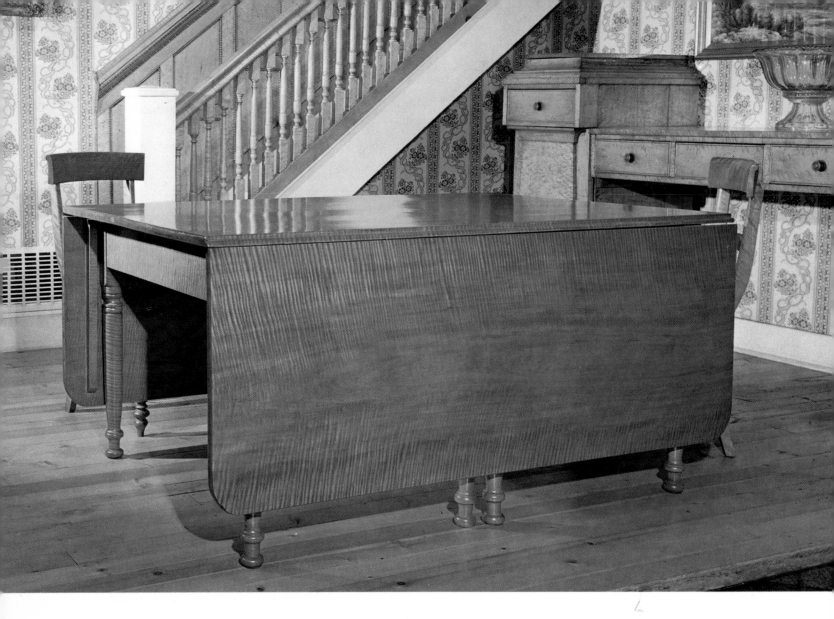

Large gate-leg dining table with turned legs, of curly maple, with extremely wide planks forming the top and leaves, central Ontario, c. 1840. CANADIANA, ROYAL ONTARIO MUSEUM

modified Windsors as well as the rush- and cane-seated "fancy chairs" which combine Sheraton and Empire style features. These two extremely popular and inexpensive types of chairs were among the earliest products to be made here by what later came to be called mass-production methods.

Although small shop craft production survived for many years, it was not long after 1840 that the first steam-powered furniture factories in Ontario were advertised in trade directories. Along with the real beginning of the factory period of furniture-making came the debased and final phase of the neo-classic style. It was pioneered by New York's leading supplier of fashionable furniture in the 1830s, and in 1840 it was codified in a book published by a Baltimore architect named John Hall.

The entire style was based on heavy S- and C-scrolls, usually as support features, which were ideally suited to fast and easy production by steam-powered band saws. In city shops, it was produced almost exclusively in mahogany veneer. In country shops, it appeared in all the domestic woods.

Whatever its esthetic merits in retrospect, the style was immensely popular throughout North America, and Ontario furniture-makers, with or without the aid of high-speed machinery, adopted it with great enthusiasm.

Thanks, however, to that conservatism we have mentioned earlier, furniture in "better" earlier styles was still made in some shops. New styles had been introduced in such numbers and with such frequency that work of considerable variety in character was being produced at the same time. It was inevitable under such conditions that hybrid pieces appeared—chairs with legs contributed by one school of design, superstructure by another. Even in Britain, George Smith wrote in 1826 in his *Cabinet Maker and Upholsterer's Guide* that contemporary chair designs showed that all the different styles in vogue had been mixed together.

The French antique revival that restored rococo principles to favor in a heavy version of the old Louis XV style was probably first seen here in the 1840s but it became the complete favorite in the next decade. The balloon-back chair with cabriole legs and the much carved and cushioned lady's and gentleman's chairs were generally stout and comfortable; they impressed mid-19th-century citizens as extremely elegant and they remained in great favor for fifty years and more.

Associated largely with that new rococo period came a revival of shaped marble slab tops for parlor tables and bedroom furniture. The first of the advertisements offering locally made

tables with tops of imported marble appeared in the late '40s.

Cottage furniture of a type introduced by manufacturers in the United States appeared in the '50s. It was made in sets, was painted and frequently decorated with stencil work, and it was cheap. The Jenny Lind bed, more recently called a spool bed, often came as part of a cottage bedroom set. It was supplied too, sometimes in walnut or cherry, more often in cheaper woods with a dark varnish finish and, judging by the numbers that survive today, it became one of the great mass production success stories of the 19th century.

Custom furniture-making declined as the merchant became a furniture dealer. The cabinetmaker became more often a wholesale supplier and his advertisements indicated that finished stock, ready for immediate sale, was kept always on hand.

So much for basic style development and the progress of furniture-making for fashion-conscious citizens of old Ontario. Although the little city of Toronto was remarked upon by visitors as a progressive and modern capital whose tradesmen stocked the latest and most modish merchandise almost as soon as their counterparts in London, the colony as a whole was still a rural community. In the larger area, the winds of fashion were not felt so strongly. In some parts, in fact, the winds seemed not to reach at all.

The still growing body of documentary evidence, together with the actual surviving furniture to be inspected in public and private collections, makes it clear that there were Ontario craftsmen who made furniture throughout the 19th century without much concern as to its correctness according to the day's fashions. French Empire styling, sometimes confounded with French Restoration flavor but always rendered according to the interpretations of cabinet shops in the United States, remained a factor in local production well into the latter half of the century. Examples that can be dated suggest the possibility of a minor revival of Regency chair design about 1880.

Specialists and all-purpose furniture-makers pursued their trades simultaneously and sometimes in close proximity. The small town cabinetmaker—and with his fellows he probably outnumbered the city type—was usually prepared to accept any job for which he had the required tools and materials. He provided a picture framing service. He was joiner and carver on occasion. He repaired anything made of wood. If equipped with a lathe he often did custom turning work, often supplying such things as table legs for other cabinetmakers. He also made and repaired spinning wheels. He may have done interior house finishing and he no doubt supplied doors and sashes for house builders. As mentioned frequently in period literature, he may one day have been carpenter and house framer and another day the cabinet craftsman called upon to furnish the same house.

And well before the middle of the 19th century, there was scarcely a village in the province but which had one, and frequently several, such furniture-makers at work.

For the most part his tools differed very little from those used by carpenters and joiners today. Frame saws and a smaller version called a turning saw, each of them resembling somewhat the later bucksaw, were indispensable in any woodworking shop.

Every cabinetmaker also had a set of molding planes, each with a differently shaped blade to cut a particular molding profile. Otherwise the tools looked much like those on today's work bench. Even the turner's lathe was basically the same, although the operator provided his own motive power with a treadle like that on the old-fashioned sewing machine.

The woods used have been largely mentioned in the foregoing text—local cherry and black walnut were recognized from the beginning as excellent cabinet woods and the figured maple, in its curled and bird's-eye forms, was especially prized. The striking grain of the curled maple was remarked upon by book-writing visitors to Upper Canada even before 1800.

Maple with straight grain was a favorite in both cabinet and chair work, as was birch. The latter was used in great quantities to supply the hardwood components of common chairs. Birch served well also as a cabinet wood because it could be easily stained to serve as a substitute for the darker exotic cabinet woods. Butternut was recommended in an emigrants' guide in 1830; although much lighter in color than its black walnut cousin, it served when stained as an excellent stand-in. Hickory and ash were much used in making common chairs, particularly for curved parts such as the bowed back of a Windsor chair.

The use of the better indigenous woods varied through old Ontario according to the immediate local supply. Black walnut grew in great quantity in western Ontario but was not common east of or north of Toronto. This did not mean that walnut was not used in eastern Ontario but rather that it was reserved entirely for the better grades of furniture. To the southwest, however, because it was in great supply locally, walnut was used for the most common and humble of pieces as well as for parlor-grade furniture.

The use of cherry was much the same. The great hardwood forests of southwestern Ontario provided the richest supply of black cherry lumber and so cherry went into the making of ordinary cupboards and chests in that area. In eastern Ontario, local white pine was the standard basic material for common furniture. Northward from Lake Ontario and the St. Lawrence, butternut took the place of black walnut because it thrives in the colder areas where the latter does not.

Such distinctions did not so much affect the choice of woods for better furniture, but among common furniture the woods employed may offer the first clues to suggest its possible origin.

One special interest pursued by present-day collectors has already been mentioned in this text—the provincially modified work relative to more formal fashions in furniture design. The derivative styles of the colonial cabinetmakers offer local flavor of some distinction as well as home-grown material and workmanship.

The other collecting specialty of considerable appeal to many is concentration on that furniture peculiar to one or more regions within the province. The varying national and cultural backgrounds of 18th- and 19th-century settlers were responsible for the establishment here of important communities where different traditional designs and decorative techniques prevailed. Immigrant groups were inclined to settle among their own kind, and the slow development of transport and communications reinforced their cultural insularity and helped to preserve for many years some purely local styles.

French traditions are met at each end of yesterday's Ontario, along the Detroit River where French-speaking farmers pioneered in the 18th century, and along the Ottawa

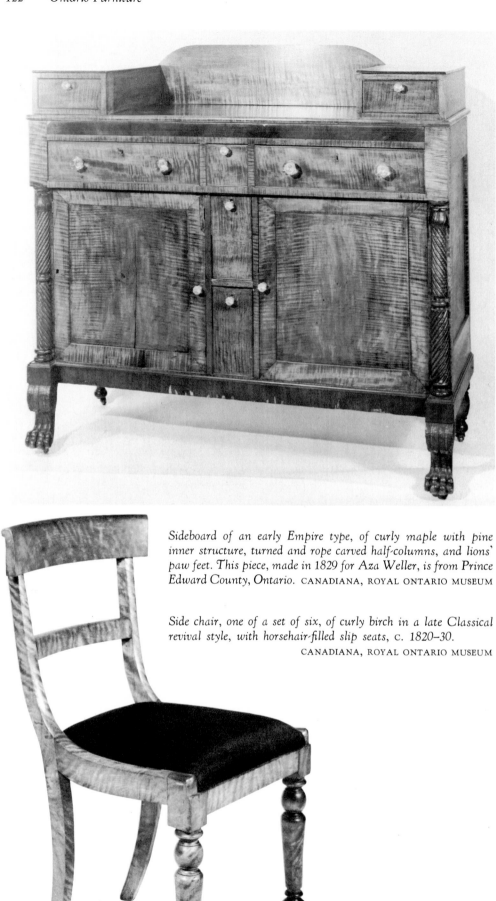

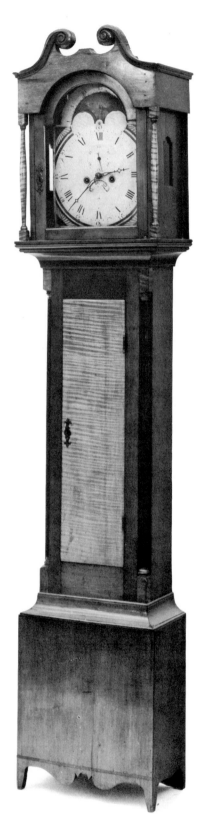

Sideboard of an early Empire type, of curly maple with pine inner structure, turned and rope carved half-columns, and lions' paw feet. This piece, made in 1829 for Aza Weller, is from Prince Edward County, Ontario. CANADIANA, ROYAL ONTARIO MUSEUM

Side chair, one of a set of six, of curly birch in a late Classical revival style, with horsehair-filled slip seats, c. 1820–30.
CANADIANA, ROYAL ONTARIO MUSEUM

Tall clock, with a case of cherry, and curly maple door, and upper case and turned pillars. The clock from the Brantford area, c. 1840, has a face and works from an earlier clock.
CANADIANA, ROYAL ONTARIO MUSEUM

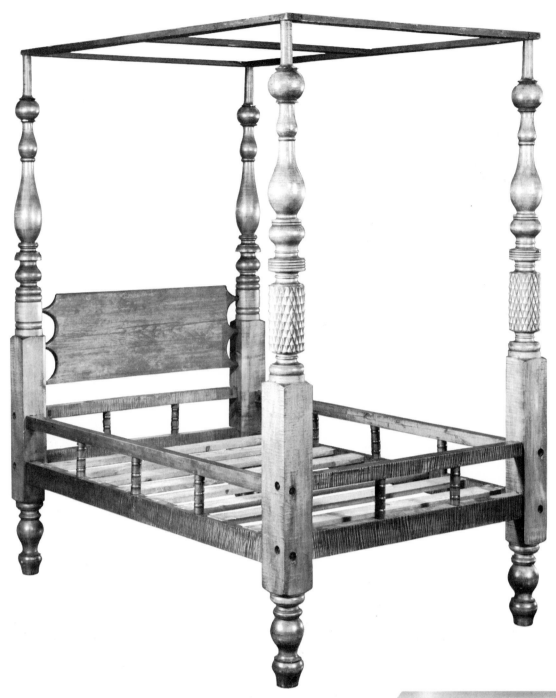

Canopy bed of curly maple with pine headboard. The turned posts are bolted to the double side and end rails, and the foot end posts are pineapple-carved. This bed, perhaps for a child since it is shorter than usual, is from the upper Ottawa Valley, dating c. 1840. CANADIANA, ROYAL ONTARIO MUSEUM

Platform-base card table with hinged top, of curly maple and maple veneer over pine, and cherry top, carved feet, and inlays. This table, in a late Empire manner, dates c. 1845–55. CANADIANA, ROYAL ONTARIO MUSEUM

Early Empire chest of drawers, with birch case and turned 3/4 columns, and bird's-eye maple drawer fronts outlined with walnut veneered bands in a rather incongruous style—none on the upper drawers, a wide band on the upper main drawer, and thinner bands on the lower two drawers. This chest is from western Ontario, c. 1830–40. CANADIANA, ROYAL ONTARIO MUSEUM

Round hinged-top table in a most unusual form, with concave triangular pedestal and platform base. The top, pillar panels, and feet are of cherry, while the top apron, pillar corners, and base sides are bird's-eye maple veneer over pine. The table is from central Ontario, and dates from c. 1840–50.

CANADIANA, ROYAL ONTARIO MUSEUM

Empire sofa, of curly maple upholstered in red velvet, with carved arm facings, end blocks, skirt, and legs, and a shell-carved crest. This piece is from the Toronto area, c. 1830–40.

CANADIANA, ROYAL ONTARIO MUSEUM

Valley and in Glengarry County, which for many years have enjoyed some cultural influence from next-door Quebec. Simple habitant chairs were evidently sold in great numbers through eastern Ontario, and that chairmaker and dealer who advertised in York in 1802 appears also to have ordered common chairs from Quebec for resale in the Upper Canada capital.

There is a fascinating incidence of "country Sheraton" style chairs in several parts of Ontario. The chairs are very much simplified in design and most frequently have only a flat board seat, but the debt to the Sheraton design school is unmistakable. Chairs of similar line were made in England and Scotland in the early 19th century but in Ontario the greater numbers found have originated in counties first settled by Scots. Glengarry is one but Lanark is the county where they have appeared in greatest numbers. In these areas and in Prince Edward County, where other chairs have been found in recent years, birch has been the wood most often used. The Royal Ontario Museum has a couple of this genre found in York County. Chairs of the same style appear from time to time in western Ontario, usually in cherry, but they are seldom as well designed as those from the eastern part of the province.

Middle western Ontario seems to have produced a significant amount of furniture in the mid-19th century in countrified designs of twenty to thirty years earlier. These pieces appear invariably in black walnut. Their usually stout character implies that they are virtually unbreakable, and they suggest nothing so much as a kind of furniture designed for prosperous farmers who have retired and moved to town. Mrs. Anna Jameson, after a visit to St. Thomas, wrote in 1839 of the fine furniture made there of black walnut, and she offered the judgment that its wood is more beautiful in color and grain than the finest mahogany. Coming from a lady who found a minimum of pleasure in this raw land, this was praise indeed for a local material and craft.

A couple of pieces of furniture have appeared which, while by no means exclusive to the Ontario experience, were

Washstand in a Gothic revival manner, of oak with color-contrasting walnut carved and applied appurtenances, and drawer and door-panel inlays of walnut, cherry, and maple. This is one piece of a set of three, including also a bed and a chest of drawers, made by A. T. Davison of Lucknow, Ontario, about 1865 for Sir John A. Macdonald. Sets or "suites", in the sense of matching groups of furniture, became popular only after about 1860, and were unknown before then.

CANADIANA, ROYAL ONTARIO MUSEUM

Manufactured chairs of the late Empire period, c. 1850, these are from a set of six, with caned seats and painted grain finishes in virtually new condition. The chairs are stamped under the seat frame "Wallace & Co." of Bowmanville, Ontario, and date c. 1850.

PRIVATE COLLECTION

not always familiar in other provincial societies. The first and older is the bunk-bed, a legacy more of Scottish than of French antecedent here, although the same piece in the French tradition was well known in Quebec. It is a long settle-like seating unit, probably used most commonly in the kitchen. Its lower box-like section opens to serve when needed as an extra bed.

The other piece is the "spooley" couch or settee derived from the low-post bed. Although not unknown prior to 1850, it was manufactured in greatest numbers in the second half of the century. It shares character and quality level with the Jenny Lind bed and appears to have been a ubiquitous fixture on farmhouse verandahs in eastern Ontario.

The Niagara Peninsula has been the source of a considerable quantity of better quality furniture, made in a Georgian period manner. Fine Hepplewhite style chests of drawers in curled maple have been found a few miles back from the Niagara River. That restraint which suggests a proper understanding of the best ways to interpret the older sryles under provincial limitations appears to have been a trademark of some Niagara area cabinet men. And some of the more effective and earlier of the decorative inlay work found in Ontario has been traced back to that area.

Even more distinctive in the Niagara Peninsula is a school of Georgian style cabinet work of Pennsylvania-German influence. It appears probable that several cabinetmakers among the Pennsylvania immigrants settling in Lincoln County were responsible for the preservation there of cabinet styles as much as a hundred years after they had been discarded in Pennsylvania. The case pieces are usually large—desks, chests of drawers, cupboards—and they stand usually on Chippendale ogee bracket feet, have lipped drawers, plain or reeded quarter columns at each front corner, and frequently even the lower pieces have decorative cornice moldings. Walnut, cherry and curled maple are the woods generally used.

Waterloo County is the heartland in Ontario of transplanted Pennsylvania-German people, but their traditions are met well east and west thereof. Some other districts, Markham Township in York County most particularly, were pioneer homes for groups arrived more or less direct from Germany.

In these communities the peasant arts and crafts of northern European origin thrived; their furniture has always been distinctive and their styles spread over much of western Ontario. Large storage chests with canted sides and domed tops were brought to Ontario by old world German immigrants. Some of the same type were no doubt made here, but the already indigenous box with right-angled corners soon became the norm for local make. Many of the finest blanket chests with beautiful bracketed feet have originated in Waterloo County and certainly the most charming and most gaily colorful of peasant style painted decoration is credited to that county.

The Pennsylvania-German tradition has been dramatically expressed here in decorative painting and low-relief carving in traditional patterns—geometric forms like hex signs, the always familiar heart, and their very own bird called a *distelfink*.

Most case pieces are extra large and cupboards are frequently huge. Corner cupboards of massive scale, incorporating 18th-century broken arch pediments and Georgian glazing patterns, were still being made by Waterloo craftsmen about 1860. Some chests of drawers were as much as six feet high and wardrobes were so huge that they were usually designed and built in sections to facilitate their moving.

The old Chippendale style ogee bracket foot was much used in this kind of cabinet work; it can be seen on furniture throughout western Ontario and, although modified and debased, it was still in use well after 1850. Walnut and cherry were the favorite cabinet woods, but a great deal of white pine was also used, invariably being given a plain paint or painted-and-grained finish. Sometimes that grained surface turned out a most convincing mahogany or figured maple, but the decorators often produced non-objective treatments that suggest exotic woods that the rest of us just don't yet recognize.

Gothic revival side table, with the contrasting woods, angular design, and appliqués and finials typical of that design fashion. This table, of bird's-eye maple, with walnut base center and appliqués, was made and marked by "David Dougal, cabinet-maker, Barrie [C.W.]" about 1860–65.

CANADIANA, ROYAL ONTARIO MUSEUM

Ontario-German Decorative Arts

A. Lynn McMurray

During the American Revolutionary War and for at least a hundred years afterwards, waves of Germanic peoples emigrated to Ontario. Some were United Empire Loyalists; some came later from Germany. Today these people are known for their skills and traditions in the decoration of furniture and other utilitarian objects of the home.

Certainly it is unlikely that the earliest groups crossing the Canadian frontier during the last quarter of the 18th century would have brought many worldly possessions with them, least of all furniture.

> In 1776, there arrived at Fort George, in a starving state, Mrs. Nellis, Mrs. Secord, Mrs. Young, Mrs. Buck, and Mrs. Bonnar, with thirty-one children, whom the circumstances of the rebellion had driven away.

This is the first record of persons reaching Upper Canada after the outbreak of the Revolution. From this and other sources it can be established that the Secords were of French Huguenot descent (de Secour); the Nellises (or Nelleses) were also French; Bonnar is most probably an anglicized form of Bonheur; Young for Jung; whereas Buck is definitely German. The men of this Loyalist group had fled their property in New York State earlier in the struggle, due to their views warmly supporting the King's cause, and made their way as best they could to Kingston and Niagara, often by way of New Brunswick. The homeless women and children, following at a later date, endured frightful hardships in the wilderness and in an "almost naked and starving" condition arrived at the fort with the aid of Indian guides.

Recently, a small dome-topped abstract-painted box from the Niagara Peninsula was offered for sale in Toronto. It has a history of continuous ownership by the Secord family since the War of 1812, and although it probably does not date back beyond that year, its surfacing does point out that immigrant pieces can still be uncovered by the serious collector. Indeed, this outstanding box may have been made in the peninsula, and I mention it here simply to tie it in with the Secord family. The

variety of colors: yellow, cinnamon, and deep red-brown, provide a visual excitement in a utility piece. It is a good example of a box being given collectability by the decorative enrichment of what would otherwise be a plain pine surface—an early characteristic of country furnishings in Pennsylvania and New York State, and later in the Germanic settlements of Niagara, Detroit, Bay of Quinte, and Waterloo County.

It is difficult to find and properly document pieces of furniture and smaller household items that might have been brought into Ontario by groups of Germanic peoples emigrating from Pennsylvania. However, following the War of 1812, migrations from south of the border slackened considerably, while there were many immigrants from the British Isles and the Continent. A few immigrant chests can be traced with some degree of accuracy to these later arrivals, and their study gives clues to the European roots of the decorative arts associated with Ontario-German settlements. Similarly, Pennsylvania-German chests, through their decoration, communicate an earlier European history.

In 1968 an antique dealer in Waterloo County was able to find, after much door-to-door work, a small painted immigrant chest of European origin, signed and dated on the lower front panel, "Andreas Fleishhauer von Lehrbach, Anno 1838." In its as-found condition the chest was covered with chintz and linoleum which, when carefully removed, had preserved the original painted designs underneath. Immigration into this county was most important during the 1820s and in about 1825 a mass migration began from Germany which extended as far as Upper Canada and lasted for some twenty-five years. The Fleishhauer chest was probably part of that migration. The decoration is typically European, although it does have some of the characteristics of the decorated Mahantango Valley furniture of central Pennsylvania. There, early in the 19th century, an unknown decorator, or possibly the furniture-maker himself, painted not only a date and the owner's name on his chests but also a simple vase of flowers. The surviving examples of furniture from the Mahantango Valley seem to be

Farmhouse and out-building compound; the house is American late Federal in style, of brick, and with a full front verandah or porch. This house, just south of Conestogo, Ontario, is typical of Pennsylvania-German immigrant architecture of the earlier period, and was built c. 1820. Very similar houses are common in southern Pennsylvania, and northern Maryland, Delaware, and West Virginia.

part of the last flowering of decorated furniture in Pennsylvania. The immigrant chest from Waterloo County is not only signed and dated but also is decorated on two of its three front panels with flowers in a vase. It is not to be suggested that it may have Mahantango Valley origins, but rather that the two regions have a common European ancestry as revealed in their decorative arts.

The decorations found on chests made in Waterloo County differ considerably from their European and Pennsylvanian counterparts. Finger painting and feathering were quite common, usually over a red-brown base. The contrasting color frequently was black. A known Ontario-German chest, small in size, with this combination of colors and brush strokes, has ten inset panels across the front and four on each end. The black wispy lines over the red base give this simple utilitarian piece of furniture a country charm all its own. Larger dower or marriage chests were also made by the Mennonites; one,

having two drawers below the box portion, is raised on a simple, though lofty, bracket base. Dovetailed construction in pine is typical, and the use of single boards from top to bottom is not uncommon. Painting is often more colorful on these heavier pieces: brilliant reds finely worked over a faint yellow or cream base, lightening the feel and enhancing the beauty of the chest—a color combination not unlike that of the fall pomegranate. Nature must have inspired them.

The use of color and decoration in the home provides a rather dramatic contrast to the plain outward appearance of many Germanic groups in Ontario. The Mennonites, for example, have retained their dress with its broad-brimmed black hats, clothes of sombre hue, and, at least in the old order, use hooks and eyes instead of buttons for the fastening of their garments. The men of the community wear their hair long, shave the upper lip, and have long beards. A suggested explanation for the adoption of this manner of dress lies in their loathing

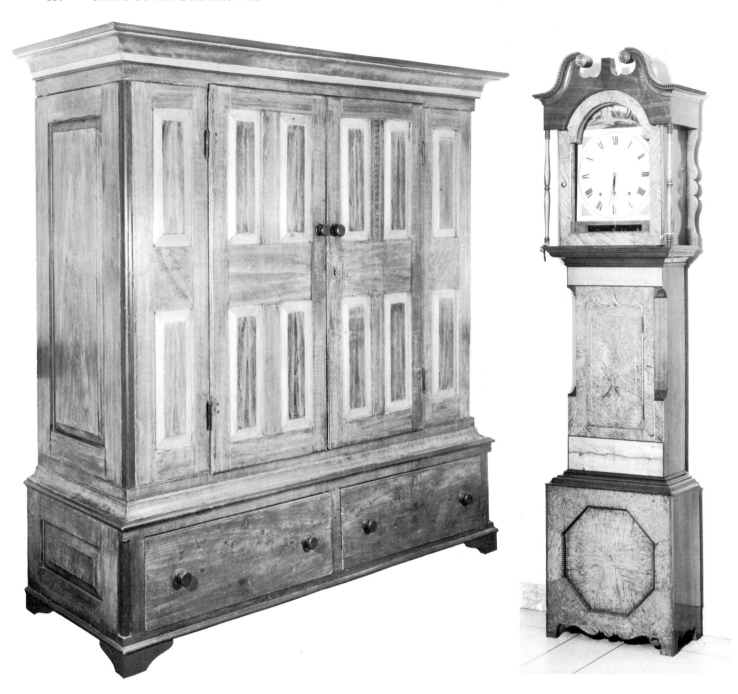

Ontario-German schrank or cupboard of pine with painted grain finish, plus yellow and green painted outlining on the panel bevels and corner columns. This schrank, from Waterloo County, Ontario, c. 1800–20, was built to be easily dismounted, with the base and the cornice molding the only solid units. These hold the vertical panel and back sections in position when assembled. The paint is original. CANADIANA, ROYAL ONTARIO MUSEUM

Tall clock, with case sides and bonnet top of cherry, and varied maple, bird's-eye maple, and walnut veneering over pine on the front. This most unusual clock is from Markham, Ontario, and was probably made by a German immigrant cabinetmaker, c. 1850–60. CANADIANA, ROYAL ONTARIO MUSEUM

of war. The costume is a direct opposite to that of the European soldier of an earlier period, whose closely cropped hair, clean-shaven chin, mustache, colorful many-buttoned coat, and smart hat stood for everything that appeared to them wrong with the world, a world from which they sought to withdraw. Perhaps, and only perhaps, the love for natural color and the tradition and flair for design and decoration was an attempt by the Germans from Pennsylvania, and later by related ethnic groups

in Ontario, to put something back, as it were, into their world that truly reflected their love for life and for nature.

Painting as a form of decoration was not confined to the smaller, less formal items of furniture in the Germanic communities. Nor was the brush and color the only art form employed by these "Plain Folk." Carving, inlay, and an interpretive design on the line of a piece of furniture often were clear expressions of decorative skill.

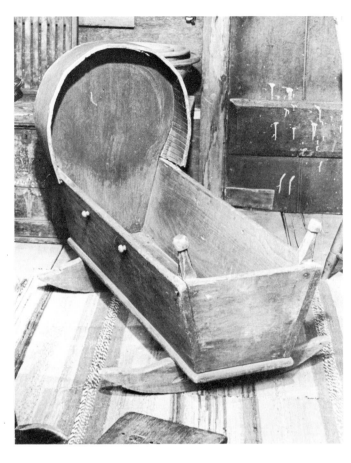

Painted pine rocker cradle with scroll-cut sides and heart cut-outs in the end panels. This was also a popular motif in Pennsylvania children's furniture. This cradle is from southwestern Ontario, c. 1830. PRIVATE COLLECTION

Tall chest of drawers of pine, grain painted to simulate bird's-eye maple, and with flared front feet and a fluted frieze below the cornice. From Waterloo County, c. 1820, this chest is one of several known examples. CANADIANA, ROYAL ONTARIO MUSEUM

Hooded rocker cradle of pine planks, and painted with red stain, from Waterloo County, c. 1820–40. DOON PIONEER MUSEUM

The carving on the two upper raised panels of a multi-paneled, *Kas*-like wardrobe from a house in Maryhill (New Germany prior to the end of World War II), takes the naive form of a bishop's miter, clearly a local interpretation of a remembered European tradition or style, and is probably associated with a later group of immigrants into Waterloo County from the German-speaking Alsace-Lorraine area of France.

Erbsville is another small Germanic community in southwestern Ontario. In the late 1960s, one of the finest examples of inlay work to be found in the region was uncovered there at public auction. Over-painted with many coats of white enamel, the only distinguishing features of this small worktable were the two drawers side-by-side beneath the cracked and damaged top, and its unusual compact size. Parts of the surface stood out in raised relief, and when the caked paint was carefully scraped away, hearts, geometric designs, and other symbolic features appeared in various thick inlay woods of black-ash burl, bird's-eye maple, and apple. The inlay is chunky and not of the fine veneer type, but rather of a process known as *intarsia*, where solid blocks of wood are used in the design, causing the protrusions above the normal surface. From this sale emerged a Canadian folk rarity, and one of the finest pieces of folk-art furniture ever to have been made either in Canada or the United States. The table dates from the early 19th century and is either of Swiss or German ethnic origin. The symbolic inlays suggest that the piece may well have been a betrothal table, a

Fraktur frontispieces, left and right, from the Benjamin Eby Bible, dated 1823. Fraktur illustration was a specialized art form derivative of European medieval manuscript illumination. Fraktur illustrating was widely practiced in Pennsylvania, and some dozens of 19th-century Ontario Frakturs are known.

KITCHENER PUBLIC LIBRARY

gift made by the father of a bride to mark her impending marriage, and thus followed an old and traditional Palatinate custom.

To find in Waterloo County a small lamp table in pine and maple, retaining much of its original red-orange color, pegged and glue-blocked throughout, is rare indeed. But to find such a table with these qualities and, in addition, exhibiting a socked, heavy, Dutch clubfoot is even more of an event. And yet when this unique Ontario table was offered for sale, it was bought by a Pennsylvania dealer and taken to the United States market, at that time perhaps more aware and knowledgeable of country furniture with a Queen Anne influence. Fortunately, a determined and thorough Ontario collector tracked the piece down, bought it, and by so doing returned it to this country. Many great pieces of furniture, though, must have been lost to collectors in Canada in this manner, but that trend has been changing. Like the betrothal table and the miters carved on the wardrobe panels, the style influence in this table is directly Continental-German rather than Pennsylvania-German as one might expect.

Does it not seem unusual that a betrothal table with such outstanding decoration and family tradition should be over-painted several times, perhaps by later generations descended from the original builder, and ultimately relegated to the fields and the auctioneer's hammer? Somewhere in time its intended function must have been lost and it became just another piece of furniture. Its history in the family was forgotten. It is true that the Pennsylvania Germans were some of the earliest settlers in Ontario, but they were not the only Germans to immigrate. Others came from New York, New Jersey, Maryland, the Carolinas, and Vermont; many came direct from Europe. Collectively they were often referred to simply as early settlers or United Empire Loyalists, terms usually associated with the English, Irish, and Scottish peoples of Canada. Intermarriage was common. Old ties and identities were lost as nationalities mixed and new religious views replaced old-country traditions. Ethnic roots were forgotten, and the new owners of the table simply could not remember the significance of the hearts and other symbols from the past. A woman who had the table in her house for more than fifty years remembers

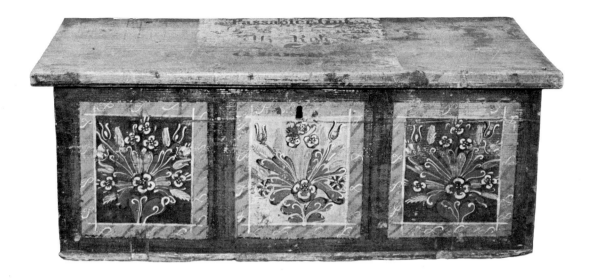

Painted immigrant chest of pine, German rather than Pennsylvanian in origin, with the front decorated to appear as three panels, though it is in fact a single plank. PRIVATE COLLECTION

Immigrant chest, probably from Pennsylvania, with painted flowers in vases on the front panels and simple spotting in black on the ends. Though this piece was made as a storage chest, possibly c. 1820–30, it was later strengthened as a shipping chest with the addition of iron bands and rope handles.
▽ DOON PIONEER MUSEUM

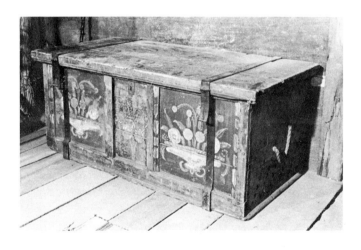

Dome-topped storage box, painted in yellow, cinnamon, and red-brown over pine, with motifs as well as graining. This box, found in the Niagara Peninsula, may have originated in Pennsylvania, c. 1810; it had descended in the Secord family since the War of 1812. PRIVATE COLLECTION
▽

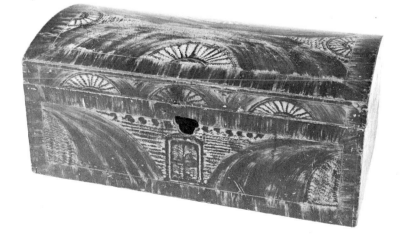

it over-painted in white. She had no idea of what lay underneath. To her it was heavy to move and nothing more.

Decorated furniture made in Ontario and related by style to that of an earlier period in Pennsylvania is rare. Hardwood pieces from the 18th century are not generally associated with applied color or embellishments. The native woods bespoke the natural beauty of the piece. The style gave it a date. Accordingly, a *schrank* or wardrobe from the Baden area in western Ontario displays all the refined features of Pennsylvania-inspired furniture. The wood is cherry; the size massive, recalling the *Kas* used by the Dutch in their Hudson River settlements. An early style ogee bracket base gives the piece loft and apparent lightness in spite of its size, the work of a skilled craftsman. Narrow bands of patterned maple inlay and hand-forged rat-tail hinges relieve the angular appearance of the wardrobe and may be taken as a form of decoration. Other items of furniture attributed to the same area, and possibly the same maker because of design and direct American inspiration, include two high-daddy chests of drawers and three chests of smaller size. Similar furniture of late 18th-century classical design has been found in the Niagara Peninsula and could very well have been made there. For although based on a Pennsylvania form, there have simply been too many walnut high chests of drawers, linen cupboards, and low chests of drawers found in the peninsula for them all to have been brought from other areas.

Although the style and design of the furniture found in the Germanic settlements of southern Ontario can be related, at least in part, to the earlier periods in Pennsylvania, the painted decoration is not nearly as elaborate as that of 18th-century Berks and Lancaster Counties. Comparisons can be made, however, in the choice and use of color.

Waterloo County has yielded many decorated wardrobes, somewhat later in period, though similar in style to the *schrank* previously described from the Baden area. Grained finishes were common. A piece dating from 1830 to 1850 and presently displayed in the Royal Ontario Museum in Toronto has a yellow-brown feathered tone as its basic color. The raised panels are framed in a subdued tone of yellow with no feathering, and the quarter columns have been restored to their original green. In comparison, a painted wardrobe of Ontario-German origin turned up several years ago at a small shop in Sheffield, near Galt. It had been sold by the same dealer some years before to a major collector of Waterloo County furniture and when the

Side table, possibly made as a bridal gift, with bird's-eye maple legs and frame, and cherry top. The thick heart, geometric motifs, and top band inlays are of black-ash, apple, and bird's-eye maple. This very unusual table, from Erbsville, Ontario, dates c. 1830.
PRIVATE COLLECTION

Footstool of pine, with heart, swastika, and six-pointed star in circle motifs carved in the top. The stool is painted a soft red, with the skirt and end boards outlined in blue. This piece is from the Saint John River Valley of New Brunswick which, like southwestern Nova Scotia, had a German-American Loyalist community.
PRIVATE COLLECTION

opportunity arose, he bought it back. With two doors above and four drawers below (two over two), it was a massive piece. The door panels were raised; the drawer pulls were wooden pegs. The colors here were red and black, with the red as the background color and black feathering on top. Yellow was used to accent the panels and the drawers. The end boards proved the high point of its decoration: an elongated tulip or lily, crudely done in black on the red ground and running the full length of the upper section—an outstanding example of folk art.

Two painted chests of drawers, both made in Ontario and both attributed to German craftsmen of Pennsylvanian ancestry, bear mentioning here when dealing with the use of color to simulate native woods. The first, a high chest of six feet, was found in Waterloo County and dates between 1810 and 1830. The shaped base, brass pulls, and escutcheons suggest a country Hepplewhite style. The wood is pine throughout. Brown and yellow colors have been combined by the maker with a daubing and graining technique to simulate bird's-eye maple. With time, however, the colors have darkened considerably. The second turned up in an antique shop in Hamilton. Niagara Peninsula in origin, it dates from about 1850 to 1860, and may possibly be attributed to John Grobb or to a member of the Fry family. The style has a definite Pennsylvania-German background. Mahogany seems to be the wood that the painter intended for the case portion of the chest, although the color is light and resembles old cherry. The drawer fronts are painted and grained in a brilliant yellow to simulate a curly or tiger maple and are bordered with a crotch mahogany design, almost suggesting a veneer inlay. Dark green is the accent color used on the feet, edges of each drawer, and the mid-19th-century gallery, typical on a number of pieces from the Niagara area. The end result is a fine example of rural Ontario folk furniture.

The old-order Mennonites can still be found, although in decreasing numbers, west of Elmira. Often the houses have no electricity, no telephone, and few conveniences that most people would consider essential today. In 1972, a corner cupboard with a style and color definitely related to Pennsylvania was bought from a family in this area. It had been over-painted, probably during the last quarter of the 19th century, in an ochre color and with Victorian graining. The paint and varnish were carefully removed to the old red, which was much more like a paint than a stain on this piece. But red was not the only color uncovered. The raised panels on the two lower doors were faced in yellow as were the reeded columns on either side of the cupboard case. A blue-green color was found on the upper parts of the cornice and as accent to the yellow on the side columns. The interior had also been painted in the blue-green, and the overall effect of color and style is, to say the least, quite dramatic. Excellent cupboards of similar style have been credited to Waterloo County but seldom, if ever before, with this combination of yellow, red, and blue paints. It is more usual to find black brush strokes over the red, and drawer facings painted to resemble tiger maple or bird's-eye maple graining. In fact, I have recently seen an excellent corner cupboard in absolutely mint condition with this type of painted decoration. It was unknown in the county and simply turned up at a Saturday farm auction. One or two very early Pennsylvania-German pieces came out of the same sale, including an 18th-century wool winder with sausage-like turnings to the

Fraktur birth and baptismal certificate, or taufschein, of "Barbara Risser, the daughter of Johannes Risser and Anna Gross . . . born in Markham Township, Province of Upper Canada, on January 22nd, 1818." This taufschein was drawn in the 1830s, though the Mennonite confirmation section is left blank. Many Fraktur found are difficult to attribute as to Upper Canada or Pennsylvania origin, but this example is undoubtedly Canadian.
PRIVATE COLLECTION

Fraktur book-plate from a manuscript music book belonging to Magdalena Meyer and dated 1804. This Fraktur includes a full-length figure, two birds, and elaborately drafted flowers. The family of Jacob Meyer came to the Niagara Peninsula from Hilltown, Pennsylvania in 1799. JORDAN MUSEUM

main post and a shaped wooden cup to hold the ball. The last I saw of the cupboard was in a shop not far from the house where it was found. It looked splendid with a complete set of spatter-ware plates in colors of red, blue, black, and brown in the glazed upper section with its gothic arch to the doors. I thought the plates to be an excellent complement to the cupboard in that they had a record of ownership in the Reist family of Elmira, a Mennonite family, and were probably bought in a local store for just such a placing. They are unmarked and were usually imported from England or Scotland for the Canadian market.

Hanging corner cupboards, too, are typical of German communities in Pennsylvania and Ontario, but are rare when compared with the standing cupboards, especially if decorated with a shaping in the side boards below the cupboard, and supporting a small shelf in the same position. The wide cornice molding shows a directly American influence in these small cupboards. Evidently used to store and display fine dishes,

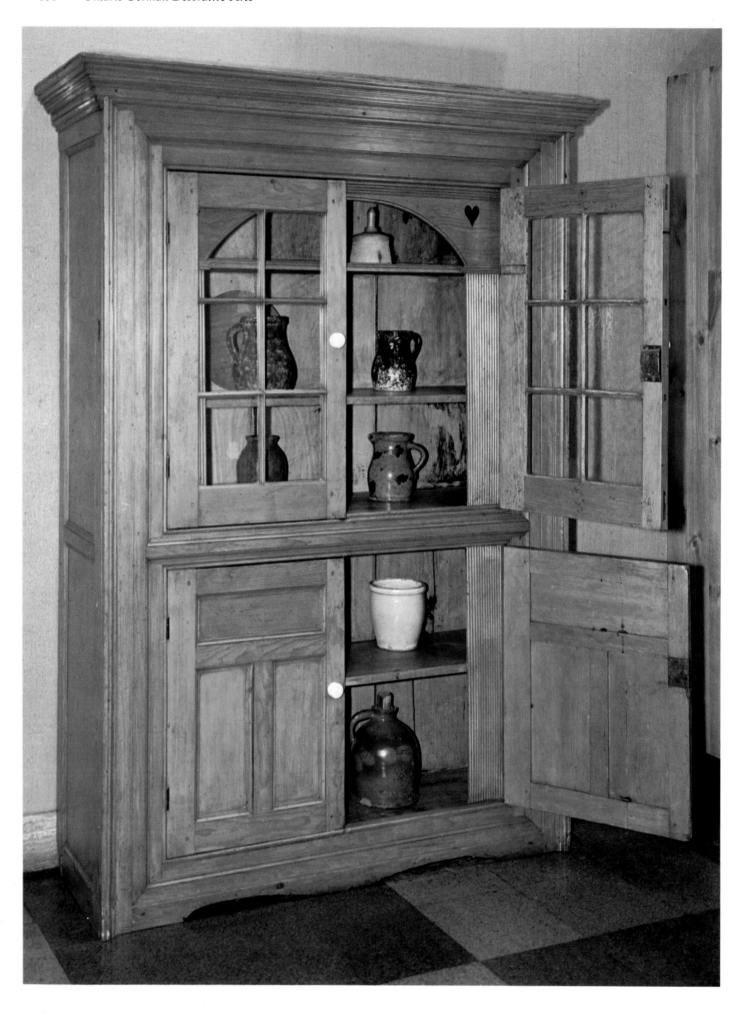

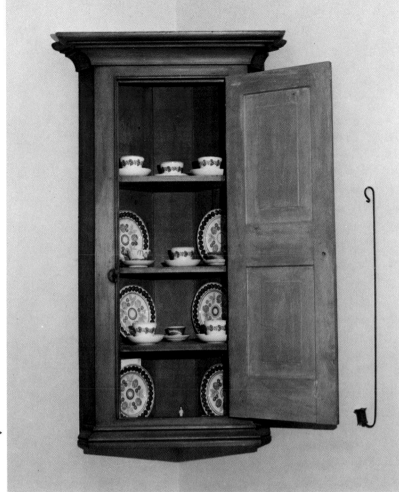

<Two-tiered cupboard of pine, with paneled lower doors and sides, and glazed upper doors. The inner section has an arched top, reeded side panels, and heart cut-outs in each upper corner. This piece, from the Markham, Ontario, area, dates c. 1830, and was probably originally painted.

CANADIANA, ROYAL ONTARIO MUSEUM

Hanging corner cupboard with paneled door and a heavy cornice,▷ pine, painted in original blue, from Waterloo County, c. 1840–50. Hanging corner cupboards are scarce, but occasionally are found with doors made from single wide boards, carved and grooved to simulate paneling. PRIVATE COLLECTION

plates, cups and saucers for special occasions, they were usually painted in unusual colors of soft green, greenish-blue, and gray. Known hanging cupboards of this type in Waterloo County date from 1840 to 1860 and the highest quality is to be found in those of small size.

The painting or stencilling of names on furniture is yet another form in the European tradition of decoration. A lamp table from Wellesley, Ontario, bears the name of its owner in stencil on the raised drawer front and, accordingly, has become known as the Virginia Shulz table. The paint under later varnish is red-brown with black brush and sponge markings for contrast. The stencil is in a subdued gold color and is raised above the surface. A brass mushroom-type pull and escutcheon on the drawer appear to be original, and combined with the stencil and painted decoration make it a very important piece of documented Waterloo County furniture. Similarly, a foot-stool from a dispersed collection of Ontario-German furniture, painted dark green under a later coat of red, has the name Mary Shuh in gold stencil across the shaped skirt. The green and gold make an effective combination on pine.

The decorative symbols used by the German peoples in Pennsylvania were handed down through tradition and custom. In time they became stylized. Flowers, especially the tulip and lily, six-pointed stars, the true swastika and cross, unicorns, peacocks, and fish all lost much of their original, often religious, meaning and in turn became nothing more than conventional motifs. The colors used were always vibrant and frequently the

designs were lightly scribed onto the bare wood surface before the painter began his work. Although this type of folk art is well documented in the U.S., similar work can seldom be found in Canada.

New Brunswick and other Maritime Provinces, because of their proximity, were the destinations of migrating groups of Germanic peoples from the New England states and New Jersey. The earliest Loyalists fleeing the war often had to use a route through New Brunswick to gain access to Upper Canada. The male members of the Secord family, mentioned earlier, came to Niagara by way of Kingston and New Brunswick. It is quite possible, then, that a small stool decorated in the traditional Germanic folk manner was made in the Saint John River Valley, where it was recently found. The shaped skirt and end boards are outlined in a dark, almost royal, blue. The background color is a soft red or pink. Carved into the soft pine is a large swastika flanked by two hearts and cornered by four six-pointed stars, each cut into a perfect circle. Symbols indeed! The colors here are yellow, red, and blue—and they are loud. Similarly, a desk from Markham in colors of dark green and orange displays several geometric designs inscribed and painted on the slanted top. Two small dome-topped boxes in blue and yellow from an area north of Brockville are decorated with flowers reminiscent of closed tulips painted in bold colors of red, green and yellow. All show an inspiration for decoration that probably came from the Pennsylvania-German tradition.

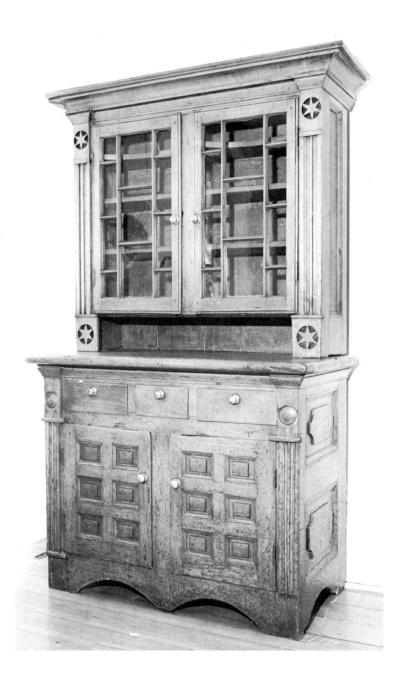

Sideboard-cupboard, with six-paneled doors, raised end panels, and six-pointed star in circle motifs carved in the corners of the upper section. This very heavy and substantial cupboard, dating c. 1830, is from the Uxbridge, Ontario area. PRIVATE COLLECTION

It is more common to find traditional Pennsylvania-German folk symbols in the form of carvings or cut-outs on furniture made in the Ontario settlements. A glazed cupboard from Waterloo County is decorated with birds, fish, coiled serpents, and what appear to be stylized tulips growing out of pots, all carved in low relief on the upper front casing and all having their special connotations. Fish, for example, were linked with baptism. This two-piece cupboard in pine dates from 1830 to 1850 and is held by the Royal Ontario Museum, Toronto. A private collector in that same city has a similar cupboard, much heavier in construction and style, with six-pointed stars carved into circles on the four corners of the upper section. It was found at a country auction not far from Uxbridge, covered in many coats of white paint of a thickness that obscured the carvings. The piece is typically American-German in its style and decoration.

The best features of an earlier Pennsylvania folk art are found in a finely dovetailed cradle from Waterloo County, c. 1830. Retaining much of its original brown paint imitating woodgrain, it had belonged to one of the branches of the Wideman family, and the wear on the vigorously scrolled side panels indicates much usage since pioneer days. Heart-shaped cut-out decoration on the headboards and footboards add to the country nature of the piece. From the same county, a red knife box, a blue-grey stool, and a decorated rocking chair, all have heart cut-outs as part of their construction. And from eastern Ontario, a pencil-post bed in maple has a heart-shaped headboard in pine. The bed dates from the early 1800s but has an 18th-century style derived possibly from Lancaster, Pennsylvania. Dark brown appears to have been the original color, a color not uncommon in some of the earliest pieces of furniture made in Ontario by the transplants from Pennsylvania. A very early child's bed, standing high off the floor and with an excellent taper to the simply turned end posts, is painted in the same soft brown. Its style, too, is early and can be dated about 1800, from Markham township. The area extending from Dundas County to the Bay of Quinte along the shore of the St. Lawrence was one of three main entry points into Upper Canada. The German settlers were led into the Markham area by William Berczy at Christmas, 1794.

Although the heart cut-out is generally associated with the German communities in Ontario, it is also found as a form of decoration in nearby English settlements. The village of Burford lies a short distance west of Brantford and was first settled by Thomas Horner in 1793. Its ethnic character is, in the main, English. Some years ago, three pieces of black-ash burl appeared at a farm auction. One was a frame with small heart cut-outs in each of the four corners. The style was Pennsylvania-German but the frame had descended in the family who owned the farm. Their background was English. The frame, now with mirrored glass, is part of the Ontario-German exhibit at the Royal Ontario Museum in Toronto.

Cut-outs were also characteristic of Mennonite valentines and quilt facings. The valentine was often done on white paper over a colored ground, usually red or pink. Hearts and tulips were a common form of decoration. A Waterloo County example is framed and glazed in pine, the frame being painted in a dark black-green for added contrast. A similar effect can be seen in a small quilt facing from the Markham area. This quilt was never quite finished. Naive tulips and oak leaves are cut

out of an early piece of red material and are applied to a white coarse cotton ground. When found, the piece was finely hand-stitched and the basting remained. Both are good examples of rural Ontario folk art.

"A great four cornered stove, a table in the corner with benches fastened to the wall, everything daubed with red, and above a shelf." The description is of a Pennsylvania-German interior of the late 1700s. Daubing was a common form of decoration on smaller household items, especially in the Germanic settlements of Ontario. In fact, graining and daubing is still practiced as an art form in many of the remaining villages. The Royal Ontario Museum has a well-used cutlery box from Waterloo County daubed in brown over a cream or faint yellow ground. Although very few pieces of decorated tinware remain that can be attributed to Germanic families, the Mennonites were known to have decorated plain tin lunch or document boxes. One was found with bright red daubing over a blue base paint, and crudely done geometric designs had been added to the top. Much of the tinware was relegated to the summer kitchen, then to the shed, and finally dumped, as newer and more modern types of housewares appeared. It was usually replaced in the home with graniteware which has now started to show up in the local autumn antique shows of southwestern Ontario. Of course, toleware was brought into Ontario from the United States by immigrants and peddlers alike, but very little was actually made here. Baden seems to be one village that still has the local tinker's tools. A number of tin pieces dating from the last quarter of the 19th century, especially lanterns with simple punched decoration applied, have been found in that area. It is, to say the least, difficult to document decorated tinware from the German communities in Ontario. Much of it depends on the history of the piece when found. And so a small pot with spout and handle, painted red with freehand brush strokes in yellow and black, resembles many documented American tole syrup jugs. It was purchased near Galt and had turned up at a farm auction in Waterloo County about 1968. This little piece may represent an attempt to reproduce a remembered decoration on a locally made piece of tin.

Some consider Fraktur and needlework to be the highest and most original form of surviving Mennonite folk art. To most, the word Fraktur refers to the brightly colored, illus-trated manuscripts of the Pennsylvania Germans, but the tradition is medieval in origin. In Waterloo County the most outstanding examples from a native hand would have to be those painted by Anna Weber in the 1870s. Floral trees with paired birds are characteristic of her artwork. The name of the artist and the date is inscribed below. Varied colors are used, but in most known examples rose-colored flowers and slender blue leaves are common. The foliage is complex, almost supernatural; the birds oversized and precarious in their perch. Symmetry with a vertical axis is the main compositional device of Anna Weber's painting, of Fraktur in general, and of most examples of primitive art.

Anna Weber was a young orphan and not much is known about her. The Weber name, however, goes back to the very earliest history of Waterloo County. Abraham Weber was one of the original settlers from Pennsylvania, where he was born in 1787. The Conestoga wagon that brought the Weber family to the area can be seen at the Doon Pioneer Village. Abraham

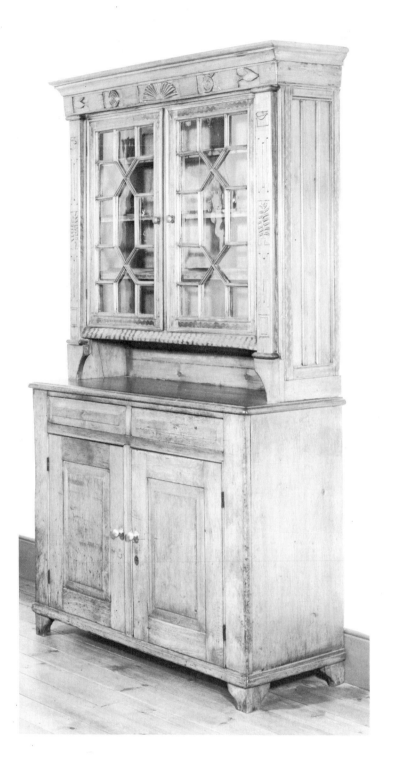

Sideboard-cupboard, with a simple lower section, but with relief-carved plants in pots, and small birds in the sides of the upper section, and Biblical fish and coiled serpent motifs below the cornice. Though painted with black graining over red when found in Waterloo County, this is one of very few pine pieces not originally painted. It was instead decorated over the bare wood with simple brush-painted looping lines of walnut juice, a strong stain, visible on the glass doors, door frame, and end-panel stiles. The cupboard dates c. 1830.

CANADIANA, ROYAL ONTARIO MUSEUM

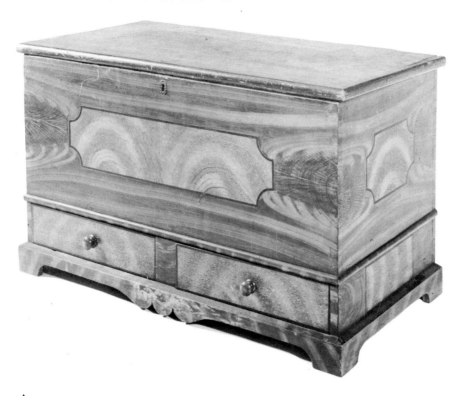

△
Storage chest with two lower drawers, of pine, but grain-painted to simulate exotic woods and bird's-eye maple veneering in a rather elaborate example of this technique. The chest is from Waterloo County, dating c. 1860.

CANADIANA, ROYAL ONTARIO MUSEUM

Low chest of drawers of pine, with the legs tapered on the inside to provide a flared appearance, from the Ottawa River Valley, c. 1840. This chest is decorated with graining in black over red paint. CANADIANA, ROYAL ONTARIO MUSEUM
▽

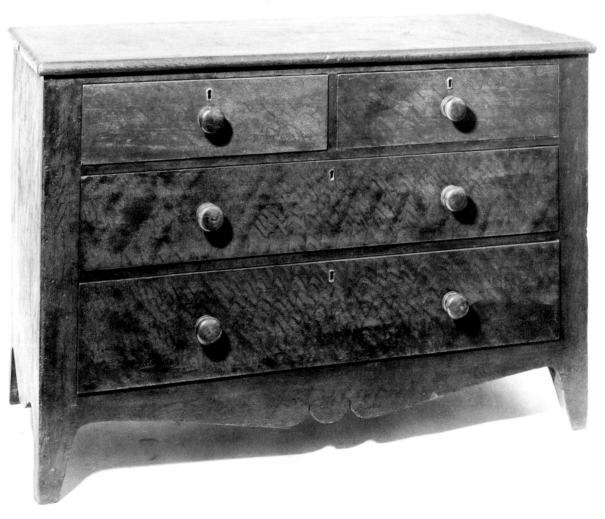

Multi-paneled pine blanket box, from the Ottawa Valley, c. 1820, decorated with black over a base red paint.

CANADIANA, ROYAL ONTARIO MUSEUM

Weber had sixteen children and it is possible that Anna was descended from one of them. He died in 1867.

The Kitchener Public Library has preserved the Bible owned by Benjamin Eby of Waterloo County. The two front pages of the Bible bear an elaborate inscription in Fraktur, Pennsylvania-German in style, and similar to the work done by the Mennonites of Bucks County. Flowers, birds, medallions, and a smiling cherub comprise the decoration, mostly done in reds and yellows. The end result is a complex interweaving of text and ornament, probably the most outstanding example of early Fraktur still preserved in Ontario. In the same collection, smaller works done by children in imitation of their elders include a flowered name plate in front of a catechism book. The page is painted with eight-pointed stars, bouquets of flowers, and calligraphic swirls in a symmetrical arrangement. The work is signed Maria Erb and is dated 1829.

Lists of births, marriages, and deaths in a family were kept on register pages in the family Bible. The careful lettering and artwork suggest a Fraktur style common in Waterloo County. Decoration and color is rare, but examples have been found, especially baptismal certificates which have cherubs, flowers, and religious symbols added in gay watercolors.

In some parts of German Ontario, needlework is still a living art form. Samplers were usually the first decorated pieces to be attempted. Show towels involved more advanced work. A small sampler signed Barbara Wideman and dated 1902 is from a Mennonite family in Waterloo County with ancestral roots in Pennsylvania. It is decorated with the alphabet, numbers from one to ten, six- and eight-pointed stars, the tree of life motif, and peacocks. Worked on homespun linen, the colors are in yellow and pink. An earlier show towel is decorated in a similar manner and with many of the same symbols.

Windsor rocking chair of the Boston rocker type, c. 1840, with an unusual back shape and arm curve, and grain-painted with stained varnish. This Waterloo County chair is unmarked, but is probably a product of an early chair factory.

DOON PIONEER MUSEUM

Sheet-iron bugle, handmade with soldered seams and japanned with black varnish, from Waterloo County, c. 1830–50.

DOON PIONEER MUSEUM

Carved wash-paddle or heavy flax scutch, evidently intended as a gift, with the upper relief panel on the blade inscribed "B C [or G, ?] 1864," and the lower panel "L B," probably the maker's initials. DOON PIONEER MUSEUM

Although the designs are much more rigid when done in textiles, the similarities to Fraktur work become obvious. Show towels are often a yard or more in length, and do a more than adequate job in hiding from the visitors' view the not so elegant hand towel.

Folk art is a personal thing. It is colorful, implies history and tradition, is often naive, and is worked from memory. But most of all it is personal. And what could summarize the concept of Germanic decorative arts in Ontario better than the rather primitive watercolor painting of horses in a rural setting, found in the summer of 1973 at an auction in German Union. The colors used are vibrant. Brown, green, soft blue, and yellow predominate. There were at least twelve horses of the same heavy breed grouped in a straight line across the paper. The painting is signed at the bottom right in black, JOHN WIECKER HIS OIL PAINTING. German Union? About halfway on a straight line between Punkeydoodle Corners and Tavistock. Punkeydoodle Corners? About two miles south of New Hamburg. It is neither a town nor a village. There are no crossroads at German Union. There is a cheese factory, "The German Union Cheese Factory," and it is really from it that German Union got its name. Rural Ontario indeed!

Silver

Helena Ignatieff

The earliest silver made, and most of the silver used in Canada was wrought by silversmiths in Quebec, the first part of Canada to have an established settlement. Before being crafted in Quebec, silver was undoubtedly brought there from France by settlers for their personal use, and for the use of Church and State administrators. The various pieces of silver surviving from those earliest days of settlement carry French marks. Although French silver was brought to Quebec in limited quantities and for specialized use by the Church, enough was brought to establish the style which native-born Quebec silversmiths followed when practicing their craft and filling the needs of the community. A few of the Quebec-born silversmiths, such as Jacques Pagé dit Carcy (1682-1742), after an apprenticeship in Quebec, went to France for further training, but these trips were rather rare occurrences. Pagé went in the hope of establishing himself as a silversmith in Paris, but returned to Quebec after probably about three or four years, and resumed his trade there. The sojourn in France may well have influenced his work.

In the main the usual training was that of apprenticeship to a master smith, who would take one or more students to be indentured to him for a set time, usually seven years, until they had mastered the techniques and were ready to work independently. A few of these craftsmen had been born in the 17th century. The 1744 census for Quebec lists eight working silversmiths.

At that time in Canada all forms of art were being developed for the same purpose, appropriately to decorate the church in a manner suitable to this important phase of life. Therefore Bishop Laval, the first Bishop of Quebec, founded a school of arts and crafts at Cap-Tourmente late in the 17th century. Mainly planned to establish artists and artisans to decorate the churches and chapels of the New World, it resulted in the establishment of the apprentice system. To examine the silversmiths in early Canada is to find a clear "bloodline" of apprenticeship which continued for two hundred years.

What articles and utensils were made out of silver? Of premier importance were the furnishings for church services. Church law required that holy vessels be made of silver, gold or silver-gilt, and the establishment and furnishing of churches, chapels, seminaries and convents were of primary concern. But not only ecclesiastical silver was in demand; the customary domestic silver in use at that time—forks, spoons, drinking cups and plates—were needed in the days before glass and china. There were various reasons to use silver for these functional objects. Silver was beautiful; silver was durable; and the equipment needed for silversmithing was relatively simple. Silver was the most malleable and ductile of substances. Hammering and rolling the metal hardened it. For articles requiring a still harder metal, such as coins or jewelry, silver could be hardened by alloying it with small amounts of copper. The silversmith needed only a furnace and bellows for melting or soldering the metal, one or two anvils, a work bench, a slab of iron with a flat surface, plus a set of steel-chasing chisels and punches. With these five or six items he could perform the simple processes of heating, alloying, shaping the sheet metal or casting the mold, drawing the design, and decorating the piece. Due to this relatively uncomplicated process the silversmith could easily establish his workshop.

Another valuable aspect of silver was its negotiability. It was a good investment and if necessary could be converted to credit. Silver was the standard of exchange with a constant value. Added to these practical reasons for the use of silver was the personal satisfaction and prestige of having splendid household goods which reflected one's position in society. In fact, silverware was an early status symbol.

The shortage of silver was a major difficulty for the silversmith. Where could he obtain the material for his trade? Silver was in short supply in many places—nowhere shorter than in Quebec. The most practical source was coined silver. There seemed to be no way to get raw silver from France, and although silver had been found in the Avalon Peninsula, Newfoundland, as early as 1604, the extraction of it was not

pursued in economic quantities until two hundred years later. The silversmith's only resources were old silver objects and coins to be melted down and refashioned. Until the middle of the 18th century it was against the law to melt down French coins as it created a currency shortage. Coins of various other nations were hoarded until enough were saved to make a particular object. The acute shortage of coins resulted in the colony using card currency almost entirely. This took the form of a card, originally a playing card which, once signed by the governor and another high official, represented a specific amount of money. The coins used included Spanish, English, Portuguese, and others. These and any damaged old plate were brought to the smith and were melted down to be reworked in different forms. The resulting objects weighed the same amount as the material supplied, a circumstance which may account for the substantial quality which characterizes early Canadian silver. There could be no skimping. It was not until the third quarter of the 19th century that virgin silver was found in significant quantities at Silver Islet, Lake Superior. Between 1870 and 1885 three million dollars' worth of silver was extracted before the mine was exhausted. Had our early silversmiths known what a quantity of this illusive metal lay under their feet it might have hastened the advance of industrialization and shortened that precious two-hundred-year period of hand-wrought silver in Canada.

In France at the beginning of the 18th century the silversmiths were still using the elaborate styles which had evolved over many years. After Louis XIV moved his court to Versailles, a taste for the Baroque developed which was manifested in heavily decorated massive plate. Only at the death of Louis did a reverse trend of reserve set in, with an extreme simplicity of line and with piercing as a favorite form of decoration. Stylistically the Quebec silver of the first half of the 18th century followed the form of the region in France from which the silversmith came or in which he had trained. Only a few came from Paris but they showed the French idiom strongly in their work, combined with the aspects of their own region, which usually resulted in a simplified form of the current fashion. The English period brought English influences which were apparent in Quebec, the Maritime Provinces, and Upper Canada. There also were American influences which appeared following the flood of Loyalists, whose numbers included some silverworkers. At first they worked mainly in the Maritime Provinces. The American style at this time was not merely an extension of the English form, which was traditional in the United States, but also showed its own personality of pure form with a reserved composition. It favored an economy of embellishment often limited to reeding and banding on the functional domestic pieces which came from Boston and Philadelphia.

The collector of silver will find it increasingly difficult to find examples of the early Church silver of Canada. Most of the finest pieces are already in the Church and State collections or in museums. It could be that luck is with you and some well-marked piece of unusual form has remained unrecognized and awaits you. However, for the most part it will be domestic hollow ware, or forks and spoons, which are still likely to be found. Where to look? Everywhere! In the beginning of settlement, silver was made in Quebec; then in the Maritime Provinces; still later in Upper Canada. Silver, how-

Ciborium, with repoussé column and base, by Paul Lambert (working 1691–1749) of Quebec, c. 1730.
CANADIANA, ROYAL ONTARIO MUSEUM

Church silver of the late 18th and early 19th centuries. At left is a chrismatory container with the stamp of Paul Morin (1775–1805—) of Quebec; in the foreground is a pyx, marked by François Sasseville of Quebec (1797–1864); the chalice with repoussé base and column, filigree bowl base and gilded bowl is by Laurent Amiot of Quebec (1764–1838). At right is a wafer box or traveling ciborium, topped with a cross, also marked by Paul Morin.
CANADIANA, ROYAL ONTARIO MUSEUM, AND
HENRY BIRKS COLLECTION

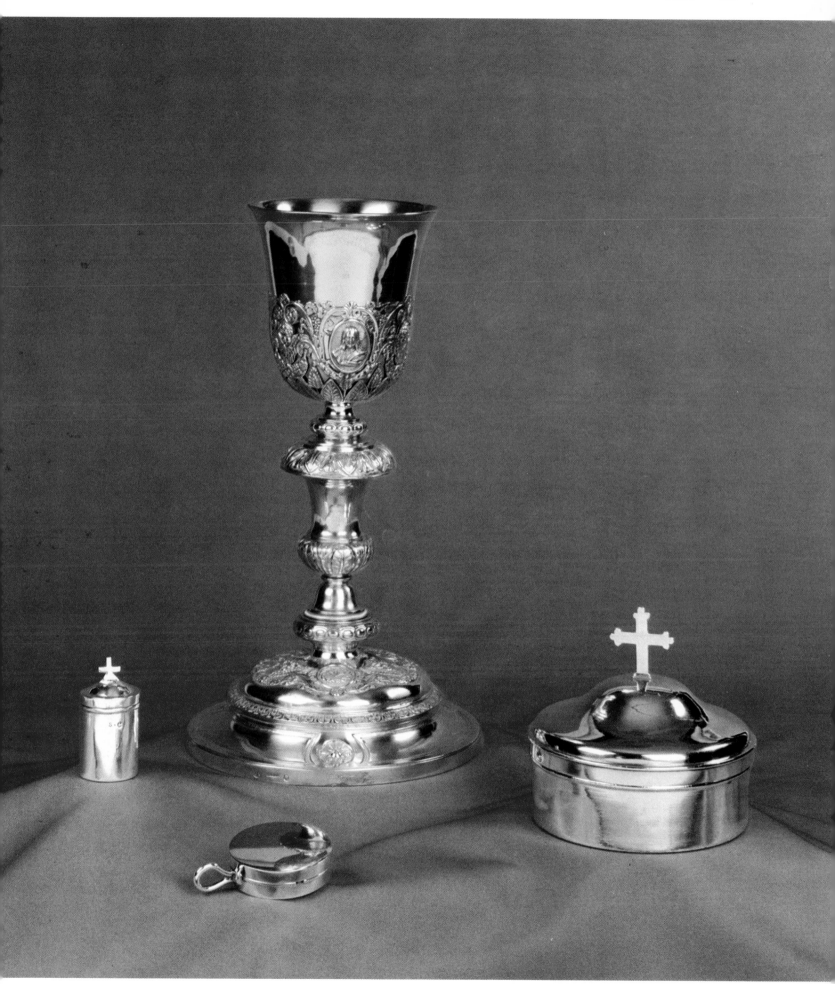

Sucrier, simply designed with a swan lid finial, with a mark very similar to that of M. Gatien of Quebec, c. 1760–65.

PRIVATE COLLECTION

Fork, spoon and large soup ladle, all by Paul Lambert, c. 1730–45. Lambert, whose pieces are marked with a punch mark P.L with a fleur-de-lis above, is the best-known Quebec silver maker of the French period.

PRIVATE COLLECTION

Large dome-lidded soup tureen, made for the Church of Notre Dame in Montreal, with an engraved monogram of the Sulpician order under a crown, by Jacques Varin de la Tour (working 1738–91), Montreal, c. 1785. The cover, however, is marked by Robert Cruickshank (RC), suggesting that Cruickshank may have done contract work for other silversmiths.

MUSEE NOTRE DAME, MONTREAL

Pair of candlesticks by Paul Morin of Montreal, c. 1800, and stamped in the underside of the bases with his P.M punch. Morin, born in 1775, was apprenticed to Laurent Amiot in the 1790s, and his last work is recorded in 1805.

PRIVATE COLLECTION

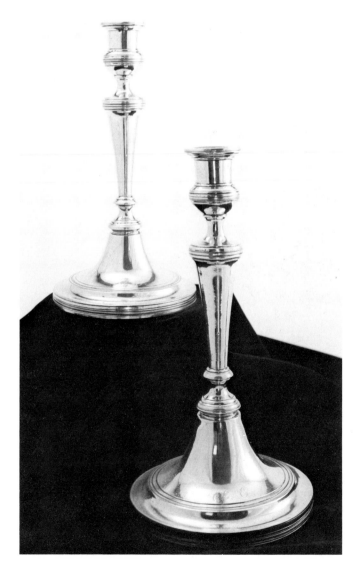

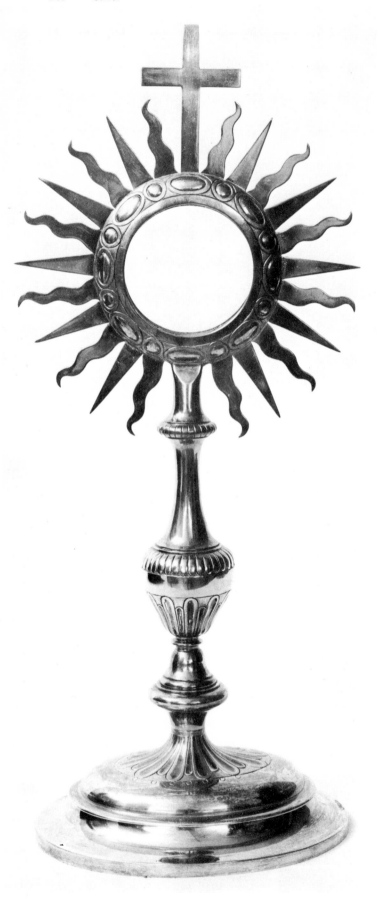

Church monstrance, early 19th century, by Laurent Amiot of Quebec (1764–1838), and well marked. Amiot was one of the more prolific silver makers of his working period, from c. 1786, and made a great quantity of church silver.

HENRY BIRKS COLLECTION

ever, traveled with its owners when they returned to France or England at the end of their sojourn in Canada and also when they trekked to the prairies and the frontiers of the far West. So you may find a silver ewer in the south of France, a coffee pot being auctioned in London, or a cream jug having spent most of its time in the Canadian West—all of which carry the marks of early Canadian silversmiths. It is necessary to recognize the mark of the maker, to train your eye to spot the authentic pieces, and to validate the piece as a whole. Some objects have been rebuilt from the work of several silversmiths and carry conflicting punch marks.

The collector of Canadian silver will have little trouble recognizing the identification mark of the colonial silversmith. There were no legal requirements such as the guild marks which bound the French and the British silversmiths. The significance of finding the maker's initials alone, without the quality mark, the warden's mark, the charge and discharge marks, and the symbols for date and location, places the object in an unusual category; that of colonial or unrestricted output. The confusion may well be as to which colony was the origin. Silver was being crafted in Malta, India, Bermuda, the Channel Islands and the United States, to name but a few of the colonies not yet under guild laws. Their common factor would be the lack of diversified marks.

In Canada the early Quebec silversmiths used the form of the punch mark or stamp commonly used in France. In the case of Paul Lambert the initials P.L are placed in a cartouche, which is topped by a fleur-de-lis, and has a star or a crescent under the initials. This French strain, found in the mark of the Quebec silversmiths in the early 18th century, helps one to identify the date and location of the piece. Sometimes the maker's mark is stamped three or four times as in the case of Jacques Varin. Also in this period an I was used in place of a capital J (mark of Varin). By the second half of the 18th century the initials of the maker in block letters were placed in oval, square or rectangular frames. Later still some makers, such as Salomon Marion, used script letters. About this time city names appeared, such as Quebec, Montreal and Three Rivers, which followed the maker's initials. The later use of the monarch head or the lion quality mark had no relation to government control. These marks were completely spurious and were in fact called pseudomarks. A control system came to Canada only in the 20th century, but the pseudomarks in customary usage seemed to be there to add importance to the object. Toward the 19th century the marks assumed distinctive personality without yet having to subscribe to any legal guild lines. John Burns (—1815–1865—) of Saint John, N.B., had closely placed cartouches JB NB, and also used the anchor symbol for maritime location. George S. Brown used his initials, the monarch head, H for Halifax, and the Sterling lion. In some cases the maker used HX to indicate Halifax. Four different punch marks have been documented for Peter Nordbeck, a German-born Halifax silversmith who used the anchor for location, N.S. or sometimes H. for Halifax, his own initials PN, and added the lion quality punch. Robert Osborne, of Hamilton, Ontario, in the mid-19th century used the Ontario beaver stamp and R.O., sometimes changing to R. OSBORNE in block print. From the same date, as well, there may be no individual maker's mark but only the stamp of the retailer or maker to the trade, such as Hendery & Leslie, whose stamp

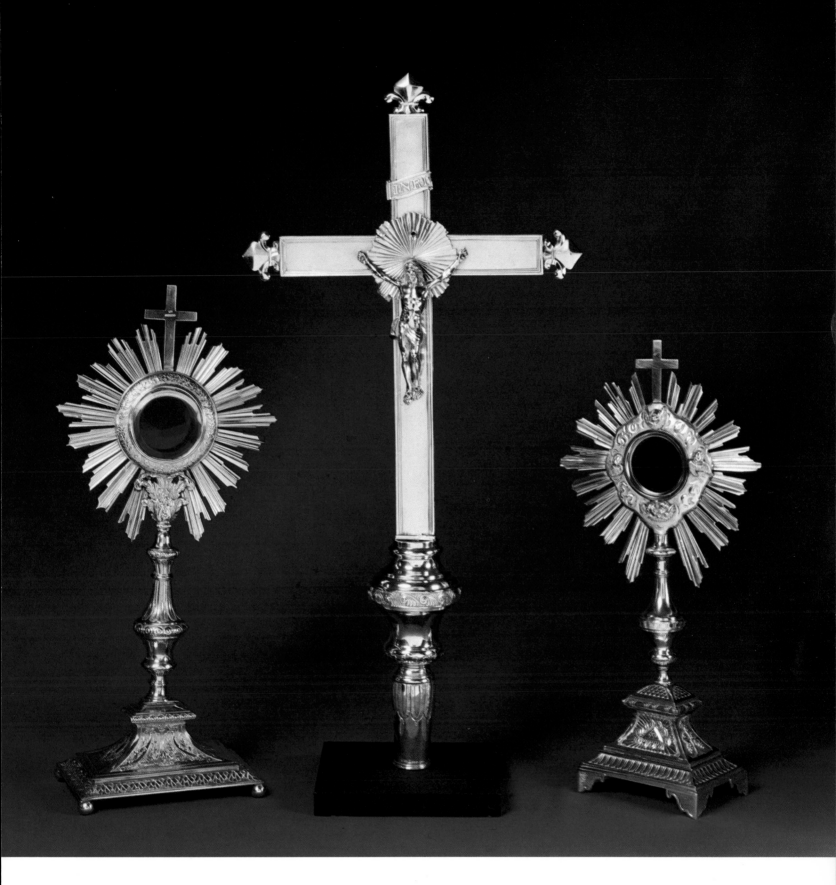

Ornate pieces by Montreal silversmiths. On the left is an elaborate monstrance of the 1800 period, marked by Pierre Huguet dit Latour (1749–1817) of Montreal. The processional cross is by François Sasseville (1797–1864), who had been apprenticed under Huguet dit Latour, and who was also a successor to Laurent Amiot (1764–1838) who made the smaller monstrance on the right. CANADIANA, ROYAL ONTARIO MUSEUM, AND HENRY BIRKS COLLECTION

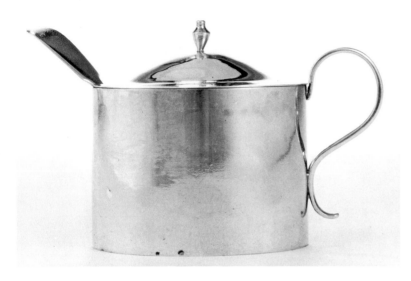

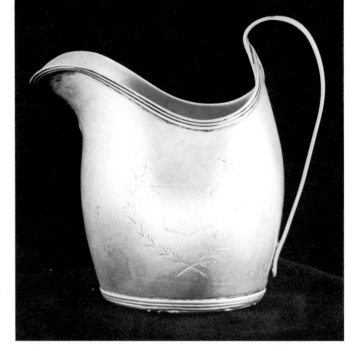

Mustard pot with spoon in a very simple but well-designed form, by Nathaniel Starnes of Montreal, c. 1840. The piece is marked NS *in script, and* MONTREAL, *both as punches.*

PRIVATE COLLECTION

Cream jug, also a fine domestic piece, by Laurent Amiot, c. 1810, ▷ *and handed down in the Amiot family. The jug has been engraved with a crest and cartouche, but never inscribed with initials.* PRIVATE COLLECTION

Cream jug by Laurent Amiot, an exceptionally designed domestic piece, c. 1790–1810, marked with his L.A *punch.*

PRIVATE COLLECTION

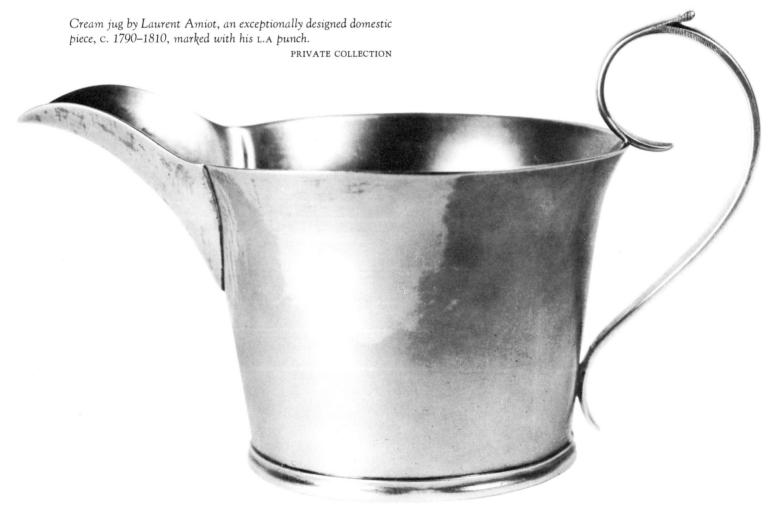

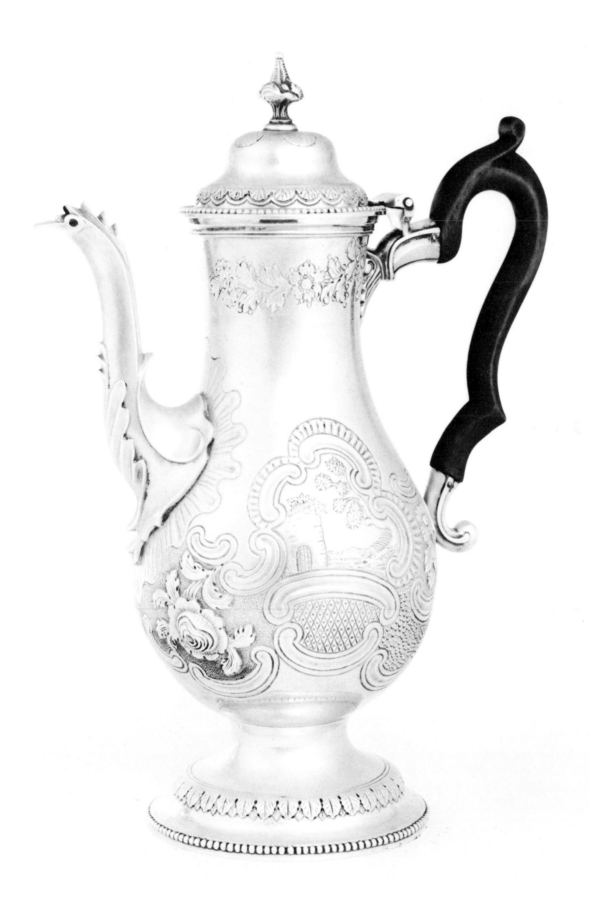

Coffee pot, with engraved and repoussé decoration, by Laurent Amiot, c. 1830–38, with a definite early Victorian flavor. Since the Church was always the prime patron of the Quebec silversmiths, domestic or secular hollow ware such as this, and the two previous pieces, is quite rare. PRIVATE COLLECTION

was often the only one found, though the work was done by one of the company's "stable" of silversmiths. The list of known Canadian silversmiths has been published by John E. Langdon, and it would be well worth while for the tyro collector to make a study of it.

There is another means of identification, although not a very scientific one. Early Canadian silver has a distinctive quality. The Quebec silver was influenced by the styles in France. Maritime or Ontario silver bore the imprint of England, and it also showed some slight influence from the United States which was originally derived from England. As you study Canadian silver a constant characteristic does emerge, that of scale and volume. Colonial art forms were consistent in having a strength of purpose and line, be it in furniture or silver. A clearly stated durability did not go amiss in a country where the wilderness and the climate were everyday problems. The very strength and substance account for its survival. So if the collector finds a piece of silver which is well designed, well made, of important weight, and with few guild marks supporting the name or initials of a maker, it will be well to think of it as probably being colonial silver. If it is found in a country where guild marks are the only guarantee of authenticity, the piece will doubtless go cheaply and you will be twice lucky. Recently in a London auction the silver was sold at a low figure because it carried the maker's initials as the sole mark, and had no special prestige in the English market.

The earliest church silver was made in splendid forms. The monstrance, a vessel in which the Host is displayed or, less frequently, in which a relic is shown, may vary in size depending on whether it is to be used on the altar or carried in procession. The Host is placed in a cylindrical container which traditionally is framed by a flaming sun, the rays of which are alternately straight and undulating. The ciborium, the vessel for the reservation of the Eucharist, is lidded, often with a hinged cover and lock. Burettes or cruets to contain the water and the wine for the Eucharist sometimes have the A and v for *Aqua* and *Vinum* engraved on the body. The holy water stoup or *bénitier* is made with its aspergill—the round-ended pierced rod used to sprinkle the holy water. The *navette* or incense boat is the vessel in which the incense is carried until it is placed in the censer to burn. The censer is a pierced lidded pot, the fragrant smoke from which is wafted about by swinging the pot on its chains. Numerous other pieces such as chalices and processional crosses were also essential to the service. The surviving examples of ecclesiastical silver are very impressive. Mostly being in the collections of convents, seminaries, churches or museums, it is a nearly hopeless task for a collector today to try to acquire this sort of silver. There is a lot to be said, however, for viewing these collections, to attain an appreciation of the skill and techniques that went into the making of the holy vessels.

Few examples of the work of the earliest documented silversmiths remain to be found. Jacques Pagé, born in Quebec in 1682, is represented in various collections, as is Michael Cotton, born in Quebec in 1700. What is left of their work is of high merit. The first well-established silversmith in Quebec, who made a great name in the history of the craft in Canada, was Paul Lambert, born in Arras, France, in 1691. Characteristically his work was well composed, restrained and original. Much of his style was remarkable for the variety of form and

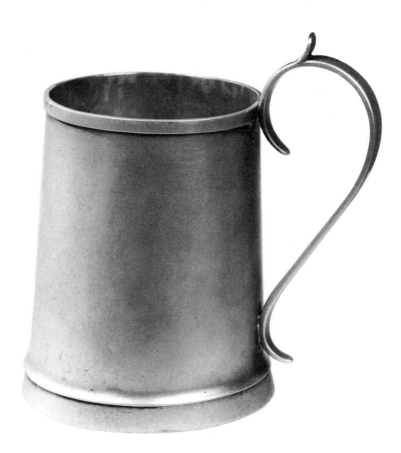

Mug with an overlaid banded rim and recurved handle with thumb grip, simply designed and well made by Henry Jackson (working 1837–1869) of Toronto. PRIVATE COLLECTION

Flat silver tableware was by far the most commonly produced form of early silver, and it is still found fairly readily. The top pieces are, left to right, salt or mustard spoons by Robert Osborne of Hamilton, Ontario (working 1851–69); Robert Cruickshank of Montreal (working c. 1773–1809); Nathaniel Starnes of Montreal, (—1794–1851—); Savage and Lyman of Montreal (1851–67); Lash and Co. of Toronto (c. 1865), and sugar tongs by Nathaniel Starnes. The three table spoons are by Laurent Amiot, Quebec (1764–1838); Michel Fortin of Quebec (1754–1812), and Joseph Varin dit Lapistole of Montreal (c. 1745–1791). The teaspoons are by Paul Morin of Montreal (1775–1854) and by Laurent Amiot.
Below are two heavy serving spoons, the left piece by Pierre Huguet dit Latour of Montreal (1749–1817), and the right by Bohle and Denman of Montreal (1863–66). The large ladles are, left, by Nathaniel Starnes and, right, by Laurent Amiot.

CANADIANA, ROYAL ONTARIO MUSEUM

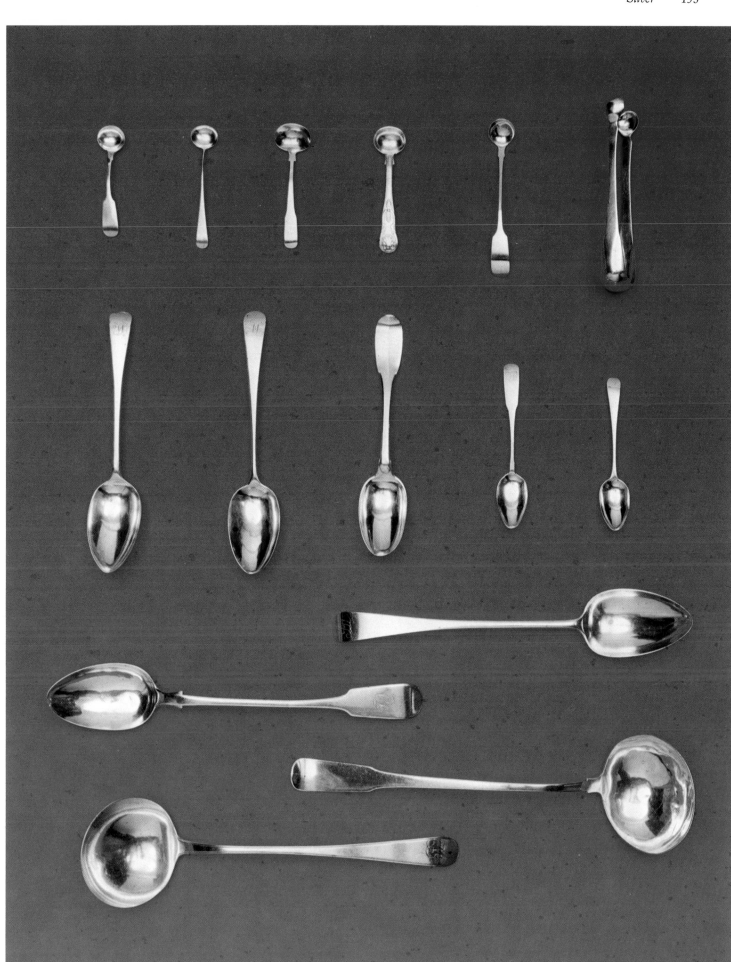

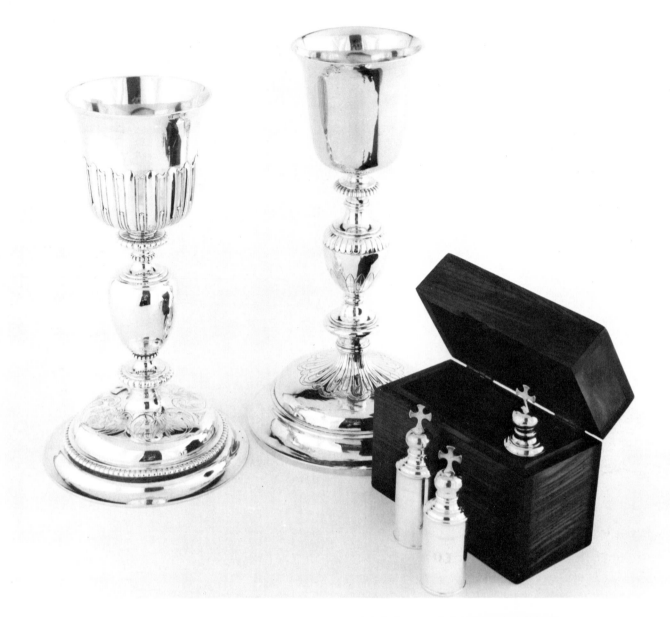

Left: Chalice with a chased design of grapes and sheaves of wheat in the dome of the foot, by Paul Morin of Quebec, c. 1800.
Center: Chalice by Laurent Amiot, to whom Morin had been apprenticed, c. 1790.
Right: Chrismatory case containing three silver stocks, all with cross finials on the lids. These pieces, as a cased set of three, are most unusual. While the stocks have no maker's mark, they are punched with pseudo-English head and lion punches used by Paul Morin in the early 19th century. HENRY BIRKS COLLECTION

Reliquary cross, with an engraved cover that is lifted after removal of the locking pin screwed into the base, by Ignace François Ranvoyzé of Quebec (working 1739–1819), who produced a large quantity of church silver, and extremely fine repoussé-decorated work. Reliquary crosses were a common form of church silver, made by most silversmiths, and are usually marked on the inside. HENRY BIRKS COLLECTION

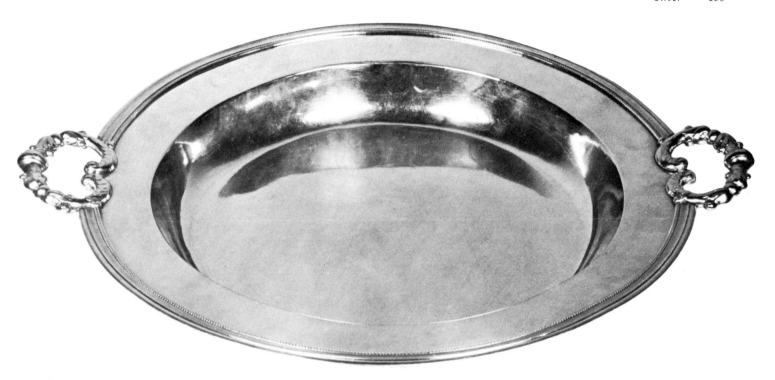

△
Double-handled deep tray or basin, elaborately made with cast handles inset to the rim, by Salomon Marion (working 1782–1832+), c. 1820–30, with the mark MARION *punched in script under the rim. Marion made a considerable amount of church silver, but is also known for his fine secular hollow ware.*

HENRY BIRKS COLLECTION

Three-sectioned inkstand with a lightly formed tray and three pierced frames to hold a glass inkwell, sander-blotter, and in the center, quill pens. This unusual piece was made by Robert Cruickshank of Montreal (working 17??–1809) about 1800. Cruickshank is also known for his production of Indian trade silver, carried west in quantity by the North West Company.

▽ CANADIANA, ROYAL ONTARIO MUSEUM

the beauty of decoration. He was active in Quebec for about twenty-five years and left behind him many distinguished objects to confirm that the early craftsman for the Church was inspired by the real fervor which unites art and religion.

The position of the silversmith in the colony must have been relatively secure, although not always prosperous. Respect was his due, as a man who undertook important commissions and who taught his craft to a number of pupils. He could be said to work for the Church, and yet also had among his customers "the good and the great" of the laity; references are found to domestic pieces which bore the arms or monograms of the early *seigneurs*. The silversmith was a necessary member of the community. Some silversmiths had to take up secondary lines in order to make a living, and advertisements tell of gunsmithing, locksmithing, wigmaking, clockmaking, engraving, jewelry making and even "excellently made false teeth" as second strings to the silversmith's bow. Paul Lambert, however, was not required to divide his interests. He was the leading silversmith in the community, a population of not more than sixteen thousand souls. It is quite telling to look at the inventory of his estate in 1749:

> Inventory notes that a certain number of pieces of his furniture were in need of repairs but the furniture was solid and honest cherry and pine. All the armoires were full of clothes made of cloth of Brie and of Elbeuf, several wigs, fine linen, pottery vases, engravings, also a few books, a Latin dictionary and one of French-Latin A Virgil in Latin, Ovid etc. A large number of blankets, some edged with dog-skin others with carbioo hide. In the cellar were the provisions; Coal, maple wood, oil to fry and to burn, olive oil, a "pocketfull" of turnips, little onions, a braid of garlic, a half barrel of apples, and a big pot of cherry brandy. Handsome silver, five spoons and forks, an *équelle*, a soup spoon and a stew spoon. The silver mounted sword of the master, his shoe buckles, buttons, etc and small objects, and in a locked drawer, card money, ordinances, and money to more than seven hundred livres.

Paul Lambert emerges as a man of position and some elegance who bore a place of respect in the structure of society. He lived simply in a community where all lived comparatively simply.

The next outstanding silversmith was Ignace François Ranvoyzé (working 1739–1819) who lived his entire life in Quebec. Generally credited with being the greatest Quebec silversmith, he began as a locksmith. His most important work was done between 1770 and 1790. His work, in addition to a great deal of church silver of note, included domestic silver: spoons, forks, winetasters and cups. Mostly his mark was F.R. in a frame with forked ends, or in a plain square. Sometimes the initials were stamped in italics. His most illustrious work was a set of golden vessels, made for the church at L'Islet in 1810. Of great sculptural beauty, they were made from gold coins melted down. They were partly constructed by casting. The set consisted of four pieces: the chalice and paten made in 1810, a ciborium made in the same year, and a monstrance made in 1812. Ranvoyzé made vast quantities of silver for the Church, and in much of it he employed the patterns common to the ones in use in France in the 18th century. His vessels

had decorations of cherubs, acanthus leaves, heads and flutings, in a technique which made use of casting and chasing freely. This also appeared on his domestic silver. There are examples, however, of a finer more original form of his work in some church collections in Quebec, such as pairs of altar candlesticks made of beaten silver, rather than chased or cast work. They are distinguished by fruit and flower garlands, wreaths, and rocaille scrolls. This beaten technique is unique for Ranvoyzé's period in Canada and gives the work a quality of exceptional brilliance.

The next great silversmith in the line of succession was Laurent Amiot (or Amyot), of Quebec, who lived from 1764 to 1838. His mark was L.A in an oval or rectangle, and sometimes was accompanied by QUEBEC. Amiot was apprenticed for a short time to Ranvoyzé and also studied in Paris for a few years before returning to Quebec to become a competitor of Ranvoyzé. He made great quantities of ecclesiastical and domestic silver, of which some of the latter is still to be found. Stylistically he moved with the times; his designs were bolder, his forms had greater thrust. However, he had the capacity for delicate romanticism in his chasing and gentle punch work. Amiot used classical decoration in the form of wreaths and swags and stylized acanthus, and Ramsay Traquair illustrates an example of this decoration of outlined laurel swags on a splendid soup tureen which Amiot made for the Baby family. In the early 19th century Amiot's style was influenced by Ranvoyzé who used the same decoration on navettes, sanctuary lamps, and *bénitiers*. Amiot's work was never as great as Ranvoyzé's—capable as he was—but his output was large and in the last twenty years of his life he was the dominant silversmith in Quebec. The community in which Amiot worked was much larger than that of his predecessors—the population had increased to nearly four times what it had been in the time of Lambert. The increase of people accompanied by an increase in prosperity resulted in more domestic silver being commissioned privately. There is an interesting comment in a literary reference to Amiot in the following exerpt:

> Robert Stobo a hostage from the Virginia Reg't taken at the Capitulation of Fort Necessity whose French captors allowed him the freedom of Quebec City: "I beg of Ms. Lacorne St. Luc to keep account of Mr. Amyot of the sum of 1320 livres the received value by the said gentleman in silver and merchandise which he had furnished me in Quebec on the second of Jan. 1755, Robert Stobo.

The French livre of this period was interchangeable with the French franc. Stobo's note was the equivalent of about fifteen hundred dollars in the currency of today. The implications are quite fascinating: that a prisoner of war under city parole could undertake this sort of debt and have a French officer stand sponsor for him. Silver utensils were a necessity at that time, and even a prisoner had to equip his household with silver. Perhaps more likely still, Stobo was allowed such freedom that he was able to indulge in a small business of trade with the Indians, and the linking of silver and merchandise meant that M. Amiot had other goods to sell besides hand-wrought silver. The Amyot referred to would most likely be

Censer or incense burner with both repoussé and pierced decoration, by Ignace François Ranvoyzé, c. 1790–1800.

Presentation cup, presented to the Rev. Joseph Hudson, "assistant minister" at St. James Church, York, Upper Canada, in 1833. The cup was made by William Stennett, who worked in Toronto from 1829 to about 1843, and later in Bermuda, and is regarded as his best work and one of the finest pieces of Ontario silver.

CATHEDRAL CHURCH OF ST. JAMES, TORONTO

Presentation snuffbox, an early piece of presentation silver, made and marked by Etienne Plantade of Montreal, who was active in the early 19th century. The inscription, above an engraving of three steamships, reads "Presented to Jacob Dorge, Esq., by Capt'ns Hall Brush & Symons as a token of their particular esteem / Wm. Henry [probably Fort] 24 March 1821."

HENRY BIRKS COLLECTION

Trophy ewer, by Robery Hendery (working 1837–1897) of Montreal, presented in September, 1859, to "C.M. Starnes, Esq'r" by the ladies of the Three Rivers Turf Club, the cup having "been WON by his Chestnut Horse MARIO."

PRIVATE COLLECTION

Jean Amyot, a general merchant of Quebec City who was the father of the silversmiths Jean Nicholas Amyot, Jean Joseph Amyot, and Laurent Amyot.

Small crosses of interesting variety can still be found in the field of church silver, some of them marked, and some not. The nun's cross is usually made from a flat piece of silver and is decorated. The nuns wore these tucked into their belts. The other form is the reliquary cross, which is made as a receptacle for relics, and opens by unscrewing the finial at the bottom, allowing the lid to be lifted.

Among the illustrations you will find works of 18th- and 19th-century silversmiths who were masters of their craft; many who were equally capable have been left out for lack of space. There is no comment on the silver craft in the Atlantic Provinces. Donald C. MacKay's *Silversmiths and Related Craftsmen of the Atlantic Provinces*, published in 1973, will be found of inestimable value in the serious study and collecting of Maritimes silver.

There are various ways for the new enthusiast to begin a collection. He can concentrate on the work of one silversmith; this is a highly specialized form of collecting, and a rewarding one. The Provincial Museum in Quebec gave an exhibition of the work of Françoise Ranvoyzé, which was the most ambitious attempt to date to assemble the work of one craftsman, and was a great study opportunity for the students of wrought silver. Another way to make a collection is to accumulate a particular type of piece as it was made in different periods; in this way you can assemble a collection for the study of the development in form and decoration and in its social use.

The domestic silver of the 19th century is a splendid area in which to collect, not as a specialist but simply to enjoy and use beautiful plate. Another functional form which can be found on the modern market is presentation silver. Not all of these pieces are in the form of a challenge cup; they have been made for one purpose, but they have an unlimited variation of excellence in athletic competitions, and other enterprises was current throughout the 19th century. These pieces, still to be found, very clearly point up the trends in social occupations and activities. The recognition or occasion tribute was made in Quebec, Montreal and Ontario, and suggests the community effort found in small towns where political, spiritual, physical, recreational, technological and humanistic efforts were being acknowledged. These were mementos of victory or success, most executed in silver. In their study one unravels the progress and the prowess in the fabric of colonial society.

The presentation piece is, in mirroring social customs of the last century, an intimate and attractive facet of the silversmith's work. One may still find these forms as they have no set function for the modern household and so may be put on the market; they are fascinating and full of human interest, however, and have good value in weight and workmanship. For those who enjoy the use of beautiful silver, there are opportunities for putting the original purpose of the piece to a modern use. For the collector of tableware, there are examples of 18th- and 19th-century spoons and forks made in the French and English styles; flat silver is handled in a very generalized way, and your main aid will come from studying the marks and recognizing the characteristics of the maker's workmanship and style.

The collecting of antique silver as an investment is often spoken of, and there is probably a secure feeling in having a commodity whose value is steadily increasing. The genuine devotee, however, scarcely considers the question of making a profit—there is an ever-growing interest and fascination with art forms of the past, especially the handcrafted. The supreme satisfaction to the collector is having learned to recognize the treasure, of having searched it out and found it, and in the sense of fulfillment in its possession. The collector plays an important part in finding the treasure of the past and conserving it for the future, meanwhile interpreting it in the present.

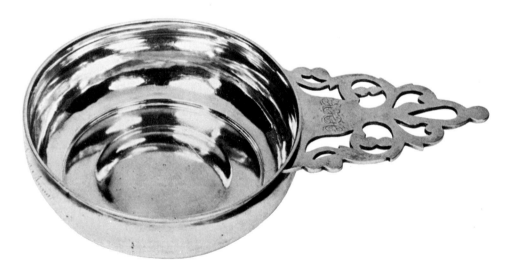

Porringer, probably as a baby's bowl, by Robert Hendery, Montreal, c. 1860–80. HENRY BIRKS COLLECTION

Pewter and Copper

D. B. Webster

For over two centuries, from earliest settlement through to the early 19th century, cast pewter utensils were by far the most common form of tableware in North America. Pewter spoons and ladles particularly, as well as plates and chargers, mugs and bowls, graced the everyday table throughout the continent. Pewter was, indeed, probably the sole type of tableware that was used by all economic groups, from wealthy urban merchants to subsistence-level frontier settlers.

While the use of domestic silver was fairly widespread, silver was still limited to those who could afford it as a luxury material and as a symbol of status. It was often reserved for entertaining and for "best," while pewter served for daily use. At the other end of the scale, households which used wooden spoons and trenchers at daily table, households which would probably never own a piece of silver, would likely have reserved the family pewter for "best."

Pewter, as a metal, is ancient and was probably discovered during the Bronze Age, for it is essentially an alloy of the same metals as bronze: copper and tin. The earliest use of pewter is uncertain, but without doubt it was well known in Roman Europe and Britain.

Bronze, without getting into myriad specific formulae, is basically an alloy of copper and tin, with copper to a proportion of about 80 percent, and tin approximately 20 percent of the total. Pewter uses the same metals but in opposite proportions, tin to an average of 80 percent, and copper roughly 20 percent. English and European guilds controlled quality as well as trade by specifying the exact proportions of metals for different grades of pewter, and over the centuries there were dozens of precise recipes. Essentially, though, the best pewter was tin and copper, usually with a very small percentage of antimony added as a hardener.

The cheapest and lowest-grade pewter, conversely, included lead as well, sometimes to as much as a third. Pewter of this grade, however, was too soft, dull, and unpolishable to be commonly used for table utensils. Instead it was reserved for such products as organ pipes and candle molds, and with a smaller percentage of lead, for mugs and tumblers, which did not require hardness.

Though early 17th-century France and England were probably still wooden-spoon and treen-trencher societies, pewter was beginning to come into general and widespread use. Pure tin was readily and inexpensively available, particularly from Cornish mines in England, which served to make the British pewtering industry and its export trade the dominant source of pewter for the North American colonies.

The early pewterer of the American colonies or of New France had a difficult time, for he had no easily available source of new raw materials, particularly of pure tin. Like the silver maker who depended on coin and old silver for his metal, the North American pewterer depended almost entirely on old scrap pewter.

Being relatively soft, pewter did not last very long when in daily use; five years has been estimated as an average life span for pewter flatware or plates. Pewter like silver, however, had a considerable part of its value inherent in the metal alone, and remelting and recasting of old pewter into new pieces was a very considerable portion of the pewterer's trade.

Canadian pewter is one aspect of this country's background of antiquities which has been almost completely ignored by collectors, and to this day it is virtually unknown. Numbers of books, not to mention magazine articles, have appeared over the years on English and American pewter and pewterers, to the point that information is reasonably complete. Nothing whatever has been written on Canadian pewter, and no specific studies have even been attempted.

From archaeological excavations there is little doubt that both English and French pewter were in universal use during the French period, though probably in limited quantities. Excavations at the Fortress of Louisbourg (c. 1715–1760) have produced English and French plates and flatware. The writer's projects at Ile de Soeurs and Fort Senneville, both early and mid-18th-century sites near Montreal, produced French pewter spoons and segments of bowls and porringers.

Four spoons, excavated at Fort Senneville, Senneville, Quebec, in a context of 1760–76. These spoons may have been cast locally, in earlier French or English molds.

CANADIANA, ROYAL ONTARIO MUSEUM

Hardwood spoon mold of birch, a very rare type from Quebec, late 18th or early 19th century. PRIVATE COLLECTION

Dinner plate, flanked by two 19th-century cast spoons. The plate is stamped MONTREAL in its base with two different punches, c. 1790–1820. PRIVATE COLLECTION

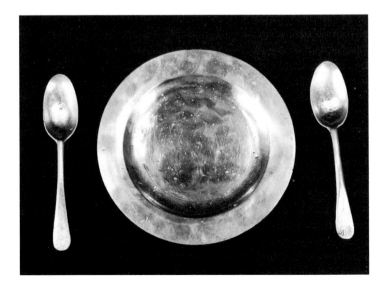

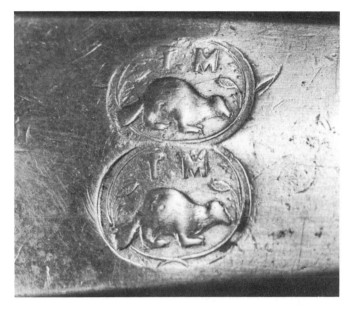

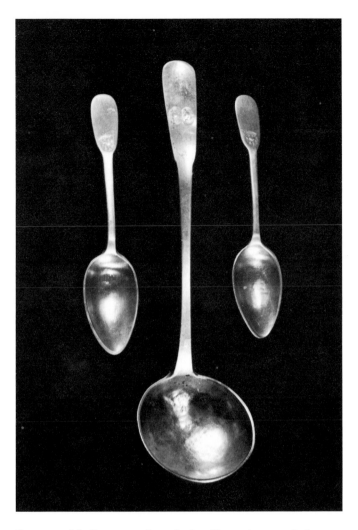

Double T.M *and beaver marking, from the handle of the preceding ladle.*

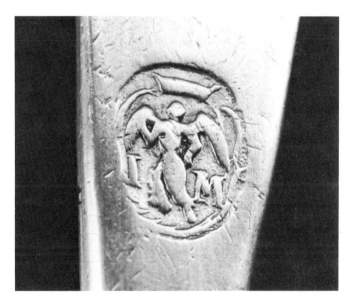

Spoons and ladle, stamped on the handles with a punch forming a beaver and the initials T.M, *and on the backs of the handles,* MONTREAL *in large letters. These spoons are attributed to Thomas Menut of Montreal, early 19th century.* PRIVATE COLLECTION

Punch marking of the initials I.M *flanking an angel, commonly found on tea and soup spoons of the early 19th century. The marking is the punch of Jean Baptiste Menut of Montreal, c. 1860.* PRIVATE COLLECTION

There is no current evidence, either as records of pewterers or as known marked pieces, of pewter-casting being carried on in Canada as a commercial craft much before the early 19th century. However, there is every reason to suppose that individual pewter-casting, the making of new pieces from old, existed at all periods. Seminaries and convents, particularly, required large quantities of pewter, and kept on hand bronze or wooden molds for recasting their own worn-out pieces. The sisters of the *Congrégation de Notre Dame*, who maintain the *Ferme Gabriel* (1689) at Pointe St-Charles near Montreal, have a spoon mold and six-inch plate mold which were used in the 19th century for casting the order's own tablewares.

Two-piece spoon molds of the late 18th and early 19th century are occasionally found. Many are engraved or chiseled in the spoon-handle portion of one or both sections, to cast spoon handles bearing relief decorations. However, these brass or bronze spoon molds are for the most part English or American. Only extremely rare hand-fashioned hardwood molds can be assumed to be of Canadian origin.

Only very rarely were the products of these molds separately marked in any way, in the sense of makers' punches or other identifying stamps. The castings of seminary and convent molds in Quebec were apparently never marked, at least beyond whatever decoration may have been included in the casting. Since the pieces were for internal use, not for sale, there was hardly reason to do so. Thus we cannot assume that Canadian pewter was not made in the 17th and 18th centuries, but only that early pewter was not produced by a craft industry with the habit of marking its output.

One very unusual and certainly Canadian piece of 18th-century pewter was excavated during our project at Fort Senneville (terminal date 1776), a barred, double-button shirt

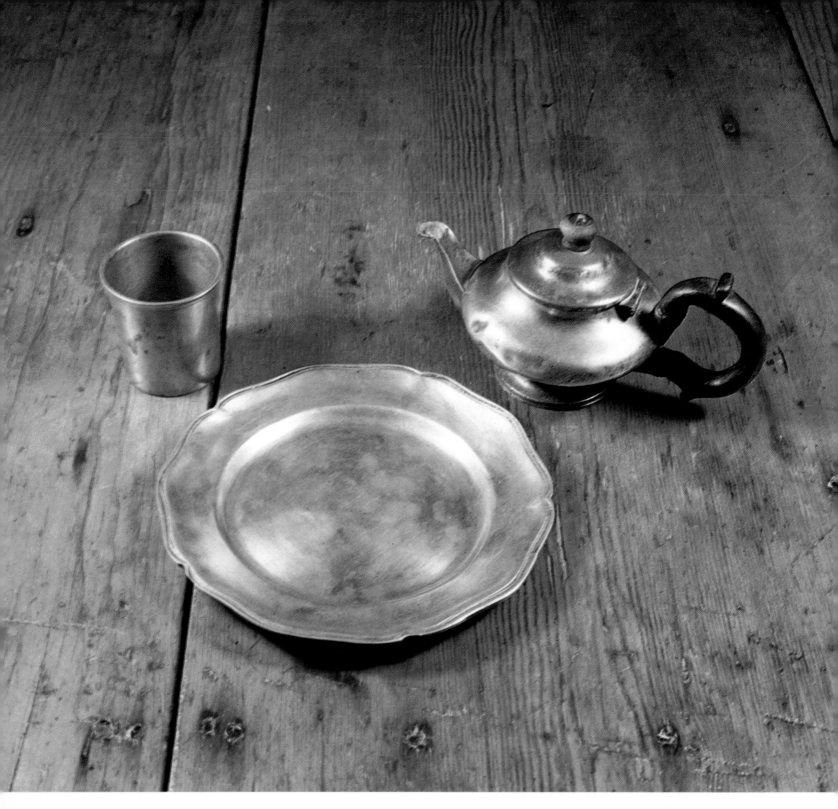

Left: Tumbler, marked on the base with D.s in an oval, probably the punch of David Smellie, Quebec, c. 1810.

Center: Plate, with a Wedgwood "Queen's Pattern" derived rim shape, marked MONTREAL in a small punch on the base, c. 1790–1810.

Right: Small teapot with a carved wooden handle, c. 1810–20, marked with a small-letter MONTREAL punch on the base.

PRIVATE COLLECTION

Mark of the initials D.s, from the base of the small tumbler (color illustration) by David Smellie of Quebec.

PRIVATE COLLECTION

or waistcoat stud, with a small blue glass Indian trade bead inset into the center of each button. Though early pewter buttons are common from such sites, pewter jewelry is rare, and would normally be assumed as being English or French. But with Indian trade bead decoration?

All Canadian pewter, like American, at least into the mid-19th century seems to have depended on scrap pewter for its metal. Wills and inventories of American pewterers show no stocks of raw tin, and there is no reason to suppose that earlier Canadian pewter-casters were able to import tin either. Based as it was on recast metal, and without European guild controls, North American pewter contains widely varied metal contents. Cheating in recasting by adding a little lead was so easy that most North American pewter will be found to contain at least some proportion of this metal.

Identifiably Canadian, i.e. marked, pewter does not seem to occur before the early 19th century, and all of that so far observed has originated in Quebec. Spoons are by far the most common type. Plates and other hollow forms are known only through a few marked examples, though given the ease of casting from molds, numerous examples no doubt existed at one time.

There is some doubt that pewtering ever emerged as a specialized occupation in Canada, and certainly it never developed as a craft industry, as in England. No pewterers listing that as their occupation in early directories or tax assessment rolls have yet been noted except in Montreal, and it seems probable that the making of pewter was often a part-time and periodic occupation of craftsmen in other fields. The same was of course true of many American pewterers. Both the scarcity of raw materials and the longevity of the product, unlike pottery for example, made pewtering less than viable as a full-time occupation or business, particularly in the face of heavy importations of English pewter.

Observed Canadian markings on pewter indicate that commercial pewtering was limited to the late 18th and early to mid-19th centuries. Perhaps the most common mark is a punched MONTREAL in large unfooted gothic relief letters, a stamping which is found on spoons and ladles of the early 19th century, on the back of the handles. Since it is eminently possible that more than one pewter-caster had stamps of this type, we cannot make attributions to any particular maker based solely on this mark.

However, the large MONTREAL stamp has been observed on many pieces in association with another punch, this forming the relief letters T.M. (also unfooted gothic) over a beaver, horizontally in a large oval. This marking is attributed by the McCord Museum to Thomas Menut of Montreal. Stylistically, these spoons and ladles date from the turn of the 19th century. Thomas Menut's working dates are not known; but he was a pewterer, not a silversmith, and neither the large MONTREAL mark nor the T.M.-and-beaver have occurred on silver.

Another mark is of a spread-winged angel in relief flanked by the initials I.M., vertically, in a large oval. This stamp is the mark of Jean Baptiste Menut (Thomas' son), listed as a Montreal pewterer in 1857–58 and in 1868, and primarily a spoon maker. His brothers Joseph and Ernest were apparently also pewterers during this period.

Pewter-casting also seems to have been a part-time occupation of at least a few Montreal silversmiths in the turn of the

century period, and it is the silver makers who appear to have produced the few presently known Canadian cast plates and hollow wares. A recurring mark is a small stamped MONTREAL, in footed Roman letters, in the bottom of plates and one known teapot. This mark occurs in two sizes, including one plate marked with both. These MONTREAL marks, however, are not alone suitable for precise attributions, except generally to the group of Montreal silversmiths of the 1780–1820 period.

Identical small MONTREAL punches appear on the silver of Charles, John, and Michael Arnoldi, Robert Cruickshank, both Louis and Pierre Huguet *dit* Latour, Salomon Marion, and Paul Morin, as well as other lesser known silversmiths. While MONTREAL punchmarks of this period vary slightly, punches probably circulated in the silver trade, and the vagaries of punching soft metal plus the effect of later wear render unreliable, at best, any attempt to sort out and attribute these marks. None of the pewter so far examined, primarily plates, with one or more small MONTREAL marks, has any corresponding maker's initial stamp.

The only piece of Canadian pewter now known which in fact bears a Canadian silversmith's initial stamp is a small tumbler marked D.S. in a small oval punch on the base. Though this mark is not well known, it appears to be the punch of David Smellie (1780–1827) "jeweller and engraver" of Quebec City, and also a silversmith.

Due to the impossibility of obtaining newly mined tin, pewter was a relatively scarce commodity in 18th-century North America, sizeable English imports notwithstanding. In spite of being in widespread and general use, pewter was of sufficient importance to be mentioned specifically in wills and household inventories, along with silver, if any, and steel knives and forks. Lesser possessions, conversely, such as woodenware and utility pottery, were often ignored or lumped into general categories.

The early period of pewter, the age of individual pewter casting and crafting, was quite over by 1830, with hollow wares and plates disappearing first, followed by the ubiquitous spoons. Pewter had gradually been replaced by increasingly popular and inexpensive ceramics, first white salt-glazed stoneware and queensware in the 18th century, and finally "ironstone china" in the 19th. By the same period, English steelware and cheap silver plate, far lighter and easier to clean, was replacing cast-pewter flatware, which had always been heavy and clumsy at best.

The later period of pewter involved so called "brittania" ware, industrially produced pewter of a somewhat harder and finer metal than casting pewter. Brittania, factory-made by spinning in molds and finishing on lathes, and later from rolled sheet, was much thinner and lighter than earlier cast pewter, and was manufactured into the 1880s. There is, however, no certain knowledge that brittania pewter was produced in Canada, and no marked Canadian examples have come to light. A vast quantity of English brittania was imported during the 19th century, however, most of it unmarked, and it is still commonly found in the antiques market.

Earlier cast Canadian pewter seems to have been limited to Quebec—the unmarked products of individual or organizational molds, plus the small marked output of a few commercial pewterers. No early pewter has yet appeared that is attributable to the Maritimes or Upper Canada. Identifiably marked spoons

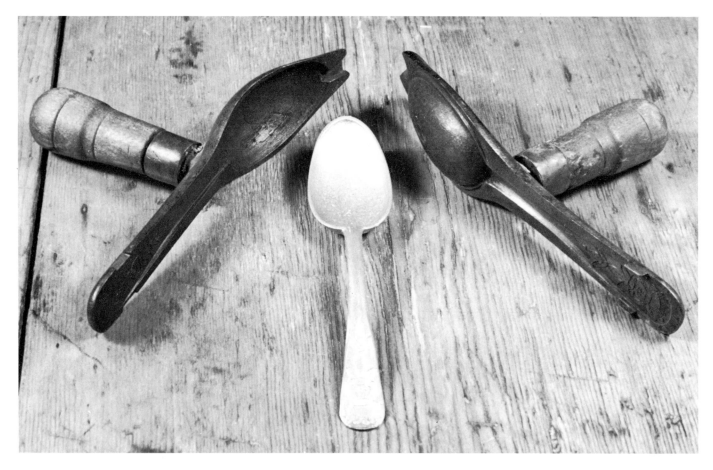

Newly cast spoon, with relief-decorated handle, from a bronze mold of the 19th century. PRIVATE COLLECTION

Spoons of the early and mid-19th century, showing the great variety of punch marks and relief decorations found on pewter spoon handles. Though bronze or brass molds were purchased, decorations could be added by further scribing or engraving of the molds. Some of these decorations are probably unique to particular molds, but cannot presently be attributed to particular people. CANADIANA, ROYAL ONTARIO MUSEUM

still appear on the market, though they are becoming uncommon, but marked plates and hollow wares are extremely rare.

We have no current idea of how great an original quantity of pewter was cast in Canada; it certainly never approached more than an infinitesimal portion of the volume of English imports, and most no doubt has long since been melted down for other purposes. Canadian pewter, therefore, fits all of the essentials for antique collectibility: it is relatively scarce whatever its type and, as a marked and identifiable form of tableware, it appears to have been produced for only a limited time period, and certainly not after 1830.

While pewter in early Canada was certainly not produced by any great number of makers, Canadian pewter has also been neglected as an antiquity. Its full range is unknown, and it has neither been examined in any depth, nor is there any existing writing on it. Collector recognition and attention, long overdue, could be a prime factor in discovering other markings, identifying other makers, and perhaps even confirming commercial pewtering to areas other than Quebec.

COPPERWARE

Another aspect of Canadian antiquities, marked copperware, while highly treasured elsewhere, has been virtually ignored in Canada. Copper, once an important material for many domestic utensils and cooking vessels, was being mined, smelted, rolled into sheet, and formed into utilitarian objects well before 1800 in the United States, and probably as early as the second quarter of the 19th century in Canada. Even competing with cheaper sheet iron, copper retained its popularity, and some forms of copper vessels were still being produced into the early 20th century.

Sheet copper was a most logical material for a great many objects. The metal is both soft and malleable, readily cut, and

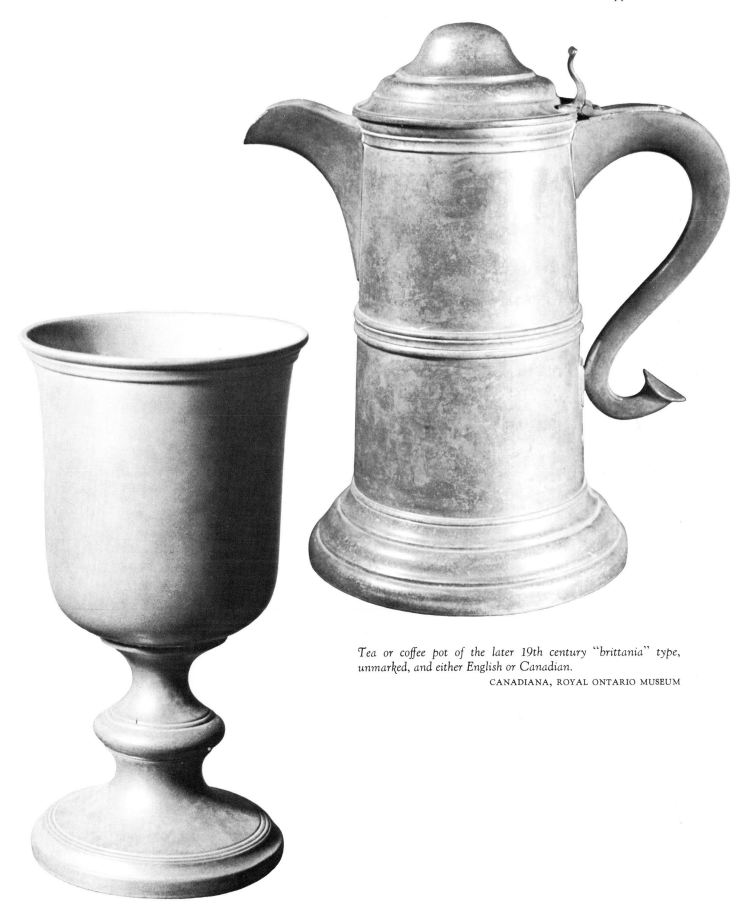

Tea or coffee pot of the later 19th century "brittania" type, unmarked, and either English or Canadian.

CANADIANA, ROYAL ONTARIO MUSEUM

Church chalice of brittania pewter, mid-19th century, and also completely unmarked. Pewter of this period is commonly found in Canada, but most is of English origin.

CANADIANA, ROYAL ONTARIO MUSEUM

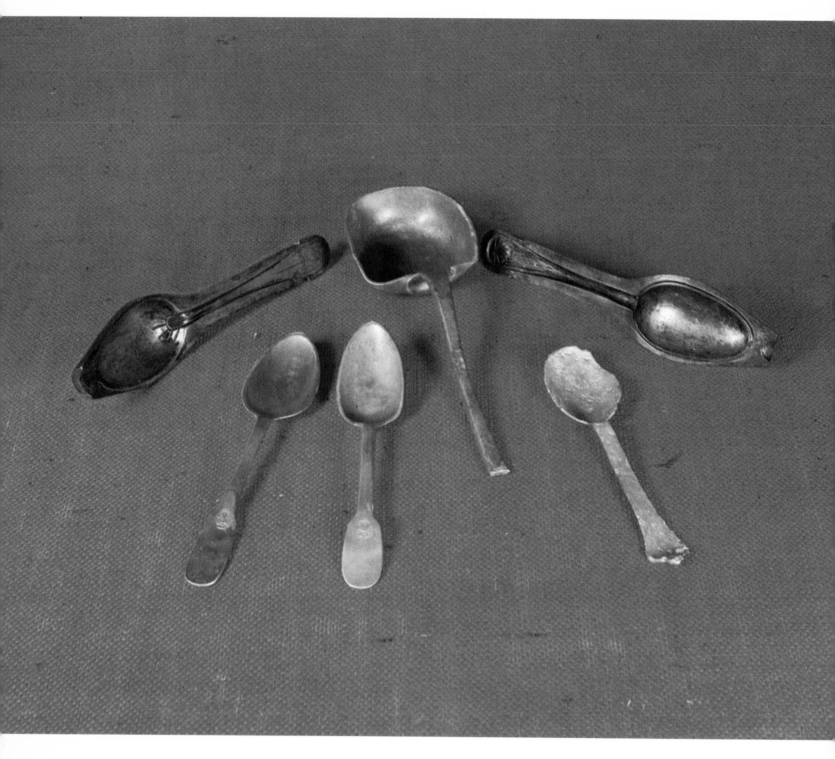

Bronze spoon mold and four spoons, the left spoon with an angel and I.M mark, C. 1860, and the center spoon and ladle with both beaver and T.M punches and a large-letter MONTREAL mark on the back of handles, C. 1810. The right spoon, with trifid-finialed handle, is probably French, dating C. 1700, from Fort Senneville.
CANADIANA, ROYAL ONTARIO MUSEUM

Spoons and ladle, the left three pieces punched with the Thomas Menut beaver and T.M mark on the handles (the ladle punched twice), Montreal, C. 1810. The two spoons at right are marked with the angel and I.M punch of Jean Baptiste Menut, of Montreal, C. 1860.
PRIVATE COLLECTION

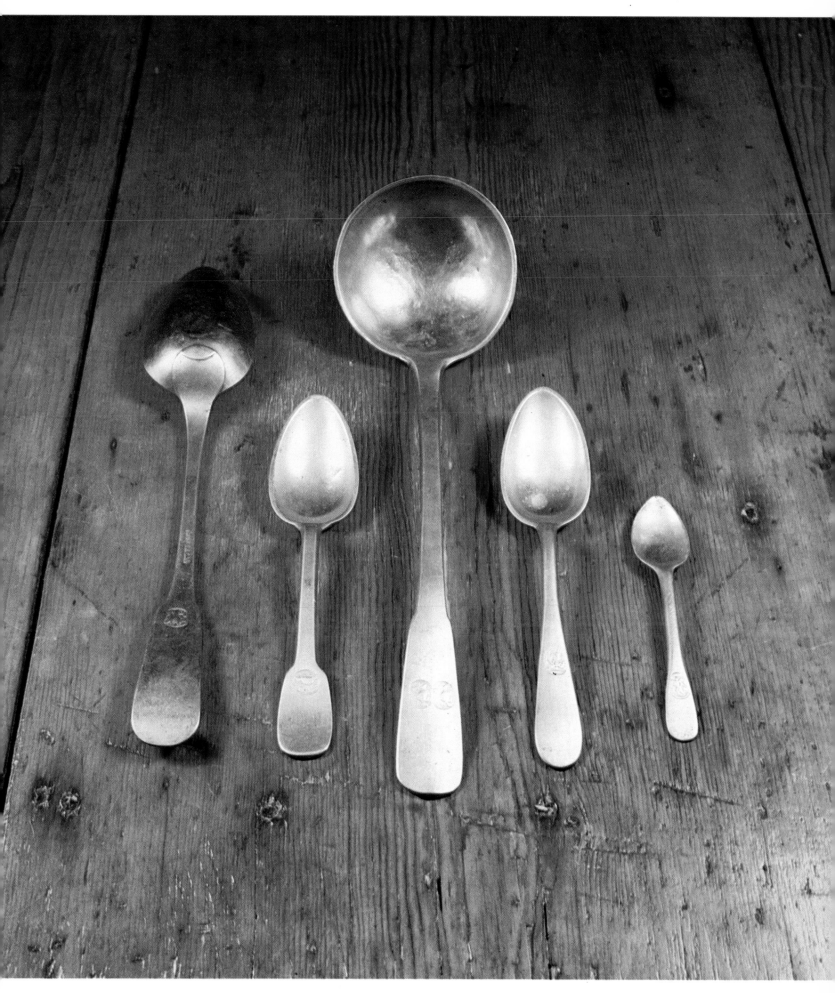

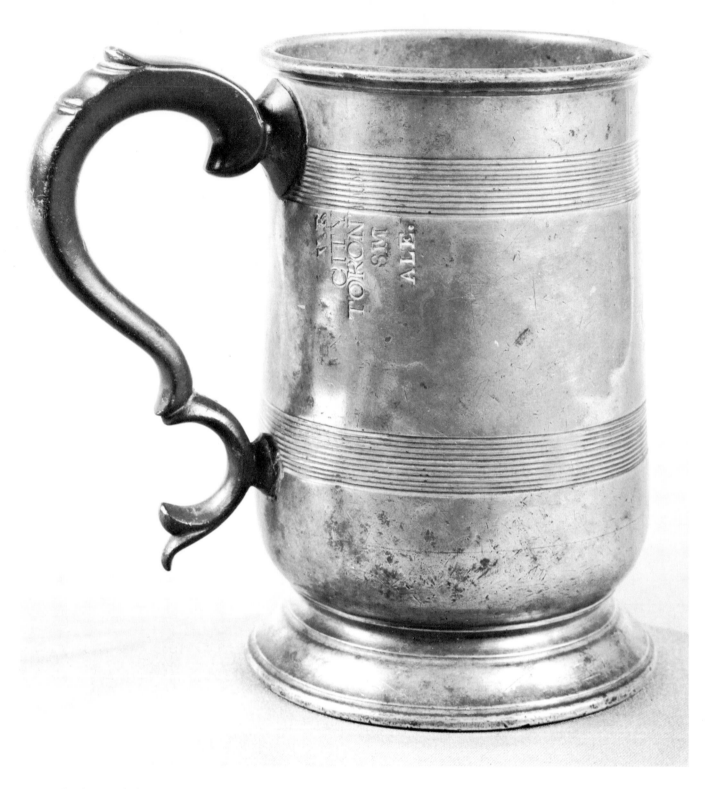

*Ale tankard of marked one-quart capacity, English, c. 1840–60,
with Canadian association markings. The maker's mark is
SURREY in a circle around the initial A, an unknown stamp. The
tankard is marked on one side V.R. [[Victoria Regina]]/CITY[[OF]]/
TORONTO/S.M./ALE, and is engraved with the initials R.M.S. on
the front in large script. This Canadian associated piece will bear
researching. One supposition is that the tankard may have
belonged to one of the several Great Lakes steamers by that name.
Another idea is that the piece was a city pub inspector's measure,
the S.M. meaning "standard measure," to assure customers of an
honest quart.* CANADIANA, ROYAL ONTARIO MUSEUM

Left: Water kettle of tin-lined copper, marked in relief on the side McClary MODEL / PAT'D 1903 / MADE IN CANADA. *Rather than the usual separate lid, this kettle has a hinged filler-hole cover.*
Right: Saucepan of heavy tin-lined copper, with riveted iron handle, and dating c. 1890–1900. The side of the saucepan is marked GEO. R. PROWSE RANGE CO./LIMITED/MONTREAL.

CANADIANA, ROYAL ONTARIO MUSEUM

Copper measures, c. 1855–60, for Gill and Pint, made and marked by G. YON/MONTREAL. *Such marked measures are most uncommon. Yon was listed as a Montreal tinsmith in 1857–58.*
▽ PRIVATE COLLECTION

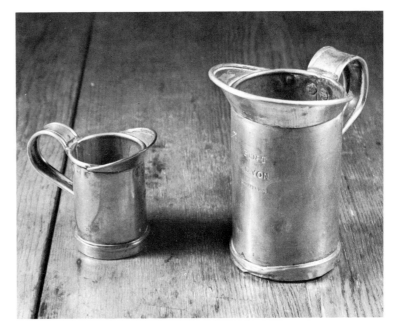

△
Tinned sheet copper plate with folded rim, a type probably manufactured in quantity by cold pressing. The plate is un-marked, but certainly Canadian, dating c. 1890–1900.

CANADIANA, ROYAL ONTARIO MUSEUM

easily joined by soldering, riveting, or rolling and crimping, or all three in combination. At one time it was fairly inexpensive, useful for any dry- or normal-temperature liquid containers, and suitable for heating to water-boiling temperatures—i.e., as water kettles or wash boilers. It is also, when polished, among the handsomer of metals, probably no small factor in its popularity.

Like pewter, the majority of early handmade copperware is unmarked, and thus not readily identifiable (as is also the case with American copper). Marked Canadian pieces so far observed mostly date from approximately the 1880–1910 period. Copperwares of this period seem limited to a few forms, though in some variation, such as water kettles, sauce-pans, and large boilers. Other forms—measures, funnels, churns, basins, scoops, dippers, mugs—are found occasionally, but only rarely are such pieces marked. Most, probably, were made earlier than the period during which Canadian copper seems to have been marked at all.

Observed pieces include substantial saucepans of heavy copper formed over a mold, tin-lined as were most copper cooking vessels, and with heavy iron handles attached by thick copper rivets. Two such saucepans, of different sizes, are stamped on the side A.T. ROUILLARD/MONTREAL. Another, very similar, is marked GEO. R. PROWSE RANGE CO./LIMITED/MONT-REAL. Both probably date c. 1880-1900.

Water kettles occur in many variations. One rather handsome manufactured model, still commonly found, is marked in relief McClary MODEL/PAT'D 1903/MADE IN CANADA. This is a product of the McClary Stove Company. Another larger kettle, c. 1905, is known, marked in its riveted iron handle mounts, G.S.W., and is attributed to a Winnipeg firm.

Copperware was finally made obsolete by the introduction of ever less expensive aluminum after 1900, and by steel enameled wares, both lighter in weight, far easier to clean in use, and non-corrosive. The American Sears, Roebuck cata-logue of 1897, already featuring aluminum, described the situation. "Aluminum being now nearly as cheap as copper, no one who has consideration for purity, cleanliness, durability, and the other peculiar quality of aluminum ware, should use any thing else. There are several reasons why this metal is so well fitted for kitchen utensils, among which are its lightness, its absolute purity (it is entirely free from all poisonous elements, no verdigris, or salts of tin) . . ." The only copper items that Sears, Roebuck still listed were tea kettles and wash boilers. The T. Eaton Company of Toronto in 1901 offered no polished copperwares at all, but only a single nickel-plated copper water kettle.

And thus another age-old craft declined, leaving another body of closed-ended objects to gain the interest of later antiquarians. Canadian copperware, though only the later maker-marked production is completely identifiable, very much exists. As with pewter, it remains for future academic and collector interest to discover just how great a range is extant in fact.

A note to collectors: It cannot be assumed automatically that any unmarked pewter or copper is Canadian, unless there is some solid evidence, such as absolutely known or documented origin. Both the Canadian and U.S. antiques markets are currently saturated with unmarked English and European pewter and copperwares. Some, perhaps, are early imports, but the great majority are recent importations by dealers.

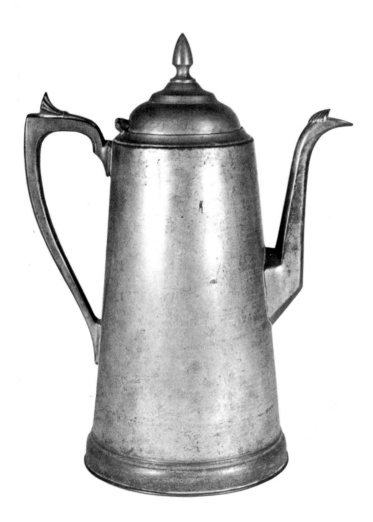

Tall teapot of formed and soldered sheet copper, tin washed except for the base. This teapot, c. 1880–1900, is stamped in the base MANUFACTURED BY/THE/C. & H. MFG. CO./TORONTO.

CANADIANA, ROYAL ONTARIO MUSEUM

Treenware
and
Wooden Utensils
Una Abrahamson

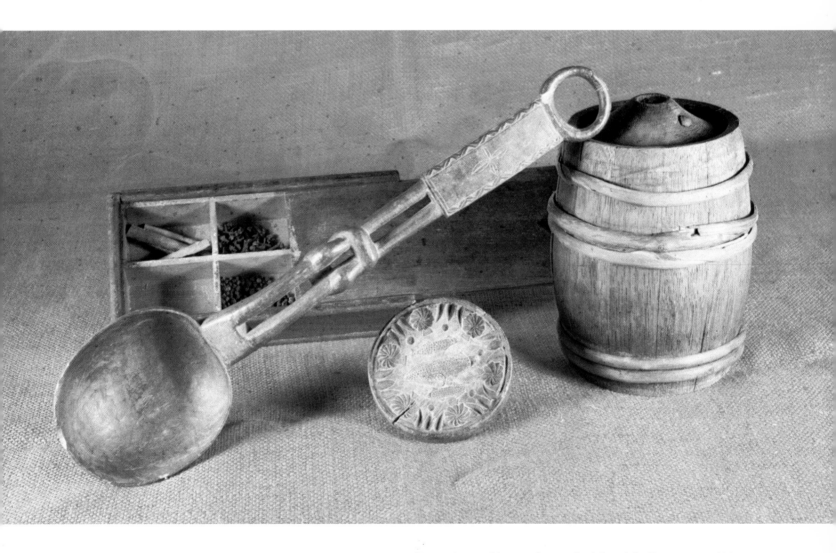

Rear: A portable spice-box with sliding lid, Ontario, c. 1870. Left to right: A large carved-handled dipper of maple, Quebec, c. 1840; a butter print with a finely carved design of pinwheels and three fish, c. 1840–60; and a small field canteen with cork-stoppered top made in the form of a small barrel, Ontario, c. 1860–80. CANADIANA, ROYAL ONTARIO MUSEUM

Treen is an ancient term for articles made of trees, and embraces the miscellanea of small wooden objects once used in the home, dairy, farm, trades and professions. The range includes pestles and mortars, barrels, locks, boxes, rolling pins, maple sugar molds and butter-making equipment. Objects intended for ornament, such as carved figures and panels, were not described as treen.

Woodenware is very practical; it replaces glass, pottery and metal. Therefore, fitness for purpose is one of its most distinguished features. For us, the inheritors, practical application is secondary, form and craftsmanship being of greater importance. In general, treen utensils are satisfying because they are unselfconscious; and having been made because of need and for daily use, they escaped gingerbread ornamentation.

There are few areas in the world young enough to enable the beginning of home life and food lore to be studied. North America is one of them, and Canada, in particular, because of its relatively short span of domestic history. Needless to say, the first settlers in any place were faced with domestic hardships, not the least of which was furnishing the household with tools and food. The families needed the basic utensils used in the kitchen today, plus all of those now used in the manufacturing of formerly homemade products such as cheese, sausage and sugar. The purchase of manufactured tools required non-existent cash money and, in most instances, the manufactured product was not even available.

Woodenware had served generations in Europe and became the mainstay of the American colonies, with designs reflecting those of the mother country. It follows that as commercially produced pottery, glass and metal goods became available, fewer treen pieces were carved, so that woodenware all but disappeared from the home by the end of the 19th century. Although similar articles were made for generations, the dating of pieces is difficult because there are no makers' marks or design books. While there are regional differences in the choice of wood, design and decoration, these simple objects, having once been designed correctly for a purpose, remained unchanged for years.

Great care was taken in selecting wood for the purpose, so that it would provide the necessary strength, and would be suitable for carving with the available tools. Workmanship was good and designs ingenious. In general, the hardwoods were used for pegging, the still harder woods pegged the pegs, soft wood cradled the load, and springy woods carried weight. Wooden pegs were frequently used, not only because of the shortage of metal, but because pegs or trunnels (tree nails) contract and expand and are much more practical. Our expression, "a square peg in a round hole," is frequently used incorrectly. Actually, this is an ideal situation because treen workers, like carpenters, knew that the combination of green wood with dry wood would remain together almost forever.

The choice of wood depended on the ultimate use of the article, and on availability, but some woods were sought out for their particular properties; for example, imperviousness to water, ease of handling, and hard close grain. It was also important that the wood chosen for household use should not add flavor to food either in preparation or storage. The woods most commonly used include pine, spruce, maple, cherry, walnut and butternut, but others were used for special purposes or simply because they were in good supply. Ash,

because it is hard and malleable, was used by coopers for barrel and firkin hoops. Birch, which is hard and has a close grain, and is sometimes wavy so that it is mistaken for maple, was used extensively for turned articles. Cedar was easily worked, and, because it can stand being water-soaked longer than most other woods, was the natural choice for pails, buckets, washtubs. Maple is hard and can take heavy usage, and so was used for mashers, beaters, mortars, and spoons. Pine is soft, easy to work, and was used, for example, for boxes to hold candles, salt, pumice, etc. The large wartlike growths called burls on many hardwood trees, but particularly on the maple, were very desirable, and although hard to work, were used for bowls because the grain runs in all directions and thus the bowl seldom splits or cracks.

A non-native wood used mainly for mortars and stirring utensils, in both home and apothecary, was lignum vitae, the "wood of life," imported from the West Indies and Central America. In the 16th century it was believed to be a cure for venereal diseases—the sawdust was mixed with water and dosed as a form of porridge. Its symbolic use in apothecary mortars is understandable, but the choice for domestic use was excellent because lignum vitae is hard-wearing and impermeable to water.

Pioneer housekeeping was far from easy and housewives had innumerable chores, one of them being the care of the precious treen. *The Cook Not Mad*, Kingston, U.C., 1831, published a recipe "To Prevent Wooden Ware From Cracking: After washing bowls, trays, etc. lean them up against something in the pantry, or anywhere in the shade to dry, and they seldom crack. The fire or sun inevitably riuns them." And treen that has survived needs care because excess heat and damp are still enemies. Remove any surface soil with a vinegar-dampened cloth. Items to be used for food can be oiled with corn oil; other pieces can be waxed and polished.

As late as 1877, *The Home Cook Book*, Toronto, (actually a reprint of a U.S. publication, with the title page changed depending on the location of the printer) gave a list of things "Necessary For The Kitchen Of A Small Family: Wooden ware: wash bench, wash tubs (three sizes), wash board, skirt board, bosom board, bread board, towel roll, potato masher, wooden spoons, clothes stick, flour barrel, cover, flour sieve, chopping bowl, soap bowl, pails, lemon squeezer, clothes wringer, clothes bars, clothes pins, clothes basket, mop, wood boxes (nests)."

There was a vast number of other wooden articles scattered throughout the home, including quilting frames, embroidery hoops, and sewing boxes. Boxes, of course, came in a wide variety, including containers for Bibles, documents, tools, cutlery and candles. Generally, the boxes made in Quebec and by those of German or Pennsylvania-German background are carved and decorated, the others are very plain and rely entirely on their finish, design, proportion and choice of wood. Pioneer children had wooden toys including whittled dolls, trains, wagons and farm animals, as well as rocking and hobby horses. And, of course, many had a Noah's Ark—one of the toys permitted on the Sabbath. Adult relief from hard work and tedium was sought through alcohol and tobacco, and the latter habit required snuff boxes, tobacco boxes (often lead or tin lined), and such accessories as plug cutters, slicing machines, and pipe stands, racks and trays.

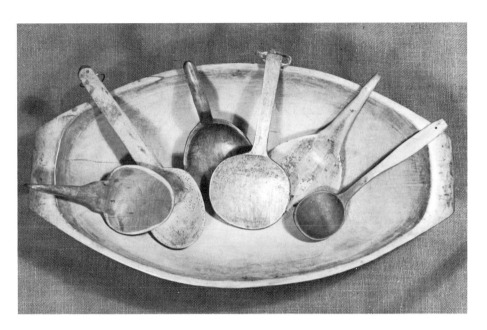

Paddle-spoons, largely of maple, used in butter and cheese making as well as for mixing dough. All are from Ontario, c. 1825–50, as is the oval maple dough bowl.

CANADIANA, ROYAL ONTARIO MUSEUM

Spoons and paddles, and a yarn skein winder, maple and pine, of the second and third quarters of the 19th century.

CANADIANA, ROYAL ONTARIO MUSEUM

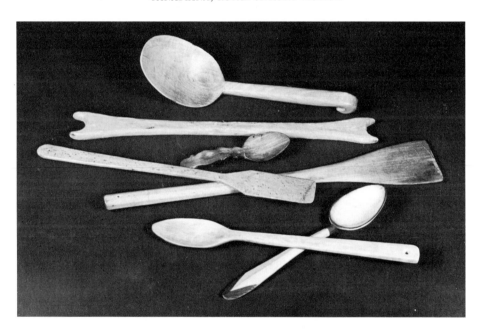

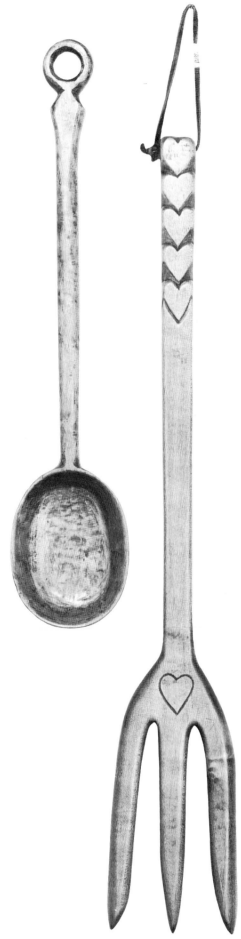

Kitchenware included spills and turned spill-holders for fire and pipe lighting; however, the earlier and most remote homes used tinderboxes. Later came containers to hold "punk," a type of fungus growth on decayed trees that dried to an excellent kindling. There were rake-boxes for collecting cranberries and blueberries, although cranberries growing close to the house were sometimes left on the bushes and buried beneath the snow to be picked as required. There were wooden funnels, sometimes also used for cooking "funnel cakes," a specialty of homes with European backgrounds. The pancake batter was poured into boiling fat through the funnel, which was jiggled to form initials, monograms and lace patterns.

Hand-carved spoon and heart-motif decorated fork, both of maple, from eastern Ontario, c. 1825.

CANADIANA, ROYAL ONTARIO MUSEUM

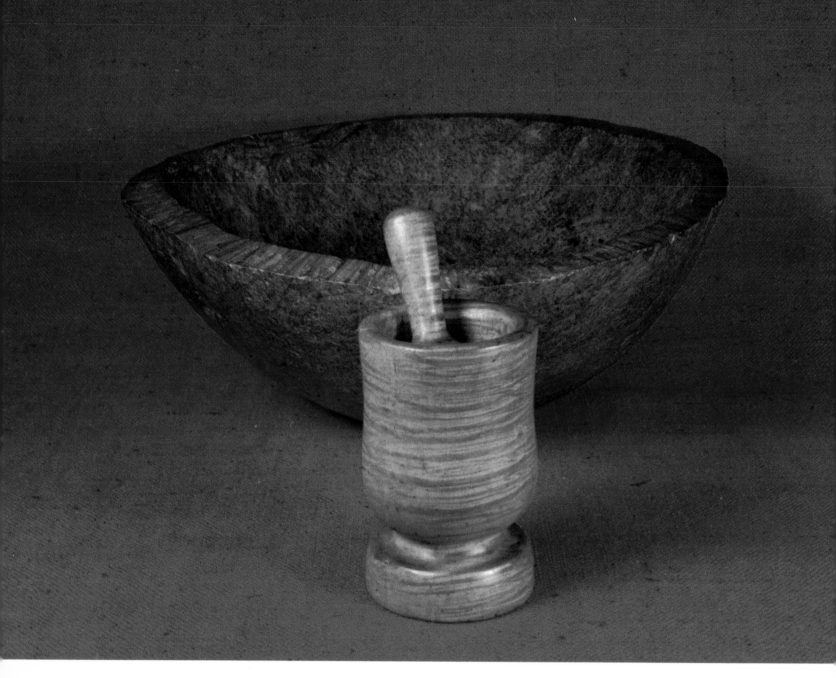

Finely turned mortar and pestle of curly maple, Ontario, c. 1820. Behind is a heavy hand-carved bowl of bird's-eye maple burl carved in the base, from northern Ontario, dated 1864.

CANADIANA, ROYAL ONTARIO MUSEUM

Pig killing was a fall ritual, supplying the family with pickled, salted and smoked meat for winter use, as well as with fat for cooking and soap making. Everything was used, apart from the grunt. All the utensils required for meat preservation were wooden including the butchering tables, salting trays, and barrels; and the sausage-making machines and grinders used a minimum of metal. There were meat (carving) boards with juice troughs, although roasts were not common, mainly because meat was tough. Long slow stewing not only tenderized the meat, but also allowed for unattended cooking while the family did other chores.

HOUSEHOLD UTENSILS

Baskets and brooms were made by Indians and sold to the housewives. Indian basketry is among the finest crafts produced in Canada. Baskets were made in many sizes and for many uses, from clothes baskets needed on washdays to conical containers to raise bread. Brooms were mainly for kitchen and dairy floors, the hearths usually being swept with a turkey or goose wing.

Boot jacks were required, to help in taking off high boots, and there are a variety of styles, but in general they resemble large clothes pins shaped to grip the heel.

Cabbage cutters were made of wood and had iron blades. Because of the heavy usage they were sturdy and generally consisted of an oblong frame with one or two cutting blades. Some large cutters have a compartment to hold a head of cabbage. The shredded cabbage was packed as tightly as possible into wooden barrels, because cabbage shrinks in the brine, and periodically the mixture was stomped down by somebody wearing a wooden shoe or using a very large beetle or masher.

Chandeliers were made by the early settlers of French background. They were generally of wood-turned spindles, and had metal arms and sockets.

Choppers have short blades with a cross-bar handle, and the blade may be straight on the cutting edge, or convex to use in a bowl or be rocked back and forth on a board.

Darners that were truly egg-shaped, or egg-shaped with a handle, could be older than the mushroom type. However, the large mushrooms are not darners but pressers, and were used for pressing water out of everything from cabbage to cottage cheese. The egg-shape darners are sometimes of solid wood, but occasionally unscrew as containers for needles and thimbles.

Egg cups and napkin rings are comparatively late 19th-century refinements.

Footwarmers and footwear. The former were designed for use in wagons and sleighs, and are basically wooden boxes lined with metal and intended to hold hot coals. The vehicles themselves were also made mainly of wood. There are wooden clogs and pattens, as well as skates. And, of course, good examples of "trade" treen are shoemakers' lasts. The early shoes were not shaped for right or left foot, but were sized and worn to shape; hence early housekeeping books have many recipes for corn removal. Shoes were expensive and, in the early days, homemade. In many areas wood was used to peg the uppers to the soles because it lasted longer than any type of sewing, which tended to rot in the wet.

Juicers. Fruits for juicing, such as oranges and lemons, were rare and very expensive although they were imported in steadily increasing amounts, and juicers were designed to use these fruits in cooking and in the many popular punch and toddy drinks. Many juicers are made of maple, but some are made of lignum vitae. The early juicers resemble a potato masher; later came the "mechanical" extractor consisting of two hinged sections of hardwood or, even later, of iron.

Knife cleaners. It is comparatively recently that knife blades have been made of stainless steel. The early knives became stained and discolored, although they held an edge longer than modern stainless steel. In most homes knife cleaning was considered a job for children, part of the dishwashing routine after meals.

The knife board was leather-faced or had a patented covering of Kamptulicon—a mixture of rubber and cork mounted on canvas. Emery powder or bath brick was sprinkled on the surface, and the dampened blades were polished on it. By the mid-19th century there were knife-cleaning machines shaped like drums. The knives were inserted into holes and a cranked handle turned the drum so that the blades came into contact with the cleaning powder. However, these machines were expensive and rarely replaced one-at-a-time knife cleaning by a youngster.

Mashers, tampers and toddy sticks. No kitchen was without a selection. There were large mashers for tamping down sauerkraut, small ones for mashing potatoes, and tiny ones for powdering herbs and spices. Made of hardwood, some had square corrugated heads to use as steak tenderizers. Squat heavy mashers were used to tamp butter into tubs and barrels. Very small ones are toddy sticks, used to crush sugar and to stir it into toddy, a hot fruit-flavored alcoholic drink. All were smoothly made, and some had heads at either end of the handle. The feed stick used in sausage-making was sometimes called a "podger" by English immigrants.

Nut crackers were a refinement, since most families were inclined to use a hammer and a board. However, nut crackers have a wide variety of mechanisms, including plain jaws, levers and screws.

Pestles and mortars also come in a variety of shapes and sizes, and were used to crush herbs, spices, sugar, etc. The earliest examples were made of wood, and this material continued to be used even after brass, iron, and marble became available. Generally the metals were used by the professions, and wood remained the domestic choice. Some large mortars were screwed onto stands, and very tall ones were used when it was necessary for the family to make their own corn meal or "samp."

Scoops were important in the home and the store. They were used to fill containers at a time when goods were not packaged and were shipped, stored, and sold from bulk containers. Similarly, ladles were used for liquids, and some were made with a hook on the back of the handle to prevent it from slipping into the liquid when at rest.

Shovels, spades and peels were made for specific purposes such as shoveling ashes (which were saved for soap making), and lifting bread and pies in and out of the oven.

Spatulas and spurtles were also made of hardwood because of the expected heavy usage. Spatulas are flat-bladed scrapers, stirrers and mixers. Spurtles are drumstick-shaped stirrers used in porridge making—the word being of Scottish origin.

Spice boxes come in various shapes and sizes. Some are pocket sized, and were carried on visits when people spiced their own drinks. These may have a small grater enclosed. Some spice boxes look like nests of small bandboxes, others look like miniature chests of drawers, and all still have a faint aroma of spice.

Spoon molds were block carved with indentations for spoons. Many of the early spoons were made of pewter, a soft metal that could easily be remelted and remolded from time to time. Molds with convex spoon-bowl impressions were used to restore the spoon bowl when damage was not too great.

Spools. Sewing thread was wound on wooden spools which were not discarded after use. The spools instead became toys or jewelry, and were often re-cut to become handles for chests and furniture.

Sugar nippers are metal scissors fixed to a wooden platform, used to break up blocks of white sugar, a very expensive commodity. The large lumps of white sugar were called loaves or cones depending on their size, and came wrapped in blue paper, which was saved by thrifty women because the dye could be soaked out and used for children's clothes.

Tea equipment included a variety of trays, although the old term was "tea board." There were also boxes to hold tea, known as "caddys"—the word being derived from the Malay "kati," meaning $1\frac{1}{5}$ pounds weight, which came to mean a box containing tea. Coffee equipment included jars for storage, and because coffee was purchased green, there were coffee roasters (usually made of iron) and coffee grinders. The major construction for domestic grinders was wood, with metal used only for the blades.

Towel rollers, rather like cased rolling pins, were part of every kitchen, and in the settlements with a German background the towels were covered, on special occasions, with an embroidered "show towel."

SPECIAL PURPOSE EQUIPMENT

Maple sugar. The utensils used to tap and collect sap and then to mold the cooked sugar are the most typically North American treen. Wherever there were stands of maple, settlers knew that the syrup and the sugar would add variety to the food and money to the purse. By 1851 Upper Canada produced over 3½ million pounds of maple sugar, and Lower Canada produced 6 million pounds, of which a great proportion was exported. Sugaring dates back to prehistory, when the Indians learned to tap certain trees, including the maple and the walnut, so that sap could be turned into syrup. They did this by pouring the sap into hewn-out tree trunks, and evaporating the sap by adding hot rocks.

The pioneers made collecting spouts of maple or pine, and buckets of cedar or maple. The latter were coopered and bound with wood or metal for additional strength. The sap was boiled in metal kettles and was transferred to wooden molds made of maple, cherry, pine or ash. In general, small molds were used for home consumption, although maple sugar was sold in one-, two-, three- or more pound blocks. The farmers of Upper Canada seldom carved their molds, usually relying only on expert choice of wood and careful craftsmanship with an excellent finish. The Québecois attracted customers and used their inventiveness to carve designs which included animals, flowers, hearts, fish, angels, and geometric shapes based on Indian designs. Some molds were very simple, being scooped-out hollows in blocks of wood, but others were elaborate sectional three-dimensional constructions. Getting the sugar out of the mold was a problem, and there were two solutions: grease the cups or use a sectional mold.

The latter were of two types. One was made by hollowing two thick pieces of wood, carving the hollows, and fitting the pieces together so that there was only a small hole through which the hot sugar could be poured. The other type was made in several sections by holding the pieces together with wooden pins and clamps. When the sugar was hard the mold was taken apart, leaving a block of sugar shaped like a Bible or a log house.

The art of reverse carving is very old and calls for much skill; furthermore, special qualities are required of the wood. It must be close-grained; free from knots; well-seasoned; not liable to warp, split or shrink during wetting, drying or change of temperature; and free from splintering. (Cookie molds and rolling pins used by pioneer women with a European background are made on the reverse carving principle, but contrary to popular belief, they were not used in baking. The dough was pressed into the mold and then unmolded onto a baking form.) It is mistaken, too, to believe that crudely carved molds are necessarily old. A few crude ones are, but generally, most modern molds are also crude.

The first run of sap in early spring was called the "robin run," and the final sap collecting was known as the "frog run." The turning of maple sap into sugar, molasses and taffy was a picturesque sight, and an occupation new to most settlers. It was also one of the most important household tasks at a time when sugar had to be imported. Sugaring went on day and night, and was an excuse for parties, dancing and courtship. Children threw hot syrup onto freshly smoothed snow to make taffy, and young women tried to throw the syrup into initials of a young man. Although sugaring was hard work, it was also a social occasion, and was often left to the women and young boys. Important as it was for household supplies, the men were needed for working in the clearings. Later, when the land was under cultivation, the men took over the sugaring, and increased the family cash holdings by sending what was not required for home use to the city markets and for export.

Butter. Buttermaking was done solely by women and children, and because the cows calved in the spring, summer was buttermaking time—only storage butter was available in the winter. The turning of cream into butter was tedious, and required both patience and skill. Even so, there were days, especially in thundery weather, when butter refused to come. Delay resulted in fatigue for the churner and a lack of rhythm, which in turn made for further delay. To keep rhythm women would sing age-old buttermaking songs. Among the most popular was:

> Come, butter, come,
> Come butter, come;
> Peter stands at the gate
> Waiting for a butter cake.
> Come, butter, come.

Because of the need for a regular rhythm it was against pioneer etiquette to interrupt anybody churning butter. If the "latch string" was out (and it usually was) and passers by stopped to visit, or a neighbor came to borrow fire or sugar, the visitor was expected to sit silently until the churning was completed. (Hinges and locks were also sometimes made of wood, and the latch was on the inside, but it could be lifted from the outside by a leather latch string passing through a hole. This might be pulled in at night but generally it was left out, hence the expression that epitomizes pioneer hospitality.)

There was a variety of churns, but the principle was the same with all types. Cream was pounded and mixed by a plunger until butter formed. Among the oldest churns are the uprights, worked with a staff and cross-dash or paddle, and this type required a great deal of laborious arm work. Upright churns were usually made with a barrel-body of staves bound with hoops. The cylinder churn with a crank handle on the side was less arduous to use, because it is easier to crank than to pound. The box churn had sloped sides, which facilitated cleaning, although some preferred the rocker churns; but no matter what method was used, buttermaking was hard and tedious work. Some churns had patented devices which allowed for the butter to be washed before removal from the churn; others allowed for the buttermilk to be withdrawn through a plughole in the bottom.

After the butter was churned it was removed with a wooden scoop and put into a treen bowl or placed on a board, to be pressed with the hands or with wooden paddles until the remaining liquid was worked out. (Surviving butter boards and bowls retain their slightly greasy finish.) Some farms making butter in quantity used wooden "butter workers" which were boxes fitted with a corrugated roller, and these were in use well into the 20th century. It was at this stage of production that carrot or marigold juice or yellow dye was added, to give the desired deep yellow. Salt was also added, the quantity being increased if the butter was going to be packed into a barrel for winter storage.

Butter was sold, fresh or stored, from a barrel or mold. Although the origins of the butter mold are not as old as the

maple sugar molds, butter molds grew from the same necessity; to identify a particular farm. As the cities grew it became profitable to send butter to town markets rather than keep it for home and neighbor use; again, it was a way of bringing in cash. Butter molds were made of hardwood and were usually rectangular or round, although there are some octagonal rarities. Most were carved with flowers, stars, animals or monograms, the earliest being hand carved and the later machine made, but it is difficult to determine age or origin of a mold by its design or shape, since all were made continuously. The small prints were intended for table use, the next size for home consumption, and the larger sizes molded butter into ¼-, ½-, 1-, and 2-pound blocks. Some of the commercial-type molds were metal banded, and the carved print could be slid through to different depths for giving different weights.

Other treen tools associated with buttermaking include curlers and patters. Butter patters or paddles are small ribbed bats used to prepare butter into small balls for the table, or to shape lumps into blocks when purchased from the barrel.

Cheese. Cheesemaking was one of Canada's earliest commercial enterprises, but its origins were in the home kitchen and dairy. This was another household task that took time and stamina. Not only did the milk have to be collected and separated, but rennet, which separates the curds from the whey, had to be prepared at home. Rennet is made from the stomach of many young animals, but most commonly from the maw or first stomach of a sucking calf. The stomach was thoroughly washed and salted, then stored either dry or in salt, or sometimes in a mixture of aromatic herbs and water. If washed between uses the rennet will last through many curdlings.

A solution of the rennet was stirred into the milk, and within an hour the curd was formed and then cut with a wooden paddle or cheeseknife so that the whey rose between the cuts. A cheese basket, a square or round wooden receptacle, was set on a wooden frame, called a cheese ladder, which was placed across the tub of curds. A cloth was laid in the cheese basket with the edges hanging over the sides, and as the curd was ladled into the basket the cloth was pressed to squeeze out the whey. Later the cloth was folded over the curds and the package was placed in a wooden press at low pressure. Gradually the pressure would be increased. Later the curds were removed, and salted or put into brine for several hours. Then a linen band or wooden hoop would be put around the edges to hold the soft cheese together and prevent cracking.

Early cheese presses had long control levers and heavy stone weights. However, some homes had "self-pressing" molds. These were wooden or metal cylinders about a foot deep and eight inches in diameter, with perforations over the surface and removeable lids at either end. The curd was put into the cylinder and the remaining whey oozed out. During the next several days the mold was turned frequently, until the cheese was firm enough to be lifted out. Other homes merely pressed the cloth-covered curds between two pieces of wood held down with stones.

By the 1860s, the first cheese factories were in operation and in competition. Cheese was an important export. At the same time there were competitions and rivalries between factories, farmers, and towns as to who could produce the best and biggest cheese. According to Mrs. S. Moodie, *Life In The*

Wooden-headed mallets, the upper two with heads of bird's-eye maple burl, and the lower piece with a turned head of walnut, all c. 1830–60. CANADIANA, ROYAL ONTARIO MUSEUM

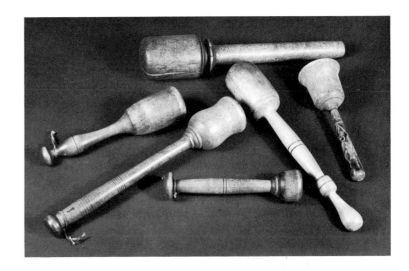

Potato and vegetable mashers of various types and shapes, all lathe-turned of hardwoods, mid-19th century.
CANADIANA, ROYAL ONTARIO MUSEUM

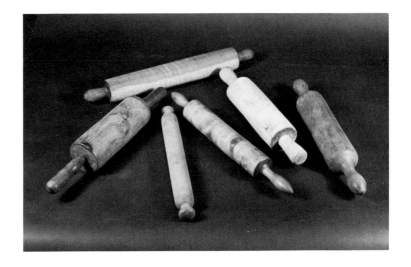

Maple rolling pins with solid handles, all of the mid-19th century. The variety in which lathe-turned utensils were made and still occur is virtually infinite. CANADIANA, ROYAL ONTARIO MUSEUM

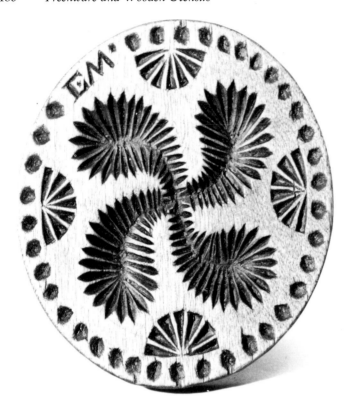

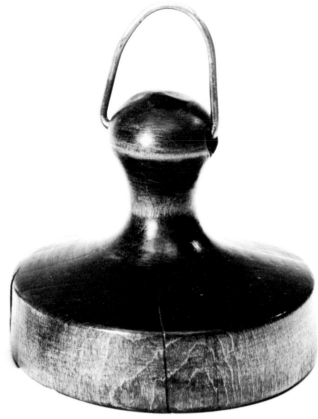

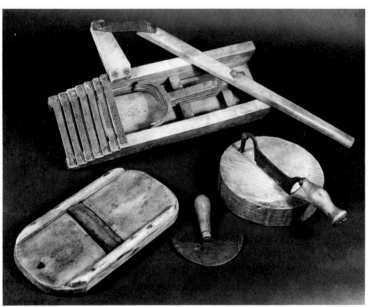

Butter press of birch, carved with a fern-like swastika design and the maker's initials EM., *from Nova Scotia and in a Germanic style,* C. 1825–40. CANADIANA, ROYAL ONTARIO MUSEUM

Household cutting tools, at the top an ingenious multi-bladed cabbage or carrot slicer, with a forked plunger to push whatever was to be sliced against the stepped blades. Left to right are a single-bladed vegetable slicer, a crescent-bladed chopper or rocker-knife, and a hinged knife for everything from vegetables to blocks of pipe tobacco. Handmade kitchen tools such as these virtually disappeared with the appearance of manufactured appliances in the 1870s and 1880s. CANADIANA, ROYAL ONTARIO MUSEUM

Clearings, London, 1853, one fair had a cheese weighing seven hundredweight, "not made of 'double skimmed sky-blue', but of milk of the richest quality, which, from its size and appearance, might have feasted all the rats and mice in the province for the next twelve months." And Canada may be the only country to have had a poet who devoted his talents to verses about bovines, milkmaids and cheese: James McIntyre of Ingersoll, Ontario. In the 1880s, he wrote about a monster cheese wheel that went to London, England, where it astounded one and all.

> To prove the wealth that here abounds,
> One cheese weighed eight thousand pounds,
> Had it been hung in air at noon,
> Folks would have thought it was the moon,
> It sailed with triumph o'er the seas,
> 'Twas hailed with welcome, queen of cheese.

Whether the cheese was made at home or purchased from the general store or market, it had to be stored, and the usual way was to take a clean wooden barrel and put in it a layer of fresh hay, then the cheese, then more hay, and so on until the barrel was filled. It was covered and stored in the cellar or a frost-free room, but examined periodically for vermin. If these became uncontrollable, the cheese was scraped, grated and melted into potted cheese with a liberal dollop of whiskey (if the family permitted the use of alcohol), and stored in a treen or pottery container.

Bread and baking. It took time to establish grist mills, and even then remote settlers had to grind grain for themselves. Many immigrants brought with them, or were familiar with, the mortar mill or quern. Hand mills are basically two circular stones, with a hole in the center of the upper one through which the grain is fed. A wooden handle turns the mill and the meal

falls from the sides of the stones onto a wooden tray. Corn, because of its tough outer skin, was difficult to grind in this way, and to overcome the problem a method of softening the kernels in lye water was developed.

One of the most important pieces of domestic woodenware was the dough box, which was developed so that bread dough could rise overnight free from draughts. Not only were the homes draughty, but homemade yeast was temperamental. Generally, dough boxes were lidded, rectangular, and had slanting sides. Those without legs were intended to be placed on the kitchen worktable. The lid was used as a kneading board, and some troughs were fitted with a long narrow rod to hold a temse or flour sifter. (Bread was often gritty because of the milling process, and usually included foreign matter.) To make the dough box watertight the sides were made from whole unjointed planks. More primitive trough-shaped boxes were hollowed from a section of pine log with an adz. In his *Early Settlement of Peterborough County* (1867), Thomas Poole gives us a description of the dough box in use:

A portion of a trunk of basswood tree about three feet long and two feet in diameter was split in two halves through the centre. One of these was hollowed out as smoothly as possible to be used as a kneading-trough. About three pounds of flour, with enough water to wet it thoroughly, was put into this and well kneaded. It was then flattened out and placed in a round long-handled pan, the front of which was held before the fire by means of a string attached to the end of the handle, while live coals were placed beneath and behind it.

Large wooden spoons or paddles were used to mix the ingredients, which could be any of wheat, corn, rye or buckwheat flours. A popular combination, and a thrifty one, was "rye and Injun"—a mix of rye flour and cornmeal. The dough was either kneaded on the dough box lid, in a deep round burl bowl, or in an oblong bread trough. For the second rising the loaf was sometimes placed in a woven basket, and among the Pennsylvania Germans the basket was conical. In some areas the bread was baked on a damp cabbage leaf or on corn husks, and was put into, and withdrawn from, the oven with long-handled wooden paddles sometimes called peels. Similar peels were used for pie baking but these were a little shorter and narrower.

The fresh bread was stored in wooden food safes, actually wooden boxes or cupboards with wire-covered windows or grille sides. Some were free-standing, but others, especially those of Quebec, were built into the wall. The eating of fresh bread was discouraged. It was more than a question of digestion, it was one of supply. Fresh bread was eaten too quickly, while slightly stale bread was easier to slice, and less was eaten since it was not as delicious. Bread was sliced on wooden boards, but bread bowls with the words "Bread" or "Give Us This Day Our Daily Bread," were popular towards the end of the 19th century as an alternative to the circular bread boards similarly lettered and sometimes carved with wheat ears. The earliest boards were, of course, just plain planks, and they were very expendable.

Sieves and sifters were important because the flour lumped easily. (There was a tendency for flour, particularly rye, to sour quickly, and to prevent this housewives kept large cool stones in the barrel. It was also necessary to turn the flour over

frequently.) Sieves were made with the outside rim of wet or steamed wood molded on a circular form, then pegged or nailed. The actual sieve was of woven horse mane or cow tail. Since a great deal of work went into making this utensil, it was highly valued. Sieves made entirely of wood with a perforated base are not true sieves, but are colanders used for draining liquid from solids.

A great deal of wood was used in the general baking equipment until factory-made metal utensils took over. The pieces ranged from doughnut cutters to cookie cutters, molds and pie crimpers. Doughnut cutters look somewhat like round butter molds with a rigid handle. The underside has an inner wooden cutting ridge, and the top has two small air holes. Pie crimpers and pastry jaggers were simple devices for cutting pastry, pie strips, cookies, and for fluting dough edges as well as sealing pie crusts. Most crimpers consist of a fluted wheel attached to one end of a short handle, and were used for both fluting and cutting. Some variants had a wheel at one end and a serrated jagger at the other end.

Rolling pins were used to flatten out dough, cookies, and biscuits, and the woods most commonly used were maple, cherry, and lignum vitae. Convex rollers were sometimes made so that pie crusts could be rolled thinner in the middle. There were many style variations in the handles of rolling pins, though some, of course, were tapered and without handles, in the French style. Rolling pins with a corrugated rib were not for pastry but were caramel crushers, and those with carved designs were intended for cookies.

In the days before the metal whisk or Dover eggbeater, small bundles of fine twiglets were used to smooth custards, and peach bundles were liked because they added flavor. Smooth rods were used to beat and whisk eggs and cream, and to mill chocolate and cocoa. These were important tools in the days when it was not uncommon for recipes to recommend that cakes be beaten for several hours. It was an age-old kitchen superstition that the hand should turn only in one direction. Wooden cooking and baking tools such as rolling pins, beating rods, and spoons were so necessary that a popular wedding gift was a handmade matched set.

Salt. Salt was a household staple that had to be purchased, and vast quantities were needed not only for the farm but for cooking, buttermaking, pickling, and preserving. It was purchased in blocks and was mortar-crushed before use. Nice cooks sifted it through a fine hair sieve after crushing, and then stored it in a wooden salt box close to the fire to prevent caking owing to damp.

There were two forms of salt storage containers, boxes that hung on the wall for the kitchen, and cellars for the table. (The word cellar comes from the French *salière*, meaning salt box, and is similar to the word "salary." Both words are derived from the Latin, *salarium*, the allowance of salt made to Roman soldiers.) Table salt cellars were made of wood, and were frequently chalice or egg-cup shaped, sometimes with shallow bowls to prevent lumping. Salt was taken with a small wooden spoon, the tip of the knife, or the fingers.

Storing, preserving and measuring. Clothes, blankets, linens, medicines, and foods required storage containers because few commodities were sold packaged and, of course, containers had to be designed to hold liquids as well as solids. In addition, measures were needed to weigh such items as

Carved sectional maple sugar mold forming a house, with a maple sugar house from a similar mold. This mold, of pine, is from Quebec, dating c. 1880. PRIVATE COLLECTION

spices, molasses, coffee, tea and meal. The first storage containers were of wood; the choice was large and included a variety of tubs, barrels, firkins, buckets and boxes—all available in many sizes, and some being nesting types.

Barrels and other watertight containers were generally made by coopers; however, there were many homemade containers constructed Indian-fashion by laboriously hollowing out logs. (The earliest meat storage barrels were 3 feet in diameter and made of hollowed logs. The method generally used was to burn the center, and this required patience and much fanning and blowing.) Barrels and buckets were made of closely fitted wooden staves. Buckets looked like small tubs and, frequently, two staves on opposite sides were left longer than the rest to serve as handles. Sometimes these were pierced so that a bucket of water could be carried by a rope handle tied from hole to hole. Occasionally, two buckets would be attached to a neck yoke, to balance the weight and to reduce the strain of carrying two buckets at once. Firkins were constructed of staves but were generally narrower at the neck, and in addition they had handles and lids. Piggins were smaller than buckets, but were made in the same way, being straight-sided circular vessels with an upstanding lug or ear used as a handle. They were used as drinking vessels and as dippers to ladle liquid from one container to another. Bickers were straight-sided drinking vessels, also of bucket shape and construction, and the name is closely related to the word, "beaker." Noggins were also drinking mugs. Some of these items were made to nest one inside another, and the names came with the British settlers.

Boxes were square, rectangular, oval or circular, and some were also jar-shaped. Some were lidded, some had coved lids, and many had sliding tops. They were used for a wide variety of storage, ranging from candles to bonnets. Many were made in graduated sets, and stencilled letters sometimes designated the contents. The circular boxes were coopered from strips of wood, softened in hot water and then wrapped around a mold, and lapped and fastened with pegs or nails. The bottom was inserted and held in place with small nails. Occasionally hoops were added to strengthen larger boxes. The circular boxes are associated with clothing storage, especially when they are lined with wallpaper or trunk paper. The smaller boxes are popularly called bandboxes, referring to the formerly fashionable lace and linen neck bands. Similar in shape to bandboxes, but sometimes less finely made, and often deeper in the small sizes, are cheese boxes, used to transport or protect it in the home and store.

There were wooden iceboxes, called "refrigerators" by contemporary writers when patents were issued at the beginning of the 19th century. These boxes were very simple, had a hinged door, air holes, and a shelf to hold ice. Most had a drainage hole, and while the earliest were quite crude, towards the end of the 19th century the mail order houses were selling "antiqued" models, and these were sometimes displayed in the dining rooms of the middle class. The early iceboxes, because of the problems of mixing smells and flavors and the tendency of the wood to retain odor, had to be washed daily—or so housewives were instructed. It was also suggested that one

Varied maple sugar molds of the later 19th century, the rear piece a two-section plank mold casting two beavers. To the left are one-piece molds making hearts and stars, and on the right is a four-piece mold forming a pyramid with vine decorations.

be kept for milk and butter, another for meat and cheese. While some liked the addition of a "furniture" icebox in the dining room, the majority of housewives kept theirs in the summer kitchen or on the back porch, believing that this would prevent dillydallying between iceman and the hired help.

For many homes the icebox was an exotic item. The majority of people preserved their food in the age-old ways of smoking, salting, and canning—methods that used many wooden utensils for both preparation and storage. "Salting in the snow" was a common method of preservation, and was explained by Mrs. S. Hale in *The Ladies' New Book of Cookery*, New York, 1852:

> Take a large clean tub, cover the bottom 3 or 4 inches with clean snow, then lay in pieces of fresh meat and cover each layer with 2 or three inches of snow taking particular care to fill snow into every crevice between the pieces and around the edge of the tub. Fowls must be filled inside with snow. The last layer must be snow, pressed down tight, then cover the tub and keep in a cold place—the colder the better.

Apples. Wild and cultivated apples were a staple in the diet and helped balance, to some extent, the steady intake of salt meat. Apples were dried for use in pies, tarts and cakes; cooked with ham (which helped cut the saltiness); turned into "sass" which was used as a sweet or spiced to a condiment; cooked with cider and sugar to a butter consistency and eaten as a butter substitute; and turned into cider, an important drink when milk was scarce, coffee expensive, and water doubtful.

The apple-preserving utensils, apart from the boiling kettles, were for the most part treen, and these included barrels, drying racks (although many homes simply strung pared apple slices on string), cider presses and apple parers. The earliest parers were wooden, using the minimum of metal, a cutting blade to pare and a fork to hold the fruit. However, from the first quarter of the 19th century on, patents were taken out for metal parers and these commercially manufactured gadgets eventually took over from the homemade treen. There were basically two types of apple parer: those designed with benches for large-scale operation, and those with clamps for use on the kitchen worktable.

The fall preparation of apples was the occasion for a bee in which the community's unmarried men and women participated. It provided an opportunity for them to meet because, like the corn husking bee, both sexes worked together and the evening ended with refreshments and games. One of these was the tossing of apple peel over the left shoulder to see if it made an initial, in order to divine the name of the future spouse. The atmosphere, and use of the apple parer, is well described by John C. Geikie, in, *Adventures in Canada*, Philadelphia, n.d.

> The young folks of both sexes are invited for a given evening in the autumn, and come duly provided with apple-parers, which are ingenious contrivances, by which an apple, stuck on two prongs at one end, is pared by a few turns of the handle at the other. It is astonishing to see how quickly it is done. Nor is the paring all. The machine makes a final thrust through the heart of the

Unusual wooden implements, on the left a horseshoe, fitted over the hoof and regular metal shoe, for horses working in snow, mud, or swampy areas. On the right is a wooden door latch, of pine, from a house near Markham, Ontario.

CANADIANA, ROYAL ONTARIO MUSEUM

apple and takes out the core, so as to leave nothing to do but to cut what remains in pieces. The object of all this paring is to get apples enough dried for tarts during winter, the pieces when cut being threaded onto long strings, and hung up till they shrivel and get a leather-like look. When wanted for use, a little boiling makes them swell to their original size again, and brings back their softness. You may imagine how plentiful the fruit must be to make such a liberal use of it possible, as that which you see all through Canada. You can hardly go into any house in the bush, however poor, without having a large bowl of "apple sass" set before you—that is, of apple boiled in maple sugar.

Trenchers and platters. Ceramic tableware was expensive, it broke easily, and one way of overcoming the problem of tableware was the making of trenchers and platters from wood. These could be fairly crude, a block of wood about ten or twelve inches square and three or four inches deep simply hollowed down to a bowl-shape in the middle. When the edges are rounded, the trencher becomes a platter, although the two terms are used synonymously. The occasional trencher shows evidence by way of marks and cuts that it was reversed, perhaps the stew first being put in the bowl and, when finished, the platter being turned over to hold pie.

The word "trencher" comes from the early English custom of serving food, in the days before plates were common, on a "tranchet" or long thick slice of bread that was depressed along the center to make a bowl. The quality of the bread depended on the social status of the diner, and it was considered good manners for the wealthy to leave the gravy-soaked trencher as a charitable offering for the poor. It is known that trenchers were sometimes shared. As late as the 18th century, the Duke and Duchess of Hamilton continued the old tradition of love and mutual affection and shared, according to W. C.

Hazlitt, *Old Cookery Books And Ancient Cuisine*, London, 1886. Certainly, there are records in New England of families sharing trenchers, not so much from affection as from need, but there is not at the moment much evidence of the custom being followed in Canada. On the other hand, there is no reason to suppose it was not. Eventually the sharing of a platter, and indeed the use of trenchers, became a sign of poverty, and treen tableware such as meat boards and other outmoded objects were made over to other uses or burned.

Laundry. Almost all of the vast amount of equipment required for laundry was made of wood, from the barrels for collecting fat for soap making to the boards required to polish shirt bosoms. Laundry actually began with the making of soap, although as quickly as possible this chore was passed along to the soapworks. To make soap, fat and lye were required, and the operation demanded hardwood ashes and stout watertight wooden barrels. Soap making required skill. The process was back-breaking, and not always successful. For this reason it was polite to wish soap makers luck or to ask God's blessing on them. The superstitious believed that soap would set better and quicker if it were stirred one way. But before the making could begin, lye had to be prepared from ashes, which were available in abundance from newly cleared forests.

To Put Up A Leach: Say A Large Tierce. Lay sticks across the bottom (of a barrel), then a covering of straw, one peck of lime should come next, after which the ashes, these to be well beaten down several times in the course of filling up, pouring in a pail of water each time after pounding. If you are in no hurry for your lie [lye], water your leach occasionally until it shows disposition to run at the bottom, then stop up until you are ready to commence making soap. It will make two barrels.

The Cook Not Mad, Kingston, Upper Canada, 1831.

Carving small boxes was a fairly common wintertime avocation in rural areas, usually from single blocks of wood very carefully shaped and fitted. On the left is a curly-maple trinket box with a fitted lid. The center piece is an Upper Canada Rebellion prisoner's box, of which some number of examples are known. This piece, of birch, is carved from a solid block and has a separate sliding lid with an engraved and inked scene. This box, "Presented to Mrs. Wm. Carrol / by John Anderson while a / State prisoner at Fort Henry / 1838," is dedicated on the reverse, as are all such boxes, to Blount and Matthews, the only two prisoners executed. On the right is a book box, of oak and bird's-eye maple, dating from the later 19th century.

CANADIANA, ROYAL ONTARIO MUSEUM

Jewelry, or book and correspondence box, with domed lid, carefully dovetailed corners, and bracket feet. This pine box is from Quebec, c. 1825, and is painted in its original dark green.

▽ CANADIANA, ROYAL ONTARIO MUSEUM

Before the soap making could begin, the lye had to be tested to determine its strength, and the usual way was to take a sampling and check if an egg would float on the surface. Fat is the basis of soap and it had to be collected and stored in barrels from one soap making to another. The fall pig killing would give the fat supply a good start, and it was added to with scraps from kitchen and table throughout the winter. The fat barrel was kept tightly closed and stored in a cool place, and as it became odorous in the early spring, plans were made for soap making, and there were as many different recipes for making it as there are recipes for cake.

The big household question was when to wash. No one could agree whether washday should be on a Monday or a Tuesday. Everything hinged on whether the housewife believed in soaking dirty clothes. If so, then Tuesday was washday, because soaking the clothes on a Sunday night was profanation of the Sabbath. However, this was town talk! In the early days, washday depended on a spell of warm weather, a supply of soap and water, and the time to launder. Illustrations of the period show women standing in the wooden washtubs pounding away with their feet or with wooden beetles, much as they fulled newly woven cloth in some areas.

By the time the first shanty home was left behind, washday was a thoroughly organized and dreaded day. The laundry area had a wet floor, steam billowed from the kettles and stoves, and the women were naturally exhausted and short-tempered. The number of articles that were required for laundering in a mid-19th century home gives some idea of the scale of operation. Harriet Beecher listed some in her *Treatise On Domestic Economy*, New York, 1849:

> A plenty of soft water is a very important item. When this cannot be had, ley or soda can be put in hard water to soften it; ... Two wash forms are needed; one for the two tubs in which to put the suds, the other for blueing and starching tubs. Four tubs of different sizes are necessary; also, a large wooden dipper (as metal is apt to rust); two or three pails; a grooved washboard, a clothes line, (seagrass or horsehair is best); a wash stick to move clothing when boiling, and a wooden fork to take them out, soap dishes made to hook on the tubs, save soap and time. Provide also a clothes-bag; an indigo-bag, of double flannel; a starch-strainer, of coarse linen; a bottle of ox-gall for calicoes; a supply of starch neither sour nor musty; several dozens of clothes-pins which are cleft sticks used to fasten clothes on the line; a bottle of dissolved gum Arabic; two clothes baskets; and a brass or copper kettle, for boiling clothes, as iron is apt to rust.

The majority of the items were wooden. Sticks were used to lift, push, and beat the boiling clothes. Sometimes these were plain sticks but they could be oar-shaped and were then called wash bats, beetles or paddles. Long treen scrubbing boards known as mangle sticks were the forerunners of the scrubbing board. These sticks had corrugated grooves cut into the thick wood, and the clothes were scrubbed against them and against the side of the wooden tub. Later the scrubbers became wider and eventually they evolved to a frame of wood, with the scrubber of metal or pottery. Water was wrung out of the clothes by hand or by a hand-cranked wringer with wooden rollers; these eventually became rubber. Other accessories included leg-shaped boards for drying stockings.

Although many settlers lived in primitive conditions, it should not be forgotten that household appliances came on the scene early. It was partly the lack of servants or their indifference to service that spurred the demand for machines to replace them. The early use of credit and the mail order catalogues as well as the persistent traveling salesmen, opened up the market. Laundry appliances were among the first labor-saving machines for sale, and the earliest models used a great deal of wood.

It was washing day, she helps her help in the laundry. But in well organized households, washing day has no terrors; it is a "heavy wash" that cannot be got through in two hours. There is no messing and slopping and rubbing as in an English farmhouse. With one of Doty's patent washing machines and wringers the linen is washed and wrung without the operator as much as wetting her fingers. It is only the ironing that is tedious, but in the woods a little ironing goes a very long way.

W. Stamer, *The Gentleman Immigrant*, London, 1874.

Ironing day followed washday, and for this a further long list of necessities had to be on hand. The wooden equipment included frames on which to air clothes, bosom boards for ironing, and in addition there were sleeve and skirt boards. Ironing boards were literally smooth rounded boards in various lengths and widths, at first without legs, being balanced across the table or chairs in a sawhorse manner.

Not exactly laundry, but part of the household cleaning equipment, were the long paddles used to smooth mattresses. Mattresses were filled with corn husks (the most economical), hair, straw or feathers. The latter were the most luxurious but they had a tendency to smell, and the filling was re-cured by being baked in a warm oven (after the bread was removed). But all mattresses became lumpy and were smoothed and pounded with long paddles.

Candles. Candlemolds were of metal, but the larger ones used for pouring eighteen or more candles were often steadied by being set into pine stands. Candle making took place in cool weather, and the freshly made candles were stored in closed wooden or tin boxes away from the mice. (Like soap, candles dry and improve with age, therefore it was economical to have stores of aging candles and soap.) Candle boxes were rectangular, with sliding or lidded covers. Similar boxes without covers are generally containers for kitchen cutlery and tools.

Home candle making took time and patience, and three methods were used: dipping, molding, and forming. The dipped candles are the slowest to make, as the prepared wicks are dipped into hot wax, cooled and hardened. The process must be repeated many times and it is important to maintain the correct temperature. If the wax is too hot it will not cling to the wick or the previous layer; if too cold, it clings to the bottom of the wick. Small boys hated candle-dipping because they were sent to the coldest room or to the yard with the trays of dips. When the wax began to harden they returned the dips to the warm dipping room, and took another set outside. Poured candles were easier to make, and the molded candle was the most primitive, of soft wax or fat hand-pressed around the wicking.

Wood is never a suitable material for candlesticks unless the socket is lined with metal; however, it is likely that more candlesticks were made of wood than any other material, simply because wood was easy to obtain. Candlesticks can be very sophisticated examples of the turner's art, or as crude as a board with a nail spike. However, because of the danger of fire not many wooden candlesticks survive, and settlers switched to metal as soon as they could—there were enough fire hazards without wooden candlesticks.

Toys and Games

Janet Holmes

Toys are a fascinating field for the collector, partly because they are themselves delightful objects from a child's world, and partly because they often mimicked the adult world and traced its preoccupations and amusements. Certainly this is true of 19th-century Canadian toys.

An agricultural country throughout the period, Canada was settled by people with the practical occupations of farmer, miller, blacksmith and carpenter. As population grew and towns developed, the demand for the work of more specialized craftsmen increased and attracted cabinetmakers, wood turners, potters, carriage and sleigh makers, tinsmiths, coppersmiths, and iron founders. It was these anonymous settlers and craftsmen who produced the earliest Canadian toys, simply made of wood or cloth, the craftsmen producing their own product in miniature, perhaps initially for their own children, and later upon special request or as a small sideline to their main work.

The desire for toys was also filled to a great extent by importing from the well-established toy manufacturers of England, France, and Germany, and after 1850, in gradually increasing numbers, from the United States.

German toys were the cheapest available, with metal toys, such as tin soldiers and trains, coming from the toy center of Nuremberg, and wooden and papier-mâché toys, such as platform pull-toys, rocking horses, Noah's Arks, farm animals and menageries coming from Sonneburg. Government support in the form of subsidies and special excise rates made it possible for German toys to sell at 30 percent less than French or English toys of the same quality in their own home market. Thus the English and French industries concentrated on the more expensive toys, with dolls and doll furnishings a specialty of the French trade.

Exchanging gifts at Christmas was not the established custom that it now is, and, in fact, the *Montreal Gazette* in 1810 and 1820 contained no December advertisement for toys or Christmas presents. However, by 1830 Adam L. Macnider advertised on December 20th a sale of "an invoice of toys" and Jesse Thayer, in the same *Montreal Gazette* issue, advertised:

JUVENILE CHRISTMAS PRESENTS
The subscriber has received a great variety of elegantly bound BOOKS, which were published expressly for the use of YOUNG PERSONS; comprising, The Garland, Youth's Keepsake, Scott's Poetical Works, Beauties of Waverly, Family Monitor, Rinaldo and Rinaldi, Gulliver's Travels, Zimmerman on Solitude, Bennett's Letters, Carcanet, The Casket, Gil Blas, Watt's Hymns, Idle Hours Employed, a Nutshell of Knowledge, Parley's Animals, Night Thoughts, Thinks-I-to-myself, Relics of Antiquity, Dodd on Death, Brown's Concordance, Course of Time, Unique, The Boarding School, The Humourist, The Looking Glass, a few splendid albums, Illustrations of the Atlantic Souvenir, a great variety of Toy Books, all of which are recommended for Parents as handsome and useful presents to Young Persons during the approaching Holidays. Also a few copies of Lady Morgan's France in 1829-30.

Although the list contains some adventure books, the emphasis was on usefulness, and some of the titles underline the serious and moral educational aspects of children's amusements of the time. The "toy books" provided a figure, with several costumes that could be cut out and put on it, or a number of moveable heads to be placed on different costumes. From these developed the later paper dolls. In 1839, H. C. McLeod's advertisement in the December 21st *Montreal Gazette* included "an elegant assortment of ENGLISH and GERMAN TOYS: composition and other DOLLS, dressed and undressed, and an extensive variety of other FANCY ARTICLES suitable for Christmas and New Year's presents." It was fairly common to sell the dolls "undressed" and sometimes only the dolls' heads were sold. Those lacking bodies and clothing were completed at home by the women of the family.

Auction was the normal selling process for household goods, and for the early importers of wine, toys, etc., up to the 1840s, when more specialized importers and wholesale dealers became middlemen in forwarding and distributing

goods from the major cities. By the 1850s English, French and German toys were advertised by the importers, including "Cricket batts and balls, Cricket Gloves and Belts, Wax and Kid Dolls, India Rubber Dolls' Heads, Slates and slate pencils, Chessmen, Dominoes, Pope Joan and Cribbage Boards, Backgammon Boards and Playing Cards, dissected maps and games," advertised by J. W. Skelton, a Toronto "importer and wholesale dealer in Jewellery, English, French, and German Fancy Goods, fancy hardware, umbrellas, parasols, willow wagons, brushes, baskets, Toys, Combs, etc."

During the early part of the century, cheap imported wooden toys such as the Dutch penny-dolls were probably sold through the countryside by itinerant pedlars. By the 1840s, alongside the more specialized wholesale trade, a similar retail trade had grown up. Toy sales, then as now, were too seasonal to allow anyone to deal exclusively in toys, and they were usually sold along with fancy goods, millinery, jewelry and wallpaper.

In Canada the range of 19th-century handmade toys remained fairly simple and was almost entirely limited to wooden toys. Since the forest had to be cleared before a home could be built and crops planted, wood was plentiful for building, for burning off to make saleable potash, for carving simple kitchen spoons, rolling pins, butter prints and maple sugar molds, and for making toys. The simple toys that remained in favor in the 19th century continued traditional European forms that had been popular in the 18th century or earlier. The most common seem to have been hobby horses, rocking horses, horses on wheeled platforms, horse or ox and cart, cows, and wooden dolls and doll furniture. These wooden toys, which could be made easily by a family member, were also the basic items made by the early toy manufacturers, whether German, American, or Canadian, and they continued to be made into the 20th century.

△
These hand-whittled dolls, one articulated and one standing, are typical of the types of toys which could be made very quickly of scrap pine, with a mother or child providing clothes later. Both dolls are without arms, but are complete with rudimentary navels and breasts, and date from the mid-19th century.

QUEBEC MUSEUM

Solid-bodied rocking horse, starkly carved of maple, and painted black, with uprights attached by pinned mortise-and-tenon joints in the same manner as pinned furniture, Quebec, c. 1830–60.
▽ CANADIANA, ROYAL ONTARIO MUSEUM

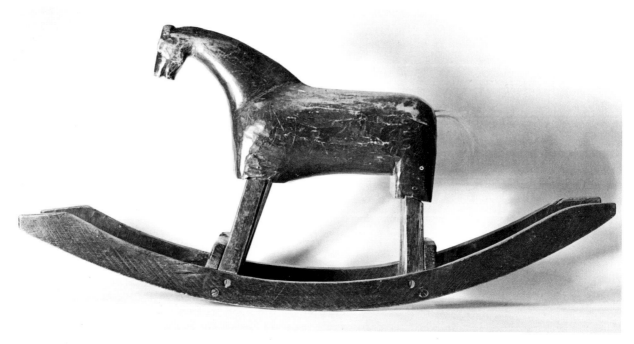

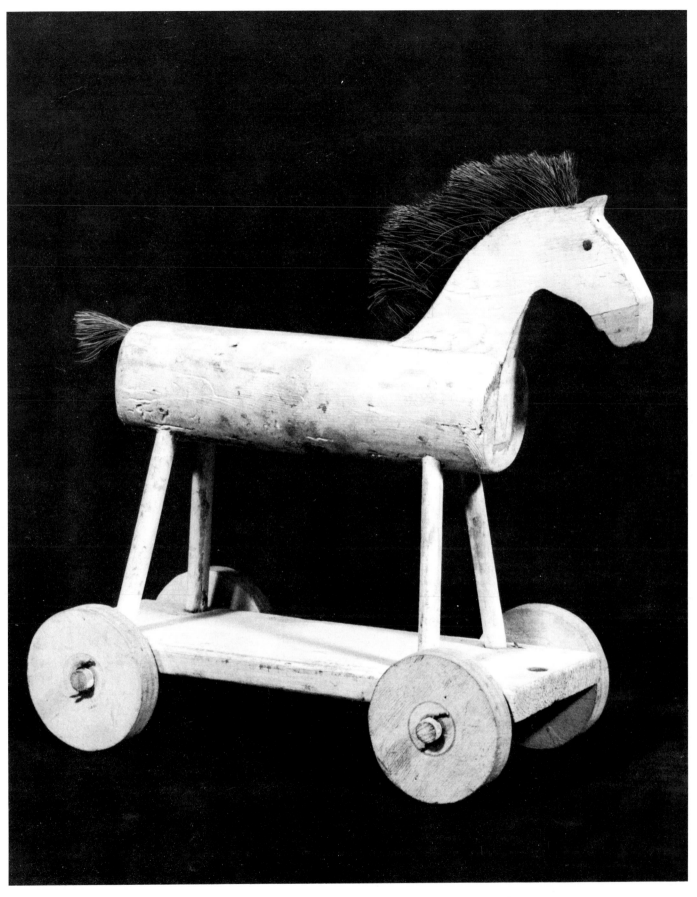

This simpler solid-bodied horse has a head of pine inlet into a segment of smoothed pine log, from Quebec, c. 1880–1900. The wheeled rather than rocker base is most unusual, since this is a child's riding horse rather than a small pull-toy.

QUEBEC MUSEUM

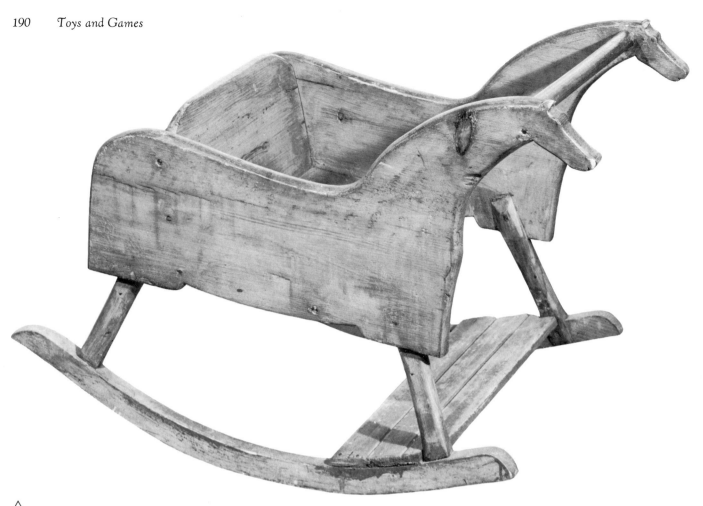

△
Double-sided pine rocking horse, enclosing a seat, with legs dove-tailed and pinned into both horse cut-out sides and the rockers, Quebec, c. 1840–60. CANADIANA, ROYAL ONTARIO MUSEUM

Double-sided and seated rocking horse, with the horses gaily painted and dappled, of pine, from western Ontario, c. 1880–1910. DOON PIONEER MUSEUM
▽

Rocking horses range from primitive ones with barrel bodies, roughly shaped heads, sometimes wild-looking eyes, and broomstick legs, through ones with shaped stairway banister legs and dappled painted bodies, to very realistic prancing horses, made from odd pieces of wood, but well joined and glued and with head details carved by a careful craftsman. The ones with banister legs were probably made by small woodenware manufacturers, while the more elaborate and realistic ones were likely the product of toy factories. Some made in the United States by the Crandalls, a family toy-making firm, in the 1860s even had leather skin covering the body and horsehair mane and tail. The platform rocking horse, an adaptation first made by Jesse Crandall, using springs attached to the platform to give the rocking motion, was made in the 1850s to answer mothers' complaints about the regular rocking horses wearing paths through their rugs. Another type of platform rocker, using V-shaped iron rods to suspend the horse, appear in United States toy catalogues as late as 1912.

Another adaptation of the rocking horse was patented in 1859 by Jesse Crandall. It was for small children who could not yet keep their balance on the wooden horses. He made for them a rocking horse of two flat boards cut in a horse's shape, but with a flat seat between them, set on rockers. It was called a "shoo-fly," and was practical and easily enough made to inspire homemade copies. Two that I have seen come from the province of Quebec, one unpainted, the other painted with red rockers, and a white horse, dappled black.

The platform pull-toy horses also vary greatly in execution. Some have the barrel bodies and stick legs of the primitive rocking horses. I have seen four or five identical ones around Montreal and in eastern Ontario, all painted red, and they may possibly be of Montreal origin. Several platform horses I have seen rest on plywood platforms. Since plywood was first factory-produced in Russia in the 1880s and fairly soon after that in other countries, these toys must date from the 1890s or early 20th century. They represent, however, a simple and small manufacturing production and are still desirable collector's items.

There are also the free-standing horses, smaller than the rocking horses, but larger than the platform toys. Many seem to follow a rather complex pattern; the head and a thin strip down the back are made from one piece of wood, sometimes allowing for an insert of horsehair mane. Each leg, joint and part of the body is cut separately to pattern and the five pieces are then glued together. These elaborate versions probably also come from a small factory rather than an individual craftsman.

The reason for this preoccupation with horses is not difficult to discern. The horse was very much a 19th-century presence, for livelihood from tilling fields, for carting produce and wood, and for family transportation. In boys' affections, this animal once occupied that special place now reserved for cars, planes, trains and space ships.

One other toy, most popular in Quebec and made by wood-turners, was the simple turnip-shaped top. Made of wood, through which ran an iron rod, these toys appear in varieties of that basic shape, some plain and some with traces of colorful paint.

The earliest craftsmen to advertise themselves as toymakers in Canada were making wooden toys, one in Ontario, the other in Quebec.

Mositz Lindner was born in Germany in 1816 and settled in Waterloo County, Ontario, in 1867. By 1881 he is listed in the *Illustrated Atlas of the County of Waterloo* as living in Berlin (now Kitchener) and as a maker of rocking horses and toys. It seems likely that he trained in Germany as a toymaker and simply continued this line of work when he arrived in Waterloo County in 1867.

Edouard Alfred Martineau was listed as a hairdresser in a Montreal directory for 1868–69 and by 1876 as a manufacturer of wooden toys and importer and dealer in wallpaper, stationery, fancy goods, etc. By 1914, the last year he is listed, his name appears under the heading "Smallwares & notions," but it is quite possible that the smallwares were still the wooden toys he had been making earlier.

Cosgrave and Co., listed as toy manufacturers in 1890–91, and the Berlin Novelty Works, making hobby horses in 1899, also worked in Berlin, Ontario.

All the toymakers mentioned, even those whose product was not specified, were undoubtedly concentrating on the rocking horses, hobby horses, platform pull-toys, carts and wagons that seem to have been the typical wooden toys produced here in the 19th century.

Other toys connected with transportation were carriages and sleighs. In Toronto from 1867 to 1880 there were several makers of children's carriages: George Phipp, 1867; Benjamin Sharpley, 1867–1874; Edwin Wilby, 1867–1880; and, William Ussher, 1873–1880. Although these carriages were child size, it is possible that toy carriages were also made. In 1869, between March 24th and May 1st, three separate patents were registered in Canada for velocipedes, a three-wheeled carriage run by foot or hand pedals, a toy that had become popular in the 1840s in the United States. In 1876–77, H. Whiteside & Co. of Montreal made as their main line "Whiteside's Patent Spring Bed, mattresses and bedding," and children's carriages as a sideline.

Several companies were making toys, carriages and sleighs. In 1878, H. A. Ziegler, of Berlin, Ontario, advertised as a "Wholesale and retail manufacturer of children's carriages, sleighs, toys and varieties." Another company, operating in Toronto from 1880 to about 1890, was the C. T. Brandon Co., who made a wide variety of wooden goods and notions, including churns, washing machines, tool handles and boxes. In the toy line, in 1880 they advertised Indian clubs and baseball bats, but by 1890 had expanded production to make "children's sleighs, standard and professional croquet sets, toy wagons, toy carts and toy washboards." In 1892–93, the Novelty Manufacturing Co. of Newmarket, Ontario, made "children's carriages, bicycles, tricycles, velocipedes, dog and hand carts, wagons, sleighs, doll cabs, and reed and rattan furniture." The Gendron Manufacturing Co., Toronto, made children's carriages, wood toys, carts, wheelbarrows, etc., and was one of the longest-lived Canadian toy companies, operating from 1890–1942 under the Gendron name. In 1942 it merged with another company that also made toys, becoming the McFarlane-Gendron Manufacturing Co. From 1890 to 1899, J. C. Cooper of Hamilton was a wholesale manufacturer of children's carriages and toys, and apparently published an illustrated catalogue in 1890. It would be interesting to see a copy of that catalogue.

In 1899, three baby carriage manufacturers are noted: the American Rattan Co. of Toronto, the Baer Brothers of Windsor,

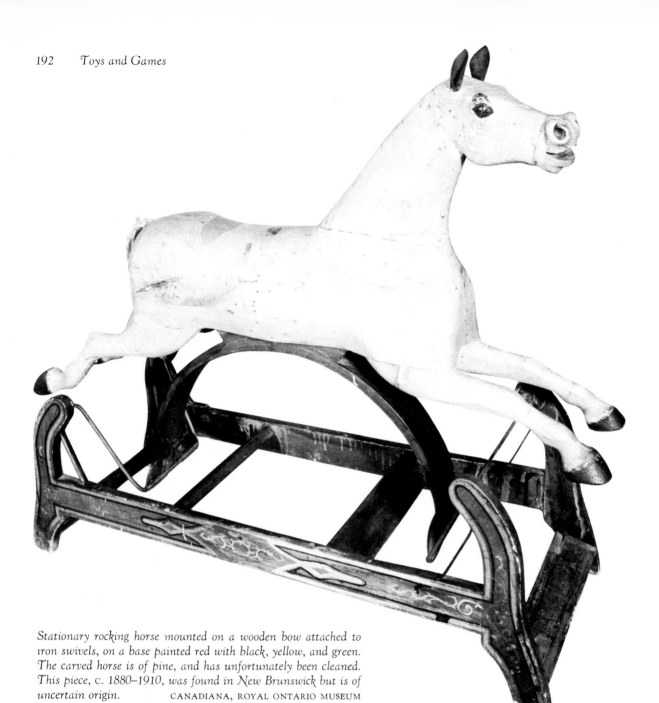

Stationary rocking horse mounted on a wooden bow attached to iron swivels, on a base painted red with black, yellow, and green. The carved horse is of pine, and has unfortunately been cleaned. This piece, c. 1880–1910, was found in New Brunswick but is of uncertain origin. CANADIANA, ROYAL ONTARIO MUSEUM

Child's wheelbarrow, ruggedly made of pine boards, and with a small cast iron wheel that appears to have been a large valve-handle. Quebec, c. 1860–80.

CANADIANA, ROYAL ONTARIO MUSEUM

At the left is a three-wheeled doll carriage with folding top, an early manufactured piece dating c. 1870, with original blue paint over pine, and red wheels, from central Ontario. The doll is a French porcelain importation. On the right is an unusual pivoted horse pull-toy, the horse hand-carved in pine and dappled in blue. An offset axle connected to a wire rod causes the horse to pivot forward and back as the toy is pulled. This horse, dating c. 1880, was found in Quebec. CANADIANA, ROYAL ONTARIO MUSEUM

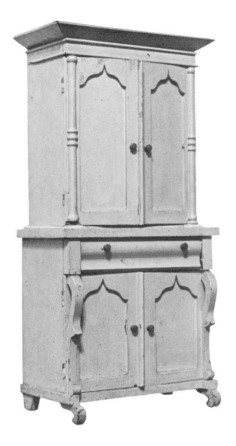

Doll house boxes are uncommon, particularly as perfect miniaturized versions of larger pieces. The paneled chest, left, is constructed in the same manner as full-sized Quebec boxes, with corner posts into which cross-pieces are tenoned and pinned, and has its original green paint, c. 1820–40. The dome-lidded, bracket-footed box on the right is decorated in white, yellow, and red over green paint, and is from central Ontario, c. 1850–60.

CANADIANA, ROYAL ONTARIO MUSEUM

Doll house furniture was made in virtually all forms of actual furniture. This miniature two-tiered cupboard, in the Empire style and with Gothic arched panels, is from Quebec, dating c. 1850–60. PRIVATE COLLECTION

Doll chairs would serve large dolls or small children equally well. The left chair, of pine with inlet seat, is from Quebec, c. 1860. The ladder-back chair, of maple and ash with splint seat, is from Ontario, c. 1860–80. A European import, the doll, probably of the 1890s, has German porcelain legs, hands, and head.

CANADIANA, ROYAL ONTARIO MUSEUM

Small Ontario-German doll cradle, of pine with carefully dove-tailed corners and heart motif cut-outs as handles, and painted in ochre red, c. 1850. DOON PIONEER MUSEUM

Horse and cart pull-toy, painted red, c. 1860–80. Animal and cart toys of this type were a particular favorite in Quebec.
PRIVATE COLLECTION

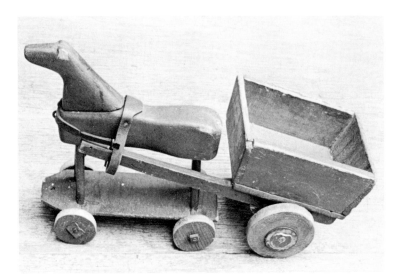

Whittled horse pull-toy with cart, simply made of pine and painted, and with recycled sewing-thread spools as wheels for the horse, Quebec, c. 1860–80. PRIVATE COLLECTION

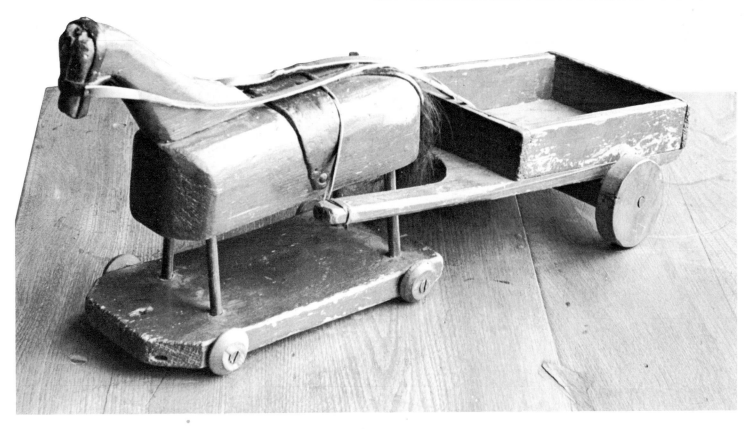

This staring horse, lacking its saddle, is of a size for a child to sit upon, but has never had rockers. Painted black on white, it is carved from a single log, with head and legs attached, and was found in western Quebec, dating c. 1850–70.

CANADIANA, ROYAL ONTARIO MUSEUM

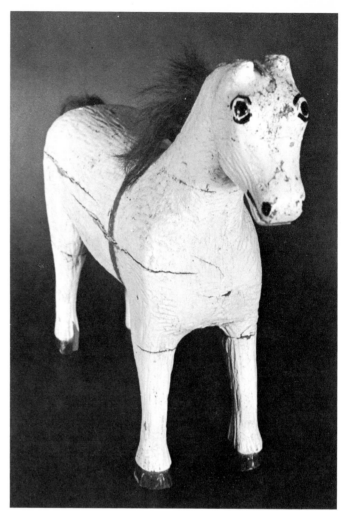

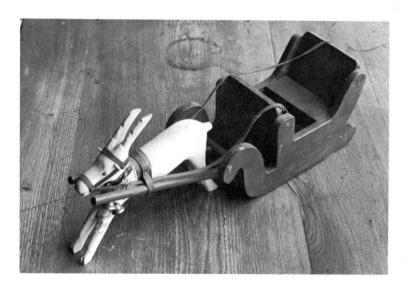

This reindeer and sleigh, complete with small bells, is very unusual, and may have been carved as a Christmas present. Also from Quebec, this piece, painted white and red, dates c. 1900.

PRIVATE COLLECTION

Differences in approach and in carving skill are apparent between the ill-tempered horse on the left, and the primitive creature, fully harnessed, on the right. Both are from Quebec, dating c. 1880–1900.

PRIVATE COLLECTION

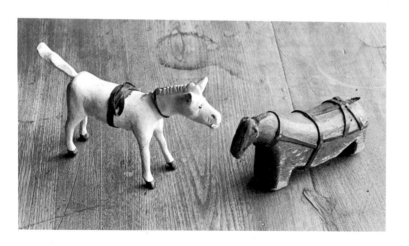

Ontario, and the Anderson Furniture Co., in Woodstock, Ontario. Although not shown under toymakers, these last three may also have made toy carriages.

These early children's and toy carriages followed the styles of the adult-sized carriages, the phaetons, and later fringe-topped surreys, usually in wood, but by the 1880s and 1890s also in rattan. Some were three-wheeled, while others kept the usual four-wheel arrangement. Both types normally had a handle extending at the back of the carriage for pushing it along.

The carriages, sleighs, velocipedes, wagons and carts, in Canadian toy manufacturing that developed in the late 19th century, held as important a place as the horse in its various forms. While the horse toys are an example of traditional handcrafting being extended into small factory production, the toy-carriage trade is an example of a specialized trade making a smaller version of its main product. Although certainly simple carriages and carts could be made at home or by small woodenware makers, the five firms advertising toy carriages were also making the larger and functional children's carriages.

With toy carriages we have arrived at toys made for girls—the dolls, toy furniture, utensils and doll houses.

English toy books illustrating a cut-out figure with changeable costumes were sold here in the 1840s. No doubt inspired by some of these examples, young girls also made their own paper dolls. One beautiful hand-drawn and watercolored paper doll with various costume changes, dating about 1850, is now in the collection of Upper Canada Village at Morrisburg,

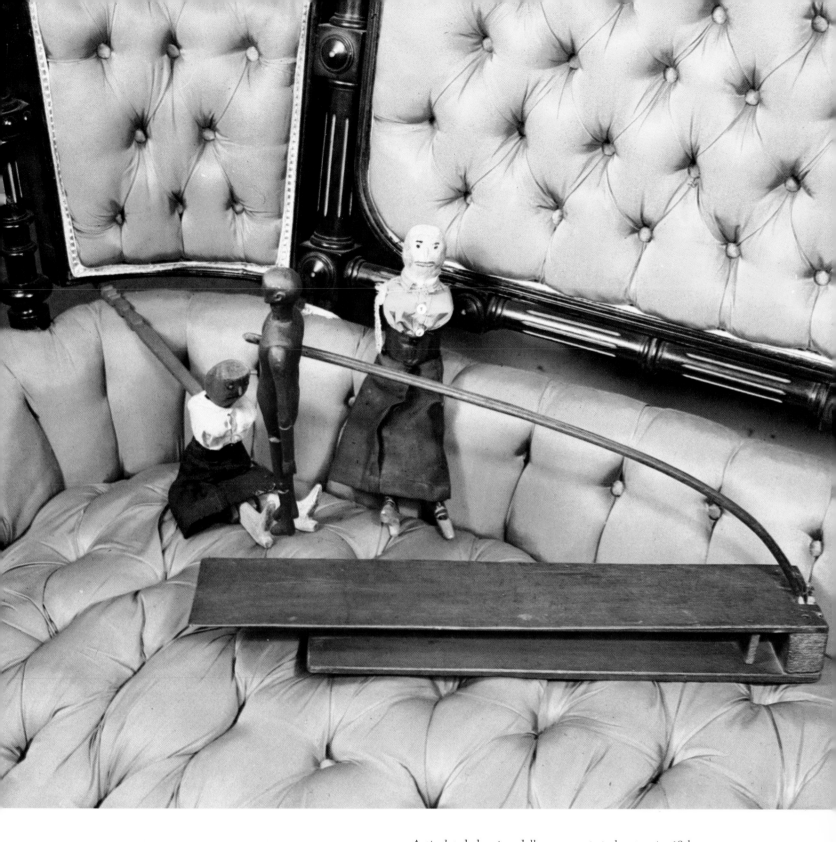

Articulated dancing dolls, a very popular toy in 19th-century Quebec. The two dolls to the rear have carved articulated legs and hand-sewn clothing, and are made to dance by stick handles projecting from the rear of each. These date c. 1880–1900. In the foreground is a much more unusual platform dancing doll, c. 1830–40. The doll is suspended on a springy wooden stick, and for it to dance is sprung up and down to the platform, which is also somewhat flexible. CANADIANA, ROYAL ONTARIO MUSEUM

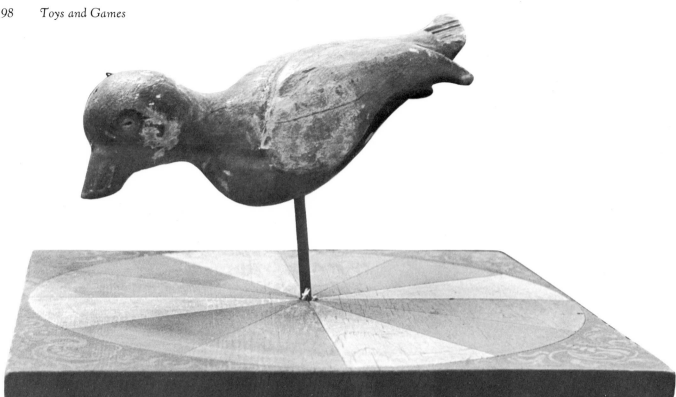

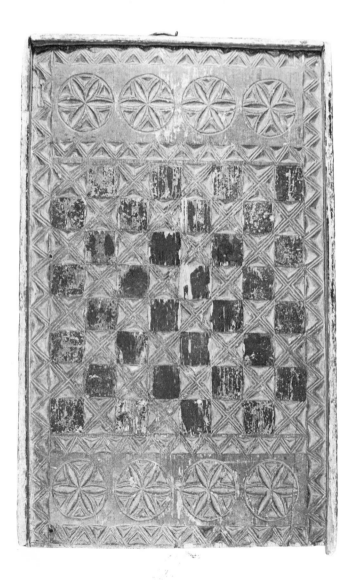

This carved bird mounted above a board, with a twelve-segmented circle, is an Ontario-German piece of uncertain purpose, but may well have served as a sun-dial. Dating c. 1850, the board and pine bird are painted in various colors.

DOON PIONEER MUSEUM

Carved Quebec checkerboards are much less common than painted types, but this example is unusually elaborate, dating c. 1850, with its original red and black paint.

CANADIANA, ROYAL ONTARIO MUSEUM

Ontario. Paper dolls became quite a fad in the 1850s. Jenny Lind's American tour in 1850 was accompanied by Jenny Lind paper dolls made in Germany, and also Jenny Lind porcelain-head dolls.

As early as 1839, composition and bisque-headed dolls were being imported into Canada from Germany and England, and in the 1850s dolls with wax heads and kid bodies, and with India rubber heads were also being brought in. In cases where only the heads were imported, cloth bodies were added here, sometimes in milliners' shops, but also often in the home. One such group of dolls, representing the fifteen family members and the servant who comprised an Ancaster household, was made in the 1850s, using small porcelain dolls' heads and linen bodies, costumed with scraps of material left over from homemade clothing.

Some wooden dolls were also made, copying wooden penny-Dutch dolls with jointed arms and legs. Sometimes, minus arms, they were attached to sticks to make dancing dolls, or attached with a supple stick to a wooden platform on which the doll danced when the stick was tapped. I have seen one pair of American stick dancing dolls from the 1775 period, and it is probable that the origin of the form lies in even earlier centuries in Europe, along with that of the rocking horse and horse pull-toys.

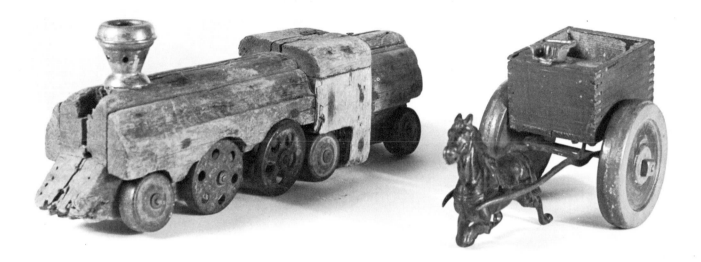

Though uncommon, toys are sometimes found constructed from parts of other things. The locomotive, of pine and from central Ontario, c. 1900–10, has wheels from miscellaneous discarded roller skates. The horse and cart is composed of a small cheese box as the cart body, a horse and wagon seat from a previous cast iron toy, and wheels from yet some other source.

CANADIANA, ROYAL ONTARIO MUSEUM

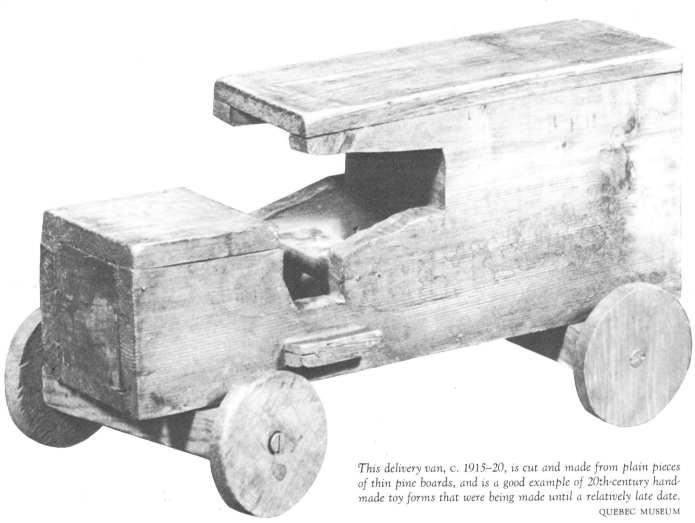

This delivery van, c. 1915–20, is cut and made from plain pieces of thin pine boards, and is a good example of 20th-century hand-made toy forms that were being made until a relatively late date.

QUEBEC MUSEUM

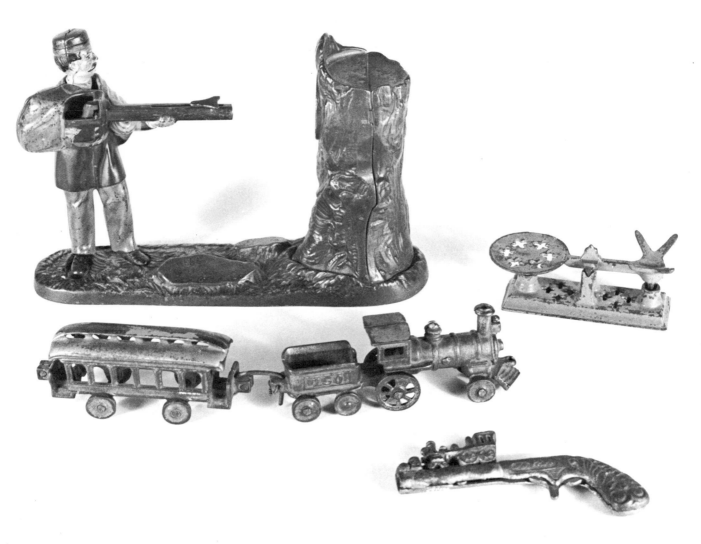

△
Manufactured cast iron toys are rather a different specialty from wooden and handmade toys. Though still commonly found, most early manufactured toys in Canada were imported, apparently in large quantities. These pieces, a coin-shooting bank, scales, a train, and an early cap gun using paper caps, are typical of imported toys of the 1880–1900 period.

CANADIANA, ROYAL ONTARIO MUSEUM

Trains and other domestically manufactured cast iron toys, particularly marked examples, are quite scarce. This marked CNR train, and the CPR train in the foreground, date c. 1900-1910, though their maker is not known. PRIVATE COLLECTION

▽

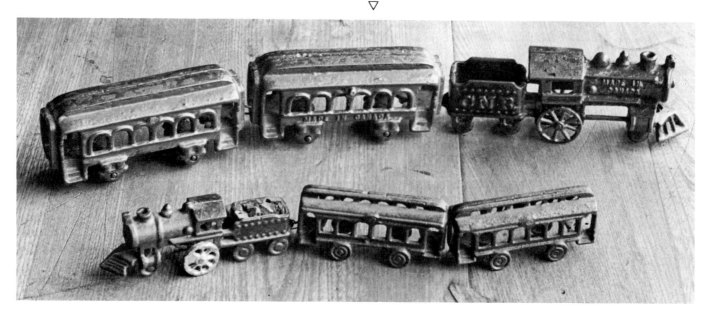

Miniature play furniture for children and doll's furniture was probably made in small quantities by cabinetmakers and smallware manufacturers during the second half of the 19th century. Some of the cabinetmakers' pieces were, in fact, so finely made that they have raised the argument that they were made as apprentice pieces or sample sales pieces. Miniature pine armoires, with the panel and pegging details of the full-sized pieces, faithfully reproduced in Quebec pieces, and Hepplewhite chests of drawers with small dovetails on the drawers and inlaid wood diamond keyhole escutcheons certainly lend credence to the idea. I would not be surprised, though, to learn that some of these carefully crafted pieces also found their way home and into the special care of children. Other pieces, less detailed in craftsmanship, were more certainly intended as toys. The earliest advertisement I have come across for children's furniture is one for C. P. Gelinas & Brothers, toy manufacturers in Three Rivers, Quebec, from 1890 to 1920. By 1920 their toys are identified as "toy sets (chairs and tables)." Many examples of toy furniture do survive from the mid-19th century: tables, chairs, buffets, beds, cradles, dish cupboards, chests of drawers. Some of these are so plainly made that their style is not identifiable, but some follow the styles of full-size furniture, with *banc-lits* and armoires from Quebec French styles, and many pieces following the later Empire style.

Although many of the doll houses, furnishings and dishes were supplied from France and England, some Canadian potters advertised and made toy pieces. An early advertisement for pottery toys is found in the *Bowmanville Messenger* for April 25, 1851, when James Bailey, a Bowmanville potter, listed " 'moulded ware' in toys." William Eby, working in Conestogo, Ontario from 1855 to 1906, is also known to have made miniature pottery crocks. The St. Johns Stone Chinaware Co. of St. Johns, Quebec, 1873 to 1893, was making "dolls sets, in both blue and plain white" by the 1880s. The Brantford Stoneware Manufacturing Co. of Brantford, Ontario, in the 1890s was making miniature sales samples. Whether any of these small pieces were also sold as toys is not known.

Doll houses, because of their elaborate nature, are rare finds among Canadian toys. Most were imported from England but some Canadian homemade ones do exist. They were not advertised by any of the toy factories, but were rather individual labors of love for a particular child.

Although Noah's Arks, with their attendant pairs of animals, were popular toys in the 19th century, and thought appropriate for quiet play on Sundays when more boisterous forms of entertainment were frowned on, the few that I have seen are German in origin. It is possible that some Canadian-made ones may turn up. I was surprised to find that Noah's Arks were still being sold in Canada in 1973, but now they were being imported from Japan.

Dominoes and checkers were popular 19th-century games which produced handmade dominoes and checkerboards. Checkers was particularly popular in Quebec, and many hand-carved examples of boards have survived. Croquet, which became a great fad in the United States in the 1860s, was also played here. In 1871, two Toronto wood-turning plants offered croquet sets. Hastings and Peterkin were "general wood turners, and builders, cabinetmakers, and furnishers, croquet, wholesale and retail, complete sets of croquet in fancy and common woods kept constantly on hand, also ten pin balls and pins made to order. Billiard and Bagatelle balls re-turned." Leslie and Garden were the "No.2 Ontario Factory," and offered "wood turning in all its branches. Manufacturers of Croquet, in Boxwood, Maple and Lignumvitae, for either lawn or parlour, Bagatelle Boards, &c. . . ."

These, then, are the types of handmade toys produced in Canada during the 19th century, both those made at home by families and those produced in small craft shops or factories. Although tinsmiths, coppersmiths, and iron founders all may have made some toys in the last half of that century, I have not seen any examples of their work. To date I have found fewer than twenty craftsmen or manufacturers before 1900 who advertised themselves as toymakers, and in the case of manufacturers, the majority produced toys only as a sideline to other wood products. This is understandable when one considers that the common complaint of the American toy industry even in the early 20th century was the seasonal nature of the market. In Canada, as late as 1959, it was estimated that "about 60 percent of all toy purchases are made during the Christmas season." No one could afford to specialize for one month's sales a year.

The toys made by those early manufacturers were still essentially handmade, and remained simple, usually of wood, and relatively untouched by the developments that were taking place elsewhere in the toy industry during the last half of the 19th century.

That period has been called the golden age of toys. As the century progressed the number and variety of toys available greatly increased. In the 18th century intricate watch mechanisms had worked the exquisitely made and expensively jeweled trinkets and miniatures destined for collectors' cabinets and the amusement of adults. In the second half of the 19th century, factory production and cheaper machine-made parts made it possible to apply some of the simple clockwork mechanisms to toys.

Improvements in dolls came early in the century, closing eyes appearing in the mid-1820s. From about 1827 on there were walking dolls, and in the 1820s the first talking doll appeared. The 1860s and '70s saw a great variety of wind-up toys, such as locomotives, dolls, fire engines, circus wagons, and dancing figures. From 1870 to 1885, bell-ringing pull- or push-toys were made for younger children. Many of these worked with an irregular axle on the front wheels, producing the movement that caused the bell to ring. Toy steam engines, steamboats, locomotives, mechanical toys, and working models were advertised in the early 1870s, which also saw the introduction of mechanical banks, with ingenious movements to encourage saving. After 1885 the bell-toys became increasingly complex, sometimes involving as many as five moving figures. In the 1890s toy pianos were brought out.

This technological development in the toy industry did not much affect toy production in Canada until the early 20th century. The impetus to growth came during the First World War, when war production drastically curtailed German and English toy manufacture. In Canada, where only some twenty firms are known to have been making toys before 1900, no fewer than eighty are recorded as making toys between 1915 and 1920, many of them still doing so as a sideline. Some only operated for one year during that 1915–1920 period, while

others closed down when renewed competition from the English and German toymakers at the end of the War made it difficult for the smaller companies to survive.

Some of the Canadian companies continued making wooden toys. Baseball bats, rocking horses, crokinole boards, wheel toys and game boards, sleds and wagons, building blocks, toy battleships, toy furniture, croquet sets, sleighs, "Bill-Dit" log cabin construction kits (first brought out in the United States in 1862 by the Vermont Novelty Works), and doll cutters are all named.

In addition many toys not previously attempted in Canada were made. In 1911 the Dominion Toy Manufacturing Co. of Toronto was making unbreakable character dolls and teddy bears, which first gained such enormous popularity in the United States in 1906. A 1915 advertisement claims that they were the only toy manufacturers in Canada, and as well as the teddy bears and dolls, were making stuffed toy animals, and cowboy and Indian suits. They continued making toys until 1933 or 1934.

From 1917 to 1919, prompted by the increased popularity that soldiers and war toys enjoy in wartime, the Toy Soldier Novelty Company in Kitchener made toy soldiers. It seems likely that the Beaver Toy Manufacturing Co. in Toronto, listed only as making lead toys, was also making toy soldiers, while the United Incandescent Light Co. of Toronto made toy bugles and trumpets from 1917 to 1920.

The Sterling Rubber Co. of Guelph from 1917 to 1920 made toy balloons, while another rubber company, Canadian Consolidated Rubber Co. in Toronto, made rubber toys and balls, hockey pucks, rattles and animals. Celluloid rattles, toy furniture, carts and building blocks were made by John Chantler & Co., Toronto, from 1917 to 1920. Dolls were made by the Bisco Doll Co. during 1919 and 1920, and the Brophy Doll Co. in 1919. Both these firms were located in Toronto. Doll furniture was made by several companies: toy brass furniture between 1917 and 1919 by the Ideal Bedding Co. of Toronto; enamelware dishes and toy trunks by the Thomas Davidson Manufacturing Co. of Montreal from 1920 to 1929; toy pails, shovels, cups, plates, banks, etc. in tin by the Macdonald Manufacturing Co. of Toronto, who between 1917 and 1942 made a general line of decorated tinware; and Soren Brothers of Toronto, who from 1917 to 1925 advertised a general line of domestic tinware, and probably made toy tin dishes.

The Coleman Fare Box Co. of Toronto in 1920 was making banks, and the Belleville Hardware and Lock Manufacturing Co. of Belleville, Ontario, in 1920 was listed as making toys cast in iron, the first mention I have found of cast iron toys being made in Canada.

The Manual Construction Co. of Toronto offered construction sets in 1917, and in 1920 the Reliance Toy Company, also of Toronto, was making steel structural toys. From 1920 to 1929, Canadian Toys Ltd. of Hamilton, Ontario, was making metal humming and dancing tops, and steel construction toys.

Although more details in the story of Canadian toys will emerge, more toymakers' names be uncovered, and perhaps some types of toys not mentioned be found, the general outline of the development from craft through the beginnings of the industry will remain the same. Toys were one area of Canadiana where the machine and standardization were late in penetrating, so that the charm of individualism still provides one of the greatest attractions for the collector.

Guns
and Gunmakers

S. James Gooding

The early history of gunmaking in Canada is obscure but, because of the conditions which were anticipated when the white man first came to America, we can be sure that the skills of a gunsmith would have been represented among the tradesmen.

There are records of the use of firearms here during the 16th century but it was not until the building of a settlement at Quebec by Samuel de Champlain in 1608 that there is documentation of the presence of one. His life in Canada was brief. Antoine Natel was one of 29 colonists who sailed from France with Champlain on April 5, 1608. They arrived at Tadoussac on the 3rd of June and went from there to Quebec where a *habitation* was built.

Antoine Natel was described by Champlain as a *serrurier*, which in translation is a locksmith but which in the 17th century was often used interchangeably with *armurier* (armorer) and *arquebusier* (gunsmith). Since the *habitation* which was built consisted of fewer than five small buildings, it is safe to assume that door locks were of minor consideration when he was employed. Unfortunately, Antoine Natel died in November 1608 "of disentery . . . (because of) eating badly cooked eels . . .," according to the diary kept by Champlain.

Natel's position was undoubtedly filled many times during the next few years but the next gunsmiths about whom records have been found were Jean Bousquet and Abraham Mussy, who contracted to come to Canada for "The Company of New France" in 1642. Nothing further is known of Mussy, but Bousquet settled at Montreal and until his death in 1714, played a major part in the Montreal business community of the time. He was described variously as a *maître armurier*, *maître serrurier* and *arquebusier* and he was a member of *La Corporation des armuriers à Montreal* (The Montreal Armourer's Company), which was established at least as early as 1676 and perhaps as early as 1645.

By the end of the 17th century there were numerous gunsmiths recorded in Canada and a considerable amount is known about them. Almost all were of French extraction, but a few arrived from the north in the employ of the Hudson's Bay Company. During the 18th century the population, and hence the requirement for gunsmiths, increased. Some continued to arrive from France, but larger numbers immigrated from Britain and the English colonies to the south.

We have a great deal of information about these pre-19th-century gunsmiths—who they were, from whence they came, where they lived, and on what they worked. But more than 25 years of searching has not turned up a single example of a 17th- or 18th-century firearm which can be said without qualification to have been made in Canada.

The work of these early gunsmiths would have varied little from town to town or from smith to smith. During this period, that is from the early years of the 17th century to the end of the second decade of the 19th century, the types of firearms available in Europe included the matchlock and the wheel lock up to about 1700, and the flintlock up to at least 1820. But in America, with the exception of a few wheel locks and matchlocks used during the very early days of settlement, the snaphaunce or flintlock was the preferred ignition. Its simplicity, reliability and ease of repair made it the universal arm in North America, and by 1630 or 1640 it was being extensively traded to the Indians.

Almost all the guns made during the first 250 years of Canadian settlement were muzzle loaders; they were loaded from the muzzle, using a ramrod, first with a charge of powder (a little of it intentionally spilled into the pan) and then a ball or load of shot. To fire, the powder in the pan and from this the main charge was ignited by an externally introduced spark.

The matchlock originated in Europe about the middle of the 15th century. On it, a match holder or "serpentine" was connected with a trigger mechanism. In the serpentine was clamped a smoldering wick which, when the trigger was drawn, was moved into contact with the powder in the pan.

The matchlock was not suited to use in the woods because of the need to have the match lit before firing. On a march or

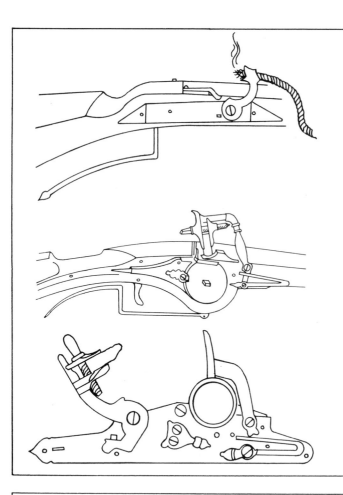

The matchlock of the early 17th century was the type used by the earlier French explorers and settlers. On the matchlock, a smoldering cord was held in the jaws of the cock. To fire, the lever underneath was pulled up, disengaging the cock and allowing it to snap down and ignite priming powder exposed in a small pan on the outside of the barrel. This in turn was connected by a flash hole to the main firing charge.

The wheel-lock, of the mid-17th century, fired by means of a piece of pyrite clamped in the jaws of the cock, which was held against a spring-loaded rotating steel wheel. Releasing the wheel caused sparks to be shot off into priming powder in the flash pan, which in turn flashed through the touch-hole to ignite the main charge in the barrel. The wheel, of course, had to be rewound after each shot. While more reliable than the matchlock, the wheel-lock was complicated and expensive, and did not appear in North America in any great numbers.

The earliest flintlock, of the 17th century, was the snaphaunce, fired by a flint striking a steel plate, which threw sparks into the priming charge. The flint was held in the jaws of the hammer, which snapped forward to strike the steel, or frizzen. The frizzen, in turn, was knocked forward as sparks fell into the priming pan beneath, the sparks igniting priming and main charges virtually simultaneously.

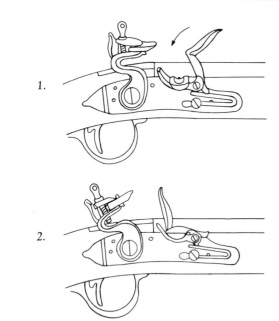

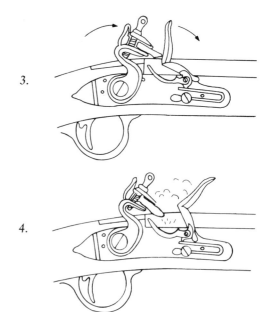

The muzzle-loading flintlock was the primary weapon of early Canada, used in different forms by everyone from soldier to fur trapper. The flintlock in its final form, which evolved in the late 17th century, had a hinged steel plate or frizzen which covered the priming pan in firing position. Thus the gun, while loaded, was reasonably weather-proof. In 1, the flintlock is positioned for loading, the frizzen forward to expose the priming pan, and the hammer with its flint in half-cock or safety position.

The firing sequence is as follows: The weapon is in firing position (2), with the hammer at full cock and the frizzen closed over the priming pan. As the trigger is pulled, the hammer is released to spring forward. The flint strikes the frizzen (3), throwing off sparks and knocking it forward. The priming charge fires almost instantly (4), igniting the firing charge through the touch-hole in the barrel.

The whole firing sequence is virtually instantaneous, taking perhaps 1/10th of a second. A flintlock in good condition is quite reliable, though a poor or worn flint can fail to strike a spark. Sometimes, as well, the priming charge in the pan may ignite, but fail to fire the main charge in the barrel, an occurrence known as a "flash in the pan."

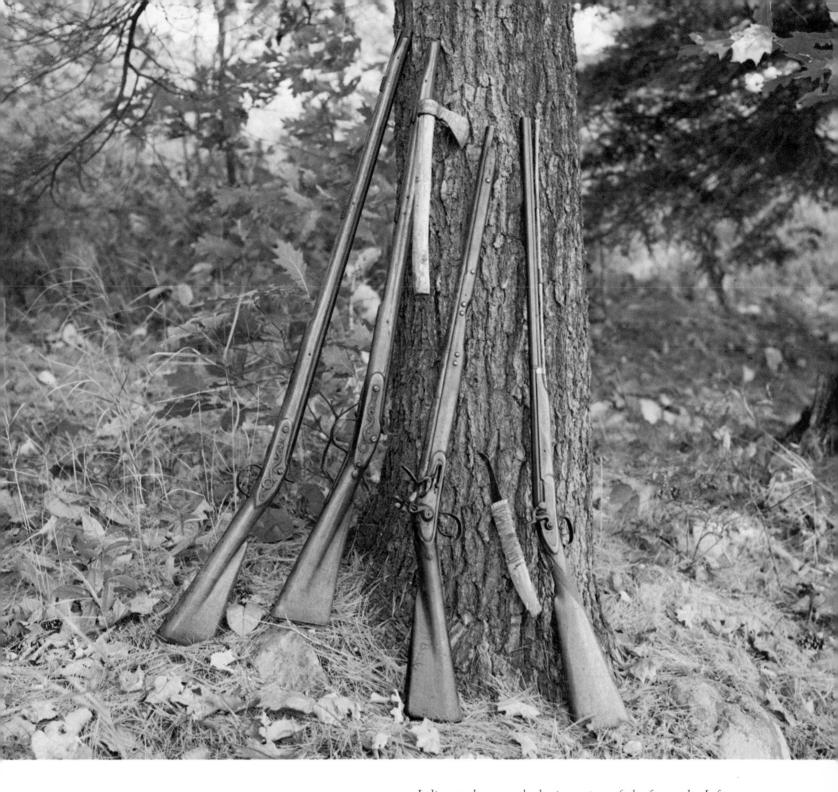

Indian trade guns, the basic weapon of the fur trade. Left to right, these smoothbore, all-purpose hunting pieces are: trade gun of c. 1805–10, by Wheeler & Son, Birmingham, and with marks of the North West Company. This piece was converted from flintlock to percussion in the 19th century. Next is a later percussion gun, with a lock stamped BARNETT / LONDON, dated 1876, and with Hudson's Bay Company markings. This and the left-hand piece have the cast brass dragon sideplate typical of 18th- and 19th-century English trade guns. Next is a late flintlock, with a lock stamped PARKER, FIELD & CO. / 1870 / LONDON, also with Hudson's Bay Company stamps. The right-hand gun is a light fowling piece, probably a chief's gun, of the very late 19th or early 20th century, with its lock marked "Hudsons Bay Company / Made in England." With the trade guns are a French-Indian trade hatchet, c. 1740–60, recovered from the French River, Ontario, and a contemporary Indian canoe- or crooked knife from Albany, Ontario.

CANADIANA, ROYAL ONTARIO MUSEUM

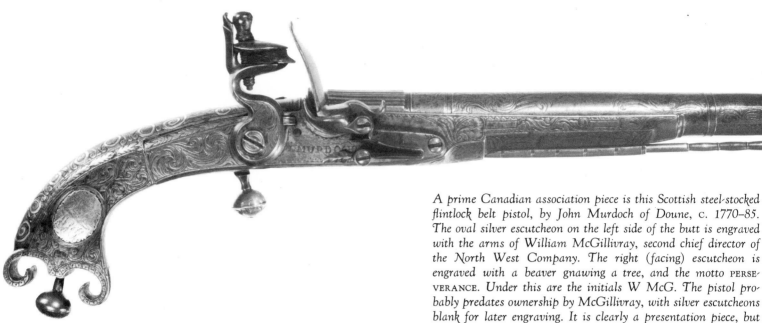

hunting trip, this was inadvisable, almost impossible, and indicates why this type of weapon became obsolete in America almost one hundred years earlier than it did in Europe.

The wheel lock, invented during the last quarter of the 15th century, was fired by a spark produced by the rubbing of iron pyrites against a serrated steel wheel. To fire the wheel lock, it was necessary, after loading, to span the lock (that is, wind the wheel so that tension was applied to the spring) and place the dog so that the pyrite came into contact with the wheel. When the trigger was pulled, the wheel rotated quickly while the edge of it scraped the piece of pyrite held in the jaws of the dog to produce the spark.

Although the wheel lock ignition was suited to Indian warfare or travel in the bush, it was too complicated and expensive for general use. A few were recorded at the *habitation* at Quebec between 1619 and 1632, but they were probably owned by the wealthier associates of Champlain.

About the middle of the 16th century and again in the first decade of the 17th century, locks using a flint for ignition were developed and were quickly adopted in the French and English colonies.

These two developments are classified by collectors as the snaphaunce and flintlock, but in the early days of their use there was no distinction made in either England or France and they were both called "snaphance" in English. The principal difference is that the pan-cover and the steel of the flintlock are made of a single piece while they are separate on the snap-haunce. The two-piece pan/steel mechanism was quickly super-seded by the flintlock, which became the universally used lock in Europe and America.

The flintlock was used exclusively in Canada from at least 1650 to 1820 and extensively for probably another 30 years. During that approximately 200-year period not less than 2,800 man-years of work was done by gunsmiths. But as of this writing there is not a single gun known to this writer which was made in Canada and which has a flintlock ignition. The only possible explanation for this is that the guns are lying, unrecognized, in attics or collections and there is a good chance

for important discoveries to be made by the collector of the future.

In 1807, the Reverend Alexander Forsyth of Belhelvie Parish near Aberdeen, Scotland, obtained a patent for the ignition of firearms with a detonating chemical compound. This was improved over the next decade and by 1818 was perfected to the point where it was accepted by the sportsmen and gun-makers of England. By 1820 it had been further improved to the point where little change was required throughout the life of the system. The percussion cap was the form finally accepted by the sporting fraternity and this was invented in England, probably by Henry Egg, a London gunsmith. In the percussion-cap system the priming compound was contained in a small copper cup. The cup was placed over a nipple having a channel leading to the charge in the barrel, and when struck by the hammer the "flame" of the primer passed directly to the charge. It is this ignition which will most frequently be found on the guns by Canadian gunmakers.

The guns made in Canada were designed for the special purpose for which they were intended and because of this are easily identified. Generally they fit into two categories: hunting arms and target arms. Within these categories there are sub-types and dual-purpose arms. Very few pistols have been located by Canadian gunmakers but they do exist, so that ten categories of arms can be recognized.

Hunting rifles. Most of this group are light in weight, averaging just under ten pounds. They are often plain, service-able rifles but heavy decoration is occasionally encountered. There is no allowance for a loading accessory and hunting sights are invariably open.

Hunting/Target rifles. The principal distinguishing feature of a rifle in this group is the allowance for a bullet starter. There is a rounded section of from $\frac{1}{2}''$ to $1''$ long at the muzzle. The open rear sight is present but allowance is usually made for a tang peep sight. Adjustable or set triggers are common. The average weight for this group is just over ten pounds.

Target rifles. These were expensive guns made for the

*Another Canadian-associated firearm is this British India Pattern ▷
flintlock musket, of the earlier, pre-1805, type, the standard
British musket of the Napoleonic Wars. This piece, found in
Canada, is property-marked "76th Reg't." on the barrel. The
76th Regiment, veterans of the Peninsular campaigns, came to
Canada in 1814, served on Lake Champlain, and remained in
Canada until 1826.* CANADIANA, ROYAL ONTARIO MUSEUM

*Full-stocked rifle, in maple, by George Rennardson of Toronto, ▷▷
(working 1856–77). Full-stocked rifles such as this .46 caliber
piece are uncommon from Canadian makers.*
PRIVATE COLLECTION

*Military musket of .75 caliber (the official British size before ▷▷▷
c. 1853), with its bayonet, made and marked by James Ashfield
of Toronto (working c. 1831–90). This unusual musket is pro-
bably a special piece, c. 1840, for there is no record of Ashfield
having had any sort of contract for manufacture of such pieces.*
PRIVATE COLLECTION

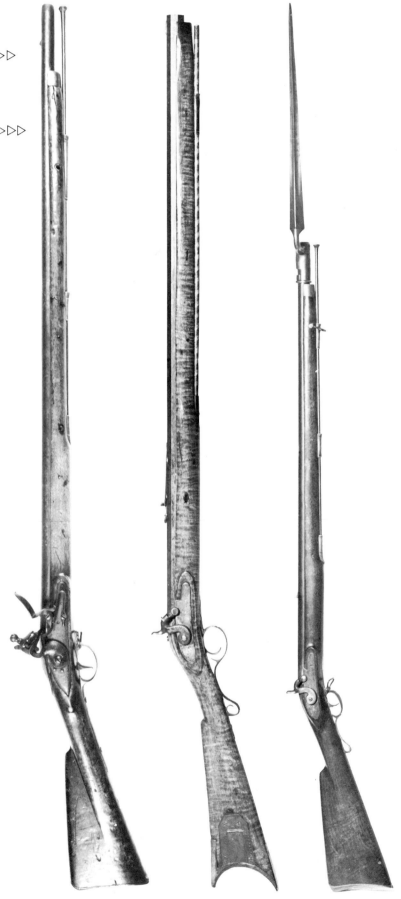

keen competitions which took place between shooting clubs
within Canada and internationally. In this group are rifles with
special sights or stock design, or of extremely heavy weight.
Many target rifles were made to Creedmoor specifications,
while others have telescopic sights, set triggers, and false
muzzles or bullet starters. Creedmoor target rifles were named
after the Creedmoor Range on Long Island, the first United
States rifle range for international competition at ranges up to
1,000 yards.

Military rifles. The lines of this group usually follow
quite closely those of the military rifle of the period and are
commonly called officer's rifles. They are usually of .45 caliber
as opposed to .58 caliber of the military rifle, and were used in
the regular competitions held by rifle clubs and militia units.

Kentucky rifles. This type of gun originated in
Pennsylvania and is characterized by its full-length stock, often
of curly maple. They could be either smoothbore or rifled and
still be classed as rifles. There was apparently so much inter-
change of design across the border that this type of gun is not
at all uncommon with the name of a Canadian maker on the
barrel.

Combination guns. One of the most useful arms for a
frontier hunter was the combination of rifle and shotgun barrels
in the same gun. Most gunmakers made them in either side-by-
side position or over-under position, if the latter, the rifle barrel
usually being on top to provide better sighting.

Shotguns. Shotguns were made in Canada but the
demand for custom-made shotguns by Canadian makers was
apparently quite small. This was probably because they could
be imported much more cheaply than they could be made here.
Details on this situation are covered below under breech-
loading shotguns.

Breechloading rifles. The development of a success-
ful metallic cartridge in the 1850s stimulated the inventors of
breechloading arms. A number of patents were obtained in
Canada and examples of some of the patented guns exist. Some
gunsmiths pirated the designs of foreign gunmakers but in no
case was the quantity produced very great. Four or five breech-
loaders by W. H. Johnson of Elora, three by Wm. P. Marston
of Toronto, John Grainger of Toronto and Michael Mater of
Chippewa are what might be called production models. Of all

Muzzle-loading percussion rifle, of .45 caliber, made by Michael Burns of Barrie, Ontario, C. 1860. Burns' gunshop operated from 1856 to about 1865. To the left of the rifle are two powder horns. The upper horn is from Quebec, C. 1850, and is decorated with incised heart, cross, leaf, and geometric motifs. The lower horn is incised with various designs, the name William Collins, and the date 1838, and is from Newfoundland.

CANADIANA, ROYAL ONTARIO MUSEUM

others made before c. 1880, only one of each pattern is known. James Paris Lee, inventor of the action which was later used on the Lee-Enfield rifle, might be considered a Canadian gunsmith although he never manufactured here. He was born in Scotland, educated in Oakville and Wallaceburg, Ontario, and moved to the United States in order to have his inventions produced. Lee's first rifle was manufactured by the Lee Fire-arms Co., at Milwaukee, Wisconsin, in 1864–65. The Lee Fire Arms Co. was organized in 1879 to market the bolt-action rifle which he had just invented.

Breechloading shotguns. Those marked with the names of Canadian gunsmiths are frequently found and represent a legitimate area of Canadiana collecting. They are

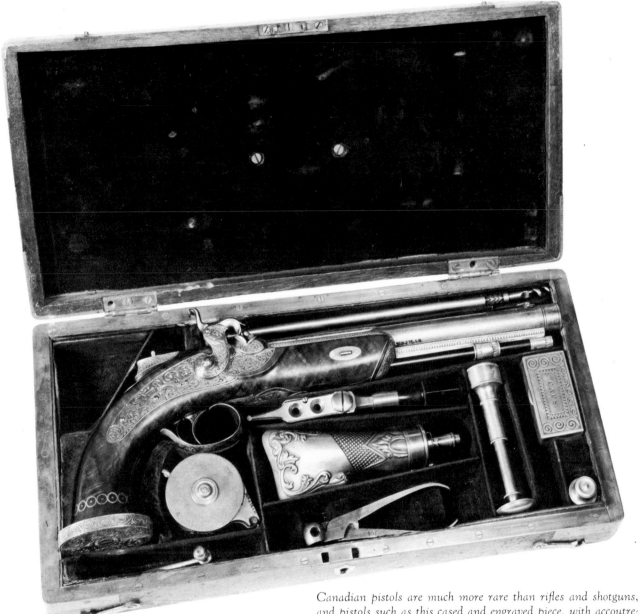

Canadian pistols are much more rare than rifles and shotguns, and pistols such as this cased and engraved piece, with accoutrements, are unique. This fine percussion target pistol was made about 1845, probably on special order, by John Gurd of London, Ontario (working 1842–88), and the piece is marked on the barrel "Safety Lock—J. Gurd, Inventor, London, C.W."

ROYAL ONTARIO MUSEUM

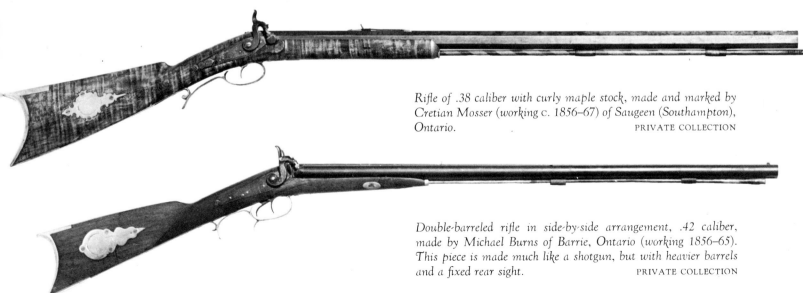

Rifle of .38 caliber with curly maple stock, made and marked by Cretian Mosser (working c. 1856–67) of Saugeen (Southampton), Ontario. PRIVATE COLLECTION

Double-barreled rifle in side-by-side arrangement, .42 caliber, made by Michael Burns of Barrie, Ontario (working 1856–65). This piece is made much like a shotgun, but with heavier barrels and a fixed rear sight. PRIVATE COLLECTION

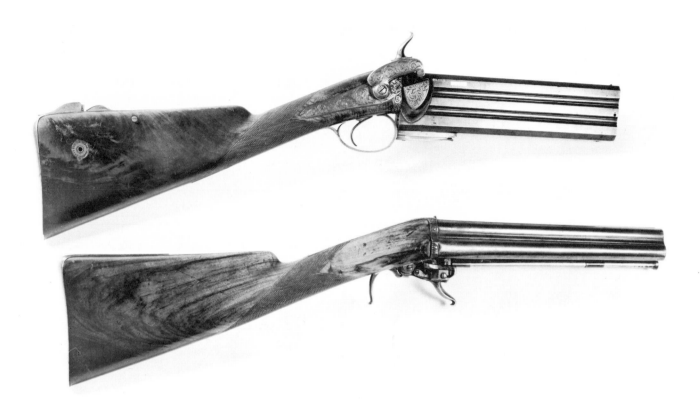

currently priced much below comparable quality rifles and muzzle loading shotguns but this situation will undoubtedly change. The reason for the lower price is partially attributable to their slightly lesser antiquity; but more important is the difficulty of stating with certainty that any particular gun of this type was in fact made in Canada.

Most of the breechloading shotguns used in Canada were of British origin; either the entire gun was imported in a finished state and marked by a Canadian retailer, or most of the component parts were imported and assembled here. If the latter is the case, they are bona fide Canadian-made guns; if the former, they should be considered perhaps as "secondary Canadian."

The principal point used to identify the country of origin will be found on the underside of the barrels at the breech. If of British make, the barrels will invariably be marked with the view and proof stamps of the London, or more frequently, the Birmingham proof house. If no marks are present it can be reasonably assumed that the gun was made in Canada.

Making and joining a pair of shotgun barrels was a job requiring a great deal of skill. For this reason, even if the gun was fitted up in Canada, the barrels would probably have been imported and could have been subjected to proof before export. In this case, the only way to tell if the gun was assembled in Canada is through an examination of the wood. The anatomical structure of English walnut being different from North American walnut, it is possible to distinguish between the two. The Eastern Forest Products Laboratory of the Department of the Environment, Ottawa, can give advice on making the samples necessary for testing.

The absence of proof marks, combined with a Canadian gunsmith's name on the barrel, is the best indication of a Canadian origin for a double-barrel breechloading shotgun. But one other possibility exists. Breech actions were available to convert a double-barrel muzzle loading gun to a breechloader. If one was used on a conversion, the proof marks would have been cut off or covered up by the new action.

Pistols. This group covers all handguns but production was extremely limited and they are seldom encountered. Most of those located are revolvers of British manufacture with the Canadian dealer's name on the barrel.

The characteristics of Canadian-made guns are so similar to those of British or more especially United States make, that it is often impossible to state where an unmarked gun originated. For these reasons, most collectors use two criteria to identify a Canadian-made gun. Firstly, the gun must be authentically marked by a Canadian maker; secondly, if unmarked, or marked only with the name of a maker and not his location, it must have been collected "out of the woods" and have the characteristics of an identified maker.

Unfortunately, the unscrupulous have taken advantage of the similarity of foreign-made guns and stamped some of them with the names of known Canadian makers. Usually they have taken the name of a maker from whom no guns are known in order to avoid comparisons, and they have used single-letter dies to mark the barrel as the limited market would not warrant the expense of a gang stamp.

Every authentic, Canadian-made gun stamped with the name of the maker which is known to advanced collectors, is stamped with a professionally made gang stamp. At the same time, almost every gun which is known to have forged markings has been marked with individual letter dies. There is, however, an exception to each of these statements: 1. a muzzle loading

Combination gun, with a .37 caliber rifle barrel and a .65 caliber ▷
shotgun barrel, in an over-under arrangement, by Guilford D.
Booth of Ottawa (working c. 1863–66). PRIVATE COLLECTION

Combination rifle/shotgun, with one .43 caliber rifle barrel and ▷▷
one .54 caliber smooth barrel, by Michael Mater of Chippawa,
Ontario (working 1858–79). This is a patented piece, with a very
unusual bronze action and forearm, the action containing integral
locks and mounting the double hammers. PRIVATE COLLECTION

Breechloading rifle, taking a .44 rimfire cartridge, by Thomas ▷▷▷
Nichol of Chatham, Ontario (working c. 1854–188?). This un-
usual patented rifle is marked on the barrel "T. Nichol, Chatham,
Ontario, Patented March 7, 1867. No. 2." This probably refers
to rifle number 2; the patent number was 2266.
PRIVATE COLLECTION

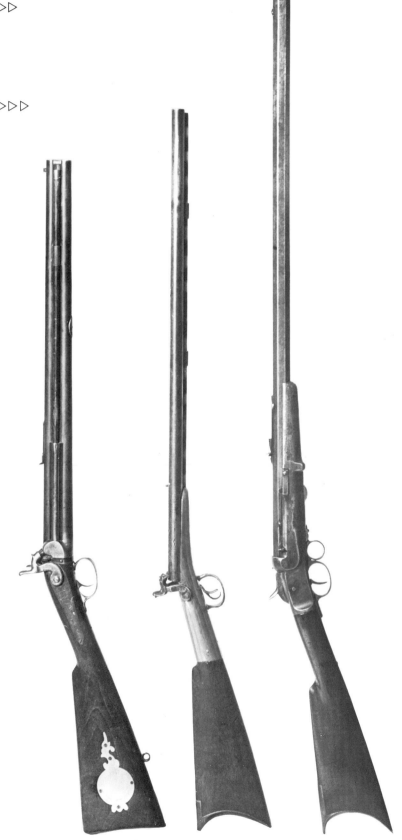

rifle stamped "Wm. Gurd & Co." The dies used are original
but the gun was marked recently. As far as is known, no guns
were made by this firm. 2. J. Bird of Sarnia was an Indian gun-
smith who apparently made his own dies. The "S" and "N"
dies were made in reverse.

Although there is some risk in presenting the above
information to the fakers, it has been given as a warning.
Perhaps now, those inclined to larceny will have gang stamps
made, but if this is done, they will have to be content with a
very limited clientele.

To deter fakers and to assist in the authentication of a
marked gun a list of gunmakers is appended to this chapter. It
was compiled by Donald M. Blyth of Guelph, Ontario, who
for almost 25 years has gathered statistics on surviving Cana-
dian-made guns. The list was made after examination of
approximately 30 percent of the Canadian-made guns calculated
to exist today. If a gun by a maker not included in the list
turns up it should be examined closely; if two guns by the same
maker are found, they should be examined with suspicion.

Of the 750-800 gunsmiths recorded in *The Canadian
Gunsmiths* and elsewhere, examples of the work of approxi-
mately 10 percent are known to collectors. These fit into one
of the ten categories noted earlier and they are marked with
the name and/or location of the maker. Some of the makers
are represented by only a single specimen while others are
known by more than 50 specimens. In this list, the production
figures are represented by letters with A representing fewer
than 10 known specimens, B representing 10 to 25 known
specimens and C representing more than 25 guns by the same
maker.

It should be noted that the gunmakers are all located in
Eastern Canada. When the West was opened in the last half
of the 19th century, machine-made repeating arms were readily
available from manufacturers in the United States. The result
of this was a change in the type of work done by western
gunsmiths. They were repairers of guns, rather than makers,
and no examples of guns made in Western Canada have been
located.

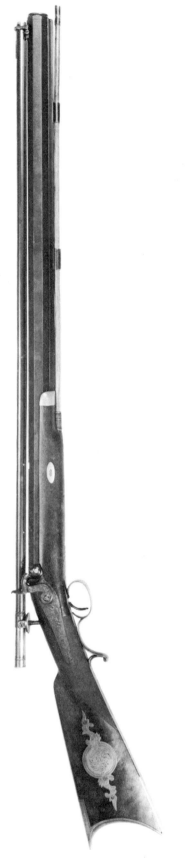

Muzzle-loading target rifle, .43 caliber, with finely checkered stock and well engraved patch-box, lock, and hammer. The rifle with its very heavy barrel was made c. 1860 by William P. Marston of Toronto (working 1851–82), and the full-length telescope sight is marked "M. James, Utica (New York)." This rifle is a particularly fine example of gunsmithing.

CANADIANA, ROYAL ONTARIO MUSEUM

LIST OF CANADIAN GUNMAKERS
With their established and known working dates

Armstrong, Richard	Toronto	–1859–1861–	A
Ashfield, —	Montreal		A
Ashfield, James	Toronto	b.1811–d.1890	C
Batchelor & Costen	Montreal	–1848–1857–	A
Blair, M. D.	Ridgetown		A
Booth, G. D.	Ottawa	–1857–1879–	A
Boyd, (Various)	Montreal	–1847–1900–	A
Bird, J.	Sarnia		A
Brock, W. A.	London	–1882–d.1949	A
Burns, Michael	Barrie	–1856–1865–	A
Catlin, R. C. (?)	Perth		A
Carter, Charles	Hamilton	–1871–1875–	A
Cashmore, E. J.	Toronto	–1890–1899–	A
Clayson, Wm.	Newbury	–1864–1884–	A
Codville, J.	Woodstock	–1866–1884–	A
Criess, Frederick	Cannifton	–1865–	A
Glynn, Richard	Sarnia	–1864–1897–	A
Grainger, John	Toronto	–1854–1856–	B
Grainger, John & Son	Toronto	–1856–1868–	C
Green, Samuel T.	Toronto	–1843–1861–	B
Green, William F.	Hamilton	–1856–1858–	A
Gurd, John	London	–1842–1869–	B
Gurd, John & Son	London	–1869–1888–	C
Gurd, William	York	–1833–	A
Hall, (Various)	Montreal	–1842–1855–	B
Harding, T.	Toronto		A
Harston, Charles	Toronto	–1886–1888–	A
Holgate, George	Chippewa	post 1867	A
Holmes, ——	Coburg	c. 1840	A
Jackson, Wm.	Playfair	–1865–1897–	A
Johnson, W. H.	Elora	–1869–1877–	A
Jones, James M.	Chatham	–1857–1892–	B
Judge, Michael	Belleville	–1850–1857–	A
Le Moine, L.	Quebec	–1847–1857–	A
Marston, Wm. P.	Toronto	–1851–d.1901	C
Masterson, Wm.	Brantford	–1867–1885–	A
Mater, Michael	Chippewa	–1858–1879–	C
Mills, B.	Hamilton	pre 1841	Á
Mosser, Cretian	Saugeen	–1856–1867–	A
McIntosh, L.	Goderich	–1857–1898–	A
Newby, Wm.	Guelph	–1857–1896–	A
Nichol, T.	Chatham	–1857–1897–	C
Nichols, Harmon	Burgessville	–1865–1886–	A
Paeckert, Ed	Stratford	–1861–1894–	B
Paeckert, Herman	Stratford	–1861–1869–	B
Patrick, W. R.	Parkhill	–1871–1884–	A
Pauli, Charles	Belleville	–1860–1865–	A
Pullen, John	Barrie	–1866–	A
Rawbone, J. L.	Toronto	b.1855–1889–	B
Rawbone, W. G.	Toronto	b.1809–d.1893	C
Reeve, James	Chatham	–1865–1880–	A
Rennardson, George	Toronto	–1856–1877–	A
Rooke, George	Berlin	–1867–1884–	A
Smith, Ira	York	–1833–1837–	A
Soper, W. H.	London	–1849–1886–	C
Soper, Philo	London	–1851–1886–	C
Stephens, R. E.	Owen Sound	–1867–1876–	A
Teal, Zachariah	Ridgeway	–1865–	A
Thompson, James	Own Sound	–1865–1882–	A
Van Egmond, Leopold	Egmondville	–1863–1898–	A
Vogt, J. B.	Wroxeter	–1863–1895–	A
Walker, J. J.	Simcoe	–1832–1886–	B
Waters, T.	Wardsville		A
Weinbrenner, L.	Chippewa	b.c.1828–d.1898	B
Wood, J.	Brantford	–1831–1844–	A
Wood, J. & Co.	Brantford	–1831–1844–	A
Webster, Wm.	London	–1881–1892–	A
Welshofer, George	Brantford	–1861–1865–	A
Wheeler, James	Chatham	–1861–	A
Unidentified maker	Prescott U.C.	pre 1841	A

Decorative Ironwork

Nancy Willson

Ironworking in Canada goes back further than might be expected: from the excavation of a forge at the L'Anse au Meadow site in Newfoundland, it is known that the original blacksmith on this continent was a Viking. The first French settlement at Port Royal had both "workers in iron" and locksmiths, and when the Jesuits constructed their mission at Ste-Marie on Georgian Bay, they reported with relief that in the second year they were at last able to complete a forge.

Not only was metal a strong bargaining item in fur trade barter, it was also vital to Europeans for establishing their own permanence. In the early years of any colony, most ironware had to be imported, and to varying degrees this has continued in Canada ever since. But shipments from Europe were subject to the seasons and the hazards of the ocean crossing, and without ironworkers of its own no settlement could prosper. The local smithy was capable of making and mending agricultural implements, shoes for oxen and horses, as well as sleigh and wagon fittings; also tools for building and other trades; and almost all of the hardware, lighting devices and cooking utensils needed in the home.

The smith used iron in its most refined form. It had to be virtually free of carbon and other embrittling elements if it was to be really malleable. In the lengthy process of refining early wrought iron, impurities were reduced by repeated meltings and pounding of the bloom under huge water-powered tilt hammers. As a side effect of this pounding, the remnants of slag were squeezed into stringers running the length of the finished bar; in badly rusted wrought iron, these non-corroding slag inclusions become visible as thin threads in the fabric of the metal. They, and the purity of the metal itself, gave wrought iron its distinctive working characteristics. When heat-softened, it could be hammered, bent or welded, and it could withstand longitudinal pressures that would snap cast iron.

This malleable wrought iron was the material used by blacksmiths until after the mid-19th century, when production of steel increased enormously. Mild steel, lacking the slag stringers of wrought iron (and thus harder to work and weld), began to replace the traditional metal in the forge; by the early 1900s, it was used almost exclusively.

The smith worked in dim light, for the changing glow of the iron on the forge hearth was his guide to its workability. Direct hammering by itself was enough to shape many pieces, but smiths also had a wide range of tools for cutting, bending, flattening and smoothing, and for altering the shape and diameter of rods. When a piece was finished, its softness was eliminated by plunging it hot into a water-filled slack tub beside the anvil. The quality of iron was far from uniform, so that every piece the smith worked required not only manual skill but constant judgment and attentiveness to its handling.

The decorative effects possible with wrought iron were closely tied to the demands of the metal; the great variety apparent in hand-wrought objects actually depends on a quite limited decorative vocabulary. Iron was inescapably a base metal, the most difficult of metals to work. Still, in the hands of a skilled smith it could be made fine and effortless in form.

It is in the long-established French-Canadian areas that the European tradition of decorative ironwork appears most strongly in Canada. English-American ironwork has always tended toward more subdued decoration. Moreover, in Canada, hand-wrought ironwork was challenged from the latter half of the 18th century onward by English imports, which met the demands of a rapidly increasing population in a way that small blacksmith's shops could not. For this reason the products of local smithies in the English-speaking areas of settlement are not to be found in the quantities that might be expected. Similarly, the magnificent work seen in older Pennsylvania German hardware finds a parallel in relatively few surviving pieces of Ontario German make.

Regardless of the decoration, practical requirements always dictated the basic design. Hinges, for example, are found in a variety of shapes which are now casually thought of as decorative types. But their shape evolved to meet specific needs. One type, the strap hinge, often reached three feet or more, its length serving to strengthen doors with vertical boarding or mortise-and-tenon joints; it was an especially useful type for large exterior doors. The simplest strap hinge had a

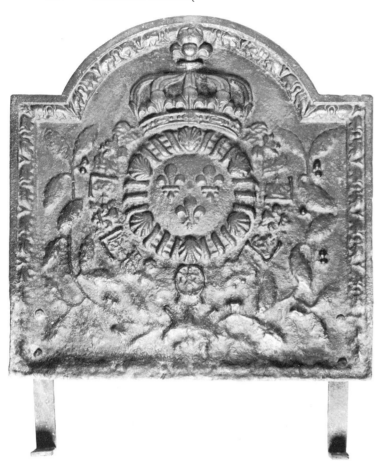

Cast iron fireback, commonly mounted against the back wall of fireplaces to retain and radiate heat. Firebacks were usually thick and flat sand castings, often with considerable decorative detail. This fireback, from Quebec, is probably French, c. 1700–50, but might also be an early Forge St-Maurice casting.

CANADIANA, ROYAL ONTARIO MUSEUM

usually on the finely controlled line of the taper and on terminals worked in variations of leaf, sword, bean and simply rounded forms.

H-hinges and their derivatives are generally considered to be an English hinge form. The traditional H has trifid or leaf-like shaping of the four ends, although those that have survived in this country tend to be quite plain. The staghorn, an H-hinge with plates curved in a double S, is occasionally found here, but the most highly worked H form, the cockshead, is rare in Canada and occurs in a standard design which may have been imported to North America from England. On both strap and H-hinges, a chamfered edge was sometimes used, for this was found to lighten the appearance of the plate.

On French Canadian furniture, armoire and buffet hinges were usually the *fiche* common to provincial furniture in France, or the rat-tail which appears to have been introduced by the English. The word *fiche* refers to the cast iron pin around which the wrought iron hinge plates were wrapped. The pin itself, the section of the hinge most evident when in place, had its projecting finials ornamented in a sequence of small knob, disc and baluster forms. Occasionally, rat-tails were given a similar treatment at the top of the pin; more often there was no finial. Attention centered on the tail itself, finely shaped and finished with a broad tip for the anchoring nail. These were more delicate hinges than the *fiches*, but quite suitable for the light pine doors of armoires.

The rat-tail also occurs on a small number of Ontario German pieces, although these usually have butt hinges. Similarly, in English-speaking areas of settlement, where iron was not a favored material for furniture hardware, the simple, virtually concealed butt hinge was preferred.

In rural areas of Canada and particularly the well-established communities of Quebec, the tradition of hand-wrought hardware persisted well into the 19th century. English imports were also readily available by this time, among them the plain H- and HL-hinges which, though still handmade, were produced on a factory scale. The use of all wrought iron hinges slowly declined following the English invention in 1775 of a method for casting butt hinges. While this unobstrusive type became more and more universally used, the decorative idea was not entirely lost; on both 19th and 20th century houses, butt hinges are often found with low-relief designs cast in the plates, to be revealed only when the door is opened.

Iron was never wasted, and worn or outdated objects usually ended up on the smith's scrap pile for reforging. But because door hardware was permanently installed, much of it has survived and may in fact still be found in use. This is true not only of hinges but of thumb latches. Even when the thumb press and lift bar of the latch have disappeared, the handle with its escutcheon plate may yet be doing service as a door pull.

Thumb latches are of two types: the Norfolk latch is backed by a single long escutcheon plate, while the Suffolk has two smaller plates, one at each base of the handle. A complete latch mechanism would originally have from five to seven parts, any of which might carry decorative touches. Simple scored patterns were sometimes worked across the surface of the bar, and usually the handle was given central bosses or a long twist down its length.

But in the early latches, most of the smith's care went into the forming of the escutcheon, which he made by scoring

looped end which sat on the embedded pintle, making the door removable.

The other basic type is the H-hinge, named for its vertically elongated plates. These evolved as a means of spacing the four or more nails on each plate in order to avoid splitting the wood when mounted. The spreading plates of butterfly and butt hinges follow the same principle. The hinge joint itself, with three or more plate-laps wrapped around the pin, equalized the strain on the iron plates. HL-hinges and T-straps combined advantages of these two main types.

A very simple hinge device sometimes occurs on blanket boxes and storage chests, in place of the usual strap, butterfly or butt hinges. This most basic hinge unit consists of interlocking cotter pins with their ends embedded in the wood of backboard and lid and is often called a snipe hinge.

In Quebec, strap hinges are found in sizes that suggest they were used not only on barns but on the interior doors of houses. Like other early hardware, their functional shape was turned to decorative advantage. The terminal of the hinge was commonly forged to a fleur-de-lis, open heart or ram's horns. On the most ornate, the edges of the strap were cut to projecting spurs or the whole length widened and narrowed in a symmetrically stepped taper. The English style of strap hinge, of the period found in Canada, was plainer: its effect depended

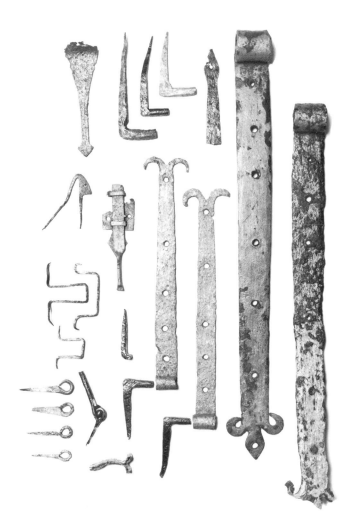

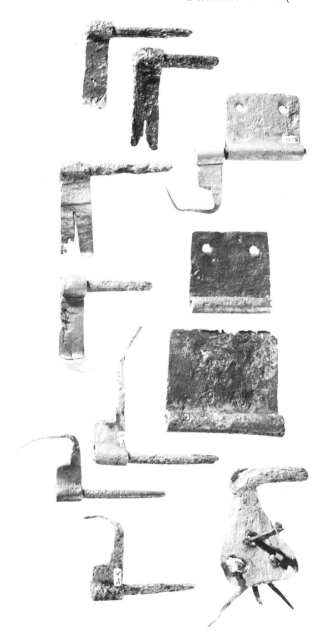

Early hinges and hardware were typically forged by blacksmiths in the immediate area of building. This group includes heavy door hinges, hinge pintles, and left, latches and staples, all excavated at the Jacques le Ber house (Fort Senneville), c. 1700, at Senneville, Quebec. CANADIANA, ROYAL ONTARIO MUSEUM

Smaller wedge and butterfly hinges, also c. 1700, from Fort Senneville, Senneville, Quebec, with their wedges and pintles. These pieces are window and shutter hinges, but very similar hardware was used on interior cabinetwork, and in furniture such as armoires. CANADIANA, ROYAL ONTARIO MUSEUM

the design on thin sheet iron and cutting it with hammer and cold-chisel. Again, those of Quebec best preserve this tradition, with forms of double cocksheads, coronets, fleurs-de-lis, hearts in openwork or outline, and elaborate abstract shapes, emerging from the symmetrical treatment of the plate. In English-settled areas, the most common type of latch is a simply decorated Suffolk, with escutcheons cut to a leaf, spade or bean shape.

Early in the 19th century, bean-plate Suffolks and quite plain Norfolks were among the wrought iron goods imported. They in their turn were displaced when, around 1845, cast iron Norfolks came on the market. These were imitative of hand-wrought latches, though seldom of the older highly worked examples. Most had detail only at the corners to relieve the severity of the backplate, and the cheapness of their manufacture proved too great a competition for the hand-forged latches.

In French Canada, escutcheon plates were used wherever there was a need to protect wood from a moving metal part. They back the sliding bolts for doors, windows and cupboards, and appear at the base of knobs in a circular form with edges cut in a scalloped or "daisy" pattern. On all of these plates, the combination of outline and openwork design gives the iron an appearance of great delicacy.

Because the French-Canadian armoire and buffet doors opened with a key, they were provided with keyhole escutcheons rather than knobs. This type of escutcheon, narrow and elongated, was worked out in forms of seahorses, birds, flames, and many abstract variations which nevertheless suggest an organic origin. To maintain the symmetry on armoire doors, the plates were often used in pairs, though only one served as a functioning keyhole.

Many other pieces of architectural hardware came from the smithy: shutter fasteners, door knockers, structural pieces for supporting beams and stair stringers; even nails continued to be hand-forged until long after nail-making machines were introduced around 1800.

In the stone buildings of Quebec, a few unique forms occur. One is the masonry tie, or tie iron, usually bent to an S

and placed high on the outer walls. Welded to the tie is a tie rod which passes through the masonry to anchor on an interior beam. Another still occasionally seen is an old form of window grille made with iron staves cut on either side to form curving projections, and set singly or side by side in the masonry at top and bottom of the window.

The work of the French-Canadian blacksmith is particularly evident in the crosses on Quebec church spires. Simple ornamentation was added to the severe lines of the cross, in the form of fleur-de-lis finials on the upper arms or fine C-scrolls in the angles. Frequently, the crossing is circled by a glory with radiating shafts or by the crown of thorns, and in accordance with a 9th-century papal edict, many crosses still have a steeple cock at the top.

Next of kin is the weathervane, made in wood and copper but also in tin and painted sheet iron. The wooden or metal ball, still intact below many vanes, protected the end of the support tube. No two handmade weathervanes are alike, and many of the simpler ones could easily have been made at home. Among these are the primitive silhouette figures in metal, occasionally cut in pairs to cover either side of the pole.

Marine subjects, of course, occur frequently in eastern Canada, and livestock vanes abound in agricultural areas, but any subject was open to the maker: beavers, birds, fresh- and salt-water fishes, trotting horses, dragons. But the traditional cock, whether religious or secular, seems to have offered the greatest appeal to the craftsman's imagination. In what is considered to be a folk art form, the maker's use of the cock's contours and plumage—painted, indented, or meticulously fastened feather by feather to the body—gives every weathercock its own distinctive character.

Vanes were also hand made by commercial firms from the early 1850s onward, and some idea of their production may be gained from the 1875 and 1893 catalogue reprints of J. W. Fiske, an American firm. In Canada and the United States, vanes with a small cow, sheep or hog in very low relief are still to be seen on many farm buildings. These were manufactured as lightning rod decorations; for this reason the livestock figure is mounted not in the center of the arrow but at its end, entirely to the back of the vertical rod. The production of this type of vane spans a period from pre-Confederation times to the early 20th century.

A great range of household articles were formed of tinned sheet iron, worked to shape by the whitesmith. Here the material absolutely dictated the design. Tin objects were built up mainly in boxes, cones and cylinders, for the thin layer of tin which coated the sheet iron base was easily cracked or damaged, and all joints had to be either riveted, or lapped and soldered.

Nevertheless, the variety in tin objects is large, for it was a good substitute for more costly materials. Among kitchen utensils alone are found spoons, ladles, strainers, canisters and coffeepots, buckets, cylindrical candle boxes that were mounted on the wall, and reflector ovens or "tin kitchens," with a spit inserted through the sides and a front opening that faced the fire. Tinned iron boxes were made for every use, including that of holding embers in wooden-framed footwarmers.

In the latter 18th century it became fashionable, particularly on trays and containers such as document boxes and tea caddies, to relieve the bareness of the tin with a coat of varnish and brightly painted floral designs. This work, known as japanned tin or tôle, was popular until the mid-19th century. Although a great deal of tôle was imported from England, unpainted tinware was often decorated in the home, and occasionally a piece may be found with an inscription or with a regional character to the decoration that gives the collector a clue to its origin.

Tinned sheet iron was useful for all types of candle holders and for candle molds as well. Outdoor lanterns were designed to shield the flame from wind; usually these were either tinned frames fitted with glass (or horn, where glass was not available), or capped tin cylinders pierced with delicate patterns to show the light. For indoor use, sheet iron candle holders were a simple substitute for those of pewter or brass. Whether the holder had a saucer, or the inverted base called a "hogscraper" which dates from the late 18th century, the candle shaft was often fitted with a sliding device for pushing up the candle stump, a design also in use from the 18th century on. Simple wall sconces were mounted with a polished tin reflecting backplate of round or somewhat keyholed shape, while the many-branched sconces of tin or iron were made for use in churches and public buildings.

With the use of candles came snuffers, necessary to trim the fast-burning wick. These scissor-like utensils had a projecting spike to uncurl the wick for cutting and a little box mounted behind it to catch the glowing end; on some, small legs on the bottom kept soot from touching other surfaces, and the snuffers usually sat in the candlestick saucer or on their own tray.

Iron and tin were also the common materials for other early lighting devices. Rushlights with moveable jaws for holding the splint, although common in Europe, appear to have had limited use here; the more usual light was a shallow pan that burned animal fat or fish oil. The simplest type, the hammered iron *crusie*, had a gutter projecting from the pan to hold the wick out from the oil. Because these dripped, double crusies or "phoebe lamps" were preferable. These were twin crusies—the wick-bearing upper pan hooked onto the lower one, whose snout caught the drips.

These simple iron grease lamps were used in Quebec well into the 19th century. The betty lamp, a modification of the double crusie, was introduced to that province by the English, and was less common there than in Upper Canada. The betty lamp had a hinged lid to prevent spills, and the drip-catching principle of the double crusie was incorporated as a small wick channel inserted in the main projection, allowing lost oil to flow directly back to the reservoir. Both crusies and betties were usually suspended from the neck by a rod with a spur for hanging or driving into wood. Sometimes a small second unit, the pickwick, was chained to the rod for pulling the wick up in the channel.

It is worth noting that all of these early lighting devices were common also in Europe, in some areas until quite a late date. Because primitive utensils were so often used for scrap

Cast-iron plate stove, composed of separate side plates held in position by a flanged base and top, and easily dismounted for shipping. The stove was cast by Forge St-Maurice, at St-Maurice, Quebec, c. 1780–1810, and has a relief marking "F. St. M." below the door. Stoves of this type, which are increasingly scarce, occur with a variety of plate decorative patterns.

CANADIANA, ROYAL ONTARIO MUSEUM

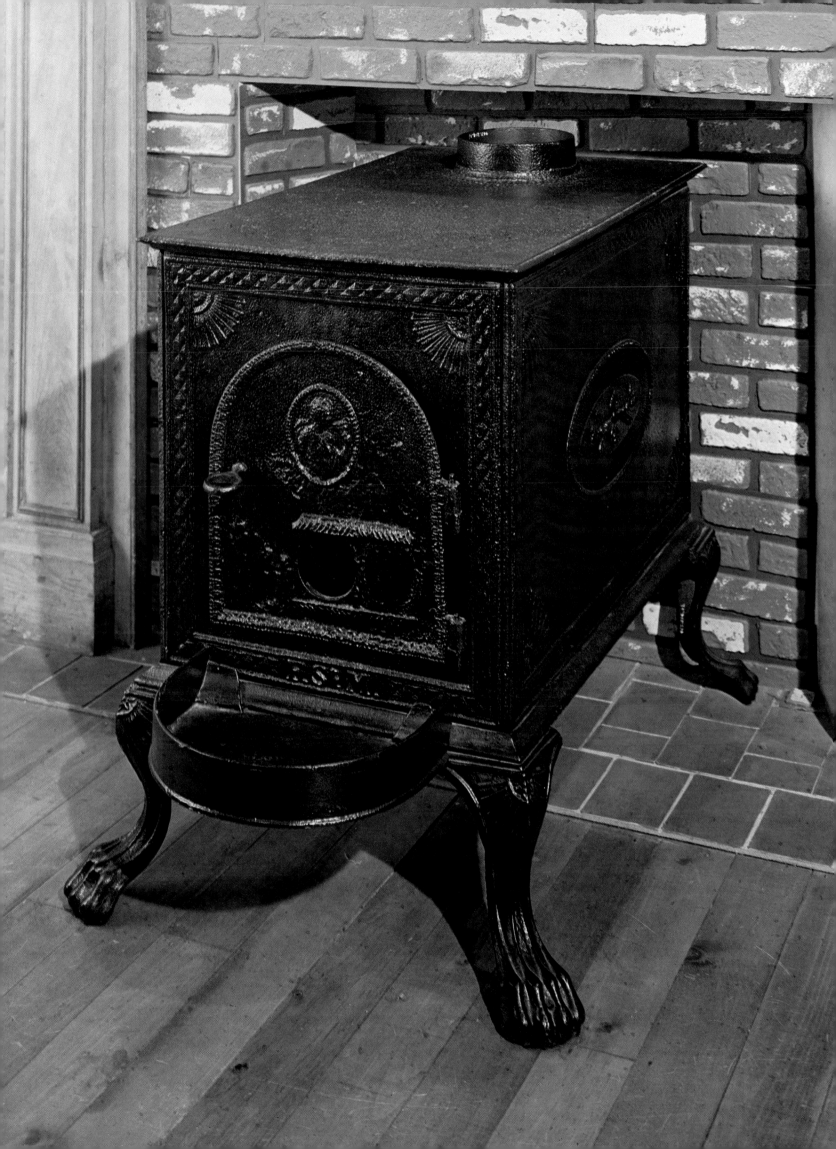

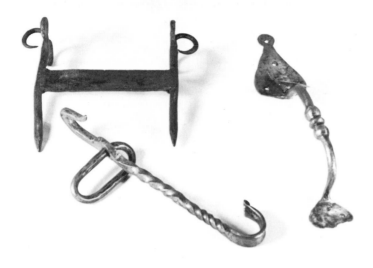

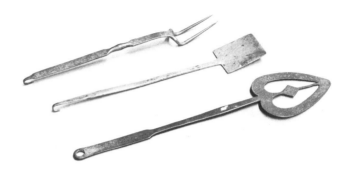

◁ *Products of early Upper Canada blacksmiths, all c. 1790–1825. At left is a spike-based foot scraper, originally driven into wood. Below is a small fireplace trammel hook, for holding cooking pots. The door handle on the right, the only firmly located piece, is from Waterloo County.* CANADIANA, ROYAL ONTARIO MUSEUM

Fireplace cooking utensils of the Ontario-German area, a fork and two peels from Waterloo County. The cut-out heart form of the lower peel is most unusual. All date c. 1825–60.

DOON PIONEER MUSEUM

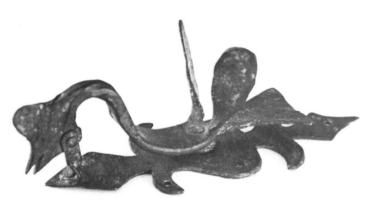

◁ *Door-latch, late 18th or early 19th century, from western Quebec. The fleur-de-lis derivative base-plate would be expected, but the bird's head and tail latch-push is uncommon for Quebec ironwork.* PRIVATE COLLECTION

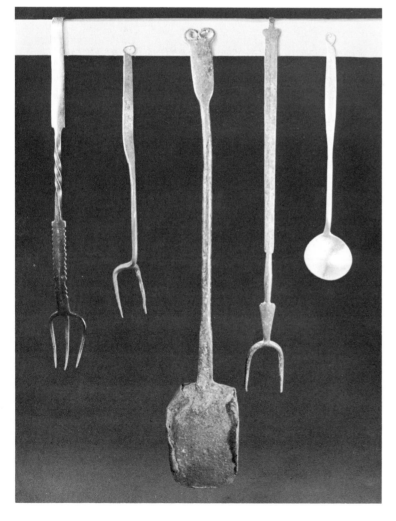

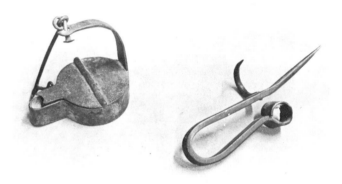

Upper Canada lighting equipment, at left a hinged-cover fat-burning betty lamp, and at right a spike-mounted candle holder. Betty lamps of this type are ubiquitous to northeastern North America, as are hook or spike mounted candle holders, the latter of which were most commonly used for barn and shed lighting.

DOON PIONEER MUSEUM

◁ *Kitchen utensils—forks, ladle, and a small peel, all of the 1780–1850 period, and typical of the period of fireplace cooking prior to the general introduction of stoves. Blacksmiths at restored village museums, such as Upper Canada Village or Black Creek Village, presently make reproductions of similar utensils.*

CANADIANA, ROYAL ONTARIO MUSEUM

Typical fat-burning lamps of the first half of the 19th century. At ▷ the left is a pivot-covered betty lamp, found in Markham, Ontario, with a spiked-hook mount, and on the right is a hinged-lidded lamp of the same type. The center lamp is a so-called "double-crusie," with an open upper fat holder, and an underlying drip pan, with mount attached.
CANADIANA, ROYAL ONTARIO MUSEUM

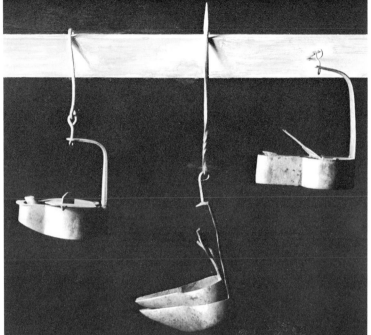

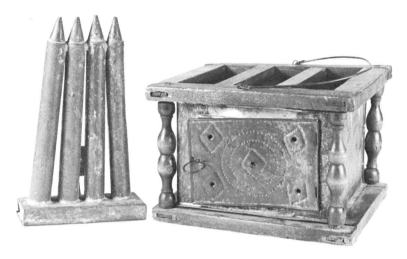

Tinned iron candle-mold, for casting molten wax around mounted wicks, and a sheet-iron foot-warmer to hold hot coals, mounted in a wooden frame. Both are manufactured pieces, probably of the third quarter of the 19th century, and were standard household equipment of the period. CANADIANA, ROYAL ONTARIO MUSEUM

Candle snuffers and wick trimmers were an essential accessory ▷ to 19th-century lighting equipment. These pieces, all dating c. 1825-75, were collected in Quebec, though the upper left and lower right examples are factory manufactures, and may have been imported. The upper right hooded trimmer, and the lower left open scissors type, are individual blacksmith-made pieces.
PRIVATE COLLECTION

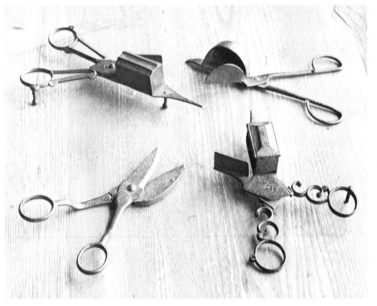

Candle lanterns in the mid- and later 19th century were standard ▷ household equipment, and were even listed in early mail-order catalogues. The pierced sheet-iron lantern on the left was essentially for barn lighting, and safe if dropped. The glass-sided lantern on the right, with carrying handle, was more of a general purpose type. CANADIANA, ROYAL ONTARIO MUSEUM

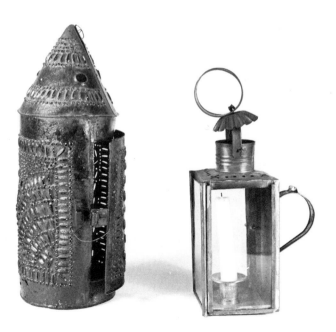

iron when improved types became available, the number that have survived in this country must be considered small.

New forms of lighting arose from the development in 1783 of the sperm-oil Argand lamp, and in 1787 of the common whale-oil lamp with its closed reservoir and one or more wick tubes. The first half of the 19th century produced lamps made of many materials and burning a variety of fuels, a trend accompanied by the spread of gas lighting in the middle years of the century and by the advent of the kerosene lamp in the 1860s.

Before homes acquired these much brighter lamps, the fire on the hearth was a major light source. At the same time it was frequently the only means of heat and, until the introduction of cooking stoves, the place where all cooking and very often even the baking was done. The durability of iron under intense heat and hard wear, as well as its low cost, made its use common for the whole range of hearth and cooking utensils.

Protection of the hearth itself from deterioration was always a problem. Firebacks, for those in a position to obtain them, saved the back wall and retained much heat that would otherwise be lost up the chimney. The flat cast plate varied somewhat in shape but its surface always carried decorative details cast in relief; it might be permanently fixed in place or simply leaned against the chimney wall.

For raising the fire off the hearth floor, firedogs were universally used. Small firedogs known as creepers or chenets were sometimes placed between the large andirons to support short billets of wood. The billet bars of all firedogs were of wrought iron, which could be rewelded if they became weakened by constant fire. The uprights were either of cast iron, giving a somewhat stocky look, or more commonly of wrought iron which lent itself to finer shaping. A feature of many wrought firedogs in the United States was a flattening of the arched neck at the top of the upright. Often the firedog carried a ball finial over the neck; in prosperous homes these finials, or the whole upright, might be made of brass.

As coal became a more convenient fuel than wood in urban areas, this continent adopted the European meld of fireback and firedogs into a single unit, the coal grate. In the United States, firebacks in the later 18th century were sometimes replaced by "backs and jambs," large permanently anchored cast iron plates that covered the entire back and sides of the fireplace. Similar plates are found in later houses for use with a gas fire, and the type is forerunner to the thin sheet-iron plates with stamped ornament which appear in houses from the late 19th century on.

One of the most invaluable pieces of equipment on the kitchen hearth was the chimney crane. Its heel bar was anchored so that the crane could be swung away from the fire, while a diagonal crossbar and the resilience of the iron itself made it possible to hang considerable weight on the arm. Cranes offered the blacksmith more scope for ornament than most kitchen objects, and the individuality of many lies in the fact that each was proportioned to fit a specific chimney opening.

Whether the hearth had a crane or the older device of a lug pole secured across the chimney throat, pot hooks, or "trammels," were needed. Some were simply rods forged to an S, or pot chains mounted with hooks. Others had a central bar on which an adjustable pot hook unit moved. These were the hole-and-peg trammels and the more massive ratchet trammels, some of which are of such a length that they could only have hung from a lug pole.

Those vessels which took the hardest wear were usually of cast iron. Frying pans were long in the handle, and one variety, the spider, stood on legs for cooking over embers. Kettles were wide-necked and normally lidless, although one type, the shallow "Dutch oven," did have a close-fitting lid; pots were narrow-necked and bellied, and both types of vessels came in a range of sizes. Their rounded bottoms required legs, and here, as with most hearth equipment, three legs were used for stability on the uneven hearth floor. Not only was boiling and stewing done in these vessels, but with the aid of a lid they served for roasting and baking, and they had the unexpected virtue of increasing the iron content in food.

From the 17th century to the 19th, pots and kettles gradually evolved shorter legs and thinner walls. By the 1850s the shape had become quite cylindrical, and legs disappeared altogether on those used with the new stoves. Legs were superseded on many pots by an indentation of the lower sides to permit insertion in the stove-lid openings.

Open-fire cooking was accomplished on short-legged grills and gridirons, or by means of spits. To support the long meat spits, spithooks were often welded directly to the uprights of the andiron, or the top of the upright was formed in a loop; otherwise the cook used a pair of free-standing spit racks. A much smaller device for cooking birds or small game was the bird spit. This had a drip tray on four short legs, over which arched a rod or a solid frame mounted with small meat hooks.

Most of these utensils would likely be found in an established household, as would be a selection of long-handled forks, spoons, skimmers and ladles. These and the spatulate utensils, the peels, salamanders and small lifters, are often found with simple shaping down the handle or with terminals divided and bent round to form open hearts or ram's horns. Toasting was accomplished either with a long fork or a hearth toaster, made frequently with a rotating toast-rack.

Another hand utensil used by merchants, but also found in prosperous homes, was the sugar nippers, for cutting up large lumps of sugar from the hard cones in which it was imported. They were equipped with semicircular steel jaws which opened on a spring; a spike on the lower handle prevented bruised knuckles when pressure was applied, or the problem was avoided by mounting modified nippers on a wooden base.

Although long-handled waffle and wafer irons are found in other contexts, the best-known in Canada are the wafer irons of Quebec, used to bake the Host. The heads of the iron were delicately incised on one or both faces with religious symbols. Because of the detailed and painstaking workmanship in these, it has been suggested that they were done by the finer metalsmiths, for a certain mobility among the metal crafts seems to have existed.

Trivets are found in almost staggering variety, both those for hearth use and the triangular type made as sad iron stands. Wrought trivets are scarce now, but they can be among the most delightful of the blacksmith's products. The unexpected and imaginative detail worked into many of these suggests that they were somewhat of a whimsy for blacksmiths, and even in the plainest trivets something of the maker's character comes through. Not all wrought iron trivets were short-legged; some sat on high legs stabilized by a series of stretchers.

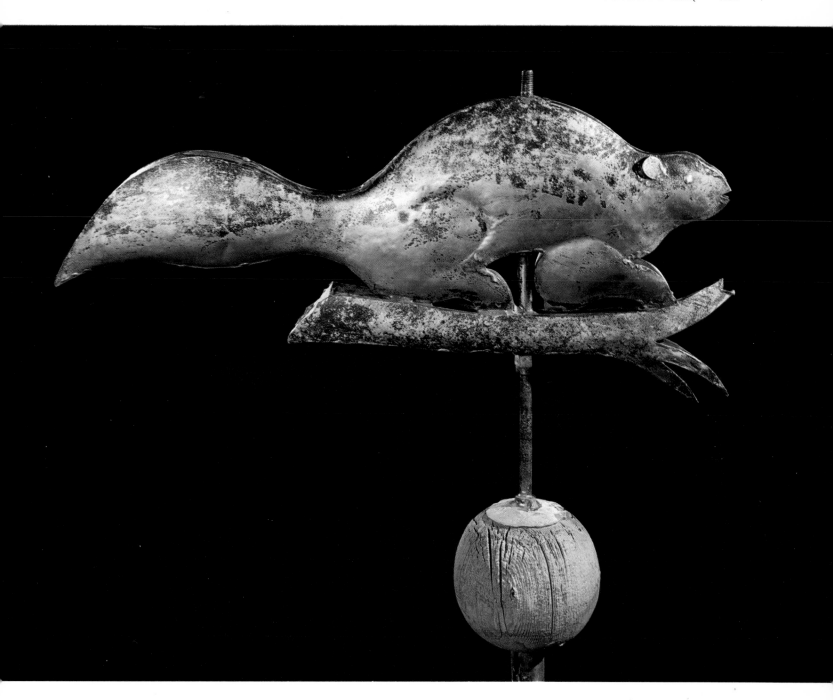

Sheet iron weather vane figure of a beaver, made of two molded sides soldered to an inch-wide center strip. Sheet iron weather vane figures were popular barn decorations in Quebec, with beavers, fish, cocks, and horses as the most common forms. This piece dates c. 1870–80. CANADIANA, ROYAL ONTARIO MUSEUM

Cast iron trivets were produced by countless foundries, and there is still a certain amount of production or reproduction today. The nature of cast iron necessitated more solid patterns in these, but again the variety is enormous. In addition, many have a foundry name or distributor's mark incorporated in the design; although this permits only rough dating, it does give an indication of the trivet's origin.

Many specialized types of clothes irons were made, the most familiar today being the sad iron ("sad" meaning heavy). These were of solid iron, and though the name is usually applied to the small household irons, the heat-retaining principle applies also to others like the thin, pointed sleeve iron and the large "tailor's goose," weighing many pounds. Another type, the box iron, had an iron slug to be inserted hot through a door at the back of the box; later adaptations of this type had a cavity designed to hold hot coals.

For delicate work, there were two-piece fluting irons

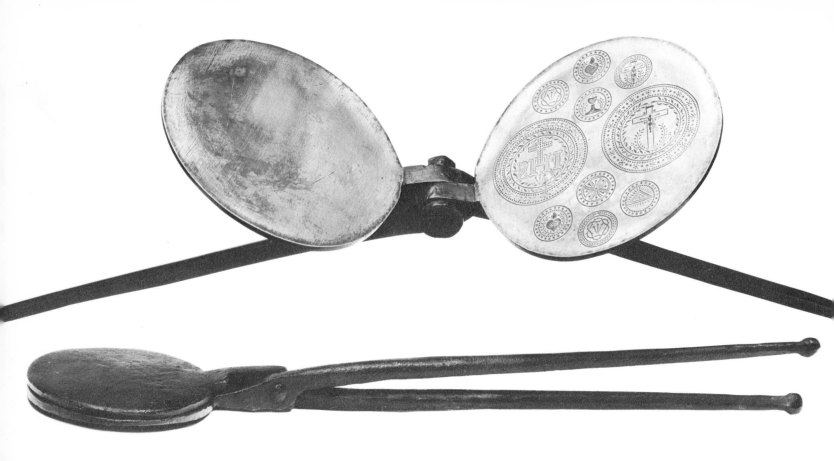

Wafer irons were commonly possessed by churches and church orders for making communion wafers and are found with a variety of incised patterns and motifs in one or both sides. This iron, from Quebec, dates c. 1850. To make wafers, the iron was first heated. Then wafer dough was poured on one plate, and the iron closed. Retained heat in the metal was sufficient to cook the wafer, and the process could be continued at quite a rapid pace. PRIVATE COLLECTION

A very fine example of a weather-vane cock, on its original iron mounting, this Quebec chanticleer dates c. 1850–60, and was made from mixed iron and copper sheet, soldered together. It was in a bad state when found and has been restored.

CANADIANA, ROYAL ONTARIO MUSEUM

Heavy cast clothes irons were produced by many foundries, in a very large variety of types and patterns. At the left and center are hollow box irons, c. 1875, each with an opening and cover at the rear for filling with hot coals. At the right is a heavy solid iron "tailor's goose." Like all solid irons, these were used three to six at a time, with some being reheated as others were used. One trivet in the foreground has the integral name SENSIBLE, while the other, initialled TE, is an early T. Eaton & Co. catalogue piece.

CANADIANA, ROYAL ONTARIO MUSEUM

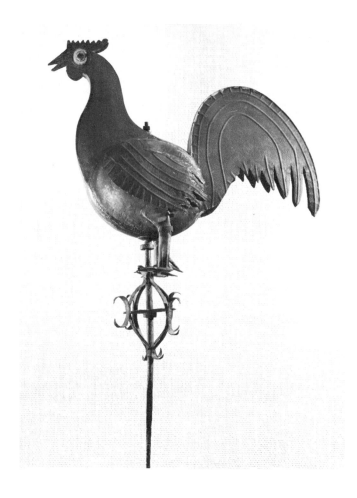

with corrugated surfaces, used by rocking the upper section over the heated lower one. And there were goffering irons for doing bonnets or frills, with a set of slugs on handles which were put heated into the bullet-shaped barrel. This barrel was mounted on an iron rod set in a wooden base; older goffering irons show quite a variation in the treatment of these rods, but by the 19th century they were becoming standardized in a strongly curved S below the base of the barrel.

None of the cast iron utensils mentioned above would exist but for the fact that iron with a high carbon content must be poured to shape. Pure wrought iron could not be used for such objects, whereas in cast iron they could be produced in quantity. This form of the metal stands up even better than wrought iron to prolonged direct heat, and it has great compressive strength. However the high impurity content makes it brittle, and once cracked it could not be welded by techniques then known. Partly for this reason, few of the early castings used here have survived.

Before 1737, virtually all iron had to be imported to New France. But in that year Les Forges St-Maurice were constructed on the St-Maurice River, north of Trois Rivières, with a furnace capacity of 4 tons and facilities not only for making castings but for the further refining of wrought iron. Using charcoal as fuel, and the easily mined bog ore which lay close to the surface throughout the surrounding area, St-Maurice produced an exceptionally fine grade of iron sufficient for the needs of the whole colony and an export market as well.

The St-Maurice works spanned immense changes in Canada's history. It may have cast ordnance for the French in the Seven Years' War, and in 1775, under a steward who later defected with the company funds, it supplied shot and shell to the American forces for the Siege of Quebec. It was the only successful producer of iron in Canada until the Batiscan works (c. 1798 – c. 1808) were built in the same vicinity.

From the turn of the 19th century on, several other furnaces were attempted in the Maritimes and the Canadas. All were dogged by technical and monetary problems, and with a few exceptions, closed down within a few years of their initial trial. The only furnace that in any way approached the permanence of Les Forges St-Maurice was the Van Norman furnace at Normandale on Lake Erie, which successfully went into blast in 1822. Normandale was for some years the only local supplier of much-needed stoves and cast hollow ware to Upper Canada, and it continued operations until dwindling ore supplies and heavy competition from English goods forced its closing in 1847.

Technical improvements from the 1830s on brought new fuels and enormous furnace capacities to the large foreign smelting industries. At the same time, the job of casting finished products was passing into the hands of small foundries located close to their markets; an Upper Canada legislative record of 1835 tentatively lists twenty-one foundries in the province, of which only two had primary smelting furnaces. Throughout the period, the St-Maurice furnace, with increasing financial difficulty, continued to produce high-grade iron until its ore and fuel supplies were exhausted. At its final shutdown in 1883, it was the oldest operating furnace in North America: its fuel was still charcoal, and its furnace capacity, 4 tons.

These few pre-Confederation furnaces were of great importance to the colonies. In 1832, St-Maurice employed from 250 to 300 men, and around the same period Normandale provided the chief livelihood for 200 families. Bog ore from the local fields and marshes gave farmers another "crop," and the making of charcoal for the blast furnace caused the rough deforestation of huge tracts of land. In early Upper Canada money was scarce, and for goods brought to the ironworks, Normandale paid in castings or in due bills redeemable in ironware. For a time these due bills functioned in the area as an alternate form of currency, with at one point over $30,000 worth in circulation.

Most castings were made by pouring the molten iron into a sand impression formed from a wooden pattern board. Early sand casting of flat plates was done directly on the "casting floor," a sand bed in front of the furnace opening. Toward the end of the 18th century, this continent adopted the use of the "flask" for castings such as stove plates. This method, which had already been in use for casting hollow ware, employed a double box mold into which sand was packed around the pattern. Flask casting permitted thinner, more even castings and avoided the rough upper surface of the open sand castings.

The pattern-maker's job was as skilled as the founder's. Carving a design on the wooden pattern boards required an exact knowledge of the limitations of iron as a casting material; the delicacy of workmanship on an old stove is their achievement. Those who prepared the molds for casting were also specialists. The packing was done with particularly cohesive sand; although its surface would imprint the pressure of a thumb, it held its form precisely when molten iron was poured over it. Once poured, very little could be done to alter a casting. It could be "trued up" to some degree and finished with abrasives, but any flaws in the metal or the design were there to stay.

An older casting method was used for the great kettles or cauldrons, some of which weighed over a thousand pounds. They were cast lip up, around cores made of loam over coiled rope, and the casting of every kettle required the making of a new core. These kettles were legless; lugs were cast in the sides so that the kettle could be suspended in a stone and masonry structure called an arch. Such kettles were basic equipment for preparing potash or maple sap, and in the Maritimes they served for boiling whale oil and the bark used in preserving fishnets.

Castings from the pre-Confederation furnaces were somewhat limited in range, but they met the needs of the settlers. From its early years, St-Maurice turned out heating stoves, pots, kettles and probably other small castings as well; in the 19th century, it was also making potash kettles and mill machinery. Of the Normandale products we have a more complete list: plows, stoves, sugar and potash kettles, sleigh shoes, mill castings, and (from an 1835 advertisement) "plate stoves . . . oval stoves (double plate) . . . cooking stoves . . . dog irons, bake pans, belly pots, spiders, etc."

Heating stoves were understandably an important part of any foundry's production. Quebec had used stoves from the late 17th century, apparently of brick with iron top plates. The earliest form of heating stove made in Canada was probably the six-plate or Holland stove. The sides of this rectangular stove fitted together and were held by flanges on the upper and lower plates and by the weight of the top plate itself. They

Late sheet-iron weathervane figure of a horse, Quebec, c. 1900–20, and painted in aluminum paint and black. Homemade cut-out figures of this type are still commonly seen on barns in Quebec and are probably still being made.

CANADIANA, ROYAL ONTARIO MUSEUM

Human figures in iron are rare in Canada. This handmade figure of an archer on a roof mount, with directional letters and a rotating wind vane arrow, came from the shop of its blacksmith maker at Oka, Quebec, and dates from the late 19th century.

PRIVATE COLLECTION

could be dismantled in a matter of minutes and packed flat for easy transport or summer storage. Usually these stoves were given Grecian or Adam motifs, simple and delicately formed in low relief. A front opening served for tending the fire, and a projecting hearth (either a detachable pan or cast as part of the bottom plate) helped in raking out the ashes.

These six-plate stoves were a part of the Normandale foundry's production, and St-Maurice made and exported them from its earliest years. In fact, though the type originated in Europe, these stoves were so closely associated with the St-Maurice ironworks that they were often termed "Three Rivers" or simply "Canada" stoves. They were also known as "Montreal" stoves, for this was a major point of distribution.

Modifications of the basic six-plate stove occurred when, around 1780, a second tier was added and, around 1840, a third. These added chambers had double doors in the side, enabling them to be used for heating or baking. These forms were made

in Quebec until around the end of the 19th century. The many side doors in such stoves made the designing of decorative motifs an awkward problem. One of the best solutions was found in the diamond pattern, reminiscent of the old diamond-point doors of armoires. The original stove bearing this design, usually called "Le Bijou," bore the fate of many popular stoves in the 19th century; it was copied repeatedly by other foundries. This was a simple matter, for stove plates themselves could be used as patterns, and many stoves, identical in all but the foundry name, are found with fractional differences in measurement caused by the shrinkage of cooling iron in the copy.

"Franklin stove" is a term now applied to all open-fronted stoves. The original Franklin fireplace was an attempt to avoid two drawbacks of the open fireplace, those of heat loss and smoky rooms. Although Benjamin Franklin's published design of 1744 was soon modified, iron fireplaces were immediately

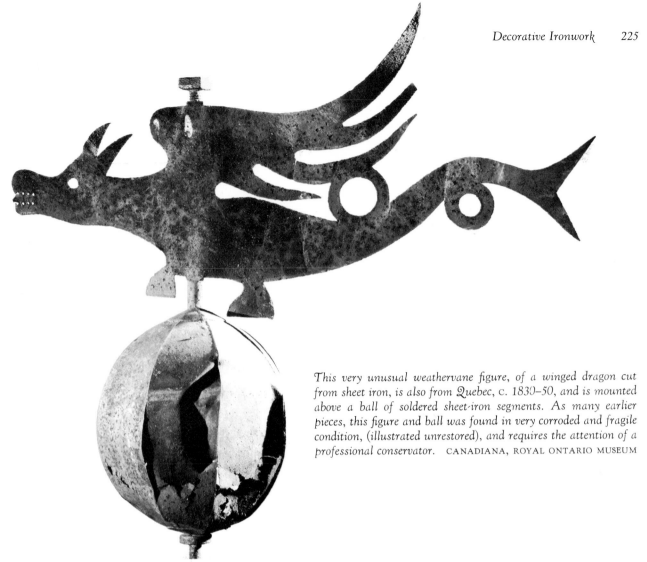

This very unusual weathervane figure, of a winged dragon cut from sheet iron, is also from Quebec, c. 1830–50, and is mounted above a ball of soldered sheet-iron segments. As many earlier pieces, this figure and ball was found in very corroded and fragile condition, (illustrated unrestored), and requires the attention of a professional conservator. CANADIANA, ROYAL ONTARIO MUSEUM

popular and remained so for over a hundred years. Originally they sat projecting out from the hearth, the stove pipe invisible and the hearth opening bricked up around the metal side plates. The wood-burning Franklin, like the open fireplace, required the use of andirons and the accompanying tongs and implements. When coal came into wider use, grates were cast with the unit. Later Franklins were provided with legs, allowing them to stand free from the hearth, and sometimes also with doors so that in effect they could be made into closed stoves. The latter type is still manufactured for cottage use.

After 1845, a modification of the box stove known as the parlor cook stove came into use. This type had a small oven and a top burner, disguised when not in use under an urn, which held perfume or water for humidity. A period of highly ornamented Gothic, Rococo and Greek revival stove decoration followed the general trend in taste around this time, and it is not unusual to find the entire surface of the metal covered with relief-cast ornament. In this period, some United States cities developed huge casting industries, and many parlor stoves and column stoves were exported to Canada.

The column stove itself was the extraordinary result of Greek revival design wedded to the most scientific principles of heating. They were cast from about 1840 on, at first with two columns and later with four. Their structure provided more heat-radiating surfaces than ever before, as smoke rose from the main firebox up the columns and out of the pipe behind the upper heat chamber. Again, a large urn in the middle could be filled with water to mitigate the dry heat.

The greater complexity and lavish ornamentation of these

castings was made possible by the development of anthracite coal as a smelting fuel in North America. This fuel allowed the processing of far greater quantities of iron than had charcoal fuel. Furthermore, the higher temperatures it produced gave a more molten iron, allowing an increased freedom in the design of castings.

Cylindrical wood-burning stoves, sometimes called cannon stoves, had been made in limited quantities in the U.S. until about 1820, although their casting was then a difficult procedure. In the 1850s a more or less cylindrical upright stove, the base-burner, became popular. Its great advantages were that it burned cheap anthracite coal, and incorporated a coal hopper which made the stove self-feeding. Most base-burners seen today have the small mica windows and lavish nickel trim which became typical features in the 1870s and 1880s. The popularity of this magnificent stove continued until the present century and was only displaced by the growing use of gas fires and central heating.

Cooking stoves are also a 19th-century development. The coal-burning stoves already in use in England did not adapt well to wood as fuel, but by about 1830 enough progress had been made in the design of wood-burning cooking stoves for their manufacture to be increased. Advertisements and patent records of the following years show a flurry of "improvements" as manufacturers vied to produce the perfect stove.

As well as the top burners of various diameters, these stoves had ovens in the side or in a raised section at the back; a small oven with side doors was sometimes fixed over the stove pipe above the top plate. Made for these stoves, and

Architectural and outdoor ornamental cast iron work became very popular in the mid- and late 19th century, ranging from fences to whole building façades. As examples of Canadian production of this type, these heavy fence-post finials with beavers and maple leaves are late products, c. 1860–70, of Les Forges St-Maurice, north of Trois Rivières, Quebec. PRIVATE COLLECTION

at times sold in a package with them, were a large assortment of pans and cooking vessels, steamers, boilers, kettles and so on, by now quite straight-sided and frequently made of heavy tinned iron.

Early cooking stoves were always low; the idea that one stooped to cook was slow to disappear. By the 1850s, a tall massive stove that fitted into an enlarged chimney opening was sometimes used. Its format was more like that of the modern stove: burners at waist level (through which wood was fed to the firebox below), the oven at eye level, and a warming compartment above.

Many of the old cooking stoves found in Canada are American-made, for newspaper advertising made competition strong. But numerous Canadian foundries turned out stoves, and, fortunately for the collector, it became common in the 19th century to incorporate makers' marks in the larger castings. At times, merely the model name and a number indicating size were used, but many stoves for both cooking and heating bear the name and location of Canadian foundries.

This period of technical refinements and unlimited casting facilities, coinciding as it did with the exuberance of the Victorian era, brought about a scale of production in cast iron that has led one writer to describe it as "The Foundry Age."

The rage for cast iron, by now the least expensive of materials, brought an erosion of the blacksmith's art and the manufacture of many objects previously thought unsuited to the metal. Wood, stone and the finer metals were all replaced to some extent as foundries offered the public cast iron garden statues and fountains, and household articles large and small. Beds, tables, hall stands, doorstops, and much other cast iron furniture became popular, as well as smaller castings such as wall brackets, mirror and picture frames, match holders and ornamental plaques.

Cast iron became an increasingly common material in architecture for bridges and buildings, and for details of roof trim, fences, grates and grills. Foundries cast not only store fronts but entire buildings, designed to be erected in one day, which were shipped from the eastern States to California during the Gold Rush.

The most remarkable aspect of Victorian taste was its eclectic borrowing from other periods of style. Often the ornamentation was adapted from a period in which the object itself would have been quite unknown. Thus 19th-century heating stoves may exhibit the densely applied elements of Gothic and Classical revival architecture, as well as the florid Rococo of parlor cook stoves. Another trend in fashion, that of "naturalist" ornament, appears in such objects as the "rustic" lawn furniture, in which the shapes of chairs and tables emerge from a tame jungle of cast iron leaves and twigs. The strong appeal of this furniture is shown in the fact that a similar pattern, the "grapevine," was still being offered for sale in a foundry catalogue of the 1920s.

The extent to which attitudes had shifted regarding the decorative aspects of ironwork can be seen in the example of the footscraper. The simplicity of the hand-wrought scraper, with its slight arch under the crosspiece and its finely shaped uprights, gave way to the liberties of the cast iron medium. One cast foot scraper, of which Upper Canada Village has an example, is set in an oval dish festooned with beading and grapevines, from which the scraper rises in the form of a stringed lyre.

A product which illustrates the most lasting trend underlying "The Foundry Age" is the sewing machine, first made in a marketable form on this continent by the Singer Company in 1850. The pride with which these new machines were produced is evident in the quality of ornament applied to them in the form of inlay work, gold and silver electroplating, and japanning. At the same time, it was one of the inventions which created a more advanced technical age, for such machines required small, highly finished, interchangeable castings. This need for absolute precision and uniformity in casting moved industry irrevocably toward assembly lines and automatic tools in place of manual skills. And public attitudes easily adapted to the shift, for the implications were difficult to perceive and the gains indisputable.

Tools
of the Trades

Loris Russell

Man could be defined as a tool-using animal. The human hand, with its superb flexibility and its extreme development of grasping power, is ideally suited to use extraneous objects to extend its range of operations.

The first tools were sticks and stones. The stick could be used to knock fruit from trees, or as a club for attack or defense. In effect it extended the arm. The stone reinforced the hand. Grasped in one or both hands, it served as a hammer to break open nuts or shells. Thrown through the air, it was the first projectile.

Combination of the stick and the stone was accomplished by binding with thongs the split end of the stick around the stone. Thus a true hammer was produced. Meanwhile men had learned to make a sharp edge on stone by striking off flakes with another stone. So the knife and the hand ax were created. Fitted to a wooden handle, the hand ax became a true ax. Set longitudinally into a stick, the knife became a spearhead and later an arrowhead.

These remained the basic tools for thousands of years. The next great step was the replacement of stone by metal. First, natural metallic copper was hammered into the desired shape. Then the art of smelting was discovered, and the separated molten copper was run into molds. The crude shapes from the molds could be more easily worked than the native copper. By adding tin to the copper, bronze was produced, a much harder metal. About 5,000 years ago it was discovered that metallic iron, previously known only in meteorites, could be made by smelting bog iron with charcoal. The iron emerged as crude chunks, which had to be heated and hammered to form useful articles. But a host of new tools, especially those for cutting, were now possible.

The Romans had most of the woodworking and many of the metalworking tools that are still in use. By the 17th century, when the settlement of North America began, crafts such as carpentry, cabinetmaking, cooperage, blacksmithing, tanning, and farming had become sophisticated enough for each to have its set of specialized tools. Refinement of these tools took place during the 18th century, but the great expan-

sion in design and manufacture occurred in the 19th century. New methods of producing iron and steel made these essential materials better and more readily available. Development of more efficient water wheels, and the invention of the steam engine, made the factory possible, where a number of people worked on different parts of the same operation. Better tools were designed for their use, or to be manufactured and sold to the public.

The advent of machine tools in the late 19th century, especially after electric power became available, brought about the decline in hand-tool industries. The power saw, the planer, the shaper, the power lathe, and the electric drill took over from the equivalent hand tools. But certain tasks still required the individual craftsman, and other skills, that were no longer needed by industry, were preserved by the hobbyist.

The lure of old tools for the collector is not just in their rarity or their decorative qualities. They record the transition from simple hand crafts to machinery and mass production. They are a direct link with the old-time craftsmen and permit reconstruction and preservation, if only in the imagination, of the skills and the industries that formed our technological and social inheritance.

WOODWORKING TOOLS

Wood is one of the earliest materials to be worked by man. It is usually available in quantity and is easy to cut or shape with stone or metal tools, yet is durable enough for many purposes. Its principal applications have been as construction material for houses and for domestic furniture. Bowls and dishes, spoons and forks of wood ("treen") were formerly in wide use.

To obtain wood, trees must be felled. For thousands of years this was done with some form of ax, but within the last hundred years, special saws have to some extent replaced the ax in felling, with wedges used to keep the saw cut open.

Dividing the tree trunk into flat boards was done by splitting with wedges, but a more efficient method was with some form of saw. Early bronze saws were not stiff enough to cut on the push stroke. By Roman times the iron saw had

made this way of sawing possible. Another problem with sawing was the binding of the blade in the kerf (saw cut). The Romans solved this by "setting" the saw teeth, that is, bending them alternately to one side and the other and thus making a kerf wider than the thickness of blade. The next great improvement was the introduction of steel saws in the 19th century.

The use of some sort of edged blade made it possible to cut wood in more detailed shapes than could be done with a saw. The commonest edged tools were the chisel, the plane, and the drawknife. Some, like the chisel and the frow, were driven through wood by blows of a hammer or mallet. Holes could be made in wood by burning with a hot iron rod or by twisting a pointed blade (gimlet). True drills were designed to remove some of the cuttings during the operation, thus making possible larger and cleaner holes.

Special wood constructions required special tools. The cabinetmaker used finer saws and drills than the carpenter, and a large number of special shaped planes. The turner, who shaped furniture legs and other cylindrical objects on a lathe, had special chisels and gouges. The cooper, who built those essential containers, the barrels, had his own tools for shaping the staves and fitting the lids. Another very specialized woodworking craft was that of the engraver, who carved blocks of wood to form raised images for use in a letterpress to produce printed pictures. The wood was boxwood, and the tools were small, chisel-like blades called gravers.

Brush hook. An ax-like tool used to clear away light vegetation prior to tree felling. The blade is relatively long, and the edge curves down in front to a blunt hook. The blade is attached to the handle by two strap-iron loops.

Ax. The basic tool for cutting wood. The head is wedge-shaped, with a cutting edge, a socket or "eye" for the handle, and usually with a poll, a hammer-like projection from the side opposite the edge. Types of axes are: felling, hewing, carpenter's, lather's, mortise.

Felling ax. Used especially for cutting down trees. Early forms have a flaring blade, a straight handle (helve), and no poll. The modern ax appeared in the 19th century. It has a large poll, which is heavier than the blade, a high, narrow eye, and an edge not much wider than the poll. The handle has a slight S-curve, concave upward in front, convex in rear, with an obliquely expanded end to prevent the hand from slipping off. The head weighs between three and five pounds.

Double-bitted ax. A felling ax with a blade on both sides of the eye and a straight handle. Does not have to be sharpened as often as the single-bladed ax. Some axmen shaped one blade for rough cutting and honed the other for precise work.

Broad ax. Used mainly for squaring timber. The head has a very expanded blade, a poll, and an oval eye. It is flat on one side, with a slope and a bulge for the eye on the other. The handle is curved away from the flat side of the head. This enables the axman to stand clear as he swings the ax in a vertical arc. The goose-wing ax is a German version with the front end of the blade extended forward as a point. The carpenter's hewing ax is smaller than the broad ax and has no poll.

Carpenter's ax or hatchet. This has a poll and a moderately expanded blade. The eye rim is extended to a point on the sides, fore and aft. The head is usually symmetrical, with a double-beveled edge. The handle is of medium length and straight.

Shingling hatchet. This has a light head, with flared blade, and a high poll like a hammer head, for driving nails. The edge is slightly convex in outline. The rear margin of the blade may be notched for nail pulling. The handle is short and straight, with a hole or screw-eye for a retrieving cord.

Lathing hatchet. Like the shingling hatchet, but with the front margin of the head straight. This enables the lather to drive nails in the wall close to the ceiling.

Mortise ax or hatchet. Used for cutting out square holes in logs or boards. The blade is long and narrow and in use is pounded, like a chisel. The double-bladed version has the two sides offset, to provide a step for hammering.

Adz. Like the ax but with the blade at right angles to the handle, and sloping back at an angle less than 90°. The eye tapers from front to rear, so that the handle can be knocked out and the head sharpened on a grindstone. Straight-edged adzes were used mostly for smoothing hewn timbers.

Shipwright's adz. Similar to the straight-edged adz, but with a spike-like poll, for driving broken nails into the timber and out of the way. Used to trim timbers of ships during construction.

Troughing adz. Also called gutter adz. The blade is curved, concave on the rear, convex in front. In some examples the side edges of the blade are sharply curved (lipped edge). There is usually no poll. This adz is used for making hollows in timbers, as for horse-troughs and gutters.

Saw. A device for cutting wood, metal, stone, etc., by forming a narrow slit or kerf. In consists of a thin metal blade, one or both edges of which are serrated with pointed teeth. These teeth may be symmetrical or with the far side steeper than the near. To prevent binding as the kerf becomes deep, the teeth are set, that is, alternately bent slightly to one side or the other. This is done by clamping the blade and bending the teeth first one way, then the other, by means of a slotted tool called a wrest. Principal kinds of saws are: pit saw (framed or open), cross-cut saw, bow saw, buck saw, veneer saw, hand saw, keyhole saw, and tenon saw.

Pit saw, framed. The blade is narrow, usually the same width throughout, with or without perforated ends. It is mounted in the midline of a rectangular wooden frame. It may be up to six feet in length. Usually it is operated by two men and is used mainly to cut boards from logs or squared timbers. The wood to be sawed may be propped at an angle or laid horizontally over a pit.

Pit saw, open. The blade is wide and tapers from one end to the other. Average length is about six feet. The wide or upper end is perforated for a cross handle or is extended as a curved rod with a handle. The narrow or lower end is not perforated and the handle is attached by a wedged block. Used similarly to the framed pit saw.

Cross-cut saw. A large saw with a handle at each end, set in a socket or riveted to the blade. The cutting edge is usually convex. Used mainly for trimming the chopped butts of tree trunks and for sawing logs into shorter lengths. The teeth are symmetrical and sharpened on both edges.

Bow saw. Like a small framed saw, but with the blade on one side of the frame, a straight brace in the midline, and a set of twisted cords on the other side. The blade is tightened

Heavy carpenters' tools of the mid-19th century. Above is a ▷ beam-shaping adz, with spike hammer on the back side of the blade. The heavy broad-ax head, chisel-sharpened on only one side of the blade, is stamped GALT, C.W. *The frow, or froe, below, was used with a heavy maul for splitting shakes or shingles.*

CANADIANA, ROYAL ONTARIO MUSEUM

Wooden gauging and proportioning tools, including a sliding-block gauge at top, a beam compass and a homemade bow compass, and at the left a folding bevel. BLACK CREEK VILLAGE

Specialized tools were required for assembling beams and fram- ▷ ing. Above is a mortising chisel, for cutting out narrow mortise holes, and below is a cornering chisel, for cutting and trimming square inside corners. The heavy chisel in the center is a slick, used not for cutting but for smoothing wood surfaces.

BLACK CREEK VILLAGE

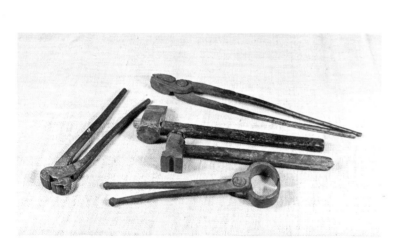

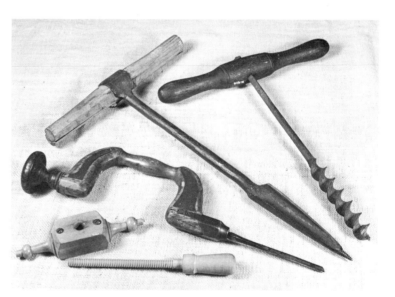

Blacksmithing tools occur in great variety, but usually with the functions of holding, shaping, or cutting of iron. At the left and bottom are cutting nippers, and above is a set of tongs. The chisel-bladed hammer was for both shaping and cutting, while the swaging hammer below was used as a die and pounded with another hammer. BLACK CREEK VILLAGE

Boring and threading tools. At the right is a carpenter's auger, for boring heavy pin holes in building beams. Next to it is a bung-hole auger, for boring tapered holes in wooden barrels. The carpenter's brace with brass fittings, and an early spoon rather than spiral drill-bit, is earlier than the other tools and dates from the late 18th or very early 19th century. The screw-box, below, was used in a great range of sizes, with a small triangular blade mounted inside for threading wooden dowels.

BLACK CREEK VILLAGE

by inserting a toggle stick in the cords at midlength and twisting them. When proper tension is obtained, the toggle stick is secured with one end against the brace. The teeth are raked to cut one way, so that the saw can be operated by one man. It can be used to cut at various angles or even to a curved line. The blade can be removed and restrung through a hole, for cutting out openings in boards.

Buck saw. Like a bow saw, but with a fixed blade. The end pieces of the frame are curved, so that the straining side (rope or wire) is shorter than the blade. One end piece may be extended below the blade to form a handle. Used mainly to cross-cut logs for firewood.

Veneer saw. A small version of the framed pit saw. The blade is strained by means of nuts on the threaded end pieces or by wedges in the frame. Used to cut off layers of wood for veneers, and worked horizontally by two men.

Hand saw. The familiar carpenter's saw, with wide blade, and a handle at one end. Early versions have a simple handle with a tang. The pistol grip and the closed grip appeared in the 18th century. The cutting edge became straight, with the blade tapering regularly. Improvements in the steel for the blade occurred in the first half of the 19th century. Hand saws are of two types. The cross-cut saw has fine teeth, with oblique edges, for cutting across the grain. The rip saw has larger teeth with chisel-shaped points for sawing with the grain.

Panel saw. A small version of the hand saw, this was once known as the gentleman's saw. An even smaller saw is made for pruning and grafting.

Keyhole saw and **compass saw**. Very narrow, tapering blade, with a pistol-grip handle (keyhole saw) or a simple handle (compass saw). Used for cutting out circular or irregular holes in boards.

Tenon saw. One form of various backed saws, with a bar of metal along the back edge, to stiffen the thin blade. Because of the bar, they cannot cut completely through a piece of wood, but have to be withdrawn after the cut is made. The tenon saw is the commonest version and is used for making fine cuts, usually in a miter box.

Bracket saw. This type includes various small saws for cutting on curved lines. They have thin, wire-like blades fitted to a U-shaped frame that strains the blade by its own springiness. The handles are simple. The angle of blade to frame may be adjusted. Examples are: bracket saw, scroll saw, buhl saw, fret saw, coping saw. They are all similar, and some of the names are interchangeable.

Draw knife. A device for shaping wood by slicing off strips with a drawing action. It consists of a narrow, straight or slightly curved blade, with the ends bent towards the cutting edge as tangs for handles. Commonly used on a special bench for tapering shakes into shingles, but can be used with any clamping device. The handles may be secured by clinching the end of the tangs.

Spokeshave. A small form of draw knife set in a wooden or metal mount. The blade is like a miniature draw-knife blade, but the tangs are bent upward, not forward. It is set into a wooden holder so as to clear the under surface of the wood, which is hollowed out above the blade. The clearance between wood and blade is controlled by tapping the tangs up or down. Later versions have set screws to be tightened against the tangs after adjustment. The wooden mount extends at each end to form the handles. A metal "wear plate" (heel or shoe) may be added behind the blade, to rub against the wood being shaved. The all-metal spokeshave was introduced in the mid-19th century. The blade is like that of a plane and is mounted in the same way.

Chisel. A blade-shaped cutting tool, the far end sharpened by bevel or taper, the near end either tanged, with or without a shoulder, or with a conical socket for a wooden handle. Woodworking chisels have parallel sides, a beveled edge, and a socket for the handle. Large chisels are used with mallet or hammer, small ones and very large ones by pressure of hand or arm. Chisels used in woodturning have the edge at an angle other than 90°, and beveled on both sides.

Forming chisel. The basic woodworking chisel, medium to rather large in size, with parallel-sided blade, single-bevel edge, and conical socket for the handle. Used for various shaping operations and for squaring holes for mortises. Also known as a firming chisel.

Framing chisel. Similar to the forming chisel but larger. Used to cut the tenons for mortise-and-tenon joints.

Slick or **paring chisel**. A very large chisel with parallel-sided blade and single-bevel edge. The blade is slightly concave on the side with the bevel, flat on the other. The handle is fitted in a socket and sometimes has a cross-grip, like a shovel, at the upper end. This chisel was not struck but was pushed with the hands. It was used for smoothing, in place of a plane.

Mortise chisel. The blade is narrow and thick, slightly tapering, and almost square at the end. The bevel is deep. The handle is fitted to a tang, with shoulder. Used to cut out square or rectangular mortise holes without predrilling.

Skew chisel. Differs from the forming chisel in that the cutting edge is at an angle other than 90°. Used for clearing out the corners of mortise holes. Another chisel for this purpose is the corner chisel, with the cutting edge in the shape of a right angle.

Frow. Also spelled froe. A form of chisel with the blade shaped like a large knife. The handle is set in a circular eye at one end of the blade and projects back at right angles to the cutting edge. Rarely the handle is a prolongation of the blade axis. Used mainly to split short lengths of logs into roofing shakes. The blade is laid across the upturned end of the log and struck on the back with a wooden mallet or maul.

Gouge. Like a chisel but with a channel-shaped blade. The bevel is on the convex side. The handle is usually fitted into a socket. Used to dig out wood to form a hollow. It is driven in at an angle by striking or pushing, then depressed to pry up the chip. Small gouges, with tanged handles, are beveled on the concave side. The gouge is the basic tool in woodturning. The turner's gouge has a heavier blade than the carpenter's gouge.

Plane. A device for shaping wood by peeling off successive thin layers. The typical plane consists of a rectangular block, perforated near midlength by a V-shaped slit, through which the blade projects more or less obliquely. The blade may be held in place by a wooden wedge or a set screw. There may be an open or closed handle at the rear end of the block, and sometimes a front handle. Metal planes were introduced in the mid-19th century. Planes are used for smoothing, grooving, or shaping. The angle at which the blade is set varies from 60° to vertical. The harder the wood, the steeper the angle.

Jack plane. A wooden bench plane about 16 inches

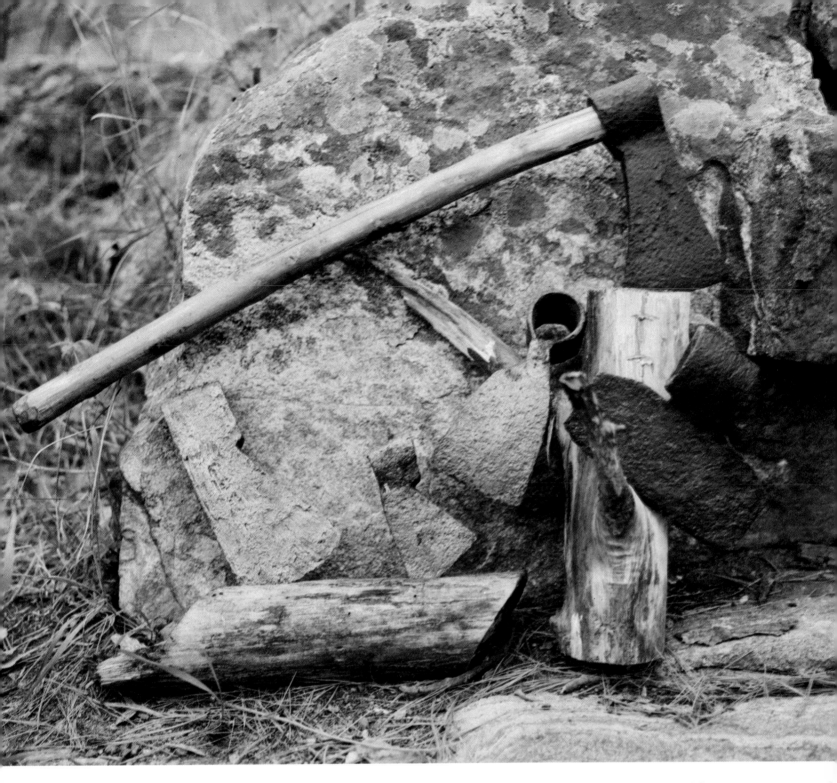

long, used for preliminary treatment of surfaces. The blade is beveled on the underside and set for a deep cut. It is slightly concave on the upper side.

Trying plane. Used for leveling surfaces. The block is long, 20 to 22 inches, and the blade is flat. There may be a second blade set over the first to direct the shavings. A very long version is the floor plane, about three feet in length, for leveling wooden floors.

Smoothing plane. Used in finishing operations, such as leveling joints. It is short, 6 to 10 inches, with no handle. The sides are convex.

Toothing plane. A small plane with a finely serrated edge on the blade, which is mounted steeply. Used to roughen surfaces prior to gluing.

Compass plane. The base of the block is convex. A smaller version is the modeling plane. Used for shaping concave surfaces on furniture.

The few tools of the 18th century that still exist have been recovered accidently or unearthed in archaeological excavations. At the top, with handle, is a felling ax, probably French, of the mid-18th century, which was recovered from the French River, Ontario. Left to right are: an English felling ax of the late 18th or early 19th century, found at an abandoned central Ontario farm site; a French Indian trade hatchet, c. 1750–60, excavated at Fort Senneville, Senneville, Quebec; a log-shaping adz, French or Quebec, c. 1730–50, excavated at the Jacques LeBer house, Ile des Soeurs, Montreal; and a broadax, also for squaring logs, c. 1790–1820, unearthed on an early-settled Ontario farm.

CANADIANA, ROYAL ONTARIO MUSEUM

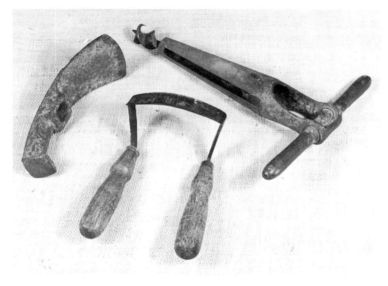

Cooper's barrel-making tools were highly specialized, usually with single functions. At left is a coopers' adz, for rough shaping of barrel staves, and below is a curved draw-knife for finer shaping. Above is a bung-hole auger, of a somewhat different type than that shown previously. CANADIANA, ROYAL ONTARIO MUSEUM

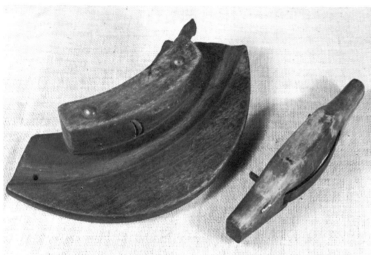

Cooper's planes were also very specialized. At the left is a croze, used for cutting out the inside groove for fitting a barrel-head, and on the right is a handmade fine draw-knife for shaping staves.
BLACK CREEK VILLAGE

Cooperage shop and cooper's bench, the latter used for wedging staves in position while shaping with a draw-knife.
BLACK CREEK VILLAGE

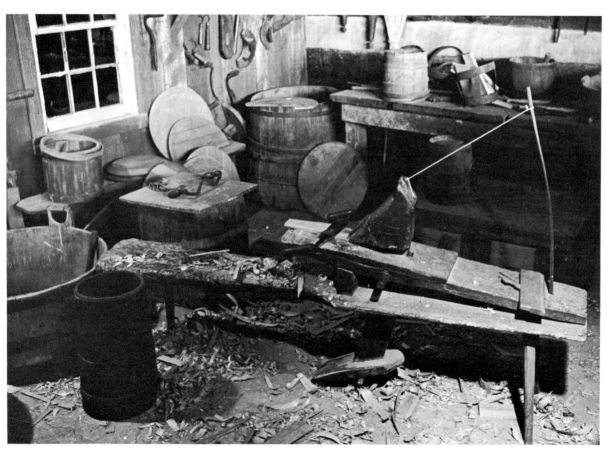

Rabbet plane. Used to cut a step-like form on the edge of a board to form a joint with another board (rabbet). The block is narrow and of moderate length. The blade is narrow and set straight or skew. A "fence" on the left side is either a lower strip of the block or an extra piece attached to the side. Some have adjustable fences to vary the lateral width of the rabbet. The depth may be controlled by a slotted strip or a metal peg on the right side of the block. There may be a small cutting blade, called the router, in front of the main blade to mark the inner edge of the rabbet. This prevents tearing of the wood.

Plow. Similar to the rabbet plane, but the blade is narrower and does not reach either side of the base. Used to cut the groove in the edge of a board for the tongue-and-groove joint. The companion piece is the tongue, in which the blade is deeply notched, thus forming the tongue of the tongue-and-groove joint.

Molding plane. The base of the block and the edge of the blade are in simple or complex lines to cut a curved, rather than a flat, surface. The forked staff or hollow plane has the base and blade edge concave, for forming handles or smoothing cylindrical surfaces. The round plane has a convex base and edge and serves to form or smooth gutters and flutings. True molding planes have complex shapes, to cut ornamental moldings. For large moldings a wide plane is used, pushed by the carpenter and pulled with a rope by an assistant. The sash plane, with two blades, cuts a rabbet and a molding at the same time, to form window frames.

Awl. A small, hand-held device for piercing wood, etc., by pushing aside the material but not cutting it. This tool consists of a narrow steel blade, with a cylindrical or cross handle. The carpenter's awl has a chisel end and is used mainly for making starting holes for nails (brads) in hard wood. The harness-maker's awl has a diamond-shaped point, and the shoemaker's awl a simple point.

Burn auger. A pointed, usually square iron rod set in a cross handle. Heated, it is used to burn holes in wood. Such holes could be square as well as round.

Auger. A perforating tool, varying from small to large size. Consists of a drill or bit, and a cross handle. The upper end of the bit may be set into a square hole in the middle of the handle, or the handle may go through a circular eye on the end of the bit. In some augers the bits are interchangeable.

Gouge bit. Used mostly as an auger. The cutting part is shaped like a half cylinder, and the edges are sharpened. Cuts only the perimeter of the hole, leaving a central core.

Spoon bit. Similar to the gouge bit but with the lower end rounded and curved in, so as to cut towards the center of the hole. Used for shallow drilling.

Nose auger (down-cutting auger). A form of spoon bit in which the lower end is notched to one side of center, and the larger part bent in at right angles to form a cutting edge. By lifting out the cuttings at intervals, this bit can drill deeper than the gouge bit.

Twisted-cylinder auger. Like the gouge bit but with the lower end drawn out and twisted into a spiral "pivot screw." This bites into the wood and draws the bit down. Used mainly for drilling long, straight holes.

Pod bit. Like the gouge bit but shorter and twisted spirally at the lower end. The tip may be like the twisted cylinder or the nose bit. More suitable for shallow holes.

Gimlet. A miniature auger, usually with a short twisted bit. It is used in one hand with a twisting motion.

Reamer. Used to enlarge holes already made with an auger. Like a gouge bit but with a taper. Some forms, like the bung-hole reamer, have a screw tip. A large form, without screw, is used to ream out the axle hole in wheel hubs.

Center bit. The lower end of the bit is expanded into a short, flat blade. The edge has a sharp pin at the center. On one side the edge is turned transversely and sharpened. On the other side it is notched, leaving a point to guide the bit and clear the hole. This bit is used with a brace and is suitable for shallow holes.

Spiral bit. Used as an auger or with a brace. The blade is twisted in the form of a spiral or a helix. The lower end has a center pin or screw with transverse cutting edges on each side. This bit is self-clearing and can cut deep holes. Modern versions have the outer ends of the cutting edge projecting down as cutting points.

Brace. A device for rapidly and continuously turning a bit. It consists of an upper knob or "button" which is held and pressed with one hand, and a double-elbow, which revolves in the button and provides a grip for the other hand at mid-length. The lower end has some device for holding the bit, such as a square socket or a chuck. Early braces were mostly of wood; later they were strengthened with brass. The all-metal brace appeared about the middle of the 19th century.

Boring machine. For drilling holes in large timbers, either for pins or to be squared for mortises. The mechanism is supported on two uprights from a horizontal platform. The drill is attached to a shaft with a horizontal crown gear, which is turned by two vertical crown gears, one on each side, attached to a crank. The machine is placed over the timber, and the operator straddles the platform and turns the cranks, one in each hand. Commonly used in barn framing.

Rasp. A kind of file, with the cutting surface formed by a pattern of raised teeth, which are formed with a triangular punch. The sides of the blade taper and the cross section may be flat or half-round. Used for shaping and smoothing wood.

Carpenter's hammer. The commonest type is the claw hammer. This has the upper end of the head drawn out into a pair of claws, with a narrow, tapering notch between. The curve of the claws may be regular or may be straight towards the tips. Prior to 1840 most claw hammers had a simple, rectangular eye for the handle. It was difficult to keep the handle in place when pulling nails. A metal tang, and strips of metal along the sides of the handle, were improvements, but the extended eye, the rim of which projects back to make a longer socket, was introduced in 1840 and has remained standard ever since. Carpenters also use the "pein" hammer, which has a chisel-like end to the head, instead of claws.

Mallet. A kind of hammer with a large wooden head. Early forms were in one piece, like a club. Normally the head is a separate block, with a square or circular face at right angles to the grain of the wood. The handle is inserted across the grain. Mallets are used where hammers would cause scarring. They are also used to drive chisels and frows. In Canada the mallet head is often made from a maple burl. Very large mallets were used to drive together the mortise-and-tenon joints of frame timbers.

Nails. Small, pointed, metal rods which are driven into wood with a hammer and serve to hold two or more pieces

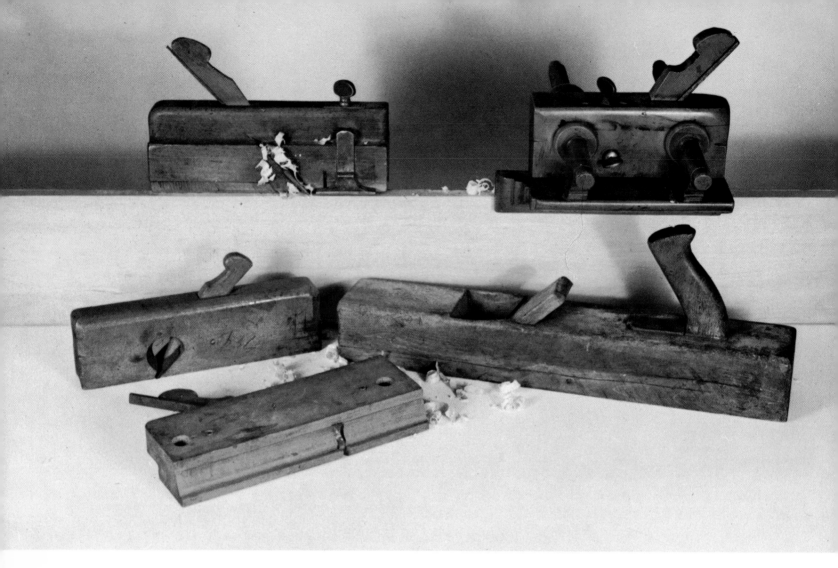

Mid-19th-century specialized carpenter's planes, of types still commonly found. On the board, left and right, are a rabbet plane and a screw-adjustable plow. Below on the left are two molding planes, which occur in great variety, with blades shaped for cutting various curves. On the right is a jack plane, for reducing and smoothing flat surfaces. Most tools of this type were manufactured; handmade examples are rarely encountered.

CANADIANA, ROYAL ONTARIO MUSEUM

together. The end opposite the point is expanded into a head, which makes the nail easier to drive and increases its holding power. Early nails were made from square strips of iron, cut to the required length, then tapered and given a head by hammering on an anvil. The cut nail, which appeared in 1798, is tapered on two sides only. Wire nails were invented in 1838. They are circular in cross section, and the heads are flat.

Square. Consists of two straight pieces of wood or metal set at right angles to each other. The all-metal type is usually made in one piece. A common type consists of a thick wooden arm and a thin metal arm projecting at right angles from one end of the wood. Early squares were unmarked but most are calibrated along one or more edges. Used to draw or scratch a line on wood or metal at right angles to an edge.

Miter square. Similar to the square, but with an angle of 45°. The simplest form is a block of wood, one end of which is cut at 45° and a thinner strip set in. More usually the form is like that of the wood and metal square. Used mainly for laying off lines in cutting boards for the corners of frames.

Bevel. Like the miter square but with the angle adjustable. May be two strips of wood or metal, riveted to each other at one end, to swing stiffly on the joint. The usual form has one arm set in a slot in the other, with a set screw to secure the joint once the desired angle has been selected.

Compass. Consists of two pointed, slender legs of metal or wood, pivoted on each other at the blunt ends, used to transfer intervals, and especially to scribe arcs or circles. One leg may have an arc-shaped piece extending through a slit in the other leg. Pressure on this from a set screw secures the compass legs in position.

Caliper. Resembles the compass but the legs are bent, either in a broad curve or at a sharp angle near the tips. Outside calipers have the legs bent inward to meet and are used to measure the outside diameter of cylindrical objects. Inside calipers have the jaws bent outward and serve to measure the diameter of holes.

Slide caliper. Consists of a straight strip of wood or metal, with or without calibration, on which are mounted two blocks with pointed ends. One block is fixed at one end of the strip, the other is slotted to slide along the strip. The movable block can be secured with a wedge or a set screw. Used to measure or transfer intervals.

Gauge (gage). A wooden rod, with or without calibrations on which a block or bar slides and is set with a wedge or set screw. Near one end of the rod a metal point projects from the side. By holding the secured block against the edge of a board, a line may be scribed with the point parallel to the edge. Used to mark a line to which a board is to be sawn or planed.

Rule. A strip of wood or metal with one or both edges straight and marked in inches and fractions. The pocket rule

folds on a brass hinge. There is also a sliding version. Used for measuring and for scribing lines.

Level. Used in adjusting a surface or edge to a horizontal position. The early form has a miniature plumb bob suspended on a bow-shaped piece over a straight edge. The spirit level, a 19th-century invention, has a sealed glass tube, not quite filled with alcohol. It is set into a bar, and when the bar is horizontal, the bubble is at the middle of the glass tube.

Scriber (scribe). Also called scratch awl. An awl-like tool with a rounded tip, used to scratch a line along a rule or square to which the wood may be sawn or planed. Replaced in the 19th century by the carpenter's pencil, which is flat and is sharpened to a chisel edge.

Cooper's hatchet. Resembles a broad ax but is smaller and with the blade extended fore and aft. Used for shaping and trimming barrel heads.

Cooper's adz. Has a square poll and a deeply curved edge. Used for shaping the inside of barrel staves and for hollowing out wooden bowls.

Scorp. A draw knife with a nearly circular blade, used by coopers for hollowing out staves. Some versions have a single handle, others have two handles.

Chamfer knife. A kind of draw knife used by coopers to make the bevel on the rims of barrels. It has a deep, short, heavy blade with two handles, one of which is an extension of the blade, the other at right angles. The first handle provides control of the angle of bevel, the second of the angle of the blade.

Cooper's plane (long jointer). A very long wooden plane, mounted with the blade side up and at a slope. Edges of barrel staves are planed by pushing them against the blade edge.

Howel. A plane with a convex base and blade edge. It is attached to a flat piece of wood on one side, the fence. With the fence resting on the rim of the barrel, the plane is used to smooth the inside of the staves, just below the rim.

Sun plane. A wooden plane, the block of which is curved, concave on one side, convex on the other. Used for beveling the rims of barrels after the staves are secured.

Croze. A kind of plane with a narrow blade and a strongly convex base. The block is attached to a large fence with handles. Used by coopers to cut the channel on the inside of the barrel just below the rim, into which the chamfered edge of the lid is fitted.

STONE-WORKING AND BRICK-WORKING TOOLS

The shaping of stone into useful objects resembles woodworking in that most of the operations involve removal of material. Blocks of stone are cut by saws and shaped by adzes and chisels. Stone can be drilled with suitable bits and smoothed with abrasives. Most stone, however, is harder than wood and usually has no grain. Owing to its brittleness, stone can be rough-shaped by chipping with hammer or chisel. Prolonged cutting of stone, either by saw or drill, generates heat, which is dissipated by a stream of cold water playing on the stone and the moving tool.

Unlike stone, bricks come fabricated in a suitable shape. Tools used in bricklaying include those for trimming, but are mostly for manipulating the mortar that cements the bricks together.

Spalling hammer. A large, heavy hammer, with two flat faces, or a face and an edge, used by stonemasons to split and trim rocks. The spalling ax has two edges.

Maul. Stonemason's or sculptor's mallet, used to drive chisels. The wooden head is cylindrical, usually with a taper towards the handle. This shape allows the operator to concentrate on the control of the chisel point, without having to keep the mallet face at right angles to the chisel head.

Mill pick. A kind of adz used to dress the grooves in millstones. It is usually double-faced, with the edges transverse to the handle.

Slater's hammer. A light hammer with circular face and long, slender, pointed pick. This hammer is used to trim roof slates and perforate them for nail holes.

Bricklayer's hammer. The head has a square face, an extended eye for the handle, and a long, curved, chisel-like blade with transverse edge. It is used in splitting and trimming bricks.

Hod. A carrying device for bricks that consists of a wooden trough, V-shaped and open at one end. A pole-like handle projects down from the middle of the lower edge. Bricks are piled in the trough at a slope, and the loaded hod is carried vertically, supported by arm and shoulder as well as hand.

Trowel. A bladed tool used in handling or shaping mortar and plaster. The mason's trowel, used in stone- or bricklaying, has an acute point at the free end, an obtuse point at the handle. The tang and handle are offset above the blade. Foundry trowels have oval or rectangular blades and are used in shaping sand molds. Plasterer's trowels have a rectangular blade, with the handle attached near the middle of one side.

Bricklayer's hoe. Like a gardener's hoe, but with two circular holes in the blade. Used in stirring quicklime and water to make slaked lime, and in combining this with sand to produce mortar. Atmospheric carbon dioxide converts the slaked lime to calcium carbonate, and the sand provides porosity to allow air to penetrate.

METALWORKING TOOLS

In working metal, some cutting with saw, chisel, or drill is practiced, but the characteristic operation is shaping, either by bending or hammering. Metalworking is thus more like modelling than like carving. But the hardness of the medium requires some force. The blacksmith works with iron at high temperatures. Soft iron, which is relatively free of carbon, can be shaped readily in the red-hot condition. Sheet iron and other thin metals can be bent at ordinary temperatures. The worker in sheet metal was at one time known as a whitesmith, in contrast to the blacksmith, but later the name tinsmith was substituted.

Bellows. A device for creating a stream of air, which is directed into the fire in the forge, making it possible to heat iron to the red-hot or white-hot condition. It is a giant version of the fireplace bellows, but is fixed in a horizontal position and worked by pulling up the lower board with a chain and lever. A continuous draught can be obtained with the double bellows, which has three boards, the middle one being stationary.

Forge. The blacksmith's fireplace. It is made of brick or concrete and has an opening in the center, through which the pipe from the bellows emerges. Bituminous coal displaced charcoal as the fuel in the 18th century. A small fire is made with wood chips around the opening and fed with the bellows blast.

Coal is raked around it and ignited. Forge accessories include a rake, a poker, and a sprinkling can to control the fire.

Anvil. The iron object on which the blacksmith hammers and shapes the iron, either hot or cold. The top is flat and usually steel-faced. It extends at one end as a pointed horn for making curved shapes. Commonly the face is perforated by a square hardy hole and a circular pritchel hole. Below the face the body of the anvil narrows, then spreads out to the base, which is secured to a stout table or the upturned section of a log.

Tongs. The tool by means of which the blacksmith handles hot iron. It consists of two iron pieces pivoted on each other near one end. The short part forms the jaws and the long part the handles. The shape of the jaws varies from straight to widely curved, and there are special shapes for particular operations.

Blacksmith's hammer. Usually this is the cross-pein hammer; the head has a flat, slightly chamfered face on one side and a chisel-like edge on the other, transverse to the handle. The straight-pein hammer has the edge parallel to the handle. The ball-pein hammer has a hemispherical face instead of the chisel edge, and is used to form depressions.

Sledge hammer. A heavy version of the blacksmith's hammer, weighing up to 24 pounds. It has a long handle and is swung with both hands. While the blacksmith holds the hot iron and directs the operation, his helper strikes with the sledge.

Chisel. The blacksmith's or machinist's chisel is a straight steel rod, one end of which has a long taper and a short, double-beveled edge. The cold chisel has an edge at about 60°; for cutting hot iron the edge is more acute. The ordinary chisel is held in one hand and struck with a hammer. The set chisel has a handle, like a hammer. It is used mostly on hot iron.

Hardy. A short, chisel-like tool with a square shank that fits into the hardy hole in the anvil. The iron is laid across the edge and struck with a hammer. The hardy is mostly used to cut hot iron.

Fuller. Like the hardy but with a rounded edge. It makes grooves rather than cuts. By making a series of grooves and then beating them out with a hammer the blacksmith makes a piece of iron thinner and longer. The bottom fuller fits in the hardy hole; the top fuller has a handle like a hammer.

Swage. A kind of die, used by the blacksmith to shape metal. Usually it has a flat face, with one or more semicylindrical grooves across it. The bottom swage fits the hardy hole; the top swage has a handle like a hammer. Used together, they shape a hot iron rod from square to cylindrical. Other groove shapes convert cylindrical to square and other kinds of section.

Swage block. A large iron block with variously shaped grooves and indentations, it takes the place of a set of bottom swages.

Flatter. A large, hammer-like tool with square face and chamfered edges. Manipulated by the blacksmith and struck by the helper, it is used to flatten rough iron surfaces such as those of welds.

Mandrel. A high, narrow cone of cast iron, used to shape rings from iron rods. The ring is rough-formed by welding, then driven down the cone to obtain the true circular shape.

Header. A flat bar of iron, expanded at one or both ends and perforated with a square or round hole, used to make the

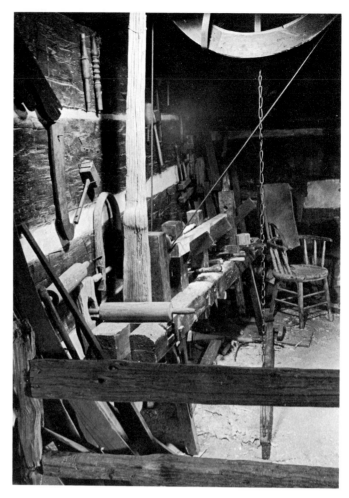

Woodturner's shop, with an early 19th-century lathe operated from a large-diameter overhead wheel. Turners were often specialized craftsmen who produced such articles as rolling pins, chair legs and rungs, wheel spokes, and anything else that required lathe work. BLACK CREEK VILLAGE

heads on spikes or bolts. A bar of iron is thickened at one end, then dropped into the header hole. With the lower end of the rod inserted in the hardy or pritchel hole and the header resting firmly on the anvil face, the thick end of the rod can be beaten with a hammer to form the head.

File. A strip or rod of steel with the surface cut in parallel grooves, used to cut or smooth surfaces, usually of metal, and to sharpen tools. Files may be flat, half-round, triangular, knife-shaped, or circular (rat-tail).

Hack saw. A saw for cutting metal. The blade is narrow and is mounted on a bow-type frame, with pistol grip or closed handle. Hack-saw blades are made of tungsten or molybdenum steel and are discarded when dull.

Blacksmith's drill. This consists of a metal brace and a pressing lever. The brace is like that used by carpenters but has a pointed upper end instead of a button. The lever is pivoted on a vertical pillar. The pointed end of the brace is fitted into a hole on the underside of the lever. The brace is turned and guided with one hand while pressure is applied through the lever with the other hand. About the middle of the 19th century the geared drill was introduced. In this the mechanism is turned by means of a vertical crank, and the motion is transmitted through a gear train to the bit. Vertical pressure on the rotating bit is maintained by means of a ratchet wheel and pawl.

heated portion of the tire is gripped by the shoes and pressed together.

Shears. The tinsmith's scissors, with short, thick blade and steeply beveled edges, used to cut sheet metal. The handles may be straight or with closed loops for the fingers.

Stake. The tinsmith's anvil. T-shaped, with a horizontal head and a vertical stem, which is either driven into a wooden block, or fitted into an anvil hole. The horizontal part has a flat face and a pointed horn, like the blacksmith's anvil, but is much smaller and narrower. Sheet metal is shaped by hammering it on either part. Specially shaped stakes are used for particular operations, such as forming corners, or narrow tubes.

Soldering copper. Also called soldering iron, although iron is used only for the tang. The head consists of a short copper bar, with the free end pyramid-shaped. The tang is usually looped through a hole in the head, and the other end driven into a wooden handle. Before use the tip of the head has to be "tinned." This is done by sanding it clean, then heating the head and applying flux and solder, so that the sides of the pyramid are coated with a surface of shiny solder.

FARRIER'S TOOLS

The art of horseshoeing is a separate craft in Europe, but in North America it is usually practiced by the blacksmith. Many of the tools are those used in blacksmithing, such as the forge, the anvil, the hammer, and the tongs. Special varieties, or special tools, are used to shape the shoe or to prepare the horse's hoof for the shoe.

In the wild state, horses wear away their hoofs about as fast as they grow, and the natural turf does not cause splitting. In domestication, the hoofs may be excessively worn or even split on paved roads, or if the animal is confined, may grow too fast because of the reduced wear. It is the task of the farrier to keep the horse's hoofs trimmed and clean, and to attach or replace the iron horseshoes that protect against excessive wear and prevent slipping.

Farriery is an ancient craft, but unlike traditional blacksmithing, is still widely practiced, owing to the popularity of horse racing and horse shows, and the revival in horseback riding.

Farrier's hammer. Various types are used in shoeing horses. The driving hammer resembles a claw hammer, but has short, nearly straight claws. It is used to drive the nails through shoe and hoof, and to clinch the points on the outside. The fitting hammer is a light cross-pein hammer used in the final shaping of the shoe. The turning or rounding hammer is double-faced, with convex surfaces. It is used to round the edges of horseshoes. The snow knocker is a small hammer with a pick on one side of the head and a metal handle with a ring at the end. It is hung on the harness and used in winter to remove accumulated snow from under the horse's hoofs.

Farrier's pincers. Like the blacksmith's tongs, but with the jaws curved in to meet each other along their edges, it is used to extract the nails and pull off the worn shoe. The hoof parer is similar except that only one jaw has a sharp edge. It is used to trim the hoof edge to fit the new shoe.

Farrier's knife. The blade is curved, with the convex edge sharpened. It is also slightly bowed and the tip is bent up sharply. The handle is of wood, set on a tang, or of cast iron, attached with a screw. The hoof is trimmed and its underside cleaned with this tool.

Simple agricultural tools were often handmade and at their finest were nearly sculptural forms. These pieces are a hand-carved wooden grain shovel, a flail for threshing grain, and a wooden hay fork, all of the mid-19th century. BLACK CREEK VILLAGE

Taps and dies. These are used for cutting the threads on nuts and bolts. The tap is a slotted steel rod with a series of sharp edges on the intervening ridges. Inserted in a hole of matching diameter and turned with a wrench, the tap cuts a spiral thread of grooves and ridges. The die is a disc of steel with a center hole shaped like a four-leaf clover. The four inward-projecting points have thread-cutting ridges. There is a slot to permit compression. The die is placed in a special wrench, in which it can be tightened with a screw. Placed over the end of a metal rod and turned with the wrench handles, it cuts a spiral thread to form a bolt.

Traveler. A small iron wheel mounted on a handle. The rim is marked with an index or an inch scale. This tool is used to measure the outside of wheel rims and the inside of metal tires in shrinking an old tire or making a new one.

Tire bender. A large machine with a cast-iron mount, used for bending strap iron to make wagon-wheel tires. There are three steel rollers of small diameter, the middle one of which can be moved up or down relative to the other two. By rolling the iron strip under the middle roller and over the two lateral rollers it can be given the desired curvature.

Tire shrinker (upsetter). Used to reduce the circumference of a metal tire by slightly thickening a portion. Two corrugated shoes on a heavy iron frame can be swung towards each other by means of a compound lever or a set of gears. The

*Nineteenth century agriculture, and domestic life, saw the intro-
duction of many simple patented mechanical devices for specific
tasks. This wooden corn-planter, c. 1870, is typical. It held seed
in the box, small amounts of which were pushed out and into the
ground each time the handled plunger was pushed down.*

*The preparation of wool and flax for spinning required consider-
able equipment, most importantly perhaps the combs used for
straightening fibers before spinning. Above are two flax hatchels,
c. 1830–50, made from stiff iron spikes, through which flax was
combed to separate fibers. Below is a pair of wool-carding combs,
manufactured pieces of the 1880s.*

Farrier's rasp. Like the carpenter's rasp, but heavier,
and with parallel sides. Usually it has no handle, and the teeth
are set both ways from the middle, which enables the farrier
to work on both up and down strokes. It is used to level the
hoof before putting on the shoe.

Clinch cutter. A knife-like tool with a stout blade,
usually made from a file, used for cutting the clinches of the
nails before pulling off the old shoe. The blade is placed under
the clinch and struck with a hammer.

Butteris. A short, chisel-like blade with a long rod
handle, the latter bent twice and terminating in, or set into, a
shoulder rest. It is used to trim out the sole of the hoof.

Foot adjuster. A horseshoe-shaped tool used to measure
the angle between the sole and the front of the hoof. With the
hoof resting on the base, a pivoted bar in front is adjusted to
the slope. This permits the new shoe to be shaped to the same
angle as the old.

TOOLS USED WITH ANIMALS

In addition to the tools used by the farrier, there were other
special tools used by those who worked with animals, such as
horse breeders, dairy farmers, sheep and pig raisers, and poultry
men. There are also the instruments used by veterinarians,
which are similar to those used by surgeons, and are not
described here.

Twitch. A device for restraining animals by clamping
the nose. The bull twitch is a kind of tongs and is used to
grip the inside of the nostrils. The horse twitch is a piece of
rope or leather thong with a wooden handle at each end. The
cord is looped over the nose and twisted, and the horse can be
held by the two handles.

Speculum. Used to hold open a horse's mouth, while
inspecting or working on the teeth, or while administering
medicine. It consists of a U-shaped frame of rod iron with a
handle and cross bars. It is forced into the horse's mouth and
twisted.

Snatch. A kind of tongs, with curved jaws, used for
catching pigs. The jaws are slipped around the pig's foot and
the handles pulled together with a rope.

Float (tooth rasp). A short rasp blade mounted on a long
rod with a wooden handle. Used to smooth the sharp edges
of the horse's cheek teeth.

Tooth key. For extracting horse's teeth. It resembles an
auger, but has a pivoted hook at the far end, at right angles to
the shaft. The hook is engaged on the inside of the tooth,
which is pulled with a twisting motion.

LEATHER-WORKING TOOLS

The transformation of the stiff, hairy hides of animals into
flexible, smooth leather is partly a chemical process, partly a
mechanical operation. In the tanning proper the tools are
simple: tongs and poles to manipulate the hides in the tanning
bath. Removing the hair and the residual flesh and fat requires
special cutting and scraping tools, and there are others used in
the final smoothing and polishing of the leather.

Bark spud. Resembling a large chisel, but with a short
blade and curved edge. The handle is long, to be used with
both hands. It is used in peeling the bark from oak trees, to be
ground and steeped for tanning liquor.

Unhairing knife. Used by tanners to remove hair from
hides after they have been soaked in the unhairing bath. It is
like a draw knife, but the long blade is moderately curved,
with the concave edge sharp. The handle at each end is set
on a tang, which is an extension of the blade. The hide is
draped over a sloping board, and the tool is pushed down the
hide, sharp edge forward.

Fleshing knife. Used to scrape the remnants of flesh and
fat from hides. It is like the unhairing knife but shorter and
with both edges sharpened. The concave edge is used in scrap-
ing, the convex in trimming the edges of the hide.

Currier's knife. Tanners use this to scrape and soften
the tanned hides. It has a relatively short, wide, straight blade,

chamfered on both edges, with a tang at each end. One tang is set into a simple handle, the other bolted to a traverse handle. The edges of the blade are tooled to a fine, hook-like curve. In use the blade is held at right angles to the hide surface.

Slick (slicker, sleek). Used to give the final smoothing to the tanned hides, this is a short, heavy blade of steel or stone set along one edge of a wooden handle. A wedge-shaped block of wood is also used for this purpose.

AGRICULTURAL IMPLEMENTS

Primitive farming was entirely a hand-tool operation. Breaking and pulverizing the soil was done with mattocks and hoes, planting was by hand-scattering of the seeds, and harvesting was with sharp, curved blades, such as sickles and scythes. The kernel was separated from the husk by beating, and the chaff was removed by tossing the mixture of kernels and chaff in the wind.

The plow was a great advance over the hoe for cultivating the soil, but it required extra power to pull it, usually supplied by oxen. Many improvements were made in plows over the centuries; the addition of the removable plowshare, the coulter, and the mold-board made them much more effective. It was not until about the middle of the 19th century that other devices operated by animal power began to displace the hand tools of the farmer. The horse-powered mower, harvester, threshing machine and fanning mill took the place of the human reaper, gleaner, thresher, and winnower. This change paved the way for substitution of the steam engine and the internal-combustion engine for the horse. However, many of the old manual tools were retained for use in gardening, but others have become only of antiquarian interest.

Spade. A flat-bladed shovel for loosening and turning soil. Early forms were of wood, with a metal edge. The all-metal blade has thickened shoulders to facilitate pushing the blade into the ground by foot pressure.

Hoe. A transverse-bladed instrument for cultivating soil. The blade is more or less rectangular, with a straight and sharpened lower edge. The upper edge has an eye for the handle. The angle between handle and blade is somewhat less than 90°. Modern hoes have a curved tang with a socket for the handle. The grub hoe is a heavy version resembling an adz and is used for breaking soil with roots. The mattock is similar but has an ax-like blade opposite the adz-like blade. It is used where roots have to be cut.

Seeder. A long, narrow wooden trough, the floor of which is perforated. Inside the trough is a loose board, with a series of slots. The trough is charged with seed grain and slung from the neck and shoulders with a strap or rope. Walking forward, the operator moves the loose board in the trough to right and left, causing the grain to fall through the slots and holes. In the late 19th century, seeders appeared in which the grain was scattered by a rotary blade turned with a handle as the operator walked along.

Sickle. A one-hand knife for cutting field crops and hay. The blade is deeply curved, with the concave edge sharpened and the end pointed. The tang and handle are at right angles to the blade. The reaping hook is similar to the sickle, but has a long handle.

Scythe. A two-hand tool for cutting field crops and hay. The blade, about three feet long, is moderately curved, with a reinforced back edge. The concave edge is sharpened but not beveled. The wooden handle is attached at a sharp angle to the blade by a tang or a socket. The handle has a slight S-curve and has two grips projecting at right angles. In use the blade is swung horizontally, the operator swinging both arms and waist.

Cradle. A scythe to which is attached a light wooden framework to catch the falling stalks as they are cut and to deposit them on the back stroke. The frame consists of a straight piece of wood from which several long, curved rods extend parallel to the blade.

Flail. Used to beat the cut wheat, and other grain stalks, in order to break the heads and free the kernels. It consists of two wooden rods attached end to end by a thong loop through holes. The longer rod is the handle, the shorter, the head. In use, the head is swung with the handle so as to hit the straw pile parallel to the floor.

Winnowing tray. Used to separate the chaff from the grain, this is a semi-circular tray, with the straight side open. The curved side has walls and two handles. Flailed grain is placed in the tray and thrown into the air in a wind or draught. The kernels fall to the floor and the chaff is blown away.

Fork. Used for lifting and pitching hay and straw. One form consists of a wooden rod split part way into four branches which are pried apart and held with wooden wedges. The ends are sharpened or tipped with metal. Another version has a braced cross bar from which prongs project. Forged iron forks with a tang or socket for the handle appeared in the 19th century. Versions with four or more prongs were used for shoveling manure or spading up potatoes.

Rake. Used to gather and pile cut hay and field crops. The wooden version has a braced cross bar, with peg-like teeth projecting down at right angles. The metal rake is similar, with a socket for the wooden handle.

Grain shovel. The wooden shovel is carved from a single piece. The blade is flat or slightly curved, with the sides forming a low wall. The handle continues the lines of the wall back to the grip, which may be a simple cross bar or a closed form like that of the modern shovel. Sheet iron blades appeared in the 19th century, but wooden shovels were retained for handling apples in cider-making.

Hay knife. A blade-like tool used in cutting out hay from a tightly packed stack or bale. A simple form has a wide, curved blade, with tang and handle at right angles. In another version the blade is narrower, and the edge is shaped as a series of long, curved teeth. This type usually has a second handle projecting from the back of the blade. A third form is like a spade, but with the cutting edge in the form of a V-shaped notch.

Hay hook. A short iron hook with a cross handle attached either with a threaded tang or a ring, used for pulling hay from a stack, or for handling a bale.

Grafting frow. A short, straight blade, continued at one end into a curved or looped handle, and bent up at the other end as a chisel-like extension. Used to split and pry apart the cut ends of branches to permit insertion of the graft (scion).

Pottery — Earthenware and Stoneware

D. B. Webster

In Canada prior to the 20th century, as in most communities everywhere, utilitarian pottery was by any reckoning one of the most essential forms of domestic and household equipment. In this period before the availability of mass-produced glass, metalware, and plastics, and before the advent of modern food processing and distribution systems, ceramics were indispensable for the storage, cooking, and eating of food. Pottery was also the least expensive and most versatile of container-ware forms available; it was produced in vast quantity, with every individual household utilizing a full range.

Finer ceramics—white tablewares and porcelain—were totally imported, both in the French period and in later British North America, and by far the largest amount of it is still imported to this day. Before Confederation, Canada was very much a colony economically, intended to produce raw exports and to import and rely on home-country manufactures. As a result there did not develop in Canada, until the 1860 to 1870 period, industrial establishments even capable of producing better grades of tablewares. Even then, the huge British ceramics industry could land shiploads of ironstone white-wares and other pottery at Halifax or Montreal, and still considerably undersell the few struggling domestic factories.

The greatest continuous need, however, in a country with a widely scattered population and relatively self-sufficient domestic life, was for basic earthenwares. Container and utility pottery, as well as simple and inexpensive tablewares, were the types most heavily and roughly used, most readily broken, but also most cheaply replaced. This was also the pottery most easily produced within Canada, by native commercial craft potters utilizing local clays. They marketed largely to their own immediate areas, since utility and container wares were coincidently heavy and cumbersome to transport, particularly overland. Being inexpensive, such pottery was not a particularly viable economic proposition for importers, except in areas with a population concentration directly accessible to high-volume sea transport, such as the Maritimes. Even then, local earthenware producers could often match or undersell utility pottery imports. Thus in Canada, from the late 18th century on, with the growth of a sufficient population base and market to stimulate indigenous manufactures, the production of container and utility wares basically became the preserve of the native pottery industry, while white-wares and finer tablewares were generally left to the British ceramics industry and its Canadian importers.

In New France, though severely restricted in order to solidify the market for French supplies, some earthenware production was licensed as early as the mid-17th century. While records are very sketchy, the earliest native commercial pottery now appears to have been established about 1655 near Quebec City. By 1700 a few other potteries were in operation, including those of Gabriel Lemieux and Vital Martel at Charlesbourg.

While there is so far no certain knowledge of the pottery types produced by the potters of New France, and no sites have been excavated, there is little doubt that the wares were limited to a few simple forms, all duplicating French styles but of native clays, with probably a predominance of pouring-spouted utility bowls. Separating early native Quebec from imported French pottery is still somewhat of a problem, particularly considering pouring bowls, though it becomes less difficult with increasing excavation and research.

Much early French pottery has a white or buff body, often full of intrusive grit, and the most common finish is a copper-green glaze. Quebec pottery, conversely, has a reddish body, varying from brick-red to pink, usually of a well-cleaned clay without intrusions. The covering glaze, however, is generally a transparent lead-oxide glaze, either over the bare biscuit pottery, or overlying a coating of brown slip. Though some types of French pottery are found with a reddish body, they are generally not the same forms as those produced in Quebec. Likewise, no indigenous Quebec pottery has the white body of French green-glazed wares, and only one 19th-century Quebec potter, Pierre Coté at St-Augustin (working 1802–11), is so far known to have produced green-glazed pottery. From examples excavated, however, other potters undoubtedly produced green-glazed wares in the 18th century as well.

It seems evident that Quebec, like the Maritimes, with the greatest population concentration accessible by water transport, depended on imports of even heavy earthenware container and utility pottery well into the early 19th century. There is, coincidentally, little evidence that the Quebec potters even as late as the 1840s were turning out any substantially greater range of types than they had a century earlier, with pouring-spouted utility bowls still the predominant form.

Quebec pottery was still largely plain and undecorated, with plain lead glazes over the fired clay, or an underlying coating of clay slip. Recent excavations at St-Denis, however, have established that potters there produced white-slip decorated bowls in the 1830s and 1840s. These excavations, when results are published, may eliminate a myth.

Some of the St-Denis decorated bowl types, if not the balance of production, appear to have been exported up the Richelieu, south to New York State. Earthenware bowls of the St-Denis type have previously been considered as New York State pottery, and were at one time not uncommon there, while intact examples seem to be virtually unknown in Quebec.

Industrialization and the factory concept came early to Quebec. Considering that facilities for long-distance shipping and transport were an essential corollary to the growth of the factory system, Quebec was in an ideal position. With its navigable river network, particularly the St. Lawrence, the Richelieu, and the Ottawa, Quebec ceramics factories could easily market essentially anywhere in northeastern North America.

St-Denis, on the lower Richelieu, had been a pottery-producing town ever since 1776, when Simon Thibodeau first established a pottery operation. In 1840 the Farrar family, who produced salt-glazed stoneware at Fairfax, Vermont, opened a factory at St. Johns, Quebec, on the upper Richelieu. The Farrar stoneware factory, still in the Farrar family, continued in operation until 1927.

Red earthenware utility bowl, with transparent lead glaze inside, and the outside unglazed, Quebec, c. 1730–50. This bowl was excavated in the Place Royale area of Quebec City, and may be from one of the Charlesbourg potteries.
SERVICE D'ARCHAEOLOGIE, QUEBEC

Large and heavy earthenware utility bowl, lead glazed internally and unglazed externally. The piece was found in Newfoundland, and was probably made there, c. 1840–70.
NATIONAL MUSEUM OF CANADA

Two small crocks, finished in brown- and white-slip underglaze, and a small lead-glazed bowl, all from the William Eby Pottery at Conestogo, Ontario, c. 1860–1900. These pieces were collected in and near Conestogo, and are confirmed by sherds from excavations at the pottery. CANADIANA, ROYAL ONTARIO MUSEUM

Pottery of early Quebec, showing the development of utility bowls, the most common single form in Quebec before the mid-19th century.

Left: Utility bowl reconstruction with a slightly green-tinged transparent glaze, probably from the Quebec-Charlesbourg area, c. 1740–60, and excavated at the LeBer house, Ile des Soeurs, Montreal.

Upper center: Bowl with brown slip spatter under a transparent glaze, from the Dion Pottery, Ancienne Lorette, Quebec, c. 1870–1900. The formed pouring spout of French bowls had disappeared by this period.

Right: French green-glazed bowl, c. 1740–60, of a type imported into New France in great quantity from the 17th century to 1760. This reconstructed bowl was excavated at Fort Senneville, Senneville, Quebec.

Lower center: Brown slip lined bowl, of a completely French form, c. 1780–1820, possibly from the Pierre Coté Pottery, St-Augustin, Quebec. CANADIANA, ROYAL ONTARIO MUSEUM

The Farrars were followed to St. Johns in the 1850s by another stoneware producer, Orrin Ballard, who had his primary factory at Burlington, Vermont, and in about 1860 relocated at Cornwall, Ontario. The Farrar Pottery in the later 19th century expanded into slip-cast wares, and hollow wares such as teapots, pitchers, and complex bowls, that were made in several sections from liquid clay cast in plaster of Paris molds.

The basic material of most of the ceramics factories was stoneware clay, a more highly fired and more durable material than the red-firing earthenware of the small single-family potteries. In the later 19th century, however, there was no known stoneware clay in Canada; (it has since been found in Nova Scotia, Alberta, and Saskatchewan).

All clay used by Quebec and other Canadian stoneware potteries, as well as the cast-wares factories, came from Amboy, New Jersey. Transported by sloop up the Hudson River, and then either across the Erie Canal to Lake Erie; via the Oswego Canal to Lake Ontario; or down the Lake Champlain-Richelieu River route to Quebec, the imported clay necessitated that pottery factories be located on navigable waterways, as much as did the economics of shipping finished pottery.

As the smaller one-man or single-family earthenware potteries began dying out in the late 19th century, the area of St. Johns–Iberville became Canada's largest pottery producing

center, including, after 1873, the St. Johns Stone Chinaware Co., the first Canadian manufacturer of white ironstone tablewares.

A second center grew up around Quebec, with the establishment in 1855 of the Dion Pottery at Ancienne Lorette. Started by Jean Dion, this pottery used local red-firing earthenware clay, but by the 1870s grew into a sizeable factory producing a very wide range of pottery types. Dion pottery is commonly found even today, and is highly distinctive, since it was decorated with brown slip spatter and dripping under its lead glaze finish, the latter often with a mixture of copper-oxide green.

In 1860, the Cap Rouge Pottery was started at Cap Rouge, just west of Quebec, to specialize in producing slip-cast hollow wares, ranging from banded and mocha-decorated yellow-glazed (caneware) bowls to Rockingham-glazed teapots and pitchers. Cap Rouge wares, though only recently identified, are found all over eastern Canada; the factory evidently marketed widely. The Cap Rouge Pottery closed shortly before 1900.

As yet, there is no evidence that potters operated in the Maritimes—Nova Scotia, New Brunswick, Prince Edward Island—during the French period. Since virtually all of the population was located on the coasts, in fortified towns or in outlying fishing villages, all domestic needs excepting the simplest of homemade utensils could be and, from archaeological evidence, apparently were wholly supplied from Europe.

The earliest indigenous potter seems to be Samuel Marshall, listed as a potter in assessment rolls at Blue Hill, Nova Scotia, in 1786-87. We do not, however, find any number of potters operating until after 1850. Even in the later 19th century, from the surviving pottery that appears in the Maritimes antiques market, it is evident that a considerable quantity of container and utility wares was still being imported from England.

Much of the basic native pottery of the Maritimes is essentially English in its characteristics, more so than that of any other area of Canada. As everywhere, the clay used by the commercial craft potters was local red-firing earthenware. Judging from quantities of surviving pottery and excavated waster, however, the clay of the Maritimes fires to a very deep red—much darker in color than that of either Quebec or Ontario. The body of Maritimes pottery is also quite dense and heavy, very similar to that of English earthenware from the Sunderland area.

While most Maritime pottery is quite simple and utilitarian, and is only infrequently decorated in any way, the use of white slip clay was general and widespread, again as in England. Milk-skimming and utility bowls, open crocks, and pitchers were often fully lined in the interior with a wash of white slip, and then over-glazed with a transparent lead oxide. Other pieces, called "brownwares" by the English, were coated inside and out with a brown slip before glazing.

Another characteristic often useful for identifying pottery of the Maritimes is the fact that the lower outer sides of utility pieces were generally left as unglazed biscuit. Since the lead-oxide glaze, as applied, was a liquid, and pottery was dipped upside-down for coating, the suspicion is that the potters had an aversion to getting their fingers wet.

Few of the smaller-scale craft potters could afford to

specialize in making pottery alone. This was certainly true in other areas as well, but from advertising and other evidence, it is most apparent in the Maritimes. Most of the potters, for example, also made brick, for there was always a good demand for building supplies. Many also made earthenware drain tubing in various sizes, wall and floor tiles, and chimney pots (many of which still grace chimneys in the Charlottetown, Prince Edward Island, area, and in southern Nova Scotia).

Though nearly thirty different potteries operated in the Maritimes over the whole of the 19th century, only two ever assumed the size and definition of factories. One was the White-Foley Pottery at Saint John, New Brunswick, established by an English potter, Joseph White, in 1861, and taken over by his grandson, James Foley, in 1880.

Rather than the native red-firing earthenware, the White-Foley Pottery produced stoneware based on imported New Jersey clay. In various utilitarian forms—pitchers, jars and small crocks, and cooking vessels—the factory finished its wares with an interior lining of brown slip, and an exterior coating of white, very much in the contemporary English manner. The White-Foley Pottery finally closed in 1921, and its products are still commonly found.

The only other true pottery factory in the Maritimes was the Enfield Brickyard and Pottery at Enfield, Nova Scotia. This pottery was started in 1856 by Robert Malcolm, Jr., but it became a large operation only after 1870. By 1875 the pottery employed sixty people, and its output was valued at $100,000 a year, which would have made it one of the largest factories in Canada. It was also the only pottery in the Maritimes now known to have utilized both local red earthenware clay and imported stoneware. Until very recently, pottery collectors have assumed that all of the brown salt-glazed stoneware container wares that turn up in great quantity in the Maritimes were English imports. Heavy brown salt-glaze of this type was the most common English container pottery during the 19th century and into the 20th century.

Surface pick-ups at the site of the Enfield Pottery, however, now indicate that heavy brown salt-glazed wares were also made there during the later 19th century. A determination of the exact vessel types and shapes, and a full assessment, will have to await excavation of this site.

The only pottery so far archaeologically excavated in the Maritimes is the Prince Edward Island Pottery at Charlottetown. This was established in 1880 by Oswald Hornsby, who previously had worked in Nova Scotia. The P.E.I. Pottery was located, like many, at its source of local clay, and produced primarily red earthenware utility wares, including a standard form of milk-skimming bowl with a unique interior dripped white-slip decoration. The P.E.I. Pottery finally closed in 1898.

The pottery of the Maritime Provinces is generally quite limited in the range of forms that was produced, and in separate decoration. Elaborate pots, and special presentation or miniature pieces, are quite rare. However, with its dense clay body, use of white slip both for linings and simple decoration, and its basically northeastern English character, this pottery in a Canadian context is quite unique to the Maritimes area.

The pottery-producing situation in Upper Canada in the 19th century was wholly different from that of Quebec and the Maritimes. First, Upper Canada was not accessible to directly landed imports in its earlier days. The transportation

Red earthenware 1-gallon jug, from western Ontario, c. 1840–50, and decorated with sponge-applied brown slip under the transparent lead glaze. This is a piece probably from one of the Germanic potteries west of Kitchener. PRIVATE COLLECTION

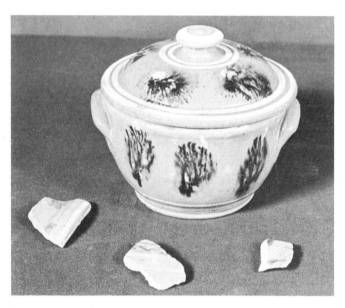

Unusual small covered bowl, decorated with white-slip banding and spots, the spots then covered by mocha-like diffusions of brown slip. The bowl has transparent glaze over its red earthenware body. The piece if from western Ontario, c. 1880, and the very similar sherds in the foreground are from the William Eby Pottery at Conestogo, Ontario.

CANADIANA, ROYAL ONTARIO MUSEUM

aspects of shipping goods on from Montreal, either overland by wagon, or up the St. Lawrence rapids by flatboat, severely limited the access of English exports. It was in fact easier to ship heavy goods from New York than from Montreal, via the Hudson River and the Erie and Oswego Canals.

English ceramics reaching Upper Canada appear largely to have been limited to the more durable and expensive types, that is, higher quality white tablewares and porcelain. Transportation problems, however, made any substantial importation of cheaper and heavier English utility wares economically out of the question.

The earliest settlements in Upper Canada occurred in the 1780s, during and following the American Revolution. Because of the difficulty of importation of goods, independent potteries, and craft industries generally, were established much sooner after initial settlement than had been the case in either Quebec or the Maritimes. Though English, Scottish, and American Loyalist immigration was constant, it was the Pennsylvania-German migration and influx after 1785 that provided many potters, and the ethnic background for what was to become a very large Ontario earthenware industry.

One of the earliest Pennsylvania-German potters was Jacob Yeigh, who settled and established a pottery at Burford, Canada West, about 1805, and worked until nearly 1840. Several Pennsylvania-German potters settled in the Niagara Peninsula, and by the late 1830s or early 1840s people such as John Kulp at Grimsby, Daniel Orth at Campden, and Abraham Roszel, Kulp's son-in-law, were active. By the early 1850s, over thirty commercial craft potteries were in operation all over Canada West, all but a few making red-firing earthenware in the Germanic tradition.

Much of the Germanic pottery of 18th-century Pennsylvania had been heavily decorated with colored slips, and scraffito incising before firing. Elaborate work of this sort had declined and nearly died out before Ontario-German potteries came to be heavily established in Upper Canada, but the Germanic potters, as those of 19th-century Pennsylvania, still maintained a very colorful use of glazes.

Though the basic products of the rural one-man or one-family potteries were red earthenware utility vessels, the Ontario-German potters often used a combination of metallic colorants in their glaze mixtures: copper oxide for greens, and iron oxide or plain powdered rust for red and orange, and very often, brown slip as a spatter or drip under the overlying glaze. The end result, in better pieces, was often great contrast in the colors—brown spatter on the brick-red pottery body, orange speckling (from rust) over an olive-green glaze, copper-green decorative motifs on yellowish-white slip, or black speckling on a yellow glaze, to outline just a few of the combinations. The same manner of pottery coloring and glazing was also current in Pennsylvania, as particularly epitomized in the products of the Bell Potteries of the Shenandoah Valley.

The Ontario-German potters produced a far greater range of pottery types than those of either Quebec or the Maritimes. As well as large quantities of container and utility pieces, we find also in western Ontario a great variety of miniature vessels and whimseys, probably all made as special or gift pieces, but made often and in quantity nonetheless. These can range from small crocks and jugs, which are relatively common, to coin banks, toy furniture, whistles, and molded King Charles spaniels, which are increasingly rare.

Some few potteries also produced tablewares, and occasional pieces as very thin-walled and light, fine work, particularly considering red earthenware as the material. Pitchers, soup or stew bowls, and serving dishes were the most common, but such things as covered sugar bowls, dinner plates, salt cellars, and small dishes are occasionally found.

The salt-glazed stoneware industry had its beginnings in Ontario with the establishment of factories in 1849 at Brantford and Picton. Both were started by experienced New York State stoneware potters, Justin Morton coming to Brantford, and

Samuel Hart to Picton. Morton did not restrict his operation to salt-glazed containers, but in the 1850s also produced large and heavy slip-cast molded wares. By 1867, when the Brantford Pottery came under the control of William E. Welding, it was by far the largest ceramics factory in the province, and was shipping pottery throughout Southern Ontario.

Welding, in the 1870s, also diversified into production of Rockingham and yellow-glazed tablewares, very like the pottery produced at Cap Rouge and St. Johns-Iberville, Quebec, but the first manufactured in Ontario. Among the Brantford wares were such unique pieces as beaver-and-maple-leaf-patterned teapots, small banded yellow-glazed bowls, and patterned Rockingham-glazed spitoons.

Other stoneware factories became established in Ontario in the 1860s and 1870s—the Eberhardt and the Burns Potteries in Toronto, the Flack & Van Arsdale Pottery at Cornwall, and a second Hart Pottery at Belleville.

Though salt-glazed stoneware was considerably more durable than red-firing earthenware, because of dependence on imported clay, it was also more expensive due to the necessity to ship and market factory output long distances from the potteries. Both the stoneware and the red-earthenware producers, however, had a steady market for household container and utility wares, which made up by far the greatest part of production and sales.

After 1880 or so, it is evident that a slow and gradual decline began to affect the markets of the utility-pottery producers, the outgrowth of changes in food marketing and distribution, and of new techniques for food preservation. Refrigeration, using ice, meant less need for home drying and pickling of foods, and less demand for crocks and jars.

The growth of commercial canning, and the introduction of other processed foods, also began eroding the necessity for large-scale home canning, and for pottery canning jars, which were then a staple form of earthenware pottery, in capacities of up to three gallons. Mass-produced glass, metalwares, and even the beginnings of plastics by the late 19th century were also providing, for the first time, cheap and price-competitive alternatives to pottery.

Red-earthenware pottery making became, particularly throughout Canada, an obsolete craft, just one small casualty of a great cultural shift being forced by the rise of technology. The individual commercial potting craft remained strongest in Ontario, no doubt partially due to the strong Ontario-German ceramic tradition. However, Ontario was also the only area of Canada where a considerable proportion of the population was scattered and removed from direct access to navigable waterways. Even as late as 1900, overland roads were by far the most expensive, slowest, and least favored of routes for shipping goods; water or rail was much preferable. The craft system could survive best in somewhat isolated rural areas, reasonably insulated from the competition of industrial output.

King Charles Spaniels, molded after imported Staffordshire figures, were common products from 19th-century Ontario earthenware potteries. At left is a biscuit-fired but unglazed dog excavated at the Samuel Burns Pottery, Markham, Ontario; the right piece (private collection) is a finished piece coated with white slip, spattered in brown slip, and with collar and leash touched in blue. CANADIANA, ROYAL ONTARIO MUSEUM

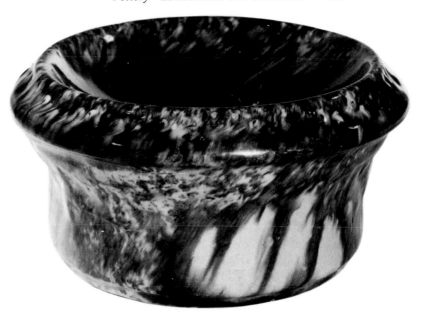

Spittoon of red earthenware covered with brown slip spatter, with a clear lead overglaze. This piece is marked on the base "Orangeville Pottery," a mark of the Collins Pottery at Orangeville, Ontario, c. 1866–92. PRIVATE COLLECTION

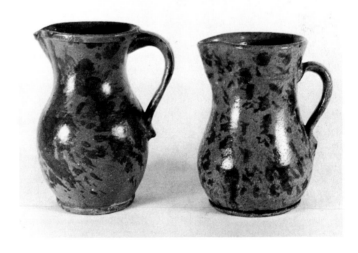

Ontario-German pitchers, c. 1870, both pieces brown-slip spattered over the red earthenware body, and overglazed.
CANADIANA, ROYAL ONTARIO MUSEUM

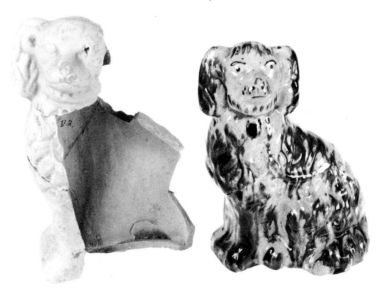

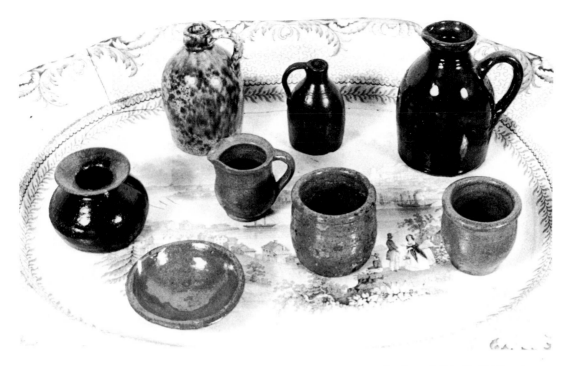

Ontario-German potters, like Pennsylvania potters, were very productive of miniature, toy, and special gift pieces. These small red-earthenware pieces are all from western Ontario potteries, c. 1865–90. CANADIANA, ROYAL ONTARIO MUSEUM

▽ The Prince Edward Island Pottery (excavated in 1970) made a wide range of red-earthenware pottery forms, including standard jugs sometimes stamped with the pottery name, "P.E.I. Pottery," or "P.E.Island Pottery." This pottery in Charlottetown was operated by Oswald Hornsby from 1880 to 1898.
PRIVATE COLLECTION

Another characteristic of P.E.I. Pottery wares was an unusual ▷ curved-slash coggled decoration, pressed in the wet clay from a rotating wheel. This spittoon, with underglaze white slip, and rim-dipped brown slip, is a particularly heavily coggled piece, c. 1885.
PRIVATE COLLECTION

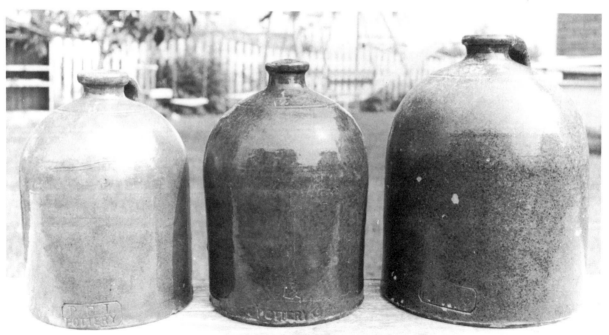

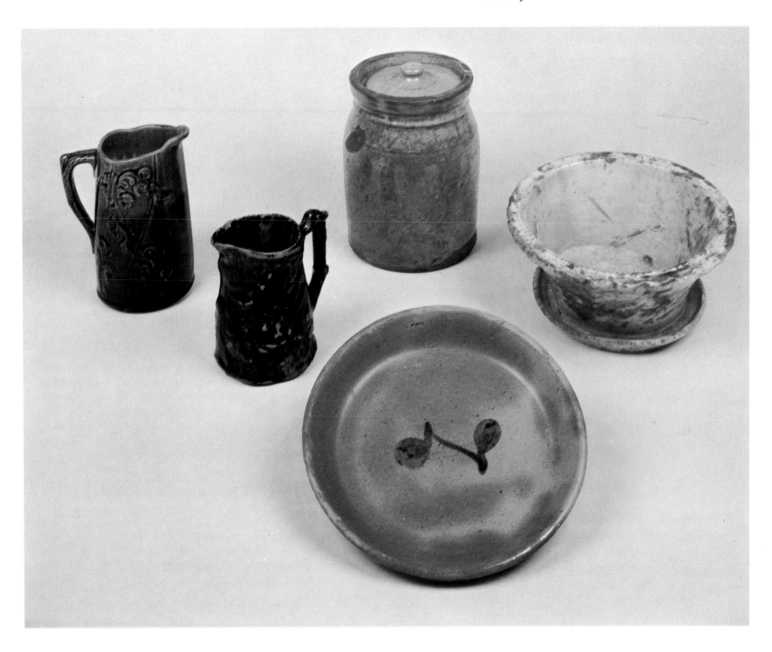

In Quebec, by 1880, industrialization was predominant. Census returns of 1881 and 1891 make this very apparent, showing an increasing number of individual employee-potters in relation to a declining number of establishments, and an increasing ratio of potters to pottery operations.

In Ontario the reverse was true. In 1881 there were 72 potteries and 182 listed potters, an overall ratio of less than three people per shop, even discounting the effect of larger employers such as the Brantford, Hamilton, and Belleville factories. There was clearly still a proliferation of one-man establishments. By 1891 the overall ratio of enumerated potters to potteries in Ontario was less than 2 to 1; in Quebec it was nearly 40 to 1.

In the 19th century and well into the 20th, only one factory was established to produce finer forms of ceramics than those dependent on natural clay. In 1873 the St. Johns Stone Chinaware Company was opened at St. Johns, Quebec, by George W. Farrar, who also had the Farrar stoneware factory. For twenty years, until it closed in 1893, the company made a wide range of white ironstone table china, both plain, and

Ontario earthenware of the middle and late 19th century. The green pitcher to the left is from the Brantford Pottery, c. 1895; next to it is a mold-cast earthenware pitcher from western Ontario, molded and copied directly from an English white ironstone pitcher. The covered jar, with its mottled red and apple-green glazing, is typical of Ontario-German potteries of the Niagara Peninsula and western Ontario. The plate and the green-spattered flowerpot are both from the William Eby Pottery at Conestogo. CANADIANA, ROYAL ONTARIO MUSEUM

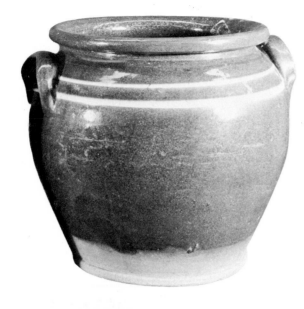

Pottery of the Maritimes was much more Northern English and Scottish in derivation than that of other regions of Canada. These two Nova Scotia jars are banded underglaze, with white slip, dating c. 1860–75, and are typical of Maritime pieces in being lead glazed inside and out except for the exterior just above the bases. CANADIANA, ROYAL ONTARIO MUSEUM

◁ Salt-glazed stoneware, produced in Canada after c. 1840, was a much more durable pottery than red earthenware, and was typically marked by its makers or for merchants ordering large quantities. It was also often decorated with motifs in cobalt-oxide blue glaze, usually simply, but sometimes elaborately. This four-gallon crock, marked CORNWALL / POTTERY. C.W., was made at the Flack & Van Arsdale Pottery at Cornwall, Ont., c. 1880–85, and is well decorated with a bunch of grapes in blue.

PRIVATE COLLECTION

Late 19th-century red earthenware from the Antoine Dion Pottery at Ancienne Lorette, Quebec. The Dion Pottery was a large factory, and typically decorated its wares with brown slip spatter, and often a mixture of copper-oxide green in its covering lead glazes. These bowls and baking dishes could date to the early 20th century; the Dion Pottery, started about 1860, closed in 1922.

CANADIANA, ROYAL ONTARIO MUSEUM

Salt-glazed stoneware crock, with faces of King Charles Spaniels as unusual applied handles. This piece was made at the Hart Bros. and Lazier Pottery at Picton, Ont., c. 1865–70, and is marked G. I. LAZIER / PICTON, C.W. PRIVATE COLLECTION

Stoneware made at the Brantford Pottery during the period of ownership by Franklin Goold (1859–67) was the most elaborately decorated of any Canadian pottery. This water-cooler, a special rather than production piece, is incised on all four quadrants, between trees, with riders on horseback, double-birds, and this standing horse. CANADIANA, ROYAL ONTARIO MUSEUM

Six-gallon salt-glazed crock, marked S. SKINNER & CO. / PICTON, C.W., *from the Hart Pottery at Picton, Ont., c. 1864–67. The double-bird decoration, in trailed cobalt-blue glaze, is uncommon for a piece of this type.* PRIVATE COLLECTION

Industrial wares, produced by casting in molds rather than by potters at their wheels, were introduced in Canada only in the 1850s, and were not in general production before the late 1860s. The Brantford Pottery was a major producer of cast- and relief-patterned wares. This small cast stoneware teapot is the Brantford "Rebecca at the Well" type, c. 1875–85, and its lid is from excavations at the pottery. PRIVATE COLLECTION

One of the more striking Brantford patterns is the beaver-and-maple-leaf tapot, also of cast stoneware, and occurring in two, varieties. This example dates c. 1880–85, and, as the Rebecca-at-the-Well type, was confirmed by quantities of sherds, c. 1883, excavated at the Brantford Pottery.

CANADIANA, ROYAL ONTARIO MUSEUM

In the early 1860s the Brantford Pottery produced cast stoneware oval picture frames in two sizes and several varieties and glazes. These were cast in a one-piece mold, and hand finished on the back side. Most frames are found hand inscribed on the back by George Beech, an employee at the pottery, and dated 1862 or 1863.

CANADIANA, ROYAL ONTARIO MUSEUM

banded with colored enamels and gilt. It also produced apparently small quantities of imitation Wedgwood, of light blue ironstone with white appliqués. This variety is quite scarce today.

Other than this single factory, no other Canadian pottery producer attempted ceramics of clays finer than stoneware, or in quality beyond the range of ubiquitous Rockingham-glazed or caneware dishes, teapots, and pitchers.

By the end of the 19th century the Canadian earthenware craft industry and the stoneware factories, as much of the whole commercial craft system, were approaching their end. Based on obsolete materials, and with their markets eroded both by a changing domestic environment and by competitive mass-produced goods, potteries closed as potters retired, and as potters' sons sought other more viable occupations. By 1910 there were few red-earthenware potteries left, and the last of the larger producers, the Dion Pottery, finally closed in 1918. The Farrar Pottery, as the last of the salt-glazed stoneware factories, followed suit in 1927.

All Canadian ceramics are now of great appeal to collectors, and all of the types—red earthenware, salt-glazed stoneware, and slip-cast hollow wares—are "closed-ended" objects, no longer produced in any form. Generally speaking, the survival rate of Canadian pottery has certainly been low, for virtually all were utilitarian wares, heavily and probably roughly used in daily living, and subject to a high risk of breakage.

Maritime pottery is peculiarly English in its derivations, and is the only Canadian pottery that routinely has white slip as an inside lining and for decoration. The pitcher and jar are both from Nova Scotia, the pitcher dating probably c. 1860, and the jar somewhat later. The bowl to the right is from the Prince Edward Island Pottery at Charlottetown, which has been excavated, and is an example of the only Maritime earthenware known to have been decorated in this way. The white-lined bowl in the foreground, c. 1870–80, is a Nova Scotia piece, from any one of several potteries; similar bowls were also made in Prince Edward Island. CANADIANA, ROYAL ONTARIO MUSEUM

The simplest and plainest wares, the most common in their own day, are also the most common now on the collectors' market—undecorated earthenware crocks, jars and jugs, and plain stoneware. Types originally made in much smaller quantities, particularly decorated pieces, special forms and miniatures, and examples of maker-marked red earthenware, are increasingly rare.

Problems of identification are not what they once were. Salt-glazed stoneware, and ironstone of the St. Johns Stone Chinaware Co., is typically marked (though stoneware sometimes with a merchant's name rather than the factory's) and self-identifying. Red earthenware, conversely, was only occasionally marked. Here, however, much of the pottery is sufficiently distinctive, visually, for identification at least as to region or area.

Beyond this, archaeological work at early potteries is continually resolving more precise identity questions, and making increasingly possible the attribution of existing pieces to specific potteries or factories. Most pottery sites, when excavated, produce quantities of waster sherds representative of a pottery's original production. When reconstructed, either physically by picture-puzzling and gluing, or as drawings, this pottery, found in original context, becomes the key to identification of perhaps many more existing and intact, though previously unknown, pieces.

Archaeology, rather than limited documentary sources, has also given us much of what is now known of the whole range of pottery production in Canada into the present century, and every published excavation report provides that much more. Through this method of research, which is the only way of examining early pottery in its original context, has emerged a great deal of technical information. This tells us not only how various types of pottery were made, but what materials were used, and what was and was not possible, as well as offering clues to the whole state of technology in the early craft system and in early Canadian industry.

The object alone, though viewed as an end in itself to most collectors, need not be considered so narrowly. When placed against the broad background of original context, the object—the Canadian antique—then often becomes additionally valuable as a document and is a means to another end, the goal of information gathering and interpreting to achieve a better picture of the early culture of Canada.

Factory-produced pottery of the late 19th and early 20th centuries occurs as complex moldings, and is finished with a variety of glaze colors. This tall three-piece flower stand, of mold-cast stoneware, is glazed a deep copper-green, and is marked BRANTFORD/CANADA, *a stamp of the Brantford Pottery used on most wares after 1894.* PRIVATE COLLECTION

The highest form of early pottery produced in Canada was white ironstone china, very similar to the material of English export tablewares of the period. The only 19th-century Canadian maker was the St. Johns Stone Chinaware Co. of St. Johns, Quebec, which operated from 1873 to 1893, and produced these pieces as well as numerous other forms. All St. Johns ironstone is marked with an enamel stamping on the base.

▽ CANADIANA, ROYAL ONTARIO MUSEUM

△
The St. Johns Stone Chinaware Co. made both white ironstone, and a limited quantity of pale blue wares. This pitcher pattern was produced both in white and in pale blue. The St. Johns company, by accident or design, also produced a few near-porcelain pieces, which are slightly translucent in strong light.

NATIONAL MUSEUM OF CANADA

Nineteenth-century British Ceramic Imports

Elizabeth Collard

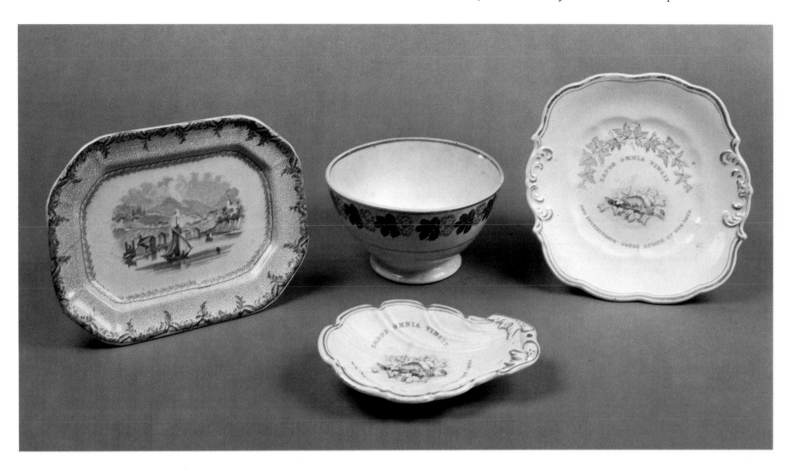

Ironstone china produced specifically for the Canadian market. On the left is a small rectangular platter, part of the "British America" series, with a pictorial transfer-printed scene of Port Hope, Ontario. This large series was produced by Podmore, Walker & Co., at Tunstall, Staffordshire, 1842–59. The center bowl, with decoration in enamels and sponge-stamped underglaze, is a common type of the 1870–1900 period, exported to Canada in great variation by several Scottish potteries. Similar sponge-stamped wares were also made in France and Belgium, and in very small quantity at the St. Johns Stone Chinaware Co., St. Johns, Quebec. This ware is known in Quebec as "Portneuf." The beaver-and-maple-leaf pieces, part of a full table service, are imprinted with Latin and French mottoes, and are marked by Edward Walley, Cobridge, Staffordshire, who registered the design in 1856. CANADIANA, ROYAL ONTARIO MUSEUM

◁ *"Maple" pattern plate and tureen, produced by Thomas Furnival & Sons, of Cobridge, Staffordshire, from c. 1875 to 1890. The brown tureen with fanged beaver is part of a full table service, and probably the earlier version of the pattern; the later multi-colored maple leaf pattern is known on plates, platters, etc. On the right is one of the "British America" steamship plates, done in several colors, c. 1831–40, by Davenport & Co., Longport, Staffordshire.* CANADIANA, ROYAL ONTARIO MUSEUM

Imports accounted for most of the tablewares and all of the porcelain used in 19th-century Canada. These imports came overwhelmingly from the potters of Great Britain. In the first half of the century the Canadian market was almost exclusively theirs; they continued to dominate it to the century's end.

Even in pre-Confederation days the quantities of kitchen crockery, toiletware, tableware, and even ornaments that poured into the Canadian colonies from England and Scotland were staggering: 47,348 pieces of "Loose Earthenware" (wash basins, chamber pots, tureens) are recorded in a single shipment to Quebec (1839); 1,000 packages of both earthenware and porcelain came to Renaud, Prieur & Co., Montreal (1857); hundreds of printed dinner plates ("new patterns just out this season") were shipped from Staffordshire to Alexander Christie in Niagara (1854). Ornamental figures of Jenny Lind were a bestseller in Toronto in 1856. "Miss Nightingale in China" was being promoted in Fort Garry (Winnipeg) in 1867. Lack of cash (a perennial colonial lament) did not inhibit the crockery trade. Furs were bartered for Worcester teapots in New Brunswick; fish for "choice Scotch earthenware" in Newfoundland.

There was scarcely anything made by the British potter that could not be purchased, one way or another, in Canada. Though some immigrants, such as Mrs. William Notman, wife of the celebrated photographer, thought tablewares "very costly" in mid-century Montreal, and though residents of the Northwest complained that everything in the crockery line was twice the Toronto price by the time it reached Fort Garry, there was no lack of supplies, except perhaps in the spring, while merchants awaited a new season's stock. "The stores display a first-class assortment of empty shelves, but the large assortment of goods expected shortly . . . will put a different

face on affairs," said Edmonton's first newspaper at the close of winter 1883.

Because the products of the British potteries were the typical ceramic wares in use from St. John's, Newfoundland, to Victoria, British Columbia, and because they crossed the Atlantic in such volume and variety in the 19th century, it is these wares that today offer the widest range of form and are most easily found by the collector. They evoke the years when they were part of the daily household scene in Canada, not only in the towns and larger settlements but in the farthest outposts. Though imports, they are made Canadian by long association with the domestic life of this country. In the 19th century it would have been almost impossible to find a house, from a Montreal fur trader's mansion, to a prairie "soddy", that did not have something from the British potteries on table or washstand.

Most often the import from Great Britain was a piece of the ordinary underglaze transfer-printed earthenware. The 19th century opened at the moment when underglaze printed wares were coming into their own. The technique whereby a picture or decorative design was transferred, by means of paper transfers, from an engraved copperplate to a piece of pottery prior to glazing, was of 18th-century origin, but only in the 19th century was it perfected and exploited to the full. In the 19th century, underglaze printed wares put an end to the reign of fine creamware (with its more expensive handpainted or else less durable on-glaze printed decoration) just as creamware itself had earlier superseded salt-glazed stoneware for the table. How quickly these new printed wares gained a grip on the Canadian market is seen in a Halifax advertisement of 1811. Edward Alport announced in the *Royal Gazette* (March 13th) that his crockery on hand included "blue printed WARE . . . now so generally used."

Blue was the first color mastered in underglaze printing. The result was a burst of blue, the potter's favorite color. "Tip it wi' blew an' then it'll dew" was a Staffordshire saying that was more than borne out in the first great rush of printed wares. It was because blue looked best against white that the old cream color gave way to what the Canadian advertisements called "pure blue and white."

By the 1820s other underglaze colors were in production. They were soon available in Canada. In 1836, for example, dinner services printed in pink and described as "neat" could be purchased in Bytown (Ottawa). In those days each full set of dinnerware normally comprised several hundred pieces. Today a single place from such a service would go on the collector's shelf.

A new approach to printed wares came about with what were called "flowing" colors: the color was purposely blurred, giving a misty outline to the print. Flowing or flown wares (they were known by both names) found a ready market in Canada beginning in about the 1840s. A typical advertisement, listing some of the underglaze colors used, appeared in the *New Brunswick Courier* on November 27th, 1847: "36 CRATES EARTHENWARE . . . of flowing blue . . . brown, green and olive . . . " A deep brilliant blue was the most effective of the flowing colors. It usually rates highest with collectors although it is not by any means as scarce today as the "brown, green and olive" of the old advertisement.

All the best makers of printed wares, together with many lesser potters, shipped goods to Canada literally by the ton. Some of the more enterprising retained Canadian agents to push sales. The Herculaneum Pottery of Liverpool (in business until 1840) had as its Trois Rivières representative Ezekiel Hart, the first Jew to be elected to a legislature in Canada. (His election in 1807 and again in 1808 caused a storm of controversy and he never took his seat, but he was a powerful agent in the pottery trade, as he was in other branches of business.) Enoch Wood of Burslem had a Montreal agent from 1829. William Taylor Copeland, who acquired control of Josiah Spode's old firm in 1833, secured extensive orders from the Hudson's Bay Company, with the result that wares from this factory, one of the most important in Staffordshire, and one that had taken the lead in underglaze transfer-printing, were distributed throughout the Northwest. In the 1850s John Goodwin of the Seacombe Pottery, situated on the Mersey River opposite Liverpool, opened his own warehouses in both Quebec City and Toronto. Members of the Goodwin family resided in Canada to direct sales, principally of transfer-printed earthenware.

One of the prime reasons for the popularity of printed wares was the multiplicity of patterns. Every year, as Alexander Christie said, there were "new patterns just out this season." The whole world of the engraver's art came to the Canadian dinner table. There was something for everyone: chinoiserie, floral designs, religious themes, topographical views from every quarter of the globe. Collectors will frequently find the name of the view or pattern printed on the back of these old pieces.

The pattern name was sometimes taken not from the main design but from the printed border. Borders were important to the appearance of printed wares. Today they are sometimes helpful to the collector in identifying makers: a particular border may be associated with a particular potter. But the collector should not be misled by the often quoted statement that borders, unlike actual patterns, were never copied, which is not true. Borders are not an infallible guide to the maker. Not infrequently both border and central design were common to several potters.

While borders were generally designed to complement and enhance the main decoration, they were on occasion totally incongruous. The most incongruous of all must surely be the border featuring a lion, tiger, and luxuriant flowers that one British potter used to surround a series of Arctic views printed in blue or in pink. "Arctic Scenery" is the title on this surprising and otherwise unmarked tableware that dates a little before mid-century. The search for the Northwest Passage, and for Sir John Franklin's ill-fated expedition that left England in 1845, kept the Arctic in the news for years. British potters were quick to seize on topical events for whiteware decoration, a fact that now gives added historical value to many of the ordinary tablewares of the 19th century.

Interesting evidence of printed patterns popular in Canada comes from pieces that turn up with the names and addresses of Canadian importers on the back. The practice of adding an importer's name (it was done at the manufactory) was, however, relatively rare. Special significance is, therefore, attached to anything so marked: it is indisputable proof that the piece was made for the Canadian market. Collecting pieces with 19th-century importers' names on them has developed into a specialty in recent years. There is sometimes as much interest

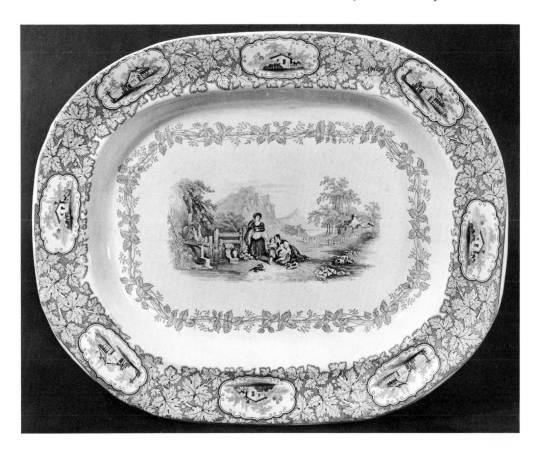

*Serving platter with transfer-printed pattern of "Rustic Scenery"
in brown, from the Joseph Clementson Pottery, Staffordshire.
The Rustic Scenery pattern was registered on December 2nd, 1842.*
PRIVATE COLLECTION

*Portrait bust of Edward Blake, leader of the Canadian Liberal
party from 1880 to 1887, of Parian porcelain. The bust, 8¾
inches high, is marked* R.C. PRIVATE COLLECTION

in knowing who sold the tablewares in Canada as in determin-
ing who made them.

On the evidence of pieces marked in this way it is clear
that floral decoration had a good sale. Tablewares printed with
floral designs have turned up with the name of James Jackson,
Toronto's fire-fighting china merchant of the 1850s (he was
captain of Jackson's Hose); of H. F. Norris, another Toronto
china seller, active in the 1840s; of Samuel Alcorn, who had
the carriage trade of Quebec in the 1830s; of Glennon & Bram-
ley, successors to Shuter & Wilkins, the most important of the
early Montreal china importers.

Easily the favorite of all china patterns throughout the
entire century, and the only one consistently advertised by
name in Canadian newspapers was the Willow. There was
actually no one "true" Willow. There were simply many varia-
tions on a theme, the best known being the version that
included a bridge with three figures on it, a drooping willow
tree nearby, a pagoda, apple tree, and a pair of birds flying
against the sky. Chinese potters had supplied component parts;
English potters assembled them into a success story without
parallel in the history of ceramics. Canadian buyers contributed
to that success, year after year. They were obviously fully in
accord with an English writer of Victorian times, Mrs. Loftie,
whose books on household furnishings were sold in Canada.

Small earthenware advertising plate of a type given away by china-ware dealers, marked for Francis Clementson of Saint John, New Brunswick. The plate, a now uncommon type, is transfer-printed in brown. PRIVATE COLLECTION

Toy dinner service of earthenware, transfer-printed in blue, and marked DAVENPORT *on the back. This set, the largest platter only 5¾ inches long, was originally purchased in Saint John, New Brunswick, c. 1845.* PRIVATE COLLECTION

According to Mrs. Loftie, the Willow pattern was "good enough for anyone."

For some collectors the patterns that were the favorites of the 19th-century housewife still have most appeal: the garden flowers, blue Willow, pastoral scenes that reminded many a homesick immigrant of a gentler land left behind, never to be seen again. Other collectors seek the rarer printed wares decorated with Canadian views or emblems (beavers, maple leaves). These Canadian views are what some collectors like to call "Historical China," a term that originated in the United States.

Canadian views are rarer, because in their own day such patterns were in comparatively little demand in the Canadian market. Their number was just a drop in the flood of transfer-printed whiteware that rolled across the colonies.

Not all the Canadian views collected today were made for the Canadian market in the first place. Some of the most striking occur on pieces that have the impressed mark of Enoch Wood & Sons (the business style of the firm c. 1818–46); but the Woods' dark blue views of Montmorency Falls, Quebec, and Table Rock (Niagara) were primarily intended for their United States customers. They made this perfectly clear by using an additional printed mark displaying an eagle and the motto of the United States: "e pluribus unum" ("one out of many"). Neither motto nor symbol was calculated to encourage sales in a Canada still close to the War of 1812, when Canadians had refused to be made a part of the "one" and had vigorously repelled American invaders. The Woods' Canadian views were, in short, places chosen because Americans found them of interest and were visiting them as tourists from an early date. The Woods threw in their Canadian views as part of a long list of American scenes designed for the United States market. Their Montreal agent made no attempt to advertise them; his sales would have been chiefly of the many other printed patterns that the Woods sold both at home and in the colonies.

More specifically Canadian were the wares produced a little later by the Staffordshire firm of Podmore, Walker &

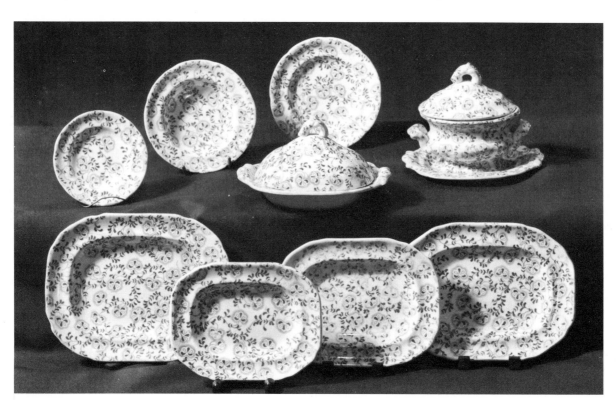

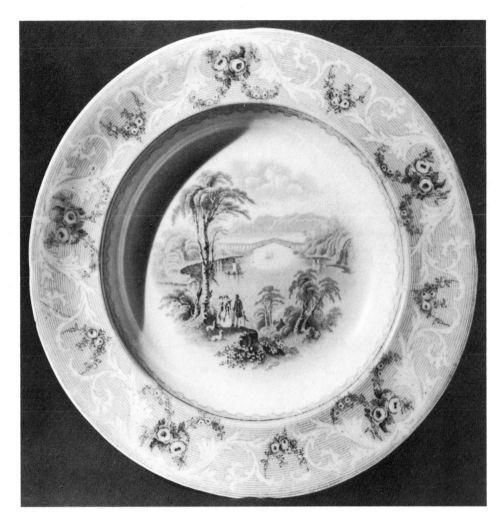

Soup plate, transfer-printed in gray, with a scene of the Chaudière Bridge, from a William Henry Bartlett engraving. The plate, from a full service once owned by Sir William Dawson, Principal of McGill University, was made by Francis Morley & Co., Hanley, c. 1850–58. PRIVATE COLLECTION

View of "The Chaudière Bridge" (near Quebec), the engraving on which the Morley plate pattern was based, from N.P. Willis' Canadian Scenery, illustrated by William Henry Bartlett.

Mark of Francis Morley for the Lake pattern, from the back of the previous plate.

Transfer-printed mark from the base.

Ironstone vegetable serving dish, c. 1870, unmarked by its maker, but marked instead for its import agent, McCaghey, Dolbec & Co. of Quebec. PRIVATE COLLECTION

Co., under the pattern name British America. It was a multi-scene pattern. In multi-scene patterns different views appear on different pieces of a table service: one scene on dinner plates, another on soup plates, and so on. An advertisement in the *Novascotian* (Halifax), November 6th, 1843, probably refers to this pattern, and gives a clue to the date of its introduction: "a few choice Dinner Sets of FANCY and Wilton [Willow] Patterns, together with Patterns of do. with British North American Views, which can be got to order."

Podmore, Walker & Co. adapted their views, printed in light blue, sepia, or black, from W. H. Bartlett's *Canadian Scenery*, first advertised in Canada in the original "parts" in 1840. On the back of most pieces they identified the particular Bartlett print used. These comprised views from Nova Scotia to Upper Canada, including Halifax, Fredericton, Saint John, Quebec, Montreal, Kingston, Port Hope, and Toronto. In many ways Podmore, Walker & Co.'s Canadian views are the most attractive of all. The printing and colors are sharp and clear, the potting good, the fern border eminently suitable, and—most important—the connection with the Canadian market is less tenuous than in some of the other Canadian views now collected. Since the firm was in business until 1859, the "British America" pattern was probably produced over a period of some years.

Another Staffordshire firm that made use of *Canadian Scenery* was Francis Morley & Co. (in business under that style from the mid-1840s until the end of the 1850s). Unlike Podmore, Walker & Co., Morley only rarely added his name or initials to his wares, and he did not give the titles of the adapted Bartlett scenes. He named his multi-scene pattern "Lake." The pattern name is usually on the back of these wares, which were printed in light blue, pink, gray, or brown.

Morley selected some of the same Bartlett views chosen by Podmore, Walker & Co. (the Village of Cedars, for example,

and the Chaudière Bridge). He used, too, the Rideau Canal at Bytown, Hallowell (Bay of Quinte), a scene in the Thousand Islands, Lévis (opposite Quebec), and Georgeville and Lake Memphremagog in the Eastern Townships.

That the Lake pattern was not produced exclusively for Canada is proved by pieces that have the name of a Philadelphia importer of the 1850s. Canadians, however, bought it, and one who did was Sir William Dawson, "the man who made McGill" (he was principal from 1855 to 1893). The McCord Museum, Montreal, now has a number of pieces once owned by him.

Ashworths, Morley's successors, revived the Lake pattern some thirty years after its introduction. A coarser style of engraving and (sometimes) the impressed mark ASHWORTH indicate the later pieces.

For the collector who wants still other Staffordshire views related to Canada, whether or not such earthenware was ever used in this country, there are many pieces for which to look. But the distinction must always be made between tablewares now of interest to collectors because of incidental Canadian pictures on them, and tablewares that actually formed part of the crockery trade in 19th-century Canada. The two are not necessarily the same. When the important distinction between them is overlooked, accuracy in reconstructing the Canadian scene is impaired.

An example of incidental use of a Canadian scene is the "Death of General Wolfe" printed in blue on a large platter. This Canadian scene was part of a multi-scene pattern entitled British History, produced in the 1820s by the minor and short-lived Staffordshire firm of Jones & Son. Events depicted ranged all the way from the Britons' fight against the Roman legions to the coronation of King George IV in 1821. The "Death of Wolfe" was the only Canadian subject. It appeared not because it was Canadian but as an example of British prowess in war and had its parallel in the death of another hero,

"Lord Nelson at Trafalgar," used on a fruit dish. That Jones & Son had any export trade at all during their brief existence is doubtful; certainly their British History series was not designed with the Canadian market in mind.

A Staffordshire firm that did export heavily over a long period to both Canada and the United States was Davenport. So great were the exports to Canada that big trade sales of Davenport wares used to be held on the wharf at Montreal, as the crates were unloaded from sailing ships. But despite the immense volume of Davenport's Canadian sales, the firm only once produced a Canadian view. It was intended for sale in Canada, but the fact that it was the only one indicates how little such views were considered necessary for the Canadian market. Davenport named the pattern Montreal. It showed Montreal in the background, and in the foreground the well-known St. Lawrence steamboat *British America* (built in Montreal in 1829). The pattern was printed in a choice of half a dozen colors, including blue, lavender, and gray.

The evidence indicates substantial sales of Davenport's "Montreal" in the United States as well as Canada. Like Montmorency Falls and Quebec, Montreal attracted American tourists, many of whom must have steamed down the St. Lawrence aboard the *British America*.

The Davenport artist drew much, though not all, of his inspiration from Robert Sproule's view of Montreal from St. Helen's Island. It was one of six views announced by Sproule in the *Montreal Gazette* on November 12th, 1829 (the original watercolors are now in the McCord Museum), and subsequently published by Adolphus Bourne of Montreal. Bourne was a china merchant as well as the owner of an engraving business. In the 1830s he and a partner, J. T. Wright, advertised that they were agents for an important Staffordshire firm. It is tempting to speculate that that firm may have been Davenport.

Two imported pieces, both probably part of full services, and also with Canadian importer–dealer imprints. The plate on the left, floral patterned in blue, is marked on the back for James Jackson of Toronto, c. 1860. The sauce or gravy tureen with flowing blue decoration has each unit—body, cover, and stand —marked for Glennon & Bramley of Montreal. PRIVATE COLLECTION

Ironstone sugar bowl and plate, made by the Clementsons of Staffordshire for the Methodist New Connexion Church, Toronto, and the Methodist Church of Canada. The sugar bowl is c. 1855, the plate c. 1874. PRIVATE COLLECTION

Plate with a transfer-printed scene in dark blue of Montmorency Falls, by Enoch Wood & Sons, Burslem, c. 1840.
PRIVATE COLLECTION

The so-called Willow pattern in plates was one of the most popular forms in North America from the late 18th century, and the most heavily advertised pattern in 19th-century Canada. This ironstone plate, with the classic Willow scene transfer-printed in brown, was made c. 1880 in Staffordshire for the Allan Steamship Line of Montreal, whose name is marked on the back.
PRIVATE COLLECTION

Scottish as well as English potters did a lucrative trade with Canada. They gave their English rivals stiff competition, maintaining their own Canadian agents and offering practical, durable wares at realistic prices. "Good Scotch Crockery—the best to be had for the price" was a slogan that in Canada sold everything from Aberdeen flower pots to the Bell Brothers' Glasgow porcelain. Some of the first trading vessels into Quebec after the Cession of 1763 brought cargoes of Scottish earthenware.

As would be expected, printed wares accounted for a significant part of the Scottish trade in the 19th century. Patterns such as Robert Cochran's "Syria" and the Bells' "Triumphal Car" turn up today almost as often in Canada as in Scotland itself. Another potter who strenuously cultivated Canadian orders for printed wares was John Marshall of Bo'ness (Borrowstounness in Linlithgow). Marshall died in 1870, but the pottery continued under the old name of J. Marshall & Co. almost until the end of the century. It was J. Marshall & Co. who were responsible for a multi-scene pattern called Canadian Sports.

Canadian Sports was printed in a heavy black or a dark brown (sometimes with color crudely added over the printing). Sports illustrated included lacrosse, skating, snowshoeing, and tobogganing. Because these quaintly Victorian wares have been increasingly collected in recent years, it is of interest to determine just when the designs were popular. The date has been in question, but now new information has come to light to establish it. The designs reproduced by Marshall & Co. were popular in the 1880s and, in fact, appeared (printed in color) on a series of Christmas and New Year's cards published by Bennet & Co. of Montreal.

Bennet & Co. were in business for only about ten years, from the end of 1876 or early in 1877 until 1887. The date of their attractive Canadian Sports cards can be pinpointed even more closely. One of these cards, printed with the skating scene used by Marshall & Co. on small plates, was received by Grace Collard, who came to Canada from England in 1878. From 1878 on she preserved most of her cards, and she made a habit of writing on each one who had sent it and when. On the back of this card she noted: "From Nelly . . . Xmas 1882."

In late Victorian days Christmas cards with Canadian views were big business. Montreal and Toronto publishers strove to produce Canadian designs to compete with the avalanche of English and American cards that inundated Canadian shops each season. Keen competition ensured that the Victorian thirst for "something new" was met every year. "We never carry last year's stock," boasted one Montreal stationer in 1882. "True pictures of Canadian scenes," said another advertisement that same year. "Send them home [to Great Britain] and show them what life is like in Canada."

It was the custom to produce these Canadian cards in a series, in the same way that potters used a multi-scene pattern. Bennet & Co. printed their name on each of their cards. On earthenware that carried the same pictures, Marshall & Co. made identification equally clear. Many pieces have both the pattern name Canadian Sports and the initials J. M. & Co.; sometimes even BO'NESS impressed or BO'NESS POTTERY is part of the mark.

Robert Cochran's Britannia Pottery in Glasgow had a long association with Canada, from the time when it sent out a

White ironstone plate, transfer-printed in blue (with pink versions known), from a rare "Arctic Scenery" series. No maker can be attributed and the plate, though unmarked, dates from c. 1840-50. The scene shows Edward Parry's Hecla and Griper at Melville Sound in the autumn of 1819 and is inspired by illustrations in his Voyage of Discovery of a North West Passage, London, 1821. The exotic border animals are totally incongruous to the scene. CANADIANA, ROYAL ONTARIO MUSEUM

young salesman named James (later Sir James) Fleming to gather orders at mid-19th century, right through to the early years of the 20th century, when the firm was directed by Fleming's son. For Francis Thomas, a Quebec City china merchant who began business in 1874, the Britannia Pottery produced a multi-scene pattern showing views of Quebec and its environs. On these wares, printed in brown or in pink, and surrounded by a patriotic border of beavers, maple leaves, shamrocks, thistles, and roses, the name of F. T. Thomas, the importer, appears (only rarely is the maker's mark present). The Quebec views had a long run. They were first sold in Quebec in the 1880s; there was still a demand for them in the early years of the present century.

A beaver and maple leaf pattern—this time from the English manufactory of Furnivals—also had a long life. Entitled Maple (the pattern name was sometimes impressed in the wares, along with the Furnival name), it was a mid-Victorian import that was still selling at least as late as the 1890s, when the

pupils of a country school in the Eastern Townships of Quebec purchased a tea set in this pattern to give to their teacher. The pattern name was taken from the maple-leaf border; the central design was a beaver. The printing was in brown, pink (the school teacher's set), green, or multi-colored. The multi-color printing process had been in use in Staffordshire since the 1840s. Most of the printed wares sold in Victorian Canada, however, were printed in a single color.

Though underglaze transfer-printing could be and frequently was used on porcelain, it was the earthenwares that accounted for the great bulk of the ceramic trade in Canada. One particular type of earthenware admirably suited to the Canadian market was ironstone: a tough, long-lasting earthen ware, at times so heavy that one dinner plate might weigh several pounds. Better than any other ceramic body, ironstone stood the rigors of Atlantic crossings that saw sailing vessels limping, ice-scarred and battered, into Canadian ports in the spring. It emerged intact from lurching over the prairies in Red

Large platter of the later 19th-century "Canadian Sports" series type, with small transfer-printed scenes of snow-shovelling, lacrosse, sledding, skating, and tobogganing. The platter was made by the John Marshall & Co. Pottery of Borrowstounness Scotland, c. 1875. PRIVATE COLLECTION

River carts, heralded at far-flung outposts by what Charles Mair called the "simply hellish" screech of these outlandish conveyances. Ordinary British earthenware, such as has been described up to now, was sturdy; ironstone was all but indestructible.

The first of these high-fired earthenwares was developed in Staffordshire by John and William Turner, and marketed as Turner's Patent (the patent was taken out in 1800). Turner's Patent wares were the beginning of a long line of related ceramic bodies known by a variety of names: stone china, white stone, opaque porcelain, white granite. But the name that topped all others in imaginative inventiveness, and that has passed into general use for a durable tableware, was Ironstone. The name originated with a flamboyant Staffordshire potter, Charles James Mason, who in 1813 brought out Mason's Patent Ironstone China (a body similar to that of the Turners' and with which his father, Miles Mason, had undoubtedly been experimenting). The name Ironstone belonged officially to Mason; everybody used it, just as everybody had helped himself to Wedgwood's name of Queensware for cream-colored earthenware.

In the 19th century there were two types of ironstone. First, there was the earlier, often expensively and showily decorated ironstone of bluish-gray tint, that attempted to reproduce the grayish body tone of Chinese porcelain. Mason's

Patent Ironstone of 1813 was of this type. In Victorian times there was also the cheaper, whiter, thicker ironstone that was meant to simulate the gray-white of French porcelain, which had begun to cut into British sales in the second half of the century. "WHITE STONE WARE, Equal in appearance to FRENCH CHINA and more DURABLE" was the significant description of one Montreal shipment from Staffordshire in 1881. Both types of ironstone, therefore, were originally in competition with china (i.e. porcelain). Their very names were usually calculated to convey the idea of china. The earliest Canadian advertisement for any of these dense earthenwares called it "Mock China" (Montreal, 1805).

Mason's own ironstone came to Canada at an early date and in impressive quantities. An advertisement in the *Quebec Mercury* of June 6th, 1820, almost certainly refers to it: ". . . a few hogsheads printed ware, china, and the new Invented *Iron Stone Ware.*" It was in use in some of the finest houses. Thomas Torrance, the Montreal merchant who built Belmont Hall on Sherbrooke Street (dubbed "Torrance's Folly" because in 1818 it seemed ridiculously far from the business center of town), ordered a double dinner service of Mason's ironstone with his initials (T T) in gold on every piece.

Decoration on the early ironstone was most often printed, either an all-over design or an outline-printed pattern, the outlines later filled in by hand in rich enamel colors. The later

Plate printed in black, c. 1880–85, of a woman and man skating, from the J. Marshall & Co. "Canadian Sports" series.

PRIVATE COLLECTION

As an interesting comparison, this colored New Year's card was published by Bennet & Co. of Montreal (1876–1887), as part of a sports series, and with a scene identical to that on the preceding plate. The card is dated as received in 1882.

PRIVATE COLLECTION

wares, though sometimes with printed or painted patterns, were frequently left plain white, relying on embossing for effect. One embossed design of wheat and flower sprays was named the Canada pattern by the Clementsons of Staffordshire, who had a retail outlet in Saint John and an agent in Montreal. The Clementsons registered the pattern at the Patent Office, London, in 1877.

Robert Cochran of Glasgow and several Staffordshire potters cultivated the Canadian market with white ironstone embossed with beavers, and with beavers as finials on lids.

The most ornate and perhaps the most sought after of all Canadian china merchants' marks is found on well-potted white ironstone imported by McCaghey, Dolbec & Co. of Quebec in the late 1860s and early 1870s. It includes not only the Mc-Caghey, Dolbec & Co. name, but also a beaver, maple leaves, and the French-Canadian nationalist slogan "Rendre le Peuple Meilleur."

Heavy ironstone made for 19th-century Canadian hotels, steamboats, and institutions has also become collectors' quarry. It did not have to be filched to get out of the hotels. It was the custom of the day to sell furniture and crockery when, for example, a redecorating program was undertaken. Whole sets of hotel-ware have been known to survive in the possession of private families, acquired legitimately at some auction sale long ago.

Donegana's Hotel in Montreal (destroyed by fire in 1849) was supplied with ironstone by William Ridgway, a Staffordshire potter who visited Canada to take stock of the market. A view of the hotel was printed in sepia on this ware. The Clementsons, staunch Methodists who turned religious ties into business benefits, made ironstone to the order of a number of Canadian Methodist churches, including the Methodist New Connexion Church, Toronto. The name of the particular church appears on the face of each piece. T. & R. Boote filled an order for the Wesleyan Methodist Church on McNab Street, Hamilton, using ironstone in a shape they had registered in 1853. The Boote brothers shipped ironstone in consignments of fifty and sixty crates at a time to Canada, and it was of their products that the Canadian doggerel versifier, J. T. S. Lidstone, wrote in fulsome praise in 1866:

> . . . famous o'er the globe on all its lands and seas.
> Yes; their Granite or Opaque Porcelain,
> Otherwise Iron-Stone China, doth attain
> To empire throughout the bounds of Nature's reign.
> And could modes of travel make them better known,
> Other worlds would claim them for their own.

Edward Walley was still another Staffordshire man who profited from this type of Canadian business, and whose once

Ironstone bowl of the so-called Portneuf type, probably of Scottish manufacture, c. 1880, with sponged decoration in colors. These sponged wares, with great decorative variation, were imported in quantity in the last quarter of the 19th century and are still commonly found. PRIVATE COLLECTION

inexpensive wares are now commanding collector's prices. It was he who made the ironstone printed in gray with beavers and maple leaves worked into a design that combined a Latin motto ("Labor Omnia Vincit") and another French-Canadian nationalist slogan ("Nos Institutions! Notre Langue et Nos Lois"). The printing was on ironstone in Walley's "Niagara Shape," registered on November 29th, 1856. (A number of other printed and painted patterns exported to Canada by Walley also appear on this same Niagara Shape ironstone.) Both institutions and families in Quebec purchased the British ironstone with the French-Canadian nationalist slogan. It was a slogan that had been taken up by the St. Jean Baptiste Society some years before, and on every June 24th (St. Jean Baptiste Day) it was seen on banners and decorations.

A type of earthenware widely advertised in Canada from the 1840s was sponged ware. Its name implies the nature of its decoration: sponged or stencilled, a rapid and cheap method of color work. Sometimes sponged decoration was combined with freehand painting in a rustic style. These were the wares of "a bright fancy character" which Llewellynn Jewitt, the 19th-century English ceramic historian, spoke of as selling well in the "out-markets" of the world. Canada was one of those out-markets. Sponged wares made their way right across the country. In 1873 crates of sponged bowls were among the casualties of a general alarm fire in Victoria. The fire (on the night of October 18th) heavily damaged a shipment of crockery that had just completed the long and adventurous voyage from England.

With sponged wares belong what were some years ago misnamed Portneuf. Far from being products of Portneuf (near Quebec City) these ingenuously bright wares, with sponged decoration featuring repetitive patterns of birds, animals, butterflies, flowers, medallions, or with rosettes scattered profusely, came from a number of sources. They were imported from Wales; from Staffordshire; and from the Tyneside potteries, which exported vast amounts of assorted earthenware to Canada, including crate after crate of wares that might now

be thought of as Portneuf. Many of the best of them came from Scotland. By and large, they were all intended for the cheaper market—for kitchen use (bowls, milk jugs, mugs), or for the tables of the unsophisticated. Much that is collected as Portneuf (mainly in Quebec and Ontario) is late Victorian and even 20th-century in date. "Country Crockery" was the heading under which these wares were usually advertised when they were new. Their attraction for today's collector is in their lively naiveté.

Every type of earthenware and stoneware flowed into Canada: Wedgwood's black basalts; caneware (in "Imitation Pies and Tarts"); green-glazed dessert services that rated as prizes in Montreal lotteries; fancy jugs in every conceivable form. Alert importers kept Canadians abreast of the latest artistic developments. Christopher Dresser's art pottery designs of the 1880s were offered in Toronto smartly on the heels of their English acceptance. Fireproof baking dishes (from Sunderland) and toy tea sets (from Longport) helped to stock Canadian stores operating under such names as "The Staffordshire and Yorkshire Earthenware Warehouse" (Saint John, 1839), or "Staffordshire House . . . British Earthenwares" (Halifax, 1868). It would seem that every need of the market for both "fine and common wares", as the importers put it, could be met without looking to porcelain at all. The earthenwares and stonewares did, of course, account for an overwhelming proportion of the imports; yet there was also, from the beginning of the century, a strong demand for porcelain. In this area, too, British potters took firm advantage of opportunity and sustained their lead throughout the century, even in the Victorian years when inexpensive European porcelain and some from the Orient challenged their former monopoly.

All the best Regency and Victorian porcelains were available. Their names emerge from Canadian sources with surprising frequency and in unexpected context. Worcester and Liverpool porcelains were spread out for inspection on the wharves in Halifax and Saint John. Miles Mason's rare British Nankin China was stocked at a general wholesaler's in Montreal in 1808. Montreal trade auctions in 1832 offered Rockingham and Derby—"Tea, Coffee, Breakfast, Dessert and Supper Setts."

The 19th century saw bone china, Staffordshire's lasting contribution to the history of porcelain, push to the fore in overseas markets, crowding out older rivals. Copeland's bone china, the best to be had, was in use at remote fur-trading posts in the Northwest and on the Pacific. Names, now forgotten but once prominent, had sales appeal for china-buying Canadians of former days. Charles Ford's bone china from Staffordshire was in advertising headlines in Canada in the 1880s. Handsome dessert services by Ford survive to tell of a trade that flourished when plates were ordered in four-dozen lots. (One Quebec bride of Victorian times began housekeeping with a bone china dinner service of 800 pieces.)

For the collector of commemorative wares there is Worcester porcelain made at the time of the first official royal tour of Canada. The Prince of Wales (later King Edward VII) came to Canada in 1860, the principal object of his visit being to open the Victoria Bridge at Montreal. Tradition has it that it was for one of the Montreal entertainments in his honor that the Worcester tablewares were ordered. They were decorated in green with the Prince of Wales' Feathers and a border of

maple leaves. The order for them was placed through Sharpus & Co., London china sellers. The Sharpus name is printed on the back of these pieces, which has misled some collectors into thinking Sharpus was the maker. The maker was Kerr & Binns of Worcester.

The occasional Canadian scene appears on hand-painted Victorian porcelain, not because the wares were necessarily made for the Canadian market, but as incidental decoration. In a Coalport dessert service of about 1850, for example, one plate was painted with a view of the Chaudière Bridge, copied from Bartlett.

A Victorian porcelain enthusiastically admired in Canada was Parian, the china that looked like marble. It was a Staffordshire invention of the 1840s, known at first by several different names. Copeland's name for it was Statuary Porcelain; Wedgwood's was Carrara. The Minton name of Parian (after marble from the Greek island of Paros) eventually prevailed. It was as Parian that it was advertised in Canada, regardless of the potter.

So great was Canadian interest in Parian that trade sales of Parian alone were held. Some of these sales offered nothing but "beautiful busts and statuettes," reproducing classical sculpture or the work of distinguished contemporary sculptors. At other sales vases ("flowered and graped") and ornaments of other kinds (jewel boxes and ring holders for the dressing table, match holders, brooches) were included. Dessert services, jugs, covered butter dishes, and cups and saucers, were made in Parian, but they were more often considered ornamental than useful.

Parian met the Victorian wish "to fill a space and gratify the eye." Every Canadian drawing room had its complement of portrait busts or of sentimental groups and figures. At least four prominent Canadians were themselves reproduced in Parian. There were portrait busts of Sir John A. Macdonald, the first prime minister of the Dominion of Canada; Hon. Alexander Mackenzie, the second prime minister; Edward Blake, who succeeded Mackenzie as leader of the federal Liberals in 1880 but who led his party to defeat in the election of 1882; and Edward Hanlan ("Our Ned"), the Toronto athlete who became champion oarsman of the world in 1880, when he triumphed over the Australian, Edward Trickett, in a race on the Thames in England.

The three political figures were the work of a British potter who marked them only with his initials: R. C. The identity of R. C. has not been conclusively proved. A potter named Robert Cook (or Cooke) was working in Hanley in the 1870s and, according to Jewitt, made Parian for the North American market, but until a fully marked specimen turns up the matter must remain in question. The maker of the Hanlan bust used no mark at all.

The situation with Parian was the same as with earthenwares printed with Canadian views; there was a demand in Canada for these Canadian subjects, but though party politics and "Hanlan fever" must have guaranteed rewarding sales, Macdonald, Mackenzie, Blake and "Our Ned" would have ranked ignominiously in the total number of Parian purchases. "Jenny Lind" or Canova's "Dancing Girl" were advertised far more frequently. Hiram Powers' "Greek Slave" accounted for more paid lines of advertising space than politicians and sculler combined.

After years of neglect, Victorian Parian is back in favor with collectors. The new interest has returned to the market many pieces long hidden away. Some of them are a reminder that art on a gamble swept the country in the second half of the 19th century. The art union movement (in essence, giant lotteries in which every prize was a work of art) began in Great Britain just a little before Parian made its appearance. As the movement gathered momentum some of the art unions, notably the London Art Union and the Ceramic and Crystal Palace Art Union, began offering Parian busts and statuettes among their prizes. All the major art unions had active Canadian agents. Advertisements stressed that the purchase of a ticket held out "peculiar advantages to persons of taste." Many Canadians took a chance on the advantages and, if lucky, became owners of Parian prizes. Their prizes may be identified today, for the name of the art union will be found on the back of the piece.

China merchants liked to describe themselves as "well assorted." Almost any item of their well-assorted stock, earthenware or porcelain, now has its collectors. With some collectors what was actually given away is today high on the list of desirable Canadiana. The little advertising plates that the 19th-century Canadian china merchants handed out free to prospective customers are now rare, sought after and expensive. They were usually earthenware plates of the kind made for children, with the alphabet embossed around the rim and a transfer-printed picture of some kind in the center. But also on the face of the plate (not on the back, as with items imported for sale) appeared the name and address of the china merchant.

Those who gave away plates of this kind included Francis Clementson of Saint John, and Renaud, Prieur & Co. of Montreal. One of the Clementson plates is in the New Brunswick Museum collection. In Montreal the Château de Ramezay Museum has a Renaud, Prieur & Co. plate.

Francis Clementson, eldest son of the founder of the Staffordshire pottery, came to New Brunswick in the late 1840s and remained there until he assumed control of the Staffordshire business upon his father's death in 1871. He himself died in England in 1875; the warehouse in Saint John continued as Francis Clementson & Co. The advertising plates belong to the period when Francis was alive and in Canada. Renaud, Prieur & Co. were on St. Paul Street from May 1857, when they took over John Glennon's business, until the beginning of the 1860s, when Hon. Louis Renaud became the partner of John L. Cassidy. The business style of the firm then changed to L. Renaud & Cassidy.

In 1878 the Toronto *Mail* told its readers, in an article published on September 20th, that the "legitimate taste" for china collecting should result in an appreciation of "representative china." The representative china of 19th-century Canada, stocked by dealers such as Francis Clementson, and Renaud, Prieur & Co., came mainly from the potters of Great Britain. It was these potters who saw in the expanding colonial markets opportunities which their industrial ascendancy, commercial enterprise, and marine resources made them supremely fitted to supply.

Glass
and the
Glass Industry

Janet Holmes

For the glass collector, the period from 1839, when the first known Canadian glass factory began operating, to 1880, poses a problem. Until the 1880–1925 period, except for a few known pieces (some self-authenticated by molded lettering), products of Canadian glasshouses have not been identified.

To date, only thirteen glasshouses are known to have operated before 1880. An examination of their formation and history and a look at their products (whether advertised or known through excavations or marked pieces) indicates that, although one or two more glasshouses operating before 1880 may yet be identified, their products will fall into the range already known to have been produced during that period.

Canada in the 19th century was largely an agricultural nation and for most of the century, as population grew, there were new areas being opened up where pioneer conditions of life existed, and the clearing of land, the building of shelter and growing of crops were major preoccupations. Although by the 1820s the settled areas along the Great Lakes and the St. Lawrence had formed such administrative and cultural centers as Niagara, York and Kingston in Upper Canada, Montreal and Quebec in Lower Canada, and Halifax and Saint John in the Maritimes, by 1851 our population had only reached 2,436,000. Our main exports were furs, timber, and potash and pearl-ash to Great Britain. Ships on the return voyage brought manufactured goods from that well-developed industrial country.

Outside the main centers, the first factories erected in new settlements were the saw- and grist-mills needed to produce building lumber and flour. The first craftsmen were usually carpenters and blacksmiths. Cabinetmakers were less numerous and were located in the larger towns. Potteries were few in number and were usually one-man businesses, sometimes operated in conjunction with farming. Their products were limited to containers and utility wares, and marketed within a small local area. It was not until the 1860s and 1870s that pottery factories employing ten or more men were established in Canada.

Glasshouses were even scarcer than potteries. This should not be surprising in view of the size of the population and also taking into account the fact that glass production was a factory operation involving more than one person. In the 19th century the smallest glasshouse usually had a five-pot furnace. With a shop organization of three to four men per pot, this entailed at least fifteen or twenty men producing glass, not to mention those needed to cut wood for fuel, unload raw products for the glass batch, and pack the finished product for transporting to market.

It is not surprising, then, that from 1839 to 1880 so few glass factories were established, nor that their history should be one of changing partnerships, short-lived operations, and often a hand-to-mouth existence. Some succumbed to business depressions, which hit hard in 1847 and 1873, and all struggled against the ever present competition from English and American companies, which made expansion, and at times even profitable operation, difficult.

Credit for the first Canadian glass factory must go to Amasa W. Mallory. At the time when he operated the Mallory-town Glass Works, 1839–1840, he was a twenty-year-old entrepreneur, who later in his career was at various times a cattle dealer and owner of a cheese factory. The glass factory was operated by a glassman who was part of the northern migration of workers in the "South Jersey" tradition, that occurred after Caspar Wistar's Salem County, New Jersey, glasshouse closed in 1780 during the American Revolution. Workers from this house traveled into Connecticut and up into northern New York State, establishing small bottle and window glasshouses. There was such a house at Redford, N.Y., just a few miles across the St. Lawrence from Mallorytown. Like its counterparts in New York state, the Mallorytown house was formed to provide bottles and common tablewares for a local market.

Its known products are in the natural aquamarine color caused by ferrous (green) and ferric (yellow) iron particles in the sand used in the batch mixture. Combinations of these

elements could also produce amber and olive-green glass. In addition to the sand, the batch included an alkali, such as potash or soda to lower the melting point, cullet (pieces of earlier hardened glass or broken worked pieces) to speed up the melting process, and possibly lime carbonate for hardening the glass. In design the Mallorytown glass was free-blown and followed the "South Jersey" tradition, using decorative glass threading and the lily-pad decoration that George McKearin, an authority on American glass, describes as the only purely North American decorative element in glass. The flasks, tumblers, milk bowls, covered sugar bowls and pitchers were blown on a blow-pipe, and shaped with the iron pucellas or tongs, and wooden paddles. Once the basic shaping had been done, an iron pontil rod was attached to the base of the object by means of a small gob of molten glass, the blow-pipe was broken off, and after reheating, the final shape of the neck, the addition of decorative glass threading, the folding of the rim, or the addition of handles was accomplished. Once finished, the piece would be broken off the pontil rod, leaving a rough scar on the base, and taken to an annealing oven, where the temperature of the glass was slowly lowered to room temperature. This gradual cooling allowed the irregular molecular structure of the liquid glass to adjust to the regular pattern of bonding of a solid, eliminating the stresses that would otherwise have been locked into the glass by rapid cooling. Stresses caused by improper annealing might eventually cause the glass to crack or even explode.

Although a piece of Mallorytown glass would be prized in any collection, most of the known pieces are now in the Royal Ontario Museum, and most of the "South Jersey" pieces are either in museums or private collections. In the 1930s good reproductions were made in New Jersey factories and some modern Mexican glass, most of it with distinguishing bubbles throughout, but some in a good but heavy glass, is still being made in the "South Jersey" tradition of the 1820s to 1840s.

The first factory in Lower Canada (Province of Quebec) was started in 1845 in St. Johns. In the *Canadian Economist* for 1846, it is described as having gone "into production with two furnaces in the spring of 1845, drawing sand from Beauharnois and Vaudreuil and turning out one hundred half-boxes of window glass a day." The factory was well located. Sand from Beauharnois and Vaudreuil could be brought down from Montreal by the Champlain and St. Lawrence Railroad (built from La Prairie to St. Johns in 1836). The finished window glass found a ready market in Montreal. To the south, St. Johns was connected by the Chambly Canal (finished in 1843) to Chambly, and from there by Lake Champlain and the Champlain Canal to Troy, N.Y., and the Hudson River. This factory may have been one of the casualties of the 1847 depression, for the only mention of it is that in the *Canadian Economist*, and no glass factory is listed for St. Johns in the 1851 *Canada Directory*.

In the same year, 1847, a factory was started at Como, P.Q., in Vaudreuil County on the Ottawa River, close to transportation by river to Montreal, and to a supply of suitable glassmaking sand in Vaudreuil County. Although the partnership for carrying out this operation had been formed in 1845, changing partners and the withdrawal of their French glass chemist, François Coste, delayed opening until 1847. Named the Ottawa Glass Works in December of 1848, this works was

primarily a window glass factory. On October 25th, 1850, with a date of February 15th on the advertisement, the following appeared in the *Montreal Gazette*:

> Ottawa Glass Works
> The undersigned having purchased the above extensive works at Vaudreuil, and having also erected works for Hollow Glass Ware, are prepared to execute orders for the following, upon the most reasonable terms, and with despatch—
> Window Glass, of all sizes, to 30 x 40, thin and tick[*sic*]
> Do　　　　do　　　　colored
> Hollow Ware, Soda Bottles, Phials, Tubes, and Cylinders, and Mineral Water Bottles to any pattern.
> Glass Shades and covers, Gas bells, Milk Tureens, &c, &c.
> Door and Sash Knobs and Plates, glass or porcelain . . .
> February 15　　　　　　　　BODEN & LEBERT.

The second hollow ware factory mentioned was erected probably in 1849 by the partnership of Heinrich and Sebastian Hochmoth, George Wilhelm Hirsch and Frederick Carl Boden, a partnership that was registered on July 23rd, 1849, as having transacted and intending to transact business as glass manufacturers. On January 12th, 1850, the factory was bought by Boden, and after Jean Baptiste Lebert became his partner, they bought the Ottawa Glass Works from George Desbarats, and advertised their range of products in the Montreal Gazette. The capital of this partnership was quite limited, as they were to pay for the Ottawa Glass Works in window glass delivered to Montreal, and both properties were mortgaged to George Desbarats. Apparently by September, 1852, the Ottawa Glass Works had reverted to George Desbarats and he leased the works to a group that included Jacob Lagrange and Samuel Jones. In August, 1857, the Ottawa Glass Works are again being leased by George Desbarats to a group of glass manufacturers from New York State that included Henry W. Jones, and in the 1857–1858 *Canada Directory* the name of Henry Jones's factory is given as the British American Glass Co. Records for the second hollow ware works have not been found after 1850, and the final date of closing of the Ottawa Glass Works is not known.

Excavations on the site of the Ottawa Glass Works, besides uncovering great quantities of cylinder-blown window glass, produced some small aquamarine free-blown medicine bottles, with a pontil mark on the base and a thin outward tooled lip, and two types of "black" (dark green) glass bottle, one a mold-blown square tapered gin bottle with outward tooled lip, like a decanter top, and with a pontil mark on the base. The other was a round, mold-blown bottle with molded shoulder lettering, UNION LAVA WORKS / PATENTED 1852, with an applied lip and no pontil mark. This indicated that a snap case for holding the bottle for the process of finishing the neck, introduced in the 1850s in place of the pontil rod, was being used in this factory. The hollow ware factory has not been excavated and its products not identified, but there is the intriguing possibility that some pressed glass doorknobs came from this factory.

Another window glass factory is reported in the 1851 census for Yamaska County, on the south side of the St. Lawrence opposite Three Rivers, but its exact location is not mentioned.

Free-blown aquamarine medicine bottle, with a label for "Dr. Beach's Vegetable Composition," of a type made at the Ottawa Glass Works, Como, Quebec, from 1847 to c. 1857.
▽ CANADIANA, ROYAL ONTARIO MUSEUM

Aquamarine glass free-blown sugar bowl with lily-pad decoration, probably from the Mallorytown Glass Works at Mallorytown, Ontario, 1839–40. Mallorytown glass is very similar or identical to products of upper New York State glasshouses of the same period, and thus is difficult to identify specifically.

CANADIANA, ROYAL ONTARIO MUSEUM

△
Mold-blown sodawater bottle, marked "F. Riddell, Toronto" on the side and "Hamilton Glass Works" on the base. The Hamilton Glass Works at Hamilton, Ontario, operated from 1865 to 1898.

CANADIANA, ROYAL ONTARIO MUSEUM

By 1857, another glass factory, that of the Foster Brothers, had been started in St. Johns, P.Q., probably to take advantage of the same transportation facilities that had attracted the earlier company. They are known to have produced a soda-water bottle in aquamarine glass with a pointed bottom end, an applied lip, and with molded lettering, FOSTER BROS. / ST. JOHNS CE. Bottle glass was usually the poorest quality glass at this time, the better qualities being used for tablewares and window glass. As sharp corners in glass weaken the strength of the glass, and the carbonated soda-water would create pressure inside the bottle, the early soda-water bottles have pointed or rounded bottoms to give them greater strength. The heavy rounded lip allowed the cork to be wired in. Also made at the Foster Brothers works was a round bottle with sloped shoulders and long neck, the whole bottle being covered with a wicker case. Besides these known pieces, they probably also produced a general range of beer, soda-water and medicine bottles. The date of their closing is not known.

In the early 1860s, George Matthews, a Montreal lithographer, started the Canada Glass Works at Hudson, P.Q., and by 1868–69, had the company secretary, C. W. Walker, located at 10 St. Nicholas Street in Montreal, probably operating a sales office. The factory was located in Vaudreuil County, just a few miles up the Ottawa River from the Como factories of the 1850s. By 1867, the production had expanded from the basic druggists' bottles and telegraph insulators to include lamp ware and lamp chimneys. In 1868 they advertised druggists' bottle ware, and Benjamin Lyman, who ran a Montreal drug firm, was President of the Canada Glass Works. This was one of three glass companies of the 1860s that seems to have been connected with a drug supply firm. One known lamp from this factory is a mold-blown lamp with vertical ribs, and a hand-applied handle, in colorless, blue, and amber glass. The factory operated until about 1871–1875, using the Ottawa River for transportation as the earlier Como factories had done.

The Hamilton Glass Works was started in Hamilton,

Colorless pressed glass goblets, left to right, of the Nova Scotia Raspberry and Shield, Starflower, and Nova Scotia Diamond patterns; all from the Nova Scotia Glass Co., New Glasgow, Nova Scotia, 1880–92. CANADIANA, ROYAL ONTARIO MUSEUM

Pressed colorless goblets in a variant Nova Scotia Raspberry and a Kenlee pattern, also from the Nova Scotia Glass Co.
CANADIANA, ROYAL ONTARIO MUSEUM

Mold-blown jars, left to right, marked "B.G. Co." in a maple leaf; the canning jars marked THE BURLINGTON / B.G. Co. / P'D 1876; and the pressed jar marked MACLAREN'S IMPERIAL CHEESE. All are from the Burlington Glass Works, Hamilton, Ontario, operating from 1874 to 1897.
CANADIANA, ROYAL ONTARIO MUSEUM

Colorless kerosene lamps, with mold-blown fonts and pedestals, and pressed feet; all from the Burlington Glass Works, Hamilton, Ontario, 1874–97. These lamps, left to right, are the Canadian Drapes, Butterfly and Frosted Fence patterns.

PRIVATE COLLECTION

Water pitcher, mold-blown with diagonal lines of white opal, and a chevron tool mark on the hand-applied handle. This piece is from the Burlington Glass Works, Burlington, Ontario 1874–97.

CANADIANA, ROYAL ONTARIO MUSEUM

Mold-blown opal glass salt shakers in Burlington patterns, left to right, Nos. 6, 7, 8 (Frame and Shell), 9 (Shell) and 10 (Beaded Lattice and Frame). The pattern numbers are cast into the base of each piece. All are from Burlington Glass Works, Hamilton, Ontario. PRIVATE COLLECTION

Ontario, in 1865 by Gatchell, Moore & Co., a drug supply firm. It was convenient for them to have a glass factory to supply bottles for packaging and, in fact, bottles were the main product of the Hamilton Glass Works. They advertised all kinds of druggists' glassware in flint and green glass.

Flint glass, a term originally applied to a high-quality lead glass, for which burned flint was used instead of sand, came also to be applied over the centuries to lead glass, and in the late 19th century to the colorless soda-lime glass, which by this time contained no lead and no flint. It had simply become by transference a name for colorless glass.

The Hamilton company produced such items as THE GEM / RUTHERFORD & CO and the HAMILTON GLASS WORKS / CLAMP JAR fruit jars. The latter has a flanged inner lip to take a pressed lid, held in place by a metal screw clamp, and represents their earliest form of jar production. The Rutherford & Co Gem jars are a variation of the Mason fruit jar, first patented in 1858. The jars were blown in a two-part blow-over mold with the threading for a screw-cap closing as an integral part of the mold. The glass was blown up over the top of the mold, and the rim finished by chipping down the thin upper glass, and grinding the rim edge. The Rutherford jars were probably being made throughout the period 1872–1888, when George Rutherford was associated with the company, and may have been produced right up until the company closed in 1898.

The company's soda water bottles included one made for F. RIDDELL / TORONTO, a soda water manufacturer of the 1870s. The bottle is flat bottomed with HAMILTON GLASS WORKS in molded letters on the base. However, the round-bottomed bottles, which were an earlier form, apparently continued into the 1890s. There is one such bottle with molded lettering for the IMPERIAL / MINERAL WATER COMPANY / OF ONTARIO / HAMILTON, CANADA, a company that was operating in the early

"Bull's-eye" kerosene lamp, with a colorless mold-blown font and attached blue opal base, from the Diamond Glass Company, Montreal, 1890–1902. The same lamp pattern was made in wholly clear glass by the Dominion Glass Company of Montreal from 1913 to about 1925. CANADIANA, ROYAL ONTARIO MUSEUM

Colorless pressed glass cream pitcher and sugar jar, in the Athenian pattern, from the Diamond Glass Company of Montreal, operating from 1890 to 1902, or the Dominion Glass Co., Montreal, from 1913 to c. 1925.
CANADIANA, ROYAL ONTARIO MUSEUM

At the left are spoon holders, of blue and white opal glass, in the Maple Leaf pattern, and, center, a blue opal-based "Bull's-eye" pattern lamp, all by the Diamond Glass Co., Montreal, 1890–1902. The amber tumbler, in an Early Nugget pattern, was possibly by the Sydenham Glass Co. of Wallaceburg, Ontario, c. 1894–1913. The cranberry with white opal "Coin Dot" table pitcher, to the right, was produced at the Burlington Glass Works, Hamilton, Ontario, 1874–97.

CANADIANA, ROYAL ONTARIO MUSEUM

1890s, that is attributed to the Hamilton Glass Co. The company also made a pressed insulator marked HAMILTON GLASS CO. All of the products mentioned are in the aquamarine bottle glass color. Medicine bottles that can be attributed to the Hamilton Glass Works are not yet known.

The plant, located at Hughson and Picton Streets, was close to Hamilton harbor and to the Great Western Railway line, which had opened between the Suspension Bridge at Niagara, to Windsor by way of Hamilton and London in 1853, with a branch line in 1856 from Hamilton to Toronto. Raw materials could be brought in by ship or rail and products shipped to market some distance from the factory that produced them.

In October 1867 the St. Lawrence Glass Co. opened in Montreal. It was the third firm of the 1860s closely connected through its originator, S. J. Lyman, with a drug company also owned by him. The glass works advertised that they would make only flint glass, and included flint glass druggists' ware in their list of products. Also included was a tantalizing list of pressed tablewares, produced for the first time in Canada: goblets, tumblers, sugar bowls, cream jugs, spoon holders, saltcellars, castor bottles, preserve dishes, nappies and water pitchers. Unfortunately for the collector, specific products are not known, and although an attempt was made, after buildings on the site had been demolished, to uncover some traces of early products, the site had been so altered by later building additions that little remained. The factory was on the Grand Trunk Railway, giving ready transportation as far away as Windsor, Ontario, and Portland, Maine. The company closed in 1873.

In 1874, Edward Kent and Alfred Miles began production of glass at the Burlington Glass Works, Hamilton, Ontario. The plant was close to Hamilton harbor and not too far from the rail line. Their earliest products seem to have been lamps. In 1878, William G. Beach, the new manager of the firm, was complaining that the company could not expand beyond the basic production of lamp goods because of the price-cutting practices of some United States firms. Between 1878 and 1880, while Beach was manager, some attempt to make pressed tablewares was made. There are a few pieces, given to the Royal Ontario Museum in 1934 by Mr. Beach's daughter with the information that they were made by him in Ontario. If so, they must have been one of the branching out attempts in the Burlington production between 1878 and 1880, when Beach left to become manager of the Nova Scotia Glass Co. in New Glasgow, Nova Scotia. When he took up his new position, he stated that of their proposed products, only lamps and chimneys were being made in Canada at that time. Since the Nova Scotia company intended to make pressed tablewares, and Beach was certainly aware of the Burlington company's efforts, it seems that by 1881 the Burlington plant had not made a successful production of pressed tablewares.

In 1875, the St. John's Glass Co., St. Johns, P.Q., opened. Their products are unknown but perhaps they are responsible for the beaver goblet with the molded lettering on the base, "ST JEAN BAPTISTE QUEBEC, 24 JUIN, 1880." They closed, probably in June 1880, at the end of the glass-blowing season. The firm moved to Montreal, having come under the ownership of David & William Yuile in 1879, and changed its name to Excelsior Glass Co.

Colorless pressed glass comport in the Maple Leaf pattern, with a hand-crimped edge, by the Diamond Glass Company of Montreal. The same comport without the crimped edge was later made by the Jefferson Glass Co. (Dominion Glass) of Toronto from 1913 to c. 1932. CANADIANA, ROYAL ONTARIO MUSEUM

So little is known of the products of these early companies operating before 1880 that it is a difficult period for the collector. Other than lamps, produced by the Canada Glass Works at Hudson and the Burlington Glass Works in Hamilton, the St. John's beaver goblet, and the unknown pressed tablewares of the St. Lawrence Glass Co. in Montreal, the period produced mainly bottles and fruit jars. Of that container production, only a very small number of pieces can be authenticated as products of Canadian glasshouses. However, it seems entirely logical to extend the basis of collecting to include bottles made for Canadian distillers and brewers, and for manufacturers of ginger beer, soda water, mineral water and ginger ale, as well as those made for chemists and druggists. Even if some of these bottles were not made by Canadian firms, if they are marked with Canadian names the direct association alone makes them desirable items. Even an incomplete check, at ten-year intervals from 1851 to 1891, in Ontario directories for users of bottles reveals an astonishing list running thirty to forty pages, so that it is possible for the collector to check dates of firm names that appear on bottles, by looking through early directories in libraries and archives.

The nature of the glasshouses and their products changed over the forty-year period prior to 1880. The staple products of the 1840s and 1850s were window glass and bottles, made in small factories employing about twenty to twenty-five glass blowers, and about the same number of auxiliary people. The rail connections completed in the mid-1850s encouraged the establishment of larger operations aimed at capturing more of the Canadian market, and made it feasible to attempt to compete with the British and American manufacturers of

lamps and pressed tablewares in the 1860s and 1870s. Even so it was a struggle.

Canadian manufacturers in 1871 had a potential market of 3,689,000 Canadians. At the same date the population of Great Britain was approximately 17,000,000, and that of the United States 40,000,000. In addition to facing the difficulties of competition with manufacturers producing for a much larger market, there was throughout this early period no compensating protection from an import tariff. Import duties on glass were 15% until 1874, when the duty was raised to 17½%, compared to an American import duty varying between 30% and 65%, depending on the kind of glass, from 1860 to 1874. In 1871, Canada imported $581,966 worth of glass, mostly from Great Britain and the United States, and made $292,130 worth, or about one-third of the glass purchased in Canada that year. In the same period, behind encouraging protective duties, the American houses produced about 80% of the glass bought in the United States. Of the glass made in Canada in 1871, $100,000 was accounted for by the St. Lawrence Glass Works of Montreal, $45,000 by the glassworks at Hudson, P.Q., and $85,000 by the Hamilton Glass Works. The size of the glasshouses had also increased between 1839 and 1880, as was reflected in the number of employees. In 1871 the St. Lawrence company was employing 100 men and 11 boys, the Hamilton company, 58 men and 25 boys, and the Hudson factory, 47 men and 37 boys.

In 1878, Sir John A. Macdonald, who had been out of power for five years, campaigned with a National Policy that included a higher protective tariff for Canadian industry. He won the election and in his 1879 budget introduced a Tariff Bill that included a rate of 30% on most glass imported into Canada. The effect of the tariff was to encourage the formation of several new glass factories.

One of these was the Napanee Glass Works at Napanee, Ontario. Mr. John Herring, who had successfully run an agricultural implement factory, sensibly investigated several American window glass factories, at Syracuse, Cleveland, Durhamville, and Bernhardts Bay, in New York State, and Pittsburgh, Pennsylvania, before embarking on the project of erecting a factory at Napanee. The plant opened on November 12th, 1881 after months of preparation. It was built with up-to-date equipment, with a revolving flattening oven that allowed the cut glass cylinders to be put into the oven in the glass-blowing area. By the time the oven rotated to the end for loading into the annealing oven, the cylinders would have opened out. They were then stacked on carts which moved slowly the length of the annealing oven, from the hot to the cool end, where they were unloaded for cutting and packing for shipment. The company had a sales agent in Ottawa, a Mr. G. Howe, who operated a house decorating, painting and glazing store, and shipped glass as far away as Manitoba. Near the beginning of operation, the plant ran into some trouble with an anteaser (fire stoker), who was inexperienced in using the soft coal in use in New York State and at Napanee, causing problems with the quality of glass for a time. The primary product was window glass, but for a short period the plant may also have made some prescription bottles. The factory closed about June 1883, and there was commentary in the *Napanee Standard* in the fall on the need for additional capital to make the operation a paying one. However, the works did

not reopen, and John Herring lost some $65,000 he had invested.

In September 1881, the Nova Scotia Glass Co. opened in Trenton, N.S., with a capital stock of $100,000, and announced its intention to make tumblers, goblets, glassware for general use, and kerosene lamps and chimneys. Their manager was William Godkin Beach, formerly with the Burlington Glass Works in Hamilton, Ontario. Under his direction, the company imported machinery for making its own molds, and employed James McKay as mold-maker. Tableware patterns authenticated by excavation are: Acadian, Buttons and Bows, Centennial, Crown, Diamond, Diamond Ray, Floral, Gothic, Grape and Vine, Hobnail, Kenlee, Raspberry, Raspberry and Shield, Ribbon and Star, Starflower, Tandem, Tassel and Crest, and Victoria Commemorative. The three Nova Scotia companies, Nova Scotia Glass Co., Lamont Glass Co., and Humphreys Glass Co., were all located on the same street in the twin towns of Trenton-New Glasgow. Although a later leveling of the site makes absolute attribution of glass to one company impossible, company histories seem to indicate that the Nova Scotia Glass Company was responsible for the pressed tablewares. Located on a rail line in Trenton, the firm shipped goods to central Canada. At the end of December 1889, the company paid a 7% dividend and held plant, material and stock worth $89,891.28, and had a capitalization of $50,000. They seemed to be in fairly good financial shape. However, increased production and competition from Ontario companies, probably meaning that the Burlington Glass Works in Hamilton was by this time producing tablewares, and increased freight rates, which made it difficult to move their product to market competitively priced, resulted in their selling the company to the Diamond Glass Co. of Montreal in March of 1890. The company continued to produce tablewares under its new ownership until November 1892, when the plant was shut down and molds shipped to Montreal. Some of the molds may have continued in use at one of the Diamond Co. plants or those of its successors. There is an advertisement in a 1914 Gowans, Kent Co., Toronto, catalogue for a pitcher in the Nova Scotia Starflower pattern, showing that at least one form of a Nova Scotia pattern was being made some twenty-two years after the Nova Scotia Glass Co. had closed.

This takeover of one company by another was the first indication in the Canadian glass industry of a process of consolidation that took place over the next thirty years. The Excelsior Glass Co. had moved from St. Johns, P.Q. to Montreal in 1880, and incorporated as the North American Glass Co. in 1883. On June 27th, 1890, the company was reincorporated as the Diamond Glass Co., a move that probably allowed the company to operate outside Quebec. The company's products up to this point seem to be the familiar list of flint lamp chimneys, and prescription bottles, some pressed work and green glass bottles. In February 1891, the company gave notice in the *Canada Gazette* that under the Canada Joint Stock Companies Act, it would apply for the increase of its capital stock to $500,000, thus becoming the largest glass company in Canada. Having acquired the Nova Scotia Glass Co. in 1890, the company's capital expansion prepared the way for the purchase of the Hamilton-Burlington Glass Company in August 1891.

These companies had been undergoing some changes since the late 1870s. The Hamilton Glass Co. continued to make

Pressed glass colorless butter dish in the Rayed Heart pattern, from the Jefferson Glass Co. (Dominion Glass) of Toronto, 1913 to c. 1932. CANADIANA, ROYAL ONTARIO MUSEUM

primarily green and amber bottles, fruit jars, and green prescription bottles.

The medicine bottles found at Como, P.Q., dating about 1850–1853, were cylindrical, free-blown bottles, with pontil marks on the base and thin, outward-tooled lips. During the 1850s both the snap case, replacing the pontil for holding the bottle while the neck was finished, and a simple three-pronged tool for finishing the neck, came into use. This speeded up the process of making bottles, as did the growth of standardized molds for prescription wares, with names such as Blake, Philadelphia Oval, French Square, and Panel. The bottles were blown, usually into two-part molds, leaving mold seams on the side of the bottle that stopped near the base of the neck. The top part of the neck and the rim, finished with the three-pronged tool inserted in the neck and turned, shows no mold marks, but often has a series of thin drag lines, caused by the turning tool. This neck finish produced bottles with standard-sized openings.

Lettering panels, which could be inserted into the standard molds to make up orders for individual druggists, were introduced into the production of Whitall, Tatum, & Co., one of the major American producers of druggists' bottles, in 1868. Although I do not know if this is the earliest date they were used, the letter panels probably came into general use shortly after 1868 as a convenient and time-saving production technique, and also gained in popularity over earlier paper labels.

Although in 1869 the Hamilton Glass Co. was listed as bottle manufacturers, making flint and green glassware, in its early years, the largest concentration was probably on green bottles. Lead was rather expensive for use in making colorless bottles. About 1864, William Leighton, working at Wheeling, West Virginia, perfected a soda-lime formula for making a good colorless glass that reduced the cost by one-third, and made it feasible to make prescription bottles in colorless glass on a large scale. These new bottles, whose contents were easier to

see, gained popularity in the 1870s and early 1880s, and as a major trade item became a bone of contention between the American Flint Union and the Green Glass Bottle Blowers' Association. The Flint Association claimed jurisdiction because the bottles were flint glass, and the Green Bottle union claimed jurisdiction because they were bottles. The Hamilton Glass Co. in 1885 bought the Burlington Glass Works, probably to provide it with a flint house to meet the growing demand for colorless bottles. After 1885, until the factory closed in 1897, I think a high proportion of the Burlington Works products must have been prescription bottles. The Hamilton Glass plant closed in 1898.

In the 1880s, the Burlington Glass Co., probably encouraged by the 1879 Tariff, had also branched out into making pressed tablewares, and was producing enough for "competition from Ontario companies" to be mentioned as one of the causes for selling the Nova Scotia Glass Co. in 1890 to the Diamond Glass Co., Montreal. In 1891, the Diamond Co. also bought the Hamilton Glass Co., including its Burlington factory. This buying out of competitors to form a large corporation was not a strictly Canadian phenomenon.

In July 1891, in the United States, eighteen glass factories merged to form the United States Glass Company, with a capitalization of $4,000,000. Some of the pressed tableware patterns, made by individual companies before the merger, were reissued after 1891 by the United States Glass Company, but it is interesting to note that many of the Burlington Glass Works patterns are ones that had also been made by one or other of the eighteen merging companies before 1891. It is possible to speculate that in the streamlining of operations that undoubtedly took place to achieve economies in the United States Glass Co., some of the molds may have been sold off. If this is so, then patterns made at the Burlington Works that correspond to the earlier American production probably date from 1891 to 1897, when the Burlington Works closed down.

The following list of pressed glass patterns, except where noted, is compiled from fragments found on excavations at the site of the Burlington Glass Works by the Royal Ontario Museum in 1966 and 1969, and on private digs in 1968, and ranges from two fragments found for Westward Ho to forty-odd found for the Canadian pattern. Patterns with a single asterisk were also made by American companies that joined in 1891 to form the United States Glass Company. Those with a double asterisk were made by other American companies, mostly in the 1870s and 1880s. Acorn, Actress**, Aegis, Anderson*, Arched Grape, Ashburton*, Bar and Flute, (no site fragments found, but a cream pitcher came from William G. Beach's daughter with the information that he made it in Ontario. He worked at the Burlington Glass Co. from 1878 to 1880), Barberry (oval berries)**, Beaded Arched Panels, Beaded Band, Beaded Flange**, Beaded Oval Window, Block*, Boling, Buckle with Diamond Band, Buckle with Star*, Bull's-eye (no fragments were found, though this was listed by Gerald Stevens in *Early Canadian Glass*), Canadian, Cardinal, Cat's Eye and Fan, Chain and Star Band, Chain with Star*, Clear and Diamond Panels, Clear Fuschia, Coin Dot**, Colossus, Cord and Tassel*, Crossed Ferns with ball and claw**, Curled Leaf*, Currant**, Dahlia**, Daisy and Button*, Diagonal Band, Diagonal Band and Fan, Diamond*, Diamond Sunburst*, Deer and Dog, Eastern Star*, Filly*, Flat Diamond*, Flower and Quill, Frosted Butterfly, Frosted Ribbon*, Frosted Stork, Garfield Drape, Geddes, Gesner, Gordon, Graduated Diamond, Grape, Grape and Festoon with Shield*, Greek Key and Wedding Ring (no fragments were found, although listed in Gerald Stevens' *Early Canadian Glass*), Hamilton, Hops Band*, Jacob's Ladder*, Jewel Band, Kalbach, Late Buckle*, Lattice**, Leaf and Dart*, Leverne, Lily of the Valley, Lozenges, Minerva, Newcastle, New York*, Norman Star, Nova Scotia Diamond, 1-0-1, Palmette, Paneled Dewdrop**, Paneled Forget-me-not*, Paneled Diamonds, Peerless*, Picket*, Pitcairn, Pleat and Panel*, Ribbed Forget-me-not*, Sawtooth*, Scalloped Lines**,

Seneca Loop, Sheraton*, Square Marsh Pink, Strawberry*, Sunken Bull's-eye (listed by Mr. Stevens in *Early Canadian Glass*, but no fragments found), Sunburst Medallion, Tree-of-life (no fragments found, though a tray from W. G. Beach's daughter is regarded as having been made by him in Ontario. He was manager of the Burlington works, 1878–1880), Tulip*, Washington Centennial, Way's Currant, Westward Ho*.

Although some of the patterns made at Burlington appear as inserts in Canadian silver plate, the silver plate manufacturers were also importing glass inserts to such as extent that in the 1890 tariff they were granted a tariff reduction. Item 59 read, "Crystal and decorated glass tableware made expressly for mounting with silver-plated trimmings, when imported by manufacturers of plated ware, — 20 per cent." The general duty on glass imports at the same time was still thirty percent.

In the 1890s and early 1900s, alongside the process of operating with larger capital stock issues and bigger companies, there were several attempts to continue glassmaking on the smaller scale that had been successful in the earlier part of the 19th century. The Humphrey's Glass Co., operating in Trenton, Nova Scotia, from 1890 to 1917, and Moncton, New Brunswick, from 1917 to 1920, the Lamont Glass Co. of New Glasgow, N.S., from 1890 to 1899, the Foster Glass Works of Port Colborne, Ontario, from 1895 to 1900, the Toronto Glass Co. from 1893 to 1920, and the Ontario Glass Co. of Kingsville, Ontario, from 1899 to 1901, were all still making container wares.

The Humphrey's factory was making bottles for a Maritimes and Quebec market, supplying bottles for Minard's Liniment Co., and for liquor, ginger ale and soda water manufacturers, and were also turning out lamp chimneys. They could produce 25,000 bottles a day, and employed in 1914 some forty-four men. They closed in 1920, when natural gas rates almost doubled.

The Lamont Glass Co., located close to the Humphrey's Glass Co., advertised prescription and other bottles, battery

Pressed glass toothpick holder, goblet, and bowl in the Colonial pattern; all from the Jefferson Glass Company of Toronto, 1913 to about 1930. CANADIANA, ROYAL ONTARIO MUSEUM

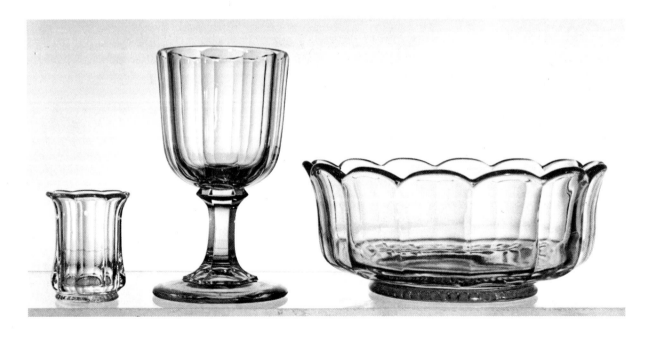

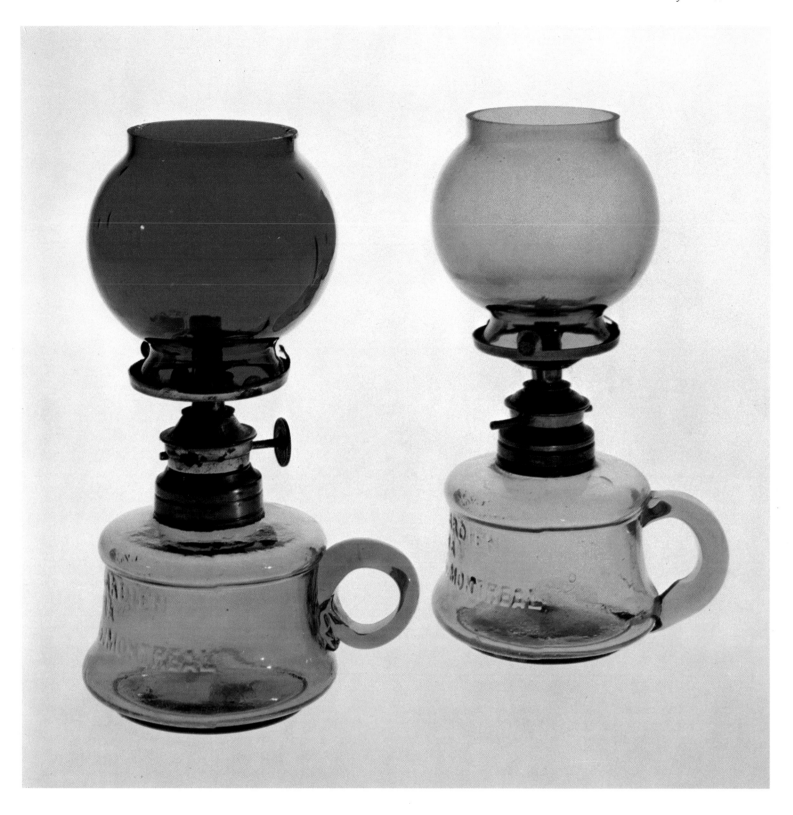

Two lamps, with oil tanks and shades in blue, red, and amber, marked in cast relief L'ANGE GARDIEN / EXTRA / C.H. BINKS & CO. / MONTREAL. These are, however, contract pieces made at the Burlington Glass Works of Hamilton, Ontario.

CANADIANA, ROYAL ONTARIO MUSEUM

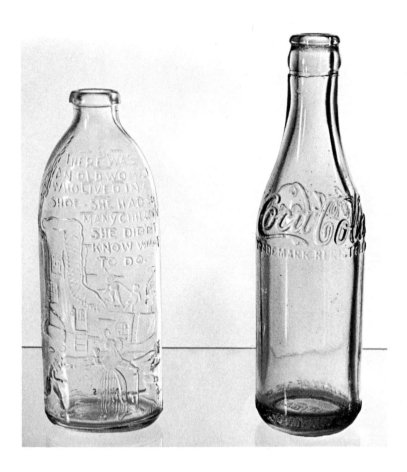

Machine-blown colorless bottles; on the left a nursing bottle with a scene and inscription of the nursery rhyme "There was an old women who lived in a shoe . . ." and at right an early Coca-Cola soft drink bottle. Both are from the Dominion Glass Co. of Montreal, c. 1920. CANADIANA, ROYAL ONTARIO MUSEUM

and fruit jars, insulators, lamp chimneys, gas and electric globes (plain, colored or decorated), and specialized in lead glass. In 1895 they had sixty employees. Some of their fruit jars are marked with a LGCo monogram. Caught by increased freight rates and competition, the company sold its assets to the Diamond Glass Co. of Montreal in 1897, and closed after a fire in 1899.

The Foster Glass Co. in Port Colborne, Ontario, apparently only made fruit jars. It was a small shop that had only six or seven blowers listed with the Green Glass Bottle Blowers' Association for the years 1897 and 1898, and operated for the short period from 1895 to 1900.

The Ontario Glass Co. of Kingsville, Ontario, is known to have produced an amber FERROL bottle and the BEAVER fruit jar during its short life from 1899 to 1901.

The Toronto Glass Company, operating from 1893 to 1920, had started out as an independent company under J. Malcolmson, formerly manager of the Hamilton Glass Co., and manufactured fruit jars, round pickle jars, oval flasks, tapered flasks, shoo-fly flasks, electric panels, and a range of patent medicine bottles. In the 1897–1898 season, the factory was bought by the Diamond Glass Co. in Montreal and continued to operate under that company and its successors until 1920, continuing its bottle production, using semi-automatic

Miller, O'Neill, and Olean machines.

The Manitoba Glass Co. of Beauséjour, Manitoba, from 1906 to 1918 was another container factory, started by Joseph and Edward Keilbach and Gustav Boehm, Beauséjour farmers, and staffed with Polish, German and American glassblowers. They produced amber glass beer bottles, green soda water bottles, and clear and green prescription bottles and fruit jars, some with numbers and the letter B on the base. Most of these, apparently, were blown in molds and had the lip completed with a finishing tool. The company had incorporated in 1907 with a capital of $100,000, which by 1911 had been increased to $1,000,000. In 1913, the threat of a price war caused the company to sell out to the Diamond Flint Glass Co., Montreal, which continued to operate the plant until 1918.

By 1913, these small companies had either ceased operations or been absorbed by the Diamond Glass Co. of Montreal, from 1890 to 1902, or its successor, the Diamond Flint Glass Co., from 1902 to 1913, and Dominion Glass, from 1913, still in operation today. They had succumbed to the increased freight and natural gas rates and to a tough competition.

This competition came to a great extent from technological changes in the glass industry. In 1892 and '93 a semi-automatic machine for making wide-mouthed wares was introduced. The semi-automatic machines eliminated the need for skilled glassblowers, but still required gatherers to take glass from the furnace to the machine. In 1903, the Owens Automatic Bottle Machine solved the problems of making narrow-necked wares, or bottles, on a machine, and also drew up glass from the furnace, doing away with the need for gatherers: In 1925, the efficiency of the Owens machine for some wares was between eight and thirty times greater than the hand operation. In this 1890 to 1913 transition period, the change from hand methods of operation to machine production was gradual, but weighed against the continued success of the small plants. The new machinery, while reducing the money needed for wages, since skilled workers were not needed, required a large capital outlay for furnace, plant and machinery.

Even the Sydenham Glass Co. of Wallaceburg, Ontario, operating from 1894 to 1913, claiming in 1897 to be the second largest glass factory in the Dominion, and having produced $120,000 worth of glass the year before, was not able to withstand the competition. They started with one tank, adding a second for flint and amber glass in 1896. They tried to keep up with the latest technological developments, blowing lantern globes by machine in 1903, and adding a machine for making fruit jars in the same year. They made the Wallaceburg Gem and the Doolittle fruit jar, and sold their products as far afield as New York and British Columbia. In their 1908 catalogue, they called themselves "manufacturers of bottles, fruit jars, tumblers, lamp chimneys, etc, etc," and this continued to be their main line of production.

Between 1906 and 1908, the Canadian Glass Manufacturing Company, a subsidiary of the Diamond Flint Glass Co. in Montreal, bought the Canadian machine rights to the Owens Automatic bottle-making machine for $104,900. They installed two machines in their Hamilton plant by July, 1907, and one at the Diamond Flint Glass Co. in Montreal in 1909. In 1910, they leased a machine to the Sydenham Glass Co. of Wallaceburg, and added a second machine to that plant in 1911. In 1913, the Dominion Glass Co. bought the Sydenham Company

and installed a third machine. In 1914 the Hamilton plant had four machines making beer, soda, catsup and milk bottles; also ball-neck panel, and emulsion bottles, and jars. The Montreal plant had four machines making beer, soda, catsup, Appolinara, "Florida Water," and liquor bottles. The Wallaceburg plant made beer bottles, and flasks, and the new plant at Redcliffe, Alberta, had one machine making principally beer bottles.

The jars made by machine had the mouth pressed first, and then the jar was blown into a full-size mold, doing away with the need for finishing the neck by chipping and grinding the edge, as had been done in the hand method. The rims on these jars are smooth. The bottles made on the machine also had their mouths formed first by pressing and blowing in a part-sized mold. After reheating, the bottle was blown into a full-sized mold. In these bottles, the mold seams extend from the base to the mouth rim, and sometimes ghost seams from using a double mold can be seen on the sides of the bottle.

Marks found on Dominion Glass bottles are a D-in-diamond on the base. They also supplied bottles to the Beaver Flint Glass Co., and the Richards Glass Co. in Toronto. These are prescription bottles marked with a Diamond, with the name of the bottle such as QUEEN OVAL or KING OVAL in the Diamond, and the letters in the four corners of the base "BFGCo" or "RGCoT". Sometimes the mark is just the letters mentioned and a mold number.

In 1913, the Consumers Glass Co., Toronto, began operations, making only containers. These are marked on the base with a C-in-triangle.

Other products from this period that should be mentioned are the tablewares. The Diamond Glass Co. in 1902 published a catalogue listing sets of Athenian, Dominion, Nugget, Numbers 20, 89, 92, 200, 202, 203, 204, 205 (Maple Leaf), 206 (New Century) and 207 (Duchess), as well as Diamond, New York and Imperial Comports, and Number 1883 dishes; and goblets in Diamond, Star, New York, Filly, Keller, Champagne, Indiana, Boyd, Windsor, also Numbers 202 and 204 patterns.

The Jefferson Glass Co. of Toronto, from 1913 to 1925 was a Dominion Glass plant and continued some of the patterns advertised in the 1902 catalogue, Athenian, Nugget, and Maple Leaf No. 205. Since this last-named pattern corresponds in name and number to the Diamond Glass Co. catalogue, it seems likely that the Jefferson Number 200 set (Stippled Swirl and Star), and Number 204 set (Bow Tie), and Number 1883 dishes, are continuations of the earlier line produced by the Diamond Company. Jefferson also produced the Colonial, Canadian Thistle, Canadian Horseshoe, Oval and Fan, Beaded Oval and Fan, Petal and Rayed Heart tableware sets, as well as illuminating ware. After the Jefferson plant was closed in 1925, the range of tablewares was gradually reduced, until in the 1930s they were limited to the simple, plain hotel wares, and the whole concentration of the Dominion Glass production was centered on containers.

In 1967, Glasfax was organized as a national glass collectors' association to encourage collectors and to operate as an exchange of information on Canadian glass. Monthly meetings are held in most areas, and a newsletter is sent out to members. Information on the organization and on the annual membership fee can be obtained by writing to Glasfax, Post Office Box 190, Montreal 101, Province of Quebec.

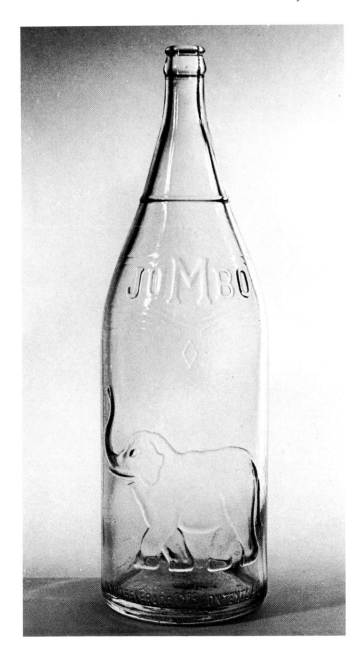

Machine-blown "Jumbo" soft drink bottle, probably of the 1930s, from the Dominion Glass Co. of Montreal.

CANADIANA, ROYAL ONTARIO MUSEUM

Handweaving and Textiles

Harold B. & Dorothy K. Burnham

Canada has a textile tradition which owes its excellence to many peoples. The country has been settled by waves of immigration, starting in the earliest times with wandering bands of Indians, and working down through the ages to our latest arrivals who come from all over the world. Each influx has brought with it skills which have held their own for a while and then blended with the rich traditions of others to produce our complex cultural mosaic. There are many areas of textile production which may well appeal to the collector of Canadiana.

The older Indian material is now so scarce that we can only marvel at the skill and dexterity of those who produced it, when we have the opportunity to see it in the few museums where it has been carefully preserved. True weaving never developed among the Indians of Canada, but complex varieties of finger weaving, plaiting, embroidery, beading and basketry attained heights untouched by the later arrivals. Some of these techniques are being revived and where taste, skill and tradition are well combined, articles are being produced which justify the attention of discerning collectors.

With the textile skills recently transplanted to this country from Europe and other areas there is much of interest: embroidery, knitting, weaving of all sorts produced in traditional ways. Usually the buyers and enjoyers of this modern craftwork belong to the same ethnic group as the maker. These crafts serve the dual purpose of curing a homesickness and preserving a much loved culture. There is, however, in this area a rich source for the collector who is interested in textiles as such. A fascinating collection could be made showing all the traditional textile techniques of one ethnic group, or by exploring one technique, such as knitting, with its variations stemming from many cultural backgrounds. The choice is wide, but even though material is readily available it is not an easy field. The collector must have a knowledge of techniques and rigid standards of quality, or the resulting gathering will have little value. A warning should be given that as time passes the traditions soften and change. The essential characteristics of a transplanted culture take on a new look with synthetic materials so temptingly available.

Although the Indian peoples, and the recent immigrants from all over the world provide a source of great interest, this book is concerned with material starting with the first European settlements of Canada and terminating with the dying out of the old traditional skills. In most of Ontario these were replaced by industrialization nearly a hundred years ago, while in the Maritime Provinces they have only recently vanished. In Quebec the craft revival has been so successful that it is almost forgotten that this revival of skills was necessary.

The first successful settlements in Canada were French, in Acadia and Quebec. When the British victories ended with the Peace of Paris in 1763, settlers and pioneers with different backgrounds arrived. The first came from the American Colonies to the south, followed by waves of immigration from across the Atlantic. In England, growing industrialization was disrupting the traditional ways of life; in Scotland and Ireland severe economic depression held bleak prospects for the future. Following the Napoleonic Wars many people from Germany left their homeland in search of a better life in North America. The stream swelled when famine struck Ireland and Scotland just before the middle of the 19th century. The early weaving of Canada is rooted in the traditions that these people brought with them, and the main elements are first the French, and then those brought from the United States followed by the Scottish and the German. What weaving there was among the many Irish immigrants was from the north and in the same tradition as the Scottish. Those who came straight from England had already been too much affected by industrialization to have been trained in the old skills. There were many weavers whose livelihood had vanished in the industrialization of Europe, but who readily returned to their profession when they found a market in the rural areas where they settled. No weaving remains from the early French period; practically nothing can be dated to the 18th century and very little to the early part of the 19th. The mass of material that is left was made after 1830 and much of it is of excellent quality.

TOOLS AND EQUIPMENT

The tools and equipment needed for preparing fibers for spinning, weaving, knitting, hooking and embroidery have a considerable interest for collectors, especially if they are craftsmen themselves. In the earliest days wool was usually combed rather than carded. Wool combs are among the rarest of tools. They come in pairs with long hand-forged metal teeth projecting at right angles from a horn and wood base with a wooden handle. One was fixed to a beam and the other heated and pulled through it to comb and straighten the wool fibers so that they could be spun into a fine hard yarn. Much more common are wool cards which made a fluffier, softer yarn. Made from a rectangle of wood, covered with leather from which projected fine wire teeth in serried rows, they also had handles and were used in pairs. Many commercially made ones of fairly recent date have survived. They were usually imported and readily available from all the mail-order houses. These are not of great interest but occasionally an older handmade pair turns up, showing the ingenuity of some local craftsman. Much beautiful woodworking was put into various forms of knives used in the preparation of flax. If a well-formed hardwood tool with a sharp edge is seen, it is probably a scutching or swingling knife for cleaning the fibers of the flax plant before spinning a linen thread. Hackles, also for processing flax, are fairly common. They consist of a board from which jut a lethal array of sharp metal points, looking like a miniature version of a bed of nails. These often show excellent workmanship with sometimes the added interest of being dated.

Many spinning wheels have survived. The "great" or "walking" wheel, which was used exclusively for wool, is the most common, with a wheel as large as a cartwheel. They were made locally in Ontario, the Eastern Townships of Quebec, and all the Maritime Provinces. The varied simple tensioning devices and driving mechanisms are a continuing source of interest. A late version which is rarely found in good condition was patented in the United States about 1860. It has a large wheel with an extendible arm to hold the spindle, allowing the spinner to remain still instead of walking backwards and forwards continually as was otherwise necessary.

Smaller wheels, which could be used for either flax or wool, required far more skill in the making, and often show beautiful craftsmanship. The spinner sat, usually turning the wheel by means of a treadle. The spindle was not a straight metal piece as on the "walking" wheel, but had a horseshoe-shaped flyer surrounding it, making it possible to spin and wind yarn simultaneously rather than in two separate operations. The early wheels of Acadia and Quebec are characterized by a free-running flyer held only by a tensioning cord. Those from the English, Irish and Scottish areas of the Maritime Provinces and Ontario, and the later ones from Quebec, have a doubled driving cord, one part of which controls the rigidly fixed flyer, while the other drives the spindle. The characteristic wheels of Quebec were gaily painted, but unfortunately are nearly always scalped before they come on the market. As with old furniture the original finish is a matter of importance. It is quite usual among dealers to supply missing parts from other wheels, with the result that the replacement is usually out of alignment, and the wheel is suitable for decorative purposes only. Anyone wishing to put a spinning wheel into usable order should be very sure that all parts can be correctly aligned and that the wheel itself is not warped.

Other pieces of textile equipment can be enjoyed for their charm and excellence of workmanship. In the Maritimes, beautifully shaped and finished niddy-noddies can still sometimes be found. They are a simple device for making a skein of yarn with a central bar and T-shaped cross pieces at either end. The bar was held in the middle and as the yarn was laid over the ends it was dipped first one way and then the other, so that the device "nidded" and nodded as the skein was wound. Reels, also for making skeins, are particularly interesting if equipped with a counting device to record the number of times they have been turned and hence keep track of the length of the skein being wound.

There is much winding and unwinding of yarn involved in textile production. Reels are for making skeins while a different sort of device is needed to hold a skein while it is being unwound. Sometimes they are in an umbrella form which can be clamped to a table and made the right circumference to hold a skein. As the yarn is drawn off, it revolves swiftly and so is called a swift. Another form has small barrel-like extensions on the side of an upright, which hold the skein and rotate as the yarn unwinds.

Few old looms have survived in a sufficiently complete form to be useful, but sometimes they can be put into working condition again, and their strength and balance prove a delight to the modern weaver. Before putting too much effort into rehabilitation, the weaver should measure the loom in relation to his own stature, for many are for surprisingly small people. Looms are always equipped with shafts on which the heddles that control the warp threads are placed. The number of shafts, sometimes called harnesses, determines what could be woven on a given loom. Old looms from the French areas had only two shafts for plain weave and the simple hand-patterning techniques. Most from the Maritime Provinces and Ontario had four, on which the characteristic twill blankets and overshot coverlets could be woven. More than this number means that they were for professional work, such as the more complex coverlets which required up to twenty-four shafts. Should anyone discover a loom still equipped with multiple shafts, it would be a rare find, for a loom was usually stripped down to two shafts to finish its career, producing plain carpeting by the end of the 19th century. An even rarer find would be a handloom with jacquard mechanism. The only old one known on the North American continent is at the Ontario Science Centre, Toronto.

Many small pieces of textile equipment can be very attractive. Shuttles are often beautifully made, looking like a little boat and finished to just the right smooth shape to slip easily between the warp threads. The eye at the side is often strengthened with an insert of bone or ebony. Heavier metal-tipped shuttles were used commercially, and also by weavers who had a fly shuttle device on their handlooms. They were mass produced rather than made by local craftsmen.

Other interesting bits of weaving equipment are old handmade reeds, knitted heddles, spools for warping racks and such like. Threading drafts, or patterns for weaving, should be mentioned, especially because of the ease with which they have been dismissed as unimportant in the past, as well as their rarity. Usually on strips of paper, an inch or two wide, they may be twenty or more inches long. The paper has often

Great spinning wheel of birch and maple, from the Eastern Townships of Quebec, c. 1830–50, and inscribed with the name Sabra Anthony. TEXTILES, ROYAL ONTARIO MUSEUM

been salvaged from a former use: old letters, sheets from account books, even wallpaper. They have lines with numbers on them which told the weaver on which shaft to place each warp thread. Sometimes they give a pattern name, and it is from these that we have learned the proper and often picturesque names of some of our Canadian weaving patterns. The weavers marked their progress by moving a pin along the pattern from unit to unit. The more popular a pattern was, the more riddled with pin holes it became, and the less likely it is to have survived. Manuscript weaving books are rare. They only belonged to professional weavers and, as with many a trade secret, were often destroyed at the owner's death if a son was not following in his father's footsteps.

With techniques other than weaving there are many things that can be of interest to the collector. Often a rug hook can be found. Like a very sharp crochet hook with a firm wood or bone handle shaped to fit the palm of the hand, their variety and the ingenuity with which they have been made are surprising. Knitting needles, crochet hooks and sewing equipment were seldom locally made but certainly played an important part in the domestic life of Canada. Blocks to stamp embroidery designs and templates to provide a guide when quilting are sometimes found, and pattern books for 19th-century needlework can provide a fascinating historical study as well as a source of inspiration for the modern craftsman.

BLANKETS

In all areas there were farm women and professional weavers producing uninspired but warm and comfortable yardage for

local use. Even to this day many an early Canadian family will find that an old blanket, still in use, has the tell-tale seam down the center indicating that its origins were many decades ago on a handloom somewhere in the country parts of Canada. Although remnants of this kind have certain romantic appeal, especially if the owner knows that the wool came from the old farm, they have little value for the normal collector. Blankets for purely utilitarian use, and lighter weight winter sheets, may sometimes become very special by the careful arrangement of colors in stripes and checks, either in plain weave or in a simple twill pattern like a "bird's-eye." There are blankets of much more complex weave which were produced on multiple shaft looms by professional weavers particularly in Waterloo County, Ontario. These are in a variety of complex twill techniques with patterns based on diagonal lines, and are usually in bright wools. Some probably were for household use, but it is known that many were for horses; nothing was too good for a fine horse.

CLOTHING MATERIALS

Little remains of the enormous quantity of yardage woven locally in most rural areas for clothing throughout the 19th century. Sometimes a patchwork quilt will turn up made all or partly of these checked and striped woollen materials. They are usually in deplorable condition but good patches can be salvaged from the unsavory remnants and, with careful washing, become an interesting addition to a textile collection. The variety can be a constant source of surprise and pleasure.

CARPETS

In the early days people were concerned with more essential things than covering their floors. As the 19th century progressed and wool became more plentiful much carpeting was woven locally. The earlier type had a closely spaced warp of handspun wool, gaily striped in colors, covering a heavier plain weft of rags or yarn. It must always be remembered that rags were not available until at least a generation after settlement. The household goods that people brought with them were far too precious to reduce to rag strips until they had been mended for the last possible time. The later and more usual type of rag carpeting, with a warp of commercial cotton fairly widely spaced so that the rag weft gave the main color to the production, did not come into being until about the middle of the 19th century, and most of it dates from fifty to sixty years later.

With competition from industry, carpet weaving was the last production allowing sufficient profit for a local handweaver to make a scant living. Most of the old weavers turned to carpet weaving towards the end of the 19th century. Much rag carpeting that remains can in no way be considered antique, even when it looks almost prehistoric after years of hard use. Miles of catalogne carpet of this type, much of it very attractive, have been produced in Quebec right up to the present time.

Good-sized pieces of early commercial carpets can be found. These are usually in a rough wool, often in quite bright colors and with heavily scrolled patterns. A few were made by late hand-jacquard weavers; some come from early mills in this country, but most were imported from Scotland.

LINENS

Before it was possible to gather a flock of sheep for wool, flax

was planted and the fiber processed and linen fabrics woven. As with so many utilitarian things, little has survived to show the excellence of the production. Most of the linens were perfectly plain, saw hard service, and after decades of use went into the scrap bag for rags or bandages. At all periods patterned linens in limited quantities were produced, particularly for tablecloths and towels. They were in simple twills, huckaback, M's & O's, diaper weave (now commonly called Bronson), overshot on a small scale, and occasionally twill diaper. The little that has survived is mostly fragmentary and a collector needs considerable knowledge to recognize the local handwoven varieties from the much more common imports.

COVERLETS

The majority of coverlets were woven in two pieces and joined by a center seam. The width was governed by the reach of a handweaver who threw the shuttle with one hand and caught it at the opposite side with the other. A few were made on wide looms with two people weaving together or with a fly shuttle attachment. The lack of a center seam cannot be taken as infallible proof that the piece is not handwoven. Life and particularly collecting is never as simple as that. Coverlets represent the culture from which they stem. They are found in different versions of the French tradition in Quebec and Acadia and in specialized techniques where people from the American colonies settled in the 18th century. A different tradition occurs in Scottish settlements, and more complex techniques are found only in the German-speaking areas, particularly in Waterloo County, Ontario. Each has a characteristic style of patterning governed by the tradition and training of the weavers.

Acadian coverlets. The traditional loom of the Acadian-French areas of the Maritime Provinces had just two shafts and so was capable only of plain weave. Little that is really old remains from this culture but material of the 19th century sometimes turns up, and for all its simplicity is well worth careful attention. Heavy bedcoverings were made using a cotton warp and woollen rag strips for weft. These have clever color and texture utilizing the scarce supplies of woollen yarn to accent bands of re-used material. They are seamed at the center and, in spite of their similarity to Quebec catalogne, are for bed not floor covering. Another type was the all white *couverture de mariage*, woven of cotton yarn, and rag strips. Worn-out white cotton material was carefully saved over a period of years before a household would have enough to weave one of these special covers which became an essential part of the dowry of an Acadian bride.

Quebec coverlets. The traditional old loom of Quebec had only two shafts and the basic weave was limited to plain cloth. The innate artistry of the women of the province overcame this strict limitation by two methods of hand patterning: *à la planche* and *boutonné*. The *planche* was a thin flat board inserted above and below groups of warp threads and turned on edge to open a special pattern shed. As the process was repeated, small blocks of color could be built up in rows or in simple patterns. *Boutonné* was a purely manual technique, with a pattern weft raised in small loops to form simple motifs.

Contrary to popular opinion, weaving in Quebec only became a domestic occupation in the early years of the 19th century. Home weaving was necessitated by economic condi-

Spinning wheel by François Oullet, and stamped "F.O.," from St-Roche-des-Aulnaies, Quebec, c. 1850-75.

TEXTILES, ROYAL ONTARIO MUSEUM

Quebec spinning wheel, from Kamouraska County, c. 1875-1900. The larger wheel is characteristic of later Quebec wheels, and this piece retains its original yellow paint.

TEXTILES, ROYAL ONTARIO MUSEUM

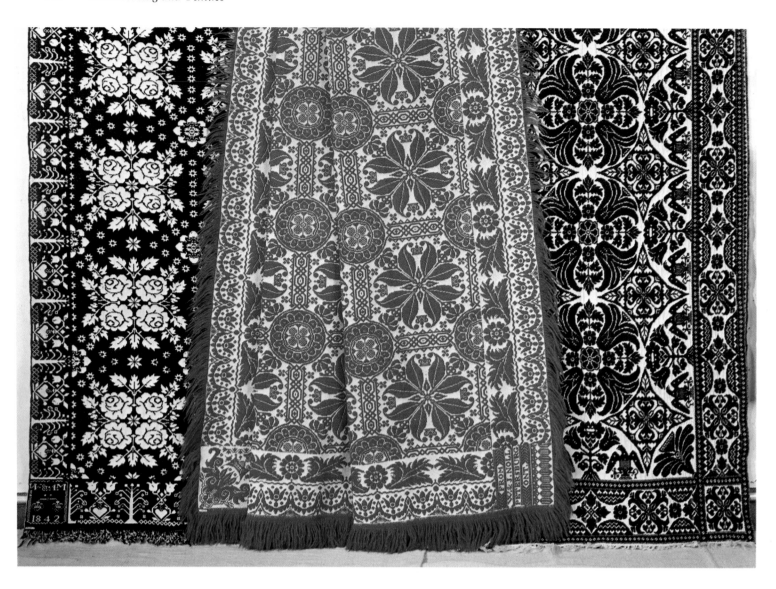

Three Ontario jacquard coverlets done by professional weavers. The white-on-blue coverlet on the left, with a four-roses pattern, was made by Wilhelm Armbrust of Jordan for William and Anne Miller of Niagara-on-the-Lake, and is initialed "W & AM" and dated 1842. The center white-on-red coverlet is marked FROM / W & J. NOLL / PETERSBURG / ONT., *and dates c. 1885–90. On the right is a blue-on-white "Tulip" pattern coverlet, woven by John Campbell of Komoka, c. 1860–80.*

TEXTILES, ROYAL ONTARIO MUSEUM

tions; in earlier days imports from Europe had supplied the household needs. Some surviving old coverlets date from the 19th century and many more from the period of revived interest in crafts in this century. A knowledge of dyes and yarns is essential in dating them, for patterns and techniques remained fairly constant over a long period of time. Overshot coverlets appear in French areas of Quebec, as a borrowing from Scottish neighbors, about the middle of the 19th century. They do not show the expert understanding that Scottish weavers brought to this technique, and they lack the verve that the French women were able to impart to their older ways of patterning which were free of mechanical considerations.

Coverlets in the "Loyalist" tradition. These are derived from techniques employed in the American Colonies before the Revolution. There are two particular types which are found in areas settled at an early date from south of the border. Both are rare today. In "Summer and winter" weave the pattern is fully reversible with light-colored motifs reserved on a blue ground on one face, and blue pattern on a white ground on the other. Traditionally the darker side was used for winter, and the lighter for summer. The rather romantic name has given an appeal out of all proportion to their importance. They are firmly and compactly woven and on the whole are rather dull, lacking the almost three-dimensional quality of the better known overshot ones and the clean

precision of doublecloth. All known examples from Canada would have required a loom with six shafts, and the weaving of them ceased at the latest by 1840. All are the work of the first generation who came from the American colonies; the tradition of "Summer and winter" weave coverlets died with them.

Most doublecloth coverlets are in the same tradition and come mainly from the Niagara Peninsula. There are traces of a Scottish tradition in Glengarry, and of a German-speaking one in Waterloo County, but these are rare occurrences. Double-cloth was extravagant of both yarn and effort but produced most striking coverlets with strong clean-cut geometric designs, almost always in indigo blue wool and white cotton. Two independent layers of cloth were produced simultaneously, and these changed position as required by the pattern. Like "Summer and winter," doublecloth is fully reversible, but as the former consists of one single layer of cloth, and the latter of two independent layers, they are easy to tell apart. They were always used for "best," and have often survived in good condition. Production ceased by 1850, when they were entirely supplanted by the newer jacquard coverlets with realistic patterns.

The Scottish coverlet tradition. Overshot weaving is one of the glories of Scottish tradition in eastern Canada. This technique is found from Cape Breton in the east to the Detroit River in the west, and is the most versatile loom-controlled method of patterning, making it possible to weave striking designs on a simple four-shaft loom. A plain ground, normally white cotton, has an extra weft, usually of contrasting wool, floating on the surface or the reverse forming geometric designs. Rectangles, lozenges, and circular motifs can be combined in endless variety and can be either very small or quite large. With the construction trapping air for insulation, overshot coverlets were surprisingly warm for the amount of never-too-plentiful wool used in them. Patterned in strong indigo blue, less often a bright red, sometimes in these two colors combined, and occasionally with other shades, they were a standard bed covering throughout the rural parts of the country, particularly where there were Scottish weavers to make them. In Ontario, they were woven until about 1900, but in Cape Breton the tradition has only died out recently. All white cotton overshot coverlets were woven about 1840–60 in eastern Ontario, and were local copies of fashionable imported white bedspreads. In the Maritime Provinces a linen pattern weft was used on a white cotton ground between 1820 and 1860 for both bedspreads and tablecloths.

These were all the work of anonymous weavers who carried on their craft with little fame. The traditional names often have a romantic ring, and are a source of interest: Freemason's Felicity, Indian Plains, Indian Review, Wellington's Army in the Field of Battle, Monmouth, Freemason's Coat of Arms, Keep Me Warm One Night, Beauty of the Lake, and many others.

The German tradition. This is a German-speaking rather than a straight German tradition and it concerns mainly two areas of Ontario. Swiss Mennonites came from Pennsylvania following the American Revolution and settled in the Niagara Peninsula and Waterloo County. The Niagara community remained small but those in Waterloo County were joined by many immigrants who started coming from Germany

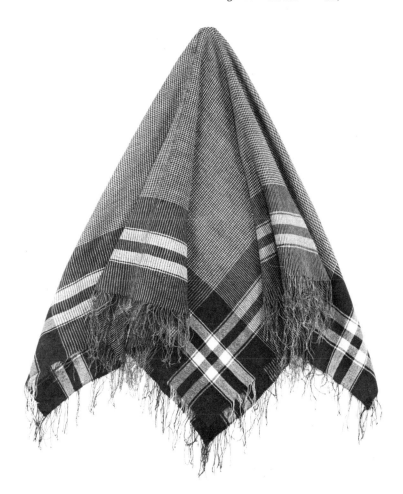

Natural white and indigo blue handwoven wool shawl, Quebec, c. 1810, and an excellent piece of weaving.

TEXTILES, ROYAL ONTARIO MUSEUM

and Alsace in the early 19th century. From here they spread over into the adjoining counties. Many were fully trained weavers, and they used the techniques they had learned in the old country to supply the needs of their neighbors. A training in fine weaving could be adapted to heavier yarns. As elsewhere in Canada, warm bedding was the product in the greatest demand. The weaving done in these areas was almost totally professional and the employment of sixteen- and twenty-shaft looms was usual. The techniques employed were twill diaper, "star and diamond," a variety of fancy twills and occasionally overshot and doublecloth.

Twill diaper makes a coverlet which is durable and not too heavy. The pattern is produced by the contrast of the warp and weft faces of a simple twill, and shows well if strongly contrasting colors are used. The characteristic diagonal of the twill runs in one direction in the field, and in the opposite direction in the pattern. Among the earliest examples are ones made by the well-known weaver, Samuel Fry, one of the very few Mennonites known to have woven professionally. As a boy he was sent to Pennsylvania to learn his trade. He set up in business near Vineland in the Niagara Peninsula in 1836 and continued weaving until about 1880.

"Star and diamond" coverlets are easy to recognize because the patterns vary little and are based on rows of eight-pointed stars with diamonds between them. They occur mainly in Waterloo County and mostly date from the second half of the 19th century.

The professional weavers of Waterloo County did a good business in specially woven fancy twill horse blankets. Judging from the number left in existence they must have been very popular over a considerable length of time, probably from about 1840 until the early part of this century.

Some doublecloth coverlets were made in the German-speaking areas and the patterns differ little from those used by the weavers of "Loyalist" or Scottish origin.

Jacquard coverlets. The jacquard mechanism could be mounted over any stout handloom. It had been perfected in Lyon, France, in 1806 by Charles-Marie Jacquard to simplify the weaving of fine patterned silks and later adapted for coarser work. The earliest example to reach North America was brought by William Horstmann to Philadelphia in 1823. The first in Canada was set up by Wilhelm Armbrust, near Jordan, in Lincoln County, Ontario, in 1834. Coverlets hand-woven on looms fitted with this mechanism, with their comparatively naturalistic patterns were exceedingly popular during the middle to latter part of the 19th century. In Canada, they were only made in Ontario, and mainly in two areas, the Niagara Peninsula and Waterloo County. There is no evidence of their manufacture in any other province. The period of production dates from 1834 until about 1918, and although thousands were woven it seems unlikely that in that extended period there were more than thirty hand jacquard weavers altogether. This is rather intriguing as it is often possible to identify the weaver of a specific coverlet, and deeper research in archives and local memories should clear up many of the remaining problems.

Wilhelm Armbrust was born in Germany and probably trained there. He wove in Lincoln County between 1834 and 1848. He had several patterns and a number of versions of each of them; his most popular had a group of four roses. His customers always seem to have chosen this for a bridal coverlet. After about 1838 he marked these not only with the name of the customer and the date but with a distinctive mark showing two hearts hanging from a balance. His other designs at this period were usually distinguished by a single heart hanging between two pillars.

Patterns fairly similar to Armbrust's were woven between 1835 and 1850 in Welland County by a weaver whose name has not yet been discovered. He also used a version of the four roses pattern and had another popular design with four lily-like flowers. His distinctive trademark was a heart lying on its side, sometimes with a small star beside it; sometimes it was the star alone. Unfortunately he did not always use his mark and work has often to be attributed to him on stylistic and technical grounds.

When Armbrust went out of business in 1848 his loom was undoubtedly bought by another weaver and it seems likely that this was Edward Graf of Gasline, near Port Colborne. There are lovely coverlets, some marked with a heart between two stars which he probably produced on this narrow loom. About 1868 he purchased a wide loom and started the almost mass production of the patterns for which he is best known.

During the years when these men were weaving there were some coverlets produced which do not seem to fit with the work of any of them. There were probably a couple of other jacquard weavers active in the Welland area for a short period around the middle of the 19th century. One of them marked his work with a strange little device like a diamond

with a forked tail on it.

Moses Grobb of Lincoln County wove utilitarian things such as carpeting and yardage and in 1853 acquired a jacquard loom. His work usually shows the date enclosed in a box in the corner cartouche. He wove a version of the ever popular four roses as well as other designs including a distinctive one with a basket of flowers.

All these men used two main constructions: free and tied doublecloth. In free doublecloth two layers of cloth, usually one cotton and one wool, change places at the outlines of the design, and in other areas are completely free of each other. Tied doublecloth is also made of two layers but these link together at intervals throughout the weaving. The way in which the linking is done can be an excellent clue to the identity of the weaver.

The early jacquard weavers drew their own designs often using elements they knew from earlier American coverlets. It took artistic ability to lay out a pleasing pattern and considerable mechanical skill to cut the jacquard cards and bring the design into actual being. These were still a strictly individual production with the customer spinning and dyeing the woollen yarns, picking the pattern from those the weaver had to offer and specifying the name and date in the corner. Each coverlet or sometimes pair of coverlets was woven specially to order.

At the start of his career Edward Graf of Gasline also operated in this way, but as the 19th century progressed it became harder and harder in the face of industrialization to make a living out of custom weaving. In 1868 Graf acquired a double-width loom and from then on his customers did not have their names woven into the corners; the cards were cut and the patterns set until those cards wore out. His characteristic coverlets, of which he wove thousands with the help of his son Albert, have the name of the pattern facing four different ways in the corners: Double Rose, Bird's Nest, Morning Glory, Bird of Paradise, Flower Pot and Cherubim. These were carried by peddlers and turn up from surprisingly far away.

Waterloo County was the other main area where jacquard coverlets were woven and, at the start, production there was also on an individual basis. The first jacquard weaver known to have worked in that area was Aaron Zelner. He came to Canada from Pennsylvania about 1845 and worked for some years in South Cayuga before moving on to Waterloo County. He put his own name as well as the customer's on his coverlets. About 1868 he stopped weaving and probably his loom passed on to John Noll of Petersburg. At first the patterns were Zelner's but as time went on Noll produced quite a variety of new and original ones. The coverlets often show the customer's name and the date of manufacture; sometimes Petersburg and the makers are shown as J. Noll & brothers, William and

At left is a twill-diaper horse blanket, of a type especially popular in Germanic areas of Ontario. This piece is red on olive green, from Waterloo County, Ontario, c. 1850–60. In the center, full width, is a blue-on-white doublecloth coverlet woven by Samuel Fry of Vineland, Ontario, c. 1840. On the right is a pointed-twill Waterloo County horse blanket, in blue and red on white, initialed "E.M." and dated 1844.

TEXTILES, ROYAL ONTARIO MUSEUM

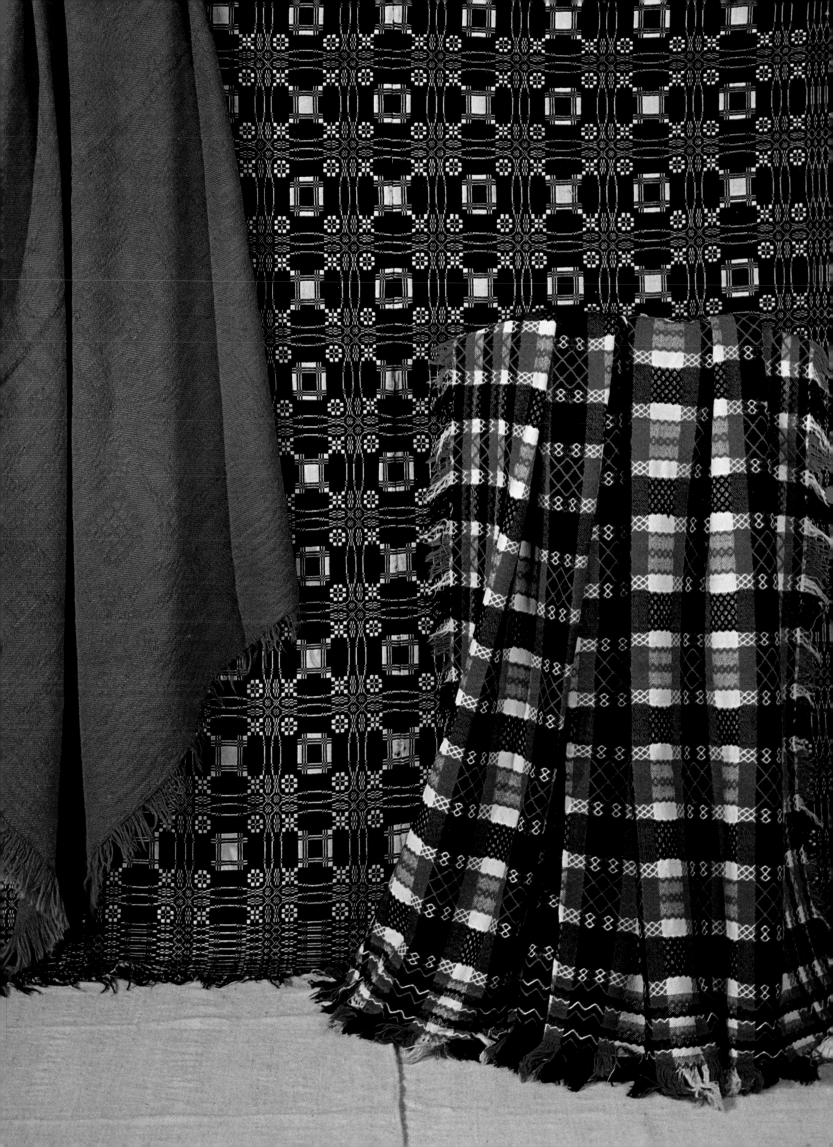

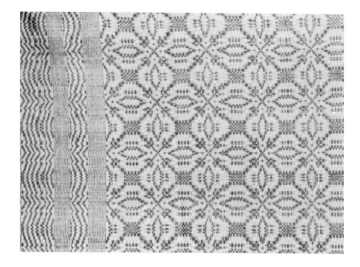

A rare type of overshot coverlet, with a natural linen pattern on a white cotton ground, from Pictou County, Nova Scotia, c. 1850–60. TEXTILES, ROYAL ONTARIO MUSEUM

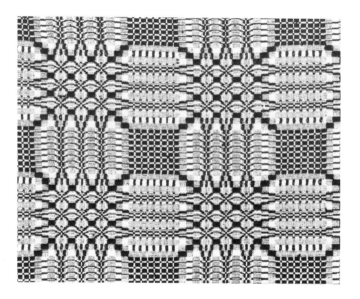

Overshot coverlet of indigo blue wool on natural white cotton, in a very popular pattern, from Lincoln County, Ontario, c. 1860–75.
TEXTILES, ROYAL ONTARIO MUSEUM

John Noll or W. & J. Noll. John Noll was responsible for the designing and production of all the jacquard coverlets that came from the partnership. William specialized in weaving on a multiple-shaft loom. Even though John Noll went on making coverlets until he died in 1905 and although many of them were produced for general sale, there remains a personal contact with the craftsman in these coverlets which is totally lacking in most of the other productions of Waterloo County.

In the same small village of Petersburg there were two other weavers, Johan Lippert and his son. About the year 1870 they started to weave fancy coverlets along with the simpler things they had been doing before. They were not originators of patterns but bought a wide loom with four ready-made sets of cards from the United States and set up in business. Two well-trained weavers who lived in Preston, Wilhelm Magnus Werlich and August Ploethner, did likewise. They had been professional weavers before they came to Canada from Germany and after they settled in Preston made all sorts of household goods. At the time of the Civil War fancy coverlet weaving practically ceased in the United States; looms with sets of pattern cards became available and were bought by a number of weavers resident in Waterloo County and adjacent areas. The patterns are on the whole heavy and florid, some of them very striking, and the colors fit the taste for strong designs that prevailed in the latter part of the 19th century. Many have eagles and other motifs suitable to their first incarnation south of the border. As there is no original creation in the work it is only through family histories and by technical considerations that the work of one man can be distinguished from that of others. These coverlets have long appealed greatly to collectors of Canadiana.

There were a few weavers of importance in other areas. Because his account book has survived, we know a lot about John Campbell, Scottish by birth and training, who worked at

Jacquard coverlet of indigo blue wool and white cotton in the "four lilies" pattern, by an unknown professional weaver. From Welland County, Ontario, the coverlet has the original owner's name, Jane Smith, woven in, and is dated 1842.
▽ TEXTILES, ROYAL ONTARIO MUSEUM

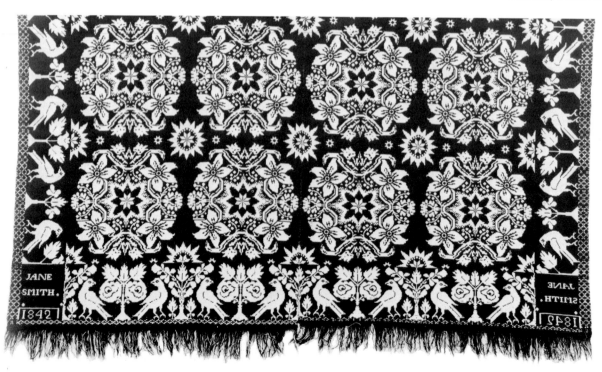

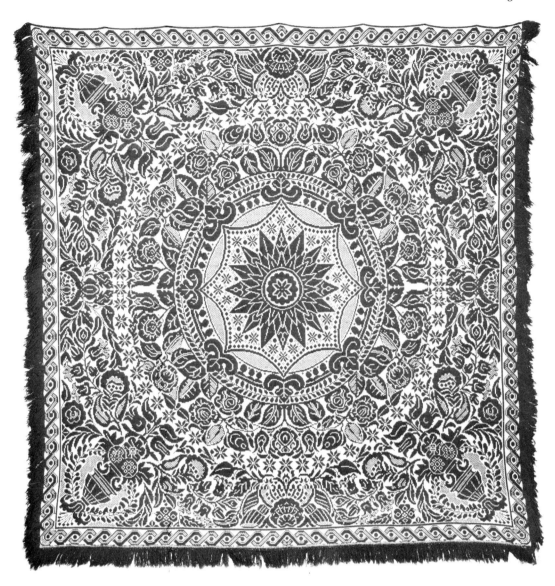

Red wool and white cotton jacquard coverlet, woven by August Ploethner of Preston, Ontario, c. 1875–90.

TEXTILES, ROYAL ONTARIO MUSEUM

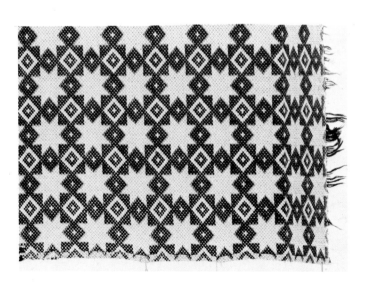

Star and Diamond coverlet, of indigo blue wool on natural white cotton, from Waterloo County, Ontario, c. 1850–75.

TEXTILES, ROYAL ONTARIO MUSEUM

Blue on white overshot coverlet in what was known in eastern Ontario as a Turkey Tracks pattern. This coverlet is from Wingham, Huron County, c. 1850–75.

TEXTILES, ROYAL ONTARIO MUSEUM

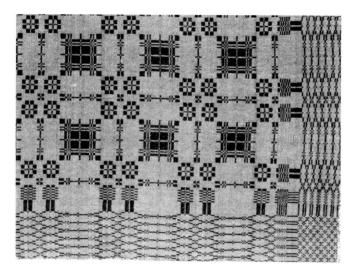

Mid-19th-century twill diaper coverlet, of dark green wool on natural white cotton, by the professional weaver Samuel Fry of Vineland, Ontario. PRIVATE COLLECTION

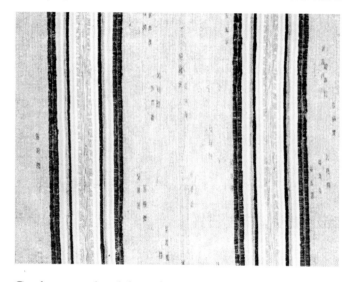

Catalogne coverlet of the mid-19th century, made from strips of blanketing and colored yarns, from Cheticamp, Cape Breton Island. TEXTILES, ROYAL ONTARIO MUSEUM

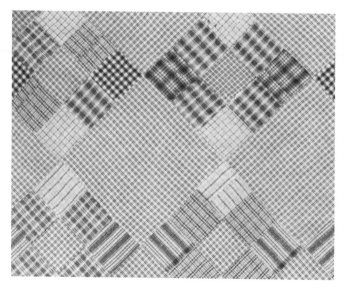

Heavy pieced quilt of a wide range of homespun wool materials in reds and blues, from Wellington County, Ontario, c. 1875–85.
TEXTILES, ROYAL ONTARIO MUSEUM

Komoka near London, Ontario. This book and his looms are preserved at the Ontario Science Centre. He had a shaft loom on which he produced overshot coverlets, thousands of yards of carpeting, clothing materials and blankets and a loom with a jacquard attachment for weaving fancy coverlets. His account book shows that during the twenty-six years after he came to Canada in 1859 he filled orders for almost a thousand jacquard coverlets as well as his more utilitarian work. The customer usually provided the yarns and he charged $2.50 for weaving a coverlet with an extra charge for putting the name of the owner into the border. Campbell had four patterns: a version of the old favorite four roses called Rose and Stars, Single Rose which had large lobed medallions, Garland which has great circular motifs, and Tulip.

A single weaver's workshop that had a large output was in Stouffville just north of Toronto. William Withers came from Scotland about 1850. He was probably a carpet weaver in the south of Scotland as his patterns show influence from contemporary carpet design. His most distinctive design was made to appeal to the mixed backgrounds of his Canadian customers with maple leaves, thistles and shamrocks added to the ever popular four roses. He died sometime between 1861 and 1871 but the business and the patterns were continued by Christopher Armstrong who went on working until 1910.

In Whitby Township, east of Toronto, another and quite distinctive type of jacquard coverlet was produced by a weaver who has not yet been identified. They are in damask weave and the designs are similar to table linens contemporary with their production. The man appears to have been active from about 1850 to 1880. There is one professional weaver shown in the census returns for the area where they turn up: John Gibson from Ireland. He may well be the maker of these strange coverlets as whoever did them must have been trained as a weaver of linen damask, which fits with his Irish origin. Like other professional weavers he would have adapted an old-country training in fine weaving to the great Canadian need for warm bedding. If he was the weaver it means that to the French, Scottish and German traditions that shaped the development of Canadian weaving we can add a dash of Irish.

QUILTS

Quilts were a generally used ornamental bed covering. They could be made anywhere with any scraps of material. No loom was necessary and no special training other than the ability to sew. Quilting is an ancient and almost world-wide technique to produce a warm covering from materials that have no warmth of their own. Two light layers, with a padding of wool or cotton fibers between them, are joined together by sewing. There are two basic types of quilted bed covers in Canada, pieced ones, sometimes called patchwork, and the rarer and more sophisticated appliquéd type.

Pieced quilts were born of the necessity to make use of every scrap of material in a not too affluent society. Any left-overs, particularly of cotton, were used and often a great variety will be found in one quilt. It is a modern idea to buy material specially for a quilt and then deliberately cut it into little pieces. There was always a desire for decoration and with a little trouble a purely utilitarian object could be made attractive. The scraps were cut into simple shapes, sometimes pieced, and then fitted together with the colors carefully

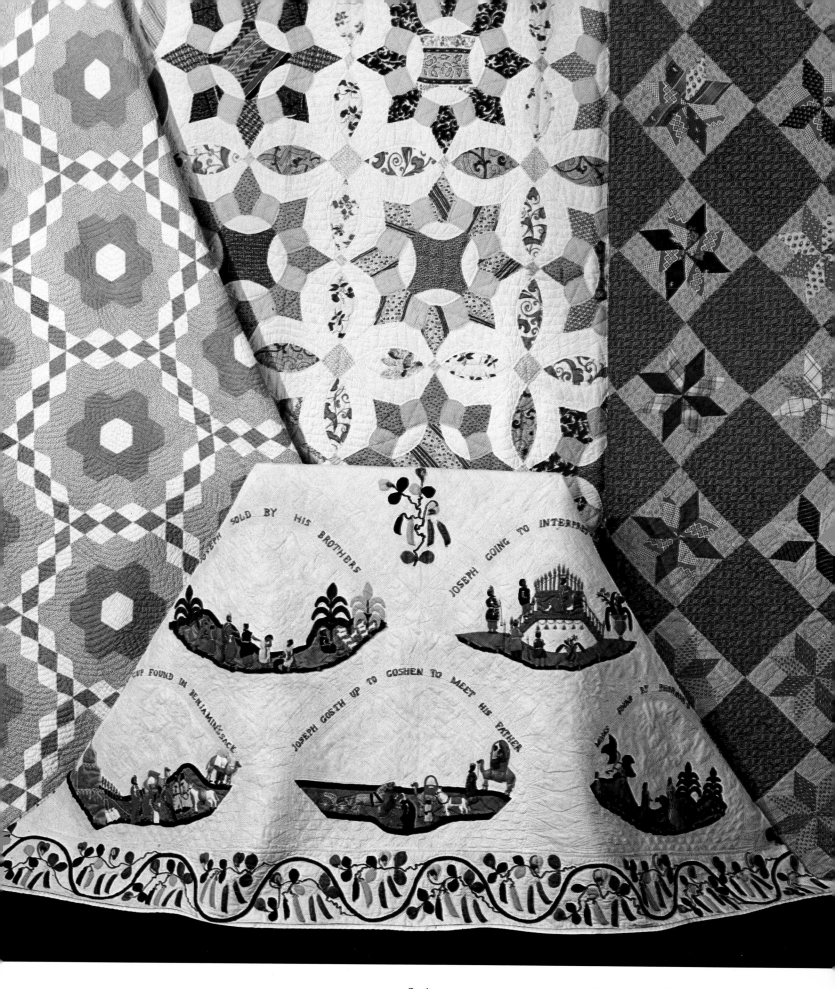

Quilts occur in a great multiplicity of patterns, and some early examples such as these late 19th-century Ontario types, were extremely elaborate. Unlike woven coverlets and blankets, quilts are still being made in parts of Quebec, Nova Scotia, and in Waterloo County, Ontario. TEXTILES, ROYAL ONTARIO MUSEUM

Ontario pieced quilt, in pink and dull purple printed and plain cotton, from Peel County, c. 1850–60.

TEXTILES, ROYAL ONTARIO MUSEUM

distributed to form a harmonious whole. There are many traditional designs and types. Ones made from tiny octagons assembled in concentric arrangements are among the most striking. "Friendship" quilts were supposed to have every patch provided by a friend and all different. The most difficult to make were with curved pieces fitting exactly the opposite curve on the adjoining patch. Dating is difficult and depends on a knowledge of the imported cottons. Fine hand sewing usually indicates a fairly early date but is not by any means infallible. Sewing machines came into more general use as the century wore on, and might be used to put on an edging or to join the backing even when the rest of the work was carefully done by hand. While a bride's trousseau required many pieced quilts it usually had only one appliquéd one. As they were for "best," quite a few have survived. They are charming with their bold flowers and stars and baskets. Those made by folding the material before cutting, so that complex designs radiate in sections from a central point, are particularly stunning.

Sewing on all quilt faces was usually done in squares that were easy to handle, and then these were put together. When a girl became engaged there were bees to quilt the faces that she had prepared over the years.

Two special forms became very popular towards the end of the 19th century. Log Cabin quilts were made from narrow strips of material sewn together into squares interlocking at the corners. Often the shades of color were carefully graded to give a three dimensional effect. The survival of old material happens by all sorts of strange chances but many pieced quilts of fine silk survived because they were just too good to use. It became a popular hobby about 1885 to make "crazy" quilts of irregularly shaped pieces of fine silks, satins and velvets. These were often further embellished with embroidery. By the time they had been backed with plush velvet or heavy satin they weighed a lot and were practically useless. They were highly valued and carefully put away.

EMBROIDERY AND FINE SEWING

In the early days there was little that was purely decorative, but utilitarian things were often ornamented to add a little grace to living. There was beautiful sewing particularly on undergarments and baby clothes. Occasionally a piece such as a spatter cloth to hang at the back of a washstand, a finely embroidered collar, or ornamental initials on household linens will turn up with a Canadian history. These were part of the general needlework tradition which was common to Great Britain and North America. As elsewhere samplers were much used as a means of teaching. These differ little from those made in England but sometimes have the name of a Canadian town. Similar stitches to those used on samplers were put on the show towels which were part of every Mennonite household. Later in the 19th century, when women had more time to spare, there was a great surge of ornamental work of all kinds: embroidered pictures, wool work for cushions and stools and bedroom slippers, beaded and embroidered valances for clock shelves, fire screens, bell pulls, small boxes and all sorts of useless things. All of these are part of the large picture of Victorian needlework, the influence of which was spread widely through pattern books and periodicals.

The same books brought patterns for other techniques. Fancy white cotton bedspreads were popular in knitting or crochet, and open-work knitting was used for fancy stockings and for edgings on household linens. Purses were knitted with colored beads dropped into place as the work progressed to form a pattern. Netting was a popular pastime and was used for purses and gloves and sometimes for collars. Macramé, finely and firmly done, made bags and particularly ornamental valances for shelves and skirts for small tables. It was an era when nothing was left unornamented. Canadian women were just as good at these useless arts as others, but there is nothing peculiarly Canadian about these productions.

THE CARE OF OLD TEXTILES

A word of warning for the owner or collector: textiles age fairly rapidly. Sometimes if a coverlet has been put away unused it will appear to be just as it was when it came from the loom but even if it does not show the years they will have taken their toll on the vitality of the fibers. If an owner wishes to enjoy a prized item, not just to fold it away in a cupboard, it should not be given hard use and particularly it should not be put on a sofa. Old coverlets or quilts can be used as the best possible of best bedspreads or, safer still, be hung on the wall. They make a perfectly stunning decoration used in this way.

Dirt accelerates deterioration and old fabrics should be made as clean as possible but the cleaning must be done carefully and gently. Never wash an old fabric by machine. Too

Sampler of colored cotton on homespun linen, by Catherine Grahame (age 13) of Halifax, Nova Scotia, April 2, 1832 (or '52). Named, placed, and dated samplers are most uncommon.

CANADIANA, ROYAL ONTARIO MUSEUM

much good old material has already been damaged beyond repair by this kind of rough treatment. Bedding was made to be washed and, although heavy to handle, can be done quite easily in a bathtub, by hand, using neutral detergent and water of the same temperature that would be used for bathing a baby. Old fabrics should not be hung on a clothes line because when wet their own weight is too great for their strength. They should be laid carefully on clean grass and, if white cotton in them has become discolored, almost a miracle will occur as it whitens up again in the sunshine. When fairly dry, another gentle rinse should be given to carry off the remnants of discoloration and the drying can be finished in the shade. Old dyes are amazingly resistant to fading but a careful watch must be kept and if in doubt the piece should be dried in the shade.

White work of cotton and linen is safe to wash, but it is not recommended that an amateur touch any colored embroidery. Samplers and embroidered pictures are particularly treacherous for many of the colors are not fast. If an owner is in doubt, consult a conservation expert, and if that is not possible, find a dry cleaner who is prepared to give the material individual care.

Collectors should work at gaining knowledge about their collections, not just at gathering them, and book study can be supplemented by seeing as many actual examples as possible. In older parts of the country there are museums with material of the type described above and at various pioneer villages household weaving can be seen in its proper setting. The Textile Department of the Royal Ontario Museum in Toronto has a superb collection of all aspects of the subject and there is always some of it on exhibition, with the rest available to the serious student by appointment.

Prints
and
Early Illustrations

Mary Allodi

Early prints of Canada tell the story of the country as it was seen by explorers and soldiers, settlers and visitors. With a few strokes of brush and pencil, graver and inks, these artists have captured a physical aspect of history which columns of type could not convey. And because the print is, by definition, one of a number of exact duplicates, it remains one of the most collectible items of Canadiana.

Canadian prints are judged first for their subject matter, and only secondly for their artistic merit. For instance, the earliest print of Quebec, crude though it may be by artistic standards, has the unique historical importance of being Champlain's own view of the residence built there in 1608. If a print is both historically valid and technically accomplished, so much the better. But if it is a much later reconstruction of an event which the artist never saw, attractive though it may be, the print will be of little account to the informed collector of Canadiana, except perhaps as evidence of continuing interest in the subject.

TECHNIQUES

We are so accustomed to seeing printed pictures in newspapers, books, magazines, that it is hard to imagine a time when this form of visual information did not exist. The printing of pictures began in Europe about 1400 A.D. and, as techniques slowly evolved, woodcuts and engravings were used to embellish costly printed books or to decorate the cabinets of the wealthy. Great artists such as Dürer and Rembrandt made their own prints, which were—and are—collected as works of art. In the 18th century the printed picture was used more widely as a source of information, and technical illustrations contributed to the advancement of knowledge in the arts and sciences. By the 19th century a series of inventions had refashioned print-making into a mechanized industry. Among the advances were the invention of wood engraving in 1780 and of lithography in 1798, both of which were better suited to reproducing precise and detailed images in quantity. Paper-making machines run by water or steam power after 1798 made a wove paper which was finer and larger than before; and the steam-powered printing press of 1815 could produce 16,000 sheets a day, compared with 1,000 sheets a day on the old hand-presses. During the 19th century more prints were published than had been seen during the entire history of print-making up till then. This brief outline will explain why there are so few prints depicting Canada as it was while ruled by the French Crown, that is before 1759; and why there exists such a relatively small number of views of before 1800, compared with the flood of visual information that came off the presses throughout the 19th century.

The earliest prints of quality to depict Canada were **line engravings**. In this method the design is cut into a copper plate with a sharp instrument. The plate is then inked and wiped so that the ink remains only in the V-shaped furrows. The dampened paper is then forced against the furrows under pressure, so that in the resulting impression the engraved line stands up microscopically on the paper. As copper is fairly soft, the engraved lines tend to wear down and finally disappear after about 200 impressions are taken. In 1822 a method of facing copper plates with steel was invented, a process which enabled editions of anywhere from 500 to 1000 impressions to be printed.

The **mezzotint** is a method of tone-engraving in which the entire surface of the copper plate is roughened with a sharp-toothed wheel so that the copper stands up in prickles. The subject is formed by scraping away the "burr" and burnishing the plate in some areas so that it will not hold the ink and will thus print lighter tones. This method is well adapted to reproducing the rich gradations of oil paintings. In **stipple engraving** the copper plate is pricked with a series of dots organized to convey the subject to be engraved.

In **etching** the metal plate is coated with a material which resists acid, and the design is drawn into this coating with a sharp needle, thus exposing the metal in the drawn areas. The plate is then put into an acid bath and the exposed metal is etched or eaten away into furrows. The ground is

The Entrance of Louisbourg Harbour on the Island of Cape Breton

Aquatint of The Entrance of Louisbourg Harbour on the Island of Cape Breton, *a plate from the three-volume coastal guide* The Atlantic Neptune. The Atlantic Neptune *was compiled by J. F. W. Des Barres (1722–1824) and published in several versions between 1770 and 1781.*

CANADIANA, ROYAL ONTARIO MUSEUM

then removed, and the plate is inked, wiped and printed as in engraving. The resulting line is finer than the engraved line. This method is often used in conjunction with other forms of engraving.

The **aquatint** appears in the history of engraving as a link between the mezzotint and lithography, that is roughly between the 1780s and the 1830s. The copper plate is dusted with rosin which resists acid. When the plate is etched, these specks of rosin become tiny peaks of metal because the acid has eroded the spaces between them. The etched plate has a sandpaper texture which catches ink in a continuous scattering, with shallow acid bites printing the lighter areas, and deeper bites conveying the darker shades. It is a method of etching to convey toned areas rather than linear designs, and was used to reproduce watercolor paintings.

From about 1820 until 1860 **lithography** was extensively used to produce prints for books of views and for large editions of single-sheet prints. The image is drawn on fine limestone with a greasy crayon, and the stone is dampened, inked and placed on the press. The greased areas hold the ink and repel water, so that what was drawn in crayon is reproduced. In color lithography, separate stones are used for each color to build up a multicolored picture. Earlier color lithographs usually used only two stones, one for a background color and another for the image. In the later 19th century, lithographs were transferred to zinc plates and printed from inked rollers in very large editions.

The **woodcut**, the oldest of relief-printing processes, is a technique in which small knives cut away the wood between drawn lines, so that the drawing made on the smooth surface of the wood stands out and, when coated with ink, prints the reproduction of the pen line. This method of printing was displaced by engraving in the 17th century and hardly applies to Canadian subjects. However, **wood engraving** was used extensively for illustrated newspapers and magazines from the 1840s until superseded by photo-mechanical methods of printing. The technique is similar to that of the woodcut, except that the end grain of the wood is cut with a graver, permitting finer work on a very hard surface. Anyone who has seen a 19th-century *Canadian Illustrated News* print is acquainted with this type of engraving.

Photo-mechanical methods of reproduction were used as halftone prints in New York's *The Daily Graphic* during 1880. Between 1880 and 1905 various methods of photogravure were perfected, and older hand-cut techniques, having been displaced in the commercial world, once again became "fine art." The "screen" of dots used in photographic prints can readily be seen with a magnifying glass.

WHAT TO LOOK FOR
WHEN EXAMINING PRINTS

Most prints are lettered within the plate-line and below the subject with the names of artist, printer and publisher, as well as the title of the subject pictured. The artist's name is often

Wood engraving of the Habitation at Port Royal, as an illustration in Samuel de Champlain's Voyages . . . et Descouvertes . . . 1615-18, Paris, 1619. This view is from the 1632 edition.

CANADIANA, ROYAL ONTARIO MUSEUM

A View of the Landing of the New England Forces in yᵉ Expedition against Cape Breton, 1745. Engraved by Brooks after a drawing by J. Stevens, and published by R. Wilkinson, London. This was the landing by the Pepperell forces, supported by the British Navy, that resulted in the first capture of Louisbourg.

CANADIANA, ROYAL ONTARIO MUSEUM

A View of the Inside of the Jesuits Church. Vue de l'Interieur de l'Eglise des Jesuites.
Drawn on the SPOT by Richard Short. Engraved by Anthony Walker.

Richard Short made a number of drawings after the siege and capture of Quebec in 1759. A View of the Inside of the Jesuits' Church *(Quebec, 1759), was published by Short and sold by Thomas Jefferys, London, in 1761.*

CANADIANA, ROYAL ONTARIO MUSEUM

followed by the word *pinxit* (he painted it) or *delineavit* (he drew it); the engraver's name is followed by *sculpsit* (he engraved it) or *fecit* (he made it), or abbreviations of these Latin words. The date on which the print was issued is often included in the line below the title that gives the publisher's name and address.

A **proof before letters** is a print which is put through the press before the lettering is added to the plate. Such proofs are generally regarded as desirable because they are sharp impressions (the plate has not yet had any wear), and rare. However, the distinction between a proof *before* and a *proof after letters* is not very important in the field of Canadiana, because most Canadian subjects were printed when techniques had been improved, and were from relatively long-wearing plates or stones. **Masked proofs** are made by placing a strip of paper across the inscription before it is passed through the press; the letters can be seen as faint impressions.

The **plate mark** is the indentation that surrounds the impression at a short distance from the subject and indicates the boundaries of the sheet of metal from which the subject was printed. Book illustrations were often cut down to an area within this plate mark to fit the size of the volume. Lithographs have no plate mark because they are printed from the flat surface of a stone.

A *state* indicates various changes made in the plate after its first publication. These changes include variations of lettering as well as corrections made to the subject itself. The collecting of various states of one print applies to old-master prints rather than to Canadiana. However, the changing lettering on some much-printed and re-issued Canadian subjects, such as the steel engravings after W. H. Bartlett, can help the collector determine the date of printing.

The physical *condition* of the print is important to the collector, since a torn, yellowed or stained print is not as attractive as a brilliant and whole example of the same subject. Margins are desirable, but to pay a great deal more for a wide margin is stretching the point. There should be enough of a margin outside the plate line (or outside the lettered information in the case of a lithograph) to enable handling of the print without touching the printed surface.

When buying a print, examine it unframed and by good daylight with a magnifying glass. Hold the print to the light to see watermarks (if any) and also to see if old repairs will show up. Compare it with another impression in a public collection; or study a series of impressions in the area you collect, to train your eye in the matter of quality of impression, before venturing into the market. Buy a print for its own qualities and not merely because it is described as rare.

Print values. In general the prices of Canadian prints are related to their availability, so that the earlier copperplate engravings, which were issued in smaller editions, are rarer and more expensive than the mass-produced prints of the later 19th

century. Historic importance always counts in this field, and a "first" on any subject will be more valuable than a later account of the same story. Fashion in collecting has always affected the market; for instance, the very fine mezzotint portraits of the 18th and early 19th centuries were much sought after until about twenty-five years ago, but have fallen in price because few collectors today want to look at pictures of monarchs and generals, or anyone else related to Canada's colonial past. The best way to determine price range is to follow dealers' price catalogues and auction records. Within the last five years Canadian subjects have sold for as high as $2,300 and as low as $3 per print.

The collector who concentrates on one topic will be able to go into some of the fine points of connoisseurship in more depth, and will, by the way, end up with a more interesting and valuable collection.

Looking after your prints. Once you have acquired carefully chosen prints which are in reasonably good condition, you should endeavor to keep them in that state. Ideally, they should be backed by, and matted with, acid-free card (such as pure rag-board), to prevent staining of the paper and to keep the surface of the prints from touching the glass if they are to be framed. When hinging the print to a backing use a tape which has a water-soluble glue. You can make your own paste out of flour and water, and your hinges from fine rag paper or Japanese rice paper. Never use the plasticized types of sticky tape or masking tape; they stain prints permanently, and often cannot be removed without tearing the paper. The least mount-

Aquatint, A View of Brockville, Upper Canada, from Umbrella Island, by J. Ryall after a drawing by James Gray, published by Willett and Blandford, London, 1828.

CANADIANA, ROYAL ONTARIO MUSEUM

ing tape necessary should contact the print. Do not hang your prints where direct sunlight will shine on them, as it yellows the paper very quickly. If the print requires any extensive restoration, ask for professional advice before trying any home remedies.

CITIES AND LANDSCAPES

Most prints of Canadian subjects fall into the landscape or "cityscape" category, and these views follow the patterns of settlement chronologically starting with Quebec and the Atlantic seaboard in the mid-18th century, moving westward to what is now Ontario by the 1780s, and as far as the Red River (Manitoba) by 1824. There are relatively few prints of the prairie provinces because, by the time the railway had opened this territory to settlement, photography had taken over the field of illustration. The west coast was recorded by early explorers, but its cities do not appear on prints until after 1860.

The earliest prints to show settlements are map vignettes and book illustrations. For example, a view of the Indian village of Hochelaga decorated Ramusio's map of 1556, and Champlain's illustration of the residence at Quebec is a book plate in his *Voyages* of 1613. These "firsts" are so rare that they are virtually beyond reach of the collector.

The East View of the City of Montreal

SIR ROBERT SHORE MILNES Bart. LIEUT GOVR.

Aquatint of The East View of the City of Montreal, *a very choice early landscape engraved and etched by S. Alken from a drawing by Richard Dillon. This print was published in London, England, March 1st, 1803.*

CANADIANA, ROYAL ONTARIO MUSEUM

The first great sets of Canadian landscapes to be published as single-sheet prints were the work of English officers who served in America during the Seven Years' War. Their drawings were engraved in England between 1760 and 1777, and form the base of any historic collection of Canadian landscape views. The Canadian views by artist-soldiers Smyth, Patten, Ince and Davies were combined with views of the Thirteen Colonies to form the set of twenty-eight prints known as the *Scenographia Americana*; and artist Richard Short published his own city views.

The largest group of early landscape prints is contained in *The Atlantic Neptune*, a 4- or 5-volume atlas of the eastern seaboard which contains 182 charts and aquatint views. This immense work was undertaken by J. F. W. Des Barres for the British Admiralty, and was published between 1771 and 1781. There are nine Canadian views, each of which occupies a single atlas folio sheet, and at least ninety-one smaller coastline profiles which are inset onto charts or grouped in sets of three to five per page. Separate prints from this set do turn up, since they were only bound on demand.

The aquatint views which were published from the 1780s until the 1830s are probably the most attractive of all Canadian landscape prints. The artists (again British officers) painted in watercolor and the craftsmen who translated their work into aquatint engravings were among the finest printmakers in England. The aquatints were printed in monochrome shades of sepia (or sometimes a blue-green) and were often watercolored by hand at time of issue. If the coloring is delicate, it is a pleasing addition; but harsh coloring spoils the effect of these tonal prints. Among the most striking examples are the *Six Views of North America*, painted by Sir George Bulteel Fisher and engraved by J. W. Edy, which were issued in 1795 and 1796 in large folio size with descriptions. Fisher chose to depict "bold and romantic views" of the rivers and waterfalls in the vicinity of Quebec. Other fine examples are the 1784 to 1786 Quebec views by surveyor James Peachey, the 1801 Halifax views by G. I. Parkyns, and Ralph Stennett's description of Saint John, New Brunswick, 1815. These early views rendered a softened, romantic view of the New World. By 1828, when the Gray and Gleadah set of seven city views was published, the centers shown were linked by waterways and had built up a trading population. These pictures of Quebec, Montreal, Kingston, Brockville, York and Niagara are more solid in form, and there is a certain businesslike air about the well-dressed citizens and the ever-present steamboats blowing little puffs of smoke.

With the opening of communications by means of roads and canals, the land companies moved into the business of building new towns and settling them. Moreover, the new

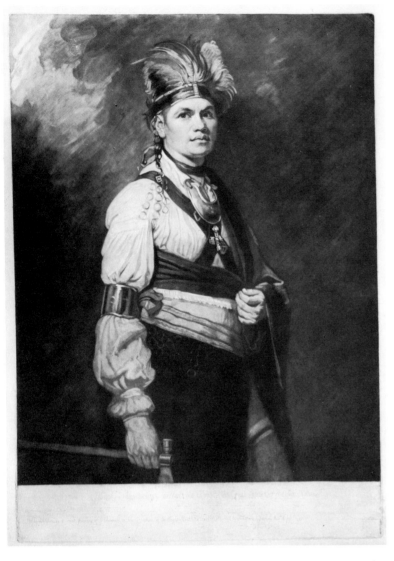

Mezzotint portrait after the painting by George Romney: Joseph Tayadaneega Called the Brant, the Great Captain of the Six Nations; *engraved by J. R. Smith and published in London in 1779.* CANADIANA, ROYAL ONTARIO MUSEUM

printing method of lithography was able to spread the word and picture, inexpensively and in quantity. In 1836 the *Nova Scotia and New Brunswick Land Company* advertised the founding of Stanley, N.B. with a set of twelve lithographs; and the *British American Land-Company* used seven sketches by R. S. M. Bouchette and others to embellish its pamphlet on the Eastern Townships of Quebec. Architects capitalized on the general feeling of civic pride by issuing views of the latest buildings, and prints in this area range from fine etchings to humble trade-cards. Among the earliest etchings to be executed in Canada are architect John Elliott Woolford's perspective views and elevations of Province Building and Government House in Halifax, published in 1819. Architect Thomas Young's four views of Toronto were among the first lithographs to be issued by Nathaniel Currier of New York, several years before he joined in partnership with Ives. English architect W. R. Best drew eleven views of buildings in St. Johns, Newfoundland, which were published as lithographs between 1851 and 1860; and in 1867 and 1868 several prints celebrated the opening of the new Houses of Parliament in Ottawa. Lists of building-prints could continue for pages, and constitute a neglected area which should be interesting to research and collect.

Comprehensive, wide-angle city views came into style in the mid-19th century. The artist Edwin Whitefield sketched cities house by house. Between 1852 and 1855 he published nine large lithographs of Canadian cities with keys to the principal buildings. They are crisp and clear in architectural definition and the layout of streets, and include an elegant rendering of foreground foliage to soften the factual intention of the study. The quality of the hand-coloring makes these lithographs very attractive. Because they have usually been kept in frames (they are too large for portfolios) and exposed to light, the paper is often yellowed.

Related to city views are the sets of prints which define the scenery of one area. Among the first lithographs of Canada to be drawn on stone by the artist are the Nova Scotia and New Brunswick views by William Eagar and Robert Petley, dated 1837 to 1839. They were issued in parts, in paper covers, and are most valuable when found in this original binding. More often to be found are the 1855 lithographs of Ottawa scenery by William S. Hunter Jr., and his 1860 set of Eastern Townships views, as well as Thomas Pye's 1866 views of the Gaspé. These oval compositions with their ornamental corner pieces, although somewhat inferior as prints, have a "period" quality in their presentation which is attractive, and they record some corners of Canada which were seldom illustrated.

It would be impossible to cover this subject thoroughly in the space available here, since there are over 100 prints of Montreal alone, not including newspaper illustrations. The books published in the last few years by Charles P. De Volpi, which reproduce historical prints of Montreal, Quebec, the Niagara Peninsula, Ottawa, Toronto, Newfoundland, British Columbia—with more to follow—will give the reader an idea of the quantities of views of early Canada which were published. However, to study the techniques and qualities of the prints, you must look at the originals, rather than at reproductions.

WARS AND REBELLIONS

The artists who drew the first great sets of Canadian landscapes were also the graphic historians of the Seven Years' War. Because they had been trained as military topographers, their views contain detailed information about terrain and buildings, placement of fleets, and even everyday activities on the streets of the besieged cities. These drawings were published from 1769 as handsome line engravings in the classic style. The best known are the Quebec campaign landscapes by Hervey Smyth, aide-de-camp to General Wolfe, and the city views of Quebec and Halifax by Richard Short, purser aboard H.M.S. *Prince of Orange*. However, actual battle scenes are rare, the most famous being Hervey Smyth's description of the beginning of the battle of Quebec. It was published about 1760, and was copied by various publishers at later dates and in increasingly crude versions of the original print. The naval sieges of Louisbourg of 1745 and 1758 were also engraved from on-the-spot sketches. Many late prints of these subjects are either imaginary compositions, or copies of prints published in the 1760s.

Actions during the American Revolution which took place in Montreal and Quebec are not recorded in contemporary prints, although there is the occasional engraving of military stations, such as the plate from Anbury's *Travels* of 1789 showing a "View of St. John's Upon the River Sorell in

W. Alexander del: from a Sketch taken on the Spot by H. Humphries *Heath Sculp.*

FRIENDLY COVE, NOOTKA SOUND.

J. H. C. Include the Territories, which in Sept. 1790 were agreed by Spain to be ceded to Great Britain

London, Published Nov. 1st 1798 by J. Edwards Pall Mall & G. Robinson Paternoster Row

Illustration, Friendly Cove, Nootka Sound (*Vancouver Island*), engraved by J. Heath after an original drawing by H. Humphries, from Captain George Vancouver's A Voyage of Discovery to the North Pacific Ocean (*London, 1798*). *This was the scene of the Nootka Sound Controversy; the area was occupied by Spain in 1789 and ceded to Britain in 1791.*

CANADIANA, ROYAL ONTARIO MUSEUM

Canada with Redoubts, Works, &c, Taken in the Year 1776, during the late War in America."

The finest prints about the War of 1812 are naval scenes. English aquatint engravings show the actions between *The Little Belt* and the *President*; the *Gipsey Schooner* versus H.M. Ships *Hermes* and *Belle Poule*; and sets of prints describing the encounters between the *Java* and the *Constitution*, and the *Shannon* and the *Chesapeake*. The battle between the *Shannon* and the *Chesapeake*, which started in view of Boston harbor and finished six days later when the British towed the American prize into Halifax harbor, seems to have particularly inspired British print-makers, who published at least twelve prints on the subject, most of them being after drawings and descriptions supplied by Captains King and Falkner. Of these views, the most notable, although not the earliest to be published, is the fine set of four lithographs designed by Captain King, painted by the professional marine artist John Christian Schetky, and lithographed by Haghe of London in 1830. If the British ruled the seas, they had less success on the Great Lakes, and prints of these actions are more often published in the United States. The Birch-Lawson version of *Perry's Victory on Lake Erie* is a striking close-up of the American commander transferring from his sinking flagship in mid-battle, with plenty of nautical detail and martial feeling. Another large and handsome lithograph shows *M'Donough's Victory on Lake Champlain*, published in Philadelphia in 1816. British printmakers celebrated the *Attack on Fort Oswego* with two pairs of aquatints, one after Lt. I. Hewett, and the other after Captain Steele, both engraved by Havell. These aquatints are printed in monochrome shades and are usually found hand-colored; the effect is attractive, but sometimes the colorist has chosen arbitrary shades for the flags and uniforms.

Land battles received less attention from the artists, most subjects having been published years after the events took place. For instance, *The Battle of Queenston* (October 13, 1812) was published in 1836 as an aquatint illustration for *Laird's Martial Achievements*. Another version of the action is to be found in an 1896 chromolithograph. The *Battle of the Thames*, a lithograph, was issued in 1840 and 1846; and the *Battle of*

VIEW OF QUEBEC

Lundy's Lane, a wood engraving, was in *Harper's Weekly* on June 16, 1866.

The most valued account of the Rebellion of 1837 is the set of seven small lithographs after sketches made by Lord Charles Beauclerk, who was present at the engagements described. The lithographs were published in booklet form with a text in London in 1840. The plates are sometimes found separately, but are considered more valuable as a set in their original paper wrappers. The views are attractive in both coloring and composition, and depict various actions in November and December of 1837 at St. Hilaire de Rouville, St. Charles, and St. Eustache. In Upper Canada the most notable contemporary print depicts an engagement near Prescott in 1837 the *Battle of Windmill Point* which was painted by Salathiel Ellis and published in New York in 1839. However, it is not distinguished as a lithograph in either draftsmanship or technical skill, nor is it known to be an eyewitness account. Other reports on this first purely Canadian war are in the form of a series of cartoons which appeared in English newspapers; in historical reconstructions of battles, such as those composed by Coke Smyth while he was touring Canada with Lord Durham; and in the exaggerated views of the burning of the *Caroline* published by Currier & Ives.

Lithograph of a View of Quebec *(from the Lévis shore) from a drawing by Captain B. Beaufoy, published by Day and Haghe, London, about 1840. The foreground river traffic is so heavy, with every sort of craft imaginable, as to indicate artist's license by either the artist or the lithographer.*

CANADIANA, ROYAL ONTARIO MUSEUM

The far-reaching aims of the Fenian Raids of 1866 are recalled by two large and colorful views of the actions at Freleyburg and Ridgeway. These abortive skirmishes (a group of Irish-American "Fenians" hoped to influence the struggle for Irish independence by attacking the British government via its North American provinces) were not conducted in the orderly manner represented in the chromolithographs, which were published in New York and Buffalo.

The illustrated weeklies contain the principal prints of the rebellions in the North West. The first, or Red River Rebellion, took place in Manitoba in 1869 and 1870 and was reported, more or less accurately, in *Canadian Illustrated News* wood engravings. The second, the North West (or Saskatchewan) Rebellion, in 1885, was more fully reported by artists accompanying government troops and prints were published by Grip Company of Toronto in weekly numbers of the *Illustrated War News*, as well as in two special Souvenir Numbers issued

To Captain Sir Philip Bowes Vere Broke, Bart.^t and K.C.B.

This representation of H.M.S. Shannon leading her Prize the American Frigate Chesapeake, into Halifax Harbour, on the 6th June 1813, is Dedicated by his obliged and most grateful Servant. R. H. King

The last of a set of four lithographs of the action between the Shannon and the Chesapeake, between 1st and 6th June, 1813, painted by J. C. Schetky and published by Haghe in London. This set of four prints depicts a single-ship battle which began in view of Boston Harbor, lasted six days and ended when the Shannon escorted her prize into Halifax, as depicted here.
CANADIANA, ROYAL ONTARIO MUSEUM

a few months later with corrected versions of the battles. The best known views are the large and rather ugly chromo-lithographs—the *Battle of Fish Creek*, the *Battle of Cut Knife Creek*, and *The Capture of Batoche*. But we have no balancing accounts of these events from the rebel side, because the Métis had no artist-reporters.

VOYAGES OF DISCOVERY

Prints which illustrate the most famous exploration accounts in books published from the 16th to the 18th centuries are so rare that they are quite out of reach of the collector. If they turn up as separate prints, it means that they have, regrettably, been torn out of those books. Illustrated accounts of travel in such early times are kept in the rare books section of libraries, and include such authors as André Thévet, reporting in 1558 on Cartier's voyages of twenty years earlier; Frobisher's

Cartoon, c. 1820, The Emigrants Welcome to Canada, published probably as a satirical answer to flowery Emigrant's Guide pamphlets of the period. CANADIANA, ROYAL ONTARIO MUSEUM

THE EMIGRANTS WELCOME TO CANADA

The Quebec Driving Club meeting at the Place d'Armes *was sketched by Ensign William Wallace of the 24th Light Infantry, engraved by James Smillie, and published by D. Smillie & Sons, Quebec, in 1826. This was one of the earlier prints actually published in Canada.* CANADIANA, ROYAL ONTARIO MUSEUM

Lithograph portrait of Louis Joseph Papineau, as a proof before lettering; after a portrait by R. A. Sproule, and published by Hullmandel, London, in 1832. Papineau at this time was Speaker of the Lower Canada Legislative Assembly and later, of course, leader of the Lower Canada Rebellion of 1837.

PRIVATE COLLECTION

publication of 1580; La Hontan's 1703 book about his inland voyage of 1688; Father Hennepin's 1678 expedition to the Mississippi from New France; Samuel Hearne's journey to Hudson Bay in 1769; La Pérouse's 1785–88 journeys along the west coast, from which he never returned (but we are fortunate in that he had sent his records back to France before disappearing); and the late-18th-century travels of James Cook and George Vancouver, whose books are still to be found, either whole or dismembered.

The Arctic, which was one of the first areas to be explored, remains the last frontier. Prints of its peoples, wildlife and terrain accompany the many reports made by scientific exploring expeditions from the 16th century onwards, and especially those voyages made in search of the legendary North West Passage to the Indies. The earlier prints were bookplates, but from the mid-19th century sets of handsome lithographs were published. Among the finest of the single-sheet prints are the four lithographs after the sketches of Commander Edward Augustus Inglefield, describing his expedition in

△
Line engraving, This Plate of the Town and Harbor of St. Johns (*Newfoundland*), *was drawn by William Eagar and engraved by H. Pyall, and was published in London, England, June 1, 1831.* CANADIANA, ROYAL ONTARIO MUSEUM

Colonel Wetherall's Bivouack at St. Hilaire de Rouville, 23rd and 24th Novr, 1837, *from a sketch by Lord Charles Beauclerk, captain in the Royal Regiment. This lithograph was published in 1840 by A. Flint in Beauclerk's book* The Rebellion in Lower Canada, 1837-1838. CANADIANA, ROYAL ONTARIO MUSEUM
▽

△

After a sketch by Lady Eveline Marie Alexander, this lithograph,
Grand Military Steeple Chase, *at London, Canada West,*
9th May, 1843, *was published by Rudolph Ackermann, London,*
England, in 1846. CANADIANA, ROYAL ONTARIO MUSEUM

This early Arctic view of The Critical Position of H.M.S.
Phoenix, off Cape Riley, on 18th August, 1853, . . . *was drawn*
by Admiral Edward Augustus Inglefield, and published by
Day & Son, London, in 1854.
▽ CANADIANA, ROYAL ONTARIO MUSEUM

Trout fishing on Sugar Loaf Mountain.

Preparing for Lunch.

VIEW FROM SUGAR LOAF LOOKING NORTH LAKE MEMPHREMAGOG.
Townships of Stanstead, Hatley & Magog in the distance & village of Georgeville. Eastern Townships C.E.

W. S. Hunter Jr. del.

Party at the Crossing.

Party & Guide on the top of Owls Head.

J. H. Bufford's Lith.

search of the lost Franklin ships. Lieutenant Samuel Gurney Cresswell also drew watercolor sketches of arctic scenery which were published as a set of eight lithographs in 1854. W. W. May and W. H. J. Browne had their sketches published in the 1850s and Edward L. Moss' illustrations of the Nares expedition of 1875–76 were printed as chromolithographs. In fact, the search for the lost Franklin expedition (which aroused public interest and caused the British to explore 21,000 miles of Arctic coastline in forty-two search expeditions between 1848 and 1857), together with earlier and later Arctic voyages, form a wealth of literature and illustration which makes this field into a specialty of its own.

SPORTING PRINTS

Among the most spirited and pleasing subjects are the sporting views which were published from the 1820s until the 1880s. The earlier themes revolve around sleighing, one of the few social pastimes during the early years of settlement. These views were usually drawn by British officers, and range from the delicate line engraving of *The Quebec Driving Club* in 1826 (which has the added interest of having been drawn, engraved and published in Quebec), to the large 1853 chromo-

lithograph *Sleighing on Toronto Bay* which the artist dedicated to the officers of the 83rd Regiment. Between these dates I can think of ten or fifteen prints which are quite outstanding, the finest possibly being the 1838 and 1839 aquatints after watercolors by Lieutenant Levinge and Captain Frazer. By the 1860s the sleighing-theme prints to be found are of inferior quality, but the subjects are charming and of interest as social studies of a simpler past. A set of six views published as chromolithographs in 1868 tells the story of *A Picnic to Montmorenci* in a style with Victorian overtones; and the H. B. Laurence sporting sketches, published in 1870 as a set of ten lithographs in rather caricatural style, describe a variety of winter sports.

The subject of hunting is launched with Lady Alexander's view of *The Grand Military Steeple Chase at London*, issued in 1843 as a handsome large lithograph. And if buffalo hunting is to be considered a sport, there are a number of lithographs of these prairie scenes. When William Hickman published his *Sketches on the Nipisaguit* in 1860, he called the book to the "attention of fishermen in general, and to lovers of the noble sport of salmon-fishing, who will appreciate the unspoiled beauties of this wild and rocky river." The eight lithographs record an early camping trip.

The yachting scenes are usually confined to ship portraits, although one early lithograph after J. C. Beamis Jr. is entitled *The Position of Piers', Howe's and Maybury's Boats coming in at the last Regatta held at Halifax, 26th September 1838*. In the 1870s international competition aroused the interest of public

THE CAMP, GRAND FALLS

This early hunting camp scene is a lithograph titled The Camp, Grand Falls *(New Brunswick), from* Sketches on the Nipisaguit *by William Hickman, published by Day & Son, London and Halifax, England, 1860.*

CANADIANA, ROYAL ONTARIO MUSEUM

From one of the earliest Canadian botanical books, this lithograph of the "Wild orange Red Lily," the "Harebell," and "Showy Lady's Slipper," is a plate in Canadian Wildflowers *by C. P. Traill, with illustrations by Agnes Fitzgibbon, published by John Lovell, Montreal, 1868.*

CANADIANA, ROYAL ONTARIO MUSEUM

and printmakers, and one finds such examples as the Currier & Ives lithograph the R.C.Y.C. Yacht *Countess of Dufferin*, probably published in 1876, the year this schooner-yacht became the first Canadian vessel to challenge for the America's Cup. It lost. The sculling champions Ned Hanlan of Toronto and George Brown of Halifax were also the subjects of lithographs in the 1870s, and about this time a number of team sports such as cricket and lacrosse are depicted in prints. From this date forward a wide variety of sporting subjects can be found as wood engravings in the illustrated weeklies and magazines.

PORTRAITS AND FIGURE STUDIES

Portraits, which were the artist's bread and butter until the advent of photography, were also one of the mainstays of the printing trade. People liked to have reproductions of famous paintings, and to look at the faces of prominent citizens. Today the field of historic portraits is generally left to museums, with

COURTNEY & HANLAN,
CHAMPION SCULLERS OF AMERICA.
VIEW OF TORONTO BAY.

The great scullers Courtney & Hanlan *are pictured in Toronto Harbor, their home rowing ground, in this lithograph published by W. J. and C. M. Baxter in Syracuse, New York, in 1879.*

CANADIANA, ROYAL ONTARIO MUSEUM

little competition from private collectors. There is a wide range of choice; in the 17th century the portraits of monarchs and statesmen were reproduced as line engravings with decorative borders; in the 18th century governors and generals who had posed for such artists as Gainsborough and Romney had their oil portraits translated into the deep velvet tones of mezzotint; and delicate chalk portraits were reproduced as stipple engravings, which often served as frontispiece plates.

Portraits of later Canadian administrators and public figures are to be found as lithographs, and finally as wood or steel engravings. It is a good idea to check on the origins of a portrait; most of the early explorers, such as Cartier and Champlain, were never portrayed during their lifetime, and portraits of them are later inventions.

Figure studies, having the charm of period costume added to their interest as social commentaries, are more sought after by the general collector than are portraits, but they are also in shorter supply as single-sheet prints. Generally they occur as illustrations in books of travel—for instance the engravings of Indians and Eskimos in the many fine volumes about explorations. Later accounts, such as those by John Lambert and George Heriot of travels in Lower Canada, include attractively

etched figures; but it is a great pity to see them cut or torn out of their original context. The figure groups drawn by Peter Rindisbacher, a young immigrant to the Red River Settlement, were reproduced as six single-sheet lithographs in London in 1824. In this general category one might also include the paintings of habitant and Indian subjects by Cornelius Krieghoff, which were published as lithographs during his lifetime.

INDUSTRY AND TECHNOLOGY

Economic history can be taken as another classification. Prints which refer to Canada's basic industries and technical advances over the years can form a most interesting collection. The cod fisheries and the fur trade, which sustained the country economically during its earliest years, are the subjects of relatively few prints, most of them engraved to accompany accounts of explorations. Lumbering is depicted almost by chance in landscape views, which include timber slides, booms of logs on the St. Lawrence, and the occasional lumberman's shanty. Bridges, canals and railways are more often found in prints which commemorate the launching of each new technical achievement. These prints range from Joseph Bouchette's views of the newly built Rideau Canal, published as lithographs in his book *British Dominions in North America* (London, 1831), to the late chromolithograph of *The Globe Special*, the train used by the Toronto newspaper to beat the London *Free Press* to the Hamilton readers.

THE FIGHT AT DUCK LAKE (1885)

△
This illustration of the first engagement in the North West Rebellion of 1885, The Fight at Duck Lake, is a litho-tint by the Toronto Litho Company, and was published in Part I of Souvenir Number, Illustrated War News, Toronto, 1885.

CANADIANA, ROYAL ONTARIO MUSEUM

The Globe Special, *sponsored by the Toronto Globe, was a "Special Fast Train" between Toronto and London, c. 1885, which anticipated (and was faster than) present-day commuter and business traffic. This print was an advertising chromolithograph by the Toronto Litho Company.*
▽
CANADIANA, ROYAL ONTARIO MUSEUM

Books
and Broadsides

Edith G. Firth

This lande was discovered by Iames Quartier a Bryton, borne at S. Maloes, in the year 1535. At that time besides the number of shippes that he had, for the performaunce of his voyage, with certaine barkes, some with 60 and 80 men a piece, he sought out this unknowne countrie, untill he came to a great & brode river, to the which they gave a name, in the whiche is founde very good fish, chiefly Salmons, and that great plentie: then they traded into so many places adiacent with kniues, hatchets, hookes and lynes to fishe with and such like, for Hartes skinnes and skinnes of other wild beastes, wherof there is great store. The wilde men of the countrey gave them good entertainement, shewing themselves well affectioned towardes them, and glad of their comming, knowledge and amitie, and with their practise in bargainyng with them.

This first printed reference to Canada in the English language is from *The New found vvorlde, or Antarctike, wherin is contained wonderful and strange things, as well of humaine creatures, as Beastes, Fishes, Foules, and Serpents, Trees, Plants, Mines of Golde and Siluer*, published in London in 1568. Originally published in France ten years before, the book was written by a Franciscan friar, André Thevet, whose account of his personal adventures is almost certainly bogus, but who had talked to Cartier and learned of Canada from him. Thevet's book belongs with the select few published in Europe in the 16th century which describe Canada.

These books are the earliest Canadiana, and are of course extremely rare and valuable. Perhaps the two most famous are the collections of voyages compiled by the Italian Giovanni Battista Ramusio, published in 1556, and by the Englishman Richard Hakluyt in 1589. Ramusio's third volume includes the earliest printed record of Cartier's first voyage to America; Hakluyt's collection contains accounts of voyages touching Canada by Cabot, Hore, Frobisher, Gilbert and Davis. Hakluyt's work was continued by another English clergyman, Samuel Purchas, whose *Purchas his Pilgrimes*, published in

1625, contained many explorers' narratives, including Abacuk Pricket's fascinating account of Henry Hudson's last voyage.

Much of the early explorers' information about the unknown world they had discovered is wildly inaccurate. It is with Champlain that detailed knowledge of Canada really began. Champlain wrote four books about his explorations and settlements in Canada, published in 1603, 1613, 1619, and 1632. His last book includes a narrative of his life and of events in Canada from 1603 to 1629, when he was forced to surrender Quebec to the English and return to France. Champlain's books are all of vital importance. The historian often prefers to use modern scholarly editions, but for the serious—and wealthy—collector specializing in early Canadiana, the original editions have a unique place. So also do the original editions of Marc Lescarbot's *Histoire de la Novvelle-France*, first published in 1609, with a revised and enlarged edition in 1617. Lescarbot was a young French lawyer with literary pretensions, who spent the winter of 1606–07 at Port Royal with Champlain. "Les muses de la Novvelle France" was published with the *Histoire* and includes "Le théâtre de Neptune en la Novvelle France." This masque was written and acted at Port Royal in November 1606 to celebrate the return of the leader of the colony, and featured the god Neptune attended by Tritons and Indians. It was the first European theatrical presentation in North America.

The earliest accounts of Canada were written by or about explorers. From 1632 to 1673 there is another major source of information about New France—the Jesuit *Relations*. These are basically annual reports of the Jesuit missions, written by the missionaries themselves. Father Brébeuf, for example, wrote the *Relations* for 1635 and 1636; his martyrdom is described by Father Ragueneau in the 1649 report. Simply written, these 41 little books were intended to arouse French support, both spiritual and financial, for the missions. The original editions are now very rare; possibly the only complete set in Canada is in the library of Laval University. The Metropolitan Toronto Central Library has been trying to collect

*Title page of the 1632 edition of Champlain's Les Voyages . . . ,
which includes information from his travels of 1615–16, estab-
lishing the upper Ottawa, Lake Nipissing, French River and
Lake Huron route to the West.*

CANADIANA, ROYAL ONTARIO MUSEUM

them for years, but still eight are missing from its collections.

The Jesuits were not the only missionaries in New France, or even the earliest. The Recollet branch of the Franciscan order sent the first missionaries to the colony in 1615. One of their missionaries, Gabriel Sagard-Théodat, was in Huronia from August, 1623 to May of the following year, and published *Le grand voyage dv pays des Hvrons* in 1632. He included a simple dictionary of the Huron language, the first ever to be printed. Four years later he wrote *L'histoire dv Canada* in which he expanded his *Grand voyage* with further information about Recollet missions as a protest against their exclusion from New France after 1632.

The Recollets were later asked to return to the colony, and in the spring of 1675, two Recollet fathers arrived who were both to write important books about Canada. Father Christian LeClerq worked among the Micmac Indians from his base at Percé, and in 1691 published two books, *Nouvelle relation de la Gaspésie* and *Premier établissement de la foy dans la Nouvelle France*. The first is a simple account of the Gaspé and the Micmacs, the second a description and defense of the Recollet missions, highly critical of the Jesuits.

The other priest was Father Louis Hennepin, who accompanied LaSalle into the interior of the continent and wrote the first eyewitness description of Niagara Falls in his *Description de la Louisiane*, published in 1683. In his second book, *Nouvelle découverte d'un très grand pays*, published in 1697, Hennepin claimed that he, rather than LaSalle, had discovered the mouth of the Mississippi, and explained ingenuously that he had not mentioned this in his earlier book because LaSalle was then still alive. Two other contemporary accounts of LaSalle's discoveries were published under the names of men who had accompanied him on some of his travels—Henri de Tonty and Henri Joutel—but both books were repudiated by their ostensible authors. LaSalle was indeed unfortunate in his chroniclers.

In the early books about Canada, it is sometimes difficult to separate the conscientious author coping with the unknown from the teller of tall tales. Probably Louis Armand, Baron de Lahontan, belongs, in part at least, to the latter category. His *Nouveaux Voyages*, published in 1703, is one of the liveliest contemporary narratives about New France. An army officer who traveled extensively around the upper Great Lakes, Lahontan describes the country and the people with an odd combination of zest and philosophy. His third volume, *Dialogues de Monsieur le baron de Lahontan et d'un sauvage*, consists of probably mythical discussions with a probably mythical Indian, Adario, who is said to be the prototype of Jean Jacques Rousseau's noble savage.

Interest in the native peoples, other than as objects of missions, grew in the 18th century, and a number of books describe their lives and customs in some detail; for example, Claude LeBeau's *Avantures*, published in 1738. Perhaps the most ambitious of these books is Father Joseph François Lafitau's *Moeurs des sauvages amériquains*, published in two volumes in 1724. Lafitau was the first author to investigate thoroughly the habits, religions and social organizations of the American Indians. In his attempt to prove their relationship with the Tartars, he compared Indian civilization with that of other societies, including classical Greece and Rome.

Although most of the contemporary books about New France are concerned with the St. Lawrence-Great Lakes basin, a few describe French activities and colonization elsewhere in Canada. Nicolas Denys was a merchant who developed the lumbering and fishing industries in Acadia and published his two-volume *Description géographique et historique des costes de l'Amérique, septentrionale*, in 1672 after forty years' residence in Acadia. He was not much of a writer, but his knowledge of the country and its resources, and of the Micmacs was unrivalled. Other books about early Acadia include the Sieur de Dièreville's light-hearted narrative of a visit, written partly in verse and published in 1708, and the Marquis de Chabert's scientific account of a surveying expedition in 1750–51, considered a model of accuracy by *L'Académie royale des sciences*.

The collector of books about New France has a comparatively wide field. The first Canadian botany, *Canadensivm Plantarvm*, which appeared in 1635, was written by Jacques Cornut, a French doctor who never visited the colony. Father François Du Creux, who published *Historiae canadensis* in

Engraved title page from Le Grand Voyage Du Pays des Hurons . . . by Gabriel Sagard, Paris, 1632, with renditions of Indians in various activities.

METROPOLITAN TORONTO CENTRAL LIBRARY

NORTH-VVEST FOX.
OR,
Fox *from the* North-west *passage*.
BEGINNING
VVith King ARTHVR, MALGA, OCTHVR,
the two ZENIS of *Iseland, Estotiland,* and *Dorgia* ;
Following with briefe Abstracts of the Voyages of *Cabot,*
Frobisher, Davis, Waymouth, Knight, Hudson, Button, Gib-
bons, Bylot, Baffin, Hawkridge : Together with the
Courses, Distance, Latitudes, Longitudes, Variations,
Depths of Seas, Sets of Tydes, Currents, Races,
and over-Falls; with other Observations, Accidents
and remarkable things, as our Miseries and
sufferings.

Mr. IAMES HALL's three Voyages to *Groynland,* with a
Topographicall description of the Countries, the *Salvages*
lives and Treacheries, how our Men have beene slayne
by them there, with the Commodities of all those
parts ; whereby the Marchant may have Trade, and
the Mariner Imployment.

Demonstrated in a Polar Card, wherein are all the Maines, Seas,
and Ilands, herein mentioned.

With the Author his owne Voyage, being the XVIth.
with the opinions and Collections of the most famous Ma-
thematicians, and Cosmographers ; with a Probabilitie to
prove the same by Marine Remonstrations, compa-
red by the Ebbing and Flowing of the Sea, experimented
with places of our owne Coast.

By Captaine LVKE FOXE *of* Kingstone *vpon* Hull, *Capt.*
and Pylot for the Voyage, in his Majesties Pinnace
the CHARLES,

Printed by his Majesties Command.

LONDON,
Printed by B. ALSOP and THO. FAVVCET, dwelling in *Grubstreet,*
1635.

1656, was also never in Canada. Despite its title, his book deals mainly with Jesuit activities; the first general French-Canadian history is *Histoire et description générale de la Nouvelle France,* published in 1744 by Father François Xavier de Charlevoix. Contemporary books and pamphlets concerning law, govern-ment, biography, science, politics, and religion in New France are also occasionally available, although very rare.

Not all of modern Canada belonged to France before the British conquest; some areas such as Newfoundland and the shores of Hudson Bay were English. Sir Richard Whitbourne was a mariner and fisherman who became interested in the colonization of Newfoundland, which he had frequently visited and where he had been governor of a colony. In 1620 he published *A Discourse and Discovery of Nevv-fovnd-land, with Many Reasons to Prooue how Worthy and Beneficiall a Plantation May there be Made.* Intended primarily to encourage settle-ment, his book is full of information about Newfoundland and enthusiasm for its future. It was submitted to the Privy Council who approved its printing and requested the Arch-bishops of Canterbury and York to have it distributed to every parish.

Besides their interest in colonization, the English were concerned with the possibility of a northwest passage to Asia. As so often in the history of Arctic exploration, a rather bad-tempered race developed between two opinionated men, Luke Foxe, backed by London merchants, and Thomas James, backed by the merchants of Bristol. In 1631 they both made important discoveries—Foxe Basin and James Bay—but neither was

North-West Fox, or, Fox from the North-west passage *was written by Captain Luke Foxe, one of the first English mariners to attempt discovery of the Northwest Passage, and published in London in 1635.*

successful in finding the passage. Each man wrote a book about his explorations, and here too there was competition, won by James whose *Strange and Dangerovs Voyage* appeared in 1633, while Foxe's *North-vvest Fox* was not published until 1635. James' book was better written and more popular; in fact it has been suggested that Coleridge used it in writing *The Rime of the Ancient Mariner.*

The negative findings of both expeditions postponed further serious search for the Northwest Passage for over a century. In 1741, Christopher Middleton, a former employee of the Hudson's Bay Company, was sent out by the British Admiralty at the instigation of Arthur Dobbs, an Irish member of Parliament who had a fanatic belief in the existence of the passage. When Middleton's expedition was unsuccessful, Dobbs attacked him fiercely as having been corrupted by the Hudson's Bay Company, which did not desire the discovery of the passage. Middleton replied and a brisk pamphlet war followed. Dobbs was one of the principal backers of another expedition in 1746–47 under William Moore, Middleton's former second in command. When this expedition also failed, there were more books and pamphlets, notably two narratives of the voyage, one by Henry Ellis and the other "by the clerk of the *California,*" the pseudonym of a man known variously

Fr. Lewis Hennepin's A New Discovery of a Vast Country in America . . . *is considered the earliest illustrated book on North America, with wood engravings of Indian scenes, and a well-known and often illustrated view of Niagara Falls. This title page and frontispiece are from the London edition of 1699.*

CANADIANA, ROYAL ONTARIO MUSEUM

as Theodore Swaine Drage or Charles Swaine. Born in England, Drage/Swaine emigrated to the American colonies and made two later attempts to find the passage, one of them financed by Philadelphia merchants including Benjamin Franklin.

Inland exploration was more successful than the attempts to find a sea passage. Samuel Hearne, a Hudson's Bay Company employee, went overland from Hudson Bay to the mouth of the Coppermine River in 1771–72, thus becoming the first European to reach the Arctic Ocean between Bering Strait and Baffin Island. After his retirement in 1787 he worked on the manuscript of his *Journey*, which was finally published posthumously in 1795. It is an engrossing narrative, with graphic descriptions of such events as the massacre of the Coppermine Eskimos by Hearne's Indians. Less interestingly written, but equally important in the history of Canadian exploration, is Sir Alexander Mackenzie's *Voyages*, published in 1801, which

records Mackenzie's two journeys, one by the Slave River, Great Slave Lake and the Mackenzie River to the Arctic Ocean, and the other by the Peace River Pass to the Pacific Ocean. Mackenzie, a North West Company fur trader, was knighted, and his book went into several editions. Narratives by other fur traders, such as Joseph Robson, John Long, Alexander Henry and Gabriel Franchère, contain much that is new, reflecting the varying interests, prejudices and experiences of the authors.

Books concerning exploration on the west coast are another interesting field for the collector. The first published account of Captain Cook's discoveries (including his voyage along the Canadian Pacific coast) was by William Ellis, a ship's surgeon who held back his papers when on Cook's death the authorities required the surrender of all records kept by the crew. Ellis' narrative was published in 1782; two years later the official account, *A Voyage to the Pacific Ocean*, was published, written by Cook, completed by Captain James King who sailed with Cook, and edited by the Bishop of Salisbury who did not.

Controversy was to develop on the west coast as in the north. In 1786–87 a joint expedition of exploration and trade was led by Nathaniel Portlock and George Dixon, both of

NEHIRO-IRINIUI

AIAMIHE

MASSINAHIGAN,

SHATSHEGUTSH, MITINEKAPITSH,
ISKUAMISKUTSH, NETSHEKATSH,
MISHT', ASSINITSH, SHEKUTIMITSH,
EKUANATSH, ASHUABMUSHUANITSH,
PIAKUAGAMITSH,
Gaie miſſi miſſi nehiro-iriniui Aſtſhitſh
ka tatjits, ka kueiaſku aiamihatjits ka utſhi.

UABISTIGUIATSH.

Maſſinahitſetuau, BROUN gaie GIRMOR.
1767.

A

CHARGE

DELIVERED TO THE

CLERGY

OF THE

Province of QUEBEC,

AT THE

PRIMARY VISITATION

HOLDEN IN THE CITY OF QUEBEC,

IN THE MONTH OF AUGUST 1789.

BY

THE RIGHT REVEREND CHARLES,

BISHOP of NOVA SCOTIA.

HALIFAX:

Printed by ANTHONY HENRY; Printer to the King'
Moſt Excellent Majeſty.

MDCCLXC.

*One of the earliest books published in Canada, this book of
catechism and prayers was translated into the Montagnais lan-
guage by Fr. Jean Baptiste de la Brosse, and published in Quebec
in 1767.* METROPOLITAN TORONTO CENTRAL LIBRARY

*An early Anglican Church pamphlet, this A Charge . . . to the
Clergy of . . . Quebec was published in Halifax in 1790. Quebec
was part of the Diocese of Nova Scotia, under Bishop Charles
Inglis, until 1793.* METROPOLITAN TORONTO CENTRAL LIBRARY

whom had sailed with Cook. In 1789 each published an account
of the voyage with identical titles, *A Voyage round the World,
but More Particularly to the North-west Coast of America,* but
Dixon's was really written by his supercargo, William Beres-
ford. The following year John Meares published his *Voyages
Made in the Years 1788 and 1789 from China to the North
West Coast of America,* in which he magnified the importance
of his own discoveries by ignoring those of his predecessors.
This enraged Dixon, and another war of pamphlets broke out.
Meares' ships were seized by the Spaniards in Nootka Sound,
which had been claimed for Britain by Cook. The Nootka
Sound Convention of 1790 provided for the restoration of
British property, and in 1791 Captain George Vancouver, who
had accompanied Cook as a midshipman, commanded an
expedition to arrange the transfer and to make further surveys.
His book, *A Voyage of Discovery to the North Pacific Ocean,
and round the World,* was published posthumously in 1798.

After the Napoleonic Wars, efforts to find a northwest
passage were renewed. The literature of the search is volu-
minous. Sir John Ross' first voyage in 1818, for example, was
recorded by Ross; by Alexander Fisher, ship's surgeon; and

by Edward Sabine, the scientist recommended by the Royal
Society to accompany Ross. Both Sabine and Fisher were
critical of Ross. This was the pattern for most of the Arctic
exploration of the 19th century; it appears sometimes that the
motive was at least as much to prove someone else wrong as it
was to discover the passage. Still, men like Ross, Sir William
Parry, Sir John Franklin, Sir John Richardson, Sir George Back,
Thomas Simpson, John Rae, Sir Robert McClure, Elisha Kane
and others led expeditions which increased the Europeans'
knowledge of Arctic Canada. When Sir John Franklin's expe-
dition of 1845 failed to return—Franklin and all his men
perished miserably in 1847—many expeditions were sent by
the Admiralty and by private subscription to find out what
had happened. Finally, Sir Francis McClintock, leading an
expedition sent by Lady Franklin, found not only the remains
of the Franklin expedition but the last link in the northwest
passage. He described his discoveries in *The Voyage of the
"Fox" in the Arctic Seas,* published in 1859.

The mass of literature on the Arctic is a rich field for
collectors. Besides the accounts and counter-accounts of expedi-
tions, there are scientific studies of flora, fauna, astronomy, etc.;

SPEECH
OF
HIS EXCELLENCY
JOHN GRAVES SIMCOE, Esq;

LIEUTENANT GOVERNOR

of the Province of Upper Canada, &c. &c. &c.

UPON OPENING THE FIRST SESSION

of the Legiſlature of the ſaid Province.

WITH

The reſpective *Addreſſes* of both *Houſes* thereupon.

AND

HIS EXCELLENCY'S ANSWERS.

LIKEWISE

HIS EXCELLENCY'S SPEECH,

Upon Proroguing the ſaid Seſſion of the Legiſlature.

BY AUTHORITY.

UPPER CANADA:
Printed by LOUIS ROY, M,DCC,XCIII.

The first pamphlet published in Upper Canada, a speech by
John Graves Simcoe, was printed in Kingston in 1793.

ST. URSULA'S CONVENT,

OR ~S H Hvasson~

THE NUN OF CANADA,

CONTAINING SCENES FROM

REAL LIFE.

The moral world,
Which though to us it seems perplex'd, moves on
In higher order, fitted and impell'd,
By wisdom's finest hand, and issuing
In universal good. THOMSON.

IN TWO VOLUMES

VOL. I.

KINGSTON, UPPER CANADA :
PRINTED BY HUGH C. THOMSON.
1824.

The first novel written and published in Canada was St. Ursula's Convent, or The Nun of Canada, *by Julia Beckwith Hart, published in Kingston in 1824.*

METROPOLITAN TORONTO CENTRAL LIBRARY

TRIAL OF ALCOHOL

BY JURY,

AS IT TOOK PLACE

DURING THREE EVENINGS,

BEFORE

CROWDED AUDIENCES,

IN QUEBEC,

IN THE MONTH OF MARCH, 1852.

Reported by JOHN MORPHY, W. P., Gough Division, No. III,
Sons of Temperance, Quebec.

MONTREAL:
PRINTED BY J. C. BECKET, AT HIS POWER-PRESS PRINTING
ESTABLISHMENT, 22 GREAT ST. JAMES STREET.
1853.

The Temperance movement was strong and vociferous by the 1850s, and lectures were often published as pamphlets such as this cover-illustrated publication of 1853.

METROPOLITAN TORONTO CENTRAL LIBRARY

government reports; children's books; and such curiosities as *The Love Life of Dr. Kane*, published in New York in 1866. The *Arctic Bibliography* prepared by the Arctic Institute of North America now consists of sixteen fat volumes. Although many of the items it describes are concerned with the Russian Arctic, it contains thousands of books, pamphlets and articles dealing with Canada's far north.

The earliest books about Canada were written by men who were in the country for a definite purpose—the explorer, colonizer, missionary, fur trader, and soldier. By the middle of the 18th century another type of author began to emerge— the traveler, whose book was the reason for his Canadian visit, rather than a by-product or vindication of his presence in the country. Many of these travel books describe journeys in both Canada and the United States. One of the earliest was by Peter Kalm, a Swedish botanist who, between 1753 and 1761, published a three-volume journal in Swedish, most of which appeared in an English translation in 1770–71. Kalm spent most of his time in the American colonies, but included a lively account of Montreal and Quebec.

Another early visitor was a French emigré royalist,

François Alexandre, Duc de La Rochefoucauld-Liancourt, who came to North America in 1795. That summer he visited Canada, crossing the Niagara River and getting as far as Kingston before being ordered out of the country by Lord Dorchester. His account of his travels, published in 1799 with an English translation the same year, describes early British settlements in Upper Canada in inflammatory terms, and includes bitter criticism of the lieutenant governor, John Graves Simcoe. Simcoe replied in a pamphlet (now extremely rare) published in Exeter in 1800.

In the 19th century the trickle of travelers' accounts of Canada became a flood. Authors brought with them their own interests—religious, scientific, anthropological, agricultural, commercial, sporting, political—and their own prejudices. Despite this, there is often a sameness in their descriptions of the country. Occasionally they copied from each other, but more frequently the similarities were inevitable because most of the travelers followed the same route, from Quebec to Montreal, down the St. Lawrence, and along the north shore of Lake Ontario to Niagara Falls. It is very difficult for the uninspired writer, as so many of the travelers were, to say

UPPER CANADA
ALMANACK,
FOR THE YEAR
1837.

RADICALS *enjoying* their betting *profits* after the late Election.

PUBLISHED BY
DAVID DWYER, Esq.
TORONTO.

The comic Upper Canada Almanack, for the Year 1837, *was published in Toronto just before the Upper Canada Rebellion of 1837.* METROPOLITAN TORONTO CENTRAL LIBRARY

anything original about Niagara Falls. Almost all the travelers deal with three main subjects: the methods and discomforts of travel, the countryside, and the people. Although their descriptions are often similar, their opinions vary widely; what one admired another despised. Mrs. Jameson, tearfully arriving in Toronto in a final attempt to save a broken marriage, did not see the city with the same enthusiasm as some of the ultra-British travelers who welcomed its sedate propriety after the untrammeled democracy of the United States.

The same general pattern emerges in most of the travelers' accounts of the central and maritime provinces. On the other hand, the 19th century traveler in the Canadian west was literally covering new ground, following the steps of the explorer and the fur trader rather than the settler. There is greater variety in books of western travel, because of the freshness of the subject, and because many of the travelers had more vivid personalities than those who followed the well-worn tourist paths of eastern Canada. An outstanding example of individuality was the young Viscount Milton, who bumbled his way across the continent in the 1860s, kept from major disaster by his companion, Dr. Walter Butler Cheadle.

Canadian travel books were widely read, especially in Great Britain, and encouraged middle-class emigration to British North America. For humbler people there was a more direct appeal in the mass of little books and pamphlets with titles like:

A Few Plain Directions for Persons Intending to Proceed as Settlers to His Majesty's Province of Upper Canada, in North America, pointing out the best port to embark at for Quebec; provisions and other things necessary to be provided for the voyage; the best and cheapest method of travelling from Quebec to Montreal, and thence to Kingston and York, a distance of 600 miles, whereby emigrants may avoid heavy expenses; the method of obtaining land in the most eligible districts; what property various descriptions of emigrants should possess on their arrival in America; advice to farmers, tradesmen, mechanics, &c.; a description of that fine and interesting province: its productions, &c. &c.; some cursory remarks on the manners and customs of the inhabitants

written "by an English farmer settled in Upper Canada," and published in 1820.

Many of these little guides (often misleadingly optimistic) were published by those with a vested interest in Canadian immigration—land companies like the Canada Company, or groups like the Petworth Committee who promoted emigration as a solution to British overpopulation and poverty. The books are frequently in the form of letters from contented settlers, a formula later used in Canada itself to encourage western and northern settlement.

Besides general description and travel, books about Canada are often concerned with specific events or issues. The first book printed in New York, for example, describes French-English skirmishing: *A Narrative of an Attempt Made by the French of Canada upon the Mohaques Country* by Nicholas Bayard and others, was published there in 1693. French-English rivalry in North America was responsible for a great number of books, discussing both war and peace. They include straightforward soldiers' narratives of engagements, accounts of Indian captivities, sermons preached in the little clapboard churches of the Atlantic seaboard arousing or congratulating the New Englanders who captured Louisbourg in 1745, leisurely 18th-century dissertations on the relative value (or lack of it) of Canada as a colony, and sheet music mourning the death of General Wolfe. Related to the French-English conflict was the visit of four Iroquois chiefs to Queen Anne in 1710; this visit caught the English imagination, and a number of chapbooks and broadsides were published about "the four kings of Canada." After the British conquest, French-English conflict was replaced by British-American controversies involving Canada: the American Revolution, the War of 1812, the Maine boundary dispute, the Oregon question. Any one of these is a rich field for the collector.

So also is fiction with a Canadian setting. Some of the earliest books about Canada were presented as fact, but are really novels. One such book, *Les avantures de Monsieur Robert Chevalier dit de Beauchêne*, was published in 1732 by Alain René LeSage, the author of *Gil Blas*; it described the fictional exploits of a French privateer, born near Montreal and adopted by the Iroquois and Algonquins in turn, before going to the West Indies. LeSage never visited Canada. The

first novel written in Canada was *The History of Emily Montague*, by Frances Brooke, published in London in 1769. Mrs. Brooke, the wife of the chaplain of the garrison at Quebec, wrote in the form of letters, like many 18th-century novelists, with a complicated romantic plot against a Quebec background. There are many later novels with Canadian settings, including books by John Galt, Frederick Marryat, Mrs. Humphry Ward, and James Oliver Curwood. Children's stories were also frequently set against Canadian backgrounds, as in R. M. Ballantyne's boys' books; or were about Canada, as in *A Peep at the Esquimaux* "by a lady," published in 1825.

Other books of Canadian interest published abroad include scientific studies, especially botanical and zoological; laws and regulations; government blue books; poetry; accounts of shipwrecks and disasters; business prospectuses inviting Canadian investment; and religious works. Missions in Canada, both among the native peoples and the settlers, were well publicized in Europe. Many books of liturgy and doctrine were published for use in Canada; the earliest was Bishop Saint-Vallier's *Catéchisme du diocèse de Québec*, published in Paris in 1702. Translations of the Gospels, prayer and hymn books, primers, and devotional works were published in the native languages. In 1861 the entire Bible was translated into Cree and printed in James Evans' Cree syllabic characters by the British and Foreign Bible Society.

In general, books about Canada published abroad were more attractive, better printed and better illustrated than those published in the new country, where equipment, materials, and printing skill were all very scarce. Some collectors, however, may find the productions of the little Canadian presses more interesting, or may collect a special subject and ignore the country of publication.

It is almost certain that the first printing press in Canada was established in Halifax by Bartholomew Green, who came from Boston in August 1751, but died a few months later after publishing little or nothing. His former Boston partner, John Bushell, took over his printing office the following year. In the city of Quebec, William Brown and Thomas Gilmore from Philadelphia set up the first printing press in 1764. Also from Philadelphia was Fleury Mesplet, the first printer in Montreal in 1776, with the first French press in Canada. Printing was introduced into New Brunswick by Loyalist printers, John Ryan from Rhode Island and William Lewis from New York, in 1783. Ryan went to St. John's in 1807 where he opened Newfoundland's first printing office. Another Loyalist, James Robertson, a printer in Shelburne, Nova Scotia, was invited by the governor to establish Prince Edward Island's first press in Charlottetown in 1787. In Ontario the lieutenant governor was also responsible for the first press, paying for it with government funds and inviting the first printer, Louis Roy, from Quebec in 1793.

The introduction of printing in the West was necessarily later than in eastern Canada. The first press was a converted fur press, with type made from the lead linings of tea chests and ink from lampblack mixed with oil. With this primitive equipment the Reverend James Evans in 1841 printed Manitoba's first publication, a Cree hymn book, at the Methodist Rossville Mission at Norway House 300 miles north of Winnipeg. The first secular press was brought by oxcart from Saint Paul, Minnesota, to Fort Garry by two Toronto journalists,

William Buckingham and William Coldwell, in 1859. Bishop Modeste Demers of Vancouver Island was given a press by the Society for the Propagation of the Faith in 1856, but the first pamphlet did not appear in British Columbia until 1858. The first press in Saskatchewan was at Battleford in 1878; the first in Alberta at Edmonton in 1880. In the Arctic, Captain H. T. Austin's expedition, sent by the Admiralty in search of Franklin in 1850–51, carried a printing press which was used, among other things, to print posters for amateur theatricals.

The King's Printer, whose responsibility was the printing of official publications, was usually the principal printer of each colony. The modest salary he received probably compensated for the circumspection he had to exercise in selecting job printing. Freedom of the press did not exist for the King's Printer, but other early printers such as Fleury Mesplet in Montreal and Francis Collins in Toronto also suffered for publications offensive to the government. In the earliest period government publications consisted of proclamations, Orders-in-Council, speeches, bills, and the statutes, journals, and gazettes. The growing complexity of government in the 19th century resulted in a greater variety of publications, as reports and papers were printed on every aspect of official concern, from education to geological surveys.

Government patronage was helpful to the early printer to supplement his income from his newspaper, which was usually his basic source of revenue. Another source was the publication of almanacs and directories. The almanacs began humbly as wall calendars showing religious holidays, phases of the moon, and the times of rising and setting of the sun and moon. The first recorded almanac was printed in Quebec in 1765, but no copies are known to have survived. Gradually almanacs included more information, and grew from broadsides into pamphlets and books. The first Canadian printed book with an illustration is *The Nova Scotia calendar*, for 1776, which contains a woodcut of Halifax Harbor. In 1789 *The British Lady's Diary and Pocket Almanack* was published in Quebec, "containing a Calendar, several useful recipes in cooking, pickling, preserving, etc., Enigmatical questions, Rebuses, Poetry, Songs, etc." The companion volume, *The British Gentleman's Pocket Almanack* includes the more usual almanac information—a calendar, astronomical observations, listings of the royal family and imperial government, the members and officers of the civil government and courts, the military establishment, clergy, local societies, postal rates, and other miscellaneous local information.

Related to the almanacs was another staple of the early printer, the directory. The first directory of Quebec was published in 1790, of Montreal in 1819, of Toronto in 1833, and of Victoria in 1860. The directories usually contain the same sort of information as the almanacs, as well as an alphabetical list of inhabitants and occasionally a listing by street. Sometimes they include a description of the town, with facts and figures demonstrating local growth and municipal pride. By the 1850s provincial directories were also published, listing each town or village with a brief description and the names of its business and professional men. In 1871 the first directory for the whole dominion was published, with over 2,500 pages. Lists of names are also included in the historical atlases published in the late 1870s and 1880s. These county atlases were sold by subscription up and down the rural sideroads of

THE FIRST NEWSPAPER AT RED RIVER.

PROSPECTUS

OF

"THE NOR'-WESTER,"

A JOURNAL TO BE PUBLISHED AT

FORT GARRY, RED RIVER TERRITORY.

THE undersigned, will, without delay, commence the publication of a Newspaper at Fort Garry, Red River, to be entitled THE NOR'-WESTER and to be devoted to the varied and rapidly growing interests of that region.

Exploring parties organized under the direction, respectively, of the Canadian and British Governments, have established the immediate availability for the purposes of Colonization of the vast country watered by the Red River, the Assiniboine, and the Saskatchewan; and private parties of American citizens, following Captain Palisser, are engaged in determining the practicability of rendering this the great overland route to the gold deposits of British Columbia. The Red River Settlement is the home of a considerable population, hardy, industrious, and thrifty; occupying a fine farming country, with all the advantages of prairie and timber combined. It has churches many; and educational advantages which will endure comparison with those of more pretentious communities. And for hundreds of miles beyond, stretches one of the most magnificent agricultural regions in the world, watered abundantly with Lakes and navigable Rivers, with a sufficiency of timber, with vast prairies of unsurpassed fertility, with mineral resources, in some parts, of no common value, and with a climate as salubrious as it is delightful. Such a country cannot now remain unpeopled. It offers temptations to the emigrant nowhere excelled. It invites alike the mechanic and the farmer. Its rivers and rolling prairies and accessible mountain passes, secure to it the advantages which must belong to a highway to the Pacific. It has mail communication with Canada, *via* Fort William; and regular communication with the Mississippi, *via* steamboat and stage to St. Paul. What can impede its development? What can prevent the settlement around Fort Garry from becoming the political and commercial centre of a great and prosperous people?

The printing press will hasten the change, not only by stimulating the industrial life of the Red River Settlement, but by assisting the work of governmental organization, the necessity for which is admitted on all sides; not only by cultivating a healthy public sentiment upon the spot, but by conveying to more distant observers an accurate knowledge of the position, progress, and prospect of affairs.

THE NOR'-WESTER starts on an independent commercial basis. Indebted to no special interests for its origin, and looking to none for its maintenance, it will rely wholly upon the honest and efficient exercise of its functions as the reflex of the wants and opinions, the rights and interests, of the Red River Settlement. Its projectors go thither tied to no set of men, influenced by no narrow preferences, shackled by no mean antipathies. Their journal will be a vehicle of news, and for the pertinent discussion of local questions; governed only by a desire to promote local interests, and a determination to keep aloof from every entangling alliance which might mar its usefulness at home or abroad. It will be a faithful chronicler of events—a reporter, assiduous and impartial. Especially will it aim to be the medium for communicating facts, calculated to enlighten the non-resident reader with regard to the resources and the geography, the life and the sentiment, of the district in which it will be published. Nor will efforts be wanting to render it equal to the tastes of the Red River settlers; arrangements having been made that will secure reliable correspondence from Canada and elsewhere.

During the early winter months of its existence, THE NOR'-WESTER will be published fortnightly, to meet the mail arrangements with Canada; next Spring it will be published weekly, and will be continued regularly thereafter.

The connection which the subscribers have maintained with the Toronto press, is referred to as an evidence of their practical ability to carry out the task they have undertaken.

Price Two DOLLARS per annum, payable invariably in advance. Letters may be addressed to Box 699, Post Office, Toronto, until the 20th September, proximo; after that date, communications to be addressed to Fort Garry—in all cases pre-paid.

WILLIAM BUCKINGHAM.
WILLIAM COLDWELL.

AUGUST 22, 1859.

Broadside or poster of August 1859, announcing the first Canadian newspaper west of the Great Lakes, the Fort Garry (Winnipeg) Nor'-Wester.

METROPOLITAN TORONTO CENTRAL LIBRARY

ROBERTSON'S CHEAP SERIES.

POPULAR READING AT POPULAR PRICES.

MARK TWAIN'S SKETCHES.

The only publication containing the complete Sketches of this celebrated Author, including those written up to January, 1881.

COMPLETE.

TORONTO:
J. ROSS ROBERTSON, 55 KING-ST. WEST, COR. BAY.
1881.

Mark Twain was the most popular author of his day, but at this period there were no international copyright agreements. This pirated edition of Mark Twain's Sketches was published in 1881.
METROPOLITAN TORONTO CENTRAL LIBRARY

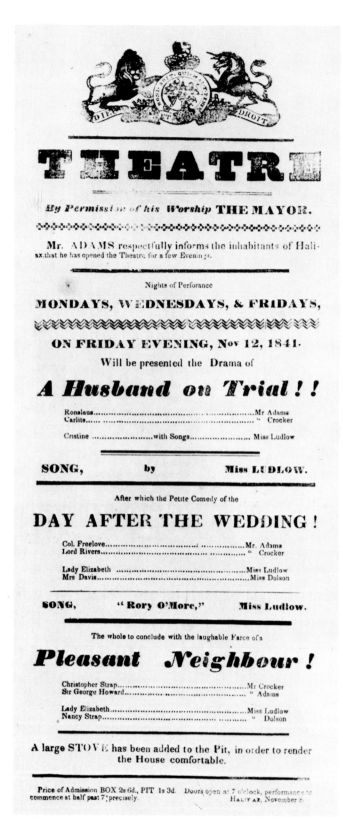

Broadside advertising three short plays at Halifax in November 1841, probably by a traveling company. Theater, one of the few outside entertainments in the 19th century, was very popular in all Canadian centers.

METROPOLITAN TORONTO CENTRAL LIBRARY

southern Ontario, the Eastern Townships and the Maritimes. They include a history of every township and village within the county, township maps with the name of each farmer on his lot, pictures of farms and other buildings, and portraits of prominent local people. Unfortunately only subscribers are included in the biographical listings and the pictures; in some atlases even the maps show only subscribers' farms.

Besides the basic information found in almanacs and directories, the early communities of Canada needed their own legal books, interpreting Canadian law both for the lawyers and the laymen who had a part in the administration of justice as magistrates, coroners and the like. Law reports and legal directories were also published, spasmodically at first, but regularly in eastern Canada by Confederation.

It was also necessary to publish school books in Canada to avoid dependence on uncertain and expensive shipments from Britain. Suspicion of textbooks from the United States (and of American influence on education generally) began early in British Canada. Most of the early textbooks are reprints of English ones; Lindley Murray's *English Reader*, for example, was reprinted by local printers throughout eastern Canada.

There were a few that were prepared by Canadian teachers, like John Strachan's *Concise Introduction to Practical Arithmetic*, published in Montreal in 1809, the *Acadian Preceptor* published in Halifax in 1823, and Jennet Roy's *History of Canada* published in Montreal in 1847. Textbooks can form an interesting collection because of the light they cast on contemporary tastes and morals, and on society. Those published after about 1850 are usually comparatively cheap at the present time and can be found easily, although often not in good condition because they were handed down from child to child and were frequently used by several generations.

Many books and pamphlets were printed in Canada before Confederation concerning religious practises and belief. Liturgies and forms of service for royal occasions, and times of special thanksgiving and adversity were frequently printed. All the denominations—and there were many more in the 19th than in the 20th century—published their proceedings, reports or magazines. More interesting than the official church records are the sermons, published in great numbers in the 19th century. Sermon-tasting is becoming a lost art, but to the average Victorian sermons were intellectually stimulating as well as edifying. Some of the published ones are funeral sermons privately printed by the bereaved family, and others owe their immortality in print more to the clergyman's vanity than to popular demand, but the majority can be fascinating to the modern reader because of their insight into the dogma and morals of earlier generations. The sins regarded as most abhorrent have changed over the years; so also have the style and length of pulpit oratory. Many sermons were preached in the cause of temperance, which produced a whole literature of its own. There are temperance newspapers, magazines, broadsides, catechisms and song books. Other sermon topics were less universal in appeal, although the number that dealt with the scriptural validity of marriage to one's deceased wife's sister would indicate there was great public concern with this now-forgotten controversy.

More significant were the controversies among the churches. Hundreds of sermons and pamphlets were published in which defending the faith meant attacking other denominations. The collector could concentrate on the clergy reserves in Ontario, the Manitoba school question, the Jesuits' Estates Act, or the mass of polemics with strong denominational overtones about the Red River Rebellion. Connected with these are the publications of the Orange movement, which permeated Ontario and the Maritimes. Societies like the Freemasons, Odd Fellows, and the Grange, were also the source of many publications.

The 19th-century Canadian was as interested in political as in religious controversy. The newspapers were of course the main source of fuel for political fires, but many pamphlets and election broadsides were also published, many of them by modern standards outrageously libelous.

Early broadsides were also published by businessmen announcing their wares and services. As Canadian commerce became more complex, there were prospectuses and annual reports of banking, insurance and investment firms, and of companies connected with industry, especially with mining and railways. The first pamphlet printed in British Columbia was Alfred Penderill Waddington's *The Fraser Mines Vindicated*, in 1858, written to encourage miners to persevere in the gold fields. Each fresh discovery of gold resulted in a number of books and pamphlets describing the finds and giving advice to those considering joining the gold rush.

While British and American books circulated freely in Canada, there was still some local printing for recreational reading. The first novel written and published in Canada was Mrs. Julia Beckwith Hart's *St. Ursula's Convent*, written when the author was a teen-ager and published by subscription at Kingston in 1824. A Gothic novel of little literary merit, the book was not as widely read in Canada as the universally popular imported novels of Sir Walter Scott, but still represents a Canadian printing landmark. Poetry had been published in Canada in the 18th century, and slim volumes continued to appear from Canadian publishers. Probably more popular than either Canadian fiction or poetry were factual accounts of local crime, in which the gallows-side repentence of the criminal balanced the gruesome details of his crime.

Another aspect of Canadian literary publishing which might be of interest to collectors is the pirated editions of popular American authors, particularly Mark Twain. American publishers had been printing British books for years; now the Canadians turned the tables, and sold cheap editions of Mark Twain not only in Canada but in the United States. As the New York *Sun* said, "These Canadian devils go to work to take our American books and reprint them for one tenth of our price, and sell them not only in Canada, which they have a right to do, but in our own country, to our own customers."

There were many other types of books published in Canada. Cookbooks were published because often the ingredients in English cookbooks were not available, home medical books because doctors were few. Announcements of social events, playbills and funeral notices are common. By 1869 Canadian publishing had reached sufficient sophistication to produce one of its earliest coffee-table books—*Canadian Wild Flowers* with illustrations by Agnes Chamberlin and botanical descriptions by Catharine Parr Traill.

The possibilities in collecting Canadiana are endless. The collector could specialize in a geographical area, an event, a specific period, a type of book, or a subject in which he was interested. Besides subjects already mentioned, there are hundreds more that could be collected: for example, sports, transportation, or books by or about women. To be satisfying, collecting must reflect the collector's interests.

It should be based on knowledge of the field. This can be gained from bibliographies, which are available in most major reference libraries. A list of some of the most useful general bibliographies is appended. Printed catalogues of libraries such as the Library of Congress, the British Museum and the Bibliothèque Nationale are also helpful. There are many bibliographies on specific aspects of Canadian books; Marie Tremaine's *Bibliography of Canadian Imprints, 1751–1800*, Bruce Peel's *Bibliography of the Prairie Provinces*, and R. E. Watter's *Checklist of Canadian Literature and Background Materials, 1628–1960* are outstanding examples. A complete list of such bibliographies can be found in Douglas Lochhead's *Bibliography of Canadian Bibliographies*, published in 1972. For general information the collector should consult such books as Norah Story's *Oxford Companion to Canadian History and Literature* and its supplement, and the *Dictionary of Canadian Biography*.

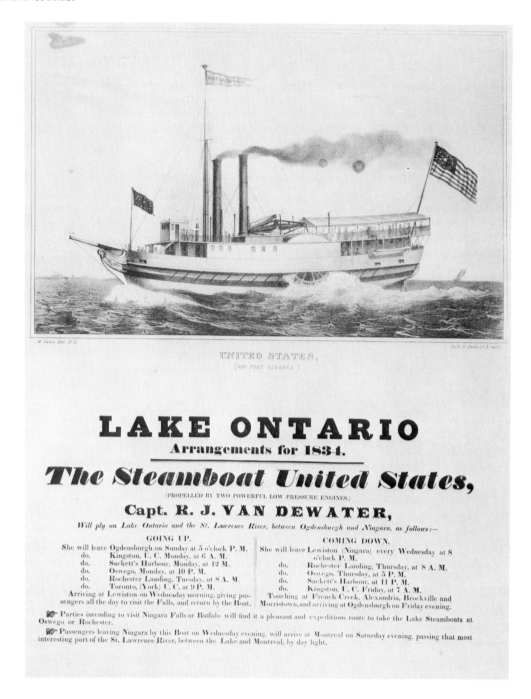

From bibliographies the collector can discover the scope of his field of interest, as well as detailed information about the books themselves. He will find the number of plates, maps, pages, etc. that a perfect copy contains. He will also find which is considered the best edition—not necessarily the first because later ones may have important revisions, added illustrations, and so forth. Some books are especially desirable because of their illustrations, like Nathaniel Willis' *Canadian Scenery Illustrated* made notable by its engravings after William Bartlett's drawings.

The condition of the book is another aspect of concern to the collector. Ideally he should acquire only pristine copies in contemporary bindings. This is not always possible, but it is usually false economy to buy badly damaged or incomplete copies. The collector should also be sure that his books do not deteriorate in his possession. They should be kept away from cellars, attics, radiators, fireplaces, sunlight, family pets and vermin. Restoration should be entrusted to reputable craftsmen. The collector himself should undertake only the simplest repairs—never with sticky tape—and only after reading such books as Lydenberg and Archer's *The Care and Repair of Books.*

Bibliomania is a disease, but an exhilarating one. The collector, however, should always remember that books were intended to be read. To the delights of acquisition and the pride of possession should be added the pleasures of reading.

Photography and Photographers

Ralph Greenhill

The first truly practical photographic process was the *daguerreotype*, named after its inventor, the Frenchman Louis Jacques Mandé Daguerre, and published on August 19th, 1839. A silvered copper plate was sensitized by being placed in a box over particles of iodine, exposed in a camera, and then developed over mercury vapor, fixed with "hypo" (sodium thiosulphate) and given a short wash. Early daguerreotypes are usually found in silk- or velvet-lined cases made of leather, pressed paper, or a plastic composition. Before they were put into these cases, the daguerreotypes were bound up with a gilt mat and cover glass to protect their fragile surfaces. The mirror-like image is unmistakable, unless it has become so tarnished and discolored that the picture is almost completely obscured.

The first daguerreotypes were still-life or street scenes. As eight to ten minutes was the shortest exposure and half an hour was not uncommon, people did not appear in them, even as a blur, unless they happened to have been standing still for several minutes. (A daguerreotype taken by Daguerre himself of a Paris boulevard shows the indistinct image of a man having his boots blacked.) Portraiture was impractical if not impossible. In March 1840, however, the world's first portrait studio was opened in New York by Alexander S. Wolcott in partnership with John Johnson. They overcame the exposure time problem with an ingenious camera that had a concave mirror at the back and an open front without a lens, but technical advances soon made the reflecting camera obsolete. The sensitivity of the photographic plate was accelerated by the use of "quickstuff" (bromine and chlorine) in addition to iodine to "fume" the plate before exposure. Improved lenses also helped to reduce the exposure for an average sitting to half a minute. Finally, "gilding" the plate after it had been fixed increased the contrast and gave some protection from abrasion and oxidation. Few portraits earlier than c. 1842 have survived, and most daguerreotypes can be dated between c. 1845 and 1860 when the process became obsolete. The heyday of the daguerreotype in North America was between c. 1850 and 1855, when it began to be replaced by the *ambrotype*.

The ambrotype, like the daguerreotype, was bound up with a gilt mat and put into a daguerreotype case, but the image is on glass and does not have the disturbing reflections of the silvered plate. The ambrotype is, in fact, a collodion negative, which has a cream-grey image and can be viewed as a positive by laying it on a black surface. (The collodion or wet-plate process was invented by Frederick Scott Archer in England, and published in 1851.) The black backing varied; black paper, black velvet, and black japanned metal were used. Often the glass plate itself was painted black, and sometimes the use of dark-colored glass made any backing unnecessary. The *tintype*, originally known as *melainotype* or *ferrotype*, is a modification of the ambrotype, and early tintypes can be found in daguerreotype cases. The iodized collodion was coated directly onto thin, black, japanned iron plates. The ambrotype was rarely made after 1865, but the practically indestructible tintype, which was first produced in North America in 1856, survived in a modified version well into the present century.

In September 1840, two Americans, Halsey and Sadd, visited Montreal. An advertisement in the *Morning Courier* for September 17th, 1840 announced that "owing to their engagements at Quebec, their DAGUERREOTYPE ROOMS can only remain open a few days longer, which renders it desirable that those Ladies and Gentlemen, who intend to have their Miniatures taken by this novel and extraordinary process will call (the first fair day that may occur) at Mr. Herbert's Music Store [Place D'Armes]." Nine days later, an advertisement in the *Montreal Gazette* stated that the Daguerreotype Rooms would only remain open for three more days. The first advertisement of the two Americans in the *Quebec Gazette* for October 7th, 1840 was more informative. Their "miniatures" were advertised for $5.00, "including the Silver Plate which they are taken on, and a fine Morocco Case"; the exposure was said to be "less than four minutes." Halsey and Sadd, who

*Daguerreotype plate of the Beaver Hall Hill area of Montreal,
c. 1850, with Craig Street in the foreground.*
PUBLIC ARCHIVES OF CANADA

possibly used Wolcott's camera, stayed in Quebec City, where they had rooms over Grace's confectionery store on St. Joseph Street (now Garneau), for nearly a month. It would seem, however, that they were merely taking advantage of the tremendous public interest in Daguerre's process and knew very little about it, since, according to contemporary accounts, their pictures faded on exposure to light.

The following June, "an artist, lately arrived from Paris," advertised "portraits with the daguerreotype" for $4.00. According to one Quebec newspaper, these were more satisfactory and impressive than those of the Americans the previous year. The anonymous "artist" was not the only daguerreotypist to visit Canada in 1841. The same year another anonymous daguerreotypist spent two weeks at Toronto, and in Montreal, Mrs. Fletcher, "Professor and Teacher of the Photogenic Art," announced that she was "prepared to execute Daguerreotype Miniatures in a style unsurpassed by an American or European artist." She arrived in September accompanied by her husband, a phrenologist, and spent about a month in the city. Mrs. Fletcher was by no means the only woman photographer in

Canada during the daguerreotype era, but she certainly must have been the first.

In spite of the many claims that the latest improved methods were used, there was considerable justification for a Toronto paper's reference in 1843 to "that dim and dingy hue which is the principal objection to the sketches of the Daguerreotype." Nevertheless, the photographic accuracy impressed the public, and itinerant artists found that they had to learn the new process to survive. The daguerreotype had brought portraiture within the reach of all but the poor, and the miniature painting and silhouette were soon obsolete. Hand-tinting increased the attraction of the daguerreotype, although the practice was regarded as pandering to popular taste and was criticised for destroying the essential quality of the photographic image.

By the late 1840s the itinerant daguerreotypist, who would have his "operating room" for a week or two in the local hotel, or above a store with a suitable skylight, was no longer sufficiently interesting to be the subject of a paragraph in the local newspaper, and by 1850 there were established "daguer-

Daguerreotype plate of a group with a dog, at the edge of the American side of Niagara Falls, by Platt D. Babbitt, c. 1855. Existing daguerreotypes of scenes, rather than portraits, are most uncommon. NATIONAL GALLERY OF CANADA

rian artists" in the leading cities. Among these daguerreotypists were Eli J. Palmer and Thomas C. Doane. Palmer established a gallery in 1849 in Toronto, where he remained in the photographic business for thirty years. He gave up being a practicing photographer about 1870, but continued as an "importer, manufacturer and dealer in photographic materials of every description." Doane is listed in the Montreal directories from 1847 to 1868. Both men were awarded honorable mentions for their daguerreotypes at the Paris Exhibition of 1855.

No daguerreotype of a Canadian scene, with the exception of views of Niagara Falls, appeared to have survived until a large view belonging to an American collector was identified as being that of Montreal. This splendid daguerreotype of the Beaver Hall Hill area taken c. 1852, is now in the possession of the Public Archives of Canada. Daguerreotypes of Canadian buildings are almost as rare, only one or two being known. At Niagara, Platt D. Babbitt had a little pavilion for his equipment at Prospect Point on the American side and was doing a thriving business there as early as 1853, yet surprisingly few daguerreotypes of the Falls exist today. Ambrotypes taken at Prospect

Point, or on the Canadian side opposite the American Falls, and less commonly on Table Rock, are not rare, despite the high prices paid for such views by collectors in recent years.

Thousands of daguerreotype portraits have survived in their velvet-lined cases. In their simplicity and realism, their directness and strength, the best of these are superb, but this is not true of the majority, which usually have little to recommend them. Daguerreotypes were made in standard sizes, a "whole plate" being $6\frac{1}{2}''$ x $8\frac{1}{2}''$. The one-sixth plate, $2\frac{3}{4}''$ x $3\frac{1}{4}''$, was probably the commonest size, and the quarter plate, $3\frac{1}{4}''$ x $4\frac{1}{4}''$, the next most frequently used. It was not uncommon in England and the United States for the case or gilt mat to be stamped, or for the velvet facing to be cut with the maker's name, but these seem to have been only rarely done in Canada. English and American daguerreotypes bearing the maker's name are often found in family collections in this country, but the majority are anonymous; many are undoubtedly Canadian, and just as many are probably not. Often they can be found in a "Union" case, which was made from a wood flour and shellac composition (not hard rubber or

Cased daguerreotype of a young girl seated on a sofa, with the velvet-faced cover embossed R. MILNE / ARTIST / HAMILTON, C.W. *Robert Milne was the first commercial photographer in Hamilton, operating from 1851 to C. 1870.* NATIONAL GALLERY OF CANADA

gutta-percha as is popularly supposed) and was introduced about 1853. Many of these cases were decorated with complex geometric patterns; others depicted scenes and are superb examples of the die-sinker's art. Charming decorated frames were also made from the same plastic composition.

The daguerreotype, the ambrotype, and the tintype were direct positive processes. Each picture was unique; to be duplicated, it had to be copied. The basis of modern photography was the work of William Henry Fox Talbot, who had given details of his *Photogenic Drawing* to the Royal Society in London, England, in February 1839, after hearing that Daguerre had achieved a successful photographic process. Talbot improved his process, which produced a negative on sensitized paper from which paper prints could be made, and patented it under the name of *calotype* in 1841. The calotype, also known as *talbotype*, and the many modifications of it were fairly widely used by European landscape photographers in the 1850s, but before the end of the decade the paper negative processes had been replaced by the collodion process on glass. The photographer coated a carefully cleaned glass plate with iodized collodion, which, while still tacky, was sensitized in silver nitrate. The sensitized plate was exposed in the camera while still moist, and developed immediately afterwards with either pyrogallic acid or ferrous sulphate. The negative was then fixed in either the familiar "hypo" or a potassium cyanide solution. As the complete operation, from the coating of the glass to the development of the exposed negative, had to be done before the collodion could dry, it became known as the "wet-plate" process. The difficulties of wet-plate photography in the

field were very considerable, as the photographer had to have a complete darkroom with him. A "dark tent" was essential, and in addition there were the chemical chest, plate boxes, and often a barrel of water. These had to be carried everywhere, along with the cameras, lenses and tripod. It was not until the early 1880s that the gelatine dry plate simplified photography, and, at the same time, provided a plate that was ten times faster.

The wet-plate process helped to popularize the *stereograph*, which gave a dramatic effect of solidarity and space by reproducing binocular vision. It consisted of two dissimilar pictures taken either by moving the camera slightly between exposures, or by using a stereoscopic camera fitted with two lenses; the two photographs combined to give a realistic appearance of depth when viewed in the stereoscope. Large calotype prints were made for the reflecting stereoscope invented by Sir Charles Wheatstone, but stereoscopic photography created little interest until 1851, when Sir David Brewster's small box-type stereoscope was admired by Queen Victoria at the Crystal Palace Exhibition. The success of Brewster's lenticular or refracting stereoscope was assured with the establishment of the collodion process, which made possible the cheap mass production of card-mounted paper stereographs. These could be sold at a quarter or less of the price of stereoscopic daguerreotypes or the beautiful albumen-on-glass views. About 1860 Oliver Wendell Holmes invented the simple type of stereoscope that was to be found together with a box of views in almost every late-19th-century home. The craze for stereographs declined in the '70s and '80s, but there was a revival of

interest at the turn of the century, when millions of views were sold.

In 1861 the *carte-de-visite* became "the picture of the day" in North America. *Cartes* were small paper photographs mounted on cards 4″ x 2½″. The craze for collecting *cartes* had started in France in 1859, and the following year was firmly established in England after the publication of portraits by Mayall of the Queen, Prince Consort, and other members of the royal family. People not only bought the mass-produced little photographs of celebrities, but, of course, were themselves photographed in a similar fashion and gave prints to their friends. When the craze for the small *cartes* had begun to wane, the larger cabinet photograph (5½″ x 4″) was introduced in 1866. *Cartes*, cabinet photographs, and tintypes made up the vast majority of portraits from 1867 to the turn of the century.

Before 1860 few Canadian photographers used the collodion process for other than ambrotype portraits; notable exceptions were the photographs of the Assiniboine and Saskatchewan Exploring Expedition and those of the construction of the Victoria Bridge at Montreal. The expedition of 1858, led by Professor Henry Youle Hind of Trinity College, Toronto, included the photographer Humphrey Lloyd Hime. The best of Hime's photographs were excellent. His five portraits of the "native races" have a remarkable affinity with the famous calotypes of Hill and Adamson of Edinburgh, whose photographs are acknowledged to be the masterpieces of early Victorian photography. Hime's portraits taken at the Red River Settlement, have the same dignity and simplicity, and the same naturalism when the attitude of the sitter is in fact posed. The construction of the Victoria Bridge, the greatest engineering work of its day in North America, was superbly documented in a series of large photographs and stereographs taken between 1856 and 1859 by William Notman. It is somewhat ironical that Notman, who may himself have been the photographer for this splendid series, was to become famous not for these forgotten pictures but for his later promotion of some of the worst features of Victorian photography—contrived studio scenes, and the even more artificial paste-and-scissor "composites."

William Notman, who opened his gallery on Bleury Street, Montreal, in November 1856, was the first photographer in Canada to have an international reputation. In 1861 the Canadian government presented the Prince of Wales with three folio albums made up by Notman, containing about 600 photographs of the province and of the Prince's visit the previous year. Presumably as a result of this presentation, Notman was appointed photographer to the Queen. At the International Exhibition of 1862, the unsuccessful sequel to the Crystal Palace Exhibition, he won a gold medal, the first of many major awards. It has often been wrongly assumed that any photograph bearing the name of Notman was taken by Notman himself. Apart from the fact that he had large studios in the late '60s in Ottawa, Toronto, and Halifax, as well as in Montreal, and later expanded his interests even further to include the United States, this assumption shows a misunderstanding of the nature of his business and an ignorance of how the early professionals worked. It was customary for the owner of a large gallery to leave most of the work to his operators, and it was also common practice to buy, sell, and exchange negatives; all

Quarter-plate ambrotype of Laura Abigail Fuller, with two of her brothers c. 1860, the children of Richard Brock Fuller, first Anglican Bishop of Niagara. This family portrait is in a molded plastic union case, the cover shown below.

NATIONAL GALLERY OF CANADA

Portrait of Laetitia Bird, a half Cree woman photographed by
Humphrey Lloyd Hime in 1858. PUBLIC ARCHIVES OF CANADA

of the work produced by such a gallery would be published under the name of the owner.

It was not Notman but another Montreal photographer, James Inglis, who first made "composite" photographs. For these, the sitters were carefully posed in studied attitudes and the resulting photographs were cut out and pasted onto a painted or photographed background. The montage was then carefully worked up by artists, and afterwards re-photographed for the final picture. Such composites became highly popular in the '70s. Notman did a large business in family groups, and even pictures of a single individual were made this way. There was some justification for the large composites of both Inglis and Notman of the skating carnival held at Montreal in 1869 during the visit of Prince Arthur, because such events were impossible to photograph at that time. However, the technique was employed in these and similar huge productions not to overcome the technical limitations of photography but to provide what were in effect tiny portraits of each person in the resulting composite—something photography could never achieve.

Much of the contemporary acclaim given to Notman, and to many other photographers of his time, seems as undeserved

as the heady praise extended to so many Victoria artists. The English *Art-Journal* described his *cartes* as "certainly among the most brilliant *carte-de-visite* portraits we have ever examined." Today these little photographs, with their emphasis on the studio properties, draperies and artificial backgrounds, appear characterless and formalized, although the best of them do have a period charm.

Notman's fame has completely overshadowed his contemporaries, Alexander Henderson, also of Montreal, and the firm of Ellisson & Co. of Quebec. Henderson's work varied in quality, but the best of his photographs give us a feeling of space and time that is rarely captured in the large, technically excellent but somewhat dull views published by Notman. Many of Henderson's albums, like much early photography, have not survived in good condition. The acquisition of a fine copy of one of his many albums entitled *Canadian Views and Studies, Photographed from Nature* (1865) showed that he did some landscape photographs of almost poetic richness. The current enthusiasm for photography and the documentary importance of many early photographs has led to an undiscriminating acceptance of them, but, as in the case of fine

prints of any medium, the best photographs of the 19th century can only be appreciated in a virtually pristine original print.

Modern enlargements have often given a spurious quality to the portraits of Notman and others; the only studio portraits of real distinction taken in Canada during the wet-plate period were those of Ellisson & Co. Their best photographs, taken between c. 1860 and 1865, have a simplicity and strength of character that are almost completely lacking in the work of other Canadian portrait photographers of the 19th century, and the firm's portrait of the two Grey Nuns can stand comparison with those of Nadar, the French photographer who is famous for his portraits of such well-known contemporaries as Baudelaire, Daumier and Delacroix. The importance of Ellisson & Co. appears to have dwindled after 1865 when Quebec was no longer the acting capital of Canada.

Portrait photographers of the '60s relied more and more on props—urns, pedestals, fancy tables, and painted representations of everything from the battlements of a castle to the most improbable classical landscape. At the same time as the cabinet photograph was introduced, the classical balustrades, columns, and vases began to be replaced by rustic ferns, leaves, and rocks, which in the larger photographs appeared even more fatuous than in the small *cartes*. Possibly the most important effect of the new size was the introduction of negative retouching, which completed the artificiality of professional portraiture. The honesty and vitality of the early photographers was lost, and studio photography in the '70s entered upon a period of appalling dreariness.

Daguerreotypists had found that there were fortunes to be made with the camera in the California gold rush, so it is not surprising that when gold was discovered on the Fraser River there were at least two photographers, George Robinson Fardon and Stephen Allen Spencer, among the thousands who arrived in 1858 at the tiny settlement at Fort Victoria, Vancouver Island, from which the would-be miners headed for the mainland. Fardon retired about 1870, but Spencer was still in business in 1885. It is impossible to attribute many of the early pictures of British Columbia to a particular photographer. The prints are often unidentified, and attribution is made even more difficult by the fact that more than one photographer—Frederick Dally, for example—sold his negatives to another when he left the colony. (Some of Dally's negatives or prints of his photographs were eventually acquired by Mr. and Mrs. Maynard, the best-known 19th-century photographers in British Columbia.) Dally took a great many of the best of the existing photographs of the 1860s, and his views of the Cariboo goldfields and Barkerville were particularly outstanding. In 1871 some excellent photographs of British Columbia were taken by Benjamin F. Baltzly and his assistant, John Hammond. The two photographers accompanied the survey party headed by Alfred R. C. Selwyn, Director of the Geological Survey of Canada; they were paid and equipped by Notman, but their traveling expenses were paid by the government. Their fine photographs can be found in "Notman" albums of the 1870s, and are sometimes wrongly attributed to William Notman himself, who never visited Western Canada or British Columbia. Few of the many western photographs taken by various Canadian Pacific Railway and Geological Survey expeditions do more than provide some valuable documentation. Only an occasional picture, such as a fine study by Charles Horetzky

The building of the Victoria Bridge, Montreal, with men laying the base of a stone crib, in 1858, taken from half of a stereograph by William Notman. AUTHOR'S COLLECTION

of an encampment on the North Saskatchewan River in September 1871, is visually exciting or gives a truly revealing glimpse of the past.

The life that was missing from so many of the large prints of the period can be seen in the exceptionally attractive stereographs of Louis Prudent Vallée. (The stereoscopic cameras used short focal-length lenses of wide aperture, and it was possible to take "instantaneous" views with these fast lenses in spite of the slow speed of the collodion plate.) Vallée, who began in photography in 1867, made a specialty of selling views to the tourists visiting Quebec. Some of his eight-by-ten views also appear in "Notman" albums, but they are even better in their small stereoscopic format where the added dimension vividly recreates the scenes, even to the ruts in the streets. A wide range of stereographs, including a series of views of both Hamilton and Toronto, were published by James Esson of Preston, Ontario. Other photographers who, during the wet-plate period, published both stereographs and larger views of historical importance were J. G. Parks of Montreal, W. J. Topley of Ottawa, and the firm of Livernois & Bienvenu of Quebec. In the Maritimes, James Notman, younger brother of William Notman, published a fine series of stereoscopic views of Saint John, New Brunswick, where two other photographers, J. S. Climo and James McClure, also did a considerable amount of stereoscopic photography.

Photography played a significant part in the development

Portrait of two sisters of the Grey Nuns, c. *1863, by Ellisson*
& Co. NATIONAL GALLERY OF CANADA

Tanneries de Roland (Quebec), by Alexander Henderson of Montreal, probably 1864–65. This and the following photograph are from Henderson's Canadian Views and Studies, Photographed from Nature, *issued in 1865.*

of the pictorial press in the 19th century. Photographs, reproduced usually as wood-engravings, became an important source of illustrations for books and periodicals, and editors often drew attention to the fact that photographs had been copied in order to vouch for the accuracy of their pictures. In the early '60s a short-lived periodical, the *Canadian Illustrated News*, was published at Hamilton, Canada West. This first production of a Canadian illustrated weekly contained many pictures engraved from photographs. On October 30th, 1869, the first issue of an entirely new weekly paper with the same name was published in Montreal by George Edward Desbarats. This was Canada's first national news magazine, and the first in the world to use halftone reproductions of photographs. These halftones were the work of William Augustus Leggo, a Quebec engraver, who, in collaboration with Desbarats, had patented his *Leggotype* process in both England and the United States in 1865. This process was only practical for the reproduction of engravings and line drawings, not halftones, until Leggo developed his "granulated photograph," which he patented in Canada in 1869 and in England and the United States in 1871. Halftones do not appear in the *Canadian Illustrated News* after 1872 when Leggo moved to New York, where in 1873 he

established the world's first pictorial newspaper, *The Daily Graphic*.

In the early '80s the gelatine dry-plate superseded the collodion wet-plate process and created a revolution in photography. Not only was the photographer freed from the cumbersome paraphernalia of the collodion process, but he could now buy commercially prepared plates that were ten times as fast as the standard wet plate. The simplicity of the new dry plates brought about an enormous increase in the number of amateur photographers, and a flood of equipment and handbooks for them appeared on the market. In 1888 George Eastman completed the revolution in photography started by the gelatine dry plate when he marketed the first *Kodak*, a small box camera that was loaded at the factory with a roll of paper coated with a gelatino-bromide emulsion. The camera took 100 exposures, and was returned to the factory for processing and printing. In 1889 Eastman substituted transparent roll film for the paper, and the camera had no longer to be sent back for processing and reloading. If the amateur could not do these things for himself, there were plenty of developing and printing firms to do them for him. Modern photography with its millions of snapshooters had arrived.

Spring inundation (1865) of the shores of the St. Lawrence River, also by Alexander Henderson (active 1859–90).

NATIONAL GALLERY OF CANADA

Dating and Identification

Dealing with all the diverse topics that could enter into a book of this type is nearly impossible, and some specialized areas unfortunately must be glossed over. Such subjects as conservation and restoration, wood analysis and identification, historical relationships, or furniture dating procedures, are important but they are also areas in which much has been published in the past.

Essentially, the process of dating early objects is one of close observation, analysis and comparison. The procedure approaches archaeological techniques of assessing earth layering or stratification in an excavation, and then dating layers or occupation periods from comparison of the artifacts found buried within them. Information, and particularly object-dating conclusions derived from archaeology, can be in fact extremely useful to the antiquarian.

Basically, all antique objects within our consideration comprise many specific, even minute, details and characteristics which must be analyzed, compared, and balanced for their usability as dating evidence. These details may be anything from the canvas used or the clothing depicted on figures in a painting, to the screws or hardware used or the manner of sawing a board in a piece of furniture.

All specific characteristics and details have some sort of definable date range, a beginning to their period of fabrication, fashion or popularity, and use. Characteristics which are wholly obsolete have as well a terminal point. Obviously those details with the shortest and most distinct chronological ranges are the most valuable as dating evidence, while those with the longest and most indistinct periods of use are far less precise.

In applying this to the examination of any particular object, observation, basic dating, and comparison of details are the primary essentials. These may be simple enough to be cogitated on the spot, or they may have to be done by taking notes on paper for subsequent study and checking in references. Examination should include check for incongruities or the imposition of non-original work or detail. In archaeology these could indicate anything from later intrusion to continuous occupation; in antiques they signal restoration, alteration, or fakery.

Once details have been checked, and presumably found basically original, with additions spotted and noted, dating of the whole antique is then a matter of balancing the date ranges determined for the individual details. There is one basic assumption—almost a law of antiquities examination—that will narrow the range: *An object cannot be earlier in date than the earliest known date of its latest characteristic.*

For a purely hypothetical and oversimplified example of this, assume a pine corner cupboard with doors mounted on cast iron butt hinges with a cast-in date 1843, but with a back of obviously original rough boards showing curved marks from having been cut on a circular saw rather than a straight-bladed reciprocating saw. The balance of just this evidence indicates that the cupboard cannot date earlier than about 1875, or the period of introduction of circular saws for cutting lumber. The older hinges must have been used simply because they were available. Though the evidence from details is rarely as precise as this, the basic rule that the latest original detail governs dating still invariably applies.

The obvious corollary to this is that an object *cannot be later in date* than the *terminal date of its latest characteristic*, and *usually* not later than the terminus of its earliest characteristic. Remember, however, that terminal dates of many details or components in antiques are much less definable or conclusive than beginning dates, because of often long continuity of use. Dates of cessation of fabrication or manufacture alone are not sufficient for ascribing end-dates of usage.

Looking at these rules archaeologically, in excavating an early French-Canadian building it would be quite possible to find, in a single level, wine bottle glass and green-glazed earthenware of the 1740s, together with perhaps a coin bearing a mid-17th-century date, as well as a gunlock and parts of c. 1690–1700. If we assumed a date for this level based on the date of the coin, or of the gunlock, the presence of the later artifacts could not be explained. If, however, the level is dated from the latest artifacts, the glass and pottery, as it must be, then it becomes logical to deduce that, since they were found in the same context, the coin was still in circulation c. 1740, and the gun still in use.

We then also establish that as of c. 1740 neither the century-old coin nor the by then aged gun had yet reached their own terminal dates, and thus are not good alternatives as valid dating evidence. Indeed, being of reasonable material permanency, barring the fact of loss and subsequent burial, both coin and gun could presumably have remained in use even longer.

The ability to observe logically and critically, and to consider detail, are talents of primary importance which must be individually developed to the point of becoming instinctive. This studied observation, of course, must derive from background knowledge of what one is looking for, and of what is important or definitive and what is not. The capability of balancing evidence and arriving at conclusions then follows naturally with experience.

Another aspect, that of wood identification, is usually a primary consideration in identifying and locating the origin of furniture. In most cases, to someone who has experience in determining wood species visually from texture and grain structure, and in obvious pieces where area context and design is against any great range of possibilities in the woods used, it is not difficult to determine what woods are present. However, *it is simply not possible to tell in all cases absolutely what species a particular wood is by visual examination alone.* Age patina or the vestige of past finishes can throw one off, and the climate and conditions in which particular trees grew can create visual difference in cut woods even from the same species of tree.

If we had leaves to examine, or budded twigs, or anything other than smoothed and finished pieces of wood, species identification would be a simple matter. However, the cell structure of wood is just as ascribable to particular species as are twigs, buds, or leaves. Identification from cell structure requires

a small sample, perhaps an unfinished splinter taken from an unobtrusive area, which can then be sliced into a thin section and examined microscopically by a specialist expert.

Microscopic wood examination may seem relatively unimportant from the collector's viewpoint, but in fact it is sometimes essential, particularly for resolving incongruities. In the early 19th century, for one thing, vast quantities of North American hardwood, both as logs and lumber, were exported to England and Europe. There is no shortage in the current antiques market, as a result, of English furniture with ever-popular North American curly or birds-eye maple as its primary wood. It is often necessary to arrive at exact species identification of the secondary woods in such pieces in order to be certain, beyond question, of their English origin. There are also many commonly used European woods which are visually very similar to North American woods—too similar for certain visual identification. These often occur in pieces of European furniture that may resemble North American, and particularly French-Canadian, design forms.

All Canadian furniture of indigenous woods is of wood from the same geographic area, from species with connecting or overlapping natural growth ranges. It happens, however, that early alterations or repairs were sometimes done with material quite different from the original, with wood that did not come from the same locale. Careful wood analysis will spot such anomalies and, at the very least, raise the immediate question— why? Microscopic wood analysis is, to be sure, unnecessary for many furniture examinations, but when any sort of question or suspicion arises that can be resolved in no other way, there is no alternative to this approach.

As an example of this, there recently appeared a basically French (and French-Canadian) form of *os de mouton* armchair, which had come to a dealer from a family in Nova Scotia and was assumed to be Canadian. The wood appeared to be butternut, but the proportions and scroll-work of legs and arms were sufficiently unusual to stimulate doing a microscopic wood analysis, from two different samples. The seat rails, under the upholstery, were reported as American beech, which would be possible but most unusual as a Quebec cabinet wood. A leg stretcher sample, however, and apparently the rest of the chair frame, turned out to be California walnut. These most unexpected results were rechecked and found accurate. American beech and California walnut do not grow, in their natural ranges, within 2000 miles of each other.

This is an extreme case, to be sure, and the origin of this chair still remains a mystery. The wood analysis, however, did raise specific questions, as well as establishing that the chair could not be a Quebec piece. It may possibly be Mississippi Valley French, or, more probably, California Spanish in a French manner; no one can be sure. No analytical system is perfect, or capable of resolving all questions under all conditions. In this case wood analysis cannot establish the origin of the chair in the absence of an explanation of how two totally incongruous North American wood species came together in the apparently original structure of the same piece.

Restoration and Care

Restoration may present the collector with some difficult practical problems and esthetic dilemmas. A great deal has been published on restoration and refinishing, including several recent "how-to" books, all basically good, but none of which should be taken literally.

Essentially, restoration *should be* the art of conserving and perpetuating the original state of an antique, not of refashioning or totally reburbishing. Thus restoration can include refinishing, done carefully and only as essential, to the point of cleaning off overlying paint layers, varnishes, and so on, but not to the removal or alteration of original finishes, stains, or decorative paint. The all-too-prevalent practice of overcleaning or scalping furniture to bare wood, while the easiest approach, is akin to cleaning a painting to bare canvas and starting over with a fresh picture.

We had a very tricky case in point a few years ago. The Ontario-German cupboard with carved fish and serpents illustrated on page 139 came to the Museum covered with a dark red paint mottled with black, a common finish on Ontario-German furniture. The paint in this case, however, was a late 19th century oil-based enamel—much later than the cupboard itself. The black-mottling-on-red finish also overlay another coat of brown enamel, that not original either.

The cupboard at one time had been too close to a wood stove, and the paint on the front and one end was badly crazed and blistered. In this state, there was no sign of an original milk-based stain. The question was whether to try to clean and keep the surface black-over-red paint layer.

After six months of periodic examinations, we decided to clean from a small area both of the non-original paint layers, to the original surface. Though the piece was pine it emerged, strangely enough, that the surface had never been painted originally. The cupboard had instead been decorated over bare wood with brushed loopings and zig-zags of raw walnut juice, an extremely strong, nearly black stain.

Our doubts were now resolved and our course was clear, though the cleaning had to proceed in an extremely slow and painstaking manner to avoid any possibility of damage to the stained decorations.

Restoration may also include the well-studied replacement of missing segments, or repair of damage, again only to the least extent necessary. From a conservative approach, whatever

possible of damaged original fabric or structure, which might otherwise be removed and replaced, should instead be repaired and retained.

Clear or deliberate alteration should be avoided at all costs. At best, alteration is artificial refurbishing, sometimes of questionable accuracy, and is known in the antiques world as "substantial restoration." At worst, heavy or inaccurate alteration, still purveyed as "antique," approaches pure fakery.

As for techniques and materials, the gentlest solvents and most careful and thoroughly considered technical approach is always preferable to the slapdash or the harsh in the interest solely of speed in getting the job done. The latter is merely destructive.

Another essential rule is never to use as a material, or to practice as a technique, anything which is irreversible—which cannot be undone later. Very strong but less than easily controllable coat-and-scrape paint and varnish removers, intended for paint-encrusted exterior woodwork, have no place and should never be present in a refinishing shop. Sandpaper, steel or glass scrapers, and chisels, though possibly necessary in fashioning replacement segments or removing old glues, should never be used in paint removal or refinishing or original furniture. Most particularly, insoluble glues, permanent epoxys, and modern instant-drying-hold-anything adhesives are disaster materials. Should the need arise as it inevitably will for further future restoration, they cannot be undone.

As important as restoration is the problem of maintenance. The collector should attempt to provide the most suitable conditions of temperature, humidity and light for his collection. The dry atmosphere of an unhumidified central-heated house in cold weather may cause shrinkage in furniture or separation of inlays and veneers. Even when the air temperature is not excessive, the radiant heat of the sun shining through a window may craze a varnished surface. Other items, such as prints, books and textiles, also have their special requirements.

Antiquities of all categories, as defenseless objects, are subject to enough natural and unpredictable hazards, from fire to floods to acts of war, to ensure an inevitable decline in their existing numbers. Human destructiveness, whether deliberate or through carelessness, is both the most predictable and avoidable, and therefore the least excusable, cause of damage and loss.

The Problem of Fakery

Canada has for many years had a few particularly far-sighted specialist collectors of Canadian antiques, the original builders of what have become the finest present-day collections. Until a relatively few years ago, however, collecting interest in Canadian antiques was limited to comparatively few people, and market prices even for prime objects were low. This was the period, among other things, when great numbers of fine Canadian antiques were exported to the United States and Britain, simply because of the economics of the antiques business.

The recent surge of popular interest in collecting has astronomically elevated the market values of Canadian antiques, particularly of prime or first-rate pieces. This price appreciation has already been sufficient largely to reverse the continental economics of antiques, to the point where the present American price structure is generally lower than the Canadian.

This rapid and volatile rise in Canadian antiques prices has engendered another problem for antiquarians and collectors —faking. Countries with a much longer collecting experience than Canada's have had to deal with fakery for decades, but it is a phenomenon fairly new to this country. Antiques faking in Canada has so far affected only a few object categories, but it is already sufficiently extensive to be a real concern, and is bound to increase both in its scope and in the expertise of those who practice it.

In the antiques market, small details and elaborations in otherwise very similar objects can make a vast difference in value, simply because basic objects are usually plentiful, while the elaborate is rare. Thus the restructuring or alteration of simple or low-priced objects, the addition of detail or decoration, or the addition of markings, if very carefully done, can add market value to the point of being extremely profitable to the faker.

The identification of fakery requires knowing, foremost, what to look for in extreme detail, as well as a thorough background of knowledge of what is and is not likely to be original. Truly expert work can be very difficult to spot, even when relatively newly done; inept work is less hard to distinguish. All restoration, alteration, and fakery unfortunately mellows with age, and with time becomes increasingly difficult, and sometimes impossible, to identify with certainty.

Consider Quebec pine armoires, in which various degrees of fakery are not uncommon. Plain rectangular-paneled armoires, for example, are the majority type and quite common, while diamond or lozenge-cut paneled pieces are scarce and expensive. The surface cuttings of plain panels into relief diamond or lozenges is not particularly difficult, but the added-value potential is considerable. After careful staining of the freshly cut wood, and perhaps overpainting, the new "diamond-point" armoire can easily fool the uninitiated. Collectors who are aware that original early diamond-point or lozenge panels were thicker than finished plain panels, or who can spot a door or frame that has been taken apart and reassembled, are more likely to spot this rather simple form of fake.

Other fakes can be more challenging. Made-up pieces of furniture, for example, are increasing in the market, produced

either by substantial addition to an existing partial piece, or by creation of wholly new pieces from assorted scraps. In both cases old wood is used, as are early cabinetmaking techniques, including, of course, careful blending of new cuts or joints. Because of the very ticklish problem of matching and blending the color and patina of newly joined old wood, it is found much easier to conceal furniture alteration or fakery with extreme "refinishing"—everything scraped to bare bones—than it is to maintain and match original finishes at the joins.

Though furniture fakery does not appear as yet to be really widespread in Canada, the collector, even the knowledgable collector, will occasionally run across a piece that simply seems "wrong," although he or she cannot put a finger on precisely what. This may be merely because it is generally easier to spot the specific alteration to a basically original piece than to be sure that a whole integral piece is not genuine. The collector who knows and can isolate those details which have value-additive potential also has a focal point for suspicion and examination. The wholly made-up piece, conversely, offers no localized points for definitive examination; rather the entire object is wrong, and what makes it so is less readily definable.

Generally speaking, if an expensive piece should seem in any way questionable, request of the seller that you let someone else examine it. If this is refused, or even greeted reluctantly, decline the piece. Likewise, unless suspicions can be totally resolved, pass up the piece. Buying a suspicious antiquity which later is discovered to have substantial but carefully concealed restoration or alteration, or to be a complete fake, is hardly a good investment.

Furniture faking so far appears limited pretty well to the rarer and more expensive early Quebec types, though extensive restoration is ubiquitous. As well as being cautious in considering armoires, be careful of made-up pieces in other categories such as commodes, buffets-bas, and early chairs, and be doubly careful with over-cleaned pieces from which patina has been removed. So-called *os de mouton* footstools should also be examined critically, since there are numbers in circulation which have been put together from parts of one or more chairs, some apparently at an early date from chairs that had become unrestorably shaky.

As well as furniture, silver has become a prime medium for faking. In particular, the false marking of "Quebec" church silver and of domestic hollow-ware has become quite common. Some of these alterations are false makers' stamps recently applied to previously unmarked but probably Canadian pieces. However, originally unmarked and recently imported French silver also turns up with Canadian punch-marks. Much of this work is sophisticated, with well-rubbed artificial wear over the new markings, and hence is very difficult to spot. It is thus essential to examine markings on silver both with preliminary suspicion, and in relation to the overall configuration of the piece. Ignoring markings *per se*, try to decide whether the piece is Canadian, and if so, whether it is reasonably compatible or consistent with known workmanship of the specific silversmith whose work it purports to be.

The situation of Canadian-made Indian trade silver is worse. Trade silver was heavily produced by a few Montreal and Quebec makers for the North West Company, with larger pieces marked. English trade silver, produced for and distributed by the Hudson's Bay Company was, conversely, rarely marked. Since so much of original fabrication has long since been lost or buried with the dead, extant pieces are scarce. Trade silver also, being generally of thin coin silver sheet, was and is very easy to make.

Generally speaking, trade silver fakery is very nearly total, in terms both of false markings on early pieces, and particularly of production of wholly new pieces. The situation is such that it is best to treat all Indian trade silver offered for sale as fake until proven otherwise, and to consider no piece that does not have a counterpart type, in a known museum or other public collection, derived from a specific archaeological context. There are many wholly imaginative fakes about at present, in forms that are not known to have existed as early trade silver.

The whole area of reproductions also causes increasing difficulties. It is those objects with the greatest collector pressure in relation to existing supply that are the most commonly reproduced for sale to those who cannot find or afford original examples. Of Canadian antiques, at least, reproductions have so far been limited to a few types of Quebec furniture, to Quebec metal weather-cocks, to glass patterns that are continental rather than solely Canadian, and to cast iron and other metalwork.

Reproductions are pieces which are not necessarily made by early methods, or with antiqued appearance or with any fraudulent intent—at least in their initial making. Once the better and more faithful reproductions begin changing hands, however, and become subjected not only to additional work but also to mellowing with age, they can become increasingly difficult to identify as reproductions. People very often buy antique objects impulsively without, unfortunately, any kind of thorough examination, and wind up as victims of their own carelessness. Dealers, too, when they occasionally offer a reproduction as an original piece, in most cases are themselves not aware of the error.

Most reproduction furniture is made in the nature of adaptations from early forms rather than as identical copies, and could never, except very superficially, be mistaken for antique. The best and most reputable makers of reproductions usually also brand or otherwise permanently mark their products. However, it is well to remember that as soon as they leave their original maker, all reproductions of antiques are released from both ethics of fabrication, and controls. Reproductions are subject to aging and the wear of usage exactly as original pieces, and they are equally subject to later "restoration," alteration, and refinishing, as well as all of the artifices of the true faker.

There is little that can practically be done to prevent either faking of antiques, or the circulation of fakes in the market. Fakers, though often excellent craftsmen, do not make themselves or their products known; the products simply appear. Fakery, and various shadings of it, of wholly Canadian antiques is definitely on the increase, and is not likely to become any less of a problem to collectors in the future.

There is no possible way, without major investigation and a sizeable book, to outline all of the aspects, manifestations, and techniques of fakery in such a way as to prevent collectors from making occasional mistakes. There are, however, a few general rules that should help.

1. Excessive enthusiasm or impulsiveness in buying, which breeds carelessness, should be avoided or repressed at all

costs, particularly if the object of the enthusiasm is expensive.

2. Approach with deliberate suspicion any expensive piece where small detail or an aspect of elaboration or decoration is essentially what gives the piece its high value.

3. Never spend a large sum of money on such a piece as in 2 above without a cool and thorough overall examination, and do not hesitate to confess doubt and seek other opinions. Self-deluding pride is as poor a basis for buying decisions as is impulsiveness.

4. Do not buy an antique at all if there remain significant unresolved questions about it.

5. There is no substitution for knowledge, and the ability to compare, interpret, and apply information practically. Gain as much experience as possible, through observing and comparing at every opportunity—whether or not you intend to buy.

Antiques as an Investment

A final question which should be looked at briefly is antique collecting as an investment. Are Canadian antiques in general a good financial investment? Are price values likely to rise sufficiently overall to provide both a cushion against inflation as well as some actual gain?

The antiques market is perhaps one of the last wholly unfettered supply and demand situations left, subject neither to regulation or government interference. In any transaction, the antiques market operates on direct individual contact, knowledge, wits, and decision-making. The person who knows exactly what he or she is about, through personal knowledge and awareness, and is quickly decisive as well, has a distinct advantage in the exercise of sorting grain from chaff, and acquiring the good and worthwhile.

One of the inherent problems of trading in an anarchistic market is the absence at any given time of firmly established price values for specific antiques. Unlike stocks, bonds, or commodities, antiques are not bought and sold through any single organized and regulated exchange that posts daily quotations. There are but two ways of establishing the approximate value of a specific antique. One is to look up prior sales records (usually auction) for similar objects, records which may be several years old. The other is simply to buy, or sell, the antique itself, the value then being the price negotiated. Even such established prices, however, represent only single sales to single buyers. At best they would only be guides to price in other transactions.

Another investment consideration is the question of liquidity, for antiques are not as readily disposable for current full value as are more standard investments. Since there is no central market, one cannot call one's broker and sell at a known price. Selling and buying, more like real estate, is wholly a matter of individual negotiation, which will not necessarily be carried out quickly.

To sell within a "reasonable" time, a collector may have to solicit offers from several dealers, for different dealers have different priorities and markets that affect what they will buy and what they will pay. Dealers will also discount their offers for an antique from what they expect in turn to get through resale.

Then there is the auction route, but the antique owner here may have to wait for several months for a sale group to accumulate before his piece is actually put up. The auction house will take a commission of 15 to 25 percent of the selling price. If the owner has given the auction house a "reserve" or minimum price, there is also the chance that the piece will not sell at all, though the owner may well be charged a commission based on the reserve price, as if he had bought his own piece back.

Overall, let us say, antiques are rather unpredictable, and certainly do not have the disposal liquidity of conventional investment forms.

Now, what about price appreciation over the short or long term—what causes it? One factor, of course, is scarcity or rarity in the face of increasing demand. While the existing supply of desirable antiquities constantly declines, ever more serious collectors enter the market to compete for the few prime antiques available at any given time. Even though rarified price levels for truly prime pieces obviously reduce the market considerably, there seems to be no shortage of potential buyers.

The categories of antiques that have showed the greatest demand-pull value increases in recent years were largely the preserves of specialist collectors—rare books, good antique silver and pewter, particularly fine furniture, good paintings by well-known artists, prime ceramics and glass, small objets d'art, and fine prehistoric, primitive and ceremonial art. Generally speaking, antiques of first-rate quality have shown value percentage gains over the last few decades very considerably greater than have mediocre or commonplace antiques.

The kind of market in which such objects most usually appear is one that the average non-specialist collector cannot or is at least unlikely to enter. Prime pieces are so scarce that the collector must, first, have that particular dedication to the hunt that leads to being considered a known and valued customer, and being on the insider list to be called, by specialist dealers. The collector must also be sufficiently motivated to pore through quantities of dealer's listings and auction catalogues, enter into endless correspondence, indulge in long telephone calls, and have a decisive chequebook.

Then there is the vastly larger general collector market, with a buyer base that supports myriad general antique shops, provides large crowds at antique shows, and produces the numbers who turn out for weekend flea markets and country auctions. Only a small proportion of these collectors specialize in any particular object category. Most, rather, are omniverous antiquarians, who acquire on a basis of personal taste and the subjective appeal of objects, and largely for home furnishing or decorating, rather than because of object significance.

This is a market allied closely to popular fashion, but the demand it exerts has resulted over the last dozen years in a considerable price escalation for commonplace antiques, for Victoriana, and for objects evocative of early-20th-century nostalgia. Many of these antiques exist in sizeable quantities, and certaintly much of the general antiques market is dependent on fashion demand rather than object rarity or significance. How stable the price structure will be over the long run we cannot really judge; at present it appears firm. Fashions, however, like general economic climates, can and do shift, sometimes rapidly and drastically.

Buying antiques as a personal investment is a gamble, to be sure, that will invariably result in long-term losses, or non-gains, as well as investment successes. (The non-gain would be the investment that in its appreciation treads water, simply staying even with general inflation.) There is also something to be said for the idea that the more one is motivated to buy as a pure investment or speculation rather than through real antiquarian feeling, the more likely one is to invest badly.

For this reason, specialist collectors are probably in the best position to invest wisely and to come out ahead in the end. Their motivations and goals lead them automatically to the qualitative aspects of antiques, and these, from past records and experience, are the most likely to hold or appreciate value. Specialists are also likely to know their specific subjects absolutely, to have a library of virtually everything ever published on what they collect, and to approach antiquarianism almost professionally.

General collectors, on the other hand, are in a more risky position as investors in antiques, and should certainly keep their real motivations in mind—that they are buying antiques which appeal to their personal aesthetic senses, and primarily for functional or decorative purposes. Collecting here, though the results are more tangible, may better be compared to indulgence in travel, books, theatre, or restaurants, all based on the enjoyment of available finances. The general collector, who in any event would seem most unlikely to see actually declining antiques values, might be best advised to view collecting as an avocation which offers great pleasure and provides enjoyable surroundings, and not think or worry over-much about capital "I" investment or growth potentials.

D.B.W.

Bibliography

GENERAL

Abrahamson, Una, *God Bless Our Home: Domestic Life in Nineteenth Century Canada*, Toronto, Burns & MacEachern, 1966.

Antiques, The Magazine, Whole issue, July 1967, devoted to Canadian antiques.

Canadian Antiques Collector, bimonthly, Toronto, 1967– —.

Clark, Victor S., *History of Manufactures in the United States* (3 volumes), New York, Peter Smith, 1949.

Comstock, Helen, (ed.), *The Concise Encyclopedia of American Antiques*, New York, Hawthorn Books, 1965.

Guillet, E., *Early Life in Upper Canada*, Toronto, Ontario Publishing, 1933.

Lessard, M., and H. Marquis, *Encyclopédie des antiquités du Québec*, Montreal, Les Editions de l'homme, 1971.

Genêt, Nicole, Luce Vermette, and Louise Decarie-Audet, *Les Objets familiers de nos ancêtres*, Montreal, Les Editions de l'homme, 1974.

Minhinnick, Jeanne, *At Home in Upper Canada*, Toronto, Clarke Irwin, 1970.

Séguin, R.-L., *La Civilisation traditionelle de l'"habitant" aux XVIIᵉ et XVIIIᵉ siècles*, Montreal, Fides, 1967.

—————, *L'Habitant au Canada français aux XVIIᵉ et XVIIIᵉ siècles*, 1968.

Stevens, Gerald, *In a Canadian Attic*, Toronto, Ryerson, 1963.

ARCHITECTURE

Arthur, Eric, and Dudley Witney, *The Barn: A Vanishing Landmark in North America*, Toronto, McClelland & Stewart, 1972.

Blake, V. B., and Ralph Greenhill, *Rural Ontario*, Toronto, University of Toronto Press, 1969.

Gowans, Alan, *Church Architecture in New France*, Toronto, University of Toronto Press, 1955.

—————, *Building Canada: An Architectural History of Canadian Life*, Toronto, Oxford University Press, 1966.

Lessard, M., and H. Marquis, *Encyclopédie de la maison québecoise*, Montreal, Les Editions de l'homme, 1972.

Lessard, M., and Gilles Vilandré, *La Maison traditionnelle au Québec*, Montreal, Les Editions de l'homme, 1974.

Macrae, Marian, *The Ancestral Roof*, Toronto, Clarke Irwin, 1963.

Rempel, John, *Building with Wood*, Toronto, University of Toronto Press, 1968.

Séguin, R.-L., *Les Granges du Québec du XVIIᵉ au XIXᵉ siècle*, Ottawa, Ministère du nord canadien et des ressources nationales, 1963. (National Museum of Canada, Bulletin no. 192).

Traquair, Ramsay, *The Old Architecture of Quebec*, Toronto, Macmillan, 1947.

ART

Allodi, Mary, *Canadian Drawings and Watercolours in the Royal Ontario Museum*, Toronto, Royal Ontario Museum, 1974.

Barbeau, Marius, *Cornelius Krieghoff*, Toronto, Macmillan, 1934.

Bell, Michael, *Painters in a New Land: From Annapolis Royal to the Klondike*, Toronto, McClelland & Stewart, 1973.

Campbell, H., *Early Days on the Great Lakes: The Art of William Armstrong*, Toronto, McClelland & Stewart, 1971.

Colgate, William, *Canadian Art: Its Origin and Development*, Toronto, Ryerson, 1943. Also in paperback.

Harper, J. Russell, *Painting in Canada*, Toronto, University of Toronto Press, 1966.

—————, *Paul Kane's Frontier*, Toronto, University of Toronto Press, 1971.

—————, *People's Art: Naive Art in Canada*, Ottawa, National Gallery of Canada, 1973.

Hubbard, R. H., *The National Gallery of Canada Catalogue of Paintings and Sculpture* (3 volumes), Toronto, University of Toronto Press, 1960.

Jouvancourt, Hugues de, *Cornelius Krieghoff*, Toronto, Musson, 1972.

Spendlove, F. St. George, *The Face of Early Canada*, Toronto, Ryerson, 1958.

Vezina, Robert, *Cornelius Krieghoff*, Quebec, Librairie Garneau, 1973.

BOOKS

Canada, Public Archives of, *Catalogue of Pamphlets in the Public Archives of Canada ... prepared by Magdalen Casey* (2 volumes), Ottawa, 1931–32. Reprinted 1967.

Gagnon, Philéas, *Essai de bibliographie canadienne* (2 volumes), Quebec, 1895–1913. Reprinted 1962.

Howes, Wright, *U.S.iana, 1650–1950, a selective bibliography in which are described 11,620 uncommon and significant books relating to the continental portion of the United States*, New York, 1962.

Lande, Lawrence Montague, *The Lawrence Lande Collection of Canadiana in the Redpath Library of McGill University*, Montreal, McGill University Press, 1965. First supplement, 1971.

Morgan, Henry James, *Bibliotheca Canadensis*, Ottawa, 1867. Reprinted 1968.

Sabin, Joseph, *Bibliotheca Americana: A Dictionary of Books Relating to America* (29 volumes), New York, 1868–1936. Several reprints.

Staton, Frances, and Marie Tremaine, *A Bibliography of Canadiana, being items in the Public Library of Toronto, Canada, relating to the early history and development of Canada*, Toronto, 1934. Reprinted 1965. First supplement, 1959.

CERAMICS

Collard, Elizabeth, *Nineteenth Century Pottery and Porcelain in Canada*, Montreal, McGill University Press, 1967.

Finlayson, R. W., *Portneuf Pottery and Other Early Wares*, Toronto, Longman, 1972.

Lambart, Helen H., *Two Centuries of Ceramics in the Richelieu Valley*, Ottawa, National Museum of Canada, Publications in History no. 1, 1970.

—————, *The Rivers of the Potters*, Ottawa, National

344

Museum of Canada, Publications in History no. 2, 1970.

Taylor, David and Patricia, *The Hart Pottery, Canada West*, Picton, Ontario, The Picton Gazette Publishing Co., 1966.

Webster, Donald B., *The Brantford Pottery, 1849–1907*, Toronto, Royal Ontario Museum, 1968. (Occasional Paper 13).

——, *Decorated Stoneware Pottery of North America*, Rutland, Vermont, Tuttle, 1971.

——, *Early Canadian Pottery*, Toronto, McClelland & Stewart, 1971.

——, *Early Slip-decorated Pottery in Canada*, Toronto, Musson, 1969.

——, *The William Eby Pottery, Conestogo, Ontario, 1855–1907*, Toronto, Royal Ontario Museum, 1971. (Occasional paper 25).

——, "The Beaver-and-Maple-Leaf Motif on Canadian Ceramics," London, *The Connoisseur*, February 1973, 117-123.

FAKES AND FAKERY

Cescinsky, Herbert, *The Gentle Art of Faking Furniture*, London, Chapman & Hall, 1931, and New York, Dover, 1967 (paperback).

Kurz, Otto. *Fakes*, London, Faber & Faber, 1948, and New York, Dover, 1967.

Yates, Raymond, *Antique Fakes and their Detection*, New York, Gramercy, 1950.

FIREARMS

Gooding, S. James, *The Canadian Gunsmiths, 1608 to 1900*, Ottawa, Museum Restoration Service, 1962.

——, (ed.), *The Canadian Journal of Arms Collecting*, Ottawa, Museum Restoration Service, 1963-——.

——, *The Gunsmiths of Canada*, Ottawa, Museum Restoration Service, 1974. (Historical Arms Series no. 14.)

FURNITURE
Canadian

Collard, Elizabeth, "Montreal Cabinetmakers and Chairmakers: 1800-1850," New York, *The Magazine Antiques*, May 1974.

Ingolfsrud, Elizabeth, *All about Ontario Chests*, Toronto, House of Grant, 1973.

MacLaren, George E. G., *Antique Furniture by Nova Scotia Craftsmen*, Toronto, Ryerson, 1961.

——, "The Windsor Chair in Nova Scotia," New York, *The Magazine Antiques*, July 1971.

Martin, Paul-Louis, *La Berçante québecoise*, Quebec, Editions du Boréal Express, 1973.

Minhinnick, Jeanne, *Early Furniture in Upper Canada Village, 1800–1837*, Toronto, Ryerson, 1964.

——, *At Home in Upper Canada*, Toronto, Clarke Irwin, 1970.

Palardy, Jean, *The Early Furniture of French Canada*, Toronto, Macmillan, 1963. Also in paperback.

Ryder, Huia G., *Antique Furniture by New Brunswick Craftsmen*, Toronto, Ryerson, 1965.

Shackleton, Philip, *The Furniture of Old Ontario*, Toronto, Macmillan, 1973.

Stevens, Gerald, *Early Ontario Furniture*, Toronto, Royal Ontario Museum, 1966.

Symons, Scott, *Heritage: A Romantic Look at Early Canadian Furniture*, Toronto, McClelland & Stewart, 1972.

American

Bishop, Robert, *Centuries and Styles of the American Chair, 1640–1970*, New York, Dutton, 1972.

Davidson, Marshall, (ed.), *The American Heritage History of American Antiques* (3 volumes), New York, American Heritage, 1968.

Downs, Joseph, *American Furniture: Queen Anne and Chippendale Periods in the Henry Francis du Pont Winterthur Museum*, New York, Macmillan, 1952.

Comstock, Helen, *American Furniture: Seventeenth, Eighteenth and Nineteenth Century Styles*, New York, Viking, 1962.

Kirk, John, *Early American Furniture*, New York, Knopf, 1970.

——, *American Chairs*, New York, Knopf, 1972.

Kovel, Ralph and Terry, *American Country Furniture, 1780–1875*, New York, Crown, 1965.

Montgomery, Charles F., *American Furniture: The Federal Period, 1788–1825, in the Henry Francis du Pont Winterthur Museum*, New York, Viking, 1966.

Ormsbee, Thomas H., *Field Guide to American Victorian Furniture*, Boston, Little Brown, 1952. Also in paperback.

——, *Field Guide to Early American Furniture*, Boston, Little Brown, 1952. Also in paperback.

Otto, Celia Jackson, *American Furniture in the Nineteenth Century*, New York, Viking, 1965.

Williams, H. Lionel, *Country Furniture of Early America*, New York, Barnes, 1963.

Winchester, Alice, (ed.), *The Antiques Treasury*, New York, Dutton, 1959.

Design Books

1762. Chippendale, Thomas, *The Gentleman and Cabinetmaker's Director*, London, 3rd ed., 1762. New York, Dover, 1966.

1794. Hepplewhite, A. and Co., *The Cabinet-maker and Upholsterer's Guide*, by George Hepplewhite, 3rd ed., 1794. New York, Dover, 1969.

1802. Sheraton, Thomas, *The Cabinet-maker and Upholsterer's Drawing-book*, 3rd ed., 1802. New York, Dover, 1972.

1807. Hope, Thomas, *Household Furniture and Interior Decoration*, New York, Dover, 1971.

1853. Blackie and Son, *The Victorian Cabinet-maker's Assistant*, New York, Dover, 1970.

GLASS

Bird, Douglas and Marion, and Charles Corke, *A Century of Antique Canadian Glass Fruit Jars*, London, Ontario, the authors.

Coburn, W. Newlands, "The First Quebec Glass Factory," Toronto, *Canadian Antiques Collector*, vol. 9 no. 3, May-June 1974, 93-97.

Collard, Elizabeth, "The St. Lawrence Glass Co.," Toronto, *Canadian Antiques Collector*, vol. 5 no. 8, September 1970, 12-13.

Holmes, Janet, "Canadian Glass Patterns," Toronto, *Canadian Antiques Collector*, vol. 5 no. 1, January 1970, 10-12; vol. 5 no. 5, May 1970, 14-17.

MacLaren, George E. G., *Nova Scotia Glass*, Halifax, Nova Scotia Museum, 1971. (Occasional Paper no. 4; Historical Series no. 1 (Revised)).

——————, "Some Thoughts on Canadian Glass," Toronto, *Canadian Antiques Collector*, vol. 5 no. 10, November 1970, 27.

Provick, A. M., "Beauséjour's Glass Works," Toronto, *Canadian Antiques Collector*, vol. 2 no. 1, January 1967, 7-10.

Robinson, Beth, "Canadian Glass," Toronto, *Canadian Antiques Collector*, vol. 5 no. 7, July-August 1970, 14-15.

Sheeler, John, "The Burlington Glass Site," Toronto, *Canadian Antiques Collector*, vol. 3 no. 4, April 1968, 7-9; vol. 3 no. 5, May 1968, 11-12; vol. 3 no. 6, June 1968, 18-20; vol. 3 no. 7, July 1968, 14-15; vol. 3 no. 11, November 1968, 10-12; vol. 4 no. 1, January 1969, 12-13.

Spence, Hilda and Kelvin, *A Guide to Early Canadian Glass*, Toronto, Longman, 1966.

Stevens, Gerald, *Early Canadian Glass*, Toronto, Ryerson, 1961. Also in paperback, 1967. The basic reference work on the Canadian glass industry.

——————, *Canadian Glass*, c. 1825–1925, Toronto, Ryerson, 1967. Also a basic reference.

——————, "Canadian Cut Glass," Toronto, *Canadian Antiques Collector*, vol. 2 no. 12, 7-9.

Thompson, John Beswarick, "Vaudreuil Glass Industry," Toronto, *Canadian Antiques Collector*, vol. 7 no. 6, November 1972, 39-42.

Unitt, Doris and Peter, *American and Canadian Goblets*, Peterborough, Ontario, Clock House, 1970.

——————, *Bottles in Canada*, Peterborough, Clock House, 1972.

——————, *Treasury of Canadian Glass*, Peterborough, Clock House, 1969.

Vienneau, Azor, *The Bottle Collector*, Halifax, Petheric Press, 1969.

Watson, George, and Robert Skrill, *Western Canadian Bottle Collecting* (2 volumes), Nanaimo, British Columbia, Evergreen Press, 1971.

IRON
Canadian

Bartlett, James, "The Manufacture of Iron in Canada," *Transactions of the American Institute of Mining Engineers*, XIV (1885-86), 508-542.

Donald, W. J. A., *The Canadian Iron and Steel Industry*, Boston and New York, Houghton Mifflin, 1915.

MacLaren, George E. G., *The Romance of the Heating Stove*, Halifax, Nova Scotia Museum, 1972.

Miller, Harry, *Canada's Historic First Iron Castings*, Ottawa, Department of Energy, Mines and Resources, Mines Branch, 1968.

Patterson, W. J., "The Long Point Furnace," Toronto, *Ontario Historical Society Papers* and *Records*, XXXVI, 1944, 70-78.

American/English

Gould, Mary Earle, *Antique Tin and Tole Ware*, Rutland, Vermont, Tuttle, 1958.

Kauffman, Henry J., *Early American Ironware, Cast and Wrought*, Rutland, Vermont, Tuttle, 1966.

Lindsay, J. Seymour, *An Anatomy of English Wrought Iron*, London, Alec Tiranti, 1964.

——————, *Iron and Brass Implements of the English and American House*, London, Alec Tiranti, 1970.

Lister, Raymond, *Decorative Cast Ironwork in Great Britain*, London, Bell, 1960.

Mercer, Henry C., *The Bible in Iron*, 3rd ed., Doylestown, Pennsylvania, Bucks County Historical Society, 1961.

Sonn, Albert H., *Early American Wrought Iron* (3 volumes), New York, Scribners, 1928.

Swank, James H., *History of the Manufacture of Iron in All Ages*, 2nd ed., New York, Burt Franklin, 1892.

LIGHTING

Hayward, Arthur H., *Colonial Lighting*, New York, Dover, 1962. Paperback.

Russell, Loris S., *A Heritage of Light*, Toronto, University of Toronto Press, 1968.

PEWTER AND COPPER

Kauffman, Henry J., *American Copper and Brass*, New York, Nelson, 1968.

——————, *Early American Copper, Tin, and Brass*, New York, Medill, McBride, 1950.

PHOTOGRAPHY

Greenhill, Ralph, *Early Photography in Canada*, Toronto, Oxford University Press, 1965.

Harper, J. Russell, and Stanley Triggs, (eds.), *Portrait of a Period: A Collection of Notman Photographs, 1856-1915*, Montreal, McGill University Press, 1967.

Newhall, Beaumont, *The History of Photography from 1839 to the Present Day*, New York, Museum of Modern Art, 1949.

——————, *The Daguerreotype in America*, New York, Duell, Sloan & Pierce, 1961.

Taft, Robert, *Photography and the American Scene: A Social History, 1839–1889*, New York, Macmillan, 1938.

PRINTS

Campbell, Henry C., *Bartlett's Canada*, Toronto, McClelland & Stewart, 1968.

de Volpi, Charles P. and P. S. Winkworth, *Montreal, A Pictorial Record* (2 volumes), Montreal, Dev-Sco Publications, 1963.

de Volpi, Charles P., *Ottawa, A Pictorial Record*, Montreal, Dev-Sco, 1964.

——————, *Toronto, A Pictorial Record*, Montreal, Dev-Sco, 1965.

——————, *The Niagara Peninsula, A Pictorial Record*, Montreal, Dev-Sco, 1966.

——————, *Quebec, A Pictorial Record*, Toronto, Longman, 1971.

——————, *Newfoundland, A Pictorial Record*, Toronto, Longman, 1972.

——————, *British Columbia, A Pictorial Record*, Toronto, Longman, 1973.

Godenrath, Percy F., *The Manoir Richelieu Collection of Canadiana*, Montreal, Canada Steamship Lines, 1939.

Harper, J. Russell, *Early Painters and Engravers in Canada*, Toronto, University of Toronto Press, 1970.

Hubbard, R. H., *Thomas Davies: An Exhibition Prepared by the National Gallery of Canada*, Ottawa, National Gallery of Canada, 1972.

Jefferys, Charles W., *A Catalogue of the Sigmund Samuel Col-*

lection of Canadiana and Americana, Toronto, Ryerson, 1948.

McCord Museum, *Scenes of Canada: C. Krieghoff Lithograph Drawings after his Paintings of Canadian Scenery, 1848–1862*, Montreal, 1972.

Robertson Collection, *Landmarks of Canada: A Guide to the J. Robertson Collection in the Public Reference Library, Toronto, Canada* (3 volumes), Toronto, 1917, 1921, 1964. Reprints of volumes 1 and 2, Toronto Public Library, 1967.

Ross, Alexander M., *William Henry Barlett*, Toronto, University of Toronto Press, 1973.

Spendlove, F. St. George, *The Face of Early Canada*, Toronto, Ryerson, 1958.

Webster, J. C., *Catalogue of the John Clarence Webster Canadiana Collection, Pictorial Section, New Brunswick Museum* (3 volumes), Saint John, 1939, 1946, 1949.

REFINISHING

Grotz, George, *From Gunk to Glow, or the Gentle Art of Refinishing Antiques and Other Furniture*, Deep River, Connecticut, New Era Press, 1960.

Marsh, Moreton, *The Easy Expert in Collecting and Restoring American Antiques*, Philadelphia, Lippincott, 1959.

SCULPTURE AND CARVING

Barbeau, Marius, *Louis Jobin statuaire*, Montreal, Librairie Beauchemin, 1968.

Harper, J. Russell, "Folk Sculpture of Rural Quebec," New York, *The Magazine Antiques*, April 1973, 724-733.

Lavallée, Gérard, *Anciens ornamentistes et imagiers du Canada français*, Quebec, Ministère des affaires culturelles, 1968.

Trudel, Jean, *Profil de la sculpture québecoise*, Quebec, Musée du Québec, 1969.

—————, *Un Chef d'oeuvre de l'art ancien du Québec, La Chapelle des Ursulines*, Quebec, Laval University Press, 1972.

SILVER

Langdon, John E., *Canadian Silversmiths and their Marks, 1667–1867*, Lunenburg, Vermont, the author, 1966.

—————, *Canadian Silversmiths, 1700–1900*, Lunenburg, the author, 1960.

—————, *Guide to Marks on Early Canadian Silver*, Toronto, Ryerson, 1968.

MacKay, Donald, *Silversmiths and Related Craftsmen of the Atlantic Provinces*, Halifax, Petheric Press, 1973.

Piers, Harry, and Donald MacKay, *Master Goldsmiths and Silversmiths of Nova Scotia*, Halifax, The Antiquarian Club, 1948.

Traquair, Ramsay, *The Old Silver of Quebec*, Toronto, Macmillan, 1940. Also in paperback, 1973.

Trudel, Jean, *François Ranvoyzé, Orfèvre, 1739–1819*, Quebec, Musée du Québec, 1968.

—————, *L'Orfèvrerie en Nouvelle-France*, Ottawa, National Gallery of Canada, 1974.

TEXTILES

Brett, K. B., *Ontario Handwoven Textiles*, Toronto, Royal Ontario Museum, 1956.

Burnham, Harold B. and Dorothy K., *Keep Me Warm One Night: Early Handweaving in Eastern Canada*, Toronto, University of Toronto Press, 1972.

Davison, M., and C. C. Mayer-Thurman, *Coverlets: A Handbook on the Collection of Woven Coverlets in the Art Institute of Chicago*, Chicago, Art Institute, 1973.

Spencer, Audrey, *Spinning and Weaving at Upper Canada Village*, Toronto, Ryerson, 1964.

TOOLS

Bealer, A. W., *The Art of Blacksmithing*, New York, Funk and Wagnalls, 1969.

Fussell, G. E., *Farming Techniques from Prehistoric to Modern Times*, Oxford, Pergammon, 1966.

Goodman, W. L., *The History of Woodworking Tools*, London, Bell, 1964.

Mercer, H. C., *Ancient carpenters' tools, illustrated and explained together with the implements of the lumberman, joiner and cabinet maker, in use in the eighteenth century*, Doylestown, Pennsylvania, Bucks County Historical Society, 1929.

Nelson, L. H., "Nail Chronology as an Aid to Dating Old Buildings," American Association for State and Local History, History News 24, no. 11, 1968.

Sloane, Eric, *A Museum of Early American Tools*, New York, Funk, 1964.

Smith, H. R. B., *Blacksmiths' and Farriers' Tools at Shelburne Museum*, Shelburne Museum, Museum Pamphlet no. 7, 1966.

Welsh, P.C., *Woodworking Tools 1600–1900*, U.S. National Museum, Bulletin 241, paper 51, 1966.

Wildung, F. M., *Woodworking Tools at Shelburne Museum*, Shelburne Museum, Museum Pamphlet no. 3, 1957.

TOYS

Séguin, R.-L., *Les Jouets anciens du Québec*, Ottawa, Lemeac, 1969.

Symons, Harry L., *Playthings of Yesterday*, Toronto, Ryerson, 1963.

TREEN AND WOODENWARE

Gould, Mary Earle, *Early American Wooden Ware, and Other Kitchen Utensils*, Rutland, Vermont, Tuttle, 1962.

Lantz, Louise K. *Old American Kitchenware*, New York, Nelson, 1970.

Phipps, Frances, *Colonial Kitchens, their Furnishings and Gardens*, New York, Hawthorne, 1973.

Pinto, Edward H., *Treen and Other Wooden Bygones*, London, Bell, 1969.

Séguin, R.-L., *Les Moules du Québec*, Ottawa, Queen's Printer, 1963. Musée national du Canada, Bulletin no. 188.

WEATHERVANES

Illustrated Catalog and Price List of Copper Weathervanes and Finials Manufactured by J. W. Fiske, 1875, facsimile edition by Gerald Kornblau Antiques, 250 East 58th Street, New York, 1964.

Fiske, J. W., *1893—Illustrated Catalog of Weathervanes*, Princeton, Pyne Press, 1971.

Fitzgerald, Ken, *Weathervanes and Whirligigs*, New York, Potter, 1967.

Museums with Canadian Antique Collections

NOVA SCOTIA

Barrington, Old Meeting House. Historic house (1765) museum.

Dartmouth, Dartmouth Heritage Museum. Historical museum (general).

Grand Pré, Grand Pré National Historic Park. Historical museum with emphasis on Acadian history.

Halifax, Nova Scotia Museum. General museum, with historical branch in the Halifax Citadel, and seven furnished historic houses located around the province.

—————, Public Archives of Nova Scotia. Art and history museum, with primary focus on picture and graphic material.

Louisbourg, Fortress of Louisbourg National Historic Park. Historic restoration, including both a history and archeological museum, and furnished restored buildings.

Mount Uniacke, South Roden Museum. Historical museum in 1867 building.

New Glasgow, Pictou County Historical Society Museum. Historical society museum.

Shelbourne, Ross-Thompson House. Historical society museum with historic house.

Wolfville, Wolfville Historical Museum. Historical society museum.

Yarmouth, Yarmouth County Historical Society. General historical society museum.

NEW BRUNSWICK

Dorchester, Keillor House Museum. Historic house (1813) museum.

Moncton, University of Moncton, Historical Museum. Museum focusing on Acadian history.

Saint John, Loyalist House. Historic house (1810) museum.

—————, New Brunswick Museum. General museum, including historical and decorative arts sections.

PRINCE EDWARD ISLAND

Misquiche, Acadian Museum of Prince Edward Island. General historical museum.

QUEBEC

Bonaventure, Musée Acadien Bonaventure. General history museum with historic house (1767).

Carillon, Argenteuil Museum. Historical Society with historic building (1829).

Ile-aux-Noix, Fort Lennon National Historical Park. Museum and furnished historic buildings.

Laurentide, Sir Wilfrid Laurier House. Furnished historic house (1840).

Montreal, Chapelle Notre-Dame de Bonsecours. Historical museum.

—————, Château de Ramesay Museum. Historical Society museum in historic house (1705).

—————, McCord Museum, McGill University. Art and decorative arts museum.

—————, Montreal Museum of Fine Arts. Large general art museum.

Pointe St-Charles, Ferme Gabriel. Restored house (1689).

Quebec City, Musée du Québec. Large general art museum.

—————, Musée du Séminaire de Québec. General historical museum, in historic building (1678–81).

Rock Island, Barn Museum. Historical society museum.

Sainte Luce, Musée, Histoire de Sainte Luce. Historical society museum.

Sawyerville, Compton County Historical and Museum Society. Historical society museum with historic building (1834).

Stanbridge East, Cornell Hill Museum. Historical society museum with historic building (1830).

Stanstead, Stanstead Historical Society. Historical society museum.

Vaudreuil, Vaudreuil Historical Museum. Historical society museum in historic building.

ONTARIO

Adolphustown, United Empire Loyalist Museum. Historical museum focusing on Loyalist immigrants.

Alliston, South Simcoe Pioneer Museum. General historical museum.

Almonte, Mill of Kintail Canadian Arts and Pioneer Museum. General art and historical museum, with three historic buildings (1830–67).

Bowmanville, Bowmanville Museum. Historical museum and historic building (1861).

Brantford, Brant County Historical Museum. General historical society museum.

—————, Westfield Pioneer Village. Restored pioneer village museum.

Cannifton, O'Hara Mill. Agricultural museum, with three historic buildings.

Cayuga, Haldimand County Museum. Historical society museum, with two historic buildings.

Doon, Doon Pioneer Museum.

Dundas, Dundas Historical Society Museum. Historical society museum.

Elora, Wellington County Historical Museum. Historical society museum.

Fenelon Falls, Fenelon Falls Museum. Historical society museum.

Gananoque, Gananoque Museum. General historical museum.

Goderich, Huron County Pioneer Museum. General historical museum, with two historic buildings, 1856 and 1875.

Grafton, Barnum Museum. Historic house (1813–15) museum.

Hamilton, Dundurn Castle. Large historic house (1832) museum.

Iroquois, Carmen House and Museum. Historic house (1805) museum.

Jordan, Jordan Historical Museum of the Twenty. Historical museum with two historic buildings, 1815 and 1856.

Kingston, Bellevue House. National historic house (1838) museum.

Kitchener, Ontario Pioneer Community Foundation. General historical museum and restored pioneer village.

Lang, Century Village. Pioneer village museum with four historic buildings, 1835–98.

London, Fanshawe Pioneer Village. Pioneer village museum with twelve historic buildings.

——————, London Public Library and Art Museum. Historical museum and historic house (1834).

Milton, Halton County Museum. Historical museum with one historic building (1874).

Morrisburg, Upper Canada Village. Large restored village museum, with 40 historic buildings.

Napanee, Lennox and Addington Museum. Historical society museum, with one historic house (1826).

Niagara-on-the-Lake, Fort George. Fort restoration, including furnished quarters.

——————, McFarland house. Historic house (1800).

Oshawa, Oshawa and District Historical Society. Historical society with two early houses, of 1846 and 1850.

Ottawa, Museum of Man, National Museum of Canada. Large general decorative arts collection.

——————, National Gallery of Canada. Paintings, photographs, watercolors and drawings, sculpture.

——————, Public Archives of Canada. Paintings, photographs, watercolors, prints, maps.

Pembroke, Champlain Trail Museum. Historical society museum with historic building (1838).

Penetanguishene, Naval and Military Establishment. Reconstructed military and naval site, including furnished buildings.

Peterborough, Peterborough Centennial museum. General historic museum.

Port Carling, Port Carling Pioneer Village. Historical society museum.

Richard's Landing, St. Joseph Island Museum. Historical society museum with three early buildings.

St. Mary's, St. Mary's District Museum. Historical society museum with two historic buildings, of 1850 and 1900.

Sault Ste. Marie, Ermatinger Old Stone House. Historic house (1814) museum.

Tetterville, Windham Township Pioneer Museum. Historic house (1849) museum, with additional building.

Toronto, Art Gallery of Ontario. Large art gallery, with one historic building (The Grange), 1817.

——————, Black Creek Pioneer Village. Large restored village museum, with 22 buildings, 1816–1867.

——————, Canadiana Department, Royal Ontario Museum. Major decorative arts museum.

——————, Toronto Historical Board. Historical agency with two museums (Fort York and Marine Museum of Upper Canada) and four other historic houses and buildings.

——————, Toronto Public Library. Print collection.

——————, Todmorden Mills Museum. Historical society museum with four historic buildings.

Wellington, Wellington Community Historical Museum. Historical society museum.

Windsor, Hiram Walker Historical Museum. History museum in historic house (1812).

MANITOBA

Emerson, Gateway Stopping Place Museum. History museum with three historic buildings of 1845–80.

Minnedosa, Minnedosa and District Pioneer Museum. General pioneer museum.

Selkirk, Lower Fort Garry National Historic Park. History museum and restored buildings.

Steinbach, Mennonite Village Museum. Historical society museum with two restored buildings of the 1880s.

Portage la Prairie, Fort la Reine Museum. History museum with restored stockade and village complex.

West Kildonan, Seven Oaks House Museum. Historic house museum.

Winnipeg, Manitoba Historical Society. Historical society museum, with historic house (Ross House) of 1854.

SASKATCHEWAN

Craik, Prairie Pioneer Museum. History museum with historic houses (1904).

Raymore, Raymore Pioneer Museum. Pioneer museum and historic house (1910).

Regina, Saskatchewan Archives. Provincial archives.

Saskatoon, Museum of Ukrainian Culture. Ukrainian history museum.

——————, Western Development Museum. General historical museum with four historic houses (1882-1905). Branches at Yorkton and North Battleford.

Weyburn, Soo Line Historical Museum. Historical society museum with two historic houses.

ALBERTA

Calgary, Glenbow-Alberta Institute. Collection largely paintings and graphics; no object-antiques collection.

Fort MacLeod, Fort Macleod Historical Association. Museum and two historic houses, of the 1880s.

Hanna, Hanna Pioneer Museum. General historical museum, with four furnished historic houses of the early 20th century.

Willingdon, Historical Village and Pioneer Museum. Historical museum with four restored houses of the 1890–1910 period.

BRITISH COLUMBIA

Barkerville, Barkerville Historical Park. Restoration of the Gold Rush Town of Barkerville, c. 1870–1885, plus one additional historic house.

Fort Langley, Fort Langley National Historic Park. Site of Hudson's Bay Company post of 1827–95.

——————, Langley Centennial Museum. General historical museum.

Fort Steele, Fort Steele Historic Park. Historical site and restored village complex of the 1860–1900 period.

New Westminster, Irving House Historic Centre and Museum. William Irving house of 1862.

Vancouver, Vancouver Art Gallery. Large art museum, with primary focus on painting and sculpture.

Victoria, Art Gallery of Greater Victoria. Art museum, with historic house (Spencer Mansion).

——————, Maltwood Memorial Museum of Historic Art. General history and decorative arts museum.

——————, Provincial Archives of British Columbia. Historical museum, with two historic houses, the Helmcken House of 1852 and Craigflower Manor of 1855.

UNITED STATES

Detroit, Michigan. Detroit Institute of Arts. French-Canadian furniture and silver.

Washington, D.C. Smithsonian Institution. Small general group of French-Canadian furniture and artifacts.

Picture Credits

Photograph credits & page references (incl. color)

Henry Birks Collection, Montreal. 154, 155, 158, 160.

Canadian Pacific. 104.

James Chambers, Royal Ontario Museum. 19, 21, 25, 37, 40, 43, 45, 49, 51, 52, 56, 57, 58, 59, 60, 61, 63, 64, 67, 79, 81, 82, 84, 85, 87, 92, 99, 111, 113, 116, 120, 125, 136, 139, 141, 145, 149, 153, 170, 217, 221, 242, 245, 247, 251, 254, 263, 274, 279, 297, 300, 301, 304.

Luc Chartier. 17, 20.

Elizabeth Collard (courtesy of). 257-262; 264-266 inclusive.

Dominion-Wide, Ottawa. 101.

S. James Gooding. 207, 209, 211.

Rob Gordon, Toronto. 133, 134.

Ralph Greenhill. 333.

Peter Hart, Sackville, N.B. 97.

Harvey Studios, St. John. 97, 100, 101, 105, 107, 109.

Hayward Studios, Montreal. 19, 33.

Janet Holmes. 194, 195, 218.

Jones & Morris, Toronto. 43.

A. Lynn McMurray. 131, 133, 134, 137, 138.

Ron Merrick, Nova Scotia Museum. 72, 73, 75, 76, 78, 82, 83, 87, 88, 89.

Joe Michaud, St. John. 104, 105.

Ian Morgan, Montreal. 72.

Musée Notre Dame, Montreal. 147.

National Gallery of Canada. 38, 39, 44, 46, 48, 329, 331, 334, 336.

New Brunswick Museum. 93, 103, 106.

Pope Studios, St. John. 102.

Public Archives of Canada. 328, 332.

Quebec Museum. 47, 188, 189, 199.

Huia Ryder. 93, 108.

Toronto Public Library. 315, 316, 318-326 incl.

Leigh Warren, Royal Ontario Museum. 13, 14, 15, 16, 19, 26, 27, 28, 29, 31, 33, 34, 35, 38, 39, 41, 44, 50, 52, 54, 55, 62, 65, 66, 68, 69, 78, 90, 95, 114, 115, 117, 118, 122, 123, 124, 126, 127, 130, 131, 140, 144, 147, 148, 150, 151, 152, 155, 157, 180, 182, 184, 185, 190, 192, 206, 207, 209, 210, 211, 215, 222, 241, 248, 250, 252, 253, 270, 271, 272, 273, 275, 277, 284-295; 298-312 incl., 314, 317.

D. B. Webster. Jacket, 32, 42, 129, 131, 132, 133, 135, 142, 162, 165, 166, 167, 168, 169, 171, 172, 173, 175, 179, 180, 183, 185, 188, 190, 193, 194, 195, 196, 197, 198, 200, 205, 208, 218, 219, 222, 224, 225, 226, 229, 231, 232, 234, 236, 237, 238, 241, 244, 245, 246, 248, 249, 253.

Index